# THE POPULAR CULTURE OF MODERN ART

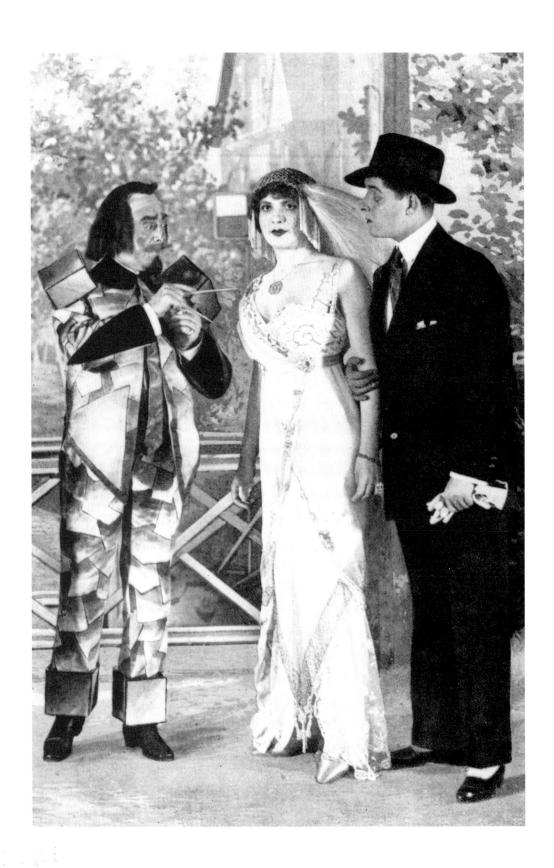

# THE POPULAR CULTURE
# OF MODERN ART

## PICASSO, DUCHAMP, AND
## AVANT-GARDISM

Jeffrey Weiss

Yale University Press
New Haven and London
1994

**Library of Congress Cataloging-in-Publication Data**

Weiss, Jeffrey S.
The popular culture of modern art:
Picasso, Duchamp, and avant-gardism, c. 1909-17/Jeffrey S. Weiss.
p. cm.
Includes bibliographical references and index.
ISBN 0-300-05895-0
1. Cubism - France.  2. Avant-garde (Aesthetics) - France - History -
20th century.  3. Modernism (Art) - France.
4. Picasso, Pablo, 1881-1973 - Criticism and interpretation.
5. Duchamp, Marcel, 1887-1968 - Criticism and interpretation.
I. Title.
N6848.5.C82W45   1994
700′.944′09041 - dc 20

94-892
CIP

A catalogue record of this book is available from The British Library

Designed by Miranda Harrison
Set in Sabon by Best-set Typesetter Ltd., Hong Kong
Printed in Hong Kong through World Print Ltd

Frontispiece: Armand Berthez as a cubist painter in *Et Voila!*, Théâtre des Capucines (1911).

For my parents
Tamar and Emil Weiss

# CONTENTS

# ACKNOWLEDGMENTS

Research for this book was conducted at a number of institutions, to the staff members of which I would like to extend my thanks: In New York, the libraries of the Institute of Fine Arts, the Metropolitan Museum of Art and the Museum of Modern Art, as well as the New York Public Library and the Performing Arts Research Center. In Washington D.C., the library of the National Gallery of Art and the Library of Congress. In Paris, the Bibliothèque Nationale, the Bibliothèque de l'Arsenal, the Bibliothèque de l'Opéra, the Bibliothèque Littéraire and Bibliothèque d'Art et d'Archéologie Jacques Doucet, the Bibliothèque Forney, the Bibliothèque Historique de la Ville de Paris, the Musée Picasso, the Musée de Montmartre, the Musée de Publicité, the Musée des Arts Décoratifs, the Centre Georges Pompidou and the Gallery A l'Imagérie.

A large share of my work was pursued on a Paul Mellon Fellowship (1987 to 1990) offered by the Center for Advanced Study in the Visual Arts in Washington, where I was in residence during 1989 and 1990. I am most grateful to the Center for its generous support and its resources. From the staff and the fellows during my tenure there, I received invaluable benefits of friendship and exchange, fond memories of which I carry with me.

Sincerest thanks go to Robert Lubar, whose contribution as a reader of this work in thesis form was generous and valuable. Roger Shattuck also read an early version of chapter two, and I benefited from his suggestions. At Yale University Press, it has been a genuine pleasure to work with Gillian Malpass, Miranda Harrison and Sheila Lee. For the support of friends and colleagues, I thank Jonathan Weil, Christopher Porter, Matthew Armstrong, David Cottington, Melanie Facchetti, Gertje Utley and Charles Moffett. Victoria Garvin, Leslie Furth, Meagen Teare, Helen Tangires, Mark Greenberg and France Mazin provided many practical contributions, and I am grateful to them.

I want to express deep gratitude to Kirk Varnedoe and Robert Rosenblum for the example they set, and for their support. It was a great privilege to study with them at the Institute of Fine Arts. I am also indebted to William Rubin, whose classes on cubism shaped my appreciation of the field.

Above all, I devote the profoundest appreciation to my wife, Stephanie Carroll, whose influence is everywhere felt, for the exquisite quality of her love, support and – not least – good humor.

# ILLUSTRATIONS

# PREFACE

This book is based on a simple assumption: that the chief experience of modern art has, throughout the art history of this century, been one of incomprehension. This is perhaps most notably the case in French avant-garde art around cubism, which is my focus of study. The mystifying effect of emerging modernism is an old story: few sentiments of art criticism are as familiar as the charge "modern art is a hoax." In the case of the war period, the extent of the disbelief with which cubism and related schools were received was actually proportional to the amount of ink that was spilled in statements intended to explain the work. Above all, the degree of debate over this matter at the time says a great deal about the difficulty of the art itself, much of which historical perspective encourages us to neglect. Study makes familiar, and the long historiography of modernist studies has distanced us from the disorientation of rapid change, and certainly from the startling peculiarity of a cubist portrait or still-life collage.

Recovering that experience would, of course, be impossible and of little real value. In any case, the act of writing history generally serves, through fact or interpretation, to resolve the contradictions and vagaries that comprise our imperfect grasp of events in the past. In many ways, it resists the state of doubt that is implied by re-envisioning that portrait or collage as a bewildering thing. Moreover, the deliberate formal ambiguities of cubism have long been co-opted and subjected to a highly cultivated appreciation that has taken generations of scholars to develop and refine. By now, these qualities are even recognized as a governing precept of modernism in all the arts during this century – the structural and narrative disjointedness that has become a cliché of modern experience. Consequently, we have neglected the rapport between the visual *esthetics* of ambiguity and the sheer uncertainty that distinguished the overall esthetic experience of early modernism.

This uncertainty or incomprehension is fundamental, a kind of principle at large that influenced the exchange of new ideas. My study is intended to chart the intellectual history of this issue, defining some of the mechanisms and implications of this quality of esthetic life. I have derived the terms of this history from period criticism, particularly non-specialist opinion (much of it derisive or parodic) concerning the new schools of painting, for this represents the discourse of mystification and incoherence. Pablo Picasso and Marcel Duchamp are featured here above all for the deliberate irony that they practice, an irony that enables us to approach their work as a critical tool, and to recognize that it both emerges from and *addresses* the development of advanced art. My narrative of the period is pervaded by a dynamic of insiders and outsiders that operates not only between artists and spectators, but among modernists themselves. Picasso and Duchamp epitomize this.

During the years under consideration here, they function within the modernist community yet largely stand apart from the manifestos and *salons* that occupied their colleagues; and while their work played to a relatively small audience, its ironic content might be said, in part, to have taken the new incomprehension as a theme. In this respect, there exists a curious symmetry according to which complaints and sarcasm in the popular critical press closely correspond to the devices (such as parody) with which Picasso and Duchamp established their own distance from the general practice of modernism.

I use the terms "modernism" and "avant-garde" somewhat interchangeably here. In this, I am writing against the grain of a popular and influential theory of the avant-garde by Peter Bürger.[1] He distinguishes modernism from the avant-garde: the one, an estheticist critique of the bourgeois value system that was itself ultimately bound up in the bourgeois institution of art; the other, a separatist "self-criticism" of the status of that institution from the outside which was intended to reintegrate or sublate art into a new praxis of social life. Theories of the avant-garde (I stress Bürger because his conclusions inform so much recent work, but am referring here to most theories of "advanced" art) require us to address the phenomenon as a unified project of shared purpose, definable goals and quantifiable success or failure. While such an argument is attractive in the abstract, and manages to comply with a handful of examples, it bears little applicable relation to the daily circumstances of pre-war cultural history as they reveal themselves to students of the archive – the art, press and random documents of the period. More developments at the time tend to confute the theory rather than prove it, and proscriptive definitions of convenient terms such as modernism and the avant-garde serve mostly to provide a false sense of security, dulling our intuitive grasp of predominating incongruities and conflicts.

The life of the new art in the public domain shows that the avant-garde was intriguingly ill-defined, and treated by its audience more as a perceived syndrome of novelty and rampant self-promotionalism than a concerted enterprise of originality or advance. As far as we can tell, spectators could not reconcile theoretical discussions of the art with their experience of the art itself. While the tendency is to correct this perception with historical perspective, by extracting intentions or motivations and ideologies in order to define a programmatic notion of the avant-garde, the extent to which this conflict just cannot be resolved is often ignored. If, instead, we restore the tangled mess, or at least describe the devices that best express essential ambiguities of the period, then we can address a quality of early modern esthetic experience – its peculiar *confoundedness* – that seems to have been more broadly shared than any other.

A hostile climate for new art is hardly new to cubism, and the provocation of modern style, since the generation of 1830 at least, is an obvious touchstone for the early twentieth century. Yet, this issue during the pre-war period in Paris, roused a debate of curious proportions. Opposing claims argued that the new art was either visual gibberish or a form of higher truth. Such conflicting extremes further suggest that the polemic of incomprehension is a compelling frame of reference for more familiar historical questions of meaning, intention or ideology. Inevitably, an emphasis on the general audience for modern art draws our attention to the role of popular or mass culture. Various applications of popular culture are germane. Picasso's collages and Duchamp's readymades actually incorporate the materials of popular consumption, the printed paper

and hardware of material culture. Further, certain intangible elements of popular culture, that were appropriated by Picasso and Duchamp, actually recapitulate the insider-outsider dynamic of avant-gardism through expressive means such as encoded allusion and bluff. This particularly applies to forms of humor such as verbal play, parody, irony and the practical joke, strategies that implicate the intellectual history of incomprehension, and are exploited by these two artists in direct conjunction with the difficult reception of modernism in general. Again, their use of popular culture will be seen to mirror the interpretation of the avant-garde as a confederacy of hoax. For example, the parodic incorporation of cubism into popular theater or advertising constitutes a challenge to the proper comportment of modern style that Picasso and Duchamp actually share with critics of the art.

Ultimately, by "the popular culture of modern art," I mean both the sources for new art that were derived from popular culture, and the progress of the art as it was interpolated back into popular esthetic experience. The role of popular culture does not turn here on a point of subversive intent, of mass culture being elevated by artists into the realm of "high art," or of painting and sculpture being indecorously dressed down. As a tidy contrast, this arrangement is clearly inadequate to the record of period discourse, as well as the art itself. At stake, instead, is the growing malleability of these categories of cultural experience during the period, the manner in which elements of new art and popular culture might, at times, be appreciated as part of a single train of thought. The esthetic life of the epoch can be addressed broadly in this way, as a realm of activity and paradoxical discourse in which the devices of innovation that are drawn from popular stock (long familiar in that context to the audience for new art) resemble the terms of popular incomprehension.

<p align="center">✳    ✳    ✳</p>

Writing on the state of contemporary art in 1913, critic Arsène Alexandre compared painting to more practical categories of visual culture. While painting is constrained to evoke ideas or emotions by means of "objects represented with the aid of lines and colors on a surface," it is otherwise liberated from pragmatic demands. Unlike the architect or the fashion designer, for example, the painter is free to exhibit and sell sketches, to market his "intentions." Rather than fully represent an object, he can abbreviate its form, and require his audience to infer its identity. In this sense, "the artist's audacity has as its accomplice the spectator's fear of passing as unintelligent or deprived of taste." Two other approaches to representation are presented as faulty extremes: *trompe-l'œil*, which is exact but inexpressive or banal, and conceptual art, a pictorial "ideology that expresses itself by means of signs that will be intelligible to [the artist] alone."[2]

In the end, however, Alexandre observes that the sketch itself – the pictorial intention or *à peu près* – is open to the same risk: on one side, a kind of prosaic simplification; on the other, a kind of abstraction "that only the *initiés* to the philosophy or the cult that inspired them" are able to understand. He identifies two primary exponents of the latter; "certain symbolist painters" and "artists who, in our epoch, have been seduced in good faith by the abstract ideal of cubism." Quoting from Maurice Raynal, Guillaume Apollinaire, Albert Gleizes and Jean Metzinger (the official literature of the cubist move-

ment), Alexandre explains that the cubists have sought to substitute "reality of conception" for "reality of vision," attempting "to represent at one time, on the same surface and the same points of that surface, aspects of the object that we see, and other, intercepted aspects as we know they exist." Ultimately, conceptual reality isolates the artist within his own intentions, and deprives him of the power to communicate to the outside, to "the most enlightened or the most obtuse passer-by."[3]

Just as Alexandre's polarity of insiders and outsiders brackets the development of new art, his two hazardous extremes of painting – *trompe-l'œil* versus art as a system of signs – quite accurately, if by accident, characterize a single body of work, that of collage cubism. Collage was both a popular and private affair. With its co-ordination of the painted or pasted paper imitation of material surfaces and the abstract representation of pictorial signs (indeed, its characterization of *trompe-l'œil* and the verbal typography of ordinary printed matter *as* a series of pictorial signs), collage almost symbolizes the tension between popular culture and incomprehension in modern art of the pre-war period. Further, possessed of an iconography that could hardly have been more familiar, the works existed in their time at a considerable remove from popular consumption. This is true both of the *un*familiar and *in*accessible pictorial language with which they express their meaning to the spectator, and, especially in the case of Picasso and Braque, of the relatively small degree of public exposure the works actually received.

It would be a mistake, however, to think of collage as an unknown quantity. References in the critical press that acknowledge its arrival as an innovation are easy to overlook, simply because they treat collage with the same scorn that was directed in general at young art before the war. "Have you seen Picasso's still lifes at Kahnweiler's, or those reproduced in the *Soirées de Paris*?," asked one spectator of another in an imaginary dialogue at the Salon d'Automne, written for the periodical *L'Occident* in 1913:

"The ones composed of newspaper fragments and wooden cut-outs?"
"Also the one where you see the lid of a cardboard box with the inscription 'Au Bon Marché, Rayon de Mercerie,' and the other, where violin strings are displayed on a kitchen oilcloth. Is it a mystification?"
"More, I think, an auto-suggestion."
"What do you mean?"
"That unconsciously, all these painters – if we can still call them that – strain to find new amazements. These are challenges that they throw, a mad, perpetual one-upmanship."[4]

For all practical purposes, these amateurs of the popular press are the same confounded spectators to which Alexandre refers in his own account of cubism that year. Reading the two references together, we see how readily informal charges of mystification and mere novelty (leitmotifs of the period to which we will return) closely compliment the specialist's disquistion on the hermeticism of conceptual art. Between the *initié* and the *mystificateur*, the sign language of cubist collage sponsors an affinity of opposites, and it is important to appreciate that, even now, the use of popular materials in collage constitutes a peculiar hybrid – what might be described as an encoded colloquialism.

Collage is composed of popular source material and rarefied esthetic meaning. As a

neologistic vocabulary of words and images that was formed according to its iconography within the setting of the café, it asks us to consider whether this apparent disparity can itself be traced to a popular source. In fact, it is to an extension of café and cabaret culture that we might turn for an intellectual history of collage. Contemporary entertainment at the music-hall suggests that collage is not just an esthetic manipulation of popular culture, but the appropriation from popular culture of a readymade esthetic system, a modish comic genre in which the placement of popular materials in the service of private meaning was already well-established as an instrument of modern style.

While the pre-war collage œuvre in general is open to study in these terms, Pablo Picasso's work contains a summation of relevant devices and motifs. I will pursue these in chapter one.

There is [in the music-hall] a certain satirical or skeptical attitude towards the commonplace, there is an attempt to turn it inside out, to distort it somewhat, to point up the illogicality of the everyday. Abstruse, but – interesting.

V.I. Lenin to Maxim Gorky, 1907

# CHAPTER I

# "LE JOURNAL JOUÉ"

## PICASSO, COLLAGE, AND MUSIC-HALL MODERNISM

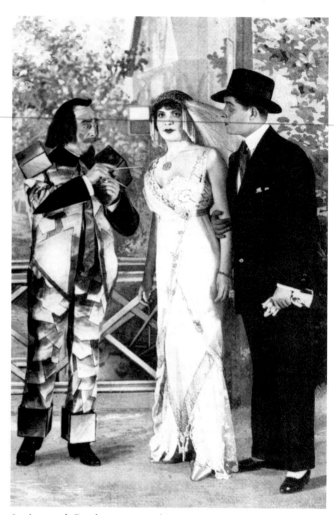

1. Armand Berthez as a cubist painter in *Et Voila!* at the Théâtre des Capucines (fall 1911).

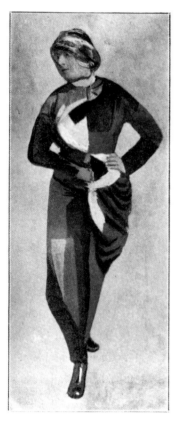

2. Sonia Delaunay modelling her "simultaneous dress" (1913).

# —1—

Cubism hit the music-hall stage for the first time on October 12, 1911. The occasion was a *revue* in two acts and three *tableaux* by Robert Dieudonné entitled *Et Voilà!*, and performed at the otherwise "straight" Théâtre des Capucines. Included among the cast of characters was a *cubiste*, played by the director of the Capucines himself, M. Armand Berthez (fig. 1). His costume consisted of a conventional man's suit that had been painted with overlapping polygons, with cubes attached at the shoulders and the trouser cuffs. The gag is that cubists parse even the most unlikely things into small, carefully calculated units of geometrical shape; the cubist painter is shown in production photos for *Et Voilà!* "demonstrating his theories of art and measuring with a compass the charms of the *commère*."[1] The critic for *Comoedia* thought *Et Voilà!* "smart, licentious, a bit naughty, ironical, lively, exhuberant, spirited. It mocks everything, including itself."[2] The cubist costume is, of course, meant to be utterly ridiculous, a joke. It also predates, by two years, Sonia Delaunay's earliest application of orphic-cubism to clothing design (fig. 2), and, by six years, Pablo Picasso's costumes for the music-hall styled ballet *Parade*, the début of cubism on the modernist stage.

At virtually the same moment in 1911, the music-hall appeared for the first time in a cubist picture: towards the bottom of a canvas representing a seated woman, Picasso inscribed the phrase "ma jolie" (fig. 3). These words, a pet name for the artist's new lover Eva,[3] were extracted from the refrain of the popular song "Dernière chanson," which begins "O Manon, ma jolie . . ." The two verses of the song were written by H. Christiné to music by Harry Fragson, but the words of the refrain were written by Fragson and set to a melodic "motif" from a piano dance by Herman Finck originally called "In the Shadows."[4] Fragson was an immensely popular *chansonnier* of the pre-war period who wrote and performed songs in both French and English (fig. 4) and on October 1, 1911, he introduced "Dernière chanson" at the Alhambra music-hall. *Le Journal* reported throughout October on Fragson's nightly performances at the Alhambra. Every concert was sold-out and the performer was greeted with "delirious" applause.[5] A number of his new songs received instant public acclaim, but the "ma jolie" refrain of "Dernière chanson" was particularly visible, appearing as a miniature musical score in the theater pages of daily newspapers such as *Excelsior* and *Le Journal* (fig. 5).[6] It soon became a fashionable dance tune played as a tango by "gipsy" orchestras (the words refer to a tune that "the *tziganes* play"); such was the case at the Cabaret l'Ermitage on the boulevard de Clichy, where the Picasso circle could often be found around 1911 and 1912.[7] *Ma Jolie* is undated, but given the vast proliferation of popular songs at the time and the speed with which one hit followed another, it seems likely that Picasso first reproduced the lyric in October, when the song was fresh in vogue.[8]

Between the cubist painter in *Et Voilà!* and the song lyric in Picasso's *Ma Jolie* there is an open channel. Identifying music-hall style in modern painting is a function of mapping the territory which they share. While the music-hall might, from our vantage, seem like a mere frivolity, it actually enjoyed great favor during the early twentieth century as a peculiarly modern entertainment charged with an exhilarating capacity for novelty and

3. Picasso, "*Ma Jolie*"; *Woman with a Zither or Guitar* (1911–12).

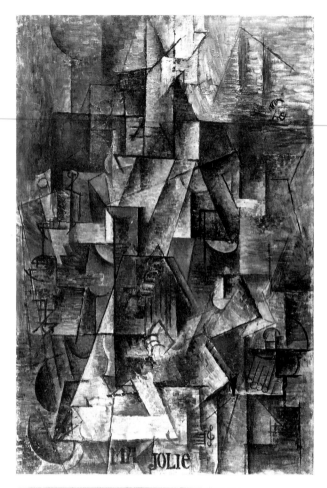

4 (below left). Harry Fragson at the Alhambra music-hall (1911).

5 (below right). The "ma jolie" refrain from *Dernière chanson*, in *Excelsior* (1911).

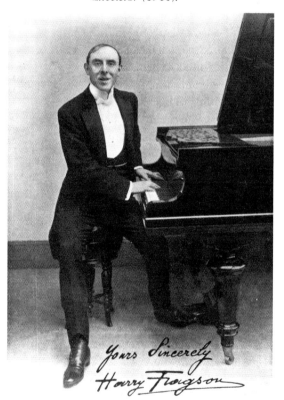

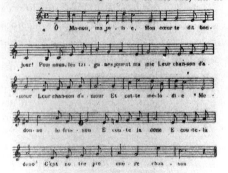

## Une des chansons de Fragson à l'Alhambra

Un air délicieusement prenant dont les orchestres de tziganes ont fait la vogue et que tout Paris fredonne, d'exquises paroles pouvant être chantées par tout le monde, un ar-

tiste merveilleux qui la détaille avec un art unique : voilà ce qui explique le succès qu'obtient *Fragson* tous les soirs à l'Alhambra dans la romance *Dernière chanson*. La musique est

surprise.[9] In 1913, F.T. Marinetti devoted an entire futurist manifesto to the music-hall, hailing it as nothing less than "the crucible in which the elements of an emergent new sensibility are seething."[10] Later, Jean Cocteau was equally direct: "That force of life which expresses itself on a music-hall stage renders all of our audacities obsolete at first glance."[11] In fact, the history of pre-war music-hall performance opens a window onto the comedics of early modernism, a structure and iconography of parody, irony and play. In Picasso's collages, music-hall manner is pervasive, and it asks us to integrate and reconcile serious esthetic purpose with a subversive practice of serious fun.[12] The music-hall permits us to address Picasso as a comic artist as well as a metaphysician of the picture plane, and to return collage cubism to its place within a larger cultural expression – to re-envision cubism as a contraption of the pre-war years.

<div align="center">—2—</div>

The music-hall (what is now often referred to as "vaudeville") is a progeny of the mid-nineteenth century *café-chantant* and *café-concert*. Its shared origins in London and Paris are betrayed by French retention of the English genre name: *le music-hall*. Music-hall performance is distinguished by its variety; the Edwardian term "variety theater," a synonym for the music-hall, was devised to emphasize the difference. *Café-concert* shows were comprised largely of song (though the songs came in an assortment of genres, from the sentimental to the nonsensical, to the crude and obscene), while music-hall incorporated song within a larger *spectacle*. Across the music-hall stage might pass, in rapid turn, circus acrobatics, juggling, sports, magic, animal acts, comic sketches, cinema (beginning in the 1890s) and *défilés* of lavish costume and female flesh.[13] Such performances were available to a wide range of socio-economic classes. There was also a good deal of mix and crossover between types of patron; workers and *petites employées* could occupy the cheap gallery seats at expensive halls such as the Folies-Bergère or Olympia, while the *haute-bourgeoisie* might seek out the greater abandon of a more "popular" theater such as La Pépinière.[14]

By 1900 the music-hall was no longer a new institution; but it had been renewed. In Paris, it was recognized as something outlandish and fundamentally modern. The French had intensified every aspect of their music-hall performance: the lavishness of the *spectacle*, the liberal sexuality of the chorus line, the energy and speed of acrobatic and slapstick *numéros* (under the influence of the English), the raucousness of the music and the bite of the satire. The *café-concert* and music-hall can never be entirely disentangled, yet we can and do speak of the gradual death of the *café-concert*. Writing in *Gil Blas* in 1901, one critical observer reported that the music-hall, "sensational, paradoxical, ultra-modern," had definitively replaced the cabaret, the *café-concert* and the theater, which were too attached to conventional formulas.[15] As late as 1912, a critic could still refer to the music-hall as a "new genre which will engender the fusion of two pleasures which were once distinct: that of the *café-concert* and that of the circus."[16] Marinetti was reflecting common, even established, pre-war sentiment when, in 1913, he extolled the music-hall for having "no tradition, no masters and no dogma."[17]

Our knowledge of Picasso's theater-going habits is largely dependent upon the recollec-

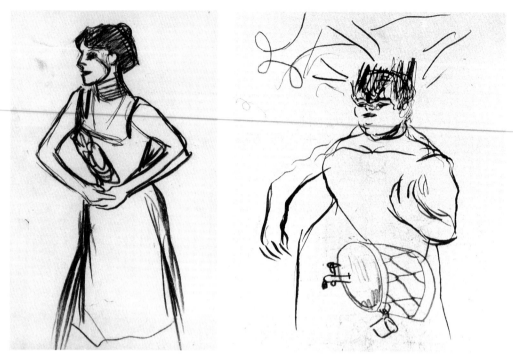

6. Picasso, sketch of a *café-concert* singer    7. Picasso, sketch of Jeanne Bloch (1901–2).
(1901–2).

tion of others in his circle. Picasso left no written memoires, and from about 1906, his art
grows increasingly less illustrative of life outside the studio and the café. The artist's
passion for acrobatic performances at the *fêtes forains* or outdoor, itinerant fairs which
took place on the streets and the *terrain vague* of Montmartre, is clear from his œuvre of
1903 to 1905, where *saltimbanques* figure in such large quantity. We have also long
known of Picasso's assiduous attendance of the Cirque Medrano. All of his closest friends
have attested to his delight in the slapstick antics of circus clowns, though it remains
curious that there is little if any real visual evidence of the clown, as opposed to the
*saltimbanque*, in his pre-war work.[18]

The visual record of Picasso's early work from Paris does, however, reveal the larger
scope of his taste in entertainment. The young Spaniard, new to Paris, was a *habitué* of the
*café-concert* and music-hall. In addition to a large number of drawings, pastels and
paintings in the manner of Degas and Toulouse-Lautrec, a half-dozen extant *carnets* from
1900 to 1902 contain some fifty sketches by Picasso of performers and spectators
(fig. 6).[19] These are probably studies for illustrations that he created for the magazine
*Frou-Frou* and the newspaper *Gil Blas* around that time, and for a contemporaneous
album of portraits commissioned by Gustave Coquiot.[20] While Picasso's compatriot
Carlos Casagemas tells us that he spent some evenings at the rougher music-halls of
Montmartre,[21] Max Jacob relates that Picasso also frequented the Moulin-Rouge, the
Casino de Paris and other fashionable halls, where he made the acquaintance of great stars
such as Liane de Pougy, "la belle" Otero and Jeanne Bloch.[22] Bloch, who built her career

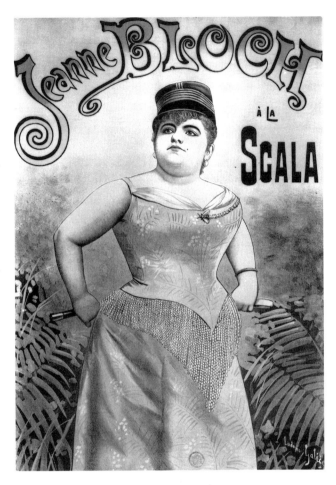

8. Ludovic Galice, poster for Jeanne Bloch at La Scala music-hall (1890s).

upon a rotund physique and an equally broad comic manner (often comprised of vulgar jokes about her own size and weight), is easy to spot among Picasso's sketches (fig. 7). Her speciality during the 1890s had been the burlesque of military life, an unusual genre for a woman, for which she appeared in an army *kepi* wielding a riding crop or a snare drum (fig. 8). Bloch was a headliner at the Cigale music hall in Montmartre throughout Picasso's early visits to Paris.[23] Since Picasso depicts her with a military drum, it is likely that he sketched her in a performance of *A nous la veine!*, the only Cigale *revue* of the period in which Bloch played roles typical of her celebrated *café-concert* persona, in this case a *député* from Dunkerque and a *majoresse*.[24]

Fernande Olivier, who lived with the artist from 1904 to 1912, remembers that Picasso "loved risqué cabarets and music-halls."[25] Members of Picasso's circle such as Olivier, D.-H. Kahnweiler and André Salmon also describe *soirées* at the Bateau-Lavoir studio and the bistros "chez Azon" and "chez Vernin", during which they were all entertained by Max Jacob, whose speciality was sentimental and comic songs from the past and present *café-concert* and music-hall repertory.[26] Nevertheless, the next introduction of the music-hall into Picasso's work comes with the song lyric "ma jolie," which will recur throughout the

pictures of 1911 to 1914. Then, during the fall of 1912, Picasso pasted sheet music onto a sequence of five collages. These pages are clipped from two other songs of the sentimental *café-concert* or music-hall variety: "Trilles et Baisers" ("Trills and Kisses") and "Sonnet" (figs. 9 and 10).[27] The first series of collages in which the pasted papers are bound by a single iconographical theme, these pictures signal a renewed significance of music-hall and popular song culture for the artist.

The case of "Sonnet" is particularly intriguing. The song was published in 1892, twenty years before Picasso pasted it down.[28] In *Violin and Sheet Music* (see fig. 10), page one of the song tells us that words by Pierre Ronsard have been set to music by Marcel Legay, who introduced the song during a *soirée artistique* at the Eldorado. Legay had been one of the great cabaret and *café-concert* singers of the 1890s, a legendary "bard of Montmartre";[29] the Eldorado, on the boulevard de Strasbourg, was the oldest and most venerable music-hall in Paris, yet celebrated throughout 1914 for its dedication to conserving the tradition of *café-concert* song recitals.[30] The "Sonnet" collages resonate not only with the history of the French *chanson*, but with Picasso's own history as a patron of popular song in Paris. During his nine years in Montmartre, the artist's circle spent

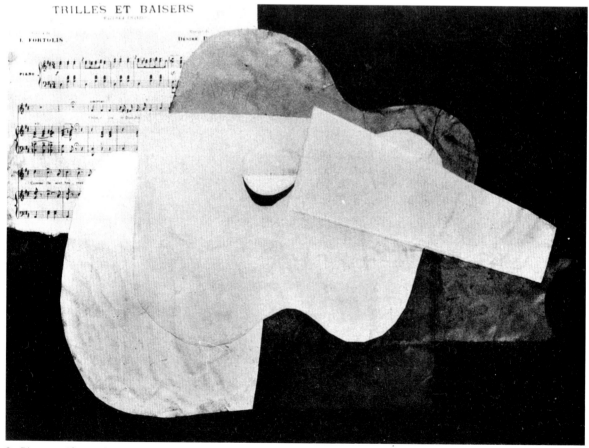

9. Picasso, *Sheet of Music and Guitar* (fall 1912).

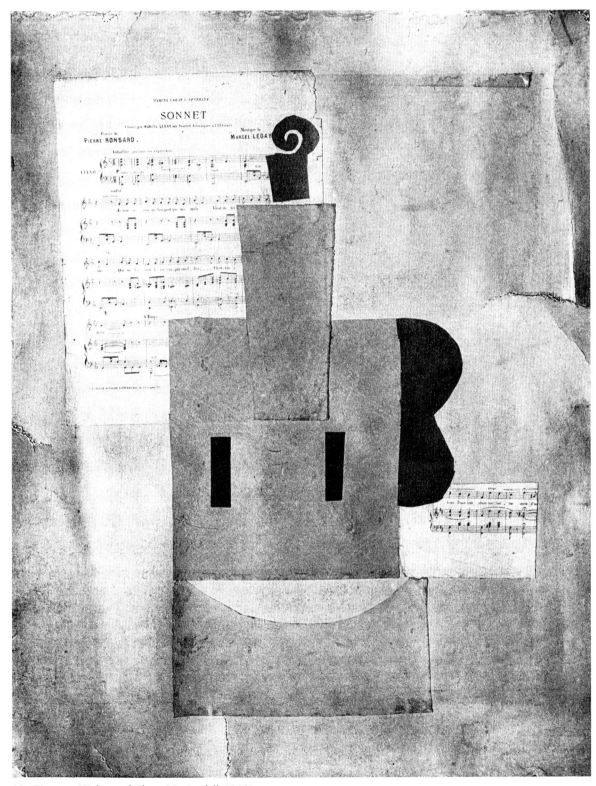

10. Picasso, *Violin and Sheet Music* (fall 1912).

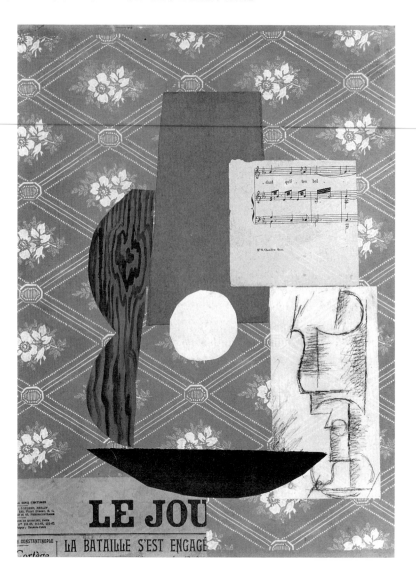

11. Picasso, *Guitar, Sheet Music and Glass* (after November 18 1912).

many evenings at the Cabaret du Lapin Agile on the rue des Saules. Performances of popular song accompanied by guitar and violin, both of which are depicted in the sheet music collages, were a nightly occurrence at the cabaret. By all accounts, the repertory of Frédé, the guitar-playing proprietor, was especially strong in dark or romantic lyrics drawn from Ronsard, Villon and other early French poets.[31] In an article on the Lapin Agile in 1911, critic André Arnyvelde even characterizes the standard fare as "a song by Ronsard or by Marcel Legay."[32] Moreover, the Lapin Agile was itself something of a legend by Picasso's time, having played host during the 1880s and 1890s to the great Montmartre singers, including Legay.[33]

Around the time of the sheet music collages, Picasso moved from Montmartre to a more urban neighborhood in Montparnasse. Echoes of the Lapin Agile therefore cast an aura of

nostalgia about the "Sonnet" pictures. The text of the song, moreover, is a plain and elegiac *vanitas* on love, beauty and fleeting youth, an especially poignant counterpart to the public and private sentiment of "ma jolie." Appropriately, perhaps, two of the "Sonnet" collages are broad, flat, uncomplicated works. A third, *Guitar, Sheet Music and Glass* (fig. 11), is a good deal less coherent in form and content; its song fragment is much smaller, and therefore it is less nostalgic than that of the other two works, and the music is mixed with five other types of paper, including the critical first appearance of newsprint in the collage œuvre. *Guitar, Sheet Music and Glass* introduces us to a series of complex pictures by Picasso (improvisatory pictorial performances which jumble the hermetic formal experiments of cubism with the banal materials of popular culture) in which the music-hall is an informing agent, not just of iconography, but of style, structure and bearing.

Picasso's collages contain a universe of pasted materials – and painted imitations with which he frequently juxtaposed or replaced them. In addition to sheet music, newspaper articles and advertisements (as well as other forms of *publicité* such as brand labels) comprise the greatest share; wallpaper and imitation woodgrain; playing cards and *cartes de visite* – the collage universe is inhabited by ephemera, cheap and disposable stuff. A large number of these papers contain printed words, which correspond to examples of commercial typography that had already been introduced into pre-collage cubist painting, such as *Ma Jolie*. It is some measure of just how utterly unprepared spectators were for the materials of collage, that some fifty years passed before any critic or historian actually *read* these words for *meaning*. In 1960, Robert Rosenblum showed us that cubists, and above all Picasso and Braque, often cropped and juxtaposed newspaper and advertising typeface for puns and wordplays, many of which alluded back to the visual puns of cubism itself.[34] The wordplay (it is not remarked often enough) is simple, as Picasso's French was little more than functional at the time. None the less, the pictures are populated by verbal games played predominantly in French, with only occasional excursions into his native Spanish. Picasso's primary pun, inscribed on numerous cubist pictures from 1912 to 1914, was derived from the name of the newspaper *Le Journal* which, when clipped, becomes "jou," suggesting the French word *jouer*, "to play," or *jouir*, "to derive sexual pleasure" (fig. 12).[35] "Jou" is, in fact, something of a logo for these pictures, the *mot d'ordre*, and it signals us to "play" Picasso's epistemological game.

The "Sonnet" collage *Guitar, Sheet Music and Glass* (see fig. 11) is a classic example, where picturemaking itself is understood as a sort of advanced practice of the pun. Sheet music (*partition* in French) suggests the division of objects throughout the collage; fragments of music and newspaper *are* what they "represent," yet the glass is a cubist stylization; a white paper disk, material yet empty, stands for the void of a guitar soundhole, while the hollow body of the guitar is described by the arrangement of pasted papers around an empty space. Woodgrain is a "real" pasted paper, yet "fake" in that it is a simulation painted with a technique borrowed from the unexalted *métier* of *peinture en bâtiment*; wallpaper concretizes the vertical surface of a wall, and of the picture itself, yet simultaneously alludes to the horizontal surface of a table upon which the objects rest. Finally, all of the objects signal both the work to which they are attached and the world from which they have been detached. Beneath "le jou" we read "la bataille s'est engagé(e)" ("the battle is joined"), words which are at once the headline of a news story

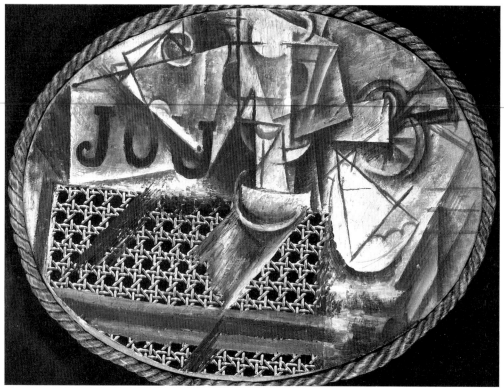

12. Picasso, *Still Life with Chair Caning* (May 1912).

on the Balkan Wars[36] and the challenging slogan of a picture which is so unlike any other before it.

Newspapers, advertising, and popular music; ephemerality and the play of the pun: these are the salient contents and qualities of collage. In the history of art there simply is no precedent for this combination of iconography and attitude. We might look for pre-cubist *depictions* of newspaper and café advertising typography in impressionist and post-impressionist painting, where they typically function as attributes of urban life. But this is clearly inadequate. We do not need a history of this subject matter in painting before cubism in order to come to cubist collage with the proper frame of reference; neither did Picasso. Like all artists, Picasso engages consciously and unconsciously with the non-art world; but Picasso stands out for having drawn striking attention to this fact by *affixing* peculiar bits of that world onto a painting or drawing. We should, then, follow his lead and venture back not into the history of art so much as into the contemporary realm of pre-war popular culture. Newspapers, advertising and song were, around the time of cubism, all far more vital to the daily esthetic life of Paris than to the esthetics of French easel painting.[37] As such, they were in turn the signal ingredients for a genre of music-hall performance that bears strikingly upon the history of collage: the *revue*. In a very real sense, collage existed at the music-hall before Picasso, and flourished there throughout the history of collage cubism.

—3—

"The *revue*, what a setting! There exists none which permits more fantasy with more reality . . . The *revue* is the triumph of the 'neither head nor tail,'" or so says Henry Buguet in his 1887 pamphlet *Revues et revuistes*.[38] The history of the *revue* as a performance genre in France is, in fact, older than the music-hall. Reaching back to the eighteenth century, it was first fully-formed during the Restoration. Peaking at the music-halls of the Second Empire, the *revue* was revived with a new extravagance after 1900, and gained a second wind. By around 1910, this revival had erupted into a virtual mania, and the *revue* exploded throughout the theaters of Paris. So popular was the *revue* during the pre-war period that it was discussed with the energy of debate in the daily and entertainment press.[39] It was also the subject of a monographic study in 1909 by one Robert Dreyfus: *Petite Histoire de la Revue de Fin d'Année*. Dreyfus provided a pedigree for the *revue*, tracing its origins and its history throughout the nineteenth century and, most importantly, furnished a detailed definition of the genre.[40]

The *revue* is a sequence of satirical *tableaux*, sometimes as many as two dozen or more, which are commentated by a mistress and master of ceremonies, the *commère* and *compère*. The text is comprised of both dialogue and song "couplets." *Revue* scenes are based almost exclusively on *actualités,* current events extracted from news of the past year. Buguet assures us that a *revue* might contain events from the very morning of the first rehearsal;[41] in 1912, the critic Curnonsky congratulated the director of the Olympia music-hall for adding new current events to a *revue* that was already a great success, making it "a kind of spectacle of incessant actuality."[42] The *revue* can be written and performed anytime throughout the year, though it proliferated with special fervor during the late fall and winter, at which time it was known as *la revue de l'année* or *de fin d'année*; literally, a "review" of the past year's events.

13. Poster for *Le Petit Journal*, Théâtre-Déjazet (1864).

The primacy of current events makes the daily press something of a bible for the *revuiste*. Indeed, the newspaper is such a fundamental source that *revues* from the nineteenth century through 1914 often sport titles such as *Le Grand Journal* and *Le Petit Journal* (fig. 13).[43] Among the *actualités* favored by *revuistes*, recent political events are among the most common, though, Dreyfus tells us, the *revue* traditionally caters to the middle class and tends to emphasize political issues on which bourgeois opinion is fairly unanimous.[44] Other aspects of the latest news were open to the "promenade" of the *revuiste*, who could be especially clever on the manners and fads of modern Paris, including the theater itself, as well as "economic life,

*machinisme*, the applications of science to industry and commerce, the continued perfection of means of transport and exchange, or, as we used to say, the 'progress' of human genius."[45] To Dreyfus' list we can append the earlier inventory of *revue* iconography by Arthur Pougin, from his *Dictionnaire historique et pittoresque du Théâtre* of 1885: "revolutions, wars, new inventions, fashions, artistic and literary matters, crimes, public calamities, etc."[46] Buguet further specifies a related branch of modern manners with which the *revuiste* had particular fun: the slogans and claims of advertising, such as *publicité* for "Mines de Cornerille" or "Pastilles Géraudel," which were set to the music of the most popular *café-concert* songs. Buguet adds that the "practical *revuiste*" would not fail to "propagate a little *réclame* (almost invisible) on the address of his tailor or bootmaker, or in favor of his wife's dressmaker and milliner."[47]

Dreyfus insists that the accessibility of the *revue* depends upon not only the diligent author, but the well-informed spectator. Similarly, if the vivid immediacy of the *revue* is a function of its source in news clippings and recent fads, future readers of *revues* past are likely to find the text impenetrable, filled with mere "*signs* of knowledge and, above all, of sentiments that they suppose once to have been alive."[48]

The tone of the *revue*, the posture which belongs to the *revue* alone among genres of theater, is glib and ironic. French vocabulary for this comic manner is specific: *blague* or irony when it is confident and careless, *rosserie* when spiteful or cynical.[49] The primary formal device of the *revue* is the play on words, or the "allusion" (the word is identical in French and English). Dreyfus elaborates:

> What is the allusion?
>
> The allusion, says Littré, is a "figure of rhetoric consisting of saying one thing that makes us think of another." Littré adds: "We distinguish historical allusions when they recall a point of history; mythological, if they are based upon the fable; nominal, if they depend on a name; *verbal, if they consist of the word alone, that is, an ambiguity.*"
>
> This last type of allusion is perhaps the most prevalent in *revues de fin d'année*. I even believe that it properly constitutes that which one calls "the spirit of the *revue*" . . . The "verbal allusion," as it is named by Littré, that chemist of our language, is quite simply that which, without examining so deeply, we call the *à peu près* and the *pun*. Assuredly, the pun is not always so humble a means of allusion . . . But I have willingly sought the bottom of the scale, because the more rudimentary the pun, the better it permits us to isolate the stark naked allusion, the drained and, as perhaps Kant would have said, pure allusion.
>
> This allusion is not sustained, touched-up, heightened by anything. Equally, the pleasure that it affords – when it affords any – is unadulturated.[50]

Dreyfus illustrates his philosophy of the *revue* pun with the poster from an 1855 *revue de l'année* entitled *Le Royaume du calembour*, "the kingdom of the pun" (fig. 14). He goes on to trace the pun or allusion as a secondary tool of political comedy and the comedy of manners, in Molière and Sardou for example.[51] But, he assures us, the *revue* is nothing so deep; in the *revue*, the allusion is not an accessory, but "the essential and the all."[52] The enjoyment of a *revue* resides almost exlusively in getting the joke – recognizing onstage figures and incidents of the past year, and understanding the "gay, rapid, satirical and philosophical remarks" or allusions made at the expense of these *actualités*.[53]

14. Poster for *Le Royaume du Calembour*, Théâtre des Variétés (1855).

By 1911, the year Picasso and Braque introduced printed words into cubist painting and one year before *collage*, the *revue* had attained the status of a craze. When, as Fernand Olivier tells us, Picasso went to the music-hall, he confronted the *revue* vogue at its highest pitch. One theater critic wrote, in December 1911, of that season's "avalanche of *revues*, the extraordinary vogue for this fashionable genre," predicting a reaction not unlike that which occurred during the Universal Exposition of 1889, when a spate of *revues* provoked one author to compose *Pas de Revue!*, which ran for 150 performances.[54] Reviewing a *revue* at the Théâtre de l'Ambigu, also in December of 1911, Léon Blum observed that the *revue* fad had extended beyond the bounds of the music-hall:

> Who doesn't have his *revue*! From the music-hall and related stages, the contagion has overtaken the large theaters. Yesterday, it was the Bouffes, today the Ambigu; tommorrow it will be the Théâtre Réjane. I well know that the *revue* is what one calls a supple genre, so supple that if need be it could finish by absorbing all the others.[55]

He might have added the Guignol to his list for, already back in May, even the puppet theater had mounted its own *revue des actualités*, entitled *Pourquoi pas?*[56]

The *revue* showed no signs of exhaustion. An article entitled "La Revue Triomphante" appeared in the magazine *Le Théâtre* in April 1912, declaring:

> The *Revue*! it is invading everywhere; the 1912 theatrical season will mark a date in the history of this original form of French spirit, and could furnish Robert Dreyfus with one of the most abundant chapters in the next volume that he will consecrate to it. Marigny, the Folies-Bergère, the Olympia, la Scala, the Moulin-Rouge, the Ambassadeurs, the Alcazar d'Eté, the Capucines, the Bataclan . . . all the *cafés-concerts* and all the music-halls are performing *revues*; there is not a *faubourg* in Paris which does not sing, to a familiar tune, about the "Dancers' Strike," "The Adventures of M.

15. Cover illustration for *L'Assiette au Beurre* (1910).

Cochon" and other *événements d'actualité* that inspire mordant, subtle or vividly satiric couplets, because [the *revue*] exhibits on all the Parisian stages, large or small, over the course of one evening, a singular expenditure of spirit. One even occasionally begins to regret that this spirit is so liberally dispensed in works which, by their very essence, are ephemeral, since they do not represent an epoch but, of necessity, a season.[57]

During the pre-war, the *revue de fin d'année* also had an intense cultural life outside of the music-hall. So convenient was the *revue* as a comic vessel for the events, trends, fashions and gossip of the past year, that newspapers and magazines themselves borrowed the genre with regularity. The format was especially popular with theatrical and humorist periodicals during the period of the *revue* craze, though it was also common in the regular press. In some examples, allusion to the music-hall is implicit. The daily paper *Paris-Midi*, for example, printed a synopsis of the year's main events from politics to sports on the front page of their December 31, 1912 issue, entitled "Revue de fin d'année pour 1912."[58] Elsewhere, the structure and tone of the music-hall *revue* is adapted literally. The humorist weekly *L'Indiscret* ran a series of "almost weekly" *revues* from fall 1912 through summer 1913, complete with dialogue, punning songs, numbered scenes and stage directions.[59] *Le*

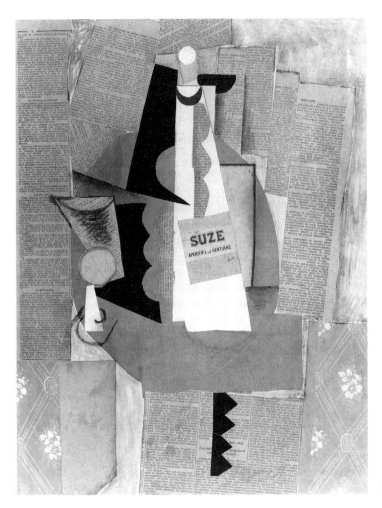

16. Picasso, *Glass and Bottle of Suze* (after November 18 1912).

*Charivari* published two *revues* in 1912: "Revue Charivarique" in October, concerning the Balkan Wars (Kaiser Wilhelm and France's allegorical Marianne are the *compère* and *commère*); and "Encore une revue d'actualité!," a send-up of advertising claims for the popular cure-all medicines Urodonal and Globeol, in which Esculape, the ancient Greek god of medical science, is administered the modern miracle drugs after being run-over by a bicycle and a bus on the streets of Paris. (Revived, he dances the cancan and sings the *café-concert* classic "Tararaboum dié!").[60] "L'année 1910, revue par M. le Président de la Chambre" occupied the entire December 31, 1910 issue of the satirical magazine *L'Assiette au Beurre*. Presented as "sung" at the "Folies Bourbon" (a splicing of Folies-Bergère and Palais Bourbon) with words and music by Henri Brisson, president of the Chambre des Députés, this mock *revue* consists of song lyrics and caricatures satirizing various events from the year's news. The cover illustration by d'Ostoya demonstrates the natural affinity of the *revue* for the newspaper clipping: as a backdrop for Brisson, who is dressed in imitation of the music-hall comic Dranem, two fragments of the *Journal Officiel de la Chambre des Députés* are reproduced in a cut-and-paste fashion that presages the look of Picasso's newspaper collages from the winter of 1912 to 1913 (figs. 15 and 16).

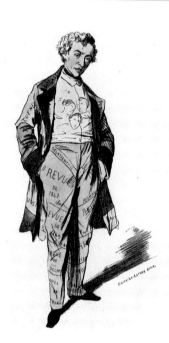

18 (above). J. Demony as the
magazine *Comoedia illustré* at
the Olympia music-hall (winter
1908–9).

17 (left). Emile Viltard,
"Compère de revues" (1855).

    To practice the *revue* in any form was, then, to cultivate an esthetic of the newspaper.
At the music-hall, the newspaper dominated in spirit and fact; embodying the raw
material of reportage, it was the essential subtext and context of the *revue* genre. To make
this point visibly clear (for the audience appeal of a *revue* depended on its being attuned
to the pulse of the daily press) the *revuiste* could call upon a stock character type: the
personification of various newspapers and genres of news. Dreyfus tells us that the first
such character appeared in a *revue* of October 1831, in which "La Politique" was
portrayed by Mlle Déjazet at the Palais Royal, "clothed in a dress on which all the
newspapers were pasted."[61] Costumes composed of imitation and authentic printed
papers were commonly featured; such a costume was worn by "Emile Viltard, compère de
revues," who appeared sometime in the 1850s in a coat and pants bearing the printed
titles and authors of past *revues* for which he had been the master of ceremonies (fig. 17).
By 1900, the newspaper costume was a *revue* fixture, most typically worn by a woman
and emblazoned with the name, in the original typeface, of a single newspaper or
periodical. The title was usually affixed as a banner to the performer's hat, though
variations might find the newspaper in question displayed for greater *risqué* effect (figs. 18

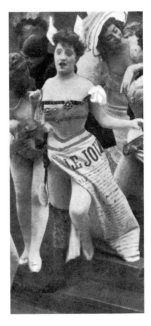

19 (above). Blondinette d'Alaza as the newspaper *Le Nouveau Siècle* at the Olympia music-hall (1910).

20 (right). *Le Journal* music-hall newspaper costume (*c.*1900).

and 19). Another version of this costume type would be to plant a larger-than-life newspaper title across the entire length of a long, wrap-around skirt. Here the title would never be entirely visible, but cut instead by the folds of the skirt and the direction in which the performer faced at any given time during her appearance onstage. In this manner, *Le Journal* might be read as "Le Jou(r)" (fig. 20). Dozens of newspapers were routinely "depicted" in this way. The results are always a typical music-hall mix of glitzy *féerie* extravagance, racey *déshabillé* and a mock, hyperbolic seriousness that is playfully ridiculous. Still, as preposterous as these costumes are, they were a fundamental music-hall motif, emblematic of the newspaper as the soul of the *revue*.

Picasso's own choice of *Le Journal*, the predominant newspaper in his collages, is a corresponding device. He may have selected it in part for its coverage of specific events and for formal reasons, such as the quality of its typeface and the disposition of its columns; it may, in fact, have been his favorite paper. But it is equally clear that, unlike *Excelsior* or *Le Figaro*, which he used comparitively little, the title *Le Journal* stands simultaneously for a specific newspaper and for the generic category of "newspaper" itself – "le journal" means "the newspaper". Moreover, though *Le Journal* provided

Picasso with the logo-pun "jou," the word "jouer" (from which we derive the implication of play in the cropped word "jou") also happens to be the French verb for theatrical performance; one "plays" a *revue*. Indeed, the proliferation of the suggestive "jou" throughout Picasso's œuvre from 1912 to 1914 virtually labels the cubist picture plane as a kind of stage space in which every object, including *Le Journal* itself, is accorded the protean adaptability of a player, changing costume and character in order to perform a new role. Picasso's visual and verbal game of journal-jouer-jou was one not lost on the music-hall *revuiste*. One *revue* in particular, which played at the Théâtre de l'Athénée in January 1912, was written exclusively and explicitly according to a newspaper format, with a different author for each category of *actualités*: society gossip, politics, foreign affairs, theater news, bulletins in brief, legal proceedings, literature, fashion and sports. The title of this *revue* is *Le Journal joué* (the "played" or "performed" newspaper), a ready play on words that seemed as appropriate to the *revuiste* as to Picasso.[62]

## —4—

Picasso executed his first and most conspicuous group of newspaper collages – a run of approximately three dozen works from 1912 to 1913 – between November and January. The dates are significant, for they correspond exactly to the annual high season of the music-hall *revue de fin d'année*.[63] While it is true that no one collage contains material touching back upon the *actualités* of an entire year, the force of the here and now in the collage œuvre is astonishing. Rather than perpetuate the continuity of values which art might once have been understood to preserve, Picasso introduced the *actualités* of news, advertising, fashions and fads into painting and drawing, shuffling and sorting the iconographical and physical facts of fleeting contemporaneity. The "subjects" of these works are as fast-fading as the newsprint which contains them, once grubby white and now crumbling brown. The anti-illusionistic shallow or flat pictorial space which results from the predominance of pasted paper signals a new role for the picture plane as a field of transience. Not since impressionism had the modern moment been given such startling pictorial urgency. This is not to say that collage comprises an appreciation of modernity in the sense of any slippery notion of "progress"; rather, it represents a more banal, immediate, everyday sensation of ephemeral events, the fabric of the artist's world as a shifting and unraveling thing. With the pun, Picasso distanced the *actualité*, treating it as material for esthetic paradox, social satire and licentious humor. It is this same fresh *actualité* upon which the *revuiste* sharpened the swift edge of his irony, for he too was less interested in perpetual truths than in the half-truths of the unfolding present.

The Balkan Wars, a hot *actualité* of the day, received simultaneous attention, and identical treatment, from Picasso and the *revuiste* during those months late in 1912 and early in 1913.[64] In *Guitar, Sheet Music and Glass* (see fig. 11), Picasso matched the headline "La bataille s'est engagée", a dispatch from Constantinople, to a snippet from the Legay song which reads "(pen)dant qu'êtes bel(le)" ("while [you] are beautiful"). The counterpoint is curious: massacre and music, sudden death and fading beauty, foreign affairs of war and domestic affairs of the heart. Under the sign of the boldface pun "le

jou," we recognize Picasso's conniving wink and think, for example, of La Marocaine's black-comic refrain in "Au Parlement Turc" from the Folies-Bergère *revue* of October 1912:

. . . The bullets are flying / tra la la la la / And the good French / tra la la la la / of the Republic / Tell us that it's / *La pénétration* / zim-boum *pacifique*![65]

It should be noted that, like *Le Charivari*, *Le Journal* published a mock program for its own seasonal Balkan Wars *revue à grand spectacle* on November 10, the very issue from which Picasso extracted the *bataille* headline, his first newspaper clipping. The "program" is an irrepressible sequence of wordplays, jokes and comic song titles at the expense of enemy and ally alike. Its author, Curnonsky, whose byline is the pseudonymous pun "l'Obscur Nonsky," introduced it as "a detailed program of the final *Revue* soon to be presented at the Theater of War." Among his list of *tableaux*, one stands out. "The Paths of War (Numbering the Retreats)" is described as a "tableau uskubiste, par Ridendum," playing on the Turkish city Uskub and the phrase "tableau cubiste," "cubist picture," as well as Bibendum, the Michelin Tire man, whose Latin name has been converted from a drinking toast into a call for laughter.[66]

Less than a month later, in *Table with Bottle, Wineglass and Newspaper* (fig. 21), Picasso cropped the December 4 Balkans headline "Un Coup de Théâtre," transforming

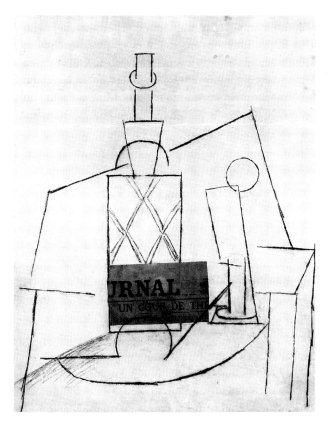

21. Picasso, *Table with Bottle, Wineglass and Newspaper* (after December 4 1912).

it into his own multiple pun: "un coup de thé," which has since been translated variously as "a cup of tea" (a printed description standing in for the representation of an object), and "a toss of the die" ("coup de dé").[67] Moreover, a synonymous phrase, "le sort en est jété" ("the die is cast"), often appeared in headlines of the period in reference to the gamble of irreversible military action.[68] The original headline, however, was a readymade pun before it was cropped, since the metaphor "coup de théâtre" can, as we have just seen, allude to the "theater of war" and to a dramatic turn of events on the theatrical stage – or stage-cum-picture plane. Above the headline, the "urnal" fragment from *Le Journal* prankishly places our cup of tea, or tossed die, beneath a *urinal*.[69] Smaller print which reads "La Bulgarie, la Serbie, la Monténégro sign" discloses more detailed contents of the dispatch, but we cannot approach with a straight face.

Compare *Table with Bottle, Wineglass and Newspaper* with, for example, *Madame est Serbie*, a *revue* which opened at the Gaîté Rochechouart in December 1912. Its punning title alerts us to what one reviewer described as "a spirited and amusing satire of all diplomacy."[70] The third *tableau* of Act II is entitled "Les Alliés balkaniques," and features a banquet given by the Great (European) Powers to the Balkan allies at the Elysée palace, where Raymond Poincaré, France's foreign minister, serves as the *maître d'hôtel*. Among the dishes "passed under the noses of the poor, starving allies" (one representative each from Serbia, Montenegro, Greece and Bulgaria) are territorial offerings such as a roast pork, *rôti de porc*, renamed "Rôti de Port sur l'Adriatique."[71] In collage, the typography of mastheads and headlines, where the gags generally occur, catches our eye before (or displaces) the columns of news. Picasso's treatment of the bold print subverts the subtext, or fine print; like the burlesque of news and newsmakers at the music-hall, it dominates the way we "read" the collages.

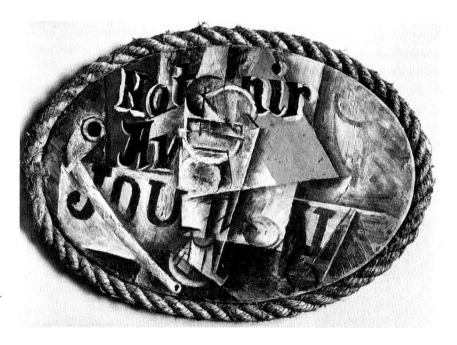

22. Picasso, "*Notre Avenir est dans l'Air*" (spring 1912).

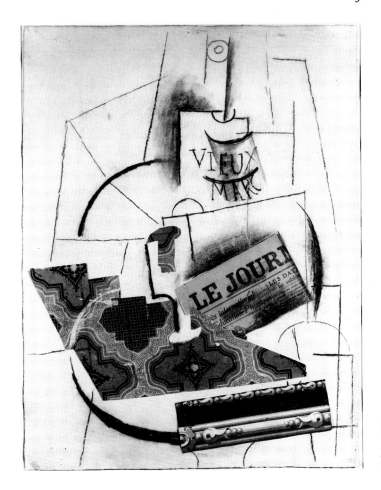

23. Picasso, *Bottle of Vieux Marc, Glass and Newspaper* (after March 15 1913).

Politics is just one category of myriad *actualités*. Flying machines appeared in the papers virtually every day during the pre-war period, as aviators from around the world vied with one another for long-distance flight records. While many reports dealt with tragic failure, both Picasso and the *revuiste* emphasized the promise of flight. Three works by Picasso executed around the time of his first collage depict the cover of a brochure on the development of French military aviation that bears the title *Notre Avenir est dans l'Air*, "our future is in the air" (fig. 22).[72] A number of *revues* were titled in the same spirit: *L'Année en l'Air* ("the Airborn Year") at the Apollo in fall 1908; "Tout en l'air" ("Everything in the air"), a *tableau* at the Cigale in September 1911; and, at the Ambassadeurs in summer 1912, *En avion . . . marche!* (an *avion* is an airplane; the phrase is a pun on "en avant, marche," or "forward march").[73] Sports were another popular music-hall *actualité*, since they permit a variety-theater display of athletics, and slapstick, within the *revue* format. Among dozens of examples, a *tableau* from *A la Baguette!* at the Cigale entitled "La Culture Physique"[74] matches the date, spring 1913, of the collage *Bottle of Vieux Marc, Glass and Newspaper* (fig. 23), onto which Picasso has pasted the *Le Journal* headline for a "Congrès International sur l'Education Physique."

Cubism itself was a popular music-hall *actualité*. Between 1911 and 1914, modern "isms" were a visible, semi-annual scandal at the Salon d'Automne and Salon des Indépendants, where cubism and related schools were subjected to ridicule and hostility in the daily press. For example, the article "Cubisme, Futurisme et Folie" ("Cubism, Futurism and Madness") appeared on the weekly Health and Science page of *Le Journal* just as Picasso rescued his first clippings.[75] In the *revue*, every season was open-season and, beginning with M. Berthez in *Et Voilà!*, the music-hall of those years was riddled with costumes, sets and skits lampooning new art. Cubism, the dominant "ism," bore the biggest brunt, and was characteristically renamed *cucubisme* from *cucu* (or *cucul*), with connotations of idiocy that are the same in French as in English. There was a cubist at the Ambigu in November 1911 who "recalled the early days when, succumbing to the first *frissons* of his vocation, he showed his cube to all passers-by";[76] there was "Sem's Cube Game" at the Ambassadeurs in June 1912 (Sem was an illustrator who adapted a cubistic style to caricature); "Paris Cucubique," the prologue for Rip and Bosquet's *La Revue de l'Année* at the Olympia in fall 1912, featured a set-design by Paquereau depicting Paris as a cubist city; and there was a cubism song at the Eldorado in January 1913 as well as a "Fauste cubiste" at the Petit-Palais in February 1914.[77] It is clear that the perceived extravagance and eccentricity of cubism is being treated by the music-hall here as a fad.

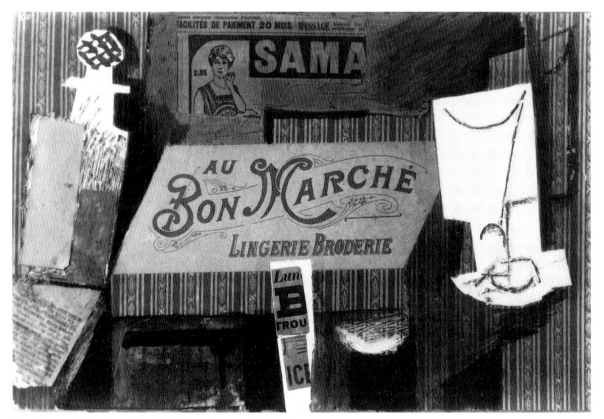

24. Picasso, "*Au Bon Marché*" (after January 25 1913).

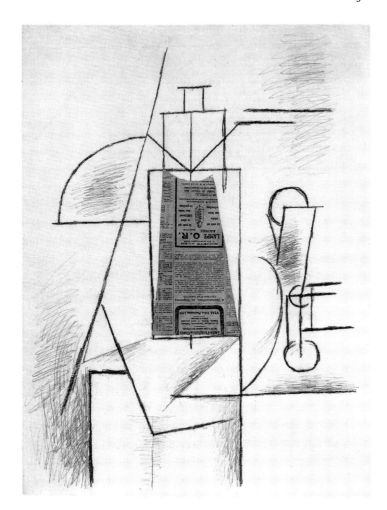

25. Picasso, *Bottle and Glass* (fall-winter 1912).

The Olympia's "Paris Cucubique" stage-set was the backdrop for a prologue in which "all the 'folies à la mode' are ridiculed."[78] Years later, Albert Gleizes recalled music-hall jokes at the expense of the new art and remarked that it was as if Paris had discovered the word "cube" for the first time.[79] How would Picasso have been struck by all of this cubist stage business? Cubism is, obviously, the "backdrop," as well as the very fabric, of collage. But it is also intriguing to consider cubism as its own current event; in *Guitar, Sheet Music and Glass* (see fig. 11), Picasso has pasted the cubist drawing as an autonomous paper *actualité*, a counterpart to world news and popular song.

The range of advertising *actualités* in Picasso's collages is broad, reaching from the well-known to the obscure. Labels and logos for Job cigarette papers, the aperitif Suze, Bass Ale, Vieux Marc and other drinks occur throughout the work (see fig. 16). For the newspaper collages, Picasso clipped various kinds of *publicité* and *réclame* just as often as he did news items: the department stores Bon Marché and Samaritaine (fig. 24) are represented, as are products such as Laclo-Phosphate de Chaux ("truly the most powerful fortifier") and Lampe Eléctrique O.R. (fig. 25); "readymade garments for men and

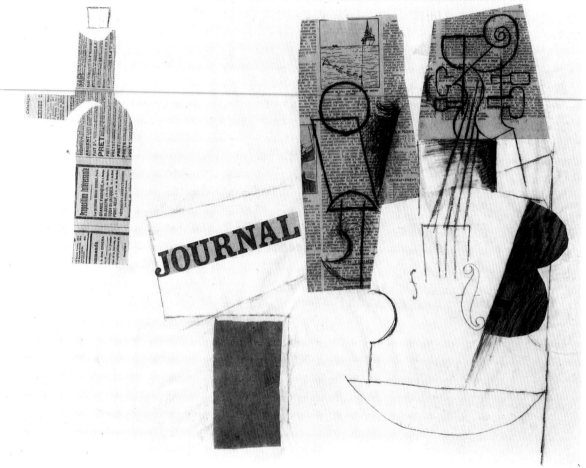

26. Picasso, *Syphon, Glass, Newspaper and Violin* (after December 3 1912).

children," furs, gramophones, *petites annonces* for loan agencies (fig. 26); and theater listings, including music-halls and *cinématographes*.[80] Newspaper titles, such as *Le Journal*, *Le Figaro* (fig. 27) and *Excelsior*, also qualify as a type of *publicité*.[81] Advertising functions at the personal and private levels as well; Picasso appropriated the *cartes de visites* of friends "Miss Stein/Miss Tolkas" and the dealer André Level, in addition to a modest prospectus circulated by a publisher on behalf of a forthcoming book by Max Jacob entitled *La Côte*, which was three years old when Picasso used it in 1914.[82]

Hardly a *revue* was played during the collage years that did not include some run-down or send-up of recent brand names and marketing schemes. Newspaper costumes were, of course, a music-hall staple, a device calculated to prove the currency of a *revue*. *Madame est Serbie* contained a scene in which two companions train through the French provinces, taking the trade names on large advertising signboards (a recent phenomenon in France)[83] for the names of cities and towns. The Cigale's *A la Baguette!* presented "La Professeur

de Publicité Théâtrale," a sketch concerning a rash of advertising endorsements propagated by music-hall stars for products such as Cadum soap, Coryza *crème de riz*, A. Bord pianos and Kub bouillon; the *tableau* closes with a parodic ode to the advertising kiosk ("O, little kiosk, kiosk that I adore . . ."). In *Pourquois pas? . . .* at the Cigale, February 1914, "La Publicité ambulante" told the story of a painter who has been rejected from every annual *salon* exhibition (nineteen of them, if we are to believe the authors) and sells his paintings to manufacturers as commercial advertising. One scene from *Ce que je peux rire!* at the Alcazar d'Été, June 1912, transforms the Place Vendôme into a giant *magasin de nouveautés,* bringing together the Printemps, Louvre, Bon Marché and Galeries Lafayette department stores. Another satirizes Dr Macaura, inventor of a cure-all massage apparatus which is applied to the "infante Euphémie" by the comic Dranem (Dranem's song is set to the music of the *ma jolie* refrain from *Dernière chanson*). The first act of the Cigale's *La Revue des T.*, of summer 1911, even included a parade of living *cartes de visite*; the thirty-third *tableau* of the Folies-Bergère's spring 1912 *revue* was entitled "L'Origine du Prospectus."[84]

"On réclame, on réclame," sang the music-hall comic Montel in 1912: "Everybody's advertising through the newspapers / In these claims, there are some laughable schemes."[85] Both in the *revue* and collage *tableaux*, advertising is addressed with equal doses of fascination, bemusement and mockery. It is clear that advertising graphics and extrava-

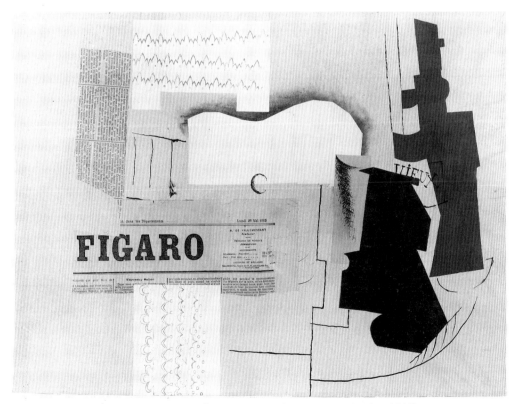

27. Picasso, *Bottle of Vieux Marc, Glass, Guitar and Newspaper* (spring 1913).

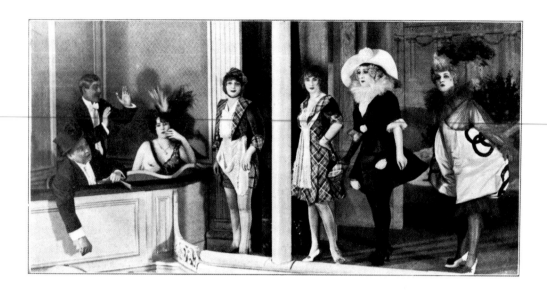

28 (above). Performers impersonating spectators in *Paris Fin de Règne*, Théâtre des Capucines (winter 1912–13).

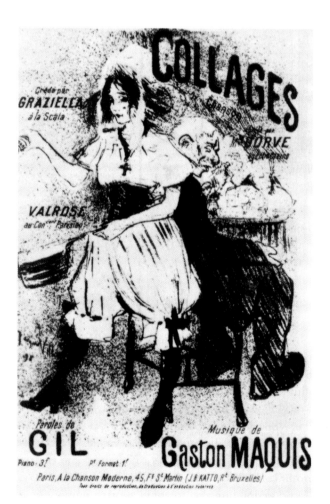

29 (right). Jaques Villon, cover illustration for sheet music of the song "Collages" (1898).

gant promotionalism could be perceived as especially striking in the alien context of a stage or an easel picture. In addition, marketing tactics such as uncomplicated presentation and bold, shameless claims – crucial ingredients for fast read and hard sell – rendered *publicité* susceptible to canny manipulation for an inside joke. As Rosenblum has pointed out, the text in Picasso's advertisement for the "Lampe Electrique O.R." (see fig. 25), which "sheds light in every direction" and can be "placed in any position," puns into a caption for the stylistic peculiarities of cubism (in which a newspaper clipping can be placed upside down, as it has been here, and made to stand in for the contents of a bottle.)[86] Acting as what Buguet called the "practical *revuiste*," Picasso has appropriated commercial *réclame* as a claim for cubism, a boast and a spoof on the forward march of pictorial and technological progress. The "Publicité Théâtrale" *tableau* at the Cigale activates the same device; celebrity endorsement could be an object of mockery and a pretext for parodic self-referentiality. In the prologue for *En Scène . . . Mon Président!*, earlier in 1913, the Louvre department store was transformed into the Cigale, one giant, reciprocal metaphor of dizzy self-promotion called "Le Magasin Music-Hall." Act I was entitled "Assez de Boniments!" ("Enough Sales Talk!").[87] Similarly, the *revue* often contained scenes depicting its own backstage and its own audience (fig. 28). Transforming the popular stage into a Moebius-strip of esthetic ambiguity, the music-hall addressed itself *to* itself, and to its own artifice.

The still life "*Au Bon Marché*" of 1913 (see fig. 24) contains Picasso's most notorious pun of this kind, an allusion that is at once licentious speculation and pictorial fact. The printed words "trou ici" ("hole here") designate the hidden lower anatomy of the poised representative from Samaritaine as well as the pictorial anatomy of a pasted paper, cut to expose a gap.[88]

> The revue is also the art of incarnating individuals, events, manners, absurdities, fashions and ideas of the day as small women scantily clad who regale the public with some couplets. These couplets can be satirical, licentious or sentimental . . . Their spirit is not always inoffensive. There are those which are vulgar and wicked.[89]

Picasso's heavy dose of wallpaper in "*Au Bon Marché*" raises the stakes. The very word "collage," from *coller*, to paste, has two meanings which are germane: technically, in the phrase "collage du papier," it describes the job of hanging wallpaper; as period slang, however, collage also refers to the unmarried cohabitation of two people (a particular set of domestic circumstances to which Picasso was no stranger), and bore overtones of sexual impropriety.[90] Sexual *collage* was, indeed, familiar to pre-war music-hall slang; examples include the songs "Collages," introduced at La Scala music-hall and published in 1898 with a cover illustration by the future cubist painter Jacques Villon (fig. 29), and "Les Plaisirs de Collage" ("The Pleasures of Collage"), published in 1911.[91]

The music-hall was, in fact, subjected to numerous debates on censorship and pornography between the 1880s and World War One. High on the list of "immoral" transgressions were onstage nudity and scatalogical or licentious songs. While nudity could be remedied with flesh-colored body-stockings, supporters of the music-hall defended vulgar and licentious text, *grivoiserie*, as a risk worth taking in order to preserve the music-hall's native *saveur*.[92] Official censors, who themselves became the subject of many *revue* sketches,[93] had some effect in curbing content that was explicitly coarse and

crude. The music-hall, however, had a built-in line of defense: the sly and refined art of saying one thing while meaning something else. Puns or allusions, the *à peu près* and the *sous-entendu* were mechanisms with which the lyricist or *revuiste* not only skirted the censor, but invested an evening at the music-hall with an aura of conspiracy; censorship only served to sharpen the technique. In the *à peu près*, for example, a performer would begin pronunciation of a questionable word such as *merde*, only to pause, then finish the thought on safer ground, as in "Viens te rouler dans la mer D . . . ominique!" ("Come roll in the waves/shit Dominique!").[94] This manner of pause before the moment of truth was typical of *revue* titles themselves, including innocent titles such as *En avion . . . marche!* The punning allusion was equally common, as in La Scala's *revue Ménage à Troyes* ("Trojan Household," a homonym for the sexual *ménage à trois*),[95] or the song *Mon Thermomètre*: "I have a thermometer, a thermo mo / A little thermometer / I have a shocking thermometer / Which goes up and which comes back down"; here, the comic effect would depend in part on stage gesture.[96] Yet another method was mispronunciation: one could sing "je bisse partout" ("I sing *encores* everywhere!") but suggest, with a slight slip, "je pisse partout" ("I piss all over").[97]

Picasso's word fragment "jou" is a typical case of the *à peu près*, for it suggests larger meanings that are both innocent (*journal* and *jouer*) and sexual (*jouir*). "Trou ici" is a classic *sous-entendu*; and "coup de thé" forever waits to be completed (at the music-hall, it would be written "Coup de thé . . . âtre!"). The cropped word also conforms to patterns of informal speech at the music-hall. The dropped vowel or syllable would shorten a word, making it fit into the predetermined cadence of a song (music-hall lyrics were typically written to an existing popular tune), or to speed up the performer's delivery. Such ellipses were often transcribed into *revue* titles, where the missing letters are marked by apostrophes: *R'mettez-nous ça!* (*remettez*) and *Sauf vot' respect* (*votre*).[98] The title of the aviation brochure in Picasso's third still life "*Notre Avenir est dans l'Air*" (see fig. 22) has been abbreviated in exactly this fashion; transcribed, it reads "Not' Av'nir." The missing "e" of *avenir* is not simply hidden by another object in the picture; it represents a verbal elision and signals a visual rift. Ultimately, Picasso's wordplay is the natural linguistic equivalent of his pictorial gambit. Abbreviation, ellipse, allusion, *à peu près* and *sous-entendu* – these are the tools of cubist engineering, fabricating a world in which objects suggest but do not describe, changing and exchanging identities; where guitars are heads, walls are tables, newspapers are bottles; a rarefied plane where no contiguous illusion of our world pertains, yet is inhabited by fragments of illusion and of real things.

The cardinal structural principle of the music-hall *revue* is the jumbling and splicing of current events in *tableaux* which occur in rapid succession and utter disregard for continuous narrative. True to the "variety" aspect of music-hall performance, plurality is the prime directive, both from category to category and within a given group. The *Grande Revue* of March 1912 at the Nouveau Cirque is typical: a "parodie clownesque" of the Chambre des Députés is followed by "Marocco in Paris," the "Théâtre ambulant Rémier," a lampoon of the Carpentier-Lewis boxing match, a scene from the Chinese revolution, Dr Tacaura, "Mlle Beulemans' Return to Brussels," the ballet dancers' strike and a finale which takes place on the Pont de l'Alma. In February 1913, under the rubric "Les Déstractions Parisiennes," *La Revue de la Scala* introduced the characters le Polo, le Golf, la Boxe, le Cinéma, le Skating, Luna-Park, l'Aérodrome, and a

— Et si tu veux, Dranem, j'entre à l'Eldorado!

*Photo Larcher*

30. Impersonations of Mounet-Sully and Dranem, in *La Revue de l' Ambigu*, Théâtre de l' Ambigu-Comique (winter 1911–12).

Télégraphiste. Mutually exclusive *actualités* or character types might also greet one another in the same *tableau*: Mounet-Sully, a toga-clad tragedian from the Comédie Française, meets the comic Dranem in the *Revue de l'Ambigu* of December 1911, where both stars are actually impersonated by music-hall performers (fig. 30); Madame Job (dressed in a poster for Job cigarette papers) convenes with Louis XIV in the final scene of *La R'vu . . . u . . . e!* at the Boîte à Fursy, February 1913 (fig. 31).[99]

There were, in fact, a number of attempts at the time to write and produce *revues* endowed with a more coherent flow of events, often by linking tableaux with explanatory interludes narrated by the *commère* and *compère*. These met with the disapproving protest of music-hall purists:

In effect, the dramatic action of a vaudeville or operetta . . . is a *whole*, and includes characters preordained to act from the beginning to the end of the play, while the *cortège* of a *revue* is composed of multiple characters, disparate, ceaselessly renewed, always inevitably foreign to an initial postulate . . . All of this sufficiently proves how much the *revue* is a special genre, quite different from all the others. It is precisely the *revue*'s lack of cohesion which gives it its charm.[100]

"Lack of cohesion" is equally the fundamental law of collage. The cropping, splicing and shuffling of paper *actualités* heeds the disjointed structure of collage-period cubism itself. Even for pictures that include a single clipping, Picasso often selects the area of a

31. "Madame Job" and "Louis XIV" in
*La R'vu...u...e!* Boîte à Fursy (1913).

newspaper page in which news items or advertisements are shown back-to-back.[101] The confounded formal coherence characteristic of both cubism and the *revue* takes its comic toll on the news of the day. The results are a jump-cut from seriousness to frivolity. In *Bowl with Fruit, Violin and Wineglass*, sports, finance, a *roman feuilleton* episode and *réclame* for "Huile de Vitesse" motor oil are jammed together with fake woodgrain and cheap color reproductions of fruit (fig. 32); in the still life "*Au Bon Marché*," department stores and dirty jokes offer comic relief from a political assassination (see fig. 24); news from the Balkan Wars could be followed by a new prescription to facilitate blood circulation;[102] advertisements for readymade clothes, fur coats, loans and gramophones accompany items on rugby, track and field, skating and a new record for calculating the depth of the ocean floor with a plumbline (see fig. 26); dispersed among medicines such as "Sakalom," "Force virile" and "Vin Désiles" ("the best tonic") are reports of a construction-workers' strike and the theft of 27,000 francs worth of registered mail;[103] sandwiched in-between "Lampe Electrique O.R" and "Lacto-Phosphate de Chaux" is an item concerning a vagabond in Fontainbleau who has turned himself in as the perpetrator of a grisly murder, while the international congress on physical education appears with news of an artist who has poisoned his lover (see fig. 23). (Picasso cultivated his penchant for stories of dark, violent crime by reading the tales of Fantômas, a villainous master of disguise from pulp fiction who also appeared in *La Revue de la Scala* in March 1912.)[104]

Picasso's sharp elision of *actualités* is the modern newspaper's own, but collage and *revue* estheticize this quality, manipulating it as a source of comedy and urgency, of disrupted narrative and spirited incoherence. As exaggerations of newspaper syntax, both are critical operations that reveal the daily press itself to be a manipulative artifice disguised as an objective sequence of simple or transparent reportage. Further heightening this effect, Picasso and the *revuiste* also share the juxtaposition of contemporary current events with *old* current events. Clippings from *Le Figaro* dated May 28, 1883, concerning the coronation in Moscow of Czar Alexander III, are included amidst the pasted papers of at least four collages from spring 1913 (see fig. 27).[105] In *Guitar, Sheet Music and Glass* (see fig. 11), the fragment of the song "Sonnet," from 1892, floats in close proximity to the Balkan Wars bulletin from *Le Journal*; nostalgic scenes from the *café-concerts* and

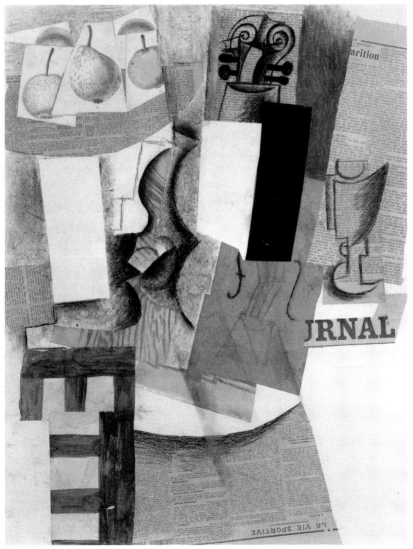

32. Picasso, *Bowl with Fruit, Violin and Wineglass* (between December 2 1912 and January 21 1913).

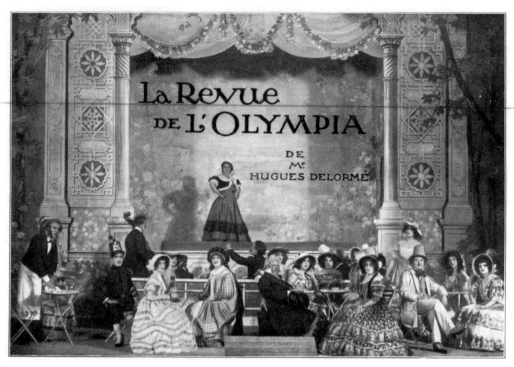

33. The *café-concert* Alcazar d' Eté during the 1860s, in *La Revue de l' Olympia*, Olympia music-hall (1913).

cabarets of times past were a staple subject of the pre-war *revue* (fig. 33), and reciprocate Picasso's choice, a song that was created by Marcel Legay at the old Eldorado.

In addition to the shuffling of paper *actualités,* "lack of cohesion" also characterizes Picasso's abrupt juxtaposition of visual components, dynamic shifts in handmade and readymade pictorial style. In this regard, every pasted paper, whether it contains printed words or not, commands the autonomous weight of a *tableau de revue*. In *Guitar, Sheet Music and Glass*, for example, the apposition of bold, unmodulated papers, decorated wallpaper, imitation woodgrain, newspaper, sheet music and a cubist drawing violates every previous standard of pictorial coherence. Equally startling are works such as *Bottle of Vieux Marc, Glass and Newspaper* (see fig. 23), where fragments of newspaper, wallpaper and imitation picture frame project bold, dense graphic patterns that are utterly irreconcilable. One critical factor for this property of disjunction has to have been speed. Building a work from the juxtaposition of discrete parts is, in a sense, easier than establishing an overall unity of narrative and formal structure.[106] Simultaneously, it represents a challenge, a breach of decorum which substitutes quick wits for slow study. The facility and speed with which a collage can be constructed must have represented an exhilarating departure from old rules of picturemaking, for the impact of dynamic heterogeneity within given pictures is matched by the brisk momentum of innovation and change across the entire collage œuvre. Music-hall observers recognized this dual role,

practical and esthetic, of self-imposed haste. The distinct thrill of good music-hall was a function of variety plus reckless pace, each of which amplifies the other. Remarking on the unprecedented favor that the *revue* genre seemed to be commanding during the pre-war period, the critic Ergaste wondered if this wasn't because, "the *revue*, where all esthetic liberties are permitted, is more readily mounted than the smallest play, and that, these days, it is above all a matter of rapid production?"[107]

Rapid production pertains as well to the décor of *revue* and collage. While *revues* were sometimes sumptuous affairs, including large, luxurious *tableaux* on exotic themes, most music-hall settings were expectedly provisional. One can observe, in period photographs, that music-hall stages were generally quite small. Some scenes took place against a curtain backdrop, others before broadly brushed background settings and readymade interiors that suggest, rather than contain, real luxury. In collage, pasted and painted imitations of marble, woodgrain and chair-caning, and objects such as tassels – stick-on luxury – are stage-effects of this kind, inexpensive substitutes for expensive materials. Further, at the music-hall, wallpaper was also a handy means of evoking the ambiance of a formal room, a dress-up foil for the comic antics occuring downstage. In *La Revue de l'Ambigu*, such a wall, contained within an elaborate molding that recapitulates the shape of the procenium arch, offsets a scene involving the *commère*, *compère* and Fallières, the president of France (fig. 34). Applied against the entire background of a collage, as in *Guitar, Sheet Music and Glass* (see fig. 11), Picasso's wallpaper elicits a corresponding impression of bourgeois formality. The paper game of ambiguity constitutes both an esthetic pretense and a mockery of social pretentiousness. The game is also a mannerism of the music-hall: in the "foreground," newspaper fragment and popular song comprise our comic *tableau*, a current event set to music. In *Glass and Bottle of Bass* of 1914

34. "A l'Elysée," *La Revue de l'Ambigu*, Théâtre de l'Ambigu-Comique (winter 1911–12).

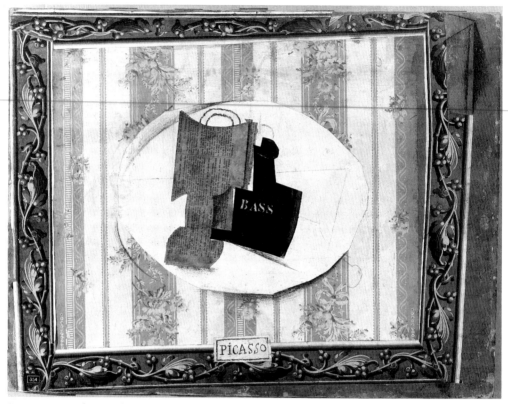

35. Picasso, *Glass and Bottle of Bass* (spring 1914).

(fig. 35), fake picture frame molding heightens the effect. Here now is the proscenium arch, within and before which the Bass and the glass, cut from a newspaper *roman-feuilleton* narrative, show and tell.

—5—

The *revue*, a comic system according to which French society commentated itself, comprises a set of larger cultural co-ordinates for collage. Paris was permeated by the music-hall *revue* during precisely those months when Picasso was introducing, into cubist pictures, verbal and material facts from the ephemeral world of contemporary printed paper. The *revue* furnishes virtually a complete agenda of the motifs and devices in cubist collage, especially in the œuvre of Picasso. As a model, it comprises the entire jumble of pasted subjects in any given picture, rather than requiring us to acknowledge some and ignore others. The vocabulary of the *revue* is the vocabulary of collage, a period lexicon of technical language specific to both: the *actualité*; the pun, the *allusion* and the *à peu près*; the *sous-entendu* and *entente*; irony, satire and *grivoiserie*; newspaper, advertising and song.

One factor in the growing currency of the *revue* during the collage period was the new

momentum it received from the authors "Rip" and Bosquet, whose *revues* of 1911 to 1912 were treated by critics as a virtual revolution in the genre; such is their achievement, as it was perceived by critics of the day, that Aristophanes was invoked as a rightful ancestor. The terms "literary" or "intellectual" were coined for the sophistication of their work, and they were credited with having saved the *revue* from corrupting at the larger halls into a pretext for lavish costume display, by deftly blending a *grand spectacle* style with satiric sketches of brilliant wit.[108] While Rip and Bosquet were accused by some of straining the very nature of the music-hall as non-taxing entertainment, their fall 1911 *revue* for the Olympia theater set a music-hall box-office record.[109] The most prominent example of a theater piece predicated on the "intellectual *revue*" was *Mil-neuf-cent-douze*, by Charles Muller and Régis Gignoux, performed at the Théâtre Antoine in April 1912. The authors implemented the classic *revue* devices of short *tableaux*, extravagant costumes and comic personifications (characters include an Ubu-like "1912," the *Journal Officiel*, and "Illusion"). Their work is a dense satire of public dupery, and draws throughout on *l'actualité* – the false claims of modern advertising, for example, or the appropriation of the workers' café as a pulpit for vote-seeking politicians.[110] Most reviews of *Mil-neuf-cent-douze* congratulated Muller and Gignoux on bringing a fresh sense of style and bite to *revue* buffoonery; Ernest La Jeunesse hoped that this "masked *revue*" would excercise a positive influence outside the music-hall.[111]

In fact, the flexibility of the *revue* format, and the "today's-paper" currency of its contents, proved irresistible to non-specialists, and the *revue* was not without its impact on members of the "bande à Picasso."[112] Most significantly, André Salmon, a close friend and critical supporter of Picasso during the pre-war years, wrote a thoroughly idiomatic *revue* entitled *Garçon! . . . de quoi écrire!*, which was performed at the Salle Malakoff in June 1911. *Garçon!* was written as a "*revue* of literary life" but, Salmon confirmed, conceived along the lines of the music-hall *revues*, like those at "the Européan, the Cigale and the Gaîté-Montparnasse, with titles like *Pour qui votait-on?* and *Denichons, denichons!*"[113] Salmon's own title quotes the poet to the café waiter, calling for a paper and pen. His *revue* is set in two legendary literary cafés, the Pré Catalan and the Napolitain, and populated by a typically heterogeneous music-hall cast that has been skewed towards the literary theme: parodies of *littérateurs* such as Maurice Rostand, Henri de Regnier, Saint-Pol-Roux, Jules Romains and Marinetti; personifications of newspapers and literary periodicals including *Excelsior*, *Mercure de France*, *Revue des Deux-Mondes* and *La Phalange*; various fantasy figures such as "Glory" and the nymph Glycère; and familiar personalities from the world of arts and letters including an Academicien, a *Réfusé*, and an Agent. Each character sings punning or satiric couplets set to the music of recent popular tunes.

The rhyming refrain sung by *Excelsior* derides the large two-*sous* newspapers of the day for cheapening serious but low-paying journalistic and literary material with the money-making trivia of commercial advertising:

> Hop! *Excelsior*, hédi, ohé! / Hop! I give you, for two sous: / Some Lemaître and some rubber, / Some Barrès and some bamboo chairs; / I propose with Tristan Bernard / Some liquors and some duck paté, / I propose with some Lavedan / A nice tooth brush. / Hop! Excelsior! ohé![114]

*Excelsior*'s parodic refrain calls to mind the very structure and content of *revue* and collage as ironic *journaux joués*. One year later, in an article on the Paris daily press (which appeared in a small literary periodical), critic Jean Puy would accuse the large two-*sous* papers of pandering journalism, excessive commercialism and an improper *ton de blague*; such newspapers, he feared, simply confirm the low opinion of Paris intellectual life that visitors will have already formed at the music-hall.[115] Yet, like collage, the "intellectual *revue*" and its progeny further demonstrate that the music-hall could also be perceived as a vehicle of fresh potential among younger authors. Even the irony and screwball quality of the *revue* (its *loufoquerie*), which might be perceived as the equivalent of bad journalism written in a *ton de blague*, could be a source of energy, a purge. One of the compliments Salmon fondly remembers having received on the occasion of his *revue* was that before him lay "a career as attractive as that of Rip." In the chapter on *Garçon!* from his memoirs, Salmon confessed that he keeps his "texte de revuiste" more carefully bound than most of his other works.[116] It represents for him a spirit of *blague* and of the studio; of irony, pranks and inside jokes. "There was," he writes, "an 'esprit de blague et d'atelier' around 1913 at the Bateau-Lavoir where, at the same time, modernism, orphism, cubism were all in serious preparation."[117]

Salmon's *revue* is composed in a popular mode, but its contents are confidential. Collage and the *revue* share this paradox of accessibility and hermeticism. Collage works abound in mundane materials, yet cubism was virtually impenetrable to all but a tiny proportion of its pre-war audience; the materials constitute a vernacular, but the syntax is abstruse. The devices of cropping and splicing in collage subvert the easy, common currency of the pasted papers, and the visual and verbal games that result suggested, and still suggest, an inside joke. As at the music-hall, the structure and comic irony of collage cause the *actualités* of the day to function as their own parodic critique. Both genres also presuppose what Dreyfus calls "the secret *entente*" between author and audience. Of course, at the *revue* "hidden" meaning was a charade of sorts, for the music-hall needs a large audience in order to survive. But the *entente* was real to the extent that the pleasure of the *revue* was derived from decoding the allusions and *sous-entendus*. Picasso survived upon the appreciation and material support of his immediate circle, and it is to the inner circle that he pitched the jokes of collage. We have no written evidence that Apollinaire, Kahnweiler or Salmon read the pictures for puns and other verbal-visual play, though it seems likely that they did. The collages of Braque and Juan Gris, however, tell us that Picasso had a co-conspiratorial audience of at least two.

The materials of collage are forever attached to life outside art, yet they have been physically extracted from still life objects which can be confined to a relatively small actual or fictional space, such as a table or an easel picture. In *revue* fashion, collage pictures reach out to culture at large, then turn back in. Dreyfus describes a *revue* subgenre, the "revue de société." Played in *salons*, *cercles* and *cenacles*, such *revues* are more "mordant and provocative" than those of the theater, and would be unintelligible to a general audience.[118] The operative principle resembles Salmon's "esprit de blague et d'atelier." This is what permits a still life to be the perpetrator of a dazzling comic turn. Picasso's collages from 1912 to 1914 constitute a transposition of music-hall *revue* strategies to the cubist *cénacle*: a pictorial "revue de société" for companions of the café and the studio.

—6—

Collage and *revue* function according to a deliberate ambiguity of public and private expression. The cardinal conceit of both œuvres is the implimentation of the transient and banal through an esthetic *argot*, a confidential language that, in principle, conceals as much as it reveals. By its very availability in the realm of popular culture, and through Picasso's appropriation, the conceit itself serves to describe a chief quality of new pictorial art, an ambivalence, as if originiality were a kind of code. The artist not only engages directly with the raw materials of modern ephemerality for the first time, but secures an entire frame of reference from the popular life of those materials, one in which their potential energy for poetic charge is already in play. As theater, the music-hall is not especially profound; it is, however, a laboratory of restless sense, where an utterance can be both banal and obscure, a comic ambiguity that is valued for itself. The elasticity of *l'actualité* at the music-hall further evokes a whole enterprise of overturned expectations in pre-war picturemaking. The emergence of the new as a comic idiom only heightens the quality of ambivalence, a project in the secret possibilities of mass-culture propagated at the expense of conventional meaning.

The music-hall modernism of Picasso's collage œuvre touches on numerous related matters of new style, technique and decorum. Among them, it is possible to highlight what appears to have been a modernist strain of comical insolence towards the "facts" of daily news. A certain fascination with the newspaper's illusion of actuality, the pseudo-objectivity and wobbly reliability of news-truth, can be identified. In this context, the *ton de blague* is the chief device. This, in turn, suggests that the music-hall *revue* actually represents a broad category of cultural experience at the time.

In examining this comic strain of modernist *actualité*, we can begin by returning to the period's most explicit document concerning the influence of the music-hall, Marinetti's manifesto "The Variety Theater" of 1913. The manifesto is most accessible for its emphasis on the physicality of the music-hall stage: "swift, overpowering dance rhythms," "speed" and "gymnastics," "frightening dynamism" and "dynamism of form and color," the "authority of instinct and intuition," "body-madness," "all the records so far attained," "audience collaboration," and a "strong sane atmosphere of danger." In Marinetti's vision of music-hall *spectacle*, the athletics of "agility, speed, force, complication and elegance" is a performance counterpart to "new significations of light, sound, noise and language." Moreover, "the Variety Theater destroys all our conceptions of perspective, proportion, time and space" – here Marinetti notes the bizarre distortions of scale which one might encounter in music-hall set design.[119]

Indeed, "The Variety Theater" manifesto has been grossly neglected, for it contains virtually a complete repertoire of the pictorial devices of futurism, most notably the principles of dynamism and audience participation. As a futurist statement on the subject of received influence, it is singularly comprehensive. Only Giovanni Lista has examined the document in depth. For Lista, Marinetti exploits the music-hall as an *imago urbis* that estheticizes the experience of the modern city.[120] As Lista explains, montage, assemblage and other modernist devices of pictorial form are implicated throughout the manifesto. In

other words, though it appears relatively late in the pre-war period, we might read "The Variety Theater" back into the history of futurism, for the subtext of Marinetti's claims appears to be that futurism itself is virtually an avant-garde counterpart to recent developments in popular entertainment. In addition to formal invention, this would also pertain to the slapstick clash of comic exaggeration and violence in so much futurist art and activity, including the infamous campaign of violence against museums and great works:

> The Variety Theater destroys the Solemn, the Sacred, the Serious, and the Sublime in Art with a capital A. It co-operates in the Futurist destruction of immortal masterworks, plagiarizing them, parodying them, making them look commonplace by stripping them of their solemn apparatus as if they were mere *attractions*."[121]

(Further along, Marinetti describes one formula for achieving this ambition: the production of stage classics in condensed form, "comically mixed up" with one another.)[122] Futurist violence turns out to have been a metaphor; the damage is done through parodic ridicule. In this regard, Boccioni's explosive painting *L'Esciaffement de Rire* of 1911 (fig. 36) is virtually iconic: "The Variety Theater . . . is also the bubbling fusion of all the laughter, all the smiles, all the mocking grins, all the contortions and grimaces of future humanity."[123] Marinetti is so swept up in his own enthusiasm, that he makes the music-

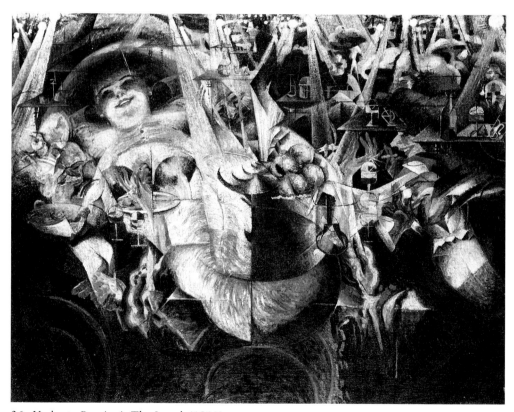

36.  Umberto Boccioni, *The Laugh* (1911).

hall a model for the ideal condition of the new art: "The Variety Theater is naturally anti-academic, primitive and naïve . . . Prevent a set of traditions from establishing itself in the Variety Theater."[124]

It is both surprising and inevitable that, as David Cheshire has discovered, Marinetti actually appeared on the music-hall stage.[125] The occasion was a performance of noise-music as a variety turn at the London Coliseum in 1913. Marinetti supplied the instruments, twenty-three of Luigi Russolo's electric noisemakers, which were played by bewildered members of the house orchestra under Russolo's direction. Laughter and derision from the audience were not quelled by Marinetti's post-performance disquisition, in Italian, on futurist theory. In at least one significant instance, however, "The Variety Theater" seems to have been Marinetti's ticket to popular appreciation. Several months after its intial appearance, the "Music-Hall" column in *Comoedia*, an entertainment daily, devoted no less than four installments to the manifesto, with a complete translation in two parts plus commentary.[126] While they cannot resist criticizing "The Variety Theater" for hyperbole, the authors (Roland Dorgelès and Curnonsky) are otherwise surprised to find themselves in utter accord with the futurist impresario. The points they chose to single out are suggestive, for they have less to do with the physical commotion of variety performance than with the qualities of music-hall as an anti-conventional medium. Marinetti is applauded in particular for his emphasis on the novelty of music-hall performance, and his remarks inspire two discussions concerning the significance of the music-hall as an agent of excess in comedy, parody and burlesque.[127] The manifesto is enthusiastically supported for its warning against "tradition" at the hall, advice that "all the directors in the world should always keep in mind,"[128] and for its description of the music-hall as an ironic purge of false sentimentality, considered a plague of contemporary theater.[129] Somewhere on the music-hall stage lies a common notion of comic originality on which the modernist and the layperson can agree. Nor is this simply a function of mutual taste in entertainment, for both Marinetti and *Comoedia* are promoting music-hall comedy as a force of modernity.

The *Comoedia* editorials encourage us to examine Marinetti's manifesto for some finer points of the modernist's music-hall. In particular, we note that Marinetti is, in fact, quite deliberate in his attack on the "Parisian *revue*," with its *compère* and *commère*, as "nearly always a more or less amusing newspaper." His disparagement is tempered, for his objections concern the "irritating logical sequence" of recent *revues*; instead, "one must completely destroy all logic in Variety Theater performances."[130] Marinetti is addressing a development of contemporary *revue* history: attempts, beginning around 1912, to unshuffle the *revue*, making it conform to a single, unbroken narrative line. His remarks actually conform quite closely to the debate as it was waged in the entertainment press. Otherwise, the currency of the *revue* is actually celebrated by Marinetti in the very opening of the manifesto: "The Variety Theater . . . is lucky in having no tradition, no masters, no dogma, and it is fed by swift actuality."[131]

Moreover, Marinetti is frank in his admiration for the incoherent, *revue*-style sequence of *actualités*:

a cumulus of events unfolded at great speed, of stage characters pushed from right to left in two minutes ("and now let's have a look at the Balkans": King Nicholas, Enver-

Bey, Daneff, Venizelos, belly-blows and fistfights between Serbs and Bulgars, a couplet, and everything vanishes)[132]

and for the simultaneous juxtaposition of discrete parts: "Put Duse, Sarah Bernhardt, Zaccioni, Mayol and Fregoli side by side onstage."[133] In fact, the only developed example that Marinetti quotes from recent music-hall performance is drawn from the *Revue de l'Année* at the Folies-Bergère in 1911. There, two English comic dancers, "Moon and Morriss," were the hit of the *revue* portraying Jules Cambon, the French ambassador to Germany, and Kiderlen-Waechter, the German secretary of state for foreign affairs (fig. 37). The dance, which was called "Conversation diplomatique," was a burlesque of the torturous five-month negotiations between France and Germany over colonial possessions in North Africa that resulted in the "Accord Franco-Allemand."[134] The Accord was signed on November 4, and the *revue* opened in December. (A stage treatment of Cambon and Kiderlen-Waechter is anticipated in the daily press, where the headline "Dix Jours d'Entr'Acte" refers to a stalemate in negotiations, and the resumption of talks means that "Le deuxième acte commence."[135]) Marinetti hailed the performance as "a revealing symbolic dance that was equivalent to at least three years' study of foreign affairs," and

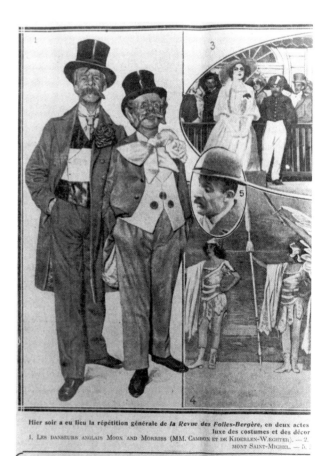

37. English dancers Moon and Morriss in *La Revue des Folies-Bergère*, from *Excelsior* (1911).

he offers a description that surpasses the entertainment critics in close observation and devoted appreciation:

> Facing the audience, their arms entwined, glued together, they kept making mutual territorial concessions, jumping back and forth, to left and right, never separating, neither of them ever losing sight of his goal, which was to become more and more entangled. They gave the impression of extreme courtesy, of skillful, flawlessly diplomatic vacillation, ferocity, diffidence, stubbornness, meticulousness.[136]

All in all, Marinetti's taste at the music-hall proves to be idiomatic. His celebration of physical prowess, for example, coincides with a small but distinct flurry of critical attention to sports at the music-hall, and the new genre of "comique sportif."[137] His call for a parody of the classics mirrors recent productions of Molière starring celebrities of the music-hall stage.[138] Above all, Marinetti appears to substantiate the existence of a modernist predilection for the music-hall *actualité*, where contemporaneity is a function of the current event as a vehicle of comic manipulation. Marinetti's emphasis on the "Conversation diplomatique" number is a valuable surprise, for it directs us back to collage, and a relatively uninvestigated category of vanguard expression which we might broadly refer to as the *journal joué*. It reveals that serious subject-matter, such as technology and science in futurist painting, may not be readily separable from parody and burlesque; that the characteristics of modernism are more complex (even as expressed in the futurist manifesto) than a positivistic belief in progress. The comic element is not a mere frivolity, but an essential subtext of the modernist enterprise. Beyond satire, it appears to have been an agent with which the modernist might dismantle and recombine the swift experience of modern times.

Outside the strict confines of the music-hall, the *ton de blague* treatment of daily news lives as an autonomous *revue*-style genre of its own. In 1906, Félix Fénéon reinvented the category of news-in-brief, or "Nouvelles en trois lignes," transforming minor news items into vehicles of deadpan wit in the pages of *Le Matin*.[139] Disguised as straight reportage, Fénéon's bulletins derive much of their humor, usually black, from the confines of the format itself. At times, the intervention of an authorial voice is barely perceptible, if at all:

> A proprietor in Gabarret (Landes), Capes, was murdered in his home. It does not appear that he was killed for reasons of theft.[140]

In many instances, however, the no-nonsense limitation of three lines, which is both practical and arbitrary, serves to compress personal tragedy into a space that barely contains the gravity of the moment, yet, simultaneously, reduces that gravity to a trifle. The effect is absurd, a straight-faced tragi-comic pratfall:

> For the fifth time, Cuviller, a fisherman in the Marines, poisoned himself, and, this time, it's definitive.

> M. Scheid of Dunkerque, after shooting at his wife three times and missing, killed his mother-in-law.

> There is no longer a God for Drunkards. Kersilie of Saint-Germain, mistaking the window for the door, was killed.[141]

Fénéon seizes the impartial tone or "objectivity" of newspaper style as a sly foil for editorial comment. The content of these reports is authentic, but Fénéon transforms the necessary constraints of telegraphic brevity into a form of dismissive sarcasm, where matters of life and death barely register as minor episodes in existential irony. With subtle shifts of emphasis, he has transformed the briefest account of given facts into an exercise in comic suspense, with occasional indications of higher meaning. Treated now as an ancestor of the late modern "minimal story," it is important to recognize that Fénéon's crafty manipulation of the news was not anomalous, but actually represented a virtual subcategory of journalism during the period. He had at least one significant predecessor: between the 1880s and 1914, the composer Erik Satie wrote a broad range of *annonces*, brief *écho* style news items and *publicité* (for his own music, in some cases) which were published in small periodicals such as *La Lanterne Japonaise*, *Revue Musicale S.I.M.* and *L'Avenir d'Arcueil-Cachan*. Both authentic and imitation, anonymous and pseudonymous, Satie's entries distinguish themselves from Fénéon's in their overwritten self-importance.[142]

Fénéon's example, however, was the most likely prototype for the playful news items in André Salmon's short-lived review *Nouvelles de la République des Lettres*, which appeared in 1910 and lasted only four issues. The masthead itself, which had originally belonged to a venerable eighteenth-century literary periodical, was ironic in its way; Salmon described his publication as a "small review with a modern spirit and an old title."[143] Under columns such as "Ephémérides," "Prédictions," and "Scénes de la Vie littéraire," Salmon, and other authors such as Max Jacob and Fernand Divoire, developed a genre of fabricated, mocking and scurrilous reportage. Among the victims were Jules Romains, who was not amused. Years later in his memoirs, Salmon was still patching up: "Jules Romains was wrong to think that I was against him because I "blagued" him in the échos of the *Nouvelles de la République des Lettres* and in a sequence of *Garçon, de quoi écrire*."[144] He recalls that Charles Morice criticized Salmon for devoting more space to jokes than to serious work;[145] and that his friend René Dalize

> reproached me for abusing everyone, insinuating that that would get us nowhere favorable . . . Dear Dalize, who was never able to conceive of a review which is not based on the express purpose of replacing and rejuvenating the *Revue des Deux Mondes*. Indeed![146]

Salmon's model was perpetuated throughout the avant-garde press. Isolated examples include a lengthy news item from December 1913 in Apollinaire's review *Les Soirées de Paris*, which details a foiled plot to massacre some 100 cubist painters in their homes (the complicity of concierges was required), and burn down the Salon d'Automne.[147] An extended version is represented by Arthur Cravan, poet, artist, critic, boxer and pretended nephew of Oscar Wilde. Cravan's little magazine *Maintenant* is nothing less than a full-dress parody of the avant-garde review. *Maintenant* appeared sporadically in only five issues, and, as Salmon himself remembers it, was almost triumphantly shoddy and unkempt.[148] Its purpose seems to have been a deflation of current esthetic pretentions, "flung in the faces of writers and artists, the young, those most convinced of their 'independence.'"[149] To this end, Cravan, who was both editor and sole contributor, created a stream of comic invective, lampooning various kinds of arts-and-letters prose.

Inverting the self-important seriousness of the literary *éloge*, for example, Cravan's article on André Gide is a disrespectful and dismissive anti-appreciation piece composed in loose, conversational style:

> Since I dreamed feverishly – after a long period of terrible lassitude – of becoming very rich (my God, how often I dreamed of that!); as . . . I was getting progressively worked-up at the thought of attaining a fortune dishonestly and in an unexpected way, through poetry – I have always tried to consider art as a means and not an end – I said to myself merrily: "I should go to see Gide, he is a millionaire."[150]

News of the arts appears in the form of hyperbolic claim, as in the article "Oscar Wilde est vivant!"[151] and Fénéonesque deadpan (one *échos* column, called "Différentes Choses," reports, "We are happy to learn of the death of the painter Jules Lefebvre"[152]). The scope ranges from full-length, in a seventeen-page review of the 1914 Salon des Indépendants (with comments such as: "Above all, I find that the first condition for being an artist is to know how to swim"[153]) to small format, in multiple examples of mock *publicité*:

<div align="center">

Where can you see VAN DONGEN

put food in his mouth,

chew on it, digest and smoke?

chez JOURDAN

restaurateur

10, rue des Bon-Enfants, 10

(*Près des Grands Magasins du Louvre*)[154]

</div>

For Cravan, the very proposition of the current affair was an absurd lie. This is *ton de blague* as a literary genre and a philosphy of life.

Later, in 1917, Francis Picabia propagated a less ambitious but equally quirky "fausse nouvelles" column in the little magazine *391*, which was directed at friends and enemies alike. Picabia's wife, Gabrielle Buffet-Picabia, later compared the column to a larger "attitude of deliberate humor and *blague* with which to approach the most vital questions," and attributed the syndrome to an unconscious affinity for revolt that was shared between the *391* circle and Zurich dada.[155] Greater irreverence towards the *actualité* had been shown by Apollinaire in 1916. André Billy, Apollinaire's close friend and biographer, tells us that, working during the war for the paper *Paris-Journal*, the poet-journalist was charged with translating news reports from the English press. Concerning politics abroad, says Billy, Apollinaire operated according to his own code of ethics, supplying "translations" of dispatches from London and New York which were, in fact, entirely of his own imagining. "There is no better way to influence events," he maintained.[156]

The sense of irony here is endemic to the pre-war modernist's appropriation of the *actualité*. This includes advertising and fashion as well as current events in the news, the common fare of the *revuiste*. The effect is often an inversion of value, an ironic device that transforms a thing into what it is not – that acts to deny face value. In order to highlight this, it should be recalled that the growing and confusing surfeit of information in the

newspaper could be met with other qualities of response. Early on, an observer like J.K. Huysmans approached the phenomenon with a kind of intoxicated attraction-repulsion:

> Consols are going up, industrial securities are holding firm; Panama is going down, Suez is steady. – Crossword and metagram: correct solutions: *Paul Ychinel*, *Le pére Spicace*, *Astre à Caen*, *Lady Scorde*, *Miss Tigry*, *les œdipes du café du grand balcon* – Rowland's macassar and Guyot's tar Russian corn cure and Wlinsi paper. – Dry nurse seeks employment. – No more bald heads! Fresh growth certain, and guaranteed; judge for yourself! Malleron. – Hidden disorders, ulcers discharges . . . These advertisements on the backpage of a torn newspaper found in one of my pockets, as I stand by the roadside with open country on every side as far as the eye can see, succeed in demolishing the long-desired tranquility which had possessed me; this piece of paper takes me back to Paris, and the apprehensions of my everyday life, which I had at last succeeded in breaking down, came back to me with renewed force.[157]

Jarring for the hyperpathic Huysmans, the rapid juxtaposition of words and images would, by the pre-war, become an esthetic stimulant. While, at its worst, such a vocabulary can represent cheap, pre-packaged feelings or empty claims, some would clearly be drawn to these verbal and visual blurbs as the caffeine of a complex expression, one in which the modern jargon of brand names, song lyrics and newspaper headlines comprise the accidental or found poetry of urban experience. However, with the *revue* sensibilty in mind, we know that the *actualité* was not lifted intact, but transformed, italicized into a parody of itself. The plasticity of the *actualité* in modernist hands is instructive. Huysmans was startled by this material; the next generation would seize control. By the pre-war period, bits of cultural ephemera were not just claimed, but routinely cropped and rearranged.

Returning to Picasso's *Ma Jolie* with the *ton de blague* in mind, we might even reconsider the sincerity of a sentiment that seems, at first glance, to have been irreducibly straightforward. The phrase "ma jolie," from the Fragson refrain, is fair game, a fleeting fragment of pop emotion. As genuine and touching as Picasso's tribute to Eva may be, it should be acknowledged that, in reference to the picture itself, the label "my pretty one" can also be read as a sarcastic remark. After all, by the fall of 1911, it was already clear that cubism – Picasso's, Braque's, and everyone else's – would come to be called most everything but "pretty." It was around that time, the story goes, that Picasso's friend Manolo mocked, "Listen, Pablo, if you went to get your parents at the station and they arrived with mugs like that, you wouldn't be happy about it."[158]

As a model for collage, the music-hall *revue* encourages us to identify and trace the life of irony in modern art. Rather than predicate any study of the period on the description of confining, programmatic motivations to which artists and objects are understood to conform, the role of the ironic (Lenin's "illogicality of the everyday"), as an essential ingredient of modernist expression, suggests that we might instead try to recapture the confusion of the moment. This may at least establish a set of conditions according to which any account is understood to be a provisional distortion. For the pre-war epoch is characterized by a degree of illegibility that is not just a function of historical distance, which characterizes the study of any period, but is built into the esthetic changes themselves. This quality can be approached most directly through the culture of popular opinion, the public and critical reception of novelty and change. The accumulation of

response constitutes an edifice of assumptions and presuppositions within which interpretation of new art occured at the time. The public and critical domain is actually another category of popular culture. It is contextual in its breadth; but when its appearance is adequately defined, it can also be appreciated as a body of ideas and issues that were directed back into the progress of events.

"L'art très moderne ne l'est déjà plus quand celui qui le fait commence à le comprendre. Quand ceux qui pourraient le comprendre commencent à ne plus vouloir le comprendre et quand ceux qui l'ont compris veulent d'un art qu'ils ne comprennent pas encore."

Max Jacob, *L'Art poétique*, 1922

# CHAPTER II

# "PRENEZ-GARDE À
# LA PEINTURE"

## THE AVANT-GARDE IN CRITICAL
## AND POPULAR OPINION c.1909–1914

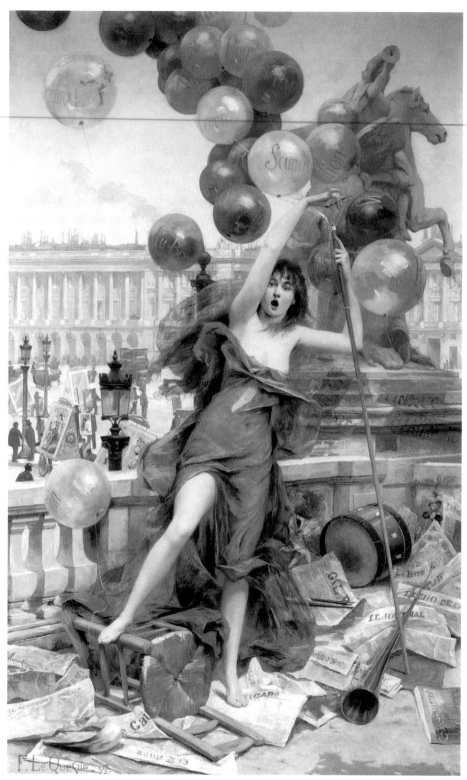

38.  Fernand LeQuesne, *Allegory of Advertising* (1897).

## —1—

The "esprit de blague et d'atelier" complicates any interpretation of modern art. With its implication of insiders and outsiders, it makes the very act of historical interpretation uncertain, and conditional at best. This is particularly true of Picasso. As a member of no organized pre-war avant-garde group, he stands somewhat apart from the mainstream of programmatic modernism. But the surprising proximity of collage to *revue* in his work points up an indeterminacy of meaning and intentions, and begins to help define a larger issue of the period. In the case of prevailing irony and related matters, we come to ponder the very experience of pre-war art. It is difficult to reconstruct this situation from the works themselves, for a true sense of their unfamiliarity at the time has been lost. The evidence of period literature on art is, however, revealing in this regard.

Applying period criticism to works of art, the better to understand them, poses a notorious risk. The irrefutable "authenticity" of a given period document could theoretically justify any interpretation of a picture that accurately conforms to an agenda of the moment, be it esthetic, political, philosophical or otherwise. Adopting the formula of a particular pre-war critic could result in an uncritical approach. Our understanding must, in some crucial way, benefit from the perspective of historical distance, accounting for yet transcending the limited, close-up vision of a contemporary observer. A selective navigation of this vast sea of words is inevitable, even desirable, for there would be little value in indiscriminately recording the entirety. Equally important, however, is to look beyond the defensive treatises and manifestos on modern art – to avoid the myopia which comes from simply taking modernists' explications of modernism at face value. By asking specific questions of the literature on a broad scale, the framework of experience within which the many sub-issues and arguments of modernism originally occured might be retrieved.

\*      \*      \*

Since Edward Fry's pioneering anthology, and especially in recent years, cubist criticism has received some significant attention. This art-historical literature tends to fall into two camps: a general historiography of serious formalistic and philosophical interpretations that might constitute accurate, therefore authentic, period appreciations of cubism; and one which spotlights various criticisms that express a single argument.[1] Emphasis is usually placed on writings that operate at a fairly high level of intellectuality; little account is taken of critical opinion that appears dismissively negative, intolerant or merely frivolous. When hostile or negative criticism does come into play, such response is commonly probed for a presumed political agenda. Yet the fact remains that expressions of antagonism towards the avant-garde all draw upon the same set of terms, quite apart from political stripe. This cannot be over-emphasized. The attitudes, rhetorical devices and vocabulary – the leitmotifs – of discontent tend to be the same for all segments of the audience, be they left or right in political orientation, high or low in cultural sophistication.

Incomprehension of avant-garde art is often ignored or dismissed as a philistine re-

sponse beneath historical study. This is unjust, if only because expressions of incomprehension occupy a far greater share of the period literature on modern art than any other kind of interpretation; it might justifiably be called the dominant esthetic condition of the period. Aspects of this condition are even shared among the relatively small segment of the critical community that professed to be well informed. A forgotten figure in the history of early modernism, the bewildered spectator is the pre-war Everyman of modern art. Just as he responds to artists' work, so too must artists have responded to his presence. What pressures did they exert on each other, and on the production and exhibition of art? What extra-esthetic cultural points of reference exist for all the hostility and confusion? To what degree can we absolutely separate the supporters of specific avant-garde groups from the enemies of the avant-garde *en masse*? Is it possible to establish a large scheme that articulates the dynamics of a community of artists and spectators, a broad popular dialogue containing the phenomenon of the avant-garde?[2]

It will be apparent to any student of the modern period that hostility to esthetic change had long been gathering momentum. Between *Hernani* (1830) and the Salon des Indépendants (1884), expressions and institutions of secession were leitmotifs embedded in the cultural dynamics of nineteenth-century Paris. By the time of symbolism, the vocabulary of incomprehension was a rhetoric of received wisdom and cliché that can be traced throughout the critical press.[3] In retrospect, resistance to the new has become the historian's common *repoussoir* of innovation, a negative proof of originality in modern art. Our task is less to establish a qualitative difference for the discourse of the pre-war period (though such a difference of degree, if not kind, certainly exists), than to show how the truisms of incomprehension were, by the emergence of cubism, governing principles of anxiety and confrontation, reflexive fears which preceded a new illegibility of pictorial form. Characterized by self-conscious debates over esthetic notions of rupture and advance, the epoch shows counter (and cross) currents of pre-established critical and popular opinion doubling back through waves of authentic change; in this milieu, the progress of the avant-garde is overtaken and disrupted or checked by the devices of its own ambition. Here, the phrase "avant-garde" must itself be flagged. The term is too convenient to be abandoned, but in the context of the culture of change, it is inadequate. Too often, "avant-garde" implies a larger project or enterprise, a shared purpose among individuals and groups directed towards a cohesive end. Cohesion is a mirage; as novelty and change are articulated, pursued and analysed during the period, through a vernacular of assumptions, artists' intentions are obscured or diffused by rhetorical screens. Again, this quality of experience is a visible subtext of the period literature. The term "avant-garde" cannot be dropped, but it can, under the circumstances, be expected to mutate; gradually, the phrase will develop a permanent set of implied quotation marks, and refer less to the nature of an enterprise of concerted effort than to the conflicting ways in which such a presumed enterprise is characterized, represented and perceived.

—2—

The pre-war youth culture in art and literature was possessed of accelerated diversity and change, a heterogeneity marked by the astounding proliferation of schools or "isms" within the community. Each ism seems to have comprised only a handful of members,

represented by its own manifesto or *petite revue*, the little magazine printed on cheap paper in small numbers which generally lasts only three or four issues before it flickers and dies. This theme of the *petite école*, the *cénacle*, the *chapelle*, the ism and its manifesto, was sounded over and over again during the pre-war period. In 1914, the critic Florian-Parmentier published *La Littérature et l'époque*, a history of French literature since 1885; the table of contents contains no less than fifty-six isms, most of them from the previous fifteen years. These include scientism, decadism, magnificism, paroxysm, naturism, neo-Mallarmism, somptuarism, impulsionism, unanism, futurism, primitivism, sincerism, intensism, druidism and philopresentism, to name only a fraction.[4] Florian-Parmentier's treatment is essentially sympathetic; the milieu of esthetic *cénacles*, he felt, nourishes debate and freedom from old pedagogy. Elsewhere, however, the ism is more commonly treated as an insidious blight on arts and letters of the day.

The best introduction to pre-war period hostility towards the ism is an article by the critic Camille Mauclair called "The Prejudice of Novelty in Modern Art." Published in the important *La Revue* in April 1909, its scope is broad: the "prejudice of novelty" is to be understood as "a synthesis of . . . general tendencies" for the epoch; it represents a "crisis of the novel . . . of the theater . . . of painting and . . . of music"; and it is attributed to the combined influence of "the organization of the press . . . the mentality of the public [and] of artists [and] morals."[5] The article contains no real analysis of artists or schools, though pointillists and fauves are mentioned in passing. Mauclair should be read, above all, as a bridge. His treatment of the "crisis" addresses the shape of the modernist enterprise since symbolism, and demonstrates the critical preconceptions which, like snares, awaited cubism and futurism on the eve of their arrival.

Novelty, Mauclair tells us, represents a new "restlessness" (*inquiétude*) in the arts, which results in stylistic "extravagance":

> One hears talk only of "making a tabula rasa" and of "starting over." The work of one's predecessors is now perceived as an intolerable weight . . . Each counts on being "original" . . . *Faire nouveau* is the entire program.[6]

"Faire nouveau" is a "singular, seductive, dangerous ambition . . . the history of the evolution and, above all, the corruption of the idea of novelty in art would be a fascinating study."[7] Mauclair insists that this notion of the "new" would have been incomprehensible to artists in the past, "the pretension to reinvent . . . the technique and style of an art"[8] would have been considered an act of pure madness. Now, to draw attention to themselves, artists cultivate personality and original style at the beginning of their careers. This is nothing less than a "fatal mania" (*manie fatale*).

Around the time of Mauclair's article, a significant document in the history of the pre-war avant-garde set the trajectory of this debate on a steady course. On February 20, 1909, Marinetti's founding manifesto of futurism appeared on the front page of *Le Figaro*: "Erect on the summit of the world, once again we hurl defiance to the stars!"[9] Criticism of the self-described avant-garde in art and literature gathered speed from the engine of Marinetti's manifesto. (Though published in April, Mauclair's article contains no reference to Marinetti, and seems to have been written before the appearance of the manifesto in *Le Figaro*.) While the origins of futurism in Italy would soon encourage some critics to label the movement a foreign invasion, most simply recognized Marinetti as the noisiest version of a widespread domestic custom. Ism-production certainly had not

abated since the symbolist period, but critical attention to the phenomenon had. With the futurist manifesto, there appears a clear body of popular and specialist critical literature devoted less to analyzing the esthetics of each group than to addressing the ism or new school itself as a meta-phenomenon.

Dominating the discourse are the themes of excess, impatience and self-promotionalism, themes that would recur throughout the public and critical response to modernism during the pre-war. The futurist manifesto does indeed correspond to the beginning of a new rush of schools and esthetic pronouncements in both art and literature which had come to comprise a single forum, and may actually have influenced a new spirit of aggressive collaboration.[10] Above all, however, Marinetti became a convenient example for critics of all that was wrong with the ways and means of esthetic youth. One idiomatic response to his manifesto came from within the community. Jules Romains had been solicited by Marinetti to pass judgment on the principles of the manifesto, and his reply was published in the small magazine *Les Guêpes* on March 3. Romains' tone is ironic throughout. He congratulates Marinetti on his initiative, especially since "it has been more than six months since any *cénacle* has solicited my conversion, and my neophyte's unflagging zeal is growing bored from neglect. You know that I am already the member of a number of schools, and that the list is not closed."[11] Romains procedes to run down the list of poets' groups, all of them genuine, who have claimed him as a member: humanists, naturists, the evolutionist-instrumentist school, free integralists, the visionaries who salute him as an "elder pioneer," the Abbaye de Créteil. He impatiently anticipates his friend Canudo founding the *école Tragiste* and Mme Hélène Picard launching vulvism, in order that he may declare himself an adherent. As for impulsionism, there are two schools bearing the name, and he does not know which to chose. He deplores the fact that pragmatism, unanimism and electromagnetism are not schools, since he has been a student of all three for some time now. He adds that he has just received a prospectus announcing the appearance of subjectivism; but Marinetti has priority, he will join futurism first, and occupy himself with subjectivism later.

Romains' remarks contain all the sarcasm of a hostile critic, and foretell ambiguities to come. Does he consider himself apart from the wave of new schools? Is the appearance of unanimism, derived from his own poem "La Vie Unanime," an ironic reminder that there really was no unanimist school as such?[12] Marinetti was undeterred by internecine conflict and dissent. In a March 26 interview for the daily arts and entertainment newspaper *Comoedia*, he was asked why his manifesto had been greeted with hostility by young poets, whose cause he was sworn to defend. Marinetti responded that this hostility comes as no surprise, "it even legitimates the explosion of futurism in the sense that it shows exactly how far the virus of routine, imitation and pedantry has infected a large part of the thinking and working youth."[13]

Response to the manifesto from outside was generally hostile, and largely in agreement concerning Marinetti's offenses. An editorial in the *Journal des débats* on February 25th was gentle, but slightly ironic: "We are a bit surprised that a literary school is founded" so quickly; "we thought time and work were more important than speeches; but a manifesto is sufficient."[14] In an article on the front page of *Gil Blas* in early March, Paul Acker was more abrupt, likening the strategy of the manifesto to that of "charlatans in the public square," and claiming that "the Third Republic will have seen born to it alone

more literary manifestos than all the dominions and kingships before it; manifestos no sooner born than dead."[15] The ardour of Marinetti's manifesto is, to Acker, characteristically Italian, but the manifesto craze is not; he cites, for example, the manifesto of "primitivism," which was published as a flyer by the French periodical *Poésie* some time in March, as a direct retaliation to Marinetti's call to arms.[16] "It is easier," Acker concludes, "to write 100,000 manifestos than to write one beautiful book."[17]

Acker's reference to the hawker of wares in the public square signals a central critical metaphor for avant-garde activity before the war. In this regard, modernism as an enterprise seems to have been conceived at the time as part of a larger modern cultural phenomenon: advertising. In his article on "the prejudice of novelty," Mauclair describes the period as an age of rapid communications and *publicité*, of *bluff* and *réclame*. In their haste to be noticed, according to Mauclair, artists have transformed the perils of yesterday – public mockery or savage criticism – to today's advantages. To shock is to be seen, to attract attention by means of "*bizarrerie*, special effects and powder in the eyes,"[18] even if the attention takes the form of public scorn; "only silence is to be feared."[19] A multitude of *petites chapelles* has replaced the academy. The prime mover is *arrivisme*; young artists are in a hurry; and to be a laggard, or *attardé*, is a fundamental contemporary fear. Some critics have also succumbed to the vogue for novelty, failing to address contemporary art in the context of the art historical past and thereby shape public taste. As for people "of good sense and good faith,"[20] they have become a simple nuisance. Novelty has produced malaise in a general public already solicited by "progress" in other aspects of life. Sapped by the fatigue of rapid pace and diminished time, audiences replace the novel with the magazine, treat the theater as an after-dinner distraction, and "understand nothing of the new formulas, which are foisted upon them with commercial advertising." Confronted with these conditions, such a public senses that the avant-garde is characterized by "great uncertainty, which is masked by the bombast of its declarations."[21] In Mauclair's assessment, modernists are false prophets, and their activity consists in what we might call false propheteering.

The critical literature following Marinetti's manifesto indicted Marinetti on this count, and extrapolated from futurism to all isms. Joseph Billiet's "Du Futurisme au Primitivisme," published in *l'Art Libre* in November 1909, is typical. Billiet begins with a prediction: "that in a century or two, some library rat ... will know quite some glory ... for the lucrative publication of a substantial and, if possible, scandalous study on 'Literary Schools at the Beginning of the XXth Century, with numerous unpublished documents'". Like Mauclair, he goes on to describe "the eruption of isms, manifestos and prospectuses" as "a symptom of general madness for recruiting and *réclame*," for advertising in contemporary culture at large, including the recent explosion of printed *publicité*: brochures, handbills and newspapers with backpage advertisements for "electric belts, marvelous pills and cure-all infusions."[22] In December, the small magazine *Arlequin* published an article on "Ecoles littéraires," reflecting the same sentiments. Citing integralism, humanism, naturalism, unanimism (a group with one member), futurism and primitivism, the author defines the question as one of "eternal currency. Not a week goes by that we do not see the birth of another literary school, announcing itself with much commotion and noisy manifestos."[23] This activity is attributed to a cultural condition that can be found "in the domain of letters as in any other[:] commercial anarchy."[24]

The ism or *cénacle* was often understood as a legacy of the symbolist period, what Ernest Raynaud later recalled as "la vie en commun des phalanstères," with its crowd of competing schools, manifestos, cafés and small reviews.[25] In this respect, the difference between the 1890s and the pre-war years is one of degree, not kind. In "Les Parallélismes," published by *Les Rubriques nouvelles* in January 1910, the art critic J.C. Holl addresses the issue as a "parallel" development in both literature and painting. Assessing the phenomenon as a revival of late nineteenth-century esthetic quarrels, Holl describes a dual wave of reaction against literary naturalism and pictorial impressionism: on the one hand, decadents, symbolists, romanists, instrumentists, *magiques*, *magnifiques*, anarchists, socialists; and on the other, neo-impressionists, pointillists, cloissonists divisionists, neo-primitivists, synthetists, cubists.[26] Holl calls naturalism and impression-ism *tendances*, *mouvements*, *groupes* and *soubresauts*, but not *écoles*: "Like Naturalism, Impressionism is not a school, but a group of distinct and characteristic painters."[27] Retreating from nature into the studio, "schools" are mired in questions of technique alone, which are defended with elaborate theories and encouraged by the allure of revolt and *surenchère*, or "one-upmanship." In fact, Holl's charge against esthetic schools as small, contentious clubs of theory and technique derives from a contemporary complaint, directed most recently at Matisse,[28] that could be traced back to symbolism. Quoting a passage from Anatole Baju's book *Anarchie littéraire* of 1892 on poets' search for methods of *réclame*, Holl maintains that "for the past twenty years we have believed in the putative value of these amphigorical or pretentious prophets."[29] At bottom, they all share one characteristic: arrivism.

—3—

The origin of the epithet "cubist" or "cubism" most certainly was related to the influence of Marinetti's blaring manifesto, and the debate it touched off on the matter of schools and esthetic propaganda between 1909 and 1910. It is worthwhile to recall that Louis Vauxcelles did not, as the familiar tale would have it, coin "the name of cubism" in November 1908; he merely identified a stylistic device, and described it as that of "cubes."[30] In fact, like Vauxcelles' first use of the word "fauve,"[31] early references by Vauxcelles (at Kahnweiler's) and Matisse (at the Salon d'Automne) to 'cubes' in Braque's 1908 pictures of l'Estaque were primarily descriptive, and only secondarily disparaging. To Vauxcelles, cubic reductivism shows that Braque "méprise la forme";[32] but Vauxcelles ends his short review in *Gil Blas* benevolently: "Let us not make fun of him since he acts in good faith. And let us wait."[33] The distinction between "cubes" and "cubism" seems slight, but it merits attention in our context. The "ism" suffix frequently denotes hostility or suspicion. Those factors in the critical press transformed cubic stylization into cub*ism*; this occurred after Vauxcelles' first review of Braque, but well before the existence of a formalized school at the salons.

"Cubism" was, in fact, born in the spring of 1909, five months at the most after Vauxcelles. We already find references to "cubism" or "cubists" as a group around the time of the Salon des Indépendants: on March 24, an "Echo" on the front page of *Le Figaro* reports that all of the "groupements" will be represented at the Salon, "from the 'impressionists,' the 'pointillists,' and the 'symbolists' to the 'cubists.'"[34] Next, as Alvin

Martin has revealed, Charles Morice referred to Braque in the April 16 *Mercure de France* as "a victim – setting 'Cubism' aside – of an admiration for Cézanne that is too exclusive or ill-considered."[35] (Vauxcelles himself will not append "ist" or "ism" until the Salon d'Automne in September, where he refers to "cubistes péruviens," followed by a sarcastic parenthetical remark which stresses the stigma of a new school: "because we do have the pleasure of a school of peruvian cubists!")[36]

It is of interest to note that, while the designation "fauve" gained some currency in the popular press in 1906 and 1907,[37] it was not fashioned into a school of "fauvism" until much later; Michel Puy's seminal article on the group in late 1907, for example, was called "Les Fauves" and not 'Le Fauvisme."[38] Conversely, there was obviously no real cubist school or formalized cubist program to speak of in 1909 (leaving aside the *in camera* activities of Picasso and Braque). Yet *Le Figaro* implicates the "cubists" as one of many groups, and Morice uses the word "cubism" disparagingly; this is thoroughly in keeping with the larger debate after February 20. In other words, the critic intones the ism as a pejorative response to the perceived perpetration of stylistic excess; it serves to italicize his mistrust. This occurs whether or not the supposed program is actually attached to a group; inventing one effectively dismisses the peculiarities of a new style as the folly of *merely* another school. On the heels of Marinetti, and throughout 1914, the ism was a convenient device.[39]

According to Albert Gleizes, cubism began to take on the characteristics of a genuine, rather than perceived, group effort during the final months of 1910, under the influence of artist-poet meetings at the studio of Le Fauconnier and, above all, the café Closerie des Lilas in Montparnasse.[40] Of course, Gleizes deliberately avoids the example of Picasso and Braque; but in terms of cubism as a phenomenon with high public and critical visibility, we can follow his lead, remembering, however, that Picasso and Braque were subsequently often named in articles concerning group cubism. It was during that time that Gleizes, Metzinger, Delaunay, Léger and Le Fauconnier planned to have themselves grouped in one room as a *mouvement d'ensemble* at the forthcoming 1911 Salon des Indépendants. Challenging the hegemony of the Salon placement committee, which was largely composed of original members from the 1880s, and the obedient voting history of the general assembly of *sociétaires*, the cubists resolved to promote a reorganization of the entire Salon according to *groupements*. This would undo the disorder of previous years, when the Indépendants looked, in Gleizes' words, like a "meaningless flea market."[41] In an eleventh-hour effort that included inflammatory posters addressed to "jeune peintres," the cubist phalanx campaigned to have candidates from the new art elected to the placement committee for 1911. After noisy opposition on election night, and thanks to flagrant stuffing of the Société ballot box, they emerged victorious. As a result, the Salon was to be organized in two wings on either side of the central hall: on one side, the *anciens*, with Signac and Luce presiding; on the other, the newcomers under the presidency of Le Fauconnier, organized into groups each of which was charged with hanging its own room. The cubists took the now famous Salle 41, attracting the collusion of sympathizers such as André Lhote, Dunoyer de Segonzac and Roger de la Fresnaye, who occupied neighboring rooms.[42]

At the time, Gleizes remembers, no one among the cubists expected Salle 41 to cause a scandal.[43] In retrospect, however, given common understanding of the avant-garde ism as

a machine of unadulterated self-promotion, a view which can only have been confirmed by the campaign tactics of the young painters, it is difficult to imagine that critical reaction to Salle 41 could be characterized by anything less. Gleizes traces the invention and common currency of the name "cubism" to the 1911 Indépendants;[44] in fact, while the invention of "cubism" actually precedes Salle 41 by two years, its currency was unquestionably a negative response to the arrival of the actual group. Launched as a pejorative, "cubism" was soon adopted in defiance as a banner of the new style (an inversion of meaning that was discussed in one journal of ideas as "the law of unexpected accord").[45] Mirroring a popular critical consensus on all avant-garde groups, most notably cubism, Gleizes himself actually recalls that "the isms would soon multiply according to the will of artists seeking more to attract attention to themselves than to realize serious works."[46]

With the 1911 Indépendants, and the cubist Salle VIII at the 1911 Salon d'Automne, cubism was an established target. What had been a trickle of references to "cubist" art in reviews of 1910 gathered into a wave of aspersion that would mount unchecked through to 1914. Cubism was now featured in general accusations against the avant-garde group as a publicity stunt. "Procedures such as the current cubism are, in reality, primarily means of *bizarrerie* by which to force public and critical attention," wrote Armand Fourreau, reviewing the 1911 Salon d'Automne in *La Phalange*:

> It is more a form of *réclame* than a true system of painting. An unquenchable thirst for noise and *réclame*: basically, that is the true evil which rages violently at this moment, above all amongst the young painters.[47]

In these terms, given events of the following year, cubism could have been judged an enormous success. So strange, even offensive, did cubist pictures appear that they came to occupy a widely publicized parliamentary debate in the Chambre des Députés. The quarrel was sparked off by an open letter from one M. Lampué, a distinguished member of the Paris Conseil municipal and of the Commission des Beaux-Arts de la Ville de Paris, to Léon Bérard, *sous-secrétaire* of the Etat aux Beaux-Arts. The letter, published in *Le Matin* on October 5 and excerpted in all the major daily papers, was a protest against the liberality of the Salon d'Automne, and specifically against the atrocities of cubists, "criminals who behave themselves in the art world like thugs in daily life."[48] Lampué called the Salon a disgrace to the Grand Palais, in which it was held, and denounced official support for an exhibition that insulted not only a national monument, but the artistic dignity of France. Issuing an immediate response, the official committee of the Salon d'Automne noted that the role of the State was "not to direct but to encourage the artistic effort of the nation."[49]

The ensuing dispute, which unfolded over the next few months and peaked at the December 3 meeting of the Chambre, was closely reported. Chief issues included the representation of cubists, and of foreigners, on the Salon jury; the liberal tolerance of the jury as a corrective to the waning influence of outmoded academic esthetic values (still represented by the Salon des Artistes Français); the judgment of the hanging committee, which had awarded cubists "a place of honor" that year; the future of the Salon at the Grand Palais; and the role of the state in matters of the arts. In addition to Lampué and Bérard, Frantz Jourdain, the founder and director of the Salon d'Automne, earned a great deal of press. Statements were issued, letters written, interviews and editorials published.[50]

At all times, cubism was at the center of the controversy, attracting its largest share of public and critical attention so far. Lampué actually received very little journalistic support. Writing in *l'Intransigeant*, editor Léon Bailby even seized the incident as a shameful demonstration of left-wing hypocrisy (Lampué and Jules-Louis Breton, his ally in the Chambre, were socialists): for Bailby, cubism most certainly was a deliberate "mystification," but free speech, an indispensable feature of the socialist philosophical agenda, was the real issue.[51] Many critics who deplored cubism found themselves in the awkward position of defending its rights at the Salon, while others defended the Salon d'Automne as an institution, cubism notwithstanding. It was around this moment of conflict that Louis Vauxcelles, undaunted, fashioned his longest-running attack on cubism in the pages of *Gil Blas*.

Since so much attention was directed at cubism and the cubists, it was commonly felt that any publicity was good publicity, from the painter's point of view. In its review of the Salon, *L'Illustration* was already remonstrative regarding Lampué's letter: "The first result of this interference, recorded in the press, is to precipitate the curious around the horrors that have been drawn to their attention with such excessive zeal."[52] Given the amount of space he had devoted to the matter, Vauxcelles had grown reluctant by November: "I hesitate to speak once more of cubists because theirs is a dupe's game, favoring their thirst for *réclame*, a frenetic stampede of *arrivisme*. Silence, no doubt, would be better."[53] This question was a staple of cubist criticism. A five-part series of "Echos" on cubism for the populist newspaper *Excelsior* in October, for example, featured a running dialogue between ordinary Salon-goers "M. X." and "Mme X." While Mme X. prescribes tolerance and respect towards the newcomers, M. X. is ambivalent; he feels that the cubists are sincere, but recognizes that they are also serving their need for *réclame* and *tapage*. He explains that, "if they painted like everyone else . . . nobody would stop before their canvasses. Scandal pays much better since, these days, histrionics have become a social virtue. It is therefore likely that, in mocking us, these cubists serve the religion of utility."[54] Such was the conclusion generally reached by this line of reasoning. That month, an article on cubism entitled "Le Fumisme" appeared in the popular *Les Annales Politiques et Littéraires*, in which publicity was again described as the primary motivation of cubist painting.[55] Here, the cubist joins a larger community of struggling young artists, who despairing of recognition, are convinced that bad press is indeed better than no press at all. Moreover, artists will claim that ridicule often attaches itself to audacity and originality (the example of Manet and the impressionists is raised); speciously, bad criticism thus becomes a source of publicity and pride.

—4—

At a time when young artists were being described as "program merchants [who] deafen us with their contradictory clamor,"[56] the developing formal eccentricities of cubism seemed to prove the point. The subject of avant-garde promotionalism was not dismissed by insiders – Gleizes' remark about the multiplication of isms is indistinguishable from the kind of disdain that was likewise directed at him by his own severest critics. The matter was treated with instructive urgency by Roger Allard. Better remembered as an early

advocate of the new art, and a co-founder of Salle 41,[57] Allard also invested a good deal of energy in pointing up the mistakes of modern painting. As David Cottington has shown, Allard's censure of promotionalistic modernism dates back to 1910, and was one way in which he distinguished stylistic extravagance from the neo-classicizing qualities of preferred cubists such as Gleizes, Metzinger and Le Fauconnier.[58] During 1913 and 1914, Allard addressed the problem at some length, focusing his reproach on the futurists: for the "intrinsic *quality* of a work of art," the futurists substitute "pretended *novelty* . . . An entire literature, an entire art, a course of spirit, a manner of being are founded upon the fear of not appearing sufficiently 'advanced'".[59] From futurism, however, Allard extrapolates, replaying a critical pattern familiar from 1909; in so doing, he coined the useful phrase "avant-gardism":

> *Avant-gardism* is not only an absurdity, it is an affliction . . . a kind of terror where the sincere *chercheur* is no longer safe, where the independent talent is forced to adhere to the category represented by his district . . . too bad for those who have no taste for fairground *parades* and *boniments*! Custom has it that the artist present his work wrapped in printed paper, in the self-serving manner of the manifesto, preface and commentary.[60]

The influence of avant-gardism, the phenomenon or syndrome of isms rather than the case of a single group, is pernicious. A "special vocabulary" has been developed in programs and manifestos which offers a "means to disguise ignorance"; further, good artists are being lost, "some sincere . . . quite intelligent painters are sacrificing themselves to this mania."[61] Allard implicates dealers and critics as well as artists in this scheme of modernism-cum-commercial advertising:

> With the aid of articles in the press, shrewdly organized exhibitions, contradictory lectures, polemics, manifestos, proclamations, prospectuses and other futurist publicity, a painter or group of painters is launched . . . It remains to be seen how long the farce can go on.[62]

Literally and figuratively, the "selling" of modern art is identified with the crass noise-making techniques of futurist propaganda.

Ricciotto Canudo certainly learned some things from futurist advertising practices, though very little from the recent complaints of the alienated spectator. On February 10, 1913, he began publishing *Montjoie!*, a magazine which would fill its pages with the images and ideas of the new modernism in art, literature, theater and music. (Apollinaire, Salmon, Gleizes, Metzinger and Léger were among the contributors.) On the front page of the first issue, he did not fail to trumpet his editorial policy with appropriate bombast, claiming to represent an *organe de ralliement* for the "male will to renaissance [that] characterizes . . . the dispersed efforts of the new generations"; in capital letters, Canudo delivers the "very clear commandment of the present, if troubled, Hour: To GIVE A DIRECTION TO THE ELITE."[63] (This represents the inversion of a more familiar utopian-socialist policy; the art periodical *Les Tendances Novelles*, for example, elevated the artist as a social and spiritual leader for "the average man."[64]) In future issues, Canudo's statement of purpose would appear on the back page of *Montjoie!* as a combination manifesto and subscription form.

Of course, in the case of Marinetti and the futurists, the publicity of extravagance most

certainly *was* a prime objective. The futurists did not so much visit Paris as storm it, with antagonistic manifestos, noisy evening "performances" and condescending *conferences*. Their pictures, they maintained, were about speed, noise and the sensory overload of urban life. Their most notorious scheme, which Marinetti freely admitted in newspaper interviews was wildly exaggerated for effect, was to burn down museums, libraries and academies and overhaul the history of culture.[65] At the time of his guest lecture at the Maison des Etudiantes in 1911, Marinetti bluntly revealed the strategic function of such remarks in *Le Temps*. Reasonable behavior, he explains, draws relatively little attention. "It is because we want to succeed that we get straight to the point with exhibitionism, that we situate ourselves violently against the grain of good taste and ordinary moderation."[66] Derision and fistfights were the order of the day at Marinetti's public appearances. In *Gil Blas*, André Arnyvelde reported at some length on the lecture that Marientti delivered in February 1912, on the occasion of the futurist exhibition at the Bernheim-Jeune gallery. In the account, which was entitled "Séance de boxe futurist," Albert Gleizes heckles Marinetti, who comes to blows with Elie Nadelman, while, in a neighboring corridor, Félix Fénéon (nobody's fool) shields Van Goghs and Gauguins from the general pandemonium.[67] Similarly, in conjunction with Boccioni's sculpture show in June 1913, Marinetti's public delivery of the "words-in-freedom" manifesto unleashed a *charivari*, according to the newspaper *L'Homme Libre*, over which Marinetti could barely be heard.[68] Clearly, Marinetti was playing out critics' most dire predictions of avant-garde *réclame* as a *succès de rire*, or publicity at all costs. "Painting is one art, and publicity is another," wrote the critic for *L'Art Décoratif* in February 1912, who concluded that the very premise of futurism was an explicit joining of the two.[69] In his book *Le Désarroi de la Conscience française* from 1914, Alphonse Séché conceded that the strategy of futurism was as modern as futurist iconography. Marinetti "beats the bass drum in order to deafen the bourgeois. He is shrewd enough to know that only the abnormal, the monstrous, the implausible attract attention today."[70] In this century of the airplane and the automobile, Séché writes, our *mal de siècle* is our hurry to "arrive". One no longer has time to learn one's *métier*. "Professional conscience" has been "replaced by bluff and audacity."[71] Marinetti's practice of the *boniment*, the sales pitch, "is fully appropriate to our epoch of bluff."[72]

It is too easy to take for granted these comparisons between advertising and the values associated with art as *réclame*. "Truly, *la Publicité* is the queen of our epoch," wrote J. Arren in 1912, in his book *Comment il faut faire de la publicité*:

I am speaking here from a commercial and industrial point of view, but among men of letters, painters, sculptors, musicians, doctors, actors, lawyers, even politicians, who has not rendered it its due? . . . It is truly one of the characteristics of modern life.[73]

As Mauclair, Billiet and Allard discussed, and scores of other critics implied, the hard sell and graphic assault of *publicité* was virtually its own socio-cultural ism during the prewar years. A picture like Fernand LeQuesne's *Allegory of Advertising* from 1897 adequately illustrates the advertising explosion to which they refer (see fig. 38). The painting is a celebration of advertising as a riot of color, noise and activity; it also demonstrates how readily commercial paper could be an object of discontent. Many Parisians felt that the monuments of Paris had been stifled by printed matter, that the streets had become repositories of refuse and the neighboring countryside commandeered by crass commer-

**Ne jetez pas les prospectus!**

*LES AGENTS NE SAVENT PAS TRÈS BIEN ENCORE LEUR RÔLE*

39. Police enforcing the prohibition of the prospectus, *L'Intransigeant* (1912).

cialism. The escalation of *réclame* and *publicité* as metaphors in art criticism exactly corresponds to actual developments in advertising culture.

The high years of the pre-war avant-garde witnessed urgent public and official backlash against the sheer profusion of *publicité* in and around Paris. In January 1912, the Conseil municipal introduced a controversial ordinance against the disposal of wastepaper in the *voie publique*.[74] Ostensibly directed at all litter, the new measure was universally acknowledged to be a direct crackdown on the distribution of the advertising prospectus, handed to passers-by and typically disposed of in the street. It was also a direct response to the Chambre des Deputés, who failed to pass a proposed tax on the prospectus. The quantity of handbill litter had escalated to such a degree, and was considered so unsightly, costly and even dangerous, that city officials judged the problem to have reached intolerable proportions. Of course, as the *Journal des Débats* and other papers pointed out, the law did not inhibit the advertiser or prospectus distributor *per se*; such a restraint was itself prevented by laws of 1880 and 1881, which guaranteed rights for the public dissemination of all forms of printed matter.[75] In this regard, some felt that the prospectus question was partially one of censorship and individual liberty, and it was debated in the press on those terms.[76] The "last day of the prospectus" and the first day of the ordinance (January 17) were front-page news,[77] in some cases even accompanied by a photo of police and pedestrians in action (fig. 39).

Poster *publicité* was subjected to a similar siege. For moralists like Maurice Talmeyr, the omnipresence of the poster transforms the walls of Paris into nothing less than a "secular cathedral of paper and sensuality," blaring messages that address only the easy commercial gratification of instincts and desires.[78] During the pre-war period, the poster exploded in size to become the *panneau-réclame* or large billboard, which came to populate the landscape around Paris in a rash of advertising gigantism (fig. 40). Referred

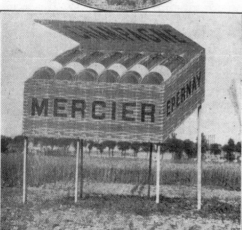

# LES BARRE-LA-VUE

Tant qu'il a fait froid, mauvais, tant qu'il a plu, tant qu'il n'y a eu personne pour *les* contempler, ils ont régné orgueilleusement sur le paysage, se sont carrés, ont pris leurs aises et leurs habitudes.

Ils trônaient tranquilles, béats, indiscutés ; ils en étaient même arrivés, petit à petit, à se figurer qu'ils étaient l'ornement le plus sensationnel, le plus esthétique, du mont, du val ou de la plaine.

Mais voici le beau soleil revenu, voici le temps des vacances, des promenades et des randonnées... et immédiatement tout le monde se plaint d'eux, hurle, proteste, demandant leur extermination. Pauvres grands panneaux, trop fiers de votre importance, de vos dimensions colossales, de vos couleurs criardes, vous jouissez de l'animadversion générale !

Il faut bien avouer que c'est en somme absolument odieux, quand on s'apprête à déguster des aperçus impressionnants, de se trouver tout à coup en face d'une gigantesque barrière qui ne laisse plus rien soupçonner de l'horizon, mais qui, par contre, vous

clame les mérites de telle moutarde, ou vous édifie sur le nombre considérable des lecteurs de tel journal.

D'un air très renseigné, on a promis à ses camarades de voyage une surprise délicieuse, pour tout à l'heure, quand on arrivera au tournant de cette route qui escalade la colline !...

On arrive... Ah bien oui !... Telles conserves sont beaucoup meilleures, beaucoup plus parfumées que le produit frais !... Telles sardines, quand on les a parées « selon les rites de telle maison », n'ont plus ni arêtes, ni peau, ni nageoires. Dame, c'est crispant !

Non seulement ces terribles annonces nous empêchent d'admirer la belle nature, mais encore elles nous assomment parce qu'elles nous rappellent notre vie de labeur, parce qu'elles interrompent la quiète et souriante tranquillité de notre villégiature, parce qu'elles nous font penser à Paris, qu'à ce moment on essaie d'oublier complètement, à ses fièvres, à son commerce, au *struggle* auquel se livrent entre elles les grandes marques. On voulait être seul avec les herbes, les arbres et la campagne ; va te promener ! voici une géante barrière, qui vous remémore que vous êtes des citadins, de malheureux et piètres citadins, qui bientôt devront rentrer dans la fournaise, qui n'ont plus que dix ou douze jours d'indépendance et qui, ces deux semaines écoulées, ne pourront plus s'offrir comme distraction que la promenade sur les boulevards, où, aux terrasses des cafés, les gens assoiffés lampent le vermout admirable dont précisément on évoque le nom à cette place.

40. Billboards, *Le Monde illustré* (1912).

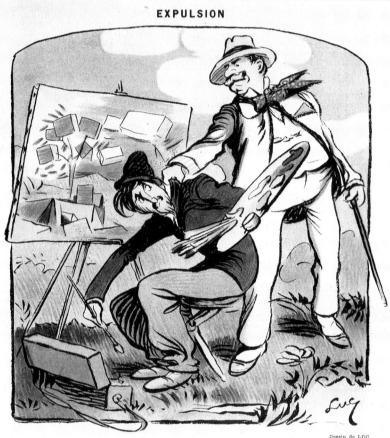

41. Luc, *Expulsion*,
cover illustration for
*Journal Amusant* (1912).

to colloquially as "les barre-la-vue" and "les affiche-écrans," the billboards were, according to the Paris papers, especially offensive during the summer months, when city-dwellers migrate into the countryside for their vacation break. An article in *Le Monde illustré* from July 1912 is a typical example of the opposition. "Poor great panels," it mocks, "too proud of your importance, of your colossal dimensions, of your shrill colors, you enjoy general disdain."[79] According to this sentiment, the billboard is a huge barrier that places itself, and its claims for the merits of a brand of merchandise, between us and the open view. "Popular referendum, in a unanimity that is seldom matched, has pronounced itself energetically against *les affiches gigantesques*."[80] Continuing in a vein that mirrors critical

42. J. Hemard, *Les Vacances du
maître cube* (1912).

complaints against avant-gardism, the article reports that many merchants have adopted this means of "propaganda" in order to keep up with their competitors since they cannot afford to "remain behind" ("demeurer en arrière").

A law of 1911 directed against bill-posting on historic monuments, "natural monuments" such as menhirs and dolmans, and other classified sites apparently failed to clear the landscape of the enormous pests. Consequently, in the summer of 1912, the French Ministre des Finances devised a tax hike on the "barre-la-vue" which was to be virtually prohibitive (leaving room, however, for rural advertising on the walls of buildings).[81] In *Le Monde illustré*, the measure was applauded as an "esthétique initiative," as well as a triumph of nature over culture and leisure over work; after all, "not only do these terrible advertisements prevent us from admiring beautiful nature, but they clobber us by recalling our life of labor . . . they make us think of Paris just when we most want to forget."[82] Editorials on the subject assumed that they spoke for the vast majority, what Léon Bailby in *L'Instransigeant* called "la collectivité française."[83] In his how-to book on advertising, even Arren warned against the negative impact of the billboard, which public opinion was coming to view as "a crime against art and nature."[84]

The esthetic crimes of *publicité* fall under the category of decorum – the relentless refusal, by definition, to self-efface. The excess was both quantitative and qualitative. In this way, Allard could describe the worst *surenchères* of new art as pictures "demoted to the rank of the *pannneau-réclame*!"[85] During the summer of 1912, at the time of the new tax proposal, caricaturists were quick to recognize the dual topicality of advertising reform and avant-gardism. In *Le Journal Amusant*, for example, Luc envisioned an expulsion from the garden in which the League for the Protection of Landscapes casts out the cubist, whose geometrical stylization of nature is an offense (fig. 41); J. Hemard's illustration for *La Vie Parisienne* demonstrates that even on vacation, the cubist painter by nature *prefers* the *barre-la-vue* to the view, especially if the billboard in question is an advertisement for the bouillon "kub" (fig. 42). This is a punning motif which Picasso

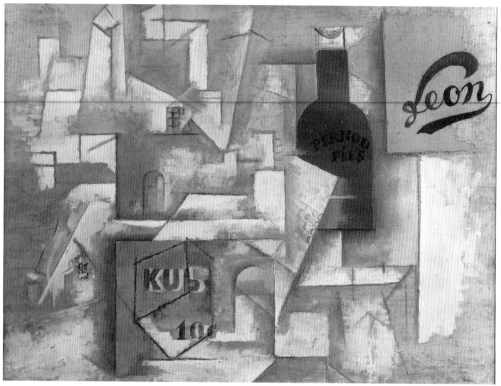

43. Picasso, *Landscape with Posters* (1912).

himself depicted at precisely that moment, in a rare landscape that features oversize advertising billboards (fig. 43).

Public debates over *publicité* correspond closely to debates concerning the nature of new art as an enterprise of *réclame*. In both cases, an issue is made of free speech versus public menace, and both are basically concerned with standards of quality and the violation of taste. According to Léo Claretie in 1912, artists have failed to exploit the unmatched opportunity that posters provide for elevating the esthetic intelligence of the general public. As a result, it has been necessary to mount a "crusade against ugly, vulgar or grotesque design, awkward form, thick or crude line, disharmony and disorder."[86] Significantly, the prospectus issue even anticipated arguments later that year between the Paris Conseil municipal (Lampué) and the Chambre (Marcel Sembat) over modern art at the Salon d'Automne, and the rights and excesses of promotionalism as a blight on the city of Paris.[87] Above all, advertising and modern art were both described as agents of hard sell. When critics came to perceive and discuss avant-gardism as promotionalism, the terms of advertising were close at hand; conversely, the audacity of contemporary advertising must have conditioned spectators to identify the startling character of new painting with the larger cultural phenomenon of unchecked commercial bluff.

One complication was certainly provided by the enormous attraction that both bill-

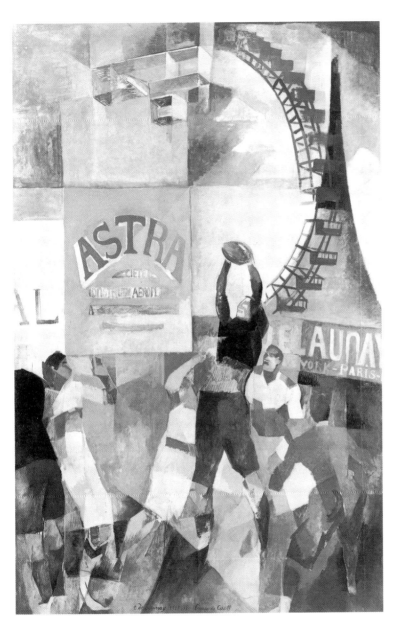

44. Robert Delaunay,
*The Cardiff Team*
(1912–13).

board and prospectus style held for some members of the avant-garde. For example, Robert Delaunay's *Cardiff Team* (fig. 44), which highlights the urban billboard, was begun in 1912, when debate over the future of the *panneau-réclame* genre was in the papers. While Delaunay's territory is city not country, or perhaps *because* of this fact, his celebration of oversized advertising has all the actuality of an editorial in the daily press; by critical standards, the addition of his own name as billboard publicity, like Picasso's "kub," further imbues this picture with the self-promotional tone of a manifesto.[88] When discussing the influence of modern life on modern painting in 1914,

45. Caro Carrà,
second page of
CD'HARCOURTEÉ
(1914).

Fernand Léger focuses on the parade of billboard advertising, "imposed by the necessities
of modern commerce, brutally cutting through a landscape," as "one of the things that
have aroused most fury among men of so-called good taste." The modern billboard is the
most striking example of "unexpected rupture and change" in our visual world; "that
yellow or red billboard, shouting in a timid landscape, is the finest of possible reasons for
the new painting." More than a worthy subject, for Léger, the billboard represents a

46. Advertising prospectus distributed in Lyon (*c*.1902).

startling intrusion of abstract formal values into the very garden of pictorial convention: "it topples the whole sentimental and literary concept, and it announces the advent of plastic contrast."[89] (The League for the Protection of Landscapes, it turns out, was quite justified in its fears.) Similarly, the strident *boniment* of Marinetti's manifestos and the striking heterogeneity of futurist experiments in typography also owe a general debt to the prospectus (figs. 45 and 46).[90] In the literature on *publicité*, the formal assessments of the

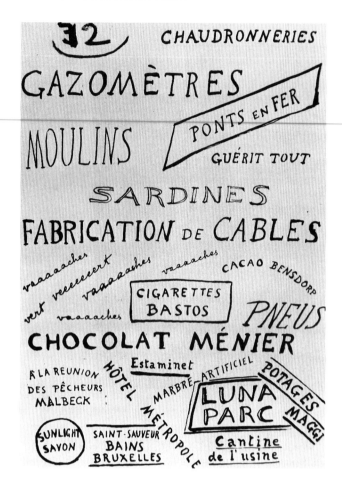

47. F.T. Marinetti, *Words-in-Freedom; Chaudronneries* (c. 1912).

prospectus even appear to anticipate Marinetti's boldface esthetic canon. As early as 1902, in his book on the history of the sign-board, John Grand-Carteret notes that the prospectus is as much a matter of form ("its exterior aspect, meaning its typography") as of content, and characterizes the handbill, quite modernistically, as a "purely typographical sheet."[91] Marinetti also reveals an attraction for the advertising logo as it was scattered across the landscape, the cityscape or the backpages of the daily press; a sheet of brand trademarks collected and copied by him in 1912 highlights the particular appeal, in this regard, of French *publicité* (fig. 47). Sonia Delaunay used color cubism in an actual prospectus that she designed to promote *La prose du Transsibérien*, the illuminated prose-poem on which she collaborated during 1913 and 1914 with Blaise Cendrars.[92] In his poem "Zône," Apollinaire referred to "prospectuses, catalogues, posters" as "the morning's poetry."[93] Finally, we might also consider the *papier collé* of Picasso and Braque as a deliberate, if private, inversion of public and official sentiment in 1912 regarding the overload of commercial paper on the streets of Paris. As an esthetic choice, the technique of littering pictures with fragments of newspaper and *papier-réclame* reciprocates the official clean-up ordinance, which had targeted newsprint along with the prospectus.[94]

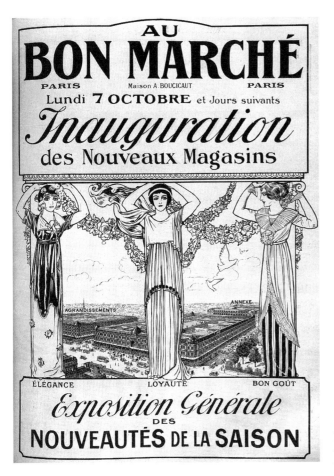

48. Advertisement for the Bon Marché department store, *Le Matin* (1911).

The critical conflation of advertising and the avant-garde reflects general suspicion of exaggerated claims to originality. Indeed, the very concept of new or original art bore an uncomfortable resemblance to appeals for consumer approval. Specifically, the word *nouveauté*, as in Mauclair's "Le Préjugé de la nouveauté dans l'art moderne," resonates with the vocabulary of the department store, the *grand magasin de nouveautés*. The category of *nouveautés*, or dry goods, represents the largest share of merchandise available at stores such as the Bon Marché or Samaritaine. In translating *nouveautés* as "novelties," we lose an inference which was probably appreciated by most art critics of the period, for the *magasin de nouveautés* had been expanding with tremendous speed since the 1860s, and was, during the pre-war period, a cultural institution of enormous visibility and influence.[95] The commanding presence of the department store is easily demonstrated by the prevalence and relative size of advertisements placed in the backpages of the daily press throughout the period, such as a Bon Marché announcement for the inauguration of a new building in October 1912 which signals an "Exposition Générale de *NOUVEAUTES DE LA SAISON*" (fig. 48). In English, "novelty" suggests a mere gimmick, while the French *nouveauté* evokes an entire realm of merchandising and consumption, that of the *magasin* as a gigantic machine of promotionalism promising a

ceaseless flow of the new and improved. This is certainly the significance of "novelty" as it was applied to the avant-garde, which was itself being identified by hostile critics as an institution designed to promote and sell the superficially unfamiliar as the authentically original. "After some years," Mauclair wrote in his article on the "prejudice of novelty" in 1909, "these *nouveautés* appear more out-of-date than a hat from the season before last."[96] By 1912, the Salon d'Automne itself could be referred to as a "*Magasin de nouveautés*," featuring cubism as the latest "unprecedented formula."[97] As late as 1914, Allard also identified the concept of *nouveauté* at the Salon with the realm of fashion in clothing design ("l'heureuse fantaisie des modes vestimentaires"), asking:

> But what is the *novelty* of the Salon? To this fateful question one would like, vainly, to avoid responding. One would like, above all, to persuade oneself that it is absurd and that novelty in art does not exist.[98]

That year, Armand Fourreau found new painting guilty of a brazen reversal of the conventional figure-ground hierarchy of pictorial values, condemning the artists as *tapageurs*, and the works as "advertising posters . . . well suited to the horrific 'artistic' publicity of a certain *grand magasin de nouveautés*."[99] His allusion is not simply a judgment of style, but, by choice of metaphor, a value judgment as well.

Of course, the nature of the salons themselves had long been given to comparison with stores, fairs and the like.[100] The salon did, indeed, partly function in this way – as a marketplace where artists hoped to gain not only critical visibility, but commercial success. The "democratic" appeal of enormous variety at the *magasin de nouveautés*[101] bears a significant resemblance to the presumed democracy of the Salon des Indépendants, haven for all varieties of pictorial merchandise. Yet, as we have seen, descriptions of the salon as a marketplace contain shades of cynicism. The implication is always that public and commercial success, which is directly proportional to the amount of attention one receives, has superceded the inherent quality of the work itself as the primary goal of new art. The successive proliferation of new pictorial styles responds more to the need of the weary spectator-consumer for fresh stimulus (what critic François Fosca called genius *à la mode*[102]) than to any genuine internal development on the part of a serious *chercheur*. In this regard, the motivations and activities of the avant-garde painter are suspect.

So seamless was the association between advertising culture and false claims (between the avant-gardist and the huckster engaged in the selling of novelty for its own sake), that the debate was joined by *La Publicité*, a pre-war periodical devoted to the modern science of advertising. In February 1912, D.C.A. Hémet, the editor of the magazine, entered the fray with an article called "Art & Littérature Vulgarisés par la Publicité: Comment on corrige les caprices de la Renommée." The bitter struggle for recognition and success in art and literature, wrote Hémet, justifies recourse to advertising; this has always been the case. Some complain of the artist or writer behaving as a *banquiste*, who simply bolsters his reputation by forcing the attention of the public. This, Hémet responds, is simply unfair. If the work in question is mediocre, like "a bad brand of toothpaste or dry biscuits,"[103] *publicité* will not help; if it is worthy of public attention, then advertising is valid and useful, a strategy required by the "current conditions of life"

or the "necessities of [the] epoch," and the artist wins a "consecration of his genius" which is legitimate and just.[104]

Certainly, as editor, Hémet had a vested interest in defending *publicité*. Two years later, the magazine published an article on "Publicité et charlatanisme," which attempts to dismantle public biases against all advertising as fraud. There the professional identity of the "charlatan" is traced back to the nineteenth-century medicine show, with its enterpreneurial *bonimenteur* beating *la grosse caisse*. The medicine in question was so often a fraudulent cure that "charlatan" came to be synonomous with "swindler" (*escroc*), and *publicité* earned its dubious reputation; but the means employed by the charlatan were not, in and of themselves, reprehensible – the *boniment* was useful and necessary in an epoch that had no posters, newspapers and prospectuses in the modern sense. If the product has authentic value, or if the techniques of *publicité* are applied to the selling of a philanthropic cause, the charlatan can be congratulated on the ingenuity of his sales pitch. According to the article, charlatanism has picked up hateful connotations because it has come to signify an "abus de confiance," the exploitation of the client's desire to believe the claims of the merchant.[105] But *publicité* is not fraud; rather, "charlatanism = dishonesty + *publicité*" and, conversely, "*publicité* = charlatanism – dishonesty."[106]

This defense of advertising is plain enough in meaning, if somewhat convoluted in expression. Hémet, however, gives the argument a curious esthetic twist: modern *publicité* "attracts the eye, the ear and the spirit of the public," and is not inherently an instrument of fraud; yet it is equally clear that

> the crowd should not be treated in the same manner, with the same discretion and the same taste, as the intellectual elite . . . man carries within him an obscure need to be dazzled, deluded, fooled by *mise-en-scène* and décor; the naked truth makes him afraid, or is insufficient. That is why, to us, the charlatan only appears to be guilty of a subtle dishonesty of intention, but not of the means of publicity employed.[107]

Hémet ends by maintaining that *publicité* be simple and clear, free of hyperbole, redundancy, and the grandiloquence of hazardous claims. Yet it is that kink in the argument which peaks our attention: the greater public needs or craves dazzle and delusion. Such an observation subtly, but distinctly, transgresses the division of honesty and fraud. Around that division there exists a zone of ambiguity where originality and hoax represent themselves as a single condition of esthetic experience.

—5—

The excesses of *réclame* are a function of artists' attempts to stand apart at all costs from any kind of pervasive cultural norm, including competing expressions of eccentricity to which the audience has grown accustomed. In this sense, the group or ism was subject to allegations of sinister collectivity – the *cénacle* as a dynamic of leaders and disciples ganging-up to inflict their doctrine on a beleaguered art public. However, each ism was small enough, and the proliferation of isms was large enough, that the overall phenom-

enon could also be characterized as a riot of rampant individualism, the atomization of what might otherwise have been a greater community of serious artistic purpose. Vauxcelles encapsulates both when he undermines modernists' claims for liberty, novelty and original self-expression (presumably, claims for the kind of individualism implied by the banner of "independence") by slyly describing the new art as, in fact, a conservative return to "discipline, order [and] harmony." The irony, for Vauxcelles, is that in expressing the desire for a "king, a leader, a confessor, a schoolmaster," modernist schools each demonstrate a "need for servitude."[108] In the case of both individualism and collectivity, the predominant fear was directed at a chaos of competing modes and theories.[109] In addition to outrageousness as a form of publicity campaign or *réclame*, this threat takes a second form: that of elitism. Taken together, *réclame* and elitism comprise a chief paradox of pre-war popular and critical opinion concerning the art and practice of the avant-garde.

By the early pre-war period, a growing abbreviation of form in new art was already taken by critics to represent a pre-eminence of formula and theory. Such a notion probably has its origin in the scientizing principles and systematic technique of neo-impressionism; and it was both the vestiges of neo-impressionism and the flattened shapes and contour lines of Matisse's painting around 1904 to 1907 that enabled critics to qualify his work as "schematic," non-representational and thereby "theoretical."[110] With the geometry of cubism, which appeared further to fulfill a prophecy of art as system, descriptions of a conceptual pictorial grammar came to imply basic questions of coherence or decipherability. Through a series of semantic turns, theory entered the vernacular of cubist criticism as both a truism and an irony.

For Paul Reboux, writing in 1910 for *Le Journal* on "the doctrine of the fauves," a fauve is any "painter-innovator" who expresses a "disdain for natural laws."[111] Contrary to the notion that they work from instinct, a belief which had been encouraged by the broad brushwork of true "fauvist" painting in the Matisse circle, Reboux believes he will surprise the reader when he reveals that it is all now a matter of theory, the chief theoretician being Jean Metzinger. Once the cubists became a phenomenon at the salons, the perception of cubism and, to a degree, futurism, as an art of theory and system was commonplace. It was always related to the notion of cubism as more a conceptual than perceptual art. Thus, Apollinaire could define cubism in 1912 as "the art of painting new configurations with elements borrowed not from visual but from conceptual reality"; it is revealing that he hastens to add, defensively, "That is no reason, however, to accuse this kind of painting of intellectualism."[112] He was responding to a pervasive grievance. In an article on cubism and futurism for *Livres et Art*, J. d'Aoust claims that each group depends on an elaborate *a priori* system to which their painting is forced to conform; *artifice* replaces "*d'art sincère*," and the public, in turn, feels left out (hence the apparent gap between theory and comprehension).[113]

Most critics were of the opinion that this disparity was intentional, even a form of hostility. Reviewing the book *Du Cubisme* by Gleizes and Metzinger in 1912, Arsène Alexandre quotes the authors on the necessity of distancing their art from the "imagination vulgair"; what they seem to be saying is that obscurity is a sign of genius. "From the moment when the appreciation of his work depends on the artist alone," Alexandre concludes, "the public need not bother looking."[114] In criticizing cubism for being top-

heavy with "system," it was but a short step to accusations of pseudo-science or "scientific pretension"[115] as a form of deliberate exclusivity and eccentric self-importance. Léon Werth complains that cubists interpret nature "as medieval logicians";[116] or that the cubist painter is a "circus-master" turned "theory-master,"[117] who delivers the spectator over to theory like a condemned man thrown to wild beasts. In many cases, the conclusion was that cubist *painting* seemed strangely beside the point, for painting had been replaced with philosophy. Reviewing the Salon des Indépendants for *Les Marges* in 1911 and 1912, Michel Puy writes that cubists "submit the testimony of the senses to mathematical intuition."[118] They "no longer work in studios but in laboratories"; their rhetoric is filled with theorems and principles, and their technique is abstruse.[119] For Léon-Paul Fargue in *La Nouvelle Revue Française*, cubists and futurists "are above all victims of pictorial and literary theory";[120] "it would be easy to explain Cubism and Futurism with ten philosophical or scientific systems . . . But then we are no longer speaking of painting."[121] Similarly, in *L'Art Décoratif*, Fernand Roches complains that "cubists do not paint nature, but their theories about nature . . . They do not paint, they describe, giving themselves over to scientific analyses."[122] Noting a tendency of published cubist theory to emphasize the chimera of *la peinture pure* (after Apollinaire's epithet for Delaunay's work[123]), Max Goth, who was sympathetic to the modernist cause, observes that the cubists are sincere but misguided. For Goth, painting by definition speaks to our senses. One cannot draw a concept with precision; only in writing can it be adequately described. Gleizes and Metzinger have shown that they recognize this "by writing books in order to justify their pictorial œuvre."[124]

The indecipherability of cubism to the lay spectator was an easy target for parody or lampoon. Writing for *Fantasio* in 1910, Roland Dorgelès describes a cubist picture as one which "could pass, according to the taste of the client, for a moonrise, the portrait of a young girl, a genre scene or a seascape."[125] The mock challenge, proposed by many humorists and caricaturists, was "can you find the face hidden in this picture?" One original variation on this theme came from Dorgelès in 1911. In his article "Ce que disent les cubes," he juxtaposed several cubist pictures with photographs taken of identical subject matter (fig. 49). Spectators laugh, he explains, because they do not understand, literally, they do not know the language. Where the cubists, so far, express haughty indifference by refusing to explicate their work to the general public, Dorgelès proposes to translate the cubist language back into the vulgate of photographic naturalism.[126] No such effort was made in October 1912, when Léger's *Woman in Blue* was reproduced on the front page of the newspaper *Eclair*, illustrating an *enquête* entitled "Le Mystère Cubiste" (fig. 50). Artists were invited to decipher the picture, and after reports on their progress in the "Echos" column throughout October, including responses from Adolphe Willette and Jacques-Emile Blanche, the mystery was "solved" in a letter from Léger himself on November 3.[127]

Ridicule of cubist inaccessibility could, however, be more pointedly directed at the notion of cubist science. Indeed, a significant subdivision of mathematical hermeticism is the counter-claim that artists' pretensions to science are a smokescreen, and that cubism, especially the salon variety, is nothing more than a rudimentary form of geometrical reductivism. As the precise opposite of hermetic science, this reading may not be unrelated to the dual meaning of the word *cube* as it is defined in dictionaries of French

# Ce que disent les cubes...

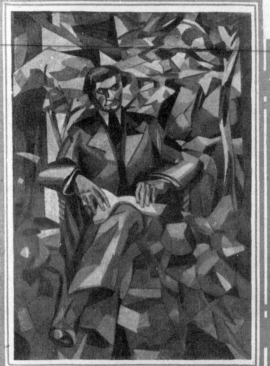

Portrait, par Albert Gleizes.

Le même, d'après nature.

Le goûter, par J. Metzinger.

La même, d'après nature.

CETTE année encore des badauds d'intelligence moyenne se rendent au Salon d'Automne dans le seul but d'y rire et l'on retrouve, dans la salle des « fauves », les ordinaires nigauds que la vue d'un tableau cubiste met en joie. Certes ce spectacle pénible nous indigne moins qu'il ne nous divertit, mais, malgré tout, il nous semble qu'il serait bon de ne pas imiter plus longtemps l'indifférence hautaine des artistes bafoués et de fournir à la foule quelques éclaircissements qui suffiront peut-être à étouffer son rire outrageant. S'ils l'avaient voulu, les cubistes, dès le premier Salon, eussent dissipé un malentendu dont ils étaient les seules victimes, mais ils ont préféré s'enfermer dans un silence dédaigneux et c'est une attitude qui n'est pas sans beauté.

D'un mot nous allons justifier les cubistes et révéler leur doctrine. Pourquoi des visiteurs sans culture rient-ils sans retenue devant les Metzinger et les Fauconnier ? Parce qu'ils ne comprennent pas. Et pourquoi ne comprennent-ils pas ? *Parce qu'ils n'ont pas traduit !* Or, c'est là l'erreur fondamentale. Que dirait-on d'un homme qui, ignorant totalement la langue allemande, aurait la stupidité de lire Goethe dans le texte et de prétendre ensuite que l'ouvrage est incompréhensible ? On dirait que cet homme est un sot.

# Le Mystère Cubiste

## LES PEINTRES ESSAYENT, EN VAIN, DE LE PERCER

La photographie que nous publions ci-dessous est celle d'une œuvre qui figure au Salon d'Automne. Nous avons vainement essayé de discerner ce que cela pouvait être ; devant notre impuissance à comprendre, un cubiste nous a crié :

— Êtes-vous peintre ?

Nous avons pensé que le mieux, en effet, était d'interroger les peintres sur ce qui est peut-être de la peinture. En plaçant sous leurs yeux la photographie que l'Éclair reproduit, nous leur avons posé ces questions :

1° Est-ce un tableau ?

2° Si c'est un tableau, représente-t-il quelque chose ?

3° S'il représente quelque chose, que représente-t-il ?

### « Je vois des gantelets de chevalier »

M. Gabriel Ferrier, membre de l'Institut, l'un des maîtres du portrait et depuis tant d'années l'honneur de notre école, nous a répondu :

*Pas plus que vous, je ne comprends cette œuvre d'art. Il me semble pourtant découvrir, au milieu du chaos, des gantelets de chevalier. A qui appartiennent-ils ? Je ne sais ! J'ai essayé de trouver la tête et n'y suis point parvenu. Mais peut-être l'auteur du tableau pourrait-il vous renseigner...*

### « C'est une rue de Paris »

M. Boldini, dont le très grand et très personnel talent n'a jamais redouté l'originalité, a bien voulu nous dire ce qu'il a vu en cette boutade brève :

*Ce tableau représente une rue de Paris. Bien à vous,*

BOLDINI.

Des gantelets de fer promettaient un chevalier... mais si c'est une rue, ce n'est pas un chevalier. On s'y perd .

### « Je vois des mains cubistes »

M. Pierre Carrier Belleuse, le peintre de la grâce aérienne et du si précieux corps fé-

**? ? ?**

minin, a entendu dire que ça représentait une femme, la *Femme en bleu*... Il nous écrit, désolé :

*J'ai retourné la photographie dans tous les sens, je n'ai pas découvert de Femme en bleu.*

*Faut-il penser que, pour éviter les regards des philistins, elle se cache dans une armure, comme sembleraient l'indiquer les gantelets .. Maintenant, sont-ce des gantelets ou tout simplement des mains cubistes ?*

Une rue de Paris, des gantelets, une femme en bleu, des mains cubistes : notre perplexité augmente.

### Est-ce la quatrième dimension ?

M. Jacques Blanche, dont l'œuvre, d'une si puissante tenue, n'a rencontré que des admirateurs et n'a jamais eu besoin de scoliastes, écartera avec indulgence ce rébus qui tourne au cauchemar, et imposera à notre curiosité la discipline d'une opinion.

*Je connais le tableau dont vous me soumettez la reproduction. La question à laquelle vous m'engagez à répondre est trop complexe pour que j'essaie de le faire ici ex-abrupto, et pour des lecteurs pressés. La peinture, semble-t-il, est parvenue à l'extrême point de son développement, il y a trente ans. Maintenant, les millions d'yeux qui s'appliquent à regarder la nature dans le monde civilisé n'appartiennent qu'en nombre infinitésimal, à des peintres-nés. La peinture est devenue un exercice de l'intelligence, auquel se livrent bien des êtres dont l'esprit est plutôt philosophique ou scientifique. Il y a une grande confusion dans l'art moderne dû à la littérature, à la critique, au snobisme et au manque total de discipline.*

*Les cubistes se réclament : 1° les uns des théories scientifiques, et parlent de la quatrième dimension, qu'un Poincaré peut, dans certains éclairs de génie, vaguement entrevoir ; 2° les autres, de M. Picasso, le jeune artiste espagnol qui, lui, n'a aucune théorie et qui fut doué par la nature d'un tempérament de peintre remarquable.*

*Quant à moi, je préfère les erreurs un peu ridicules d'hommes ayant un idéal, à l'imbécile courant des salons officiels et aux timidités de l'École des Beaux-Arts.*

*C'est peut-être « une erreur ridicule », mais que représente-t-elle ? Nous continuons à l'ignorer.*

### « C'est un puzzle sans solution »

M. Grün, qui a tant d'esprit dans ses affiches et tant de talent, du plus personnel, dans ses tableaux, allait-il nous tirer de souci ? Il y a mis, pour y parvenir, une bonne volonté dont nous lui savons un gré infini. Il nous écrit :

*Mon avis personnel sur ce nouveau genre de sport pour la cervelle est que ça peut tout de même porter le nom de tableau, aussi bien que les toiles des grands maîtres puisque le nom de tableau est utilisé dans d'autres occasions que la peinture. Le gibier tué dans une chasse forme un tableau. La planche noire sur laquelle on écrit à la craie s'appelle un tableau — il y a aussi les tableaux d'avancement. J'en passe et des meilleurs, qui ne constituent pas des œuvres d'art. Les toiles des cubistes pourraient bien s'appeler tableaux ; mais pour savoir ce qu'a ça représente, c'est autre chose !.. Enfin, c'est presque aussi intéressant que le puzzle, mais avec cette différence qu'il n'y a pas d'espoir de trouver la solution.*

M. Grün — et pourtant on sait s'il a de belles audaces ! — n'a même tenté une hypothèse.

### Le sorcier a le mot de la fin

M. Gaston La Touche, dont la palette est toute lumière et qui a fait chanter dans des harmonies d'une richesse incomparable, la somptuosité des automnes, ayant renoncé à trouver lui-même, a consulté son entourage ; il est en ce moment à la campagne, au château de Saint-Flavent, dans le Berry de George Sand, pays des cornemuseux et des sorciers :

*Une de nos charmantes amies, vous écrit-il, a suggéré une idée géniale. Nous avons, m'a-t-elle dit, un sorcier dans le voisinage ; c'est un esprit délié et retors ; il dirige à son gré de mystérieuses effluves. Allons le trouver. Aussitôt dit, aussitôt fait : notre sorcier était tout proche, la consultation fut rapide... « C'est-y vous, Monsieur, qui me demandez dans cette affaire-là ? », me lança notre auzure. — « Oui, père S... » — « Eh bien, Monsieur, je crois que vous vous moquez de moi... »*

Ce sera le mot de la fin de cette enquête chez les peintres qui sont des peintres : l'auteur de ça s'est moqué de nous.

slang from the turn-of-the-century: alternately, a third-year student at the Ecole centrale who studies advanced *mathématiques spéciales* and, in an ironic reversal typical of *argot*, a plain idiot.[128] This duality is also reflected in a common critical pun, in which the cubist painter is addressed as "maître cube" ("cube master") with mock respect, or "mètre cube" ("cubic meter") an image of dumb obdurancy (see fig. 43).

For some, descriptions of cubism as a kind of geometrical science were joined to a visual disparagement of cubist pictures as cold, dry and austere, a vocabulary of brittle cerebrality.[129] For others, the pictures were merely schematic and puerile. Louis Vauxcelles was the prime exponent of this reductivist argument, but he seems to have appropriated it from André Salmon (during 1910 and 1911, Salmon dismissed the salon cubists as tame followers of Picasso and Braque, though his tone changed somewhat in 1912).[130] Criticizing Salle 41 in 1911, Salmon complains that "Cubism is, in reality, an entirely elementary method of composition, a procedure that might serve as a beginner's manual; it is acceptable, but we refuse to take preparatory sketches for finished works."[131] In turn, Vauxcelles rejects claims for cubism as a kabbala accessible only to *initiés*; on the contrary, he asserts, the governing stylistic theory is "prodigiously simplistic and brief,"[132] consisting of little more than "the reduction of forms to geometric volumes."[133] With an ironic barb directed at the pretense of esthetic advance, he took pleasure in pointing out that this device has long been practiced at the Academy; echoing Salmon, he notes that inscribing forms from nature inside geometrical figures was even a common teaching method of primary school drawing classes. While the technique is appropriate as a tool, it has no place outside the studio. In this sense, cubist pictures were understood to be unfinished or mere studies. At best, then, the cubists were "students of the Ecole des Beaux-Arts who have left through the door and come back in through the windows."[134] Returning to this question in 1913, Salmon was probably addressing Vauxcelles' on-going polemic when, reviewing the Salon d'Automne, he alluded to "certain adversaries" of cubism who see in its practical "*rigueur*" an "offensive return to the Ecole"; but Salmon concedes that cubism does run the risk of academicism, and that he knows "such a studio where cubism is taught in 15 lessons."[135] (Something of this kind was probably intended by Picasso if, as reported in a *Le Temps* review of the 1912 Salon d'Automne, he did actually refer to salon cubism as "the evening class of the Ecole des Beaux-Arts."[136]) Revealing the secret antecedents of cubism was a leitmotif among critics bent on exposing cubist "innovation" or "originality" as a sham. In addition to the Ecole des Beaux-Arts, "precursors" of cubist geometrical figuration come in three categories: textbook exercises, such as the "drawing with square elements" reproduced from Walter Crane's turn-of-the-century design manual *Lines and Forms*; geometrized anatomy studies by the old masters, notably Dürer or Leonardo (fig. 51); and reductivist examples of primitive or ancient art, including Egyptian sculpture and *images d'Epinal*. In each case, the implication is one of historical or intellectual regression.[137]

Taken seriously, however, the charge of hermeticism inevitably encouraged critics, both pro and con, to scan the recent history of arts and letters for a context, a geneology or cubist family-tree. Symbolism was identified as the natural progenitor. This was, in part, clearly a hold-over from descriptions of symbolist Paris as a community of closed *cénacles*, and the resemblance which pre-war avant-gardism bore to the clubbishness of the late nineteenth-century literary milieu, with its designated meeting places and *petites revues*.

VARIÉTÉS

## ALBERT DÜRER, CUBISTE

On n'invente jamais rien. Nos bons rapins de Montparnasse ou de Montmartre, qui étonnent si grandement certains mécènes fortement teintés de snobisme en leur faisant des mandolines qui ressemblent à des jeux de cartes, et des femmes en bleu qui ont de vagues apparences de bateaux-lavoirs, sont des retardataires. Il y a quatre siècles que l'on fait du cubisme, et que l'on sait ce qu'en vaut l'aune. Seulement, autrefois, on se servait du cubisme; on ne l'offrait pas tout cru à l'amateur, au public bénévole; on était cubiste dans l'atelier, chez soi, pour s'instruire; et lorsque l'on produisait une œuvre véritable, on devenait « rondiste », si j'ose dire, rondiste comme les seins, comme le corps, comme les arbres, les plantes, comme tout ce qui vit enfin, puisqu'il n'y a que dans les traités de géométrie et dans les toiles de nos modernes fumistes, que les harengs saurs sont en losange, et les femmes en forme de hareng saur.

Car ainsi que le disait Ponchon :

Veulent-ils peindre un trottin,
Ils font poser un Bottin.

Tandis que l'inventeur du cubisme, qui aimait la précision en tout, cherchait dans un trottin de

51. "Albert Durer, cubiste,"
*L' Art et les Artistes* (1912).

But the two esthetics were, it was supposed, easily compared. The relationship could be defined as an analogy, generally supported by a vague contrast between realism and idealistic artifice. Arsène Alexandre, as we have already noted, identified symbolism and cubism as twin expressions of abstract representation.[138] Gustave Kahn compared the cubist search for a beauty "that passes beyond the strict imitation of natural forms," recalling "the ambition of poets from the preceding generation," whose work sought to evoke a realm of *idéalité*.[139] Marc Vromant, in *Comoedia*, envisions cubism as a duality of symbolism and science:

> As Symbolism was a reaction against the Parnassus and Realism, Cubism is a reaction against excessive realism in painting. One thirsts after idealism; one demands wings; one wants to disengage oneself from the material and soar in the empyreum of Essences. And for that, the most material means are employed, the most positivistic technique, the most exact science.[140]

The hermetic-symbolist ancestry of cubism, though, could be quite precise. The poet Mallarmé was extremely suggestive in this regard, for his work was founded on a so-

called doctrine of *l'obscurité*, deliberately oblique, delicately suspended from allusions and metaphors which are cloaked and unyielding to common interpretative sense. An unsigned article in *Les Marges* in December 1912 selects Mallarmé as the central figure:

> Cubism. This cubism, will it not prove to be mallarmism for painters? To express oneself according to the law of an infinitely obscure logic, so personal that it remains elusive to others; . . . why won't cubism give us a painter who, depicting perfectly insignificant things, is also . . . with a sort of magic, in communication with chaos and the absurd? Mallarmism gave us Mallarmé, whose verses and poems – the most opaque and devoid of sense – still, due to word choice, refined sentiment and verbal music, discharge a certain seduction. The friends of the precursor of Cubism assure us that there is such an artist. It is true that the indifferent have only found in Picasso the cubist a richly ironic boy.[141]

One year later, Roger Allard employed *mallarmisme* to describe the "hot house" (*serre-chaude*) condition of modern art, with its modes and formulas that are understood only by a handful of *initiés*; in this regard, he claimed, "the separation between artists and their public has never been more absolute."[142]

Beyond Mallarmé, the symbolist forebears of cubism could include the painters Gustave Moreau and Odilon Redon; in his 1912 account of recent painting, *La Jeune Peinture française*, Salmon said that Redon was doing *la peinture pure* thirty years before the "formula for it was proposed."[143] The abstruseness of cubism could also be traced to the symbolistic realm of mysticism and esoteric science. Perhaps the most striking instance is a series of pro-cubist articles and reviews by one Abdul-Hâdi (Johan Gustaf Agelii, a Swedish convert to Islam[144]), published from 1910 to 1913 in the esoteric review *La Gnose* and the populist magazine *L'Encyclopédie contemporaine*. In *L'Encyclopédie*, Abdul-Hâdi describes cubism, including the work of Picasso, as a "portrait of space" executed in "mental drawing" which describes the "architecture . . . of the void"[145] as a form of *éspacisme* marking the return to a pre-Christian tradition of occult science. Cubist geometry is "concrete life [expressed] by forms that are as abstract as possible."[146] Cubists are the *initiés* of a "secret doctrine in the plastic arts,"[147] while the public consists of *profanes* who cannot be expected to understand without a "certain degree of initiation"; the intensity of the cubist discipline, which is, ultimately, an expression of "*the simple truth*," exasperates them. In the case of cubism, a "*pure*, cerebral, esoteric art," the painter works only for himself, and makes no concession to vulgar taste for sentimentality.[148] Abdul-Hâdi's reading of cubism as an art of mystical hermeticism turns out to be quite concrete, unlike vague allusions to the esoteric with which other critics attacked cubism for its ostensibly deliberate indecipherability. It is a defense of cubist art, but one in which the rhetoric of elitism corresponds to the perceived exclusivity of cubism as a source of alienation for the general audience.

Within the cubist or hermetic triangle of geometrical science, esoteric science and symbolism, lies the article "Qu'est-ce que . . . le 'Cubisme'?," published in December 1913, by *initié* Maurice Raynal. Raynal explains cubism to the general audience of the magazine *Comoedia illustré* by comparing cubists to *primitifs* such as Giotto, whose "mysticism" influenced them to "*think* painting rather than *see* it" – to paint following "that remarkable idea of conception that the Cubists have revived for a different

purpose . . . The Cubists, no longer having the need to paint the mysticism of the *primitifs*, have received from their century a sort of mysticism of logic, of science and of reason," which has been "amplified and rigorously codified under the well-known name of the *fourth dimension*."[149] Theories of the fourth dimension had been applied to cubism by critics and artists since 1911, when Apollinaire publicized the term in his speech for the Exposition d'Art Contemporain, first published in 1912.[150] Similarly, Raynal's dichotomy of perceptual and conceptual painting was, as we have seen, a commonplace of popular, often negative, cubist criticism; it too had been disseminated most recently within the community by Apollinaire, who invented the label "Cubisme Scièntifique" for one of his four major categories of cubist painting.[151] By 1913, the fourth dimension was well-integrated into the specialist and popular literature on cubism. It is significant that, four months after Raynal's article, Roger Allard denounced elaborate theorizing, that "dreadful scientifico-esthetic vocabulary," as a plague of avant-garde group painting. In particular, he singled out the fourth dimension, describing it as a product of symbolist and cubist discussions at the Closérie des Lilas, the café which Allard himself attended:

> Since the time when painters frequented the Closérie des Lilas and some other highly literary *popines*, they have been afraid of not appearing cultivated enough. [As a justification for] the slightest plastic initiative, often quite timid in its audacity . . . it was necessary to call mathematics and geometry to the rescue. It became good form to speak familiarly of the geometry of Lobachinsky or the theories of Wirchow, and from Montmartre to Montparnasse, there was a desperate dance of logomachy on the wire of the fourth dimension.[152]

The most developed treatment of fourth dimensional mathematics during the period was Gaston de Pawlowski's fantasy "Voyage au pays de la quatrième dimension," published as a serial and a book in 1912.[153] As a contributor to *Comoedia*, of which he was editor-in-chief, Pawlowski had several occasions between 1911 and 1914 in which to address cubist art directly, both as painting at the salons and as the subject of two books, *Du Cubisme* and *Les Peintres cubistes*. As Linda Henderson has shown, Pawlowski appears to make no connection in his writings between the fourth dimension and cubist pictorial space (even after Apollinaire explicitly discussed the fourth dimension in *Les Peintres cubistes*). Not especially impressed with cubist pictures themselves, he calls cubism *ridicule* and *incompréhensible*. None the less, he approves of cubists as *originales*, recognizable by a family resemblance of style; and he admits that the works might at least prove to be a catalyst for positive change in the pictorial arts.[154]

Pawlowski did not "explain" cubism with metaphysical geometry. However, his opinion of cubism may have been otherwise shaped by his work on the fourth dimension. In several overlooked editorials on cubism at the salon in 1911 and 1912, Pawlowski defended the cubists against unjust ridicule. Their work may indeed be absurd or incomprehensible, but serious research, no matter how absurd, encourages audacity and opens doors; "if cubism did not exist, it would be necessary to invent it."[155] Pawlowski supports his argument with two examples from the recent history of art: Sâr Péladan's Salon of the Rose + Croix, and the Salon des Incohérents, a late nineteenth-century humorists' exhibition circle whose participating members included Toulouse-Lautrec.[156] Better than any other plea for tolerance at the time, this peculiar juxtaposition of the two Salons – one an

expression of high-minded idealism, the other an exercise in caricature and ridicule – exposes a valuable ambiguity that is built into the charge of avant-garde hermeticism. Recent literature on modern art and fourth-dimensional science appears sharply divided on the exact nature of Pawlowski's tale. In the preface to a 1923 edition, the author himself described his work in no uncertain terms as a comic fiction (there were no such authorial remarks in the pre-war edition). Of course, ten years is a long time in which to reconsider the meaning of one's early work. Still, looking back, Pawlowski insists that there were some chapters "the humoristic character of which has not always been sufficiently understood," a miscomprehension that has "given rise to false interpretations." Significantly, Pawlowski goes on to define humor as "the exact sense of the relativity of all things . . . the open door to new possibilities without which progress of the spirit would be impossible."[157] If the comic element of the fourth dimension was in place in 1912, it may have been responsible for permitting Pawlowski to value the "absurdity" of cubism; that is, in representing something more than science with a straight face, the fourth dimension can have afforded him a certain flexibility of interpretation.

It is difficult to judge the wobble which exists between 1912 and 1923. It is clear, however, that Pawlowski's appreciation of cubism is an unorthodox blend of the popular and the arcane. We might say that, for Pawlowski, scorning cubism as ridiculous (the Incohérents) and defending it as obscure (the Rose + Croix) were responses that share a common ground: the dimension of incomprehensibility. The Rose + Croix and the Incohérents are both unfamiliar and disorienting; like cubism, each in their own way is absurd, but the uncertainty they breed can be liberating. As Pawlowski would have it, given the unpredictable course of future events, who is to say which one will come to have greater value?

Pushing Pawlowski's point, the incoherence of the new art can be said to lie not within the bounds of science, gnosticism, elementary-school reductivism or the comic absurd, but in the conflict that the categories represent. Cubism cannot be each of these, but the experience of cubism, its true incoherence, can be, and was. In this way, the new morphological flexibility traditionally associated with cubist style was matched turn for turn by an equally impressive repertoire of (mis)interpretation. While some of the charges – such as schematicism or excessive theory – had been leveled before, they gather with peculiar density around cubism. In this regard, manifestos and criticism both reveal a charlatanesque syndrome, where strands of erudition, *boniment* and ridicule are increasingly difficult to tell apart.

—6—

Avant-gardism, or the proliferation of *écoles* and the perceived propagation of stylistic extravagance in the name of youth, novelty and originality, was the vehicle for a good deal of satire and parody during the pre-war period. In particular, with the rise of cubism and futurism during 1910 and 1911, the ism and its apparatus – the manifesto, the *petite revue*, the café-clubhouse – were subjected to ridicule in both the critical and humorist press. The essential issues appear to have been pictorial style and avant-garde behavior,

especially the chief impulses of hermeticism and *réclame*. This ridicule contains an element of reverse disdain, directed against modern art as a form of bluff or an insider's game. Yet at its most complex (when, for example, it takes the form of developed parody), it becomes its own game of ambiguity, bringing us a step further into the condition of esthetic disorientation that prevailed at the time.

Ridicule of the ism could be fairly simple and predictable. Armand Fourreau is typical in his review of the Salon d'Automne in 1911 for *La Phalange*: "After the cubists, perhaps tommorow we will see the spherists, when the sphere dethrones the cube, if the cone doesn't triumph in its turn with the conists!!"[158] Such lists of isms and ists, both real and invented, were common throughout the period: "Yes, there are, over there on the avenue d'Antin, tachists, pointillists, intentionists and cubists";[159] "cubists, ideaists, polyhedrists, simultanists, cerebrists, futurists, divisionists and so many other ironists";[160] "the Salon des Indépendants shelters, as last year, cubists, futurists, orphists, plurists, synchromists and other lunatics";[161] "Le Cubisme? L'orphisme? Le je-ne-sais-quisme?"[162]

The mock-invention of a new ism was easy. In the literary *revue L'Ami de Paris*, a weary ex-cubist explains the new school of Colorithermométrisme, landscape painting based on the rapport between colors of paint and the temperature of the landscape.[163] *Fantasio* staged an interview with Apollinaire, "lucid theoretician of cubism," in which the poet-critic holds forth on the current subdivisions of cubism: these include cubisme conceptionniste, cubisme rationaliste, cubisme orphique, cubisme excentrconcentrique, cubisme conceptorationaliste, cubisme rationaloorphique, cubisme excentroconcentro-conceptionniste and rationaloorphicoconcenptionniste, as well as the "resplendant, transcendent school of excentroconcentroconcepticorationaloorphisme."[164] Apollinaire himself published an article in the same magazine on "astronomisme," a "new school of cooking which is to the old culinary arts . . . what cubism is to old painting . . . Astronomic cuisine is an art and not a science."[165]

Parody gets more complicated when, in some cases, the sham school is difficult to distinguish from the real thing. This not only reveals the sneaky expertise of the pre-war prank, but goes a long way towards recapturing for us the ease with which avant-gardism could, to its audience, look or sound like a mannered replica of itself. In October 1912, the arts review *Occident* published the manifesto of "plurism," a new school devoted to abolishing the archaic practice of esthetic specialization by co-ordinating cubism, futurism and unanimism into a united effort. A hypothetical example of plurist art was included:

Suppose a plurist wants to express his concept of Abundance. In a corner of his canvas, he would paint the total or partial figure of a woman, who would symbolize Abundance. Then he would model (in plaster, aluminum or terra-cotta) a sumptuous bowl of fruit or flowers, which he will attach to another corner of the canvas. The two remaining corners will be occupied respectively by a poetic text and a row of musical measures – the poetic text and the melodic theme both suggesting Abundance.[166]

The manifesto of plurism is, at the very least, a precocious response to *papier collé* and collage in the works of Picasso and Braque. As parody, it bears a piquant relation to the actual course of events in cubism at that moment. (For Picasso, fall 1912 was a period of intense activity in *papier collé*, including the series of pictures with sheet music.) We can

only be truly certain that the manifesto *is* parody when pausing over stray remarks that are simply silly, such as replacing Nietzsche's "surhomme" with the new concept of a "plurhomme." In his book *La Littérature et l'époque* from 1914, Florian-Parmentier confirms that plurism was a joke, quoting from the manifesto as a "spirited satire" composed for *Occident* by its editor Adrien Mithouard; he also notes that it "has not prevented M. H.-M. Barzun from elaborating his theory of simultanism, and I-don't-know-which painter from inventing a new synchromist painting."[167] In other words, as ridiculous as the fictive ism appears, the real thing can resemble it in startling and embarrassing ways. Plurism seems, however, to have convinced readers and attracted some response, for the editors of *Occident* saw fit to publish a Note entitled "Progrès du Plurisme" in the November issue. Regarding the derision which the manifesto received, the authors ask whether "incomprehension and raillery are not proof of the excellence of our doctrines?" They also remark that plurism has done especially well in Germany, where the avant-garde review *Der Strom* (*sic*) has consecrated an illustrated article to the manifesto, and "the erudite Lucius Strauss . . . is publishing an important work on esthetics, *Philosophie et Cubisme, de Hegel à Picasso*."[168] Plurism, they conclude, will reveal itself at the 1913 Salon des Indépendants. It appears that plurism was, in fact, awaited at the Salon; but, according to at least one 1913 Salon review which synopsized the plurism manifesto from *L'Occident*, the new school remained hearsay after all.[169]

A similar question of true-or-false confronts us in the form of another new "school." Writing his "Les Arts" column for *Gil Blas*, opposite Louis Vauxcelles under the pseudonym of "La Palette" in March 1913, André Salmon ridiculed the recent manifesto for "Orphéisme," which had been distributed by one Georges Meunier to visitors at the Salon des Indépendants that month.[170] The subtitle of Salmon's column is "Orphisme, Orphéisme, ou Orphéonisme?," suggesting that Meunier's "orphéisme" is a misquote of "orphisme," one of Apollinaire's sub-divisions of cubism from *Les Peintres Cubistes*. But it might just as easily have been a deliberate corruption, for slightly altering the name of an avant-garde group was a common critical wisecrack of the period ("foutourisme" is one example.)[171] Salmon quotes Meunier's "petit papier" as if it were a sincere effort at esthetic prosylization, and he should know. However, excerpts from the manifesto suggest that it was intended as a joke. Salmon notes that the manifesto "must have been composed in haste since it lacks clarity,"[172] a fairly commonplace swipe at the neologistic vocabulary of contemporary esthetic doctrines; but the document reads more like an obvious pastiche of Marinetti's manifesto voice and the breathless chronicle-style art writing of the day: "To establish a subtle wireless telegraphy between all the most distant posts of pictorial thought!"; elsewhere, "To perceive the noise of Matter and to organize it according to the laws of the transcendental ideal"; or, "Painters joined in ardent faith have valiantly defended this program in well-known exhibitions in Rouen and above all Paris, at the Section d'Or."[173] Further along, adherents to orphéisme are said to include "Appollinaire," "Francis-Picabia" and "Metzeger," among others. This is not, Meunier concludes, just another "mouvement en isme."

Apollinaire was also amused by Georges Meunier and his manifesto. He brought the item into his column for *l'Intransigeant* on March 19: "An interesting typewritten document was distributed to most of the exhibitors this morning. Its subject is orphism (*sic*), and it bears the signature 'Georges Meunier.' Who is Georges Meunier?"[174] Who

indeed? Could he be the Chéret-influenced illustrator and *affichiste* by that name who was, in fact, exhibiting during the period at the Salon des Artistes français and the Salon des Humoristes?[175] He does not appear in the catalogue of the 1912 Section d'Or show or the 1913 Salon des Indépendants. Is "orphéisme" a new movement or a misspelled one; an authentic sub-division of a sub-division of cubism, or a prank? Did it have a life at the Salons? It appears, at least, to have had a death: "'Orphéisme,' the brief fate of which was to be but a stammer, is already dead," wrote Georges Lecomte in his review of the 1913 Salon d'Automne for *Le Matin*, while "'futurism' continues to announce its splendors with loud prefaces, but has the discretion . . . not to encumber our walls," and "cubism still lives."[176]

A third and most significant example of the sham ism appeared in the magazine *Les Hommes du Jour* in May 1913, around the time of the Salon des Indépendants. Entitled "L'Evolution de l'Art," it is comprised of a preamble, assessing the state of contemporary painting, followed by a manifesto for the ultimate ism: "amorphism."[177] "The moment is serious, very serious," the article begins, "We are at a turning-point in the history of art." The inflated, self-important character of the pronouncement is consistent throughout, and is used to sustain an amalgamation of recent esthetic clichés. Thus, "the patient research, impassioned attempts and audacious trials of intrepid innovators . . . are at last going to lead us to . . . the single and multiple formula that will contain the entire visible and sentimental universe." For years, we read on, painting has been on the march towards "one glittering goal," an ultimate refinement which consists in "purely and simply neglecting form in order to attend to the thing in itself." Monet, Renoir and Cézanne were forerunners, succeeded by the neo-impressionists and the fauvists. But their art is ultimately out of date, since *these painters still knew how to paint; some of them even drew.* The geometry of cubism and conism followed, with their "strangely lucid vision of the interpretation of beauty disseminated and dissolved in the universal flux," a further contribution to the "shining path of Amorphism." Among the subdivisions of cubism, orphism stands out as the "last word in contemporary art . . . the first step towards the inevitable formula." The text continues:

> Already the Rouaults, the Matisses, the Derains, the Picassos, the Van Dongens, the Jean Puys, the Picabas (*sic*), the Georges Bracques (*sic*), the Metzingers, the Gleizes, the Duchamps (whose irresistable *Nude Descending a Staircase* and *Young Man* of 1912 are unforgettable) seem to have understood the necessity for the absolute supression of form, occupying themselves with color alone.

Yet color, too, must be decomposed. "Thus, little by little, amorphism imposes itself." In a final gloss on the rhetoric of public and critical hostility, the preamble concludes that "Certainly, pig-squeals of outrage will be directed at forthcoming work by these pioneers of Art." But the authors, a "group of independent critics, enemies of bluff, free from any connection with art dealers," are here to defend "the new Art, the Art of tomorrow, the Art of all time."[178]

The short "Manifesto of the Amorphist School" proclaims a "War on Form!" Calling for the end of "objects" in painting, the amorphists turn their attention to light. "Light absorbs objects. Objects have no value but for the light that bathes them. Matter is nothing but a reflection and an aspect of universal energy." It is for the artist to indicate

# L'Evolution de l'Art

## Vers l'Amorphisme

L'heure est grave, très grave. Nous sommes à un tournant de l'histoire de l'Art. Les recherches patientes, les tentatives passionnées, les essais audacieux de novateurs hardis sur lesquels une verve aussi féroce que stupidement facile s'est trop longtemps exercée, vont enfin aboutir à la formule tant convoitée; la formule une et multiple qui renfermera en elle tout l'univers visible et sentimental; la formule libre et tyrannique qui s'imposera aux esprits, dirigera les mains, inspirera les cœurs; la formule définitive encore que transitoire et n'ayant, au fond, qu'une valeur d'indication subtile et précise à la fois.

Expliquons-nous.

Il y a des années qu'on bataille et qu'on marche vers un but éclatant. Les précurseurs, les Claude Monnet, les Renoir, les Cezanne promptement surpassés par la petite troupe néo-impressionniste et la vaillante phalange pointilliste où brillent d'un pur éclat les Signac et les Seurat ont indiqué largement la route à suivre. A leur suite, se sont rués les fauves, Gauguin en tête. Vinrent ensuite les Matisse. Disons-le tout de suite. *Ces peintres savaient encore peindre; quelques-uns même dessinaient.* On peut juger par là du retard inouï de leurs conceptions d'une esthétique surannée. Toutefois, ils faisaient de louables efforts pour parvenir à l'Art véritable, lequel consiste à négliger purement et simplement la forme pour ne s'occuper que de la chose en soi et à ne point voir l'universel en tant qu'apparence fatalement provisoire. De toute évidence, après avoir rendu un juste hommage à ces purs artistes, il fallait les abandonner à mi-côte et se lancer vertigineusement sur le clair chemin de l'amorphisme.

C'est alors que le cubisme fit son apparition, bientôt suivi par le conisme. Pourquoi avoir reproché à ces peintres leurs préoccupations géométriques? Il leur était difficile de concevoir les objets sous une forme moins rudimentaire et ils demeuraient, dans une certaine mesure, victimes des préoccupations et des préjugés de leur époque. A première vue, l'objet doit être ramené à l'état de simple notion de dimensions. Il ne vaut que par ses dimentions et ses rapports avec l'ambiance lumineuse, rapports qui varient avec les positions de l'objet et l'intensité de la lumière qui le baigne. Remarquons que, dans cette conception déjà téméraire et dans cette vision étrangement lucide de l'interprétation de la beauté disséminée et parsemée dans le flot universel, aucune place n'était réservée à l'âme des choses. Mais passons. Les cubistes ont apporté leur pierre, si l'on peut dire. Ils ont donné leur effort. Nous n'avons pas à leur réclamer davantage.

Le cubisme, d'ailleurs, comme tous les grands Arts, s'est replié sur lui-même et subdivisé en plusieurs courants. D'abord scientifique, puis physique, il est devenu instinctif et enfin — c'est là la forme supérieure — orphique. L'orphisme, jusqu'à ce jour — si nous négligeons le futurisme, essai impétueux, mais manquant de science véritable — est le dernier mot de l'art contemporain. C'est l'aboutissant logique de toutes les tentatives d'hier. C'est le premier pas fait vers la formule inévitable, vers l'amorphisme.

Déjà, les Rouault, les Matisse, les Derain, les Picasso, les Van Dongen, les Jean Puy, les Picaba, les Georges Bracque, les Metzinger, les Duchamp (dont on ne peut oublier l'irrésistible *Nu descendant un escalier* (1912), ni le *Jeune Homme* (1912), semblent avoir compris et admis la nécessité de supprimer absolument la forme et de s'en tenir uniquement à la couleur. Il y a mieux à faire, cependant. Il y a à décomposer la couleur qui peut évoquer jusqu'à un certain point la forme et à la désassocier, pour laisser à l'œil le soin de synthétiser et reconstruire.

Ainsi, peu à peu, l'amorphisme s'impose. Certes, on poussera des cris de putois en présence des œuvres prochaines des jeunes pionniers de l'Art. Mais nous sommes quelques

critiques indépendants, ennemis du bluff, et sans rapport aucun avec les marchands de tableaux, pour défendre l'Art nouveau, l'Art de demain, l'Art de toujours. Pour aujourd'hui, contentons-nous de publier ici le manifeste, trop court, mais combien suggestif, de l'école amorphiste. Les esprits non prévenus et les véritables intelligences jugeront.

### MANIFESTE DE L'ECOLE AMORPHISTE

*Guerre à la Forme !*
*La Forme, voilà l'ennemi !*
*Tel est notre programme.*
*C'est de Picasso qu'on a dit qu'il étudiait un objet comme un chirurgien dissèque un cadavre.*
*De ces cadavres gênants que sont les objets, nous ne voulons plus.*
*La lumière nous suffit. La lumière absorbe les objets. Les objets ne valent que par la lumière où ils baignent. La matière n'est qu'un reflet et un aspect de l'énergie universelle. Des rapports de ce reflet à sa cause, qui est l'énergie lumineuse, naissent ce qu'on appelle improprement les objets, et s'établit ce non-sens : la forme.*
*C'est à nous d'indiquer ces rapports. C'est à l'observateur, au regardeur, de reconstituer la forme, à la fois absente et nécessairement vivante.*
*Exemple : Prenons l'œuvre géniale de Popaul Picador :* Femme au bain :

Popaul PICADOR.

*Cherchez la femme, dira-t-on. Quelle erreur !*
*Par l'opposition des teintes et la diffusion de la lumière, la femme n'est-elle pas visible à l'œil nu, et quels barbares pourraient réclamer sérieusement que le peintre s'exerce inutilement à esquisser un visage, des seins et des jambes ?*
*Prenons maintenant La Mer, du même artiste.*

Popaul PICADOR.

*Vous ne voyez rien au premier regard. Insistez. Avec l'habitude, vous verrez que l'eau vous viendra à la bouche.*
*Tel est l'amorphisme.*
*Nous nous dressons contre la Forme, la Forme dont on nous a rebattu les yeux et les oreilles, la Fooorme devant laquelle s'agenouillent les Bridoisons de la peinture.*

52. "L' Evolution d' Art: Vers l' Amorphisme," *Les Hommes du Jour* (1913).

"the relationship of the reflection to its source, which is luminous energy." The viewer, in turn, "reconstitutes the form, which is at once absent and necessarily alive." As an example of the amorphist program, the manifesto reproduces the "brilliant work of Popaul Picador," obviously a play on the name Pablo Picasso. The two pictures, *Woman in the Bath* and *The Sea*, are illustrated as empty frames labelled with the artist's name (fig. 52). "By the opposition of tints and the diffusion of light," we learn, the subjects of these pictures "are not visible to the naked eye."[179]

The manifesto of amorphism, with its blank pictures by the artist Popaul Picador, looks and reads like a blatant parody. In fact, its tone and figures of speech suggest a specific model (or target): Apollinaire's "Du Sujet dans la Peinture moderne," a manifesto-like essay published in the first issue of *Les Soirées de Paris*,[180] was devoted to the diminishing significance of conventional subject-matter in new art. The epithet "amorphism," a condition of formlessness, was probably derived in fun from Franticek Kupka's startling, non-objective "amorpha/Fugue" paintings,[181] which appeared at the Salon d'Automne in 1912. Kupka's abstractions, which Vauxcelles described derisively as "a tangle of blue and red ovoid arabesques on a black and white ground,"[182] would have been an open invitation to ridicule of this kind. Also, however, the word *amorphe* was one adjective critics used to express their distaste for the distortion of natural form in avant-garde painting; Georges Lecomte, for example, called the offending works of the 1912 Salon "bariolages amorphes."[183] Finally, *Les Hommes du jour* was generally hostile towards the art and activities of the avant-garde, and featured scathing reports by critics Henri Guilbeaux and J.C. Holl; positive reviews of salon cubism that appeared there in 1912, written by Pierre Dumont, were actually preceded by a disclaimer which stated that the views of the author do not reflect those of the editorial board itself.[184] A parody of avant-garde theory and self-promotionalism, then, fits comfortably into the pages of *Les Hommes du jour*.

The parodic character of amorphism is, however, neither an obvious nor a simple fact. Only one month after its publication in Paris, "Vers l'Amorphisme" appeared in Alfred Stieglitz's advanced art magazine *Camera Work*. The occasion was a special issue devoted to Francis Picabia; the page from *Les Hommes du jour* was reproduced, rather than translated and reprinted, empty frames and all.[185] The manifesto is labeled "From 'Les Hommes du Jour'." A recent study suggests that Picabia was probably a co-author of "Vers l'Amorphisme," and that Stieglitz received the article from the artist himself. The claim is made, however, on the underlying assumption that the manifesto is a sincere effort. (In her transcription of the manifesto, the author neglects to reproduce or consider the joke illustrations by "Popaul Picador;" she also corrects the misspelling, or typographical error, "Picaba," as it appears in the original.)[186] We can only speculate: if the manifesto, against all odds, was sincere, then Picabia means for it to reflect the direction of his own work towards abstraction. If, more likely, amorphism is the mockery that it appears to be, then Picabia's submission of the manifesto to Stieglitz was an exercise in self-send-up, anticipating a characteristic strategy of Dada as it would be practiced by Picabia and his circle after the war.[187]

If Picabia mocks the avant-garde using tactics that we are more likely to associate with an outsider, he distances his work through irony from the current enterprise of modern painting. In principle, this is consistent with his most advanced pictures of the moment,

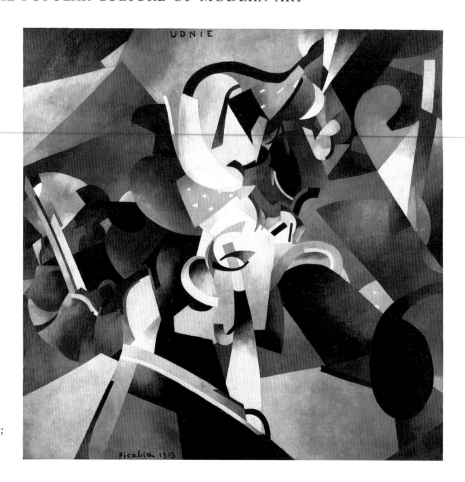

53. Francis Picabia, *Udnie; Young American Girl: Dance* (1913).

which had just begun to bear little resemblance to other forms of cubist art (fig. 53). But such sarcasm does considerable damage to Picabia's signed articles and interview statements of the period, where he describes himself as a "post-cubist" who has "passed utterly beyond the boundaries of the material" into a realm of art that is "intellectual" and "pure," or as conceptual as music.[188] Amorphism's mock-seriousness and Picabia's lofty description of post-cubist abstraction are irreconcilable, except that they are nearly identical. This is why amorphism can still deceive. If the two programs do indeed derive from the same source, then they expose the paradox of an artist whose work was coming to represent an invisible bifurcation – a real but almost imperceptible boundary – between the avant-garde as an enterprise of "progress" and the burgeoning irony of dada. We might even speculate that Picabia's "serious" statements are a deliberate send-up of period artspeak. Whether or not they issue from a single voice, however, theories of "post-cubism" and "Amorphism" represent the uneasy proximity of self-promotionalism and self-parody at a time when the bewildering speed of avant-garde activity was observed as a blur of the new and the pseudo-new. It need not be maintained that Picabia is the author of "Vers l'Amorphisme" to recognize that, at the very least, the manifesto establishes the existence of an esthetic uncertainty principle. Writ large, such a principle might be said to

govern the vast network of unease that spreads itself throughout the early experience of modern art.

It is difficult to assess whether Stieglitz was in on the amorphism joke, if indeed we can firmly conclude that the joke was perpetrated by Picabia (or whether Picabia too was an unwitting victim; the possibilities are manifold). But the episode recalls the ambiguities of advertising and charlatanism as they were addressed in the pages of *La Publicité*. Hoax and fraud involve a degree of wit and invention that, as an esthetic exercise, is capable of scrambling the distinction between originality and delusion. This may be true less on the level of practice than of theoretical justification, but it is significant enough to cast brief light on a pre-war smoke-and-mirrors show of authenticity, genuine purpose, self-representation and bluff.

—7—

For hostile critics writing under the double banner of tradition and taste, the excessive idiosyncracy of modern style may have been a kind of enemy flag. The larger fabric of this debate, however, seems to consist as much of artists' motivations and actions as of pictorial style. During an epoch which understood itself as remarkable for esthetic diversity and swift, sudden change, behavior came under careful scrutiny. The pattern of interaction between artist, critic, collector and larger public was highly sensitive to the subtle stresses and strains of conflicting and ambiguous intentions, be they real or putative.

With the co-ordinates of popular and critical pre-war esthetic antagonism in mind, a further step back discloses another contextual matter. Virtually the entire system of exchange between art isms and their disoriented, often hostile, audience occurs in conjunction with a larger, two-sided issue: sincerity and the abuse of confidence. Indeed, all critical and popular expressions of astonishment and disdain during the 1909 to 1914 period might be traced to a perceived violation of trust. Audience antagonism of the time depended on the notion that modern art can be represented as an act of esthetic betrayal. Above all, questions of sincerity and confidence generate a charged field which contains and energizes the paradox of avant-gardism, as it is understood in the popular and critical press: a dual enterprise of extroverted *réclame* and introverted hermeticism. Not so much a setting, it surrounds and courses through the instability and ambiguity of pre-war esthetic experience.

Naturally, such sentiments have a history before 1909. If sincerity was taken for granted until that time, Louis Vauxcelles would not have had to assure the readers of *Gil Blas* in 1908 that Georges Braque "acts in good faith." But we may introduce the presumed onslaught of insincerity in 1909 with "Mon ami le peintre," published in *Le Figaro* around the time of the Salon d'Automne. This is a fictional dialogue between a painter, Armand Myrmel, and his friend, who narrates. We catch up with the painter at the Salon, where a canvas of his has been accepted. The painting is described by Myrmel in convoluted artspeak, and sounds like a send-up of divisionism – light is addressed as a "transparent and vibrant fluid," and the technique consists of "vaguely rectangular" spots of color arranged according to the spectrum. In response to his friend's theoretical

explication, the author is dismayed. "Truly," he inquires, "you speak in good faith?"[189] Can it be that the old masters were following the wrong path? Has not impressionism, the last "sincere" effort at expanding upon the old formulas, been succeeded by innumerable *blagueurs* and *fumistes*? Just then, a group of young art students stop before Myrmel's picture and dismiss it disdainfully as the work of a *pompier*. Mortified, Myrmel leads the author outside.

It appears, according to the confession which follows, that Myrmel's elaborate theories and strange pictures were concocted solely to attract notoriety. He explains that, some time ago, envious of the celebrity which was being heaped upon artists of daring and extravagance, he abandoned his ideal, that of the "honest and conscientious worker cultivating his small garden – and above all, painting it – with love and with sincerity." Trading his sincerity for "effrontery and cynicism" in order "to arrive," Myrmel sought a formula capable, even after so many others, of "shocking bourgeois and comrade" alike. He dreamed of becoming both a venerated *chef d'école* (the "école philatélique irradiante") and a successful businessman. For a while, the plan was a success: Myrmel became the idol of several advanced *revues* and attracted a coterie of followers. But soon "the wheel turned," and Myrmel was displaced by innovators even "more ingenious and more cynical... more practised in the extravagant, in the stupefying and in the *abracadabrant*." By comparison, Myrmel had become a *pompier*. Myrmel ends by lamenting his wrong turn; if only he could start over, recapture "that intimate, inexplicable, delicious pleasure that is experienced only by sincere artists engaged in interpreting nature honestly."[190]

The theme of "Mon ami le peintre" is quite familiar: the avant-garde is perceived as an on-going publicity stunt, and innovation in pictorial style is a promotional strategy. This explains the speed of stylistic change in recent years – the "new" tires quickly and is easily succeeded by greater extravagance. Evidently, impressionism has indeed been followed by *blagueurs* and *fumistes*, each inventing an esthetic program with ever increasing shock value. This dialogue contains a plain example of the "sincerity" subtext. The polarization is clear: on one side, sincerity, honesty and conscientiousness all associated with a committed attention to transcribing the natural world; on the other, "cynicism" and "effrontery" associated with artifice, and calculated to appeal to the market for innovation at all costs. Does the self-styled modernist speak "in good faith"? Myrmel's own confession openly confirms that he does not.

The sentiment will come to inform reviews and first-hand accounts of the real avant-garde. In June 1910, the review *Les Tendances Nouvelles* published replies to their *enquête* on "individualism" as a tendency in the contemporary arts. Thoughts on good and bad faith recur throughout, but an architect named Gaston Ernest was the most blunt. Lamenting the migration of Indépendants-style painting into the Salon d'Automne, Ernest insisted that the excesses of modern painting are driven by the "surenchère 'nouveau style'," or "the desire to stand out and appear more original than one's neighbor,"[191] under the influence of which artists "fall into incoherence and bad taste."[192] Above all, we have lost that one "indispensable quality: sincerity."[193] Reviewing the Indépendants the following year, a critic for *Le Journal des Arts* maintained that cubists "are not even sincere enough to depict what they see before their eyes. Bad faith pushed to such an extreme becomes a mental aberration, and is no longer worthy of discussion."[194] More

specifically, in January 1912, *Gil Bas* published André Anryvelde's "Contribution à l'Histoire du Cubisme," in which the author records a visit to the studio of Albert Gleizes in Courbevoie. Admitting that he "did not understand" cubist pictures at the Salon d'Automne, Arnyvelde tells Gleizes that he has heard that the cubists are "nothing but *farceurs*," or worse, artists deprived of any talent whatsoever, "who invent *funambulesque* cubism in order to attract the kind of attention that they could not draw with their usual work." But Arnyvelde wants to believe in Gleizes, for his "entire aspect is that of a man who is honest, thoughtful and sincere."[195]

"Faire moderne," warns Roger Frène in *L'Ile Sonnante*, must be "reinforced by the science of technique and sincerity."[196] Suspicions to the contrary, of bad faith, false claims and the perpetration of fraud, could be a direct result of the polyphony (some would call it dissonance) of pre-war schools and isms. In a climate of tremendous pluralism, diversity can be taken for conflict and conflict can, in turn, breed mistrust. The Salon des Indépendants, with its agenda of tolerance becomes, in this sense, a target of symbolic significance.

According to the statement printed in the front of every catalogue, the Société des Artistes Indépendants was dedicated to offering all artists the opportunity "to present their works freely to the judgment of the public," without the intervention of an admission jury.[197] The principle of the Salon des Indépendants, posted in the first room, was: "ni jury ni récompenses," "neither jury nor prizes." The chief inconvenience of the system, as André Warnod noted in *Comoedia*, was that it permits "pell-mell all schools and tendencies, all faults of taste and all distinctions, all vulgarities and all refinements."[198] "Everybody paints," wrote Louis Vauxcelles in a review of the 1910 Salon, and "everyone exhibits at the Indépendants: artists, concierges, amateurs, the elderly, the idle, retired civil servants, fashionable young girls."[199] Under these circumstances, Henri Rousseau could emerge as "the perfect Indépendant type," according to the critic for the *Journal des Débats* that same year, the year of Rousseau's death, and one year before his posthumous retrospective at the Salon: a painting customs inspector.[200] Curiously, Apollinaire's famous proclamation of 1914, "Et moi aussi je suis peintre," which is generally taken to reflect a crossover of painting and poetry in the Picasso circle, was also quoted by a contemporary observer as the motto of an epoch in which painting for amusement seems to have replaced the artist's life of poverty, dedication and hard work.[201]

Above all, the good faith of the "independence" principle was violated less by the bad amateur than by the shrewd and impatient youths who exploit the liberality of the Salon as a free-for-all of competitive bluff. What, then, does independence stand for after all? In a review in *La Société Nouvelle* in 1910, the critic Abel Rémois worries at the very expression "artistes indépendants." Why this cult of "independence" if the artist, who relies primarily on his own genius and inspiration, is independent by definition? Deferring to the practical reality of the situation, Rémois admits that art must have its official bureaucracy of honors and awards, its caste-system of status; "the principle of the Salon des Indépendants is therefore excellent." So, Rémois continues, how many of the Indépendants are truly independent?

How many are dependent on fashion, what they believe to be the taste of the public, their desire to "arrive" . . . Each attempts to make the public believe . . . that he or his

group have found the definitive formula ... And then others follow, with no great sincerity, a successful master.

Surveying the Salon in 1910, it is clear to Rémois that the imitated master of the day is Paul Signac. "After Signac, let us speak right away of certain artists – what should we call them, *mystificateurs*?; or are they their own dupes?"[202] One year before Salle 41, Rémois has singled out Métzinger, Léger and Le Fauconnier, whose pictures are "composed of squares, rectangles, trapazoids and other quadrilaterals; I take him for an unconscious *mystificateur*." Moving from the *mystificateur* to the *mystifié*, Rémois asks that we skip over the work of Henri Rousseau, "poor man whom we mock by making him believe that he has talent," warning that "proper suckers are ecstatic over his naiveté: he has a semblance of pseudo-celebrity."[203] The liberality of the Salon is a risk. Vauxcelles agrees with Rémois, writing in 1910 that the inexperienced spectator will be repulsed by "the insincere excesses, the *gaucheries* of the pseudo-primitives ... [and] the coarse, easy effects of the *bluffeurs*," including both the practitioners of "frenzied, deceitful imitation" and the new "ignorant geometers."[204] By 1911, a critic for the *Revue Septentrionale* could identify this rogue's gallery of false-prophet types without even leaving the confines of Salle 41:

> A long study would be required to determine those who, among these innovators, have been led sincerely towards this evolution, and separate them from the inevitable tribe of imitators. For these sincere ones, it is incontestable that their research, misunderstood by the public, sometimes even by the elite, is not, as many believe, a different impotence of expression; they are doubtless capable of making something other than these *folies*.[205]

In at least two intriguing instances in 1910 and 1911, suspicion of this sort was implemented as official Salon policy. In 1910, a new "General Rule" was added to the submission guidelines for the "Poets' Afternoon," a poetry reading sponsored by the Société des Indépendants in conjunction with the Salon. It reads: "Toute œuvre *mystificatrice*, obscène ou injurieuse sera refusée." In reporting the regulation, Maurice Robin in *Les Hommes du jour* admitted that "among the painters, *mystificateurs* are numerous," but pointed out that since there was no art jury, establishing one for poets was decidedly unfair.[206] Writing for *Paris-Journal*, the following year, André Salmon reports on a similar "Article 3" from the eighteen rules of the Salon des Beaux-Arts Modernes in Cannes: only "serious" works will be admitted; "cubism," "pointillism" and works that bear the character of *réclame commericale* are not allowed. A prospectus attached to the rule-sheet reminds the artist that the Salon will be a rare opportunity to have his work appreciated by the rich clientele of the Côte d'Azur, but reiterates the restriction: no cubism.[207]

The Salon d'Automne controversy of 1912 refocused the risk of excessive exhibition tolerance from a juryless salon to a salon jury. One day after publishing Lampué's letter of protest against the Salon, *Le Matin* published a frontpage editorial, illustrated with works by Léger and Metzinger, called "Ne cherchez pas: c'est de l'art." A statement issued by the Salon committee and reprinted in the editorial contains the Salon's charter principle, "To admit all efforts of conscientious art," which amounts to the committee's own profession of good faith. *Le Matin* suggests that such a description cannot possibly justify "works" such as the ones they have reproduced.[208] In the December 3 debate at the

Chambre des Deputés, supporters of Lampué framed their argument against cubism with the underlying assumption that the art public had been defrauded. Jules-Louis Breton complains that under the pretext of renewing art or "modernizing its procedures [with] new forms [and] unprecedented formulas, certain exploiters of public credulity have given themselves over to mad *surenchères* of extravagance and eccentricity."[209] Marcel Sembat, parliamentary champion of cubism, responded by accusing Breton of promoting censorship; the government, he warns, should not meddle in the quarrels of art and literature. Sembat's is a freedom-of-speech defense for new art and for the Salon d'Automne as an institution. As for intolerance, he believes that a lesson should have been learned from the example of symbolist poetry (Gustave Kahn and Mallarmé are named) over whose work similar objections of "sincerity" and "obscurity" were once raised, objections since proven to be unwarranted.[210] Essentially both Breton and Sembat argue the issue of sincerity – the exhibition rights of the sincere *novateur* versus the good faith or "credulity" of the Salon authorities and the Salon-goer, violated by the perpetration of bad art for the sole purpose of *surenchère*. Further, the example of symbolist poetry serves to remind the spectator that premature lack of confidence impedes sound judgment.

One year later, in his preface for the 1913 Salon d'Automne catalogue, Sembat had an opportunity to reaffirm his own faith in the sincerity of young painters. Recalling the debates of 1912, and the failure of the opposition to win government restrictions on the content or location of the Salon, he argues from a position of moral superiority: "We were right because we defended the only solid principle: our cause was that of the liberty of Art." Quoting Clemenceau, he reminds the skeptic that "liberty is the right of each to discipline himself."[211] Pointedly denying any role as champion of a specific avant-garde group, Sembat dwells instead on the issue of comprehension. His proscription reverses a familiar theme by shifting the burden of "good faith" to the spectator, who should simply "admit that you have to make an effort in good faith in order to understand, and not to resign yourself too quickly to not understanding."[212] Sembat's name, and the spirit of his argument, crops up often in the criticism of the Salon d'Automne that year.[213] Sounding the dangers of pluralism in *Le Temps*, Thiébault-Sisson finds the Salon d'Automne a "vast field" of "the most contradictory tendencies"; some "are not always very sincere," motivated as they are "now by fashion, now by an obscure instinct for arrivism, and consequently, a bit of 'bluff'." He is grateful, however, that the intervention of the state has been forestalled, for "the artist has the right to choose freely his sources of inspiration, his doctrine and his mode of interpretation." Still, Thiébault-Sisson remains more skeptical than Sembat, suspicious of an impending transgression, a betrayal of trust: "If [the artist] abuses his right, it is for the public to warn him, or, by turning away, to challenge the *faiseur* and the 'amateur de scandale'."[214]

A reversal of this claim usefully highlights the central issue. In his defense of cubism as a form of pictorial "truth," the critic Olivier-Hourcade makes a simple and direct case for the sincerity of modern style. In his example, the still-life painter who depicts the opening of a round cup as an ellipse, though he knows it to be a circle, is "not sincere; he makes a concession to the lies of optics and perspective, he makes a willful lie." The cubist painter, on the contrary, "will attempt to show things in their tangible truth." In this way, "the *principle tendancy of contemporary painting* . . . was a desire to recapture the sincerity and the truth of the primitives." The last sentence of the article reiterates this

sentiment, that "Fauves or cubists . . . bring French art back to sincerity and to truth."[215] The sentiment matches Jean Lemoîne's, writing that year in the arts review *L'Oeil de Veau*, for whom cubism is an "essay in the renovation of art," a species of constructive classicism: "One senses in the work of Monsieur Metzinger and his friends a sincere research into physical truth."[216] In a defensive critical mode, the geometry of stylistic extravagance could also be described as misunderstood science, and the perceived hermeticism of cubist painting could be transformed into an act of good faith. Abdul-Hâdi, for whom cubism is a form of esoteric science, defends the cubists against accusations of insincerity and "puffism" by claiming that the grammar of their art is economical and clear, and that its metaphysical context is pure. For Abdul-Hâdi, audience hostility to the art reflects an "instinctive hatred" that *la profane* typically brings to the esoteric, but the esoteric expresses a spiritual truth that, once understood, reveals itself to be simple. Charges of cubist insincerity "do not stand up because all effort to be simple is the supreme guarantee of sincerity."[217]

Retaliatory protestations of unsullied pictorial truth neatly convert audience hostility into an unprovoked act of bad faith. The dealer D.H. Kahnweiler employed this strategy in his exhibition policy for Picasso and Braque, who were quite clearly subject to the pressures of this debate. During the period of cubism, the two artists were exhibited without fanfare at Kahnweiler's gallery on the rue Vignon, all three having agreed not to submit the pictures to inevitable ridicule at the salons. Those few collectors and admirers who wanted to see the work could do so anytime; the rest of the public were only worthy of disdain.[218] The terms of this decision are illuminated when we observe Kahnweiler in action with a visitor from the popular press. In April 1912, the magazine-digest *Je sais tout* ran a recently rediscovered article on cubism and futurism called "La Peinture d'après-demain(?)," which included a trip to Kahnweiler's gallery.[219] The author of the article describes how he was, at first, shunned by Kahnweiler:

> For *Je sais tout*! . . . I prefer that your magazine not speak of my painters. I don't want them to be ridiculed. My painters, who are even more my friends, are sincere, convinced *chercheurs*, in a word, artists. They are not those *saltimbanques* who pass their time stirring-up the crowd.

Upon being assured that *Je sais tout* is not out to mock, but to cover the "extreme avant-garde of today," Kahnweiler relents. But his defense reveals the ready argument of sincerity and bad faith. Likewise, it is telling that Kahnweiler rejects the epithet "cubistes," and attacks the group in quite conventional terms: artists call themselves "cubists," he explains indignantly, to fulfill their "love of *réclame*. My painters are not cubists."[220] While Picasso and Braque are sincere and their work, as such, is above the scorn of the philistine, this is decidedly not the case with salon cubism. Later in the article, Kahnweiler (*l'initié*) rewards good faith in kind by deciphering pictures for his visitor (*la profane*), who mistakes a "poet" for a landscape. A visit to the Bernheim gallery futurist exhibition follows. There, Marinetti is interviewed, and praised for not having required *Je sais tout* to state whether its intentions are "just or injust."[221] Marinetti, we observe, clobbers any spectator within reach, abandoning all pretense to a sincerity of style.

It would seem, in any case, that an argument of this sort on behalf of futurism would be strained. As we would expect, futurism (with special emphasis on Marinetti), was a

natural touchstone for debates over the sincerity of the avant-garde. The hysterical claims of futurist manifestos bore all the signs of bluff, or exaggeration for effect; we recall that Marinetti freely described the violence of the first futurist manifesto as a kind of *réclame*.[222] His subsequent advice to the composer Fransisco Pratella is a credo of avant-gardism:

> To conquer Paris and appear in the eyes of all as an absolute innovator . . . I advise you with all my heart to set to work to be the most daring, most advanced, most unexpected and most eccentric emanation of all that has represented music to date. I advise you to make a real nuisance of yourself and not to stop until all around you have declared you to be mad, incomprehensible, grotesque and so forth.[223]

By the time of the Bernheim-Jeune exhibition in February 1912 (accompanied by its own manifesto, "The Exhibitors to the Public"), futurist insincerity was virtually a given for most critics, so much so that a positive review of the show by Lemoîne for *L'Œil de Veau* could begin "Once again, misunderstood sincerities!" Lemoîne shames his readers into being "grateful to these eccentrics who, from time to time, have the courage to offer up their honesty as a target for the ironic laughter of their contemporaries;" for Lemoîne, as for Sembat, it is the audience who acts in bad faith.[224] Mockers mocked, the futurists would, none the less, be persistently plagued by retaliatory laughter. In December 1913, the newspaper *Homme Libre* compared them to a performing troupe on a tour of Europe, mounting the boards and eliciting boos from the bourgeois, who are treated as imbeciles. Since their desire to "épater la foule" is undeniable, sympathetic efforts to understand are in vain; "one cannot help finding their *réclame* a little excessive. As for myself, I really do want to believe that they are sincere," the critic concludes, "but why all this intense *bluff* unworthy of true artists?"[225] The question of futurist motives could even be subjected to speculation of a philological sort. One article, published in the journal of ideas *Le Spectateur*, and entitled "Une discussion sur les Futurists: 'Principes' ou 'faits',", contains a debate conducted between spectators viewing the Bernheim exhibition, "faithfully transcribed."[226] The dialogue concerns Marinetti and free speech, and revolves around whether or not Marinetti is *sincère*. If he is, says one speaker, then he has the right to use every means at his disposal in order to convince his audience; but if his propoganda is simply *charlatanisme* and *bluff*, then he ought to be supressed. From there the author extrapolates to the nature of abstract principles, such as free speech, and their varying practical application to individual examples.

Significantly, this argument introduces a slight but perceptible element of esthetic license: sincerity justifies the means. The critic Alexandre Chignac, who also addressed futurism in the body of Marinetti, its one "original figure," was inclined to attribute his originality to the combustible *mix* of authenticity and farce. "Marinetti appears to me to be the *raison d'être* of Futurism, and I don't know if I should laugh or be serious before this *farceur*, whose very southern tall tales contain so many biting truths." One need not, according to Chignac, choose between Marinetti the false-prophet and Marinetti the true innovator; there is something remarkable and larger than life about his justifiable claim to both titles. "Marinettism," (Chignac prefers that term to "futurism") is "composed now of buffoonery, now of the heroic-epic; there is above all a curious, original, ultra-modern temperament."[227] Beneath "the buffoonery of his purpose," Chignac detects Marinetti's

grasp of the "paroxysm of modern times."[228] He is a "visionary" possessed of lyricism, bombast and "*blague* which creates laughter, but for all that, there remains no less a love of life magnified to its hiddenmost power."[229] Arguing for the reciprocal inclusivity of antic bluster and original genius, Chignac has crossed into the ideological space of *La Publicité*, in its treatment of advertising and confidence abuse: "man has an obscure need to be dazzled, deluded, fooled by *mise-en-scène* and décor; the naked truth makes him afraid, or is insufficient."[230]

If cubism and futurism were so appalling to so many spectators, then how could cubists and futurists have been accused of commercial motivations? Beyond attention-getting *réclame*, what kind of a marketing scheme could be served by "bad" art? The operative principle at work among the audience of new art was generally identified as "snobism," the counterpart to arrivism and *nouveauté* in the artist's studio. If avant-gardism is charlatanism, its victim was the bourgeois philistine, whose self-conscious fear of philistinism was easy to exploit. "The worst deficiencies of drawing, color and composition, in truth, will find takers," wrote Alphonse Roux in *La Renaissance Contemporaine* in 1911, the year that cubism appeared as an organized offensive at the salons. "The rich buyer is so often afraid of appearing to be a vulgar bourgeois, that he is readily convinced he is discovering an artist ahead of everyone else, and you can make him purchase almost anything you want."[231] By 1913, Tristan Leclère could flatly divide the uninformed public into two camps: "on one side, the friends of a ridiculous, valueless academicism; on the other, snobs or speculators on the lookout for the most bizarre *nouveautés*."[232]

Typically, artists, critics and merchants were implicated together in this market conspiracy. The bourgeois snob stood somewhere between the position of victim and perpetrator, like a sort of self-inflicting dupe. "Some happy art students, seconded by *critiques mystificateurs* and shrewd dealers, have wanted to plumb the depths of public naïveté, but they have found it to be bottomless," observed Urban Gohier, reviewing the 1911 Salon d'Automne in *Le Journal*. Addressing the dumb bourgeois in the name of Henri Monnier's popular literary caricature, he explains that "M. Prudhomme no longer intends to be treated as a Philistine; henceforward, he does not judge a picture; no matter that the drawing resembles the attempts of cavemen, and that the colors scorch the retina; he is not protecting the arts, he is practicing speculation."[233] (Gohier's remarks were quoted in a Salon review from *Livres et Art*, where "cubisms and other bad jokes" are distinguished from art which possesses "qualities of sincerity."[234]) Returning to this theme in 1912, Théodore Duret described a dramatic new expansion of the marketplace for *artistes-inventeurs* or *hors-cadre*, both inside and outside the Salon des Indépendants. Local dealers are responsible for countless exhibitions, and art critics have been seized by the spirit of independence, which fuels their jealous pursuit of original genius. What a marked change from fifty years before, when most critics expressed little more than disdain for new art. As Duret reads the trend, unprecedented critical *praise* is being heaped upon new schools of art; a kind of journalistic arrivism has reversed the old antagonisms, and modern artists are "taken to be the masters of their time."[235] Duret also bore witness to a sea-change in the bourgeoisie:

There are no more "bourgeois" in the old sense of the word. They have been transformed by snobism. Those unhappy "bourgeois" who, in the last century, exposed their dullness before artists and were self-satisfied in their incomprehension, have been

definitively shamed. The disdain that has been lavished upon them has impelled them to want to quit their own kind. They too have aspired to comprehension . . . Now nothing scandalizes them. They are prepared to swoon before any eccentricity. Ah! the bourgeois as they were jeered by Courbet and Daumier, they are long gone![236]

During the 1912 Salon d'Automne controversy, the rising influence of the bourgeois *amateur* was noted by a member of the Salon committee, who explained that the high prices claimed for new "extravagances" in art make it difficult for a jury to reject the works as violations of good taste.[237] The following year, however, Marius-Ary Leblond continues to blame snobism on the critics. According to Leblond, critical hostility is a pretext that masks the fear of hasty approval. This drives a wedge between painter and spectator, for "the public, far from being as stupid as the collective opinion of newspaper directors would have, is full of good will." In a gesture of reconciliation, he warns us that "the greatest modern evil in effect always has its source in an incomprehension that is woven only from misunderstandings, from faulty relations between people born to understand each other."[238]

"Faulty relations" is euphemistic: it connotes the insincerity of *nouveauté* as a marketing strategy, and the self-inflicted ridicule of the new bourgeois, who is both a perpetrator and, as snob-dupe, a victim of bad faith. The faulty relations occur within a perceptible rift between insiders and outsiders. Given the self-interest of dealers and critics as well as artists, the exact nature of insider status may be deceiving. The roles of producer, promoter and consumer are elastic, and subject to shifting exigencies of exchange between the various combinations of players, rather than any immutable qualities in the nature of the art. In this regard, abuse of confidence crops up somewhat unexpectedly in relation to the rapport between modernists themselves, quite apart from the figure of the suspicious spectator.

In 1912, the review *Les Tablettes* published Albert Fleury's "Nouvelles Ecoles et Nouveaux '. . . ismes'," which was prompted by "un paquet de prospectus" that the author had just received in the mail from the futurists.[239] Fleury describes the phenomenon of *écoles* as a "recent" one, with its earliest roots in Romanticism (noting, with reference to the *réclame* and *nouveautés* issue, that all of these names and categories now have the ring of department stores like Printemps and Bon Marché). From the experience of his own literary youth, Fleury writes that most members of most schools do not really know where they are going; they march, but their path is directed at grandiose ambitions that are, in reality, but vague dreams. The dual task of the group is always the same: "to negate the Past and construct the Future."[240] Manifestos, articles and theories serve a *galerie* composed of disciples, admirers, sincere enthusiasts and *poires*, but signify very little. The true goal, "guarded like a precious secret and known by one man alone, has no connection with this nonsense . . . This guardian of the secret is the *Chef de l'Ecole*, the Master." According to Fleury, even those who are closest to the leader are ignorant of the group's higher purpose. Ultimately, however, if the *chef* becomes a luminary, the "secret and unnamed objective" reveals itself to be nothing more than "the *Will to Arrive*," the single-minded ambition of one man.[241] In Fleury's scenario, the esthetic school or ism is a kind of trap. The *chef* needs a group around which to spread propaganda, but the school functions only as his promotional machine. Even the disciples, the apparent insiders, are dupes of this enterprise. In the end, only the *chef* really benefits; followers have been used

without ever having achieved anything of their own by practicing the group style.

Victimization of the sincere disciple is a recurring critical perception of avant-garde folly; a related theme is the pitfall of self-delusion. In his review of the 1913 Salon des Indépendants, for example, Vauxcelles insists that young artists reflect their society, "even when, in all good faith, they believe themselves to be enclosed in an ivory tower." Arguing that the avant-garde represents a decadent reactionary need to serve a group credo and a *chef de l'école*, he concedes that "they do not all know . . . where they are going or, better, where they are being taken."[242] This foreshadows Allard's deprecation of avant-gardism as "a kind of terror where the sincere *chercheur* is no longer safe, where the independent talent is forced to affiliate with his district."[243] Yet such hand-wringing was dismissed by Apollinaire: "Excess of *nouveauté*? who knows? I repeat, that is not dangerous for art, but only for mediocre artists."[244]

A variation of this argument, in which modernists can be victims of other modernists, occurs at roughly the same time in René Ligeron's "Notes d'Art" column for the Niçois journal *Cahier des poètes*. Among the dangerous influences to which Ligeron feels the young painter is susceptible, that of his *confrères* is especially grave. Many studios are places of chatter, where the *raté*, a failure and a cynic, holds forth. Further,

> the artist is sensitive, theories impress him; the excesses of certain works find in him an interested spectator, an indulgent listener to *théories abracdabrantes*, afraid of not understanding, of doing injustice to a discovery which is, perhaps, really only astonishing for its novelty. Hence the enormous deviations of occasionally sincere spirits who end up pointillists, cubists, isocelists. They are gentle lambs led by *pince-sans-rire* shepherds to the Salon d'Automne slaughterhouses.[245]

Ligeron advises the painter to combine sharp observation, acquired science and individual temperament, and to avoid this or that banner or "school" and leave the theories and "querelles de mots" to the critics.

The subject of the artist-victim was not always treated as an abstraction; specific names could, of course, be called into play. Reviewing the 1914 Indépendants for the newspaper *La France*, the critic R. Kimley comes to a room of "cubists," including Jacques Pick, Czobotka, Hofer and Surwage. The low quality of their work represents

> the habitual lot of unimportant followers, who allow themselves to be taken in by brilliant theories, and are their first victims . . . M. Metzinger and Gleizes, more intelligent than the others, are in the process of sacrificing to their arrivism a lot of poor devils whose greatest sin is having believed that the more tenebrous a doctrine, the more true it is. Metzinger and Gleizes have made a pedestal out of the stupidity and naïveté of their contemporaries.[246]

We see that the issue of sincerity was, during the pre-war years, central to both the attack and defense mode of writing about the avant-garde. It could even be called an exposed nerve. When Max Goth defended cubism for *Les Hommes du Jour* in September 1912, he simultaneously attacked Louis Vauxcelles who "systematically refuses to examine in good faith the works of these painters." Stung, Vauxcelles wrote a letter to the magazine in heated protest: "My good faith is complete, in the case of all endeavors that are new, probing, worthy of interest. Ridicule my critical faculties, write that I have

neither competence, nor perspicacity, nor syntax. You have the right to do that. But my good faith; stop there! I do not permit you to place it in doubt."[247]

By late 1913, a critic could rebel against the very terms of the debate. Reviewing an exhibition of synchromist painting by Morgan Russell and Stanton MacDonald Wright in November, Francis Carco addressed the matter with some exasperation: "I do not believe that the primary quality of an artist is to be sincere, but rather to be practised in his art." Carco goes on to complain that the question of an artist's sincerity seems now to dominate the debates over modern painting. A wave of sincerity "by principle or application" has taken over, particularly with regards to the cubists, who are always on the defense against charges of "farce," and the futurists, whose claims of "good faith infiltrate everything that they undertake." Indeed, this fashion has bred a "pretension" to sincerity, as an excuse for permissive excess that is responsible for "so many [pictorial] extravagances."[248]

Carco observes an artifice of authenticity that signals for us the degree to which claims and counter-claims on the subject were piling up at the time. From the condition of uncertainty which results, it is difficult to extract an irreducible distillation of true and false. The problem could be heightened by the scientizing appearance of cubism, which was subject simultaneously to charges of hermeticism, simple-mindedness and fraud. According to *L'Art Décoratif*, the predominance of intellect over sensation and temperament in their art makes cubist painters difficult to compare; worse, since the dry, schematic quality of cubist style is easy to imitate, "it is impossible to distinguish . . . the most serious intellectual work from the coolest *fumisterie*."[249]

As ridiculous as it may appear in retrospect, the overall issue of modernism as a large-scale hoax or mystification is our best index of suspicion and doubt. Throughout the pre-war period, the charge was commonplace in the popular press. Apollinaire addressed this matter on two occasions in 1912, in his essay "La Nouvelle Peinture" for *Les Soirées de Paris*, and in an imaginary dialogue between three young women at the Salon de la Section d'Or, published in *L'Intransigeant*. In both instances, he assures the reader that "in the whole history of art, there is not a single known case of a collective hoax."[250] Of course, such an assertion is injudicious at best, since a successful hoax, collective or otherwise, is one which remains undiscovered or undisclosed. It might also be successful only for a time, like the notorious third century B.C. tiara of Saïtapharnes, acquired by the Louvre in 1896 and subsequently discovered to be a nineteenth-century fake. In 1903, following the revelation, Apollinaire himself wrote an article for *Revue Blanche* (published, perhaps deliberately, on April 1), in which he extolled the esthetic virtues of the tiara and deplored the bias against "fakes" or counterfeits in art and literature.[251] Fakery is not quite the "hoax" to which Apollinaire refers in relation to cubism, but the principle of a duped collectivity is the same. In this light, we detect a hint of delectation when we return to Apollinaire's imaginary dialogue at the Section d'Or; Louise, "who prides herself on understanding cubism," denies the previous existence of collective hoax, but adds that if, in the case of cubism, "we had one for the first time, that would be interesting in itself."[252]

Accusations of hoax were so widespread at the time that they were answered by defensive critics in all seriousness. As we have seen, Roger Allard was highly suspicious of "avant-gardism." As a champion of cubist painters at the salons, however, he argued from ambivalence. In late 1913, he could report that, at last:

the most dogged adversaries of the new schools of painting are beginning to admit the sincerity and loyalty of efforts that they once wished to ridicule . . . Soon, none but the incorrigibly vain will be left to believe that artists adopt this or that manner with the intention of mocking them. To believe oneself the object of a concerted mystification is, in the end, a kind of persecution delirium, and the sign of unbearable self-importance.[253]

Writing in *Art et Décoration* in January 1914, as if to prove the point, Émile Sedeyn was hard-put to maintain anymore that the new art was invented solely as a means of "flabbergasting and agitating the bourgeois and the art critics . . . Such a persistence in *blague* contradicts human nature. Upon reflection, we are forced to admit the good faith and artistic sincerity of these young men, whose art resembles nothing else."[254]

Questions of tolerance do seem to appear with greater frequency and thought in 1914. This does not represent a suspension of hostilities between artists, critics, dealers and amateurs. Rather, it is as if the sensibility of uncertainty pertaining to the works and actions of the avant-garde had matured enough to permit a new degree of inherent ambiguity. Writing on the 1914 Salon des Indépendants in *Le Temps*, Abel Hermant begins by claiming that he is a mere spectator, not an art critic; he distinguishes himself from the artists and *amateurs d'art* who fill the *baraques* on the Champs-de-Mars, and both of whom display signs of "disquiet [and] distress." The artists are accused of "willingly inventing new procedures of art" without having mastered the rudiments, and of mocking their audience. Hermant finds both of these critical claims untenable, and the artists deserving of our sympathy. The only real offense is that artists amuse themselves from time to time by shocking the bourgeois, though a good deal less than is often maintained. In fact, young artists at the Indépendants are otherwise too serious, too lofty in their ideals, and largely too simple-minded in their anxious quest for originality. But if the artist's anxiety inspires Hermant to respect and pity, that of the amateur is merely laughable: the simplest passer-by seems terrified that he will neglect to admire a work which might, in a dozen years time, be the object of universal admiration. This fear of not being sufficiently *en avant* is, for Hermant, the most comical form of snobism. More diverting still are the tribulations of the collector, the "disoriented speculator." In his case, the only criterion of quality is a dramatic jump in price, which represents the belief that today's ugly painting is tomorrow's masterpiece. Yet this, Hermant claims, is a distortion of the historical record: true artists have never been without the intelligent admiration of their peers. Hermant fears "timid judgements" on the one hand, and "dogmatism" on the other; "but still more, we must fear absolute skepticism." Beauty and talent cannot be so relative or illusory that we should abandon them altogether as tangible qualities in art; there is hope for the perceptive critic. Hermant ends by bestowing his respect upon the Indépendants: even if they manage to offend us with a "spectacle of ugliness and perversion,"[255] they work for a disinterested ideal rather than for medals and prizes.

Absolute skepticism: Hermant's fear applies to all sides of the controversy. His review is a thoughtful attempt to address the reality of artist-audience conflicts, a kind of no nonsense plea for reasonability. Yet his even-temper highlights by contrast the quality of skepticism as an essential condition of the period's esthetic debates. How can the artists be technically deficient *épateurs*, yet over-diligent in their pursuit of a lofty ideal? Hermant wants it both ways, and in so doing describes two sides of a quarrel which, therefore, can

only be understood as inevitable. If we follow the press, skepticism indeed seems to be the genius of the moment: it guides the artist's self-conscious search for originality, and his disdain for the lessons of the past; the *prudhomme*'s dual fear of being mocked and of being left behind; the collector's belief that the degree of scorn is directly proportional to that of genius, and that contemporary critics are consistent in their bad judgement. If the speculator is "disoriented," who can wonder why?

A related treatment of esthetic skepticism appeared at the same moment in the newspaper *Homme Libre*. Citing a recent interview with Francis Picabia, and confusing Picabia with Picasso, critic André Maurel reflects on the rapport between the avant-garde and its audience. Disdaining new art is too easy, he suggests, a convenient excuse to avoid effort. After all, "you have to be quite shrewd in order to disentangle sincerity and *fumisterie* in a work of art." Picabia/Picasso is the "cleverest of the group," for his cubism clearly serves a larger purpose: to draw attention to an artist who is at his best when he is not painting cubes. As a result, a picture like his *Saltimbanques* could sell at the Drouot "Peau de l'Ours" auction for 11,500 francs. "The cubist Picasso is not a menace to the Picasso of the *Saltimbanques*," but can be useful; "we must, however, pity those innocents who take the former seriously, and are incapable of profiting from the latter." Ultimately, at the Salon des Indépendants as well, "artists' schools are *parades* designed to draw spectators into the *baraque*." (This is a pun, for the word *baraque* describes both the temporary exhibition halls erected on the Champs-de-Mars for the Indépendants in 1914, and the fairground tent outside of which the attention-getting *parade* is performed at a *fête foraine*.[256])

Rather than follow the usual critical logic and condemn new schools for bad faith, Maurel concludes with a plea for tolerance. In the arts, standing still is a great danger. Whether it pleases us or not, new art often represents "la belle avance." "I am always sympathetic," he declares, "to that which revolts me at first . . . I prefer seeking to understanding." Indulgence is in order, for young artists "educate themselves as they educate us. We grow closer little by little, and from the complicity of the painter and the amateur is born the art of an epoch, which will take its place in the future of all art."[257] This, we recall, was Leblond's gesture of reconciliation in 1913, a way around the "incomprehension that is woven only from misunderstandings, from faulty relations between people born to understand each other."[258]

In 1914, Allard also continued, if ever so slightly, to soften his tirade against avant-gardism, futurism in particular, as a strategy of *réclame*. In his article "L'avant-gardisme et la critique," Allard extends sympathy, quite unexpectedly, to the plight of young artists competing for attention in an arena that has never before been so crowded:

> The organization of the painting salons, the conditions under which paintings are bought and sold, constrains the artist to have recourse to *publicité*. This may be regrettable but, for my part, I find the thing quite natural, on the condition that this *publicité* be honest and in good faith, that it not be founded on ambiguity, delusion or mystification.[259]

This train of thought brings Allard back to futurism. He considers the "*lancement*" of futurist painting to have been "perfectly regulated." As regards publicity, futurism has achieved a certain success. Allard even troubles to compliment Marinetti on this score: "I

have already said, and it pleases me to repeat, that M. Marinetti's manifestos remain, some faults of taste aside, models of the genre."[260] Nothing in Allard's prior writings really prepares us for this concession.

However, the polarity of "good faith" and "mystification" stands out. Where matters of art are concerned, praise for the skillful *bonimenteur* is, at best, a left-handed compliment. Allard hastens to add that we can even indulge the futurists as long as they pay proper homage to their precursors; once they claim priority over others, though,

> we have the right to say that they are mocking us. Vis-à-vis MM. Picasso, Delaunay, Le Fauconnier, Metzinger, Gleizes, Léger, etc, the Italian futurists have appeared in all cases as imitators and *pasticheurs*, not to say worse.[261]

In other words, self-promotionalism is one thing, false claims are another. From futurism, again, Allard comes back to avant-gardism as a larger issue. "The discredit which begins to weigh on all *group painting* has brought to futurism a fatal blow." "The other schools of painting," he maintains, "now only survive thanks to the talent, to the *personal* temperament, of this or that painter."[262] In the final analysis, insofar as it is a phenomenon of groups, the avant-garde *has* crossed from good faith to mystification. Like the greater critical community and salon-going public, Allard scorns the avant-garde; but he can only save his stable of cubist painters from implied collusion in avant-garde crimes by dissolving cubism as a group (the pernicious ism) and reintroducing the cubists as a series of "personal temperaments." In the spirit of a complaint that goes back to the influence of Marinetti's 1909 futurist manifesto in *Le Figaro*, "group painting" perpetrates bad faith, while individual painters are more likely to be defensibly sincere.

—8—

In 1913 and 1914, Carco, Hermant, Maurel and Allard all addressed sincerity and good faith as a governing issue, making an effort to settle excessive distrust in the community. For our purposes, however, they rather point up its persistence. The nature, purpose and comportment of the avant-garde appeared to be unstable or, at best, elusive in nature. Claims for authenticity carry little or no weight in a gravity-free climate of ever-shifting esthetic orientation. The cry of "hoax" seems to have been a release mechanism for the helium of uncertainty building up inside the baffled spectator.

Yet even hoax had its apologists. Among them is André Salmon. In his review of the 1913 Salon d'Automne for *Montjoie!*, Salmon raises the stakes on bets concerning avant-gardism and mystification. Coming to the painting *Conquest of the Air* by Roger de la Fresnaye, Salmon muses over a matter that he promises to analyse in a forthcoming work, despite the enmity he will undoubtedly earn as a result. For Salmon, this problem originates with an element that is misunderstood, but native to the new art: "les artistes modernes s'amusent," he explains: modern artists are enjoying themselves, or playing:

> They are not fantasists; fantasy is only a veneer; but they are what all artists should be: whimsical; in a word, *ils s'amusent*. This is no doubt the reason that they are treated as *farceurs* . . . This, which scandalises so many fine connoisseurs, is of extreme importance; this boldness opens doors slammed shut on unsuspected horizons. It is in this manner that all the arts renew themselves."[263]

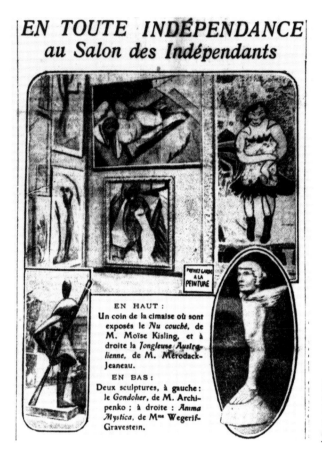

EN TOUTE INDÉPENDANCE
au Salon des Indépendants

EN HAUT :
Un coin de la cimaise où sont
exposés le *Nu couché*, de
M. Moïse Kisling, et à
droite la *Jongleuse Austra-
lienne*, de M. Mérodack-
Jeaneau.
EN BAS :
Deux sculptures, à gauche :
le *Gondolier*, de M. Archi-
penko ; à droite : *Anima
Mystica*, de Mme Wegerif-
Gravestein.

54. Edouard
Helsey, "En Toute
Indépendance au salon
de Indépendants," *Le
Journal* (1914).

Salmon's answer to the charge of hoax or farce is cryptic, but extremely suggestive. His sense of play as an agent of renewal somewhat alters the parameters of the debate, for in Salmon's terms, the epithet *farceur* has genuine value as a password to the new society of modern art. Salmon legitimates audience antagonism, implying even that esthetic sincerity and public confidence have indeed been abused; but rather than deny the ambiguity and instability of this exchange, he attributes to it a higher purpose. The doubts and skepticism which were invested into modern art by the greater share of public and critical opinion remain unresolved, but irresolution is a form of freedom.

This truly is the double-edge of "independence." Modern art could be exhilarating and disturbing, and the speed of change seemed to encourage the best or worst in the name of liberty. The practice and propagation of new painting were undergoing a process of conflict; motivations were so unclear that artists' groups were charged simultaneously with obscurantism and hard sell. The explosion of modern isms, as vessels of "original-ity," produced a thick haze through which the contours of authenticity and sham appear to merge. Esthetic theory, for its part, appeared to be a smokescreen of words, and the contours of genuine conviction were indistinct. Suspicion multiplied itself, so that the spectator approached artists' claims to sincerity and trust with profound doubt, and this,

presumably, escalated the artist's need for a strategy for success. This dynamic was diagnosed during its own time as a syndrome, for which Allard coined the phrase "avant-gardism." Reviewing the Salon des Indépendants in March 1914 for the newspaper *Le Journal*, Edouard Helsey was more colloquial. Helsey drew attention to two signs posted in every room, both of them befitting the Salon as a danger-zone. One, "Sortie de Secours," "Emergency Exit," is, he suggests, most reassuring; the other notice reads "Prenez-Garde à la Peinture" (fig. 54).[264] The sign refers to the fact that many of the works have just been finished or varnished, it is the equivalent in French of a notice which cautions "Wet Paint." Helsey and other critics, however, chose to read the sign in a punning fashion, as a sage warning: "Danger. Beware of the Painting."

"Prenez-Garde à la Peinture" reads like the sign "NO TRUST" that appears in a barber shop in Herman Melville's *The Confidence-Man*. Published in 1857, Melville's novel can be considered a kind of prototype for the condition of uncertainty, both perceived and real, which prevailed in modernist Paris during the pre-war years. Set in Melville's mid-nineteenth century American cultural landscape, on a steamboat called the Fidèle, the book addresses hucksterism as an institution that flourishes wherever wide horizons of promise and change create conditions of social instability; where a climate of as yet displaced conventions of social exchange permits people to reinvent themselves as circumstances require.[265] Clergymen, frontiersmen, herb-doctors, carpet-baggers, beggars and scoundrels all prove to be of elusive shape; the confidence-man is never named as such, but questions of trust, good faith and confidence thread their way through recurring episodes of swindle and sham, and the figure of the con-man is defined as a kind of negative space. The emblematic words "NO TRUST" are posted by the Fidèle's barber, whose suspicions of fraud unsettle any inclinations he may once have had to extend credit to his clients, one of whom manages to engage him in a lengthy debate and brief wager over his lost "confidence in men."

There are other novels on the confidence-man theme,[266] but only Melville's embodies the shifty nature of the subject in the very structure and utter ambiguity of its narrative. The figure of the confidence-man appears in multiple guises, and may, in fact, be many men. As the various tales of faith and deception unwind, the reader himself is subjected to his devices. The book, then, is as much about its audience – its reader, who is addressed directly by Melville at several intervals – as it is about the characters within. This is to say that the audience is actively implicated in the pattern and discourse of skeptical exchange which characterizes the business of the confidence-man as he moves among the passengers, both wary and naïve, of the Fidèle (itself unmoored from the more concrete social relations of the town or city, and thus ironically named). Melville's confidence-man is not just a deceiver, he is a figure of cunning, craft and original genius. His influence is felt throughout the immediate vicinity, for he emanates about him a field of uncertainty and disorientation. Further, by projecting his fictive universe of irony and contradiction into the reader's own realm of experience, Melville himself plays authorship as a confidence game, confounding his audience with syntactical ambiguity, yet thereby revealing a higher plane of linguistic incertitude and existential disarray.

As a device, Melville's *Confidence-Man* is useful. It represents a conveniently self-contained, almost incoherent, fictional world that articulates through analogy the exact stresses and strains exerted by the avant-gardist on pre-war Paris, likewise moving

through a landscape of radical change and new cultural promise, generating his own rhetoric of genius and bluff. The disquiet that characterizes *The Confidence-Man* belongs to the same discursive realm as the *inquiétude nouvelle* (in the words of both Mauclair and Allard[267]) that distinguishes the community of modern isms. Trafficking in a broad rush of cultural ambiguity that enmeshes professionals and their general public, and incorporating all variations of sincere and skeptical cultural exchange, the book charts the activity of the avant-garde.

The experience of pre-war modernism is characterized by a large-scale grappling with the unfamiliar; this single element, though it occurs in various weights and colors, is virtually universal. Though concrete evidence concerning this ur-experience of modern art can only come to us now from the written accounts of comparitively few observers, its breadth amply demonstrates that it was culturally pervasive and remarkably uninflected by different frames of reference. We only know this if we take stock of the bad press, the largest share of critical literature by far, as well as the good. In so doing, it becomes apparent that professional criticism discloses itself to have been, in at least this one fundamental respect, a sophisticated expression of the same bewildered uncertainty that is generally dismissed as a sign of the ignorant philistine. A true picture of the diversity of modernism during the pre-war moment should incorporate the challenge of rapid change. Ultimately, to the extent that artists and their critical supporters also express or exploit this quality, the modernist experience of disorientation might be characterized as a kind of popular culture of production and response. We return then to the persistent irony of mass culture and modernism, that of accessible materials and hermetic art. This larger fabric of disorientation is not just a bi-product or after-effect of modernism, but appears almost to contain it. As a popular culture of this kind, it was, then, also a body of material from which artists could draw. Salmon maintained that suspicions of a hoax, if imprecise, are correct to the spirit of the modernist enterprise. Our investigation of the new art should, in turn, be adjusted to account for this possibility, for part-time and even fulltime confidence-men moving with purpose into the esthetic gray zone that lies between originality and incomprehension.

"He's a fool, I say again."

"Others might call him an original genius."

"Yes, being original in his folly. Genius? His genius is a cracked pate, and, as this age goes, not much originality about that."

"May he not be knave, fool and genius altogether?"

"I beg pardon," here said a third person with a gossiping expression who had been listening, "but you are somewhat puzzled by this man, and well you may be."

<div align="right">Herman Melville, <em>The Confidence-Man</em>, 1857</div>

# CHAPTER III

# "MARCEL DUCHAMP QUI EST INQUIÉTANT"

## AVANT-GARDISM AND THE CULTURE OF MYSTIFICATION AND *BLAGUE*

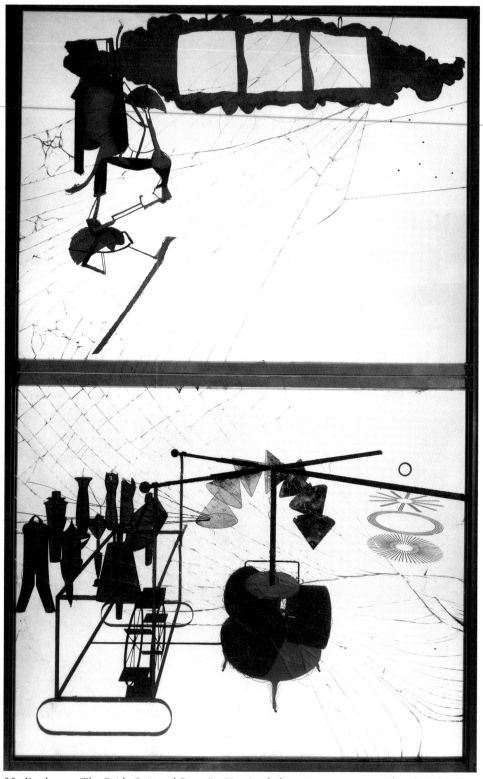

55. Duchamp, *The Bride Stripped Bare By Her Bachelors, Even* or *Large Glass* (1915–23).

## —1—

The act or anticipation of "bad faith" represents a breach in the fabric of pre-war esthetic experience. Single isms and isolated examples of critical interpretation appear, at moments, to reveal very little beyond themselves; their value as clues to a general continuity of purpose is compromised by the agents of heterogeneity and conflict. Above all, relentless questions of authenticity make it extremely difficult to assess the evidence of intentions and period interpretation. "Modern art is a hoax": this is the cliché that epitomizes public and critical scorn. When the charge is dismantled, we find a rhetoric of dissatisfaction which the critics share beneath other ideological differences. While hostility can signal shallow intolerance, it also discloses a struggle with the difficulties of the new art that is, after all, quite to the point. The avant-garde around cubism is a complex field of rapid development, changing allegiances, difficult pictures and ambiguous claims. The impression of sham and swindle creates a disorienting relativity of design and meaning.

Taken altogether, the mutual characteristics of specialist and non-specialist critical response comprise our best definition of public opinion. To the extent that it constitutes a popular experience of modern art, pre-war esthetic disorientation can be identified as a branch of popular culture, a kind of collective consciousness or sensibility of ambivalence. To borrow a concept from Mikhail Bakhtin's study of the "carnavalesque" in medieval culture, it might be referred to as a "second life" or "second truth" existing in tandem with the official or prescribed truth of modernism as it is revealed in the program notes – the manifestos and proclamations – of the period. Such a "two-world condition" describes the persistence of parody, both practiced and perceived, as a sub-history of the avant-garde.[2] As an available source, this condition could be appropriated and exploited in much the same way as more concrete categories of popular culture (like the music-hall, for example) could be taken up.

The popular culture of esthetic experience reflects a high level of frustration and suspicion; it might also be understood as a province of ambiguity. While the dynamic of public uncertainty was a pervasive given, it is not surprising to find at least one figure whose work draws from the confusion of the moment. Trafficking in the terms of disorientation, Marcel Duchamp appears to fashion a sly, semi-private confidence game of significant proportions. His œuvre, or anti-œuvre, beginning in 1912 might be addressed, in fact, as an explicit articulation of modern art's second truth.

It was sometime in fall 1912 that Duchamp began to goose and tweak the business of artmaking. Having abandoned painting, he chose instead to pursue pastimes of intellectual diversion and comic *geste*. Among them are the *Large Glass* (fig. 55) and the readymades (fig. 56) – a work on transparent glass that is theoretically opaque, and objects drawn from the banal furniture of utilitarian culture that are so utterly devoid of artmaking as to be virtually see-through. The notion that Duchamp *s'amuse* is certainly no revelation; irony above all has long been accepted as his operative mode. But as Duchamp studies coat the artist's intentions with elaborate layers of programmatic philology and science, and his career comes to be read as a continuous narrative of recurring motifs that accumulate size and weight as they go, Duchamp's comic timing is

56. Duchamp, *In Advance of a Broken Arm* (1964 replica of 1915 original readymade).

tripped up.[3] Questions of interpretation have become so fiercely complex and conflicted, that his obliteration of "conventional meaning" has, inevitably, emerged as an issue in itself. In this regard, philosophical and linguistic models for contingency, ambiguity or indeterminacy of meaning have been proposed; and the artist's irony has further been taken to signal the probable hopelessness of any consistent reading.[4] It is some relief to return to the disembodied phrase on one of his own original notes for the *Large Glass*: "nothing perhaps."[5]

There is something to be gained by reintroducing a simpler Duchamp, one who is no less significant a figure than the ambitions of recent literature imply, but who is much less self-consciously so. Streamlining Duchamp, it is apparent that indeterminacy of meaning began life as the parodic solution to a kind of esthetic quandary. The critical period is from about 1912 to 1917, bracketed by Duchamp's withdrawal from the practice of painting altogether, and his submission of *Fountain* to the Society of Independent Artists in New York; the essential works are the readymades and the *Large Glass*. Despite their legacy as objects dense with philosophical meaning, and their seeming disparity of purpose, the readymades and the *Glass* both first occur within a single frame of reference that is fully defined by the motto: "Prenez-Garde à la Peinture." The Duchamp agenda belongs with specificity to the debates of the period; the popular culture of opinion is his text. The field of hoax, both as it is reflected in the art press and as it is expressed in a broader popular and practical culture of ironic humor, conditions our sense of meaning in Duchamp. Specifically, two genres should be considered: ironic *blague*, and *mystification* (the word is a cognate in French and English). Drawn from the public domain yet counter-culture by definition, they further exemplify the paradox of extroversion and introversion, or accessibility and hermeticism, which governs the pre-war dynamic of avant-garde and popular culture.

Speculation on the proto-dada quality of late nineteenth-century humor is actually something of a familiar trope in recent literature, especially in the context of bohemian culture. In accounts of the Incohérents, intimations of seminal significance for dada (or surrealism) are now customary.[6] Most importantly, Roger Shattuck cites nineteenth-century *blague* and "the cabaret spirit of mystification and hoax" as a recurring theme, an "aesthetic of erasure and cancellation" throughout twentieth-century art, and alludes to *blague* as "the central axis of Duchamp's ethos – more important even than love or language."[7] Jerrold Seigel addresses the developments of the 1900 to 1914 period as part of a 1830 to 1930 continuum, in which individual figures from the pre-war period replay

under new conditions the actions of the bohemian past.[8] Seigel cautions that the avant-garde is not bohemia, but none the less,

> as vanguard movements developed . . . they took over themes and activities that were rooted in Bohemia, identifying art as much with the life of the artist as with the production of special objects, and transforming artistic practice in ways that made the dramatization of a personal relationship to society ever more central to it.[9]

Among these "themes and activities," the practices of *fumisme*, *blague* and mystification are addressed and, though Duchamp is considered only in brief,[10] a line is drawn from the comic devices of the 1870s to Tzara and Breton.

Actually, such comparisons have long been a feature of the historical record. In his memoirs of the Third Republic "de Monsieur Thiers au Président Carnot" from 1935, journalist Ferdinand Bac explains with some astonishment that the *bonnes blagues* of the Incohérents circle have since become "*the art of the Avant-Garde*"; Jules Lévy, the founder and group impresario, had discovered a "new genre of ridicule," and the Incohérents represent a kind of "*dadaïsme* 'fin de siècle'."[11] Above all, the legacy of bohemian culture to the pre-war period would not only prove, as Seigel has discussed, to be a feature of retrospective memoirs[12] (where, true to pre-war ambiguity, such observations could alternately be words of praise and of denegration[13]); before dada, in the hostile press, cubism and futurism themselves were treated in this fashion from the start.

During the cubist terror between 1910 and 1914, references to *blague*, mystification and the like were all routine. Only partly colored by the "bohemian" antics of the Montmartre and Latin-Quarter art student, the *rapin*, the terms were generally employed to characterize the avant-garde as a perpetration of deliberate ridicule. "In contemporary art," wrote Henri Guilbeaux in 1911, "*blague* is erected as a principle . . . We have been too benevolent in our recent acceptance of *fumistes*; it is now necessary to hunt them down and prevent them from accomplishing their nefarious mission."[14] More specifically, popular critic Alfred Mercoyrol informs us, in 1912, that "they like to laugh in the studios":

> *La blague* is even compulsory. It is cheerful and resounding, and it is also ironic and bad-tempered, with its strident derision and secret revolt . . . Well then, the cubists and the futurists are, in my opinion, apart from some exceptions, young painters proposing to mock the public![15]

A related warning that year from an art critic on the other end of the editorial spectrum, a small literary review, reads: "Honest people must not be misled: cubism is nothing but an enormous mystification by people who thirst for *réclame*, and to whom a conspiracy of silence will mean death."[16] Such examples are legion.[17] As has already been seen, the specific charges were so common that defensive critics could respond directly, knowing that they would be readily understood.[18]

However, the life of *blague* and mystification is culturally broad, and its pre-war implications of incomprehension are intrinsic to the mounting proliferation and unfamiliarity of new art. Questions of authenticity may have been posed by the behavior of individuals and groups of the past, but they permeate the discourse of the pre-war present. While *blague* and mystification were inherited as epithets and options from the preceding

generation, the prior history of bohemian culture should not be mistaken for a pre-history of the avant-garde. Regardless of how it resembles autonomous examples of previous nineteenth and twentieth-century dissent, the dynamics of mistrust are peculiar to the avant-garde debates. As forces of disorientation in pre-war esthetic history, incomprehension and *inquiètude nouvelle* fundamentally alter the circumstances of recurrence, and disclose a meta-phenomenon of instability in esthetic life that pertains less to continuity than to mounting change. Some account must be taken of this condition. Perhaps as it approaches the path of the intolerant philistine, the pursuit of bluff and sham presents a risk that has effectively warned away most students of the avant-garde.[19] It might be said, however, that our very proximity to the hostile critic also signals our vantage onto the second truth of pre-war esthetic experience. Similarly, Duchamp's proximity to hoax shows him to have been transposing the experience in precise ways.

<p style="text-align:center">—2—</p>

The circumstances of Duchamp's abstention from painting in 1912 are familiar and often-told, if, none the less, somewhat vague.[20] Duchamp had been painting and exhibiting in the salon system with regularity since 1908. Beginning in 1911, Duchamp joined meetings at Gleizes' studio in Courbevoie and at the Duchamp brothers' home in Puteaux, where he established a relationship with the salon cubists, as well as other avant-gardists such as Henri-Martin Barzun, Jean Cocteau and Maurice Raynal. Following a phase of fauvistic painting, he developed a metallic, biomechanical variation on cubism, which would culminate in 1912 with a series of figural works, some of them quasi abstract, including *Nude Descending a Staircase* (fig. 57), *Virgin*, *The Passage from Virgin to Bride*, *Bride* and *The King and Queen Traversed by Nudes*. The pictures owe a general debt to the cubist palette of Picasso and Braque and the cool coloration of Félix Vallotton.[21] They bear closest kinship, however, to works by Picabia, who developed a similar conflation of biomorphic and machine imagery in large-scale canvases of the same period. Beyond his immediate circle, Duchamp, like the Italian futurists, was also attracted to the idea of a static representation of movement, for which the chronophotography of Etienne-Jules Marey was a basic source. Since 1908, he had been exhibiting his work regularly at the Salon d'Automne, the Salon des Indépendants and, in Rouen and Paris, with the Société Normande de Peinture Moderne.

Everything changed in the fall of 1912. Duchamp had spent close to four months away from Paris, traveling to Munich where he painted a number of pictures that would relate to the subject of the *Large Glass*; and to the town of Etival in the Jura, with Picabia and Apollinaire. Upon returning, Duchamp effectively laid down his brushes. Gaining part-time employment at the Bibliothèque Saint-Geneviève, he moved from his studio in Neuilly to an apartment in Paris. Subsequent "studio" activity was confined to the tinkering of an amateur: the slow elaboration, through diagrammatic images and cryptic notes, of scientizing iconography in the *Large Glass*; the *Glass* itself, a fantastical machine represented in lead foil; the *3 Stoppages Etalon* (fig. 58), three glass plates cut according to the contour of a one-meter length of string dropped three times from a height of one

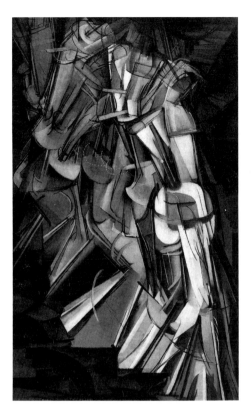

57 (left). Duchamp, *Nude Descending a Staircase; no. 2* (1912).

58 (below). Duchamp, *3 Stoppages Etalon* (1964 replica of 1913–14 original).

meter. His most significant work of the time is the readymade, really a *j'en-ai-marre* form of non-work which required little more effort than that of selection (with occasional inscription). Duchamp's œuvre from the 1912 to 1917 period is, then, most striking above all for its loopy asceticism, an absence of artmaking sparsely populated by bizarre, unreasonable facsimiles of painting and sculpture.

It is impossible to identify a single moment or incident in Duchamp's experience which is responsible for the break in late 1912. One episode, however, is particularly compelling. During the spring, members of the cubist hanging committee of the Salon des Indépendants chose to reject Duchamp's *Nude Descending a Staircase*, apparently piqued by the jesting silliness of the title, which was actually inscribed on the front of the canvas. The committee was composed of Archipenko, Léger, Le Fauconnier, Gleizes and Metzinger, though it was the last two who enforced the decision. The obvious irony is that the Indépendants was, by definition, jury-free ("Ni Jury–Ni Récompenses"). In a later interview, Duchamp himself remarked that the Salon affair "helped liberate me completely from the past... I said, 'All right, since it's like that, there's no question of joining a group – I'm going to count on no one but myself, alone'."[22] Duchamp's late writings and interviews must be approached with caution. Though he abandoned the Salon circuit after 1912, Duchamp's new-found independence is somewhat mitigated by the fact that he continued to exhibit, in Paris, Barcelona and the United States, most prominently at the Armory Show in 1913. Still, conventionally speaking, his career had come to an end.

While Duchamp's withdrawal responds to the pressure of multiple circumstances, these may be metonymously represented by the occurrence of the *Nude*. The rejection of his work from the "juryless" Indépendants is authentic to the pervasive conditions of avant-gardism: insincerity, bad faith, abuse of confidence and suspicions of hoax.

We cannot be certain that Duchamp meant for the inscription "nu descendant un escalier" to have been funny, much less that the joke was propagated at the expense of Gleizes and Metzinger, although their authoritarian gravity would have been a natural target. Both appear distinctly plausible. More significant, however, is that this is how Duchamp's contribution seems to have been received. There could be no plainer demonstration of avant-gardism from the inside, the perception of a disorienting danger-zone emanating from unfamiliar art to which even avant-gardists themselves might fall prey. Such fears were simply a given of period experience. While critics such as Allard, Vauxcelles, Fleury, Ligeron and Kimley described the tyrannical and deceitful influence of avant-garde *nouveauté* on the young apprentice, cubists at the salon were apparently wary of any internal threat to the coherence of the group and its public representation. Indeed, their response to Duchamp ironically conforms to the Indépendants' General Rule of 1910: "Toute œuvre *mystificatrice*, obscène ou injurieuse sera refusée." The phenomenon of the *refusé*, inherited from the nineteenth-century creation myth of the avant-garde as an institutionalized assault on official taste, was still alive during the pre-war. One year after an *ad hoc* jury rejected Duchamp from the open Salon, a critic in *Gil Blas* satirized the free system as a mirage, describing the committee meeting of a modern day Salon des Refusés, for which excessive submissions necessitate the creation of a jury and a "Salon des Refusés-au-Salon des Refusés."[23] In the case of Duchamp, the sincerity of the *refusé* is no more dependable than the good faith of the committee. Precise intentions are ultimately elusive.

Regardless of its real impact, the rejection of 1912 is clearly a potent defining moment in Duchamp's career. Still, it is so seamlessly of a piece with the larger climate of avant-gardism that it is tempting to extrapolate further – to suggest that the popular and critical esthetic debates of the period comprise a larger momentum within which the impulse of Duchamp's own decision was contained. Duchamp's action is a repudiation of modernist activity, and as such, is securely situated within the belief-system of the hostile press; moreover, the artist's own break originates at the breaking-point of pre-war tension.

A number of the basic issues are summarized in a well-timed article by Camille Mauclair for *La Revue hebdomadaire*, published in January 1913. It is easy to search the article, "Le Prolétariat des peintres," for expressions of Mauclair's ultra-conservative political bias; but politics aside, his diagnosis of esthetic ills will be familiar for the rhetoric of discontent it shares with critics of every orientation – for the broad experience of the confidence game that it reflects. Mauclair begins with the contextual concept of excess, which takes two forms. Micro-excess is represented by the avant-garde: "the excesses and the errors of certain painting," notably cubism, a "very disquieting debasement of French art," which he opposes at the Salon d'Automne to exhibitors who are "worthy and sincere."[24] After explaining that he has chosen to characterize the problem as a function of commercial speculation, Mauclair turns to the issue of macro-excess: "the most general and most striking quality of current painting is unprecedented overproduc-

tion."[25] A thumbnail sketch of the exhibition system reveals a modern history of rapidly expanding accommodations for new art; salons born of scission from the Academy, private exhibitions, retrospectives, group shows, sub-group shows and, "finally, the formidable mobilization of the Indépendants." The year in art is jammed with activity; "the Salons are great *magasins de nouveautés*, and the rest resemble *maisons de blanc* or speciality stores."[26]

For Mauclair, "the overproduction is terribly disproportionate to the value of the artistic results," though "the mass of exhibitors still grows." The current condition can be called a "congestion of painting"; the inevitable outcome "is called, commercially, a crash."[27] Claiming to by-pass the byzantine esthetic controversies of the moment for a direct understanding of the hard facts, Mauclair addresses the matter as a simple function of supply and demand. Further, as commercial preoccupations dominate the ambitions of the artist, the collector-speculator and the dealer have come to replace the critic as an intermediary between artist and public. *Lancement* is the universal "hope of 15,000 painters," though it remains elusive for most. The race for glory has set the struggling art-masses on a "frantic course for *nouveauté* and originality, which is one of the calamities of our epoch." Theories are invented in order to justify "the worst follies,"[28] not unlike the *boniment* which accompanies the introduction of any new commercial product. Dazzled by the success of a few, thousands clamor for their place at the Salon d'Automne, "a refuge of malcontents," and the Indépendants, "open to any party, without control."[29]

Mauclair is speaking here of general circumstances; the avant-garde is one player in this broad scenario. His "congestion of painting" incorporates bad art of every kind, including the avant-garde, tired academicism and the work of the so-called Sunday painter, to whom the Indépendants lends self-respect. As the worst offender, cubism points up the extent to which painting has become a mere game; improvisation replaces study, "paradoxical theories disguise ignorance of technique, criticism is overwhelmed, opinion disoriented."[30] Mauclair goes on to blame the faulty system, in part, on a democratized dissolution of standards; the liberal state, he maintains, indiscriminately protects or encourages a devalued, free-for-all notion of the practice of art. Once uninformed in the affairs of arts and letters, M. Prudhomme has now become a collector of Cézanne and, in the name of business, encourages his sons to take up painting. Mauclair finishes by hoping, above all, for "the fatigue and boredom of the public";[31] checked by exasperation, the system will run aground.

Mauclair's article draws from a wide popular and critical discourse of complaint. He differs from many critics in his lengthy explication of mechanisms and motives, in particular the economic, but his grasp of the disorder reinforces our own sense from afar of the pre-war dilemma as a whole. Above all, there is the sense of excess: bad art, and too much of it. Given the congestion of painting, the prevailing syndrome recalls "et-moi-aussi-je-suis-peintre," a motto of mediocrity: "The principal inconvenience of this system," wrote the critic Laran, "is that it permits pell-mell both the audacious, who want to rejuvenate and renew the grammar, and the illiterates, incapable of grasping the basics. That is the price of liberty."[32] "Modern art" could refer to any new art devoid of respect for conventions of technique. The Indépendants, where anything goes, was a paradigm in this regard, a disoriented flood of motivations and means: "palette, impasto, touch,

rhythm and volumes, relationships and *passages*, schools, systems, currents, affiliation."[33] In his article on Metzinger for the *Revue Indépendante* in 1911, Gleizes writes of extracting the innovations represented by Salle 41 from "the current overproduction."[34] Revised submission policy (three per member) had reduced the number of works at the Indépendants from close to 7,000 in 1911 to around 3,500 in 1912 and thereafter,[35] but references to astounding quantity were still routine; we know, for example, that there were 8,000 meters of canvas in 1911, 450 meters of exhibition gallery in 1912.[36] New organization was imposed in 1913, when works were grouped according to "affinity," and individual pictures were no longer being selected at random to "fill in the holes."[37] That year, René Turpin could still write that, "unfortunately, quantity is no substitute for quality, and we would prefer a selection of interesting works to the profusion of canvases, insignificant and frankly bad, which burden the forty-seven rooms."[38] As for the cubists, futurists and orphists, their "noisy attempts, which usually do not even possess the merit of sincerity," are "the unfruitful effort of false artists who, lacking talent enough to interest the public in their works, attempt to peak its curiosity with eccentricities."[39]

Criticisms of commercialism, mediocrity and glut draw on a convention that dates at least to 1848, well before the existence of the Indépendants, when the official Salon was still mounted in the Louvre and the outrages of new painting appeared to deface the very halls of tradition.[40] By 1913, then, the Indépendants could resemble a shrine to the problems of liberality. The charge of overproduction is still quantitative and qualitative, for it pertains both to an inundation of painted canvas in general, and to a surfeit of avant-garde stylistic and theoretical extravagance in particular. Prodigality, incoherence, market *réclame* and hoax: the current practice of painting was perceived to be bankrupt. It may be tempting to treat Duchamp as an anomaly, but the truth is perfectly neat: far from being enigmatic, Duchamp's secession from painting is a prank that was almost overdetermined by the situation at hand. The sensory overload of schools and scandals presented him with the sarcastic yet logical option of disowning his brushes and tubes. Quietly excusing himself in accordance with Mauclair's prognosis of fatigue and boredom, his timing is synchronized to the high tide of critical dissafection – the 1912 Salon d'Automne, which marks Duchamp's final appearance on the official Salon circuit (with one submission, a drawing for *Virgin*), was the Salon of the Lampué controversy, the watershed of pre-war public debate on the excesses of avant-gardism and the future of painting in France. The irony of Duchamp's gesture is the critics' irony, the spirit of "Prenez-Garde à la Peinture" and "Sortie de Secours." Pulling out, of course, as the post-1912 œuvre demonstrates, does not mean that Duchamp adopts a corrective proscription concerning the proper comportment of young artists and the preservation of French taste. Duchamp is neither reactionary nor radical in the customary sense. Rather, his career move designates a pre-war place where such simple categories of artworld ideology and behavior break down; better, he italicizes the breakdown for us as a general condition, more authentic to contemporary circumstances than crude notions of progress and retreat.[41]

As a prank, the repudiation of painting was inevitable enough to have been featured in the critical press. There, it is derived from the implied subtext of critical arguments that fault the modern ism for its prejudice of cerebrality over proper considerations of craft; on

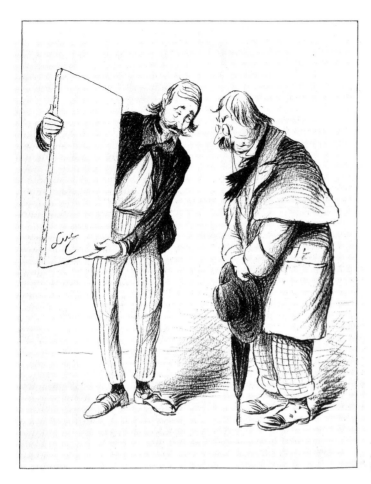

59. Luc, *L' Ecole
Moderne*, *Journal Amusant*
(1912).

this, it has already been seen that Léon-Paul Fargue wrote in 1912: "It would be easy to explain . . . Cubism and Futurism with ten philosophical or scientific systems . . . But then we are no longer speaking of painting." If the avant-garde would substitute theoretical incoherence for proper picturemaking, the urgent rhetorical question might appear to be: why paint at all? Reviewing *Du Cubisme* in 1913, Francis Carco takes derisive satisfaction in recording the comment of a certain cubist painter, who told him, "It is not painting that matters!"[42] The new intellectualism was an easy mark. In the daily *Paris-Midi*, an "Echos" item of October 1912 reveals "Une Nouvelle Ecole." The Spanish painter "Fricasso," it appears, has decided to replace fugitive pigment with chemical and mathematical formulas, which he will inscribe on canvas. Next year, the anonymous critic promises, we can expect to see "in the *salle d'honneur* of the Salon d'Automne, magnificently framed white canvases on which formulas, written with care, will replace colors and forms, which only cubists, now 'pompiers', still employ. The imagination of the visitors will do the rest."[43]

In caricature, the spirit of reductivism is even more suggestive. The joke here is that theory not only replaces representation, but prescribes the absolute evacuation of form. The cardinal motif is the blank canvas. In the *Journal Amusant* of March 1912 (fig. 59),

a futurist painter presents his latest work, an empty picture, to the *poire*-snob; the caption reads: "It's the most futurist picture of all – so far it's only signed, and I'll never paint it." The following spring, *Les Hommes du Jour* publishes "L'Evolution de l'Art: Vers l'Amorphisme," including the "War on Form" manifesto which is illustrated with vacant frames, the amorphist work of Popaul Picador. As in *Paris-Midi*, "it is up to the observer . . . to reconstitute the form."[44] (Among the precursors of the new school, the adherents of cubism and orphism are all named; only two paintings are listed, however, both by Duchamp.) We would be forgiven for assuming that the painter Marcel Lenoir was riding the crest of the new wave when, as *Homme Libre* reported in 1913, he whitewashed his submission to the Salon d'Automne as a protest against having been "mal placé."[45]

The empty or white picture, and amorphism in particular, is a retaliatory critical hoax directed at the perceived hoax of avant-gardism. As a spoof on the history of style, it actually suggests two consequences. One would be the metaphysical reductivism of Malevich, the painted "depiction" of spiritual flight into the absolute. And in Duchamp's case, allusions to modern art as the end of painting represent an invitation less to blank canvas than to blank space. Not to be mistaken for an idealist's *tabula rasa*, his action is better taken as a disappearing act. By the standards of the moment, his rooms were cleaned of art as labor, then only barely restocked with the cryptic traces of other pursuits.

—3—

The matter of rupture in Duchamp's work has been an object of surprising neglect in studies of the artist. His departure from painting is easily taken for granted, since it can be understood to represent a kind of dead calm, disregarded as a pause rather than addressed as a moment of meaning in and of itself. Yet Duchamp's choices so closely correspond to a larger significant moment in the history of avant-gardism as a condition or syndrome, that we cannot fail to see the ironic spin his actions place on the prejudice of novelty before the war.

In the only recent examination of this moment in 1912, Thierry de Duve draws our attention to a number of personal conflicts and esthetic debates that are reflected in Duchamp's abstention from painting, and that together served as a "field of possibilities" for the artist.[46] In this scenario, Duchamp's trip to Munich represents the "displacement" into an unfamiliar climate, one in which he encountered cultural and esthetic debates that enabled him to "traverse" and transcend those of the Parisian avant-garde. De Duve also compares Duchamp's abandonment of painting to the contemporaneous denial of figuration in Malevich and Mondrian, among others. Indeed, he suggests that the history of modernism might be described as a series of strategic abandonments, of chiaroscuro in Manet and perspective in Cézanne, for example. Duchamp's own reductivism bears an affinity with non-objective ambitions for a "foundational" language of pictorial abstraction, but his project actually contradicts their originational aspirations for a utopian esthetic order.[47]

This description of a shared pre-war secessionary impulse is significant. The impulse is

especially pervasive if we consider the internal contradictions of Duchamp's milieu. The critical discourse shows that the abandonment strategy was actually built into the condition established by debates over novelty, originality and hoax. The abundance of painting at the salons and the mounting confusion of good and bad faith represent a certain degree of futility, and this critical frame of mind ironically resembles the strain of waning conventions that preconditions any impulse to start over. Concerning Duchamp, it would be a mistake to treat his escape of 1912 as another manifestation of avant-garde change (no matter how meta-critical his role would be in that context). Rather, Duchamp observes the extent to which avant-gardism had overtaken the avant-garde. With perspective, "Vers Amorphisme" may be gibberish, but it was also enough of a foundational language to anticipate the extreme reductivist implications of non-objectivity. Ambiguities of this kind had become, by the immediate pre-war period, more rule than exception.

With the abandonment of painting, Duchamp's apartment had been emptied out by the vacuum of a preparatory hoax. Stepping into the bare room, we enter a parodic chamber. Anything art-related that Duchamp does here will exist in quotation marks, conditioned at least in part by the sarcasm that precedes it. The decision to stop painting is startling in retrospect, not because it represents a wholly original or improbable gesture, but because, as a joke, it was fully organic to the conditions of the moment. The mock-studio shares conceptual ground with the mock ism: the simultaneity of authenticity and sham that described the fluster of pre-war esthetic life, and that transformed avant-gardism into an ever unfolding parody of the avant-garde. Duchamp's refusal of 1912 is a virtual colloquialism of the pre-war debates; similarly, if we acknowledge the conjugation of meaning and incoherence as a theme of period discourse and experience, then the readymades and the *Large Glass* also subsist in the vernacular. Within this culture of popular opinion, *blague* and mystification were accessible expressions of critical dissent, the obvious tools with which to perpetrate a parody of contemporary esthetic anxieties. Often merely figures of speech, they were possessed of a history and an ideological life.

*Blague* is properly understood as a school of irony, though the loosest definition can imply any sort of joke or prank. The *ton de blague* treatment of *actualités*, for example, is both. As a practical joke, the *blague* or *charge d'atelier* was generally attributed to the milieu of the *rapin*. The cardinal mythification of this social group was Henri Murger's mid-century tales of "la vie de Bohème," with its closed-society discourse of fantasy, criminality, conspiratorial antics and raillery.[48] *Blague* of this sort was, by the late nineteenth century, a working cliché, compulsory to any treatment of student culture, and it recurs in criticism of the avant-garde. (Mercoyrol's reference to studio laughter and the inside-jokes to which Salmon alludes in his remark on cubist-period studio *blague* might be contextualized in this way.)

Strictly speaking, however, *blague* is as much posture as practice – simply put, a kind of ironic banter. The word is an argotic neologism, the earliest use of which probably dates from the beginning of the nineteenth century, when the new meaning was added to the original definition of *blague*, a tobacco pouch.[49] By the Second Empire, *blague* was not only established, it was considered an indispensable commonplace of the French national character, and especially "parisien par excellence." These are the words of the *Grand Dictionnaire universel du XIXᵉ siècle*, published in 1867, where *blague*, as it is defined by the editors, and illustrated by a long list of primary and secondary references, is colored

by shades of deceit: *mensonge*, the white-lie; *hâblerie*, the boast; and *charlatanisme*.[50] But the connotations are of playful buoyancy: a substance of irony modified by the qualities of *esprit* and *gaieté*; "the distinctive character of *blague* is to be completely inoffensive: it is gentle mockery . . . which will ruin no one."[51] As an activity, *blague* represents a lack of seriousness, a certain liberty of irreverence and wit.

In their novel *Manette Salomon* of 1865, however, the Goncourt brothers give us something more reflective: "*La Blague* – the great Joke, that new form of French wit, born in artists' studios . . . raised amid the downfall of religion and society . . . the modern version of universal doubt . . . poisoner of faith and murderer of respect."[52] The Goncourts link *blague* to a specific value-system of "modern" amorality. Journalist-critic Francisque Sarcey, who confirms that *blague* was "sharpened and aggrevated" during the Second Empire, also means to expand our comprehension both of attitude and practical application:

> *Blague* is a certain taste which is peculiar to Parisians, and still more to Parisians of our generation, to disparage, to mock, to render ludicrous everything that *hommes*, and above all *prud'hommes*, are in the habit of respecting and caring for; but this raillery is characterized by the fact that he who takes it up does so more in play, for a love of paradox, than in conviction: he mocks himself with his own banter, *il blague*.

Sarcey specifies that the *blagueur* may ridicule a personal value or public virtue to which he none the less subscribes: "he *blagues* the beauties of Italy," for example, "and kneels down before a Raphael." *Blague*, then, is a form of critical artifice, a mannered affectation the very hypocrisy of which is a further expression of disdain. "There is in *blague* a certain contempt . . . for conventional admirations, for stock phrases"; but "to this contempt is joined the pleasure of puncturing inflated balloons, of feeling oneself superior by proving that one is not a dupe."[53]

The core meaning of *blague* remains fairly stable, but the precise implications could be adjusted or reclaimed to suit the philosophical exigencies of each generation. During the Third Republic, *blague* was refashioned as a vehicle of post-Franco-Prussian War spiritual malaise, an irony of disillusion that recalls the Goncourts. In his eyewitness account of the symbolist epoch in Paris, Ernest Raynaud describes the life of the intellectual after "the disaster of 1870,"[54] suffering the abuses of obligatory military service, drifting atop the collective anxiety of national uncertainty and succumbing to the undertow of "profound disarray,"[55] an ennui of dissolution that follows him to bureaucratic desk-jobs and bohemian dives. A slackening of moral discipline even penetrated the *lycée*, where a sense of coherent purpose had broken down; literature, philosophy and history were reduced to "fragments and anecdotes," science to "a chaos of formulas." From his own experience at the Lycée Charlemagne, Raynaud relates the example of two professors of rhetoric, M. de la Coulonge, an impassioned and inspiring "idealist," and M. Cartaut, "a skeptic and joker":

> Thus their teaching was neutralized, and we were left without any support at all, suspended in the void. With Cartaut, *blague* had penetrated the once pompous and solemn teaching. It was a *mot d'ordre* for the last students to affect a boulevard spirit

and to forsake the study of the classics . . . in order to consecrate themselves to journalism, to the study of fashionable novelists and vaudevillistes.[56]

In its quality of disaffection, Raynaud's *blague* assaults, even as it signals, a new relativity of ideological convictions: "Politics of the day fluctuated from extreme right to extreme left, marked an unstable and disoriented opinion, fruit of the current cosmopolitan restlessness."[57] *Blague* was nurtured in a shifting climate of disenchanted faith, and the disdain of the *blagueur* would appear both to target and to recapitulate the uncertainty of political trust.

It is intriguing to note that Raynaud lists Sarcey among the progeny of post-war disarray; Sarcey's developed sense of Second Empire *blague* can here be fathomed from a Third Republic slant. Raynaud's account also provides the real-world history of a fictional character from the period. In Joseph Conrad's novel *Nostromo*, published in 1904, Martin Decoud is a Creole Latin American native son who has only recently returned from Paris, where he had spent the better part of his life thus far. Conrad's Decoud is an "idle *boulevardier*," a journalist and a cynic, and his presence is designed to contrast with the sometimes bloody political and socio-economic struggles at home. His life, "whose dreary superficiality is covered by the glitter of universal *blague*, induced in him a Frenchified – but most un-French – cosmopolitanism, in reality a mere barren indifferentism posing as intellectual superiority." With his native grasp of local developments, Decoud had been invited to contribute an article to "an important Parisian review," which he "composed in a serious tone and in a spirit of levity." To his French colleagues, he described the situation as "*une farce macabre*" of "exquisite comicality." For Conrad, Decoud's "pose of disabused wisdom" is the vehicle for a moral and spiritual journey that touches on commitment but ends in solitude, "a state of soul in which the affectations of irony and skepticism have no place." He dies at his own hand, "a victim of the disillusioned weariness which is the retribution meted out to intellectual audacity."[58]

Once identified, the philosophical weight to which Raynaud anchors the buoyancy of *blague* would appear to tug even the most casual, anecdotal reference. In 1901, the American observer F. Berkeley Smith seems to detect this duality in his first-hand experience of *blague* as a mode of bistro conversation:

> The French do not bring their misery with them to the table. To dine is to enjoy oneself to the utmost; in fact the French people cover their disappointment, sadness, annoyances, great or petty troubles, under a masque of "blague," and have such an innate dislike of sympathy or ridicule that they avoid it by turning everything into "blague." This veneer is misleading, for at heart the French are sad.[59]

Significantly, both the practice and philosophical substance of *blague* were accessible to the outsider as a salient feature of Parisian discourse. Moreover, if we maintain that Smith is borrowing a touristic cliché, for his description is admittedly simplistic, than his report is even more valuable, for it confirms a certain common currency.

*Blague* exemplifies the self-sufficient longevity of trenchant slang. Recurring idioms such as "bonne blague" and "sans blague" demonstrate its popular familiarity as a catchword or device. Yet, formalized definitions of *blague* disclose the palpable texture of an intellectual and cultural history; the thinking-man's *blague* is just as familiar and

available as the offhand reference, but it serves to connote an intellectual orientation. The frivolity of *blague* was taken seriously, and it is not surprising to find that it is possessed of a dark side. If, according to Sarcey, *blague* as an act of skeptical distance might be said to shield the author from his own sentiment as well as from the convictions of others ("he mocks himself with his own banter"), then the peril of *blague* is its proximity to nihilism. Sarcey goes so far as to define bad *blague* as the inability to distinguish true from false, good from bad, the just from the unjust.[60] Victor DuBled, in whose 1913 treatise on *argot* Sarcey is quoted at length, extrapolates: "One could almost maintain that *blague* is a common bridge between atheism and moral anarchy, and that it prepares their way."[61] The simple joke, the pointed perpetration of irony, the philosophical condition of ambivalence or distrust, the disoriented state of utter denial: the locus of meaning in *blague* is quite specific, but its ambiguity lies in its reach.

Jules Wogue published his article "La Philosophie de la 'Blague' " in 1902. His context is the plays of Meilhac and Halévy, for which he believes *blague* is the defining mode. Wogue's extended treatment is especially valuable not only as an overview, but because it enables us to specify a *blague* style. He begins with a familiar claim for *blague*: "the word is not yet French: it deserves to be. Meanwhile, it is Parisian, and it's one of the most successful finds of boulevard language." Wogue explains that *blague* is a modern substitute for the aging and archaic *persiflage*, but cautions that "to define is to limit, and the field of *blague* is infinite." None the less, we may specify the "essential and manifest characteristics": "above all, *blague* is an overthrower, and when it is successful, it has a certain critical value. It attacks all forms of illusion; beneath the mirages that it dispels, it reveals the sadness of things." Wielding irony, the *blagueur* takes pleasure in confounding naïveté "with all species of faith, conviction and dogmatism." Suggesting a kind of prehistory of *blague*, Wogue insists that the word is the "current denomination" of an existing "state of spirit" in France:

> the tyrannical reign of intelligence, a cunning perspicacity which seizes shortcomings better than qualities, an idle carelessness which delights in the superficial *aperçu*, conspiring to form in the people of Paris a species of light skepticism, hostile to the brutality of affirmations which are too crude and the heaviness of categorical principles.[62]

Wogue also comprehends the inherent risk: "doubt – a pessimistic, discouraged doubt; it leads [the *blagueur*] in joy to nihilism."[63]

Wogue's philosophy of *blague* is familiar, if especially thorough. His treatment of *blague* in a theatrical context, however, supplies a useful demonstration model. Given its capacity for nihilistic doubt, Wogue contrasts *blague* to "simple laughter," explaining that "it is extremely rare that comic theater be so dangerous." The obvious alternative is farce, which depends for its popular accessibility on recurring character types, "easily recognized by the crowd. Born from the people, it addresses the people." Farce is broader than *blague*; "it is grand Guignol made for grown-up children . . . The goal is to relax the nerves . . . Laughter there is peaceable, impartial, without bitterness."[64] If Labiche is farce, than Meilhac and Halévy are *blague*, "where satiric observation, instead of being inoffensive and 'bon enfant', will be more caustic and meaningful"; they have developed a "dramatic repertory of smiling nihilism," a "fleur de mal" of "perverse grace."[65] In a

crucial observation regarding comportment and style, Wogue highlights this distinction between the two genres by contrasting their treatment of the bourgeois, the "traditional victim of comic verve": "farce caricatured – and still caricatures – the bourgeois, and exaggerates his narrow-mindedness to the point of implausibility; *blague* . . . restores his personality traits to life-like proportions."[66] In this way, Meilhac and Halévy observe the bourgeois "with a photographer's fidelity."[67] The stylistic imperative of *blague* is the quality of deadpan. An informal reference is, again, useful: a popular joke-book pamphlet of sarcastic anecdotes from 1894 tells us that the "Blagueur fin de siècle" is "superior to his predecessors in the *sang-froid* of his delivery." On the cover is the model, a self-possessed ironist holding forth with nonchalence at the café (fig. 60).

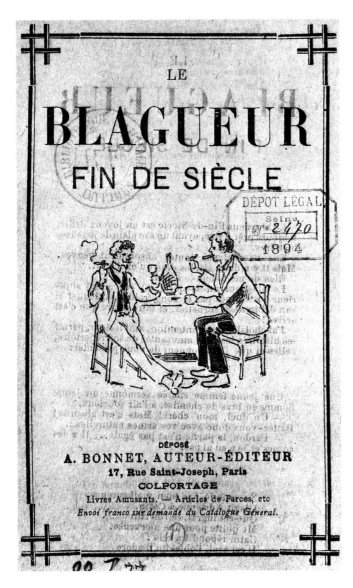

60. Cover illustration for pamphlet *Le Blagueur fin de siècle* (1894).

61 (right). Duchamp,
*Fountain* (1917).

62 (below). Duchamp's
New York studio, date
unknown.

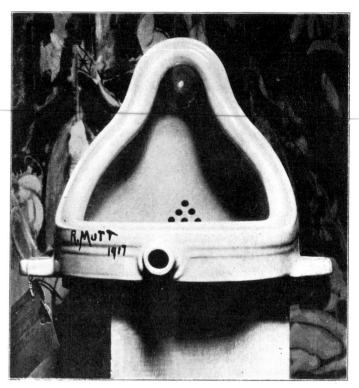

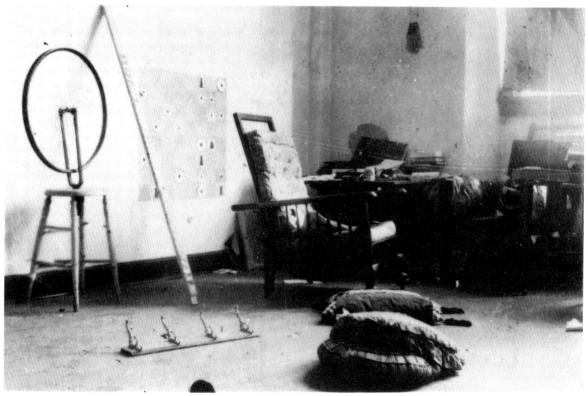

—4—

In spring 1917, Duchamp submitted the readymade *Fountain*, an inverted urinal, for exhibition in the Salon of the Society of Independent Artists in New York City (fig. 61). That May, the avant-garde review, the *Blindman*, published "Buddha of the Bathroom," a statement on the philosophy of *Fountain* written by Duchamp-circle insider Louise Norton. There, Norton quotes the puzzled spectator: "Is he serious or is he joking?," and sensibly replies: "Perhaps he is both! Is it not possible?" Both question and answer are familiar, the call and response of esthetic disorientation. By way of explanation, she adds: "And there is among us today a spirit of 'blague' arising out of the artist's bitter vision of an over-institutionalized world of stagnant statistics and antique axioms."[68] She might as well have been cribbing from Wogue, whose *blague* is "hostile to the brutality of affirmations which are too crude and the heaviness of categorical principles." Norton's remark, which is never quoted, is indispensable. But for a title from Remy de Gourmont, *blague* is the only French word in the article, and she most certainly secured it from Duchamp himself.[69] Above all, the context of her description of the philosophy of *blague* conforms to conflicts over avant-gardism and hoax in Paris, and raises the salient duality of a defense that heightens rather than denies the worst fears of the philistine.

The content and demeanor of *blague* is like a chassis of principle, sensibility and style for Duchamp's readymades. It is one of the miracles of the readymade that it can have become the subject of intense debate over the elusive definition of art. But before it is anything else, the readymade is Duchamp's deadpan answer to overproduction and avant-gardism – the congestion of words and paint, of craft, theory, *nouveauté* and *réclame*. In its next-to-nothingness, it is highly attuned to the decorum of his studio (fig. 62), an empty chamber ("Mon atelier a été peint en blanc," Duchamp wrote to Louise Arensberg in August 1917, "c'est très bien"[70]). Yet the bare studio is a parodic space, emptied out but still charged with the aura of art; the objects that Duchamp brought home represent an esthetic equivalent of inactivity and blank stare. Bicycle wheel, bottle rack, snow shovel, chromolithogaph, cattle comb, urinal, coat rack, typewriter-cover: originally a mundane functional thing, the readymade is transformed into a gag on the nature of art that cuts both conventional and avant-garde expectations of what art ought to be; and according to Wogue's model of *blague* versus farce, it does so disguised in utter conventionality. The banality of the readymade is at once authentic, and a straight-faced foil for its outrageousness as an art object; its standardized commercial shape and surface are a cold envelope concealing the gibe, a slippery baffle to the barbs of skepticism that lurk beneath the polished skin.

For the *blagueur*, "all species of faith, conviction and dogmatism" constitute a form of naïve self-delusion. True to the global, non-sectarian leveling principle of pure *blague*, Duchamp's readymades address the activity of the avant-garde as well as popular esthetic *inquiètude* and the perceived inauthenticity of avant-garde extravagance. As tokens of esthetic taciturnity, nothing could be less original and advanced; as objects of bourgeois prosaicism, nothing could be more familiar and "sincere." In 1913, Duchamp asked himself, "can one make a work of art which is not a work of art?"[71] In 1917, the official

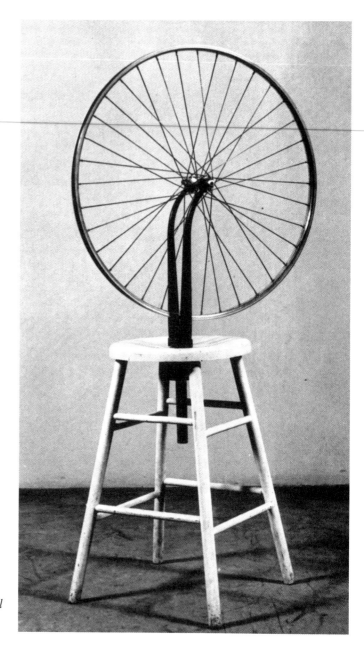

63. Duchamp, *Bicycle Wheel* (1951 replica of 1913 original readymade).

defense of *Fountain* at the Salon was the claim that an artist's act of "choice" alone is sufficient to transform, by implication, any functional object into a functionless sculpture.[72] Later, Duchamp noted that "the choice of these 'readymades' was never dictated by esthetic delectation. The choice was based on a reaction of visual indifference," a "total absence of good or bad taste . . . in fact, a complete anesthesia."[73] At best, the *Bicycle Wheel* (fig. 63) was "just a distraction."[74] The objects are said to have been "things that

weren't works of art, that weren't sketches, and to which no art terms applied."[75] "Indifference" is idiomatic *blague*. Recent study challenges Duchamp's indifference by quoting his colleagues of the period for an esthetic appreciation of the readymade; but comments of this sort are thoroughly ambiguous – like the readymades themselves, they are two-ply, period fabrications of sincerity and irony. Concerning *In Advance of a Broken Arm* for example (see fig. 56), a newspaper reporter quoted Duchamp's friend Jean Crotti in 1916: "As an artist I consider that shovel the most beautiful object I have ever seen."[76] Crotti's observation is dry; it could be a declaration of genuine feeling, or a taunt. As a manipulation of popular and critical opinion, the concurrence is unexceptional, for it mirrored familiar questions of authenticity in the critical dialogue.

If, moreover, the legacy of the readymade has since come to incorporate a local modern taste for industrial beauty,[77] then the *blague* is a complete success, for it has revealed the very notion of beauty to be, in terms that are wholly consistent with the disorientation of pre-war debates, a chimera of relative values, dogmatic claims and shifts of fashion. Scattered about his studio – mounted, suspended, leaning, inverted or tipped over, according to the photographic record – the readymades are reluctant objects of delectation. Eventually they achieve an aura of esthetic presence, and subject themselves to our judgement. Duchamp admitted that, "at the end of fifteen days, you begin to like it or to hate it,"[78] and this is verified by the historian's search for a proper scaffolding of visual taste on which the readymade might securely hang, as well as Duchamp's later curatorial and commercial appreciation of the objects. But first, the readymades are machine-made especially in that they are not handmade. Their common denominator for Duchamp was simply that they were all "manufactured goods,"[79] selected to eschew the sensuality of paints and handicraft. Seeking a ground-zero of the banal, they arrive cloaked in the cool exterior of *blague*. Inevitably failing to achieve utter neutrality, they succeed, as Sarcey would have it, in mocking their own inability to escape content or conviction.

In this regard, Duchamp's fabled visit with Léger and Brancusi to the 1912 Salon de la Locomotion Aérienne, can, like the Crotti quote, be doubly construed. According to Léger's later account, Duchamp

> was walking among the motors and propellers without saying a word. Then he suddenly turned to Brancusi: "Painting is finished. Who can do better than that propeller. Tell me, can you do that?" He was very taken with these precise things.[80]

Naturally, Duchamp's remark, if indeed he made it at all,[81] was taken by Léger (and has been taken since) to signal the artist's taste for the purity of mechanical design; by 1954, when Léger told the story, streamline style was long established as a standard of the modern esthetic canon, and Léger himself had positioned a good deal of his own work on the ideological platform of neo-classicizing machinism. Duchamp's observation, however, is also fully intelligible as *blague*, acting in this case to puncture the inflated modernist balloon of originality and *nouveauté*. According to the disabused wisdom of an ex-avant-garde *blagueur*, the industrial salon is a lesson in futility, for Brancusi and Léger had both been beaten by the *surenchère* of the airplane engineer. In fact, Duchamp was drawing a comparison that, like the epithet "maître cube," disturbs the distinction between praise and ridicule. As a bemused dismissal, it would not have been out of place in a review by Louis Vauxcelles. Earlier that year, cubists had demonstrated to Duchamp that a certain

bourgeois intolerance lurks beneath the freedom of the Indépendants; acting within the bounds of "idle carelessness" and "the superficial *aperçu*," Duchamp, in turn, floats a *blague* at Brancusi's expense, cutting him lightly with the double-edge of the avant-garde philistine. After all, Brancusi had been admitted to the Indépendants that spring, but subjected in the press to a kind of derision that is essentially indistinguishable from Duchamp's fate at the hands of Gleizes and Metzinger: grouped in *Le Rappel* with the "*mystificateurs* who abound at this Salon," the critic H. Ayr complained that "placing a marble ball on a cube of stone and entitling it 'Sleeping Muse' does not appear to us very comical."[82]

Given the esthetic climate, a definitive, pro-modern reading of the propeller story is hasty; governing questions of sincerity at the time require us to entertain the option of sarcasm. Likely confidence abuse of this kind illustrates a larger point: in the readymades, pretensions to beauty are tempered by avant-gardism, and the deep ambivalences of intention and reception that it represents. Further, the very notion of "taste" as a target of Duchamp's indifference is not unannounced, though it appears at first to be almost anachronistic as a point of concern. Rather, the matter is one of local interest. Specifically, it dominates chapter five of *Du Cubisme* by Gleizes and Metzinger, which was composed from within the confines of Duchamp's own avant-garde circle and published in late 1912, the time of Duchamp's break.[83] The first book length manual of the new art, *Du Cubisme* is not an autonomous account, but most remarkable of all for its degree of reconciliation between cubism and the offended sensibilities of the conservative art-public.[84] In reply to specific charges in the critical press, the authors are careful to point out, for example, that cubism is not an exercise in "systematic obscurity" or "fantastic occultism," nor a pretention to "objective" or "absolute truth."[85] There is a running theme concerning cubism as a superior esthetic virtue; and in the fifth and final chapter, we are told:

> Any painter of sane senses and sufficient intelligence can produce well-painted pictures; but only he can evoke Beauty who is chosen by Taste. We call thus the faculty by which we become conscious of quality, and we reject the notion of good and bad taste . . . a faculty is neither good nor bad: it is simply more or less developed.[86]

Gleizes and Metzinger set themselves apart from backward-looking notions of advance: "an indifferent artist," they tell us,

> proves his wisdom by contenting himself with acting upon ideas long ago appropriated to painting. Is not a simple Impressionist notation preferable to these compositions bristling with literature, metaphysics and geomtry, all insufficiently *pictorialized*? We look for plastic integration . . . we look for a style, and not a parody of style.[87]

Since "the influence of will on the taste facilitates selection," proper cubism can be defined as a refinement that contradicts two misconceptions: cubist painters "who painfully pretend to be spontaneous and profound," and those who "move freely in the highest planes . . . [like] the great Mystics."[88] The notion that modern painting can be a kind of universal language, like Esperanto, is mistaken: "the ultimate aim of painting" may be "to touch the crowd . . . but painting must not address the crowd in the language of the

crowd; it must employ its own language, in order to move, dominate, and direct the crowd, not in order to be understood."[89] Cubism, "which has been reproached for being a system, condemns all systems,"[90] and is guided by "no other laws than those of taste." In the end, the cubist is a "realist," "and it is the faith in Beauty which supplies the necessary strength."[91]

Chapter five of *Du Cubisme* comes close to being a reverse model for Duchamp in 1912. The readymades are an extended *blague* which, with as little effort as possible, invert the aspirations of Gleizes and Metzinger. The cultivation of "taste" and "beauty" in *Du Cubisme* indicates a semantical cul-de-sac where the avant-garde would appear to be forever trapped amidst platitudes, conventions and justifications, endlessly accountable to the conflicting preferences of critics and clients. In Duchamp's parodic domain, maxims such as the "influence of the will on taste facilitates selection" are hung out to dry. For Duchamp, "selection," or "choice," is but an exercise of minimum will and maximum "indifference" that seeks, even if it fails, to avoid the conditional pretext of taste altogether. The universal language of art is neither a rarefied confection nor a deception; it turns out, instead, to be banality itself. Duchamp agrees that "sufficient intelligence" produces "well-painted pictures"; he would come to cite the expression "stupid as a painter" in this regard, an epitaph in his mind for the "physical" and "retinal" obsessions of painting.[92] The readymades remind us that the lower intelligence of all new painting, avant-garde and amateur alike, was a popular critical complaint. If, in the case of Duchamp's penchant for language-play, one alternative to the painter's alleged stupidity could be found in replacing the lessons of art with those of poetry and linguistics, the readymade solution substitutes instead the cerebrality of the skeptic: adopting the *blagueur*'s deadpan "tyrannical reign of intelligence," Duchamp does not "look for a style," but "a parody of style," its absence, which connotes the overwhelming surfeit of isms and styles on the scene.

The readymade can be accepted as an object of deliberate beauty only by acknowledging a certain degree of sly duplicity. Clearly, Duchamp's renunciation of esthetic taste is a conceit; it is significant, though, that the indifference of the readymade was his recollected ambition. With regard to *blague*, the readymade is ultimately capable of sustaining any visual appreciation because, originally, it came as close as possible to promoting none. In Duchamp studies, the claim for indifference has suffered a loss of confidence, in part because it posits a power-vacuum, and interpretive study abhors a vacuum. If we simply fill the space with a new esthetic principle, than we commit an act of good faith that interrupts the original momentum of suspicion and disorder atop which the readymade drifts. As long as indifference, distraction and esthetic fatigue seem merely perverse, then an alternative program will be sought. However, before proceding to argue the otherwise irrefutable point that stylessness is a fiction, *blague* asks us to note that the indifferent deadpan conforms to an extant comic strategy of 1912.[93]

The same could be said for iconography. Readymades may actually reflect themes and motifs from within Duchamp's greater œuvre; rotating wheels, erotic allusions and propositions from n-dimensional and fourth dimensional science are among many that have been proposed.[94] It is also possible, however, to posit a plain, and preliminary, iconography of deadpan skepticism that is appropriate to the esoteric concerns of the *blagueur*. As a repertoire of "smiling nihilism," the readymades comprise a counter-œuvre

to the congestion of paint and canvas on the pre-war scene; we should, therefore, require that they pertain with some specificity to those terms of esthetic conflict.

One iconographical allusion of this kind concerns the readymade genre as a whole, throughout 1917: namely references in the critical press to the proliferation of new art, both "advanced" and "bad," as an experience of the "magasin des nouveautés." It is known from Duchamp's own recollection that the *Bottle Rack* (fig. 64) was purchased at such a place, the Bazaar de l'Hôtel de Ville; other readymades were selected from smaller *magasins*: the shovel from a hardware store, the urinal from a plumbing showroom.[95] But ceaseless novelty as a commercial principle of pseudo-originality at the *grand magasin*, with its variety of departments and merchandise, is a conspicuous point of reference for the readymade project.[96] As a self-sufficient esthetic act, the primacy of "choice" is inferred from the critic's metaphorical *magasin* of pictures and isms – Duchamp is completing a gesture that was originally implied in scorn by Mauclair and others. He also

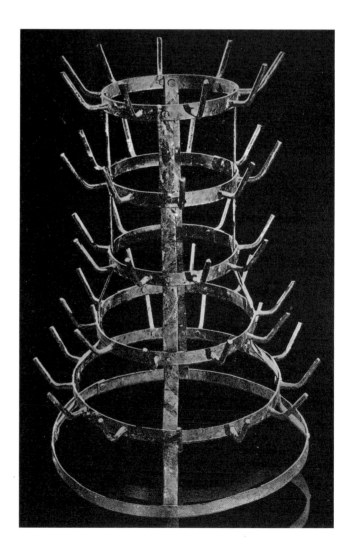

64. Duchamp, *Bottle Rack* (c. 1921 replica of 1914 original readymade).

literalizes a critical defense of the Salon d'Automne's claim to the Grand Palais, which, after all, had already been home to exhibitions of "cheap housing, toys, furniture, automobiles." (In 1913, the Salon d'Automne opened one month later than usual because it had to share the hall with the Salon de l'Automobile.)[97] Mirroring charges of *réclame*, the *blagueur* purchases rather than produces and markets his work. The final irony of indifference is that this "art" really *was* selected at the "magasin de nouveautés," yet its "novelty" is trivial at best. As a commercial strategy, snobism and the promotional allure of intellectual fashion is a fool's game. The readymades were selected in mock-sincerity according to the presumed rules of avant-garde behavior; in the end, however, they are each a kind of Monsieur Prudhomme – a dumb thing waiting to be cloaked in higher meaning and promoted as "génie à la mode."

More specifically, Duchamp's *Pharmacy* (fig. 65) draws in deadpan-earnest from a recurring critical lament about quality and quantity in contemporary art production.

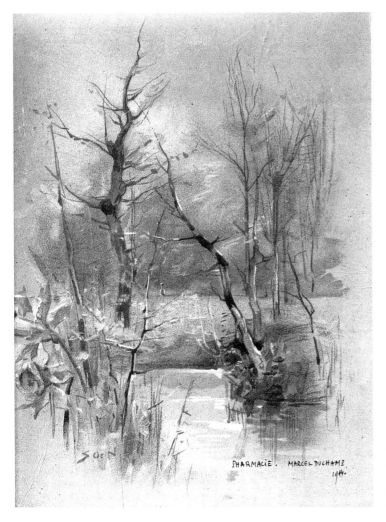

65. Duchamp, *Pharmacy*, commercial reproduction with gouache added by the artist (1914).

*Pharmacy*, which dates from 1914, consists of a cheap, commercial chromolithographic winter landscape picture, "of the worst kind," to which Duchamp has added two small figures in gouache, one red and one green, and the inscription: "PHARMACIE. MARCEL DUCHAMP/1914. It is an "assisted" or "rectified" readymade, having been altered slightly from its original state. The picture was selected in Rouen, and Duchamp remembers having had the idea on his way there by night-train. The title alludes to the spots of color, which suggested bottles of clear red and green liquid in pharmacy shop-window displays of the era; but the addition of the spots appears to have been originally suggested by Duchamp's impression of house lights in the night-time rural landscape.[98]

A mockery of individualized touch at the service of cheap sentiment and pseudo-style, *Pharmacy* is Duchamp's only early readymade that directly concerns the motto "stupid as a painter": so stupid, in other words, that his formulaic pictorial vision is easily mass-produced, to no apparent loss of quality, value or effect. In the pre-war critical press, mention of the chromolithograph, or *chromo*, was a stock insult of exactly this kind, usually in reference to bad art at the Salon. In most cases, the context is a breakdown of available options. If cubism is a disgrace to the Grand Palais, mused Léon Werth during the Salon d'Automne debates of 1912, then what is the desirable alternative? Perhaps, he suggests with derision, it is the Salons of the Société des Artistes Français and the Société Nationale, whose canvases comprise an uneasy pastiche of academicism and impressionism:

> Ah! now I understand what does honor to the Grand Palais: all those enlargements of *chromos*, made by hand, all by hand, exclusively by hand and that, were it not for their dimensions, one would take for the *images réclames* of a major chocolate or a major chicory.[99]

Similarly, reviewing the futurists in Brussels that year, Armand Eggermont maintains that cubism and futurism are forms of "arrivism [and] bluffism" created in order "to frighten the public, whose curiosity only takes interest in extremes: *chromos* on the one hand, noisy, vain rebels on the other."[100] For critic Pierre du Colombier, writing in the voice of his "provincial cousin," the 1912 Indépendants consists mostly of "dirty bourgeois," who paint "chromos, more than you'd ever need in order to furnish the *grands magasins* with gift calendars. Who can I imitate in order to be original? They imitate everybody," from Ziem and the impressionists to "color photography."[101] In 1914, the year of *Pharmacy*, Helsey will divide the artists at the Indépendants into general groups; the avant-garde comprise one, but the "first rank" consists of:

> an army of amateurs and impotent professionals who industriously paint innumerable *chromos* recalling, with lifelike imitation, the color portraits or "views" that we have all admired in our childhood in the back of some old provincial house, on panels used to close up the fireplaces during the warm season.[102]

*Pharmacy* is as cold to the touch as the other readymades, but it retains the memory of individualization and craft. Selected by Duchamp and isolated from the market place, it concretizes a critical metaphor, the chief alternative to cubism at the salons. The manufactured surface is part of that metaphor. To call a picture a *chromo* is to imply infinite sameness despite a pretense to differentiation (significantly, there were originally three

identical *Pharmacy* readymades);[103] but it is also the indifferent surface of the *blague*, which, as Wogue would have it, captures bad painting (the bourgeois) "with a photographer's fidelity," allowing faults to speak for themselves. Having stopped art, Duchamp produces a painting that is not a painting, in a pictorial manner to which everything "advanced" stands opposed, yet which is considered by a good portion of the art public to be no worse in its way than cubism or futurism. As a *blagueur*, he has left the avant-garde for the front ranks of the bourgeois, if only to exemplify a critical truism: they both dole out and receive pictorial prescriptions with the tired regularity of a pharmacy.

In addition to esthetic matters drawn from within the confines of critical debate on modern art, the iconography of the readymade may also address itself to modern style as a larger cultural expression, including the very matter of industrial design. In this regard, the *Bicycle Wheel* and the *Bottle Rack*, Duchamp's first two readymades, may have been selected in sequence as a simulation of the Eiffel Tower and Grande Roue (the large ferris wheel which was constructed as a counterpart to the Tower for the Universal Exposition of 1900), pictured together countless times throughout the period (fig. 66). Despite their age, both were still deployed as icons of modern style during the time frame of Duchamp's choice. In Diego Rivera's *Portrait of Adolfo Best Maugard* from 1913 (fig. 67), for example, the Wheel is a brilliant compositional device, spinning as if on the finger-tip of Maugard's gloved hand, an instrument of dandified elegance and dynamic charisma. That year, Duchamp's brother Raymond Duchamp-Villon described the Tower as a "master-piece of mathematical energy . . . drawn up from the subconscious domain of Beauty."[104] Together, the Tower and the Wheel were also an enduring set. Despite their tremendous

66. Postcard (*c.*1905–10).

disparity of size, they are fantastically juxtaposed in compatible scale by Delaunay, in his orphist paintings *Windows* of 1912 and *The Cardiff Team* of 1912 to 1913 (figs. 68 and 44). In the final line of Blaise Cendrars' "Prose du Transsibérien," published in late 1913, the autobiographical traveler returns to "Paris / City of the unique Tower of the great Gibbet and of the Wheel."[105] Side by side on a double-page spread in the June 1914 issue of *Les Soirées de Paris*, the Tower and Wheel are depicted in Apollinaire's calligramatic poem "Lettre-Océan" – the Tower is pictured from an aerial view and both structures are conceived as wheels (fig. 69).[106] As *blague*, Duchamp's *Bicycle Wheel* and *Bottle Rack*

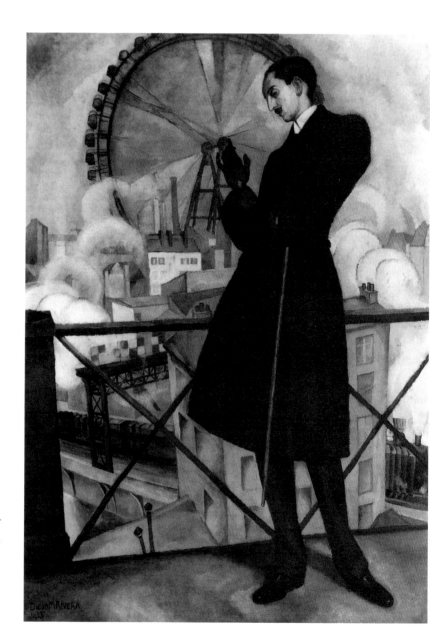

67. Diego Rivera, *Portrait of Adolfo Best Maugard* (1913).

68. Robert Delaunay, *Windows* (1912).

69. Guillaume Apollinaire, "Lettre-Océan" (1914).

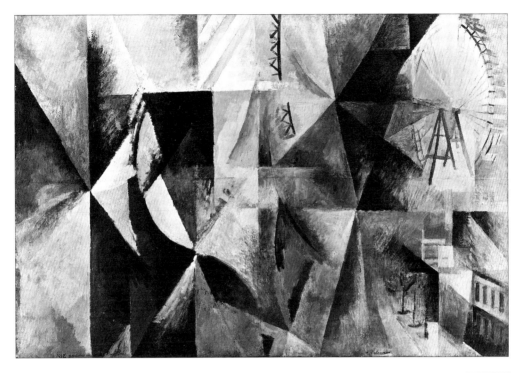

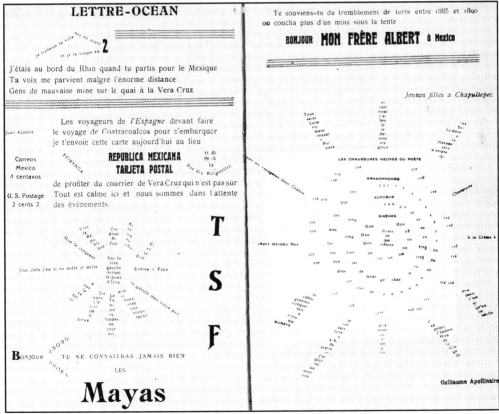

Guillaume Apollinaire

would represent a kind of apathetic, low-risk counterpart to the large-scale practical and symbolic boast of the Tower and Wheel. Even the very question of function and functionlessness is framed by the readymade's sly allusion to monuments of modern engineering that were themselves objects of little real use, suspended somewhere between art and tool. As the readymades literally belittle the promise of a new industrial faith, Duchamp's deadpan parody resonates beyond the studio and the salon; it remains, however, site-specific to avant-garde associations of painting and progress.

—5—

Duchamp's escape from the sincerity of the "retinal" into the moral ambiguity of supposed indifference was marked, he later insisted, by the search for "new" means. In addition to the readymades, this includes other "mental" exercises that might be construed as esthetic, but that eschew the physicality of paint.[107] The *Large Glass*, with notes, and the *3 Stoppages Etalon* qualify; word games and various speculations on science, language and the limits of meaning also represent excursions into verbal expression that distanced Duchamp further from the "stupidity" of the painter.[108] These activities share the readymade's skepticism concerning positivistic faith in the forward march of the conventional art object. They also collectively extend the readymade's basic allegiance to the joke – both one-liner witticisms and extended parody – as a strategy of intellectual remove and playful but suspicious doubt. The canny, offhand spirit of Third Republic *blague* is unmistakable, even if it is only an underlying disposition over which the elaboration of other philosophical, literary or scientific sources are then introduced. Searching for a prior case-study in the non-art of the *blagueur*, we may turn back to Wogue, and to Wogue's own example from the theater of Meilhac and Halévy.

In his discussion of the two authors, Wogue includes their play *La Cigale*, produced at the Théâtre des Variétés in 1877.[109] His focus is the character Marignan, a young, bourgeois *peintre-amateur*. Supported through his successful father by independent means, Marignan can afford to be a "bold innovator" with a "supreme contempt for old painting."[110] He need not work to satisfy the demands of a clientele, though he is confident that the market will catch up to his genius. Over the course of the play, Marignan passes through the two schools of Luminism and Intentionism (declaring himself a "Luministe," Marignan is taken by one visitor to have said "le Ministre," and asked to specify: the Minister of what?[111]). Both isms stand for the primacy of the artist's conception over considerations of accessibility. "I make painting," he explains, "which is not painting."[112] Marignan's studio is filled with "tableaux étranges" and "peintures bizarres."[113] One such work, *Le forêt de Fontainebleau pendant le brouillard*, is a blank canvas, lightly tinted gray; in order to demonstrate how thick the fog is, the artist has attached a knife.[114] Another is composed of two bands of pure color, blue and pink: placed one way, Marignan demonstrates that it represents the sea, illuminated by a sunset; inverted, it is the burning desert sand beneath an azur sky. "It's admirable!" exclaims a visiting Marquis, whom Marignan corrects: "It's original . . . It's not bad to put a little originality in painting."[115]

Wogue describes Marignan's work as "the rebus-picture, or again, in an unexpected form, intellectual painting."[116] In fact, the two pictures also anticipate the Expositions des Incohérents; there, for example, in 1883, the humorist Alphonse Allais exhibited an empty white Bristol board entitled *Première Communion de jeunes filles chlorotiques par un temps de neige*.[117] As Denys Riout has shown, in his study of the 'monochromatic' picture as an ongoing device of nineteenth-century salon caricature, Marignan and Allais[118] permit us to establish a lineage of empty-picture pranks that extends through to amorphism. The alternate seascape-or-desert picture presages Dorgelès' pre-war joke of the "metaphysical" cubist picture which passes for a moonrise, the portrait of a young girl, a genre scene or a seascape.[119] Wogue explains that Marignan's "*charges d'atelier* attain a snobism amenable to *blague*":[120] snobism as an act of intellectual and esthetic condescension. Yet in *La Cigale*, the *blagueur* is less Marignan, who works with a gravity of purpose, than Meilhac/Halévy, whose Marignan is a deadpan character assassination of the pseudo-*novateur*.

Marignan, who, according to Wogue, "takes eccentricity for originality,"[121] reveals two things. As an object of ridicule, the pre-war charlatan of new art has ancestors in the late nineteenth-century. (Marignan also refers to his work as an improvement on impressionism, and the blank Fontainebleau picture was probably devised at the expense of Monet or Whistler.) Further, Marignan's example, though comparatively simplistic, indicates the *plausibility* of a figure like Duchamp; if a career art-*blagueur* was to emerge from within the disorientation of pre-war esthetic experience, a rough outline of his capacity and disposition was already available. Supported in part by his father, like Marignan,[122] Duchamp's conceptualism was anticipated as the pose of a liberated amateur who mocks dedicated esthetic labor.[123] "Contempt for painting"; "painting which is not painting"; "an unexpected form of intellectual painting": whether or not he knew Wogue or *La Cigale*, Duchamp's post-1912 vocabulary conforms to a local code of ironic alienation. Even the radical chance procedure of his *3 Stoppages Etalon* resonates with a prior example of procedural indifference that adheres to *blague* logic. At the end of Act III, Scene 2 of *La Cigale*, one of Marignan's pictures is accidentally knocked off its easel and falls onto a palette of fresh paint; Marignan is momentarily horrified, but "calms himself suddenly" and exclaims, "Well, it's better than before!"[124] The epilogue comes from Duchamp; discussing the accidental breakage of the *Large Glass*, cracked *en route* from the Brooklyn Museum in 1927, he insists: "It's a lot better with the breaks, a hundred times better. It's the destiny of things."[125]

"Chance" marks a philosophical extreme and, as such, a variation on the model of the *blagueur*. As a "pose of disabused wisdom," the risk of *blague* is nihilism, the skeptic's belief that all conviction is worthy of a certain disdain. When the light skepticism of the *blagueur* takes on the ballast of lassitude, it loses buoyancy and spirals down. We might distrust Duchamp's later claims to lack of faith ("I don't believe in positions"[126]); but the iconography of Duchamp's self-invented post-1912 persona suggests an acquaintance with the gravity-bound *blagueur*, a familiar figure related to the frustrated *fumiste* and known as the *raté*.

The *raté*, who appears to have emerged from the nineteenth-century bohemian culture of arts and letters, is a failure. Embittered by the success of others and betrayed by the disparity between high ambitions and meager talent, he withdraws from endeavor and

struggle, and occupies himself instead with *blague* at the expense of the working world. The *raté* was usefully portrayed in 1906, when he was featured in Catulle Mendès' play *Glatigny*. Named after the writer Albert Glatigny, a member of the 1850s Realist circle and a co-*habitué* of the aptly named Brasserie des Martyrs, the play depicts the trials of bohemian struggle.[127] The *raté* was a central fixture of the popular Act III Brasserie scene. (Salmon remembers that the Montmartre community dutifully descended to the left bank in order to attend this recreation, a "masterpiece of the *estaminet*."[128]) There, the character Jean Morvieux describes himself as an "anathema of the unfortunate, of the out-of-form, / of the *ratés*, the *blagueurs*, the fallen, the atheists."[129] Writing with regard to *Glatigny*, critic Lucien Descaves confirms that the "cruel word *raté*" was invented in this bohemian milieu, in order "to designate the man who has reached maturity without having shown the measure of his talent."[130] Interviewed on the occasion of the opening, Mendès spoke at length about the role of the Brasserie as a clubhouse, first stop of the rising star, last stop of the *raté*, "those *rapins* without ateliers, those journalists without newspapers, those poets without editors, those dramatists without theaters":

> Those who remain in the prison will look unfavorably on the former convicts who choose to return as visitors. But all the victims of idleness and bad luck, all the impotents and all of the strong reduced to impotence gathered there. And they amused themselves bitterly. Against insulting triumphs, the Brasserie took all the revenge one could by disparagement and parody. And the frightening thing is that, most of the reputations being, in reality, illegitimate, they were often right, the jealous ones![131]

Far from outmoded, the *raté* was kept alive during the pre-war as a pre-packaged, reference to disillusioned failure and the occupation of cynical derision. Even casual use of the word retains these implications. In his article on the congestion of painting from 1913, Mauclair explains at length how the sporadic commercial success of avant-garde extravagance promotes false hope, a miserable deception which generates the "sorry proletariat of *ratés*." The *raté* is not the man who fails at material success, for genius is often accompanied by poverty; rather, he is "the man who believes himself to be an artist and has nothing to say."[132] Some would-be *novateurs* have been graced with good luck, but the greatest share are embittered victims of self-delusion. In October 1912, Vauxcelles describes the cubists as pedants, with "a need to astonish and shock, to wrap themselves in an aggressive *raté* attitude. With X, it's to avenge his lack of success; with Y, the cynical thirst to make his name known; with Z, simple telling of tall tales."[133]

Duchamp is not operating from a position of insufficient talent or unjust neglect, though his experience with the cubist hanging-committee at the 1912 Indépendants actually implies both. He is not a bohemian *raté*, but his retreat quotes from the history of the *raté*. Just as his exasperation mirrors that of the hostile critic, his actions fulfill the characterization of the cubist *raté*. Better, he creates a double-*blague*: the deadpan, near-perfect impersonation of the *raté* who, in turn, is a cynical practitioner of *blague*. This is parody at the expense of perceived arrivism and *nouveauté*. Duchamp's invalidation of *Du Cubisme* might be so described, for it suggests a scenario of mock envy and spiteful scorn. In this sense, if Duchamp failed to abandon the exhibition circuit altogether after 1912, his practical withdrawal from the art activity of his colleagues implicates the *raté* as a prototype of parodic freedom, a substitute for aspirations and work. This was appreci-

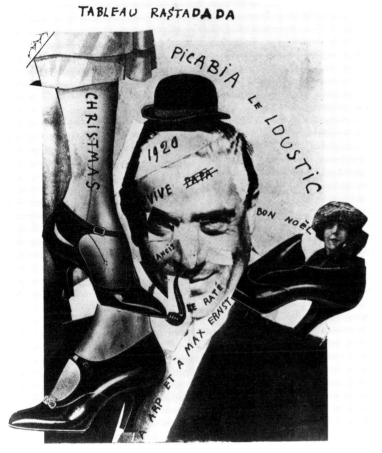

70. Francis Picabia, *Tableau Rastadada* (date unknown).

ated by Picabia; in a 1920 photo-collage self-portrait, *Tableau Rastadada*, the artist labelled himself "LE RATÉ" (fig. 70).

Finally, Mendès' use of the word "impotence" in describing the *raté* is striking. The principle of inadequacy is fitting, and appears to have been customary in this context.[134] Clearly, this is the source and implication of "impotence" as it occurs throughout cubist criticism. Above all, the cubists are "impotent" for the desperation of their pretended novelty, a negation of art as commitment and vision. "Encouraged by the most inane snobism and the crassest ignorance, these *épuisés* of painting seek . . . that so-called *originality* that actually confirms their *impotence*."[135] Other artists, such as Matisse or Van Dongen, "tormented by the same thirst for *réclame* and scandal" that afflicts the cubists, are also prone to "a sort of pictorial nihilism which, if they persevere in this way, can only lead them to impotence or suicide."[136]

It was during Duchamp's early investigation of not-painting that he devised his first alter-ego, the *célibataire*. In plans for the *Large Glass*, nine bachelors would populate the lower half of the composition, which portrays an elaborate tale of quasi-cosmic sexual frustration. The bachelor machine was a chocolate grinder, and the Bachelor "grinds his chocolate himself";[137] "illuminating gas," directed at the Bride through capillary tubes and sieves, fails to attain its appointed target.[138] Themes of narcissism and castration are also implied in the notes,[139] and the mechanization of futility was further sustained at the

71. Duchamp, *Coffee Grinder* (1911).

time by Duchamp's apparent enthusiasm for mechanical rotation in devices such as the *Coffee Grinder* of 1911 (fig. 71) and the *Bicycle Wheel*.[140] (In this regard, it should be noted that art-critic Henri Guilbeaux also described cubism as "artistic onanism."[141]) Duchamp's self-identification with the bachelor is conjecture; but it is reinforced by his later description of the *Glass* as

> a negation of women in the social sense of the word, that is to say the woman-wife, the mother, the children, etc. I carefully avoided all that, until I was sixty-seven. Then I married a woman who, because of her age, couldn't have children.[142]

As a variation on inefficacy, the bachelor does not necessarily represent impotence *per se*, but around 1912, it was tantamount to the same thing. That year, troubling new official statistics were released revealing that France had the lowest birthrate in Europe, declining steadily since its peak in 1872, and reports appeared throughout the daily press.[143] *Dépopulation* was a crisis, perceived on the Right as nothing less than a grave threat to the future of the French race. The chief villain of the scenario was the *célibataire*, upon whom the government Commission on Depopulation proposed a heavy tax, which would be redistributed as tax benefits to the working fathers of large families.

According to the biases of the national cause, the bachelor is a pre-war socio-cultural *raté*. His failure to produce, however, was open to question. Duchamp and his bachelor-protagonists were indeed childless, and in this sense the *Large Glass* reflects the status of the artist-*raté*, and the example of the *raté* as a colloquialism for fatigue induced esthetic irony. But the narrative of the *Glass*, the sexual activity of the *mariée* and the *célibataire*, is a *blague* that takes its cue from the popular music-hall depopulation joke concerning marital infidelity, which held that it was the nation's bachelors, not its husbands, by whom most French wives actually produced their offspring.[144] A *raté* is also a *blagueur*; and the desirable Bride, "stripped bare by her bachelors, even" (not only by her husband, but *even* by her bachelors) was a topical choice for socio-esthetic irony; good material for what Duchamp described in his notes as "a hilarious Picture."[145]

Both as philosophy and as joke, *blague* teaches a discreet but significant lesson for the period: that French cultural history comes equipped with its own critique, a built-in self-winding nemesis that ticks beneath significant episodes of disovery and change. The music-hall *revue* is, in some respects, such a form of critical *blague*, a running parody of politics and fashion that is so resolutely fresh it would seem to unfold in concert with the very events to which it refers. (Here, the deadpan is less a matter of style than of content, the newspaper-truth of *actualités*; the conceit is the secret *entente* between spectator and *revuiste*, where, unlike farce or caricature, the jokes are hidden.) In Duchamp's case, both the prank and the skepticism it represents reveal hoax to be a universal joint which couples the history of the avant-garde to the experience of avant-gardism, a single unit of multiple moving parts.

The deadpan is all the more significant here, for it reminds us that the joint can be virtually transparent. In other words, if the *Bottle Rack* represents the Eiffel Tower, or

signifies the very redefinition of art, it is also just a bottle rack. This is *blague* at a height of technical proficiency – not deceptively simple, but authentically so, far-reaching almost despite itself. Above all, it is devoid of caricature, while, Wogue notwithstanding, we cannot quite say the same of Marignan. As the readymades approximate the simple student prank or *charge d'atelier*, yet resound with a more complex style and philosophy of *blague*, they also implicate the practice of mystification, a related category of comic critique.

Mystification is a broader act of comic defiance than *blague*. It can be a forgery or pastiche; it can refer to something that is meaningless, but made to appear arcane or hermetic; or it can be a practical joke. In most cases, it implies a counterfeit or sham. According to the evidence of the press and of memoirs, the period around 1880 to 1914 is awash in mystification, which can be described as a virtual genre unto itself of anti-social behavior. In order to envision its reach, it is worth recalling that the cardinal event of the French 1890s, the Dreyfus Affair, was fueled by the mystification of a forged letter.[146] In October 1899, the *Revue des Deux Mondes* reported the exploits of one Lemice-Terrieux, who sends letters to newspapers about scandals that never occur in places that don't exist, announces *conférences* that never take place, and submits the forged or fictive "unpublished" correspondence of significant figures from recent history, which is duly published and discussed in the press. He has, they add, plenty of imitators: "a wind of mystification blows over our society."[147]

The history of mystification is, according to Paul Lacroix, the "*bibliophile* Jacob", in 1875, older than the word itself. Lacroix traces mystification back at least to the period of Louis XI, and the propagation of *farces* and *soties*, the comical deception of the gullible and naïve *mystifié*. The word, however, was invented during the mid-eighteenth century, when mystification, in the hands of the playwright Antoine Poinsinet, became an art. The etymology is obscure, but Lacroix believes it to have been derived from *mystagogue* and *myste*, which had been previously used to designate the *initiateur* and *initié* of a religious cult. Quoting from a period source, the original definition was: "those snares into which a simple and credulous man, whom one wants to ridicule, are made to fall." Adapted by the Académie Française, the verb *mystifier* was formalized: "to abuse the credulity of someone in order to amuse at their expense."[148] Subsequently, mystification became a society fashion, the history of which Lacroix relates in elaborate detail.

It is from the early history of the genre that we learn the basics of mystification style. In an article on the subject from 1830, mystification is presented as a modern social phenomenon, and the *mystificateur* described as a "cold and impassive being" who remains "calm amidst all the people he stirs up and puts in uproar about him; . . . that great social mechanism hidden beneath bourgeois dress who, according to his malicious pleasure, makes the cogs which he sets in motion rotate and reverse, indeed jump up." Observing the effects of his own misconduct, he "stands beside you [and] shares your astonishment with utmost sincerity." The *farceur* is but a modest sub-category of this elite, which composes "a true social aristocracy."[149] Implacable amidst the calamity of his own devices, the *mystificateur* shares a fundamental rapport with the *blagueur*. Joined by the demeanor of the deadpan, they are cold-blooded comrades in hoax.

Since mystification and *blague* are not absolute, distinctions in usage often break down. By the Third Republic period, the two were often conflated. Such is *fumisme*, itself a mid-

nineteenth century term of mystification which was revived in 1878 by the Latin-Quarter bohemian student community of "Hydropathes," and the splinter group which called themselves "Les Fumistes." (Originally a "chimney sweep," the *fumiste* came to be a *mystificateur* after his depiction as such in a mid-nineteenth-century vaudeville.[150]) In his book on the period, Emile Goudeau describes the struggle of his generation to overcome the pessimism of the moment through a release of "imperturbable *boufonneries*."[151] This is the climate of post-war spiritual malaise in which Raynaud planted the sociology of *blague*. Goudeau, in his context, specifies "*blagueur à froid*, these experiments in *mise en scène fumiste*";[152] the expression "cold *blagueur*" is valuable, for it exemplifies the stylistic identity with mystification. The technique of *fumisme*, which Goudeau describes as a form of disdain expressed through the aggression of hoax,[153] was explicated by Georges Fragerolle, in an article for the house organ, *L'Hydropathe*. Fragerolle distinguishes between the *fumiste* and the *homme d'esprit*, who draws attention to his own wit:

> How much more brilliant and more complicated at once is the *fumiste*, who, beneath a naïve, quasi-prudhommesque envelope conceals this core of skepticism which is the very stuff of *esprit*. To make someone feel . . . that he is an imbecile, that's the nature of *esprit*. To agree with him and make him reveal the very quintessence of his imbecility, that's the nature of *fumisme*. *L'esprit* asks to be paid on the spot with bravos or discreet smiles; *fumisme* carries its own reward: it makes art for art's sake. In order to pass for an *homme d'esprit*, it is sometimes necessary to be an ass in a lion's skin; in order to be a good *fumiste*, it is often indispensible to be a lion in the skin of an ass. In the first case, the effect is direct; in the second, it is once, twice, sometimes ten times removed.[154]

Like Wogue's *blague*, which represents bourgeois stupidity by incarnating it, Fragerolle's *fumisme* mocks the unwary victim by encouraging him to be himself. Impassivity is the chief agent. We have few real instances of *fumisme* from the period that adhere closely to Fragerolle's proscription, though there is abundant reference to the custom of the practical joke. Chief among the young professionals of the Latin Quarter was Eugène Bataille, better known to his cohorts as "l'Illustre Sapeck" (and editor of the magazine *L'Anti-Concierge*). In addition to the spontaneous verbal sally, Sapeck was legendary for prankish mystifications, and his exploits, which consisted largely in confounding clerks and functionaries, were considered to have been textbook demonstrations of *fumisme*. Descriptions of Sapeck's mien – cold, grave, ostensibly oblivious to his own eccentricity and thoroughly composed during the execution of the gag[155] – show us where *fumisme*, *blague* and mystification meet; even the practical joke was as much a function of style as content, and if the deadpan did not necessarily imply a bourgeois masquerade, it did serve as a kind of imperturbable source of bourgeois frustration, and a joke-for-joke's sake composure.[156]

With the subsequent commercialization of Latin Quarter *blague estudiantine*[157] by entrepreneur Rodolphe Salis at the Chat Noir cabaret in Montmartre, a culture of professional humor emerges from these principles of *fumisme* and the practical joke. Somewhat generically, mystification came to be understood as "the secret of chatnoiresque laughter," directed in general against that *mystifié idéal*, the bourgeois *poire*.[158] Certain humorists help us to further specify the stylistics of mystification. According to Pierre Mille writing on the Chat Noir in 1912, the element of surprise was critical:

"the true humorist should be serious, even reasonable in appearance; and from a premise that is logical, cold, sensible, even banal, he comes suddenly to a conclusion that is unexpected, baroque, outrageous."[159] The cabaret singer Mac Nab, for example, adapted this technique to the comic *chanson*: in one song, an affectionate hymn to the effects of a warm stove which reminds him of young love during the garret-bound December days of student life, he inserts a bit of straight *publicité* for the untold benefits of a newly devised portable heating unit; the interjection of bourgeois practicality deflates the cliché of bohemian sentiment.[160]

Among the most celebrated figures from the Chat Noir milieu, Charles Cros and Alphonse Allais were the most enduring. Poet, inventor and former member of the "Zutistes" group who actually spent his last years around the Chat Noir, Cros was, according to Gustave Kahn, a master of the deadpan manner, which he practiced in the performance of comic poems and monologues. His delivery was dry and clean, his gestures minimal, and with barely a hint of malice in his eye, "he immolated the philistine on the altar of his thought, but all of that remained internal."[161] Kahn maintains that Cros' comic style was influenced by his abiding interest in science, which inflected both his poetry and his monologues with "an excessive sobriety."[162] Both "hard-working and indolent," Cros was adverse to self-promotionalism, never having troubled to market his inventions, which included color photography and the phonograph; a profile of practical, stylistic and "philosophical indifference" emerges, a psychological alloy of the deadpan *mystificateur* and the apathetic *raté*.[163]

Unlike Cros, Allais began his career as a humorist in the Hydropathes circle, followed by stories for Le Chat Noir. Allais' work was also closely associated with a certain spirit of science. Literally speaking, his early short stories and anecdotes from Montmartre frequently concerned fantasies on science and technology, which was something of its own genre during the period, and a precedent for Alfred Jarry's celebrated "pataphysics" and Pawlowski's fourth dimension.[164] Figuratively, Allais was also a humorist *à froid*, and most assessments of his work draw the inevitable parallel between form and content. Kahn remarks on Allais' "logical" madness,[165] and Donnay describes him as "an admirable clown of logic, a marvelous mechanic of fantasy."[166] During the pre-war, on the occasion of a monument to Allais erected in his native Honfleur, Allais' science of humor was still recalled as a cardinal contribution: "Allais, devoted to chemistry and the natural sciences, developed his burlesque reasonings with a rigor so relentless and so impressive, that we were introduced, if I may be so bold, to a kind of new *frisson*."[167] For Jean de Pierrefeu in 1912, Allais and other ironist-*mystificateurs* of the Chat Noir were "*humoristes d'attitude* whose comedy issues from the contrast between a grave delivery and the joyful absurdity of that which they relate . . . lucid, cool *mystificateurs* . . . mathematicians of the absurd."[168]

In mystification, science is a matter of style, regardless of content. When the *mystificateur* addresses the subject of science, the correlation between pseudo-reason and comic deadpan is explicit; here, a lineage can be traced from Lewis Carroll to Allais to Jarry and 'pataphysics, for the genre of absurdist science-fantasy itself depends on the objective proposition of subjective nonsense.[169] Jarry is clearly a critical example. His manner of speech (*parler Ubu*) corroborates the bridge between deadpan mystification of the bourgeois and science-style as matter of comic technique, whether or not it was

applied to an actual parody of science: as André Gide describes it, Jarry affected a "bizarre implacable accent – no inflection or nuance and equal stress on every syllable, even the silent ones."[170] In this manner, Ubu, Jarry's bourgeois grotesque (himself a descendant of Monnier's Prudhomme), ridicules his own pomposity with the stilted inflection of inflated seriousness and mock formality. Yet, despite the tremendous impact of Jarry in general, something more significantly mundane can be noted: a vast culture of mystification in Paris within which Jarry can be set. There, the mechanics of hoax are the common apparatus for a broad range of activities, from student pranks to a philosophy of anti-social behavior cloaked in the moral imperative of disdain. It might be tempting to treat Jarry and his influence as a special case, but, out of context, he is almost too prominent and eccentric to represent the daily-life of mystification and its insinuation into the fears of pre-war experience.

In this regard, figures like Sapeck, Cros and Allais are only a little less problematic, though they help us to fill in crucial period assumptions about qualities of style that, in turn, transcend their individual example. As a single proponent, Lemice-Terrieux and his unnamed "imitators" probably represent a better low-profile choice; fake news possesses a certain banality that is attractive, for it reveals the scientizing objectivity of mystification at work and play in a context of daily truth. To return from there to the specialized realm of avant-garde history, we can turn to the false-dispatch *blague* of Fénéon, Satie, Salmon, Cravan, Picabia and Apollinaire, where news was as often invented or imitated as manipulated. A real-life exercise in deadpan mystification, and a sub-category of the broader genre, this phenomenon illustrates the infiltration of an authentic ambiguity into both the modernist enterprise and the bad-faith discourse of avant-gardism. This is to say that, though few spectators were aware of avant-garde press manipulation, the practice acquaints us with a larger socio-cultural pattern to which the art-public's esthetic disorientation belongs.

The fact is, mystification occurs throughout various segments of the pre-war avant-garde community, and while a good deal of this activity remained private, certain personalities were especially notorious in this regard. Vlaminck describes "le goût humoristique" of 1900, and reveals that, "Beneath a calm bearing, with his placid look, no one relished the pleasures of mystification like André Derain. In *blague à froid*, he had no equal . . . For Derain, mystification was a manner of being."[171] In memoirs and accounts of the period, the daily practice of arts and letters is inflected by an ironic timbre. Celebrated figures include poet Jean Moréas, a despotic genius of paradox and *raillerie* at the café Vachette, whose young disciples included Apollinaire and Salmon.[172] Others are now forgotten, but equally significant because they were taken for granted: the artist Zyg Brunner, a *habitué* of the Montmartre cabaret milieu, was a straight-laced *mystificateur* in proper bourgeois dress; Jacques Vaillant, a resident of the Bateau-Lavoir, belonged to the hoaxish Mortigny group, which was comprised of students at the Académie Jullian and the Ecole des Beaux-Arts.[173] Studio farce among the Picasso circle was witnessed by Jules Romains, who used the material for his 1913 novel *Les Copains*, concerning the mystification of an entire town in the Auvergne by a conspiratorial band of students from the capital.[174] That year, a celebrated hoax was mounted by Paul Birault (editor of the newspaper *Eclair* and publisher of Apollinaire and Jacob), who succeeded in soliciting dozens of donations from senators and deputies for a statue commemorating the cente-

nary of an imaginary "precursor of Democracy," Hégésippe Simon. The revelation was a scandal, but the magazine *La Publicité* considered it a classic of its kind, fully befitting an age of "*boniment*, bluff and the imposition of ideas."[175] Thereafter, the ruse would become a familiar analogy: discussing Picasso's collages, critic Tabarant remarked, "Madness has its limitations, but who would be able to assign any to mystification? I await the works of Hégésippe Simon, that great patron of Precursors."[176]

Birault derailed bourgeois certitude with an invisible charade of bourgeois decorum. The same might be said for Max Jacob, whose poetry has been described by historian Jean Cassou as a form of anti-bourgeois incoherence delivered in a tone of bourgeois imperturbability: "The most audacious negation that can be made of a thing is to reproduce it ... He presents himself and denies himself at the same time."[177] Cassou's remarks conform to tales of Jacob during the cubist epoch, at which time he cultivated a persona of ambiguous dimensions in which sincerity and irony were virtually indistinguishable.[178] "Max knew everyone and no one knew him," he wrote of himself.[179] His performances of comic burlesque were the delight of the Bateau Lavoir and the bistro haunts of the Picasso circle,[180] but his philistine "explanation" of cubism as a studio hoax was probably responsible for encouraging a hostile reception in the press.[181] A genuine practitioner of astrology and cartomancy, he was believed to be deceiving himself as well as others.[182] His predilection for the arcane and the esoteric, including ancient Celtic verse, did not fool *Les Hommes du Jour*, where Jacob was ridiculed in 1911 as "founder of the Ecole druidique, cubist and professor of the Cabala."[183] Raynal later maintained that Jacob's avocations compare to pre-war interest in fourth-dimensional science, "less for reasons of technique, of which very little was understood, than as a source for examples of lyricism, invention and non-conformist audacity"; and that this, in turn, pertains to a broader concern among the Bateau-Lavoir cubists for "anything that relates to hermeticism, magic, the cabala, esotericism in general."[184] From high to low, we should also recognize the one truly formalized cult of secrecy: the Société des Amis de Fantômas, devoted to the pulp-novel master of disguise and villainous mystification. Members included Picasso, Salmon and Apollinaire; Jacob was the unofficial president.[185]

Apollinaire's own practice in mystification was well developed; practical jokes, fake expertise, tall tales at the cafés Flore and Rotonde – the range is broad and deep. "His erudition was completely modern," Jacob wrote, "He came to invent whatever he didn't know."[186] Among the testimonials to Apollinaire's duplicity, Gabrielle Buffet-Picabia remembers having been caught up in his stories for their entertainment value, though it was impossible to tell whether they were sincere or simply "part of that system of mystification in which he excelled. To tell the truth, I never knew."[187] Duchamp remembered how difficult it was to know Apollinaire, especially in the context of literary conversation, describing it as:

> a series of fireworks, *blagues*, lies, all untoppable because it was in such a style that you were incapable of speaking their language ... One day I went with Picabia to have lunch with Max Jacob and Apollinaire – it was unbelievable. One was torn between a sort of anguish and an insane laughter.[188]

Accounts of this kind are an obligatory feature of every memoir concerning the poet-critic, be they affectionate or hostile.[189] As a result, Apollinaire's personality was nothing if not

slippery or opaque, "mysterious and secret . . . deliciously impenetrable."[190] To some, he appeared engaged in persistent role-playing, adopting different intonations of voice, even different styles of handwriting, in order to suit his intentions of the moment.[191] Among the *initiés* of Apollinaire's pre-war *Soirées de Paris* circle, including Salmon, Jacob, André Billy and René Dalize, a *ton apollinarien* was developed, "at once prudhommesque and derisive," through which solemn truisms were dispensed with bourgeois gravity, much to the consternation of café waiters.[192]

Apollinaire's reputation probably did little to mitigate police suspicions in August and September 1911, when he became inextricably bound-up, and briefly implicated, in the theft of the *Mona Lisa*.[193] It certainly did influence the critical reception of his work. Reviewing his *Alcools*, a book of collected verse published in 1913, Henri Martineau observes that Apollinaire's skill in "pushing farce to mystification" should be taken as a warning, which is fulfilled as such by the fact that the book is entirely devoid of punctuation. Martineau's review is otherwise largely positive, and Apollinaire, replying with gratitude and tact, also paused to admonish, "I have never indulged in practical jokes or mystifications concerning my work or the work of others."[194]

This, of course, is demonstrably untrue. In late 1912, Apollinaire composed his poem "Les Fenêtres" with the help of Billy and Dalize at the café chez Crucufix. As Billy relates, Apollinaire had suddenly remembered that his catalog essay for a Delaunay exhibition was overdue, and the three men composed the poem for this purpose on the spot, "over three glasses of Vermouth," each contributing a line in turn.[195] There is some controversy over the degree to which the finished poem, which was used for the catalog, was actually reworked later by Apollinaire. (Delaunay, clearly unwilling to accept the casual nature of a game on behalf of his esthetic idealism, later claimed that "Les Fenêtres" was written in his studio.) Billy's account, however, conforms to the methodology of the *poème-conversation*, according to which Apollinaire recorded stray bits of café and bistro talk, including snatches overheard at other tables.[196] Whether or not the striking disjunction of otherwise unrelated phrases in "Les Fenêtres" was subsequently refined, the technique touches on a tangential relationship between innovation and hoax which, in the case of Delaunay, could very definitely be exploited by Apollinaire for his "work [*and*] the work of others."

More explicitly, in one case, Apollinaire's practice of a deliberate extended hoax is well-documented: this is the column on women writers, for the literary review *Les Marges*, which Apollinaire wrote in 1909 under the pseudonym "Louise Lalanne." The series, which included some original verse, generated a good deal of favorable comment at the time, but the failure of the author to appear in public necessitated her disappearance from the scene (she was said to have been abducted by a cavalry officer).[197] Literary mystification, a natural for Apollinaire's repertoire, was a long-established genre with an active recent history. Symbolist poetry lent itself to imitation of this sort, due especially to its experiments with oblique metaphor and neologism. The most celebrated case was perpetrated by Gabriel Vaucaire and Henri Beauclair, who invented the poet Adoré Floupette and published a volume of poetry under his name in 1885 entitled *Déliquescences*. The book was hailed as a masterpiece of the genre, even after it was recognized as a parody-pastiche of Mallarmé, Verlaine and Rimbaud.[198] This and other examples were legendary during the pre-war years. In his *Nouvelles de la République des*

*Lettres*, Salmon layered hoax atop hoax with news items concerning the erection of a monument to Floupette, complete with on-going reports on the progress of the fake subscription (donations included one *lire* each from Marinetti and Riciotto Canudo, and a 25-centime postage stamp from Ernest de la Jeunesse).[199] In a tellingly ambiguous claim, Salmon notes "the happy influence which the author of the Déliquescences has had on his contemporaries and on current poets."[200] In *La Plume* in 1913, Laurent Tailhade remembered *Déliquescences* as a "tour de force raté."[201]

As proper mystification, literary pastiche succeeds only to the degree that its actual author is invisible; as the imitation of a pre-existing style, it is parodic when it is exact. If it succeeds, as in *Déliquescences*, it can be appreciated both for its ingenuity and its qualitative approximation of the original; as an exercise in the ambiguity of authenticity and pseudo-style, it is seamless. According to André Billy, "pastiche was *à la mode*" before the war.[202] To Apollinaire's example, we should add that of his close friend Fernand Fleuret, whose brilliant pastiches of sixteenth and eighteenth-century French verse were genuine fakes in the tradition of Ossian, Chatterton and other historical mystifications. (This was a genre which was itself the subject of *Les Grandes Mystifications littéraires*, published by Augustin Thierry in 1912.)

While it most commonly takes the form of a fictitious author, literary mystification could also be pre-disclosed with the simulation of one known author by another. Of course, open imitation of an historical style is a recurring issue in the history of French art and literature, and, as Alexandra Parigoris has demonstrated, the irony of pastiche poses fundamental ambiguities to the interpretation of post-war neo-classicism.[203] During the pre-war period, pastiche appears to have flourished within the culture of novelty to which advertising and avant-gardism also belonged. The popular favorites in this genre were Paul Reboux and Charles Muller. Between 1908 and 1913, Reboux and Muller composed three volumes of parody entitled *A la manière de . . .* Their range embraces Shakespeare and Racine, but their specialty was recent literature, including among others Verlaine, Mallarmé, Moréas, Fort, d'Annunzio, Huysmans, Barrès, Mme de Noailles and Tristan Bernard; Adoré Floupette, already once-removed from original style, was spared. *A la manière de . . .* was a popular success. Here, comic effect requires that the pastiche be exaggerated just enough to draw out the salient characteristics of a given manner, yet "photographic" enough to pass, with only a slight suspension of disbelief, for the real thing. "As such," wrote Pierrefeu, "their work is an object of science. While having no other apparent purpose but to amuse us with admirably successful imitations, they have realized a sort of literary criticism the truth of which astonishes us." For Pierrefeu in 1913, Reboux and Muller had developed parody into an infallible detection system, designed to extract novelty from originality. Moreover, they had managed to seize a peculiar quality of the modern spirit:

> Their title is significant. "Manner," that manifestation of the modern malady of originality, is what they have highlighted . . . Our contemporaries have no other goal but to attain that originality at all costs. From that comes this disastrous research into the unusual expression, the unfamiliar subject.[204]

The precise contemporaneity of *A la manière de . . .* as a catchphrase of cultural criticism derives both from what its authors reveal about "manner" in the work of others,

and from the nature of their own project, the parodic facsimile of manner. As a work of "criticism," the books are variations on the "prejudice of novelty" theory, and their pertinence to the current censure of avant-gardism was obvious; in the literary review *Pages Modernes*, Reboux and Muller were welcomed as "brilliant demolishers of literary illusions," and their "blustering parody" of d'Annunzio was said to resemble a caricature of "the intellectuality of these youths of the moment among us who extol futurism, cubism, orphéism (*sic*)."[205] But as mystification, the books also suggest a model with which to characterize, rather than caricature, the activity of the new artist. *Le Parthénon* praises the title "à la manière de" as a perfect fit to "our epoch, during which reigns the unconscious *fumisterie* of the unanimists, the futurists, and the progeny of washed-out symbolism."[206] Few slogans better represent the age of isms, *réclame* and hoax; the popularity of *A la manière de . . .* corresponds to pre-war critical depictions of modern esthetic history as mere pastiche, a substitution of novelty for innovation fulfilled by a rapid succession of pseudo-styles.

One pastiche of the period stands out for having addressed itself to extravagance and originality in new art. In 1910, the Salon des Indépendants accepted *Et le soleil se coucha sur l'Adriatique*, a picture painted by the switching tail of Lolo, pet donkey at the Lapin Agile. This *farce de rapin* was engineered by Dorgelès, who awarded the title (after considering still life and portraiture as alternatives), named the painter – Joachim-Raphael Boronali, an anagram for the ass Aliboran from La Fontaine – and issued a manifesto. The new school was dubbed "Excessivism": "Holà, great excessive painters, my brothers, holà, sublime and renovating brushes, let us dash the ancestral palettes and pose the great principles of the painting of tomorrow. Its formula is Excessivism . . . Excess is a force in all things."[207] One obvious target is Marinetti (Boronali is listed in the Salon catalog as Genovese[208]), though Dorgelès claimed to have in mind all recent excesses perpetrated in the name of "independence":

> In sending the work of . . . a true ass to the Salon des Indépendants, we did not mean to offer ourselves the too-simple satisfaction of idiotically and pointlessly mystifying the artists who, with a courageous independence, accomplish meritorious work. Instead, we meant to show to the fools, the incompetents and the vain who encumber too large a part of this exhibition . . . that the work of an ass . . . is not out of place among their works.[209]

Matisse, Henri Rousseau and Le Fauconnier were the designated victims,[210] though Dorgelès' memoirs further specify futurists and cubists. (There was no futurist painting as such in 1910, but the futurist manifesto was already one year old.)[211] The execution of the picture was photographed and certified by a bailiff, P. Brionne; the photograph was published for the first time by prior arrangement on March 28 in *Le Matin* (fig. 72).[212] Opinions differed on the success and impact of the prank, though one jury member of the Salon de la Société Nationale was "persuaded that a *fumisterie* of this kind can have a great influence on the taste of the public and the confidence it will show in anything that appears extraordinary."[213]

Dorgelès was careful to note that the Lapin Agile, where Boronali painted his picture, was also home to many of the Indépendants themselves.[214] And though the broadly-brushed canvas bears little resemblance to any work of the avant-garde (save, perhaps, a

LE MATIN

# UN ANE CHEF D'ÉCOLE

*Il expose aux " Indépendants "*
*un tableau peint avec sa queue*

## CET ANE, IL EST VRAI, EST DE MONTMARTRE

**L'ARTISTE**

Elle naquit, cette école immodérée, au dernier Salon des indépendants, d'un manifeste et d'une toile. Par ses giclées de cadmium, ses ruissellements de chrome, ses fusées de cobalt, le tableau intitulé simplement *Et le soleil s'endormait sous l'Adriatique* éteignit comme piètres chandelles d'épicier les toiles de Monet, Manet, Pissarro et Merticelli... Et le nom jusqu'alors inglorieux de son auteur : Joachim-Raphaël Boronali, sonna l'hallali triomphal de la nouvelle école avec toute la sonorité de ses claires voyelles ultramontaines. Joachim-Raphaël Boronali, un maître ! Pendant quinze jours, le Tout-Paris artistique défila devant son *Soleil sous l'Adriatique*. On exalta, on disséqua, on copia la technique. On commenta avec excès le manifeste suivant que le nouveau maître semble avoir rédigé avec un tube de vermillon :

L'excès en tout est une force, la seule force. Le soleil n'est jamais trop ardent, le ciel trop vert, la mer lointaine trop rouge, l'obscurité trop épaissie noire, comme ne sont les héros trop audacieux, les fleurs trop odorantes.

Ravagéons, ravagéons les musées absurdes ; piétinons les routines infâmes des faiseurs de boîtes de bonbons, et allons d'un pas souple et précis vers le meilleur « devenir ».

Haut les palettes ! Haut les pinceaux et haut les tons ! Vivent l'écarlate, la pourpre, les gammes corruscantes, tous ces tons qui tourbillonnent et se superposant sont le reflet véritable du sublime prisme solaire !

Ne nous laissons pas rebuter par les braillements des putois écorchés vifs qui agonisent sous la Coupole.

Plus de lignes, plus de fluctuations, plus de métier, mais de l'éblouissement, du rutilement !

En lisant cet « évangile de la couleur », plus d'un se trouvèrent peintres sans y avoir pensé.

Une chose inquiétait cependant le chœur sans cesse grandissant des disciples de Joachim-Raphaël Boronali : c'était l'excessive modestie du maître. Où gîtait-il ? Comment portait-il sa gloire ? Nul ne savait ; on ignorait sa vie. Mais on l'imaginait fière et laborieuse, sur les hauteurs indépendantes de Montmartre. Et ses admirateurs lui tressaient une belle couronne.

Hélas ! cette couronne, quand on la lui

**L'ŒUVRE**

offrit, Joachim-Raphaël Boronali la brouta avec une simplicité rustique, car ainsi qu'il apparaît du curieux constat d'huissier suivant, *Et le soleil s'endormait sous l'Adriatique* et son auteur J.-R. Boronali, ne sont qu'une farce de rapins indignés de l'hospitalité trop facile du Salon des Indépendants.

Nous nous sommes transportés, dit l'officier ministériel dans son exploit, au cabaret du Lapin-Agile, sis à Paris, rue des Saules, où étant devant cet établissement, MM. X... et X... ont disposé, sur une chaise faisant office de chevalet, une toile à peindre à l'état neuf. En ma présence des peintures de couleurs bleue, verte, jaune et rouge ont été délayées et un pinceau fut attaché à l'extrémité caudale d'un âne appartenant au propriétaire du cabaret du Lapin-Agile, et prêté pour la circonstance.

L'âne fut ensuite amené et tourné devant la toile, et M. X..., maintenant le pinceau et la queue de l'animal, le laissa par ses mouvements barbouiller la toile en tous sens, prenant seulement le soin de changer la couleur du pinceau et de le consolider.

J'ai constaté que cette toile présentait alors des tons divers, passant du bleu au vert et du jaune au rouge, sans avoir aucun ensemble et ne ressemblant à rien.

Après ce travail terminé, des photographies furent prises en ma présence de la toile et de son auteur.

En conséquence et de tout ce que dessus, j'ai dressé le présent procès-verbal pour servir et valoir ce que de droit.

Coût : Dix-huit francs vingt centimes.

P. BRIONNE.

L'école excessiviste survivra-t-elle à ce coup ?

72. "Un âne Chef d' Ecole," *Le Matin* (1910).

distant recollection of fauve landscape), Boronali would become a convenient critical reference to self-promotionalism and pretensions of novelty in cubism and futurism.[215] Generally, the implication is that Boronali proves the prospect, if not the likelihood, of avant-garde mystification. If *Et le soleil se coucha . . .* is not an imitation of new art, it is

a pastiche of originality; and its success is a demonstration of mystification as deadpan, sneaking into the Salon concealed as an accurate simulation of philistine expectations. In a deadpan example of reverse-hoax in 1912, the critic for *Journal des Débats* explains that Metzinger's cubism, "reason itself, being transcendent geometry," opposes the "free instinct or . . . unconscious inspiration" of Boronali, the "mad poet" who unleashed such enthusiasm" in the soul of the bourgeois."[216]

Questions of mystification and pastiche would continue to penetrate critical speculation about the activities of the avant-garde. On March 5, 1914, an anonymous observer in *Les Ecrits français* reported that chief attractions at the Indépendants include sculptures by Archipenko, criticism by Arthur Cravan and a canvas by Serge Férat. In particular, Férat's submission has stirred trouble in the cubist community, which refuses to recognize him as a disciple "of the Master" (Picasso). With its pipe, guitar strings and newspaper clippings, all "according to M. Picasso's latest formula," his work has been taken to demonstrate not mere plagiarism, but outright mystification intended to "provoke discussions of a new order". The proof of Férat's "hoax" (*supercherie*) is a masthead from the Italian review *Lacerba*, which the critic takes as a reference, at Picasso's expense, to some internal conflict among the cubists. He admits that "we will remain outsiders to the debate," but only means "to ask MM. Derain, Braque and certain young cubists, whose illuminated admiration for Picasso is fading, if it is true, according to rumor, that 'Férat' is the pseudonym of one among them who enjoys the circumstances of mystification. And if Férat exists? He should still clear his name."[217]

Of course, Férat was the pseudonym of Serge Jastrebzoff, a wealthy Russian who (with his sister Hélène d'Oettingen, under another pseudonym, the pun "Jean Cérusse") had been financing the publication of *Les Soirées de Paris* since late 1913.[218] As a minor cubist painter, his work of the period bears a closer resemblance to Marcoussis than Picasso; but Picasso did execute two *Lacerba* collages in spring 1914,[219] and one of these may have been the presumed referent of the alleged fake. Some days after the item in *Les Ecrits français*, *Gil Blas* published a follow-up to the question, "Is it the work of a disciple or a *fumiste*?" Férat, they report, is really "J . . ."; "and here is André Derain, cleared of a terrible accusation, which should make him happy."[220]

The Férat incident clearly reflects a certain degree of misinformation. What remains significant, however, is the ease with which misinformation breeds speculation over mystification, which is its natural adjunct. The *Lacerba* picture was undoubtedly an authentic Férat, but the circumstances of avant-gardism were such that a genuine picture might be mistaken for a shrewd pastiche "à la manière de . . ." Given the dense confusion of conflicts, claims, isms and *nouveauté*, space for certainty is scant at best. The highly uneven quality of painting in general at the Indépendants, and the work of "salon cubists" in particular (including many names which are forgotten today), heightens critical suspicions of arrivism, or art according to fashion; it is a short hop from perceived imitation of this sort to the facile simulation of hoax, which itself can be motivated as an allegation of fraud. Even more than Boronali, the Férat affair demonstrates that pre-war *blague* and mystification constitute expressions of a spectacle of disorientation and distrust that persists at the time. A hoax which is not a hoax best reveals the condition of the avant-garde to have been permeated by second-truth ambiguities which were peculiarly new.

—7—

The deadpan of mystification betokens transparency and silence, an overlay of hoax and authenticity that can go undetected or that can be imagined where it does not exist. Like *blague*, it operates best from a distance; but unlike *blague*, which can most often be envisioned as a remark or statement, mystification is an act, possessed of greater dimensions and unspoken implications. While mystification can be an elaborate practical joke which is finally revealed with great flourish, it is equally interesting as a broader, thinner procedure that coats the ordinary course of events. And if the style of *blague* and mystification are identical for their virtual invisibility, style itself can be the very content of mystification. Above all, in the context of the pre-war avant-garde and questions of duplicity or bad faith, mystification or hoax – gross and subtle, actual and perceived, deliberate and unconscious – is a law of esthetic nature which touches or conditions a wide range of experience and observation.

These circumstances are reflected in the ways which mystification both infiltrates and is drawn into Duchamp's work. It is curious, for example, that a principle influence on Duchampian linguistics, Jean-Pierre Brisset,[221] was the subject of a presumed mystification in 1913, when Duchamp's interest in his work would have first peaked. A published philosopher and natural historian, Brisset developed an elaborate linguistic system according to which the syllables and phonemes of different words are analysed for their punning similarity to one another, and explicated according to hidden meanings or analogies that can be derived as a result. From "poussin," for example, he isolates "scin," and concludes that, during an early stage of natural history, the baby chick once suckled the breast (*sein*) of the mother hen. This and other dubious "discoveries" captured the attention of Paul Reboux, writing for *Le Journal* in January 1913, who reports that, within some unspecified academic-literary circle, Brisset had recently been elected "prince des penseurs."[222]

The authenticity of Brisset's new honor was, in fact, open to question. In April, Victor Meric ran an editorial in *Les Hommes du Jour* concerning the "prince of thinkers" ceremony, charging that the whole affair was an "atrocious *blague*" initiated by Jules Romains – only a schoolteacher and the author of a book "uniquely consecrated to schoolboy pranks" (*Les Copains*?) could be responsible for such a *facétie*. According to Meric, Brisset was a harmless if loony septuagenarian who had been victimized by a conspiracy of young *littérateurs*, crowned in sarcasm and ridicule at the Panthéon before Rodin's statue of *The Thinker*. Meric draws the obvious comparison, recalling Rousseau, the simple "peintre-douanier," similarly celebrated in his time, whose posthumous restrospective shows that he was survived by little more than a practical joke. Cubism, futurism and orphism are sufficiently ludicrous, Meric continues, implicating the avant-garde in general; "no need to set oneself searching for simple souls" in order to perpetrate an outlandish hoax.[223]

The example of Rousseau is significant. There is no doubt now that Rousseau's esthetic genius, whether or not it was an accident of appearances, played an essential shaping role in the development of avant-garde pictorial style.[224] During his lifetime, of course,

Rousseau's critical fortunes were far more complicated, and he was taken by critical consensus to have been the perpetual victim of malicious deceit: "discovered" and promoted in jest by Jarry and Apollinaire; "decorated" by Maurice Cremnitz, pretending to be Dujardin-Beaumetz, Surintendant des Beaux-Arts; tricked by Gabriel Sauvaget, a crooked employee of the Banque de France, into opening an account with faked credit-transfer notes using forged identity papers, and arraigned before the Cour d'Assises; and fêted by the avant-garde in a rowdy banquet that bore every sign of a classic Montmartre *farce de rapin*.[225] Rousseau's pre-war reputation is well characterized by the title of an article in *Le Petit Journal* written on the occasion of his trial: "Mystification."[226] In fact, though it is tempting to describe the 1908 Rousseau banquet in Picasso's studio at the Bateau-Lavoir as a sincere celebration that was overrun by joking high spirits,[227] the event epitomizes the ambiguities of mystification, in which elements of sincerity and hoax are indissolubly mixed. Criticizing Gertrude Stein for believing the banquet to have been something of a farce, Salmon would later claim that Stein

> understood little of the tendency we all had, Apollinaire, Max Jacob, myself and others, to frequently play a rather burlesque role. We made continual fun of everything. When we dined together, for instance, Jacob would often pretend that he was a small clerk, and our conversations in a style that was half slang half peasant amused everybody in the restaurant. We invented an artificial world with countless jokes, rites and expressions that were quite unintelligible to others. Obviously she did not understand very well the rather peculiar French we used to speak.

He concludes in astonishment: "And what confusion! What incomprehension of an epoch!"[228] It is no wonder, given Salmon's description of the goings-on.

Salmon represents hoax as broad, but hermetic. Yet his reference to Jacob's performance reminds us of the bourgeois-deadpan, and it prompts us to consider that Rousseau, who was capable of grave self-importance, fits squarely into the mold of the middle-class *mystifié idéal*. Rousseau is exceptional, however, for having been at once advanced and conventional, and his presence must have been suspect to critics of the period, partly because it raised the issue of conscious versus unconscious sham. (Reviewing the artist's posthumous retrospective at the Salon d'Automne in 1912, one critic described him as an ancestor of cubist bluff.)[229] Nothing could be more esthetically sincere than Rousseau's work, yet the quality of the pictures is thoroughly at odds with the artist's well-known academic ambitions; and those ambitions, in turn, would seem to preclude any interest on the part of the avant-garde. His pictorial style, suspended somewhere between the *image d'Épinal* and Bouguereau, is not simply another form of primitivism, for it was cultivated from within the precincts of the ordinary. Both bourgeois and *faux*-bourgeois, Rousseau encompasses the complete circuit of mystification – victimization, self-delusion and walking hoax in the guise of a manufactured *succès d'estime*.[230] Rousseau's art has been traditionally defended as unintentionally original or, more recently, reductivist by design;[231] both descriptions are definitive and, as a result, unsatisfying. Rousseau and his art exist in the condition of mystification, broadly defined, where hoax is not merely a charlatan's trick, but a sign of rapid and abrupt esthetic change at a time when the definition of originality was plastic, stretched and continuously redefined both in theory

and practice. In Rousseau, terms of debate such as sincerity and confidence-abuse are essential issues of ambiguity which cannot be resolved.

The same can be said for Brisset. For Duchamp, both Brisset and Raymond Roussel "were the two men in those years I admired for their delirium of imagination." Looking back, Duchamp actually recalled that Brisset was "discovered" by Jules Romains, and remembered the formal tribute before Rodin's *Thinker* at the Panthéon, "where he was hailed as Prince of Thinkers." Like Meric, Duchamp described Brisset as "a sort of Douanier Rousseau of philology."[232] Brisset was not a charlatan but a sincere pseudo-scientist, and his avant-garde apotheosis was a hoaxish appreciation of absurd but original poetic claims formulated as serious natural and linguistic science. His achievement obeys the esthetics of mystification (his demeanor is accidental deadpan), though it need not be depicted as a practical joke. Brisset is akin to Princet, for example, the insurance actuary and amateur mathematician who, according to Duchamp, "played at being a man who knew the fourth dimension by heart." Princet's influence, at least according to Duchamp's account, was similarly conditioned by this fascination for the kind of erudition that falls somewhere between positivistic bourgeois sincerity and outrageous hoax. "We weren't mathematicians at all," Duchamp explained, "but we really did believe in Princet. He gave the illusion of knowing a lot of things."[233] As exercises in deliberate self-delusion, the pursuit of both Brisset and Princet exemplify, in Raynal's words, the investigation of "examples in lyricism, invention and non-conformist audacity." Duchamp concurred: "And for all our misunderstandings, through these new ideas we were helped to get away from the conventional way of speaking – from our café and studio platitudes."[234] Rousseau, Brisset and Princet respectively represent art, linguistics and science as mystification, a straight-faced game that stretches the limitations of conventional wisdom, but represents itself as a form of learning or common sense.

As for Roussel, Duchamp attended a performance of *Impressions d'Afrique* sometime between May 11 and June 5, 1912, with Apollinaire and the Picabias; played at the Théâtre Antoine, this was actually a reprise of the 1911 run at the Théâtre Femina.[235] Like Brisset, Roussel had devised a word game system of elaborate puns that reveal "ordinary" language to possess alternate levels of linguistic sense. As Marcel Sanouillet points out, however, Roussel's system was not codified in print until 1935; Duchamp remembers having been more impressed with the "striking" spectacle than the text of the play, for all that it might have introduced him to Rousselian language.[236] Duchamp claimed that Roussel "was responsible for my glass," and admired him "because he produced something I had never seen . . . nothing to do with the great names or influences."[237] The play relates the adventures of European travelers stranded on the shores of a fictional kingdom in equatorial Africa, Ponukélé, ruled by emperor Talou VII. Many reviews of *Impressions d'Afrique* were especially impressed with the coherence of Roussel's "disquieting" world, a "lucid nightmare" or "chimerical reality" related with clarity and logic.[238] The nature of the work was baffling, "laying claim at once to the *féerie*, the *revue*, the opera, the cinema, farce and certain other genres."[239] Deliriously unconventional, it is in this sense, as much as any other, that it must have appealed to Duchamp. The critic for *Le Charivari* characterized the work as a mystification at the expense of the theater community as well as the public, who willingly fill the hall regardless. Roussel's success is understood here to have been formed by snobism and *réclame*; it is believed that,

if instead of signing the work himself, Roussel had it signed by one of his assistants and represented himself as the patron, a school of art would be formed, one would have cried genius, according to common practice, and, in this case, the mystification would have been successful and complete.[240]

The commentary might be read as simple derision, but it closely recalls the conflation of innovation and hoax in Brisset and Princet, as well as Rousseau. Taken, or mistaken, for a shrewd and deliberate *mystificateur*, Roussel completes a picture of Duchamp's models – unfamiliar enough to have provoked suspicions of sham, but resolute or sincere enough to have been addressed as original. Authenticity is both indeterminable and beside the point. As a matter of style, the lucid or deadpan delivery of bizarre new truths would appear to be Duchamp's criterion for the relevance of innovation; and the popular and critical reception of the avant-garde as a set of similar pseudo-truths establishes a sympathetic condition of disorientation within which Duchamp functioned as an invisible critic. It is just as urgent to acknowledge the culture of hoax in the intellectual history of Duchamp's pre-*Glass* formation as it is to investigate the exact debt he owes to the specific achievement in science or language of each of his preferred thinkers; "Roussel *thought* he was a philologist, a philosopher and a metaphysician," Duchamp explained. "But he remains a great poet" (emphasis added).[241]

The deadpan, that stylistic transparency which is shared by *blague* and mystification, is the one salient feature which bridges the forked road of Duchamp's œuvre around 1913 to 1917. The readymades and the *Large Glass* would appear to have little in common: the one a body of sly banalities, the other a project of arcane convolution. Yet they both subsist in a cold dry climate, where the machine-made drives out the hand-crafted. Even if the *Glass* can be described as a kind of drawing, the line is presented in lead-foil, disguising the role of the artist's hand, and no different in that respect than the prefabricated materials of many readymades. Duchamp did not simply supplant painting with abstractions like chance, choice and science; he replaced the *engagé* quality of touch with the semi-illusion of authorial absence. Of course, the invisibility of his own presence is just that, a semi-illusion or conceit, and this, in part, is what qualifies the governing esthetic stategy as mystification. The readymades and the *Glass* are, then, also joined by the reciprocity of content, as well as style, which *blague* and mystification enjoy. The matter of style, however, is a threshold to that larger experience.

It is no accident that Duchamp's transition from cubist painting to the readymades and the *Glass* is represented by the *Chocolate Grinder*. Handmade to appear machine-made, the *Chocolate Grinder* is a neat package, a painting that joins easel picture and readymade, as well as readymade and *Large Glass* (where the *Chocolate Grinder* will subsequently appear). The *Chocolate Grinder* comes in two versions, in oil from 1913, and oil with thread from 1914 (figs. 73 and 74). For Duchamp, they represent a defining shift. In fact, they were preceded in this by the *Coffee Grinder* of 1911, a painting that simulates mechanical drawing. "It was there," he said, "I began to think I could avoid all contact with traditional pictorial painting."[242] To a painter, "mechanical drawing . . . upholds no taste, since it is outside all pictorial convention."[243] It might be argued that the tastelessness of diagrammatic style is an illusion that simply substitutes one pictorial convention for another; but in the context of paints and canvas, it is enough to accept the

73. Duchamp, *Chocolate Grinder No. 1* (1913).

mechanical manner as a rift, and a close pictorial approximation of Duchamp's ideal. As demonstrations in paint that teeter on renunciation, the *Chocolate Grinder* pictures are closer still:

> I couldn't go into the haphazard drawing or the paintings, the splashing of the paint. I wanted to go back to a completely *dry* drawing, a *dry* conception of art . . . And the mechanical drawing for me was the best form for that dry conception of art.[244]

It is extraordinary in its way that Duchamp's attempt to change the rules of the avant-garde game drew him back to a convention of representation at its most mundane. But the banal mode affords a stylistic implacability that is antithetical to avant-gardism, and it enabled Duchamp to attain a chilly distance from debates over originality, progress and good faith. While Rousseau, Brisset and Princet are at once targets and unwitting instruments of mystification, Duchamp possesses a deliberate cool. In his work, banal machinism is both a subject of modern bourgeois faith, and a dry style capable of cloaking the confidence-man. With the readymades, Duchamp replaced the imitation of a mass-produced object with the real thing, and he was careful to confine himself to choices that were modern but ordinary; as *blague*, they are unimpressive and blasé, or remote. Conversely, in the *Large Glass*, Duchamp brings the deadpan to a project that closely

resembles a contentious ambition of the avant-garde: to formulate the scientizing precepts of a new pictorial order. As a mystification, the work is a parody that might also be taken for a serious and committed extension of cubist science; the ambiguity is idiomatic. The transparency of the *Glass* is both a practical and a symbolic measure of the hoax.

Turning back to critical debates over the nature and purpose of cubism, references to science are relatively consistent. The primacy of "theory" and "system" is a lofty pretense to "pure painting." Cubists are *initiés* and the spectators are *profanes*. Obfuscation has a double edge: it maintains an illusion of higher learning, yet it appeals to the insecurity of the bourgeois client, the self-deluded victim of a marketing scheme defined by snobism. When the pictures themselves are scorned as training exercises in geometric reductivism, then the science is revealed to be a pseudo-science, the *initié* a *mystificateur*. And if cubist ambitions are accepted at face value, the result is more arid conceptualism than painting

74. Duchamp, *Chocolate Grinder No. 2* (1914).

proper: "Based on a geometric formula, cubism is the product of dry cerebrality. It banishes emotion, sacrifices color to linear researches."[245] The corollary is a cubist renunciation of "that *volupté* that their colleagues try to enclose in a nude body; they aspire to essence, to the pure idea, to a speculative drunkenness comparable to that which springs from the study of mathematics."[246]

The cold style of the *Large Glass* freeze-dries a bourgeois depopulation narrative, played out in fourth-dimensional space by a technology of rotating parts and "illuminating gas." Duchamp's investigation of non-Euclidean geometries in the *Glass*, its diagramatic drawings and its abstruse, cryptic notes has been fully established, if not overdrawn.[247] As the literature has demonstrated, the *Glass* touches and skirts various mathematical and geometrical propositions, while adhering to no single system with anything like scientific rigor. Duchamp's appropriation of science or pseudo-science shows him to have been plundering a rhetoric of hermetic technical vocabulary that exploits broad contemporary intolerance for esoteric exclusivity in new art. His later denial of mathematical expertise in the *Glass* is significant and only partly disingenuous, for it is true to the pre-war debate. Following Duchamp, the inception of the *Glass* emerges as a paradox: a liberation from the slur "stupid as a painter," or a work that was produced "without an idea."[248] The matter was one of "producing the precise and exact aspect of science . . . It wasn't for love of science that I did this; on the contrary, it was rather in order to discredit it, mildly, lightly, unimportantly. But irony was present."[249]

The *Large Glass* simultaneously invites and repulses programmatic interpretation. When Duchamp is pushed too far for exegetical consistency, the salient parodic quality of the *Glass*, its incoherence, is lost. The proper climate for the *Glass* is defined less by science than by popular and critical suspicions of cubism as a scientizing mystification, alternately an insincere exercise in deliberate incomprehensibility or a sincere self-delusion of hermetic claptrap. And if Duchamp frustrates subsequent interpretation with contradictions and denials, the nature of mystification (wherein Duchamp subsumes both cubism and its critics) will simply tolerate nothing less. Compare the *Glass*, and Duchamp's evasion, to critic Jacques Rivière on cubist science in May 1912:

> There is nothing for which one should be more cruelly punished than having taken for granted the intelligence of a painter. As soon as you think you've confirmed his position by explaining the sense of his research, he inflicts upon you an explosive denial and makes everyone know that you've understood nothing of his business . . . What good does it do to critique their works? I would only like to describe their state of spirit. They pretend to think; they would have you believe that they are theoreticians; for them intelligence dominates sensibility. They feel that in order to be new, they must pose as intellectuals . . . But in their brain there is nothing; consequently, an idea dilates there like the gas in the cylinder of a motor, expanding to fill the available space, inflating and carrying them forward.

Among the repertory of cubist pseudo-ideas, Rivière includes "representing objects in the 'four dimensions of esoteric space'."[250]

As a matter of record, Duchamp was implicated by name in these speculations over cerebrality and nonsense. At the Salon d'Automne in 1912, for example, Vauxcelles described him as "intelligent but misled," and his drawing *Virgin* as "a trigonometry

diagram."[251] Exhibited at the Section d'Or, his *The King and the Queen traversed by Swift Nudes* attracted attention for its extraordinary title: Vauxcelles mentioned it four times that fall;[252] Tabarant referred to the work, with *Nude Descending a Staircase*, as "agreeable syntheses of mystification";[253] and Max Goth defended it against Vauxcelles' objection that the title disproves any avant-garde claim to have transcended the representation of form:

> I agree with you that the title is not felicitous. I believe, for my part, that the painter wanted to evoke in us the sensation of strange obsessions – too well-known to overworked intellectuals – obsessions which torment with a chaos of hallucinating absurdities, the brain fatigued from logic.[254]

Goth's version, an erotic hallucination brought on by the sleep of reason, already resembles Duchamp's ambitions for the *Glass* as a physics demonstration.

The world of the *Large Glass* is governed by "modern" erudition, "the illusion of knowing a lot of things," where cubist cerebrality and critical suspicions of bad faith generate an omnipresent threat of mystification. The story of the Bachelors, an entire group of men who fail to seize the aerial domain of their erotic ideal, virtually allegorizes the progress of the avant-garde as it was represented in the hostile press. To achieve full measure of hoax in the *Glass*, we can account for Duchamp envisioning his work from both sides; it is a project in art-as-science (and has since been explicated as such) and a complex, on-going and abandoned pastiche of scientizing ambition. When Gleizes and Metzinger post official policy concerning the real proximity of cubism and science, in *Du Cubisme*, Duchamp's act of parodic transposition comes clear: "But if [the painter] ventures into metaphysics, cosmogony, or mathematics," they warned, "let him content himself with obtaining their savour, and abstain from demanding of them certitudes which they do not possess. At the back of them he finds nothing but love and desire."[255] Taken as irony, no more succinct period text for the *Glass* can be imagined.

<div align="center">—8—</div>

About *Du Cubisme*, Arsène Alexandre would soon write that, "from the moment when the appreciation of a work depends on the artist alone, the public need not bother looking." No large public ever *did* see the *Large Glass*, which remained a private enterprise through all of its early life. If the *Glass* belonged to the practical joke variety of mystification, then we would expect it to have been exhibited with some ceremony, since the practical joke requires both victim and audience to be complete. Perhaps the *Glass* more closely resembles a literary mystification like *Déliquescences*, with its small, specialized audience, and its ambiguous destiny as both a hoax and an authentic specimen of symbolist style. For the *Glass*, however, mystification is more a workshop than a categorical limitation, more an area of liberated critical activity than an end in itself. Almost by accident, it might be said to have fulfilled the generic function of hoax when Duchamp sold it to Walter Arensberg, who sold it to Katherine Dreier; in seeing the light of day, the *Glass* was permitted to circulate as a "legitimate" work, and run the full circuit from studio to dupe. In Arensberg, Duchamp certainly found the perfect Brissetian pseudo-scientist of a client (Arensberg's avocation was the cryptographic analysis of the

Shakespeare plays, where he searched for arcane linguistic clues that proved the author-ship of Francis Bacon), and thereby established a startling symmetry of mystification between the origin and the destination of his masterwork. "Arensberg twisted words to make them say what he wanted," Duchamp said, "like everyone who does that kind of work."[256]

Yet Duchamp was not above the *farce de rapin*, the practice of simple prank, which helps us acknowledge the larger ambitions of mystification in a work like the *Glass*. The fortunes of the *Nude Descending a Staircase*, which was blasted with ridicule as a *succès de scandale* at the Armory show in 1913,[257] may have encouraged Duchamp to recognize the American audience as a relatively fresh community of uninitiated *mystifiés*, especially during the war, when Paris had other problems on its collective mind. *Blague* can remain private and still be *blague*, an act of philosophical indifference or disdain that is largely localized or internal by definition; it answers extravagant claims with low-profile irony. But the practical joke is a high-profile stunt, equally ironic, though much more conspicu-ously so. If, according to this distinction, most of the readymades constitute the work of a *blagueur*, the potential for a big laugh that they imply may still have been irresistible. When Duchamp describes "replenishing" the "scandal and publicity" of the *Nude* with the readymade and the *Large Glass*,[258] he was probably referring, from the perspective of 1966, to his esthetic legacy; but the remark also suggests that the reception of the painting inspired new possibilities for the public life of his work.

Duchamp had already exhibited two (still unidentified) readymades in New York, at the Bourgeois Gallery in April 1916, alongside works by Gleizes, Metzinger and Jean Crotti; while *Pharmacy* was shown at the same time, and with the same co-exhibitors, at the Montross Gallery.[259] Their appearance appears to have gone relatively unremarked, perhaps due to their idiomatic invisibility, at least at the Bourgeois Gallery, where they were placed in an umbrella stand near the door. Duchamp's submission of *Fountain* to the first Salon exhibition of the Society of Independent Artists in 1917 was, however, a much broader act of provocation. The Society was formed in reaction to juried exhibitions of the National Academy, and the officers included dissenting representatives of the New York art community: among them, William Glackens and Walter Pach, who had worked as organizers of the Armory show; George Bellows, Rockwell Kent and Maurice Prendergast, former members, with Glackens, of "The Eight"; John Marin, from the Stieglitz circle; and Arensberg, with his own contingent consisting of Man Ray, John Covert, Joseph Stella, Morton Schamberg and Duchamp. The official program of the Society was explicitly lifted from the Paris Indépendants, promoting the exhibition of eclectic variety under a principle of "no jury, no prizes."[260] Esthetic democracy seemed to have come home.

With *Fountain*, Duchamp is generally understood (most recently and at length by Thierry de Duve[261]) to have been testing the very premise of the Independents, even contriving to replay the lessons of his own early experience with the *Nude* in 1912. In this sense, he not only graced his Society membership with first-hand knowledge of the French avant-garde, he also brought with him the quandries of avant-gardism – the debates over originality, novelty and *réclame*, and the hidden release mechanism of self-sabotage that lurks within the enterprise of unchecked "independence." Sure enough, in response to the outrage of the urinal as an insult to good taste and a threat to the Society's reputation, an

eleventh-hour meeting of directors and committee members was called – a *de facto* jury – and *Fountain* was voted out. As a result, Duchamp resigned,[262] a gesture which essentially ritualizes the implications of his shift away from avant-garde artmaking in 1912.

As reported in the *Blindman* soon thereafter, *Fountain* was pure *blague*, a bemused puncture-hole in the inflated balloon of axiomatic esthetic idealism. As mystification, however, it was a semi-public exercise in good and bad faith; *Fountain* never reached the art-going public of the Salon, but it did detonate in the local New York community of advanced art, and the controversy was then reported in the daily press. Of course, in deadpan fashion, Duchamp's role in the *Fountain* episode remained largely, if not wholly, a secret. His activity within the Society was a perfect cover; virtually invisible in the context, he was a double-agent-*mystificateur* with insider knowledge of its ideological vulnerability. The effect (following Fragerolle's precept of *fumisme*) was "ten times removed." Further, the urinal itself, for all of the "indecency" it represents, is obdurate and cold, displaced yet relentlessly banal. *Fountain* poses a dilemma in which, having greeted the ordinary object with outrage, the Society's defense of modern art against philistine intolerance looks rather hypocritical, and certainly more elitist than democratic. Through it all, both *Fountain* and Duchamp remain epitomies of calm.

*Fountain* can also be described as a double-reverse on mystification as counterfeit: rather than submit his own work as the work of someone else, Duchamp has submitted someone else's work as his own, masquerading as the work of a third party, "R. Mutt." The name was originally derived from the period cartoon strip "Mutt and Jeff" (Mutt was the prankster, Jeff the dupe), then altered with respect to the name of the urinal's presumed manufacturer, the J.L. Mott Ironworks.[263] In fact, the pseudonym reminds us that the issue of choice, a fundamental precept of the readymades, is itself a variation on mystification of this kind, the history of which has always problematized the role that authorship plays in judgments of quality and taste. (Extracted from the readymade style of other poets, the works of Adoré Floupette were initially appreciated as good verse.) In this regard, it is significant that the *Blindman* cites vulgarity and "plagiarism" as two official reasons for the suppression of *Fountain*.[264] Duchamp would continue the device of the pseudonym with "Rrose Sélavy" ("Eros, c'est la vie"), a female alter-ego he invented in 1920 or 1921, under whose name he produced a number of objects. Her real identity was no secret, but the ambiguity remains because the pseudonym transformed his own work into a Duchamp-pastiche. (Psychoanalytical and mathematical interpretations of Duchamp's female persona aside,[265] the male-female pseudonymic travesty was relatively unexceptional by that time: Satie as "Virginie Lebeau," Apollinaire as "Louise Lalanne" and Hélène d'Oettingen, with Férat, as "Jean Cérusse" are three pre-war examples from the avant-garde; Apollinaire's theater piece *Les Mamelles de Tirésias* of 1917 concerns a woman who transforms herself by force of will into a man, from Thérèse to Tirésias. For "Sélavy" as a pun on "c'est la vie," note the pre-war journalist and cubist critic Emile Zavié, whose name, according to Carco, was changed by a typographical error to "Zavie"; at his expense, "'Za la vie, Za la mort!' became by *blague* the rallying cry."[266])

The urinal is familiar now. When revisionism hastens to demonstrate that it was actually an object of beauty or programmatic meaning, it betrays the disaffection represented by Duchamp's practical joke. Back in Paris, Guillaume Apollinaire compared the "Richard Mutt Case," as he called it, to the Boronali episode. In his column for the

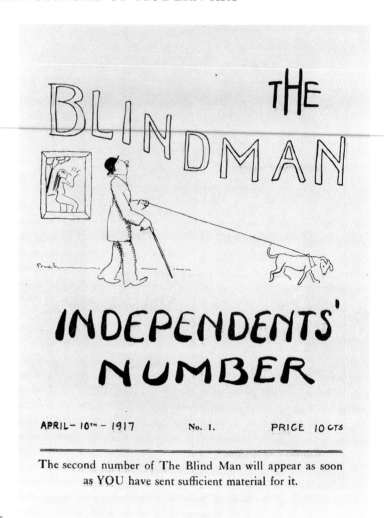

75. Cover illustration for
the *Blindman* (1917).

*Mercure de France*, Apollinaire quoted from the *Blindman*, both issues of which had made their way into his library.[267] He defended the *Fountain* against supression, which only showed that the Society of Independent Artists is "less liberal than the Indépendants of Paris, who would exhibit the picture by Boronali, knowing all the same that it was a *blague*, or better, a frame-up . . . they did not permit themselves the right even to prohibit a farce."[268] Two things are striking here: that Apollinaire refers to Boronali as having been a known hoax at the time of submission; and that true "independence" means to have tolerated it anyway. Perhaps this is not unexpected coming from Apollinaire, given his established taste for mystification, and the *mystificateur*'s natural aversion to playing the dupe. It does, however, open a valuable vantage onto the role of hoax as a period touchstone of esthetic risk.

Apollinaire does not let the matter rest there, but goes on to indict the bad faith of the daily press. It seems that, with Boronali, the newspapers were responsible for "trying to

make the public believe that the Indépendants, the painters, the critics and the collectors of the avant-garde had been mystified," proving once more that "the French newspapers have made it their business, with all the influence represented by their circulation, to oppose all that is young and new in art, as well as in science and literature."[269] In other words, the blame for a geuine conspiracy of mystification falls on the popular press, not the avant-garde, who are simply open to a breadth of novelty and wit that lies beyond the confines of the status quo. We come full circle from avant-gardism and the charge of confidence abuse only to find that, in the characteristic instability of the moment, the equation can be effortlessly reversed.

Enter Duchamp, who is both Professor de la Coulonge and Professor Cartaut, Raynaud's idealist and *blagueur*. As a former avant-gardist, his parody was well-informed, but played close to the vest. The test of his deadpan is the legacy of his work and its appreciation, which reveals an on-going conflict between gravity and irony, science and hoax, the philosophy of art and Duchamp's own *je m'en fichisme*. *Blague* and mystification permit us to account for an element of instability in Duchamp's œuvre that haunts the act of interpretation. Genres of comic resistance, they belong to the public domain of popular culture, yet they represent a philosophy and a practice of exclusion; that is, they contain the working ambiguity of avant-gardism. The *Blindman* (fig. 75) is not a possessor of inner-sight, he is a symbolic philistine, no better than a blind art-lover with a seeing-eye dog. He reminds us that hoax, as a claim, an act and a condition, suffuses the experience of modern art. Disorientation and questions of intention dominate the second truth of pre-war period esthetic history, and Duchamp is addressing a series of variables that pervade those circumstances. So plain – or so well-disguised – that it is practically invisible, this larger quality is easy to overlook.

Quand on ignore la première lettre d'un mot, il est
excessivement difficultueux de trouver sa signification
dans la dictionnaire.

Eric Satie (as Virginie Lebeau) 1888

# CHAPTER IV

# "LE SPECTACLE INTÉRIEUR"

## *PARADE*, POPULAR CUBISM, AND THE LAW OF SYSTEMATIC CONFUSIONS

76. Picasso, overture curtain for *Parade* (1917).

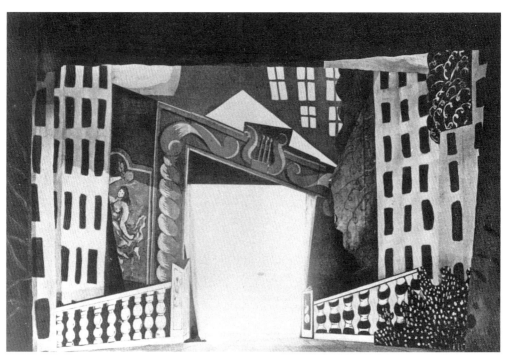

77. Picasso, set décor for *Parade* (1917).

—1—

Duchamp's example demonstrates that questions of meaning in modern art are conflicted by the antagonism between private and popular opinion. If Duchamp's career, from the conception of the *Large Glass* at least through the war, is understood as a parody of the modernist predicament, best defined by "mystification" both as a condition and a practice, then the signs indicate that this predicament probably exerted some pressure or influence on the work of others throughout that period. At one extreme, as a corollary to Duchamp, all of dada during and after the war might be recast as a series of exercises in aggravating the problem (which can be termed socio-esthetic, given its broad occurence as a larger cultural phenomenon) of hoax and originality; this would be an obvious place to look. But it would be at least as provocative to consider whether these issues exerted pressure on an artist like Matisse, for example, whose work would appear to exist outside the sphere of deliberate mystification and *blague*. Another unexpected voice is suggestive in this regard. Writing to Maurice Vlaminck in 1909, André Derain actually claimed that "the only thing that can save painting is *blague*." Prescribing a life devoid of emotional and spiritual extremes, he continues: "*Blague* is all powerful. With *blague*, one is removed from everything."[1] It is difficult to say how a philosophy of *blague* might have informed Derain's art, though the dry quality of his work at that time might be considered a form of studied indifference, rather than classicism, to which his severe style is more commonly ascribed. Clearly, however, the issue was persistent enough to have influenced the progress of modern painting in subtle but meaningful ways.

Given the prevalence of *blague* and mystification in the critical press, we would expect to find some instance in which members of the avant-garde address the subject outright. In fact, at least one significant example is presented by the ballet *Parade*, first performed by the Ballets Russes on May 18, 1917 at the Théâtre du Châtelet. The work was created by Jean Cocteau, Eric Satie, Pablo Picasso, and Léonide Massine, who were responsible, respectively, for the scenario, the music, the set and costume designs and the choreography. According to a statement by Cocteau published on the day of the premiere, "*Parade* is the story of the public who does not enter to see the *spectacle intérieur* despite the *réclame*, and without doubt *because of the réclame*, which is organized at the door."[2] Cocteau's theme is borrowed from the milieu of fairground entertainment, though the characters and performance protoypes represent a hybrid of source material from the fairground, the music-hall and the circus.

The *parade* itself is a sideshow performance which occurs traditionally on a *baraque*; the platform erected outside the performance tent of a carnival or *fête foraine*; its purpose is to attract or cajole passers-by inside for the *spectacle intérieur*, the main event, by seizing their attention with rapid banter, loud music, comedy and other snatches of performance. As a subject, it occurs frequently in French painting of the nineteenth century, perhaps most familiarly in works by Daumier and Seurat. The ballet *Parade* is now regarded as an allegory of the avant-garde and its hostile reception during the pre-war years, even though Cocteau nowhere states this in so many words.[3] In fact, this understanding of *Parade* conforms to Cocteau's writings from sometime after 1917. In

particular, his 1922 preface to the play *Les mariés de la Tour Eiffel* reads like an explication:

> All living work comes equipped with its own *parade*. Only this *parade* is seen by those who do not enter. But the surface of a new work offends, puzzles, irritates the spectator too much for him to enter. He is turned away in spirit by the face, the unfamiliar expression, which distracts him like the grimace of a clown at the door. This is the phenomenon which fools critics who are least slave to routine.[4]

Retroactively, such a statement seems to confirm that *Parade* is emblematic. The *parade* performance genre embodies attention getting surface novelty, while the *spectacle intérieur* stands for genuine originality; themes of *réclame*, shock and scandal, misunderstood intentions – these are among the cardinal stresses and strains of pre-war modernism. Even setting the story in a popular-theater milieu reveals a canny symbolic sense of site; an avant-garde fable of folly and misunderstood genius belongs almost organically to such a place. Finally, the fact that *Parade* was greeted by a house divided between cheers and jeers, not to mention a largely hostile press, demonstrates that it was controversial enough in 1917 to be of interest now as a significant moment in the history of art.

For a synthesis of themes in popular and avant-garde culture, we can do no better than *Parade*, both for what the ballet was intended to be and for what it came to be, from conception through production and performance to aftermath. Arriving on the stage in 1917, it demonstrates splendid timing, for it comes on the cusp: far enough from the pre-war years to offer a perspective, and close enough to the post-war years to be the *parade* for a whole new spectacle of exchange between modern art and its audience. Indeed, given the significance which Cocteau attributed to the *parade* theme, the failure to read backwards from the work into the history of the avant-garde is a curious omission of modern studies, for *Parade* confirms the existence of very specific problems. And with *Parade* we return to Picasso. Picasso's role in the work affords a rare opportunity to observe his dynamic with the general public. His constructed costumes for *Parade* were not only the largest examples of cubism to date but, as has been noted before, the first feature presentation of Picasso's cubism to a large general audience.[5] The results pose intriguing questions: Is there a popular complexion to cubist style at its most challenging (Picasso), compared to which less radical exponents of cubism (Gleizes and Metzinger, for example) prove, ironically, to have been more hermetic and popularly inaccessible? Can laughter elicited by the avant-garde be transformed into a pretext for cubism as popular entertainment? In order to approach these issues of cubism and comic style, we should begin by re-examining the conception of *Parade* in the context of the ballet's allegorical themes: originality, incomprehension and defeated expectations.

—2—

The history of *Parade* has been told many times.[6] Cocteau had been a friend of the Ballets Russes since 1909, and a collaborator since 1912, when the director Serge Diaghilev first showed interest in bringing Parisian modernism to the ballet stage. In 1914 and 1915, Cocteau proposed two ballets which were to incorporate circus-style performance: *David*

and *A Midsummer Night's Dream*, the latter with set-designs drawn from paintings by Albert Gleizes; neither was realized. During the war, with the dispersal of company stars, the Ballets Russes changed complexion. Diaghilev turned to younger advocates of a fresh new style, such as the Russion rayonnists Gontcharova and Larionov, and the choreographer Léonide Massine. The time was right for Cocteau to try again. As early as October 1915, he began to court Satie, but it was not, apparently, until May 1916 that Satie actually began work from Cocteau's notes. Around that time, Cocteau made the acquaintance of Picasso, and turned to him for sets and costumes. It took until late summer, but Picasso finally agreed, probably as much from boredom and the lack of community in wartime Paris as anything else. Predictably, however, his designs and narrative ideas were to change the character of the ballet. Work proceded in Paris until February 1917, when Cocteau and Picasso joined Diaghilev and Massine in Rome, where production of the ballet was completed after three more months of steady work.

*Parade* takes under twenty minutes to perform, and the action is fairly simple. By the time it was complete, Cocteau's synopsis of the scenario read as follows:

> The scenery represents houses in Paris on a Sunday. *Théâtre forain*. Three music-hall numbers serve as the *Parade*.
> > Chinese Prestidigitator
> > Acrobats
> > Little American Girl
>
> Three managers organize the publicity. They communicate in their terrible language that the crowd is taking the *parade* for the *spectacle intérieur*, and coarsely try to make them understand. No one enters.
>
> After the final number of the *parade*, the exhausted managers collapse atop one another.
>
> The Chinese, the acrobats and the little girl come out of the empty theater. Seeing the managers' supreme effort and their failure, they try in turn to explain that the show takes place inside.[7]

The audience to which this narrative refers is, in fact, meant to be the actual audience in attendance at the ballet since there is no fictional onstage representation of one; in this way, the action of *Parade* is addressed to the spectators, who are directly implicated in the plot.

Picasso's designs for *Parade* consist of the drop curtain, the stage-set and the costumes. The drop curtain (fig. 76), in effect a painting of enormous size, depicts a gathering of figures drawn in part from the *dramatis personae* of Picasso's rose period – a Harlequin and a Pierrot, a dog, a monkey, a winged mare and her foal. Other characters include a Moor, a Spanish guitarist, an Italian sailor, two young women in costumes of late eighteenth-century *pastorale*, and an acrobat-ballerina, winged in the fashion of *La Sylphide*. Props include a parade drum, a large blue acrobat's ball decorated with stars, and a tricolor ladder. The scene, painted with a soft palette of reds and lavenders, is a curtain-hung "backstage" setting that gives out onto a picturesque view of Italianate countryside and ancient ruins. But for the ballerina, the characters are depicted at table; while the guitarist plays and the others look on, the ballerina performs a bare-back dance. The setting is suffused with warmth and easy charm.

When the overture is complete, the curtain rises, and the scene shifts from the country to the city. Picasso's backdrop set shows a cubist *place*: buildings at least six-stories high arranged to frame a tilted proscenium arch, a kind of booth or *baraque* portal through which the performers will soon appear (fig. 77). The shift is aural as well as visual: after Satie's solemn opening Chorale and a gentle, haunting Prélude, the music suddenly turns raucous and vulgar. Enter the Managers, one from France and one from New York (figs. 78 and 79). The Manager dancers wear oversized cubist-construction costumes composed of wooden frames and an assemblage of cardboard planes; each is roughly ten feet tall.[8] Picasso's other costume designs were less startling: a decorated blue and white leotard for the Acrobats (fig. 80); a girl's sailor suit (purchased at William's sporting goods store) for the Little American Girl (fig. 81); and a picturesque *chinoiserie* outfit in red, yellow and black for the Chinese Prestidigitator, danced by Massine himself (fig. 82).[9] Only a comic horse (fig. 83) – two men in a horse suit, originally designed to be a third Manager on horseback – picks up the cubism of the Managers in a highly simplified, planar horsehead mask.

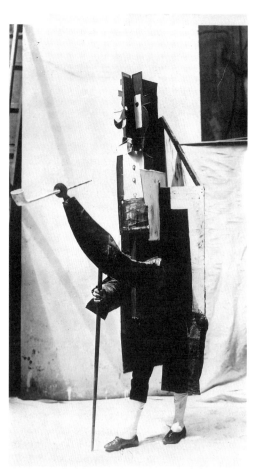

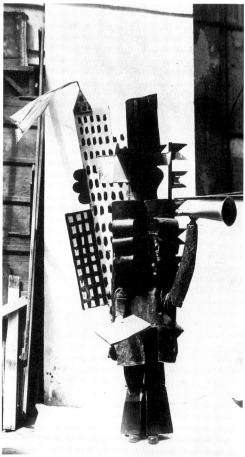

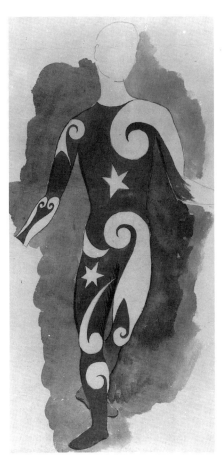

80 (far left). Picasso, sketch for the male Acrobat's costume (1917).

81 (left). Marie Chabelska in Picasso's costume for the Little American Girl (1917).

78 (far left). Picasso, French Manager costume (photograph of 1917).

79 (left). Picasso, New York Manager costume (photograph of 1917).

82 (right). Léonide Massine in Picasso's costume for the Chinese Prestidigitator (1917).

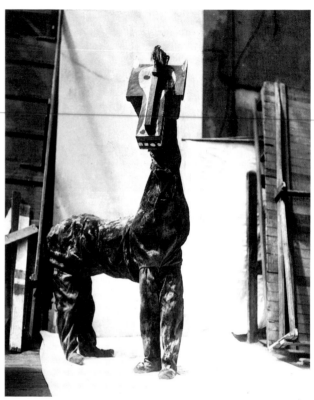

83. Picasso, Horse costume
(1917).

84. Edgar Degas, *Mlle. Fiocre*
*in the Ballet "La Source"*
(1867–8).

In addition to stage décor, the urban jolt of *Parade* was also characterized by sounds and images drawn from *l'actualité*. For two of his original characters, the Acrobat and the Little American Girl, Cocteau planned dance motifs from modern urban French and American culture. In pantomime, the American Girl was to "vibrate" like a silent film, imitate Charlie Chaplin, chase a pick-pocket with a revolver, box and dance a "Ragtime." (The ragtime dance was a popular feature for which Satie adapted an Irving Berlin tune.)[10] Cocteau's notes for these characters also include cryptic references to the Eiffel Tower, the Brooklyn Bridge, transatlantic steamers, gramophones, arc lights and radiotelegrams, as well as modern celebrities such as Walt Whitman, President Wilson, Helen Dodge and "the beautiful Mrs Astor."[11] Similarly, Cocteau had originally planned to place sirens, dynamos, telegraphs and typewriters in the orchestra – instruments of "trompe l'oreille" (but for the typewriters, these were abandoned due to material limitations, such as a wartime shortage of compressed air).[12]

<center>*     *     *</center>

*Parade* seems straightforward enough in plot and meaning, but its function in 1917 is actually somewhat elusive. One measure of this is the scope of contextual interpretation that the ballet sustains in recent art-historical literature. The full range can best be represented by two largely dominant extremes: *Parade* is described either as a deliberately provocative avant-garde theater piece that is cubist and/or futurist throughout, or as a work of calculated restraint, as cubism vastly tempered by a spirit of charm and nostalgia. Picasso's drop curtain is a useful vehicle with which to examine this interpretive conflict.

In the first case, that of the avant-garde *Parade*, the drop curtain is described as a work of covert cubism (and futurism): floor-board orthogonals, aerial perspective, bodies that are alternately flat and volumetric, a tilted table-top and curtains, are said to undermine the consistent illusion of space. Characters from Picasso's past and present, from realms of fantasy and reality, are understood to represent a futurist "compound memory," and ambiguities of onstage and backstage narrative embody a self-consciousness of pictorial convention that alienates the spectator even as it invites him to enter the depicted space. In this way, the curtain is characterized as a full-dress exercise in the cubist idiom.[13] Such a reading is difficult to reconcile with the fact that most of the curtain's ambiguities can be traced back to impressionism, if not before; for example, to Degas' *Mlle Fiocre in the Ballet "La Source"* (fig. 84), over fifty years old by 1917, and characterized by a strikingly similar set of questions concerning backstage/onstage/outdoor space and narrative (though, to be fair, the function of a theatrical drop curtain introduces a fundamental ambiguity in this context that is not raised by an easel picture). Interpreting the curtain as a cubist exercise reveals an impulse to value *Parade* as a radical enterprise, undiminished by the apparently deceptive initial appearance of pictorial naturalism. Logic then requires that cubism, or futurism, be imposed on other seemingly innocent aspects of Picasso's set and costume design: the store-bought sailor-suit for the Little American Girl is compared to the pasted objects of collage, and the Horse is "not a real horse but a sign for a horse."[14] From the planning stages through to opening night, the whole ballet might be said to have

been pitched over the heads of spectators who were unsympathetic to the conceptual demands of modern style.

The *Parade* drop curtain has also been reinterpreted as a work of sunny Mediterranean charm, virtually devoid of anything remotely suggesting the tough esthetic challenge of the avant-garde. In this reading, the style is naturalistic, the mood carefree, the iconography Latinate, reassuringly traditional and familiar; the entire scene is, accordingly, suffused with a rosy glow. New sources are identified, such as Picasso's postcard of a drawing by the early nineteenth-century Neapolitan painter Achille Vianelli, which depicts a *taverna* scene populated by picturesque itinerant musicians and mealtime revelers overlooking a landscape vista with Mount Vesuvius. The curtain, like Vianelli's picture, is said to have been drawn from a pattern-book of Latin cultural mythology, with its wine, music, good-nature and gentle climes. Ultimately, it is identified with a larger program of appeasement, wherein avant-gardists of the pre-war period adapted themselves to the vissicitudes of wartime nationalism, determined to redress the negative reputation of modern art as a propagation of foreign esthetic offenses against the golden history of French taste. By extension, the whole of *Parade* itself is recast as an exercise in moderation, designed throughout to promote the new avant-garde and to forge – according to Cocteau's ambition – a compromise between the cultural Left and Right.[15]

In order to support the interpretation of *Parade* as a monument of wartime esthetic conciliation, it has been necessary to minimize its utter failure as such. Conversely, to read *Parade* as a deliberately provocative exercise in modern style is to take period failure as a badge of honor, a sign of merit merely misunderstood in its day. In both cases, the negative reception of *Parade* is acknowledged to have been the fulfillment of the work's own allegorical prophecy, an eager audience put off by the attention getting eccentricity of a work that is, in truth, possessed of deeper originality. This irony – that *Parade* became the demonstration of a conflict it sought merely to represent – is a staple of *Parade* studies. However, though *Parade*'s failure in 1917 is often alluded to, it is rarely accounted for from the vantage of the bad press. Discontent is correctly noted, but the voices of discontent, namely critics and the general public, are rarely heard.[16] In fact, treating *Parade* as a work that concerns the uneasy antagonism of artists and spectators, the critical literature reveals terms of debate that scramble the perceived division between moderns and conservatives.

The implication of either cubist or Latinist schemes in *Parade* would seem to be that the ballet can be reconstucted for a consistent underlying agenda; accepting the two in tandem equally circumvents the question of conflict that they raise. Any cohesive programmatic reading of *Parade* requires a false sense of security. The tacit assumption is that the four collaborators were of a mind, most often Cocteau's mind (accordingly, he is generally cast in the role either of conservative mediator between the avant-garde and the public, or young *agent provocateur*, learning lessons in cubism from Picasso);[17] and that the narrative and design of the ballet were largely Cocteau's invention, and were essentially consistent throughout the conception and realization of the piece. It is, however, well-known that the history of *Parade* was marked by internal controversy. Cocteau's published statements on the ballet from the time of its premiere clearly show that these conflicts cut to the very heart of its life as an allegory.[18]

*Parade* was born from a spirit of collaboration and rapport, but it lived according to a

rupture of purpose and design which marks its true character as a parable of the avant-garde. The break in the progress of *Parade* is plain, especially from the evidence of Satie's correspondence in fall 1916.[19] When we observe Cocteau's account of the moment, however, a familiar struggle of originality, novelty, scorn and betrayal emerges in which Cocteau himself plays the role of the wronged spectator-outsider, and Picasso and Satie the perpetrators of insincerity and excess from within the inner-circle. Cocteau's own esthetic fears bring us back to the pre-war leitmotifs of avant-gardism. To see *Parade* change before Cocteau's eyes is to relive the larger disorientation of avant-garde esthetic experience. For all of the softened cubism that *Parade* is purported to represent, and for all the changes in socio-political climate at the time, *Parade* was explicitly presented and understood to have been an avant-garde effort, very much in the pre-war sense. The reception of the ballet, by both Cocteau and the audience of 1917, is consistent with the established public and private parameters of the earlier debate: what separates modern art from hoax?[20]

—3—

All interpretations of *Parade* begin with two documents: program notes by Apollinaire entitled "'Parade' et l'Esprit Nouveau," and an introduction by Cocteau, "Avant 'Parade'," both of which were published in the newspaper *Excelsior* during the week of the first performance.[21] The choice of *Excelsior*, a popularizing paper; reveals an attempt to reach beyond the fashionable art society to the general public. The two articles appear to define *Parade* as an effort in Latinate nostalgia; if we read between the lines, however, it is apparent that they are, at least in part, eleventh-hour attempts to soften the blow of the ballet, suggesting that the production was already understood by insiders to have been problematic. On the eve of *Parade*, Apollinaire and Cocteau are already trying to effect a reconciliation between modernists and their public. Both texts abound in good-natured compromise scented with wartime caution.

Uncertainty and discretion are palpable. Clarity and simplicity, attributes of French cultural nationalism, characterize Apollinaire's vision of the ballet, a manifestation of the "marvelously lucid spirit of France." As a motto for *Parade*'s embodiment of the future of French culture, he selected the popular phrase "esprit nouveau," a kind of wartime trick that might be likened to rallying a room full of quarreling patriots by standing on a chair and singing the national anthem. Collaboration is an important theme, and Apollinaire hails the teamwork of Picasso and Massine as the "herald of a new, more comprehensive art." Boldly, he attaches the new esthetic to cubism (referring to "la peintre cubiste Picasso"), but he grafts cubism onto a family tree that is inhabited by Chardin, the Dutch masters and the impressionists. Redefining cubism as a new kind of realism, he invents the celebrated epithet "sur-réalisme." Apollinaire's definition of the cubo-realism hybrid is somewhat convoluted, but he regroups at the end: "*Parade* will change the ideas of a great many spectators. They will be surprised, but in a most agreeable way, and charmed as well. *Parade* will reveal to them all the grace of modern movements, a grace they never suspected."[22]

Cocteau also recognizes the marketability of charm, explaining that *Parade* "hides its poetry under the vulgar exterior of guignol," and that "laughter . . . a weapon too Latin

to be neglected," is important even during the gravest times. He likes "esprit nouveau," which he characterizes as nothing less than "the force of France," opposed to "heavy German estheticism." Cocteau makes much of *Parade* as a group effort "so close that the role of each marries that of the other without encroaching upon it"; he would have preferred that the public observe the collaboration, rather than come upon the ballet unprepared. But Cocteau's gambit is safer still than Apollinaire's. Significantly, he mentions cubism only once, calling Massine's contribution "choréographies cubistes." Instead, he identifies Picasso with the drop curtain, its "giant figures fresh as bouquets," studiously avoiding the artist's pre-war bad-boy identity. Like Apollinaire, who in turn claims to be following Cocteau, he portrays *Parade* as the manifestation of a higher form of theatrical realism, but he fails to introduce cubism as the stylistic touchstone. For Apollinaire, Picasso's Manager costumes are "fantastic" and "surprising" (*inattendus*) constructions that have liberated the choreography of Massine; for Cocteau, who does not attribute them to Picasso, they are in-character as "vulgar divinities of *réclame*," "arrogant posters," "machines," "inhuman personnages."[23] The mutual evocation of *esprit de corps* is here slightly strained, but it will sag more visibly in Cocteau's post-mortem commentary on *Parade*, in the context of which "Avant 'Parade'" reads more like a disclaimer than a manifesto.

Cocteau's next major statement, "La Collaboration de 'Parade'," was published roughly two months after the performance, in the June–July issue of the avant-garde periodical *Nord/Sud*. It is clear that the response to *Parade* was largely hostile, for Cocteau began his article with contempt, addressing a pile of critical insults that had been heaped upon the ballet. (Nine years later, in an article on "scandals" for the *New Criterion*, Cocteau said that all the bad press he received over *Parade* persuaded him to cancel his subscription to Argus, the press-clipping service.[24]) As the title of the article suggests, he means once again to stress that *Parade* was a group effort, as if to say that this proves good faith. In deliberate contrast to the bad press, he recalls the "wonderful months" with Picasso and Satie, nurturing the ballet, "this little thing, so fertile, whose modesty consists precisely in not being aggressive."[25] All of this is designed to chasten critical truculence. Still, Cocteau's article has a subtext; his emphasis on collaboration actually allows him to itemize individual contributions. And to Picasso and Satie, he distributes the responsibility for two familiar problems of avant-gardism: mystification and *réclame*.

Cocteau traces his original inspiration for *Parade* to a performance by Satie of the composer's "Trois Morceaux en forme de poire." The title of the piece, which "baffles" (*déroute*), serves Cocteau as a distancing device. In a brief, cautionary tangent, he explains that it reflects a "humorist attitude which dates from Montmartre," and that it "prevents the distracted public from properly listening to the music."[26] This conflict of the comic and the serious appears to be essential. Cocteau assures us that his original outline of the ballet and instructions for Satie

> had nothing humorous about them. On the contrary, they stressed the occult aspect, the development of the characters, the verso of our fairground stage. There the Chinese was capable of torturing missionaries, the little girl of sinking on the Titanic, the acrobat of confiding in the stars.[27]

(It is interesting to note that Cocteau's sequence of ultra-modern dance motifs for the character of the Little American Girl concludes with two images from the tragic repertory, Paul et Virginie and Icarus.[28]) Accordingly, Satie's score emerged as "sober" and "clean," suggesting an "unknown dimension thanks to which one hears simultaneously the *parade* and the *spectacle intérieur*."[29] Cocteau maintains that his original scenario for *Parade* was to have struck a balance between outside and inside the performance tent, and he had fully intended to reveal the dark mystery of esthetic truth "within"; as has been noted, the subtext is a throwback to the symbolist *parades* of Rimbaud and Seurat.[30] Above all, laughter was not a significant item on the agenda. In "Avant 'Parade,'" Cocteau pretended to celebrate the humorist element of the final ballet; here, however, we sense that he had been uncomfortable with it all along. Indeed, he had exhibited prudence of this kind from the start. Writing to Misia Sert about Satie's progress during the early planning stages, Cocteau declared that *Parade* "is *his* drama, and the eternal drama between the public and the stage." He also insisted that "my part of the work does not give him a hint of farce."[31]

In *Nord/Sud*, Cocteau refers to a "first version" of *Parade*, in which the Managers did not exist. Originally, each number was to be announced offstage through a megaphone with extravagant sideshow patter. In Cocteau's notebooks, the barker's lines are strident imitations of true *boniment* style, but he softens the description now, characterizing the *cri* as a *phrase type*, and the megaphone as a *"trou amplificateur."*[32] Now that *Parade* is history, Cocteau is eager to reveal that Picasso was responsible for bringing the Managers to the stage. According to Cocteau, Picasso's sketches introduced a shocking contrast in size between the "inhumains, surhumains" Managers and the "réels" dancers. "Therefore," he recalls, "I imagined the 'Managers', ferocious, uncultivated, vulgar noisemakers, harmful to those whom they praise and unleashing [which is what took place] the hatred, the laughter, the shrugs of the crowd with the strangeness of their aspect and of their manner."[33] The arrival of the Managers would appear to mark the moment at which Cocteau more or less lost full control of the "collaboration." Indeed, in September 1916, Satie had been excited but troubled to report that Picasso was changing *Parade* "for the *better*, *behind* Cocteau's back," with a text of his own that was "astounding! prodigious!"[34] Satie never says what the changes are, though they clearly have something to do with Picasso's preference for a broader, brasher form of *spectacle* over Cocteau's dark, symbolist narrative. Ultimately, Picasso and Satie suppressed Cocteau's barker *réclame* (Massine later concurred, canceling Cocteau's final effort to incorporate the lines into Satie's score).[35]

With the Managers, the balance shifted towards *parade* and away from *spectacle intérieur*, thus changing the very meaning of the ballet. Identifying audience hostility at the Châtelet with the fictive scorn of the allegorical spectator, Cocteau blames the Managers. This is critical. Cocteau's plan for *Parade* as a modern, noisy popular-culture ballet was undeniably bold, but the barker's *cris* were to be kept in the wings. Following the production and the press, he emphasizes this by way of justification. The *cris*, he explains, were meant to heighten by contrast the charm and mystery of the ballet proper, "opening a breach on the dream,"[36] and allowing the *numéros* to achieve a plane of unexpected lyricism. The overwhelming presence of Picasso's Managers did not simply destroy this effect, they did so as blatant and grotesque emissaries of cubism, the extremist associa-

tions of which Cocteau meant to subdue in his pre-*Parade* statement. Retaining the *cris* might have preserved a certain narrative specificity for the role of the Managers; without them their function was blurred, risking the kind of misplaced hostility to which the allegory itself refers, and which it was to explain away. Cocteau is still willing to make a virtue of necessity, admitting that the great weight of the Manager costumes obliged Massine to "break with old formulas" and choreograph an "organized accident [of] false steps", stumbling endowed with the "discipline of a fugue."[37] One year later, however, he would recant, complaining that the introduction of Picasso's "carcasses" deprived the Managers' dance of its lyric force (reportedly, the dancers themselves despised the weight and constriction of the costume).[38]

Finally, there is the matter of the Horse. As Cocteau relates, the Horse costume was only delivered by the *cartonniers* during final rehearsals. Ineptly constructed, it was transformed from a "thundering" animal into a delapidated "Fantômas taxi horse mounted by Charlie Chaplin." This was greeted by the crew with gales of laughter. Knowing how Cocteau resisted the absurd, we detect disappointment when he says that their hilarity "convinced Picasso to keep this fortuitous silhouette." Broad burlesque was fated to govern. Of course, the *salle* laughed just as hard on opening night, and Cocteau took offense: "We could not have supposed that the public would take so badly one of the only concessions we made to it."[39]

Cocteau's history of *Parade* is plainly, though covertly, a self-exoneration. In a display of war-era sobriety, he subtly distanced himself from public skepticism over modernist motives. All of this was certainly heightened by post-1914 political sentiment; none the less, the issue is a pre-war hold-over. It was, after all, in 1914 that one critic actually portrayed the visual extravagance of the new art as having "more to do with the music-hall and the *baraque foraine* than with real painting."[40] Cocteau was making a new effort to avoid old questions concerning the serious purpose of modern art. Rather than grapple with humor as an inseparable part of Satie's enterprise, he attempted to save the authentic beauty of the composer's work from elements of deliberate mystification; this, in turn, allowed him to perform the same operation on *Parade*. Early in the life of the ballet, Cocteau actually stressed the coarse immediacy of the popular *spectacle*, but sentiments of this kind were tempered in a manner that clearly presages his ambivalence. For example, to the defiant "SOYONS VULGAIRES" which he inscribed across a double-page of his Rome notebook in 1916, Cocteau added "puisque c'est impossible."[41] Ultimately, Cocteau's appreciation for the quasi-primitive genius of popular entertainment was caught off-guard by Picasso's representation of cubism as a vehicle for the one aspect of popular culture which he had intended, both actually and symbolically, to portray as coarse and vulgar in a negative regard.

By the time of "Avant 'Parade'," the production had entered the realm of the comic burlesque. In this way, the final version of *Parade* retained Cocteau's original theme, but virtually subverted his premise. It is not simply that the ballet had actualized its own allegory; in effect, the meaning of the allegory had changed, even been inverted, and *Parade* now seemed to justify philistine intolerance. The noise and antic burlesque of the sideshow stood alone, quashing the emergence of "poetry" beneath the "vulgar exterior of guignol." In a contrast that was clearly intended by Picasso, the tone of the performance was set not by the roseate drop curtain, but by the "inhuman" Managers, whose force of character was both a monument to bluff and a gross distraction from the "new

spirit." Promoting cubism in a brash, graceless manner, the Managers actually *were* what they represented, vulgar monsters of avant-garde *reclame*; as such, they broke loose from the libretto and violated it. Cocteau's "Avant 'Parade' " seems to be a last-ditch effort to retrieve something of the ballet's early purpose: anticipation of hostile derision is converted into Latinate laughter; broad formal and physical slapstick becomes an interpretive dance about crass commercialism; and somewhere behind it all hovers the spectral vestige of the *spectacle intérieur*, now unseen, yet still a lofty ideal before which the barker's posturing is merely rude. Conversely, the "Collaboration" essay punishes public obstinancy and bad faith; there, *Parade* becomes a tale of good modernism and bad modernism both onstage and backstage.

One year later, in his book *Le Coq et l'Arlequin*, Cocteau himself recasts the *Parade* problem as a twist on his original allegorical theme. The philistine is back, and his hostility is valued as a sign of esthetic innovation. The "opposition of the crowd to the elite stimulates individual genius." Appeasement is conspicuous by its absence in any form: "The extreme limit of wisdom, that is what the public baptizes folly." Popular-culture source material, such as the music-hall, is valued as a "force of life which renders all of our audacities obsolete at first glance." But Cocteau is still conflicted and regretful. "In *Parade*, the public took a transposition of the music-hall for bad music-hall." The performance "was so far from what I wished that I never went to see it from the *salle*." (He contented himself instead to work as a stagehand). Picasso's Managers are unwieldy *carcasses*. Satie's humor is actually given its own subheading, "Satie contre Satie," and his baffling titles are still treated as an obstacle to public appreciation of his works.[42] Only much later still, in 1922, will this change, in a tantalizing pronouncement from his preface to *Les mariés de la Tour Eiffel*: "the spirit of *bouffonnerie* is the only one which authorizes certain audacities."[43]

Cocteau is both modernist and skeptical spectator of modernism. His frustrations properly point up the value of *Parade* as a study in avant-gardism. The ballet is far more useful to us as a scene of conflict than one of co-operative effort. In its allegorical theme, its production and design, its promotion and its reception, it raises difficult questions. Above all, Cocteau's repudiation of mystification and *réclame* beg us to grapple at once with the dynamics of *Parade* as a vehicle for precisely those problems of meaning and style. *Parade* was generally perceived as a case of cubism playing for laughs. The cross purposes of *esprit de corps*, "sur-realism" and farcical burlesque attracted new attention to the old matter of modern art and the propagation of bluff. Moreover, as the most public exhibition of cubism to date, *Parade* plunged Picasso back into the center of debates over the purpose and pretensions of the avant-garde.

—4—

Cocteau relates that his initial inspiration for *Parade* was a piano work of Satie's performed by the composer himself. At first, this appears to mean that Satie's peculiar blend of lyric simplicity and surprise kindled Cocteau's own fairground fantasy of simple characters transformed through mystery and poetic allusion. But the theme of an "eternal drama between the public and the stage" was in place early on, and Cocteau later pinned this idea to the example of Satie's own public and critical reputation. This could have been

Satie's first, unconscious contribution to the germ of *Parade*; Cocteau seems to be saying as much when he annotates his recollection of Satie's performance with reflections on mystification. In any case, it is clear that Cocteau's scenario was motivated by a common esthetic conflict of the pre-war period over avant-gardism and bluff, or the publicity of hoax, framed by questions of sincerity, good faith and the abuse of confidence. Given the size of this debate, it is not surprising to discover that Cocteau's allegorical metaphor, the fairgound *parade*, was actually common in the critical literature. Cocteau did not invent *Parade*, so much as develop it from the critical vernacular of the time. His allegory of avant-gardism was risky, in part, because it was so familiar.

Most advertising metaphors in pre-war criticism were meant to equate new art with false claims, to suggest that very little lies beneath the attention-getting surface extravagance of modern style but the ambition to set oneself apart at all cost. Emptied of any real meaning, "originality" shrinks to mere novelty and gimmick. After Marinetti's futurist manifesto in *Le Figaro*, readers were fully expected to understand a lengthy editorial statement in the first issue of the literary journal *L'Effort* in 1910, dedicated to "urging authors, critics and public away from the abominable comedy of bluff and falsehood that they have been performing for the past 20 years."[44] In this context, the image of the itinerant fairground troupe was readymade, since the *fête foraine* was widely associated

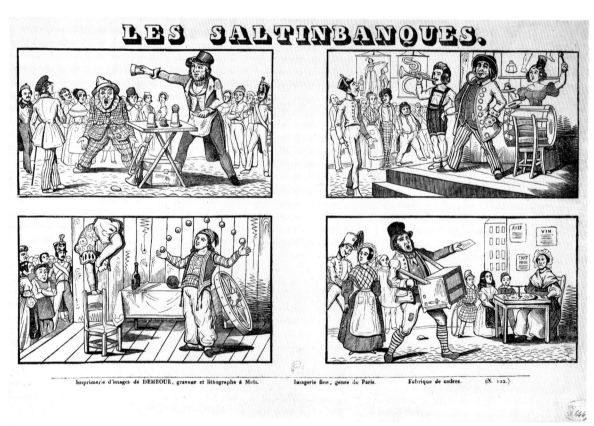

Imprimerie d'images de DEMBOUR, graveur et lithographe à Metz.    Imagerie fine, genre de Paris.    Fabrique de cadres.    (N. 122.)

85. *Les Saltinbanques* (*sic.*) nineteenth-century engraving.

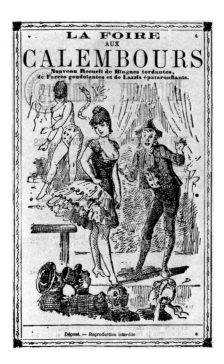

86. Cover illustration for pamphlet *La Foire aux Calembours* (1897).

in the public imagination with promotionalism and hoax. The accumulation of *tromperie* represented by fairground culture encompasses the performers themselves (including conjurors and freakish *phenomènes*), a secondary group of hawkers and charlatans, and a tertiary community of gipsy con-artists and thieves.[45] An undated mid- to late nineteenth-century print of "Les Saltinbanques" (*sic*), (fig. 85), reveals an interesting sense of proportion in this regard: of the four panels showing *saltimbanque* activity, only one depicts familiar forms of entertainment such as acrobatics and juggling; the other three are devoted to themes of mystification and *réclame*: an *escamoteur*, who astounds his spectators with the shell game; an organ-grinding street-hawker; and a noisy *parade*.

The raucous *parade* sideshow was, in fact, primarily a phenomenon of the period *c*.1790 to 1840, when it flourished at the *foires* St. Germain and St. Laurent, as well as the Boulevard du Temple. The great *paradistes* of the period, Bobêche, Galimafré and Bilboquet, became legendary figures of popular performance.[46] Beginning in the 1840s, with the introduction of laws restricting the activities of the *paradiste*, the true *parade* seems to have been reduced to vestigial examples at the itinerant *fête foraine*. The *parade* sensibility, however, thrived as a form of commercial advertising,[47] and the word itself enjoyed great currency as a figure of speech. As a genre, the *parade* had always been valued for a certain brand of comic genius, and equally associated with most any professional manifestation of hucksterism and fraud. By the pre-war period, these connotations, both real and metaphorical, were simply taken for granted.

The *parade* was just one of several variations on the theme of comic exaggeration and false claims at the *fête-foraine*. As the most visible, though it became a prominant, emblematic motif, a kind of generic category that functioned on and off the fairground.

For example, according to a dictionary of French *argot* from 1896, *Romanichels*, or Bohemian gipsy thieves that circulate at the itinerant fair, engage in "parade" when they promote counterfeit jewelry and dupe the unsuspecting passer-by.[48] The patter of the *parade* contains types of verbal humor that, we might say, disorient the listener, such as the pun and the *coq-à-l'âne*, or rapid jump from one subject to another.[49] For this reason, the *parade* often found its way onto the cover of joke pamphlets or brochures, such as the *Almanach des Abrutis* ("Idiot's Almanac"), *La Foire aux Calembours* (fig. 86) and *Les Blagueurs de Papa Rigolo*. They were all collections of puns and word plays, and some featured characters with names like "Blague-fort" and "Dérange-tout".[50] Moreover, the *parade* was still being celebrated as a dying art during the pre-war period, and became the subject of a festival at Saint-Cloud in the summer of 1911, where hawkers, known as *camelots* and *bonimenteurs* (derived from *menteur*, or "liar"), were judged in competition as modern *paradistes*, and awarded prizes for their skill. The magazine *Fantasio* covered the event, and published a long history of the *parade* in all its permutations: sideshow publicity, medicine show charlatanism, popular performance satire at the expense of the monarchy and official power, and other farcical forms of street theater.[51] Even Aristide Bruant's ploy of mounting table-tops and berating his customers at the cabaret Le Mirliton was traced back to a *parade* genre called *boniment insolent*.[52]

In its most picturesque form, the *parade* could be safely appropriated as an advertising device; Ibels' poster for the Galerie Pierrefort is typical (fig. 87), where *parade* performers are dressed as charming, commedia dell'arte figures. More commonly, however, *parade* vulgarity was a motif of biting political caricature. By representing the campaign speech or political harangue as a fairground *parade*, politics was thereby exposed as an arena of

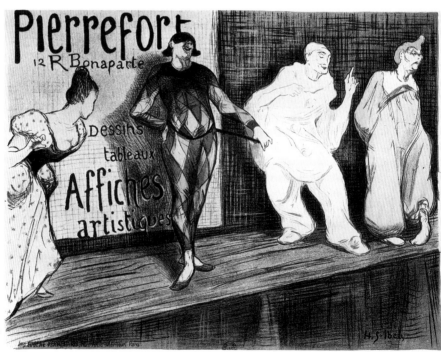

87. H.G. Ibels, poster for Galerie Pierrefort (1897).

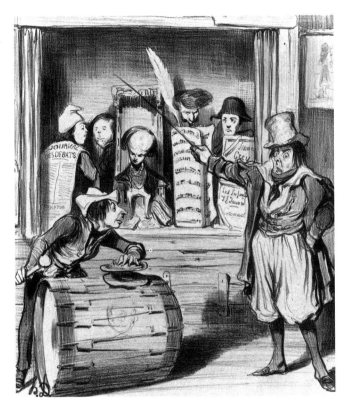

88 (left). Daumier, "Les Saltimbanques" (1839).

89 (below). Guydo, *Le Cirque Claretie* (1893).

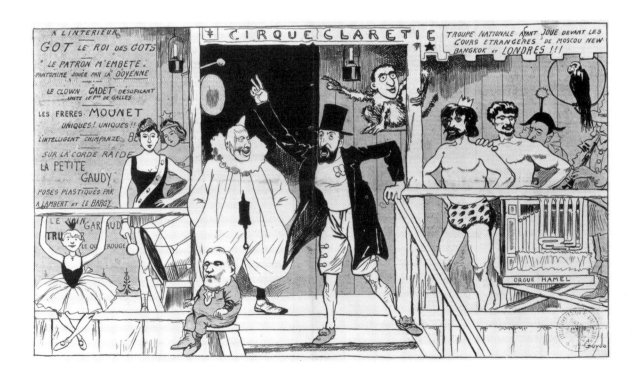

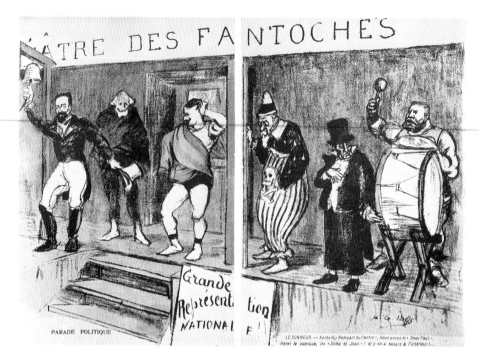

90 (right). H.G. Ibels,
*Parade politique.*

91 (below). F. Fau,
*Les Boni-menteurs
Parlementaires* (1913).

92. J. Hemard, cover illustration for *L' Assiette au Beurre* (1912).

false promises and empty, self-serving rhetoric. As we would expect, Daumier is the progenitor of this motif (fig. 88), but its accessibility is long-lived. In Guydo's "Le Cirque Claretie" for the satirical journal *Le Triboulet*, in 1893, (fig. 89) the stumping campaigner appears as a cajoling sideshow barker for his own circus of associates. In case the motley crew of Ibels' "Parade Politique" is insufficiently convincing (fig. 90), the bell-ringer promises "encore à l'intérieur." With F. Fau's "Les Boni-Menteurs Parlementaires" for *Le Rire*, in 1913, (fig. 91) *parade* politics took a hard left. Addressing the working-class *populo*, the caption accuses radical and socialist parliamentarians of being "all *marchands de blagues*," and in a pun on the original meaning of *blague*, or "tobacco pouch," it goes on to read, "For them, the tobacco, for you the smoke!" Note the Palais Bourbon on the horizon, and, at the lower left, a card-playing *escamoteur*.

As a practice and a metaphor, the pre-war *parade* alludes to a fairly broad culture of comic hyperbole and misrepresentation, a curious coupling of entertainment and fraud. The *parade* was therefore ample enough to contain the antagonisms of modern art and its suspicious public. In particular, *parade* was custom-made for the double charge of mystification and *réclame*. As such, it has an illustrious ancestry, as Paula Hays Harper has shown in her work on Daumier. In 1880, Emile Zola defended the impressionists against their critics:

> They are treated like *farceurs*, charlatans mocking the public and beating the bass drum around their works, but they are, on the contrary, severe and convinced observers . . . These martyrs to their own cause are unique *farceurs* indeed![53]

References of this sort during the pre-war period shower the critical press. On the cover of *L'Assiette au Beurre* (fig. 92), the poet beats a bass drum (*la grosse caisse*), the staple

instrument of attention getting clamor. The Salon des Indépendants is a *baraque* where one "enters with curiosity" to see the *phenomènes*; schools of painting there comprise "a *parade* produced in order to entice the public inside the *baraque*";[54] the artists themselves are "buffons et clowns," though the shock-value of their "parades funambulesques" diminishes every year.[55] The Salon d'Automn was a "parade bruyante" where new systems of painting propagate "tapageuse réclame" aimed at snobs and dealers;[56] one could no more distinguish a work of sincere effort than one could "make out the sound of a beautiful instrument in a *parade foraine*."[57] The *publicité* and bluff of the avant-garde in general could recall the "illustrious memory of the *banquiste* Mangin."[58] More specifically, Marinetti's lecture at the Maison des Etudiants in 1911 was a "*parade* [that] finished in laughter and boos";[59] his style of public address is the "Zim! boum! boum!" of the bass drum;[60] his onomatopoeic report on the battle of Tripoli in *L'Instransigeant* is composed of "expressions funambulesques";[61] his manifestos of "prétendue nouveauté" are so many "parades de foire et les boniments."[62] The salon cubists stood "at the door of the circus," having "proclaimed themselves the clowns in charge of *boniment*";[63] in *Je sais tout*, as we have already seen Kahnweiler himself assailed them as "*saltimbanques* who pass their time stirring up the crowd."

The *parade* metaphor of avant-gardism was an *idée reçue* when Cocteau sat down to hear Satie play his *Trois Morceaux en forme de poire*. In order for the image to succeed as an allegory on the avant-garde stage, it probably would have had to transcend its own currency as a familiar trope. Indeed, this very familiarity enabled Picasso and Satie to exploit the implications of Cocteau's tale. Under their influence, *Parade* became a *parade*, and the avant-garde lived up to its promise of false promises. As Jerrold Seigel has written, *Parade* occurs within "the tense and ambivalent field created between modern artists and their audience by the complex of publicity, alienation and self-advertisement." More specifically, the failure of the ballet was bound up in its own source of meaning, in real *parades*, the life of the *parade* as an allusion, and the conflicted production of *Parade* itself, with its own affinity for the dynamics of the fairground. The audience for *Parade* was prepared for a *parade*, a mystifying, self-promotional stunt, and in a very real sense, they got one.

## —5—

If the *Parade* fiasco is to be addressed as an essential aspect of the work's meaning and originality, then the overall shape of public and critical response in the summer of 1917 must be described, and that response matched to the character of the work itself. Juan Gris, who appears to have attended the entire first run, wrote at the time that open hostility diminished with each performance, and was all but silenced by the last.[65] While he takes this to signify a victory for the inherent quality of *Parade*, for its "charm" and "novelty," to be precise, such an assumption implies that the same spectators attended every night. More likely, the audience reaction that Gris observed can be attributed to bad reviews and word-of-mouth; by May 29, this was bound to attract supporters and put off those who were predisposed against the avant-garde. In any case, Gris is forced to admit that the press had been terrible. In recent literature, critical hostility is generally treated as a monolithic phenomenon, and freely called upon to prove that *Parade* justified its own

allegory of intolerance. The general impression is that *Parade*, like so much modern art, was too good for its audience, though, again, the most recent variation on this theme holds that *Parade* tried (not hard enough) to please. This, of course, begs the question, for provocation, intentional or not, depends by definition on audience expectations and the work's perceived violation of esthetic decorum. The critical literature shows that the chief point of dispute concerns the degree to which *Parade* was deliberately comic. In certain respects, this problem is fueled by *Parade*'s bold appropriation of themes and source material from popular culture. (Excluding folk-cultural precedents such as Stravinsky's *Petrouchka* of 1913, *Parade* is generally recognized as a first in this regard.)[66] The overall impression of burlesque disassociates cubism – and avant-garde art in general – from notions of esthetic propriety, of art that is serious or "sincere." And it anticipates a strategy of deliberate self-parody that we might chart through the history of dada in post-war Paris.

It is crucial to recognize that virtually everything that Cocteau wrote just before and after the short run of *Parade* was closely matched to critical and popular sentiment regarding the excesses of modern art. Keeping cubism at a safe distance, Cocteau hoped to promote *Parade* as a "ballet réaliste," and he is foiled when critics would not be seduced, preferring instead the epithet "ballet cubiste."[67] On opening day, while *Excelsior* published Cocteau's "Avant 'Parade'," the theater critic for *Le Figaro* published his own "Avant-première" column on *Parade*, in which he appears to have second-guessed Cocteau's strategy of appeasement, explaining that "to avoid surprising the spectator, Picasso has been smart enough to place his most audacious conceptions on a fairground stage, and to contrast them with some pure drawings about which critics will speak of Ingres."[68] In *Le Gaulois*, Simone de Caillavet stoked the fires of internecine conflict when, summarizing Cocteau's *argument* for the ballet, she concluded that "the poet's allegorical idea has been betrayed by the pictorial and scenic realization." Anticipating Cocteau, and all subsequent observers, on the failure of the audience to accept the ambiguity of its role as an allegorical body of philistines, de Caillavet notes that "the Châtelet public . . . is the one which is supposed to turn a deaf ear" to the Managers:

> Rather than employ paid extras, the directors of *Parade* use the paying extras installed in the *salle*. But what would happen if, responding to the managers' call, they threw themselves into an assault on the theater, knocking over the musicians in the orchestra?[69]

In distancing himself from Satie and Picasso in the "Collaboration" article for *Nord/Sud*, Cocteau was responding quite specifically to the bad notices of May and June. In most cases, Cocteau's covert suspicions and fears were all more plainly stated in the press.

Cocteau's skepticism over Satie's reputation as an ironic *mystificateur* was also reflected by the critics. The newspaper *L'Heure* asked if the composer's score was "the most charming of winged fantasies or the most buffoonish of *charges d'atelier*," and reminded its readers that Satie, once a denizen of Montmartre, was the self-described "Maître de chapelle de l'Eglise métropolitaine d'art de Jésus conducteur."[70] In *Le Carnet de la Semaine*, Jean Poueigh attributed Satie's "humorist reputation" to the titles and remarks with which he captions his works; "*ironiste à froid*," Poueigh sneered, "he knows how to

put humor everywhere except in his music."[71] The critic for *Mercure de France* lamented that Satie

> seems to have turned his back on the dreams of beauty which cradled his adolescence in order to dedicate himself entirely to *blague* and even to *fumisterie*. Doesn't M. Satie have any goal . . . other than the propagation of musical *farces de rapin*, which are usually only funny for their titles, or the jokes that he inscribes between the staves?

He closes his review with the warning, "Mystification is thick."[72] One week after *Parade*, the theater weekly *La Rampe* published an article on "Le Cubisme et la Musique," which addresses futurist noisemusic and other recent developments. There, Satie is accused of lately aspiring to be the "Alphonse Allais of music" (they were both born in Honfleur) by adding "above the five customary lines [of the musical stave] a supplementary line of writing." But again, "if you take away the text, there is nothing funny left." In the end – and this almost reads like a physical description of Satie's scores – it appears that we cannot know where the "futurists and cubists stop, and the *fumistes* and *puffistes* begin."[73]

It is clear, as has been recently proposed,[74] that many critics of *Parade* were also at a loss how to distinguish between authentic music-hall or circus performance, and imitation popular performance culture appropriated for a higher purpose. As Cocteau later put it, rather than penetrate through the "vulgar exterior of guignol" to the "poetry" of *Parade*, they "took the transposition of the music-hall for bad music-hall." To this end, Picasso's Horse was useful: "This invention has been seen a hundred times at the circus, and the English clowns put more ingenuity into it," complained Henry Bidou in the *Journal des Débats*.[75]

In this line of interpretation, *Parade* was caught less between highbrow setting and lowbrow looks than advanced esthetic ambition and ordinary means. Rather than incite unmitigated outrage among its detractors, *Parade*'s imitation of popular culture was more commonly scorned for being incidental. This attitude constitutes a consensus among critics who, as Cocteau implied, disparaged *Parade* with reverse condescension as a kind of inauthentic popular *spectacle*. "Imagine," wrote Jean Poueigh in *La Rampe*, "three music-hall numbers serving as the *parade* for a *théâtre forain*, while three managers organize *réclame*. It is neither amusing, nor spirited, nor pretty to watch, nor as innovative as they would want to make us believe." Quoting from Apollinaire on realism and "Esprit Nouveau," Poueigh concludes that theoretical convolutions cannot elevate the mediocrity of the work itself: "we persist in failing to discover the least particle of art and amusement in these *élucubrations*, while, each evening, a clown at the Medrano or the Nouveau-Cirque expands and renews the treasure of his spontaneous genius."[76]

Critical praise of popular genius outplays the avant-garde at its own game. Why patronize an estheticization of popular culture when, for less money and greater satisfaction, one can experience the real thing? According to the review in *Le Figaro*, Satie has taken laborious pains "to reproduce the burlesque effects that a dozen fairground musicians produce without effort."[77] The critic for *l'Eclair* claims a qualified allegiance to the Ballet Russes, regretting the "facéties clownesques de *Parade*, ballet cubiste." He con-

cludes that "it is useless to disturb so many artists of great talent for a result which can be obtained, each day, at the Nouveau-Cirque, at the Medrano and at the Alhambra, to much better account and without pretension."[78] Something similar was probably implied by the derision that Russolo's noisemusic received at the London Coliseum in 1913, a performance that was also, though less obviously, extrapolated from music-hall style; in that case, rather than go to another theater, the audience simply had to wait for the next *numéro*.

In relation to its sources and its inflated pretext, the "ballet cubiste" falls short. "The public gave *Parade* a tumultuous greeting," wrote Pierre Lalo in *Le Temps*, "where applause and boos were mixed." He continued:

> *Parade* did not merit so much. And it certainly would not have obtained as much if the spectators had not been forewarned, by printed notices as well as widespread talk, that the ballet was the first manifestation of a new art, of a décor, of a choreography and of a music all equally cubist, destined to revolutionize the esthetic of the universe. *Parade* is nothing of that at all; nothing but a very banal thing.[79]

"Too much is too much," according to Bidou in the *Journal des Débats*; *Parade* is a "small thing, a very small thing . . . which does not seem destined . . . to change the way of the world."[80] Indeed, some critics even complained that, despite all the justifications and hostility, and but for the backdrop and Manager costumes, *Parade* was not even especially cubist – and almost disappointing in that regard.[81] The disproportion between avant-garde and popular culture in *Parade* suggests that, to its original critics, the ballet was foiled by its own devotion to an entertainment medium which was relatively uncontroversial in and of itself, but wholly at odds with its authors' claims to originality. In this context, we are required to determine the extent to which the work *was* fashioned from the material of contemporary popular performance.

As much as *Parade* would seem to derive its iconography from the fairground sideshow, throughout his notes and published statements on the ballet, Cocteau used the terms *cirque* and *music-hall* interchangeably. Significantly for *Parade*, itinerant fairground performance was sometimes actually modeled directly after the circus or music-hall. In this way, we can speak of a *cirque forain* and a *music-hall forain*, where the range of *numéros* was consistent with their counterparts in town: acrobatics, juggling, magic, dressage, clowns and other speciality acts.[82] Presumably, as befits fairground culture, the performances would have been advertised by a *parade*. As conflated hybrids, then, the intinerant circus and music-hall would appear to contain the full range of Cocteau's popular performance vocabulary. However, Cocteau called *Parade* a transposition of the music-hall. In fact, the ballet's iconography can be fully cataloged according to music-hall repertory alone. Moreover, by definition, the music-hall, or variety theater, is an amalgam of all other modes of popular entertainment. This also recommends the music-hall as a prototype for the collaborative heterogeneity of *Parade*. It is, then, to the music-hall that we best turn our attention over the matter of *Parade*'s proximity to popular style.

The war period actually saw a great deal of popular performance activity which had direct bearing on *Parade*.[83] In particular, at a time when the *parade* genre of fairground

entertainment was, in its purest form, actually extinguished by the civic authorities, the music-hall stage was, on the contrary, particularly active.[84] During World War One, at the front, light diversion was recognized as a valuable *détente* from the relentless physical and emotional strain of life under seige. There, theater was necessarily provisional, and music-hall performance was especially popular: it appealed to the largest common denominator among the troops, and was, by nature, adaptable, being easily patched together from available resources. We read in the wartime press that many *café-concert* and music-hall performers were stationed at the *arrière* rather than the *intérieur*, in order that they may better serve in their professional capacity; in a gesture of French cultural propaganda, they were also exported for the benefit of the Allies. In words that recall Cocteau's early hopes for the magic of his ballet, the *Mercure* reports from the front, in summer 1917, that even a mediocre *spectacle* is, for the soldier, "the most beautiful of doors opened onto a dream."[85] Even Cocteau's defense of *Parade* as a kind of refined vulgarity is called to mind by the *Mercure*'s description of a similar contrast at the front, where performances were given in abandoned sheds, managing none the less to express qualities such as "ingeniousness," "spirit," "finesse," and "comic sense."[86]

In Paris, music-hall flourished, as much as any performing art could during the war. Indeed, there seems to have been something of a revival of the music-hall *revue* genre. The large number of *revues* available in Paris during the summer of 1917 reminded Adolphe Brisson, theater critic for *Le Temps*, of the *revue* explosion in 1912.[87] In *La Revue Contemporaine*, Charles Darnatière found that the *revue* was "à la mode" in theaters all over the city, apparently one of the only genres of popular performance which could still hold its own against a rising vogue for the cinema.[88] Of course, the *revue* still drew its source material from *actualités* of the day, heightened by doses of nostalgia: subject matter at the Vaudeville that August included the official censor, sugar rationing, the "extravagant" *modes du jour*, a *camelot classique*, and a revival of legendary songs from the mid-nineteenth century *café-concert*.[89] *Parade* does not seem to have much in common with the *revue* on these terms; its characters only rarely allude to specific current events, and altogether avoid the circumstances of war. However, certain of Cocteau's dance motifs for the Little American Girl, and the readymade instruments with which he wanted to augment Satie's score, do borrow from the *actualités* of high technology – arc lights, radiotelegrams, sirens, dynamos and such. As the subject of Cocteau's narrative subtext, the avant-garde might also be thought of as a governing *actualité*. Structurally, though, *Parade* conforms more closely to prevailing ideas of a *revue* reform, in which unrelated performance *tableaux* would be joined by a unifying narrative idea. In the case of *Parade*, this was the allegory of the *spectacle intérieur*, a single theme that occasions a string of variety turns.[90] The revisionist *revue* was to be an elevation of the genre, and can be directly compared to Cocteau's own ambivalence over the charm and vulgarity of popular performance. Paul Souday, for example, mirrored Cocteau's preference for "poetry" over "farce" when he wrote in the daily *L'Action* that, for certain themes, the *style du "beuglante"* (the lowest form of *café-concert*) is an "enormous fault in taste," and asked: "What is to prevent [the *revue*] from raising its level of dignity, leaving behind the tone of *chansonette* and *calembredaine* in order to attain . . . that of poetry?"[91]

Reading the papers reveals that crucial aspects of *Parade* are of a piece with issues of

popular performance during the war. The history of the music-hall shows that *Parade* adapts forms of performance that were expiring and reviving at that very moment on the popular stage. Investigating on a more practical plane, it is also apparent that, with the cast of characters in *Parade*, both Cocteau and Picasso were borrowing and reinventing creatures of the real music-hall. The Little American Girl, the Acrobat, the Chinese Prestidigitator, the Horse and the Managers mirror the melange of a typical *programme* from the recent history of the hall; even the framework of the fairground *parade* itself can be traced to the music-hall repertory.

When not taken up by the *revue*, evenings at the hall were traditionally given over to a run of *numéros*. At the Olympia on January 11, 1902, for example, the performance began with an Overture, followed in succession by Jane de Méhun, Chanteuse Mondaine; Damaré, Caricaturisme International; Little-Fred et ses Chiens Acrobates; Franco-Piper, Joueur de Banjo; Melot Hermann, Prestidigitateur; Blanche de Marcigny, Ecuyère de haute école; L'Americain Johnstone, Champion Cycliste du Monde; Baggessen, Comique Jongleur.[92] This amalgam of acrobatics, animal acts, musical exoticism and magic, as well as French and American performers, is standard fare. In this sense, *Parade* is virtually generic.

In fact, as Deborah Menaker Rothschild demonstrates, the individual acts from *Parade* can each be cataloged in this way. While the Acrobats are simply commonplace, the Horse specifically resembles the horse-clown costumes of Footit and Chocolat and the Fratellini brothers at the Cirque Médrano.[93] Music-hall brethren of the Chinese Prestidigitator (he was called simply "un Chinois de music-hall" by Bidou in the *Journal des Débats*[94]) include exotic illusionists such as Ching Ling Foo and Chung Ling Soo, of popular stages in London and Paris.[95] In addition to American movie starlets Pearl White and Mary Pickford,[96] the Little American Girl was modeled on music-hall numbers such as "Miss Kathaya Florence, The Yankee Girl," "La New American 'Rag' reel dance," "La Rage (*sic*) Time" with "Miss Rag Time," and the "American Ragtimers."[97] As for the Managers, the figure of the theater impresario and agent was frequently impersonated, and often ridiculed, on the *revue* stage; one notable precedent would be Le Professeur de Publicité Théâtrale at the Cigale in 1913.[98] However, as master and mistress of ceremonies at every music-hall *revue*, the *compère* and *commère* are clear descendents of the *parade* barker, and a ready referent for the barker's reincarnation as a duo of big-city "managers" on *Parade*'s imitation music-hall stage.[99]

To this we can add that popular precedent for *Parade* also includes the appearance of both cubism and the Ballets Russes as vehicles for comic *tableaux* at the music-hall. For example, Picasso's Managers were presaged by Berthez at the Théâtre des Capucines and the "Fauste cubiste" at the Little Palace, just as his tilted cubist cityscape backdrop for *Parade* was anticipated by a startling cubistic set-design by Paquereau for "Paris Cucubique," the prologue of Rip and Bosquet's "La Revue de l'Année" at the Olympia in fall 1912. A contemporary description of Paquereau's set makes this clear: "the place de la Concorde arranged – or better, deranged – according to the cubist esthetic; the obelisk is turned upside down . . . Gabriel's palaces are planted at an angle. And all of that has the pretty little appearance of a catastrophe or an earthquake."[100] *Parade*'s marriage of Ballets Russes and music-hall was also anticipated during the 1912 and 1913 theater seasons, at which time the innovative Russian dancers, in particular

the Nijinskys, were featured as comic *actualités* at La Scala, the Cigale, the Boîte à Fursy, the Concert Mayol and the Olympia (in the same *revue* which opened with "Paris Cucubique") among others.[101] Reviewing the Olympia *revue* for *Comoedia illustré*, the singer-critic Xanrof remarked that, stylistically, the "Paris Cucubique" scene was, "alas! no more exaggerated than the *tableau* of Nijinsky and some nymphs, which is taken for a parody."[102]

Finally, and perhaps most significant of all, the fairground *parade* itself has a history at the music-hall. In one previous example from the music-hall Théâtre des Anteurs Gais, the show was preceded by a "grande parade costumée," during which the program for the "spéctacle à l'intérieur" was announced to the spectators. (Since, according to the printed program, the "parade extérieure" was followed by "2 ou 3 numéros," it seems likely that the terms "interior" and "exterior" were employed as part of the *parade* conceit, and that the "Parade" took place onstage.[103]) Included in the "Parade" cast were a *bonisseuse*, a "clown," a sleight-of-hand artist, a Turk, a Japanese, a Harlequin, an Auguste and a strongman; of the *numéros*, we might also call attention to an illusionist "dans sa Magie dévoilée accompagné de la Sorcière moderne." A charity performance for the benefit of concert and music-hall artists in 1908 at the Bal Tabarin in Montmartre similarly re-created the *parade* both as a pre-performance device and as an element of the actual *spectacle intérieur*, where spectators could see Yvette Guilbert, Colette Willy, Paulette Darty (for whom Satie had composed the waltz "Je te veux" in 1900) and others performing from "baraques."[104]

*Parade* is not, of course, merely an amalgam of popular performance motifs. But the degree to which it *was* exactly that is important, since both the conception and reception of *Parade* were partly conditioned by specifics of popular entertainment culture. This is easily lost. *Parade*'s superiority to authentic contemporary entertainment style is more often stressed.[105] The intellectual pedigree of Marinetti's "Variety Theater Manifesto," for example, allows us to transform the music-hall model into something more cerebral, suggesting a general inclination among the ballet's collaborators towards futurism.[106] A corrective is called for, if only to make certain that the issues remain as complicated as they were in 1917.

Cocteau's defense, that the ballet is greater and more complex than the sum of its popular parts, is a condescending one. When we insist on the obvious, that *Parade* elevates its source material, we reiterate the original sales pitch, and the very allegory of the *parade* itself, through which Apollinaire and Cocteau specified the disparity between *Parade*'s element of surprise and the *spectacle intérieur* that lurks within. With historical perspective, their cover-up should alert us instead to the authentic challenge of *Parade* as a workshop effort, in which clashing principles and motivations reflect a prevailing quality of irresolution. Rather than dismiss *Parade*'s original critics as hopelessly uninformed, we might read early critical objections for an articulation of this problem. If *Parade* openly corresponds to native issues of popular culture, then questions of crossover cannot be readily ignored, for they threw the work's purpose into question. Moreover, the skepticism of the critical press clearly reflects the conflicts between Cocteau, and Picasso and Satie: is *Parade* an allegory of esthetic challenge and popular incomprehension accessibly dressed as a popular entertainment, or is it a burlesque mystification that simultaneously undermines good faith on both sides of the footlights?

—6—

The broad burlesque of the final production of *Parade* was too easy to contrast with higher claims made for it by Cocteau and Apollinaire, whose Esprit Nouveau article was itself branded "la *parade* pour *Parade*."[107] The comic nature of *Parade*, particularly the Managers and the Horse, engendered its widespread reception as an elaborate prank or hoax.[108] The role of the comic and of play in esthetic novelty was thus confounded with mocking impudence, the *charge* or *farce d'atelier*. The criticism seems to divide itself into derisory definitions of *Parade* as an unintentional *charge*, and characterizations of it as a deliberatly comic stunt, and thereby relatively inconsequential. The critic for *Le Gaulois*, for example, highlighted the disparity between intentions and results, writing that

> if *Parade* is a parody, a spirited students' farce, than it's fine. But the manifestos of these gentlemen make me fear that they have wanted to attain the sublime, and that their *ballet réaliste* is the production of an outrageous avant-garde esthetic.[109]

On the contrary for the critic of *Eclair*, Cocteau's legitimate reputation as a "précoce et vrai poète" virtually guarantees that *Parade*'s collaborators "have wanted to amuse us and put us in the presence of a large, unpretentious sketch."[110] Others, such as Lalo in *Le Temps*, stated unambiguously that *Parade* was "a *farce d'atelier*, indifferently diverting,"[111] while the illustrator Ibels, writing for *La Rampe*, allowed *Parade* its comic intentions but not its comic success, calling the ballet a "pretended *boufonnerie* denuded of all interest and, even more, of *la comique*."[112]

In many cases, talk of farce, both deliberate and accidental, was clearly meant to reduce *Parade* to a diversion, and thus undermine a *succès de scandale*. In *Le Soir*, R. de Lomagne quoted from Cocteau's *argument* and his theory of new realism: "putting on the stage real objects which lose their reality the moment one introduces them into a fictive milieu." However, for de Lomagne, the ballet itself cannot support this load of conceptual freight: while Cocteau's theories are "obscure enough," *Parade* appeared to be "simply an amusing *charge d'atelier*, with a pleasantly arranged *mise-en-scène*, attractive music and, when all is said and done, despite some protestations, appeared to divert the great majority of the public."[113] Here, the audience reaction to *Parade* becomes part of the comic ambiguity: according to most reports, *Parade*'s detractors outnumbered its supporters in the *salle*, but de Lomagne seems to have taken what everyone else described as derisive laughter for the sound of a good time.

As in the pre-war, the criticism of *Parade* demonstrates that the terms of esthetic incomprehension do not boil down to mere outrage and intolerance, but are instead quite adaptable in their response to the disorienting effects of avant-gardism. *Parade* is particularly interesting as a case-study because it takes disorientation as its very theme, though the collision of intentions revealed on opening night served only to amplify the principles of skepticism and distrust. One casual acquaintance of the Picasso circle at the time, the journalist André Warnod, attempted to reconcile the seriousness and the frivolity of

*Parade* in a way that recalls the insider/outsider debates of the pre-war press. In his short review for the newspaper *l'Heure*, Warnod begins by listing the elements of the work, including "blaring music which is reminiscent of fairground and music-hall orchestras." He then cuts straight to the question of a larger meaning:

> The *initiés* know that this ballet means to represent the character of our epoch, that it is a super-realist expression of modern life. But we can assume that not all spectators are *initiés* . . . therefore, it remains for them only a madly gay spectacle, distractedly exhuberant . . . Then why that uproar, that acclaim, those bravos, those whistles, those cries of "hurrah" and "quiet down!"? Why be frightened away by burlesque in a *spectacle* which should be burlesque?[114]

Warnod is willing to accept that there are aspects of *Parade* which will, for most, remain internal secrets; he even seems to have developed a kind of outsider's shorthand epithet, "super-réalisme", in order to conflate the pre-*Parade* theories of Cocteau and Apollinaire, without really pretending to understand them. Yet he will not be forced to deny the legitimate cohabitation of serious art and burlesque. Without the benefit of a longer text we can only say that, as an exception to the rule, Warnod's attempts to save both the straight and the comic in *Parade* underscores what was, for most spectators, the cardinal problem.

The critical assessment of *Parade*'s ambiguity of intentions was most fully treated by Paul Souday, in his review for *Paris-Midi* entitled "Un Ballet Cubiste." "With this *Parade*," Souday began, "we are swimming in deep paradox." Souday's paradox revolves around the question of comic intentions in *Parade*, and he frames the matter as a familiar dilemma of disorientation and incomprehension: "Fantasy has its rights; even *fumisterie* is a literary or artistic genre that can be full-flavored. Only, it is necessary, as much as possible, to avoid misunderstandings." Souday quotes one of the ballet's chief collaborators (though he does not specify which one) as having claimed, after the performance, that *Parade* is a "joke" (*plaisanterie*), that it is intentionally funny. Public anger at the Châtelet, Souday maintains, came from taking seriously a *charge d'atelier*. Souday describes the conflict between protest and applause as a valid dynamic:

> that incomprehension . . . proves that the authors attained their goal . . . Nietzsche said, one writes in order to be understood, and also in order not to be understood. This second objective has, perhaps, priority in the ambitions of MM. Jean Cocteau, Léonide Massine, Pablo Picasso and Erik Satie.

Having established these alternatives, Souday is ready to insist that *Parade*'s creators meant to act in good faith, so much so that they actually forewarned the public; anyone could have known before opening night that *Parade* was a comic *charge*, if only he had followed the signs. Read as ironic, the writings of Cocteau and Apollinaire provided ample advance notice of *Parade*'s true nature as avant-garde mischief. (Although, Souday admits, the crowd tends to shy away from irony, perceiving it as a trap; he even cites an interview in *Paris-Midi* conducted by Apollinaire's friend Louise-Faure Favrier with the guileless Marie Chabelska, who danced the Little American Girl, to illustrate that the "innocent souls" of children repel irony as a form of maliciousness and mockery). He continues, "To call a cubist ballet 'realist' is to begin honestly by warning everbody.

Cubism is the very negation of realism." Similarly, Apollinaire's prophecy of an "esprit nouveau," "a truth so lyrical, so human, and so joyful that it would even be capable . . . of illuminating the terrible black sun of Durer's *Melancholy*," is conclusive: thanks to Apollinaire, "we know with certainty that this is a question of farce."[115] Such pronouncements are, in other words, so perverse given the work in question that the only possible interpretation is transparent hoax.

Souday's verdict is straightforward: "Taking *Parade* for a folly, an enormous *bouffonnerie*, one cannot be shocked by it, and can even find it funny enough." He reminds his readers that, on this matter, he had the direct testimony of one of the authors. And he reiterates that irony; "le style indirect" is the governing promotional strategy of *Parade*. Souday likes the poetry of Cocteau's allegorical narrative as it is presented in the program – the *parade*, the *spectacle intérieur* and the backfire of *réclame* – but he concedes that without the program notes, "it is likely that the symbolism would escape us. We would not at all have attributed that significance to the *parade*." *Parade* comes off as a virtual exercise in the mutability of intentions and meanings. Souday, then, is perfectly content to liberate *Parade*, rather than nail it down; without the single meaning of the *argument*, he continues,

> one would be able, moreover, in searching a little, to attribute others to it. One can, above all, attribute none to it, and to be frankly amused by it, like a genuine *entrée* of clowns, a number at the Guignol or an episode at the bal des Quat'z-Arts.

(Similarly, Satie's score is "a mystification, if you like, but diverting enough.")[116] Almost casually, Souday is accepting *Parade* as an operation in confounded and conflated genres, or as the expression of a meta-genre that is hermetic and accessible in turns. Unlike other critics, Souday does not seem to approve or disapprove of *Parade*; he does not feel the supporter's need to elevate the work, or the detractor's need to diminish it. In an opinion piece he wrote thereafter for the "La Vie intellectuelle" column of the newspaper *L'Action*, he called *Parade* a "prétendu scandale," subject to a certain amount of unjust critical venom. Without actually taking sides, Souday suggests that esthetic innovation has always been a threat to the established order, and that "with innovations of which nothing is understood, one no longer knows what countenance to adopt."[117] In taking the ballet as allegory, entertainment and prank, Souday expresses a tacit recognition that, in the case of some works, an otherwise unfamiliar degree of critical latitude is called for. Throughout its critical history, this remains the most sophisticated appreciation of *Parade*.

In his treatment of *Parade* as a comic work, Souday also assesses the role of cubist style. As an esthetic doctrine that appeals to the intellect with works that are "abstrait et rationnel," cubism is defensible in theory, if often unintelligible in application. Despite its pretensions to seriousness, Souday finds most cubist pictures frankly ugly. But he values cubism in another sense: "Precisely because of the liberties that it affords itself, cubism dispenses excellent resources for caricature and *charentonnade*."[118] (The second quality, derived from the madhouse at Charenton, might be translated as a lunatic caprice or fancy.) In turn, Souday is free to describe Picasso's Manager costumes as "burlesque et hideux" without being taken to mean anything less than that they were a complete success. The notion that cubism was full of burlesque potential is liberating, for it allows

us to investigate a certain period elasticity of cubism that is unjustly neglected. Bristling with loony images of the urban landscape, the Manager costumes are undeniably funny, both in a broad, slapstick sense, and as expressions of refined structural wit. As such, they suggest that, according to Picasso, comic possibilities were latent in the otherwise difficult new grammar and syntax of cubism, and that the punchline was fully audible from the street.

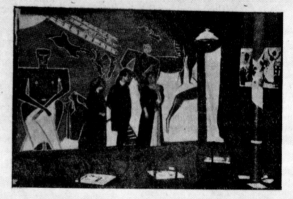

## UN CABARET DE CUBISTES A LONDRES
### qui obtient actuellement un vif succès de curiosité

Miss Floyd Ariston et deux de ses artistes sur la scène ; le rideau est aussi de style cubiste

N'allez pas croire que le cubisme, la nouvelle formule d'art en fait de peinture, soit un vain mot : il a des adeptes nombreux, des partisans convaincus, des admirateurs enthousiastes, et Miss Floyd Ariston, une cantatrice bien connue, a ouvert à Londres un cabaret qui a su en peu de temps se créer une nombreuse clientèle dans le monde des artistes et celui du High-Life. Les murs du cabaret sont ornés de peintures cubistes.

93. "Un Cabaret de cubistes à Londres," *L' Actualité* (1912).

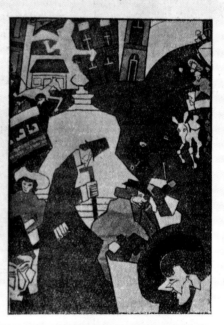

Un panneau représentant le mouvement dans le quartier de Piccadilly à Londres (?)

—7—

The pre-war transformation of cubism into popular culture is an obscure episode in the history of style. Yet as a setting for Picasso's application of cubism to the design of a music-hall type *spectacle*, the popular culture of cubism is essential. Cubism's notoriety as a regular salon scandal made it the common property of *tout Paris*; popularizing cubism, therefore, is often a form of ridicule, though it is not restricted in this way. The general stylistic principle of popular cubism is reductive geometrization and disjointed composition, and its resemblance to the real thing is typically remote at best. Flattened though it may be, however, it draws attention to the inherent pliability of cubist style. (A liberal appreciation of this sort is licensed by Fernand Léger, who wrote from Verdun in 1916 that the battle had left behind a number of tragi-comic "cubist" views, such as a chair in the branches of a tree: "so-called sensible people would say you're crazy if you showed them a picture composed in this way," he remarked.[119]) In this sense, even simple jokes can be suggestive, and the results both ironic and authentic. For example, in his Place de la Concorde for the Olympia in 1912, the stage designer Paquereau plays cubism for laughs, but he also demonstrates a sincere effort to refresh the comic stage by exploiting the latest *outrance* of visual culture. From critical accounts, the Olympia set was closer in appearance to cubist painting than the "cubist" decoration and drop curtain for a cabaret in London, reproduced in the magazine *L'Actualité* that November (fig. 93), but the principle is surely the same. In the case of the "cabaret de cubistes," hieratic stylization and a picture-puzzle geometry of interlocking parts exemplify the amusing decorative and caricatural qualities of cubism. The results suggest the kind of images that cubism was kidded for resembling, more than the actual look of cubist painting itself (although they bear a distinct likeness to the cubist mural decorations produced by Roger Fry's Omega Workshops in London between 1912 and 1914).

The same, however, might be said for the "serious" application of cubism to architecture and the decorative arts. Just one month prior to the début of Paquereau's set at the Olympia, André Mare and Raymond Duchamp-Villon unveiled the "Maison Cubiste" at the Salon d'Automne.[120] Inside, a number of artists and designers had contributed the domestic accessories: tables, chairs, lamps, tapestries, shoes, a porcelaine coffee service and so on, while painters such as Léger, Gleizes, Metzinger, Duchamp and Roger de la Fresnaye submitted pictures in the mode of Puteaux and Passy cubism. However, the collaboration is only vaguely cubist, and strictly in a light, decorative sense. Similarly, Duchamp-Villon's large plaster maquette for the façade (fig. 94) is essentially an eighteenth-century *hôtel particulier* with geometric details and cubistic relief sculpture[121] which offers nothing by way of structural innovation.

Certain claims for the Maison Cubiste might be made in accordance with theoretical discussions of décor and style from Mare and his supporters of the time, above all, that it represents a deliberate attempt through cubism to remake established prototypes of French bourgeois design. The disjunctive eclecticism of the objects in the house suggests an interpolation of the principles of cubist style into the circumstances of interior

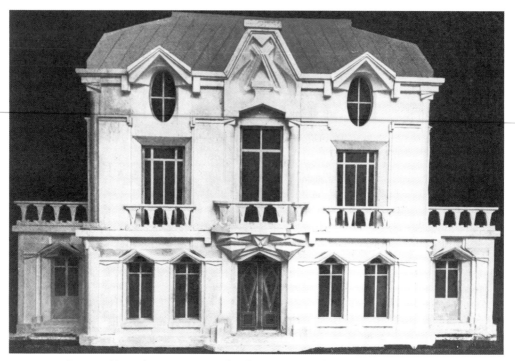

94. R. Duchamp-Villon, plaster maquette for the "Maison cubiste" (1912).

design. Yet these same qualities might equally be taken as a sign of hesitancy.[122] Moreover, justifications of the project do not diminish its resemblance to parody. We are not even certain whether the name "Maison Cubiste" was devised by the authors of the enterprise or by its critics (the ensemble was never referred to as such in the official literature[123]). In other words, is "cubism" a selling point or a pejorative? In a gesture of like ambiguity, Mare did award a label to the main room, which is listed in the catalog as "un salon bourgeois." The epithet appears deliberately to conventionalize the commercial and domestic ambitions of the décor but, irresistibly, also suggests a joke in keeping with popular hostility towards cubist art. Theory might also be said to govern Duchamp-Villon's program for the façade, which was based on the premise that visual austerity redresses the materialist excesses of modern life.[124] None the less, though it is sometimes promoted as a significant agent of architectural reform during the pre and post-war periods,[125] the exterior design is at once high-minded and superficial, the cubification of an historical façade-type that looks (program notes and theories of historicism notwithstanding) like an old hôtel reimagined by a doodling *rapin* from the café across the street. As an avant-garde attempt to prove the practicality of rarefied esthetic principles in modern painting, it falls short; in so doing, it comes instead to resemble the humorist's visualization of a cubist world. Ironically, at least one such critic lampooned the Maison Cubiste for its bourgeois restraint, calling instead for a bolder transformation of "cubisme idéal" into cubism for "le peuple." Next year, he predicted, we can look forward to cubist buffets cut from a single block, tables with cubes for feet, and pyramidal chairs.[126]

The general look of popular cubism is represented by the punning trope "Le Maître Cube," the cube master who is shaped like a cubic meter. In art criticism, as we have seen, the spirit of this one-liner was cultivated by Louis Vauxcelles, who attempted to dismiss cubism as a student exercise, though for lesser wits it simply alludes to the ludicrousness of cubism as a manner of representation. The caricaturists Hemard, Moriss, Sem and Adrien Barrère are among those who developed a jokey geometrical style of this kind.[127] Here, people and their environment are stylized by right angles, a nightmarish "what if" scenario of the world as the cubist sees it. Barrère's poster for the comic short film *Rigadin, peintre cubiste* in 1912 is a typical visualization of the artist as a zany assemblage of blocks and beams (fig. 95).[128] However, it would appear that Barrère developed his practice of popular cubism, not only as a mockery of cubism, but as a fresh vocabulary for humorist illustration. An earlier poster for Tristan Bernard's play *Le Petit Café* at the Théâtre du Palais-Royal in 1911 is signed "Cubisté par A. Barrère," a taunting inscription (fig. 96). Barrère's cubistic caricature portrays a comic quarrel between two of the female protagonists. The play has nothing to do with contemporary developments in the world of art; for the artist, cubism seems to have been innately funny, a stylistic equivalent to antic stage business. Possessed of an attention getting graphic vigor, it has, in addition, enabled him to endow the gestures of the two fighting women with comic unco-ordination, especially the actress Lavigne on the right, whose legs resemble those of a wobbly table. In turn, the 1913 Pathé film of Maurice Chevalier and Mistinguett in their music-

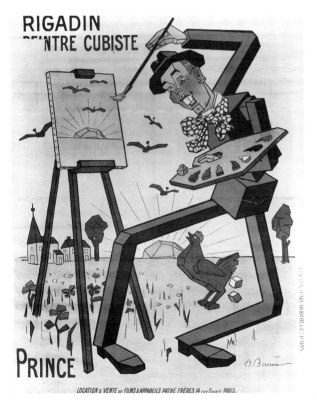

95. Adrien Barrère, poster for the film *Rigadin, peintre cubiste* (1912).

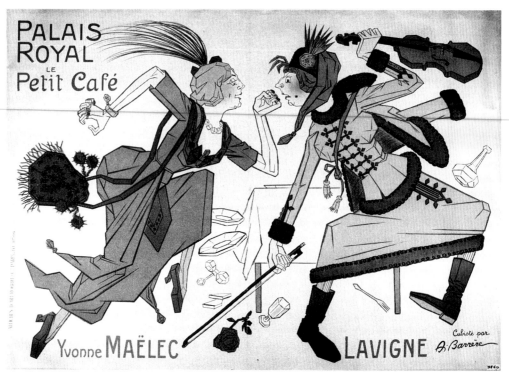

96. Adrien Barrère, poster for the play *Le Petit Café* (1911).

hall dance routine "La Valse renversante" quite correctly suggested futurism, rather than cubism (fig. 97). The comic number was a dancing frenzy of kicks and turns, crashing dishes and toppling furniture.[129] Barrère's poster depicts the two stars as a flurry of multiple arms and legs, a technique borrowed from futurist pictures such as Giacomo Balla's *Dynamism of a Dog on a Leash*.[130] The poster has been inscribed to the two performers, and signed "Bien fouturistement A. Barrère." More than a joke, Barrère's poster could be defended as an example of authentic futurist iconography and style, somewhat crudely applied to comic ends in a cultual context that is wholly germane to the futurist agenda. One year prior, Gino Severini appears to have adapted his own brand of futurism to a virtually identical purpose. An exercise in modern-style *publicité*, this striking poster of dancers at the Moulin de la Galette (fig. 98) does, of course, follow the precedent of Toulouse-Lautrec and Bonnard; so does Barrère's, however, and as essays in popular futurism, the two share the same cultural wallspace.

Duchamp-Villon and Barrére demonstrate that popular modernism can encounter "true" modernism from both above and below: transposed into the applied arts, authentic cubism can resemble a cubist caricature; adapted to the graphic arts, humorist cubism can be legitimized. In a third version, the popular acculturation of avant-garde style as mocking caricature can coexist with the style itself in the work of a single artist. The caricature "Style cubique," published by the magazine *La Vie Parisienne* in October 1912, is typical of the "Maître cube" joke (fig. 99). One of a series entitled "Le Style, c'est

l'homme!," it visualizes cubism as a facetiously chaste principle of interior decoration, where not only furniture, but flowers and clothing are made to conform. There are geometrical curtains, a cubic hat, and pictures by "Pikasso" and "Brak" on the wall (in an allusion to the close working relationship of the two artists, they are interchangeable). Clearly, this caricature was published to coincide with the début of the Maison Cubiste at the Salon d'Automne. And it is itself the work of an authentic cubist painter, the Polish-born Louis Markous, later re-christened "Marcoussis" by Apollinaire.

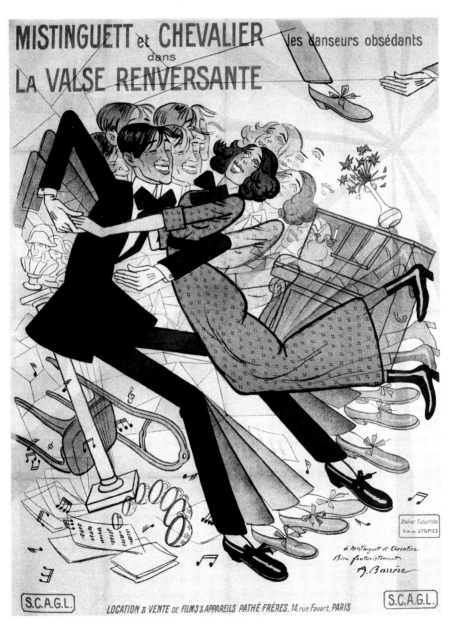

97. Adrien Barrère, poster for the film *La Valse Renversante* (1913).

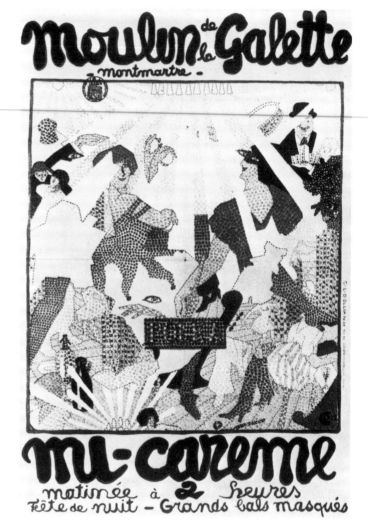

98. Gino Severini (?), poster for the Moulin de la Galette (1912).

Marcoussis created several dozen such cubistic cartoons, especially for *La Vie Parisienne*, at least between January 1911 and April 1913. (These dates are approximate, having been derived from a survey of Marcoussis' contributions to *La Vie Parisienne*; there exists no systematic account of this body of work, and Marcoussis is understood to have abandoned caricature once he began working in an avant-garde style.)[131] He is best known for the delicacy of touch that he brought to etchings and paintings in a cubist manner, among them his celebrated portrait of Apollinaire (figs. 100 and 101); these pictures were exhibited at the Salon d'Automne, the Section d'Or and the Indépendants in 1913 and 1914. But Marcoussis' signed cubist caricatures were hardly a secret at the time. Some of them appeared on the humor page of *Le Journal* in 1912, signed "Markub" (fig. 102), and four were shown at the Salon de la Société des Dessinateurs Humoristes in March 1912. They were published together that month in *La Vie Parisienne*, under the

99. Louis Marcoussis, *Style cubique, La Vie Parisienne* (1912).

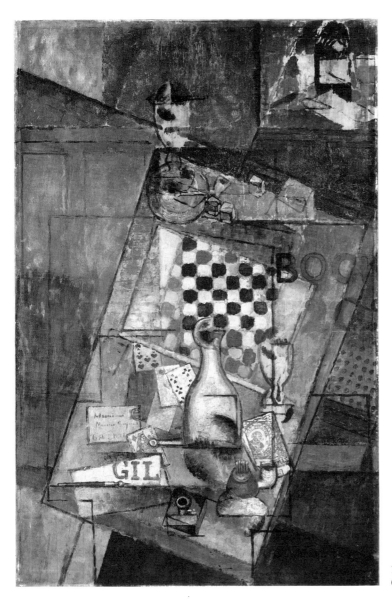

100. Louis Marcousis, *Still Life with Chessboard* (1912).

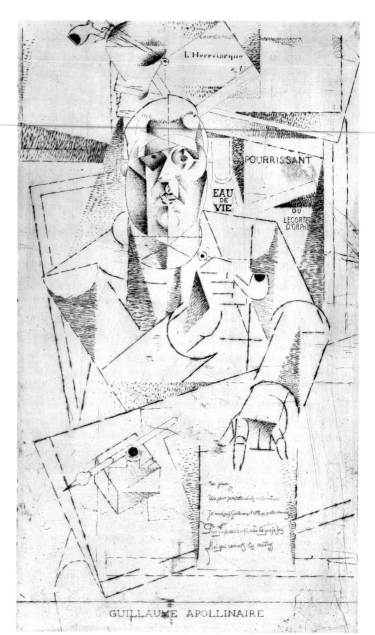

GUILLAUME APOLLINAIRE

101 (left). Louis
Marcoussis, *Guillaume
Apollinaire* (1912).

102 (below). Louis
Marcoussis, illustration for
"La Vie Drôle," humor
page of *Le Journal* (1912).

rubric "Prenez-garde à la Peinture" (fig. 103). Reviewing the Salon, Apollinaire remarked that Marcoussis "wittily scoffs at the various schools of modern painting."[132] His illustrations from early 1912 for "Costumes de Carnavale" include designs for a "Skyscraper" and "L'Art Cubiste" that share a certain amount of architectonic play with Picasso's Managers (figs. 104 and 105). Many avant-garde painters of the pre-war period worked as illustrators early in their careers, and Juan Gris, like Marcoussis, continued during his most important years as a modernist;[133] but Markub is alone in having actually *targeted* modernism. It is easy to find more differences than similarities between Marcoussis' "serious" etchings and his cartoons. Yet Marcoussis' two cubisms are significant: his dual practice of a style and its parodic counterpart constitutes the bifurcated version of what will be, in Picasso's hands, a seamless conflation.

Serious and popular modernism correspond most freely on the common cultural ground of the cabaret, the music-hall and related places of relaxed esthetic hierarchy. This was partly due to conditioning. The London "cubists' cabaret" does, after all, bear a family relationship to the long tradition of the artist's brasserie hangout, the lower dives sometimes referred to as *caboulots*, where the walls were typically decorated with graffiti, caricature and other "unofficial" sports of drawing and painting produced by *habitués*.[134] It may also be likened, in this respect, to chez "l'Ami Emile", a café-bistro on the rue Ravignan in Montmartre which was ornamented between 1910 and 1911 with cubist and futurist decorative panels by Gris, Marcoussis and Boccioni[135] (and both examples contrasted to *soigné* turn-of-the-century establishments like the Taverne de Paris, with its lush murals by Cheret, Léandre, Willette and other fashionable illustrators[136]). Moreover, modernist satire, which would peak during and after the war in Zurich and Berlin, was just then beginning to occupy the cabarets of Moscow, transforming nightlife into a gritty *gesamtkunstwerk* of the avant-garde.[137] And in its wild physicality, Marinetti's conception of music-hall performance contains all the fundamental precepts of futurism, suggesting

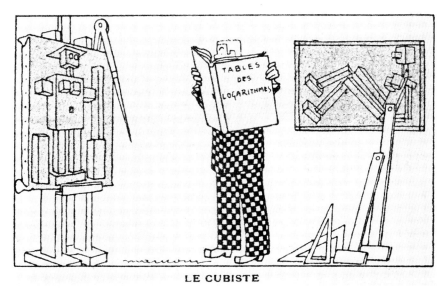

**LE CUBISTE**

103. Louis Marcoussis, *Le Cubiste, La Vie Parisienne* (1912).

COSTUMES DE CARNAVAL

*Fantaisies d'Actualité*

104. Louis Marcoussis, "Costumes de Carnaval," *La Vie Parisienne* (1912).

105. Louis Marcoussis, *L' Art cubiste*, *La Vie Parisienne* (1912).

106. Mary Max as an "Apostle of Futurism" in *A Vos Souhaits*, Boîte à Fursy (fall 1912).

that we might actually reinterpret the entire futurist movement as a riotous trans-European slapstick comedy in which the chief principle of modern life turns out to be a kind of chaotic hilarity.

Modern style resembles its own assimilation into popular design particularly at the juncture where interior decoration and fashion become popular stage décor and costume. An amused report in May 1913 for the newspaper *Homme Libre* concerning the influence of cubism on ladies' hats ("little bonnets, no longer cylindrical or rounded, as the world has demanded until now, but *en forme de cubes*"[138]) evokes cubist fashion design from the studio of Sonia Delaunay. Delaunay's "simultaneous" dress of 1912, with its boldly colored geometric panels, was created for a *soirée* at the Montparnasse nightspot, the Bal Bullier, located across the street from the Closerie des Lilas, a gathering place of Montparnasse cubism at the time (see fig. 2).[139] The dress actually suggests humorist fantasies of the cubist and futurist as harbingers of distopian geometry, a world subjugated by squares. Part of a larger campaign in the decorative arts, including book-binding as well as interior décor,[140] it might be traced to modernist interest in traditions of handicraft. But pre-war avant-garde design must also be regarded as an exercise, however earnest, in the outer limits of *haute couture*. (Both Sonia and Robert Delaunay were "simultaneously" decked-out for the Bal Bullier, and Blaise Cendrars later remembered that the futurists telephoned Milan to report this fashion coup.)[141] As a dance-hall masquerade of modernism, Delaunay's dress belongs to an extended concept of theater. In addition to Armand Berthez's cubist-painter suit, the costume for Mary Max as an "Apostle of Futurism," in the 1912 music-hall *revue* "A vos souhaits" at the Boîte à Fursy (fig. 106), helps us contextualize form and function in Sonia Delaunay. The line that separates mockery and sincerity is almost erased by the fantasy of the popular stage, an arena which Delaunay shares with Mary Max. Indeed, as a concept, the theatricalization of avant-garde style might be said to govern all transformations of elite visual culture into the popular and parodic; in this sense, simultanist fashion at the Bal Bullier is as much a parody as the checkered borders and octagonal aviator goggles of music-hall "futurism."

<center>✳      ✳      ✳</center>

The formal and expressive rapport of cubism and caricature *per se* has been established in detail by Adam Gopnik. Gopnik has shown how essential devices of caricature served Picasso's application of morphological lessons from *l'art nègre* to cubism. Concerning this process, he writes that, in Picasso,

> the decorum of norms and expectations [against which caricature was previously understood to function] is not just stood on its head, but completely rearticulated in a way that denies any secure sense of hierarchy, and therefore any simple, closed response.[142]

Following Gopnik, Christopher Green examines the work of Gris in this regard, though he concludes instead by insisting, unnecessarily, that distinctions between the two – the cubist painting and the humorist illustration – must prevail.[143] It seems clear, then, that

their compatibility can still be unsettling, challenging the commitment to cubism as a cerebral philosophy of pictorial form. That, of course, was just the intended effect in 1911 or 1912. The category of popular cubism in general is far broader than caricature alone, and the questions it raises concern more than morphology. They influence both the dissemination and the experience of the new art, and they pervade the terms of debate. By indulging the early popular opinion of cubism in order to reconstitute the original discourse, the comic can be identified as a pivotal element of pictorial novelty, rather than a trivializing one. According to popular perception, cubism (and futurism) could be disparaged as comic, yet also made to serve comic ends. The life of cubism is influenced by this ambiguity. We cannot get to the Maison Cubiste without crossing Paquereau's Place de la Concorde.

Ultimately, however, discourse and morphology should concur. The popular culture of cubism is useful, for it denotes a degree of play encouraged by the reductivist component parts of cubist form; this proximity of joke-cubism to the real thing is peculiar to the eccentricities of modern style. Understood as deliberate hoax or authentic farce, *Parade* was bound to be confused in 1917 with the frivolity of popular cubism. Yet we must ask to what degree such a reaction was not only justified, but valuable, especially with regards to the Manager costumes. As a flexible stylistic vocabulary for pictorial free-association, cubism was as susceptible to humorist fantasies of costume and décor as it was to pictorial demonstrations of esoteric science. In the case of Picasso, the history of popular cubism provokes us to consider a place for parodic ambiguity in the meaning of cubism as a new grammar of esthetic research. A practice of correlating the shapes and structures of cubism to certain artefacts of popular culture can, in fact, be observed, and described as a form of humor that was fundamental to the enterprise of Picasso's work from around 1912 to 1917. The nature of this correlation can be described as an extended function of the pun, already familiar to us from the verbal and visual play of the *papiers collés* and *collages*. It concerns, however, a more literal, and therefore a broader and funnier likeness between cubism and other things. As the light, drifting fragments of analytic cubism were reinvested by Picasso in 1912 with shape and weight, cubist style came to suggest and resemble certain elements of modern street culture; these, in turn, were actually exploited by the artist as parodic models, and allowed to have a burlesque shaping effect on cubist art. In particular, aspects of advertising culture appear to have served Picasso in this way.

—8—

Picasso's Manager costumes for *Parade* represent the most fully-developed single episode in this scenario. Virtually all the literature on the Managers includes a reference to their initial appearance in Picasso's sketchbook as an advertising phenomenon called the "sandwich-man". In French this is the *homme-sandwich*, a figure who walks the streets with two large sign-boards which are suspended from his shoulders in front and behind (fig. 107). This design, we are meant to understand, was abandoned for the larger and more abstract architectonic constructions which constitute the final Managers.[144] The sandwich-man is generally given little or no further consideration. One recent interpretation of *Parade*, however, as a vehicle of French cultural tradition, locates Picasso's design

107. Picasso, sketch for the
French Manager (1917).

in the iconography of nineteenth-century street vendors and *hommes-affiche*. Particular
attention is paid to the popular *images d'Epinal* and "Cris de Paris," illustrated reperto-
ries of figures drawn from occupations of the city street. In this context, the cocoa vendor,
the *marchand d'images* and the *vitrier* with his glass panes all suggest the Managers and
their cargo. Picasso and Cocteau are thus said to share a taste for the charm of the
broadsheet, and even the startling Managers can now be understood to have conformed,
in part, to the nostalgic agenda announced by Picasso's drop curtain, and outlined in
Cocteau's notes and statements on the ballet.[145]

   There is an error of judgment here, proceeding not only from the misleading presump-
tion of unity of purpose in *Parade* (an underlying patriotic conservatism to which all
source material must therefore correspond), but also from a common urge to elevate
popular culture, or in this case varnish it, with the handsome tint of historical pedigree.
Following this line of interpretation, even *Parade*'s "enigmatic" Chinese Prestidigitator is
said to have been derived from the occasional "Cris" figure of a Chinese porcelain
merchant, though sinister orientals and conjurors, and every other character in *Parade*,
have contemporary performance prototypes at the music-hall. It is possible to look too far

when obvious, if less romantic, source material can be found in the cultural backyard. The search for a Manager prototype in the historical past of French tradition diverts attention from the *homme-sandwich* as he was actually recorded by Picasso, a far more compelling and lively member of the unvarnished historical present. In fact, the sketchbook evolution of Picasso's Managers demonstrates an active, first-hand observation of the *homme-sandwich* apparatus that is, in turn, consistent with a broader appearance of recent advertising culture in Picasso's late cubism, in particular the sculptural œuvre.

This is not to deny that both the street vendor and the *homme-affiche* or *homme-réclame*, an early variation on the *homme-sandwich*, can be located in catalogs of "Métiers de Paris" or *cris*. In *Paris qui crie: Petits Métiers* from 1890, Henri Beraldi traces the first *homme-affiche* back to 1817.[146] However, literature on the subject from the 1880s and 1890s addresses the sandwich-board as a "modern" variation which crowds the streets of contemporary Paris. For instance, according to Beraldi, some *cris* never vary, but the change from occasional, early examples of the *homme-affiche* to recent long lines of *hommes-sandwich* is striking; such a line is, in fact, depicted on the cover and frontispiece of *Paris qui crie* (fig. 108). In *Affiches illustrées (1886–1895)*, Ernest Maindron begins his chapter on the *homme-sandwich* by observing that

> at this very moment, we are witnessing diverse attempts at the transformation of French *publicité*. These attempts are still in a state of infancy; they are entirely too young to be assigned a definitive place in the intellectual existence of Paris, but meanwhile they mark the beginning of a singular evolution that must be emphasized.[147]

In his *Le Pavé Parisien* from the same period, A. Coffignon describes the fortunes of the vagabond class, from which the advertising world draws most of its *hommes-sandwich* and prospectus distributors;[148] their lives are low, but such jobs save many men from the hospitals and the prisons. This seems to reflect the life of the *homme-sandwich* throughout the pre-war. In 1914, Pierre Mac Orlan, an acquaintance of the Picasso circle, tells the same tale, from personal work experience, in the pages of *Le Journal*.[149] The métier of the *homme-sandwich* is, it would appear, a catch-all job for the down-and-out, though as Mac Orlan reports, humor does rise to the surface: compared to the military conscript, one comrade assures him, at least the *homme-sandwich* is "free."

While the old *homme-affiche* is often depicted as having carried a single, two-sided sign-board which was supported atop his shoulders and rose above his head, the *homme-sandwich* was conceived as a two-board arrangement; Coffignon describes it as an American variation. In many of the Manager sketches, Picasso demonstrates a predilection for the sandwich style, though the final Manager costume-constructions show a dramatic elevation above the dancer's body that suggests, at first, a return to the older type. However, by the pre-war period in Paris, a fairly wide variety was in active use, including the old-style overhead sign, the new sandwich-board, and other, far more eccentric versions of the basic principle. In fact, they were all referred to as *hommes-sandwich*, though the alternate phrase *publicité ambulante* is a better generic allusion to the open-ended range and variety of types. The cover illustration by Lourdey for a December 1912 issue of the *Journal Amusant* is entitled "L'Homme-Sandwich," even though the advertising device it depicts consists of two sign-boards, one overhead and one behind (fig. 109). A similar construction can be seen from the back in another illustration

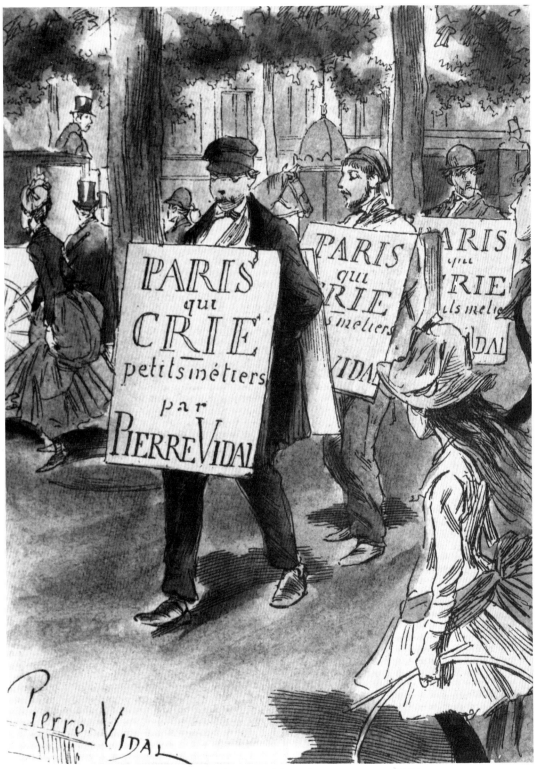

108. Pierre Vidal, frontispiece illustration from Beraldi et al, *Paris qui crie* (1890).

109. Lourdey, cover illustration for *Journal Amusant* (1912).

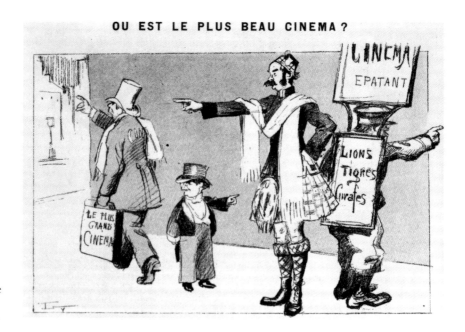

110. Lourdey, "Où est le plus beau cinéma?," *Journal Amusant* (1913).

by Lourdey for the same periodical published the following March (fig. 110). Here, the *homme-sandwich* is shown as part of an eclectic group of advertising costumes, including a tall thin Scotsman and a midget in top-hat and tails, familiar figures of sidewalk *réclame*. Roughly the same crew, "bonniseurs pour cinémas," had already appeared in a photograph for *Fantasio* that January, with the substitution of an American "Uncle Sam" character (fig. 111). Thus, in any form, the portable sign-board was not, during the teens, an object of nostalgia the way the *parade* could have been, but a walking fixture on the sidewalks of Paris. Even the little illustration for Mac Orlan's "L'Homme-Sandwich" essay in 1914 shows the familiar file of overhead sign-boards; and they also appear in contemporary newspaper ads for Portuna wine, carried by an African, an Englishman and a Chinaman (fig. 112).

Tinkering at first with the genuine sandwich-board configuration, Picasso suspends the apparatus from three different sets of shoulders. In one version (fig. 113), the figure is

**Les deux délégués, bonisseurs pour cinémas.**

111. Photograph of *hommes-réclames* from *Fantasio* (1913).

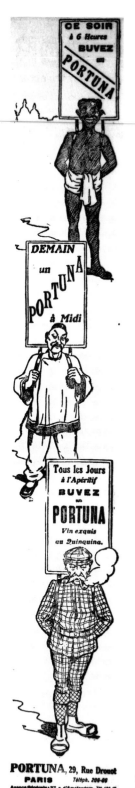

112 (left). Advertisement for Apéritif Portuna, *Le Journal* (1912).

113 (right). Picasso, sketch for a Manager (1917).

114 (right). Picasso, sketch for a Manager on horseback (1917).

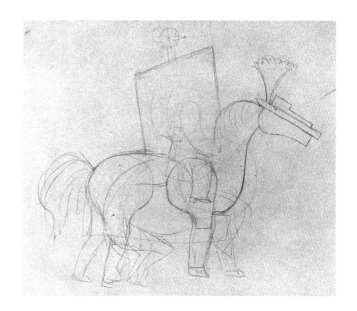

depicted in authentic *homme-sandwich* street clothes, in particular, the baggy pants and cap that are identifiable in depictions from 1890 to the war (see fig. 108). (In a marginal sketch on the same page, Picasso also experiments with a boater.) The second version is the original conception for the notorious *Parade* horse, which was to represent a third Manager. By rehearsal time, this figure had become a horseback dummy in top-hat; the dummy kept falling off, and was ultimately abandoned for the performance.[150] In the drawings, however, we can clearly see that the horseback Manager was conceived as a mounted *homme-sandwich*, bearing or encased within a huge sign-board (figs. 114 and 115). Not as fantastical as it seems, this style of *homme-réclame* was also available from contemporary street culture as yet another advertising stunt: the "homme-sandwich à cheval," an example of which appears in a photograph from the magazine *L'Actualité* in 1911 (fig. 116); presumably, the horse gave both increased mobility and visibility to the standard, street-bound promenade. Finally, in the Manager costume sketches, the sandwich-board is also worn by a figure in top-hat and formal dress, variously holding a walking-stick and a violin (see fig. 107). One drawing puts this figure in striped pants (fig. 117); these were later converted into cowboy chaps, an all-purpose American motif for the

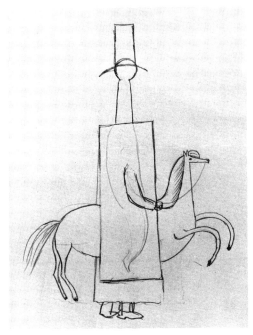

115 (above). Picasso, sketch for a Manager on horseback (1917).

116 (right). Photograph of *hommes-sandwich* on horseback from *L'Actualité* (1911).

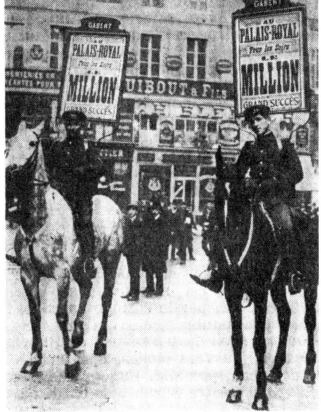

"New York" Manager. Such exotic dress-up features all bear a family resemblance to the kind of costumes, such as the kilt and the Uncle Sam outfit, worn for advertising of this kind.

It is easy to understand Picasso's attraction to the outlandishness and whimsy of publicity costumes, for they were a form of street theater, no less so than the *parade*. (Many years later, even Cocteau would come to regard the spectacle of shop windows, posters and music-halls altogether as "le théâtre de la rue.")[151] In contrast, however, to the historical resonance of the *parade*, the genre of *publicité ambulante* was relatively fresh and, plastically speaking, possessed of an irresistible, often comic potential for visual and structural play. In 1912, the magazine *La Publicité* published an update on advertising innovations in the United States, where "the citizen ... thinks and acts more audaciously ... nothing seems exaggerated, and competition provokes novelty upon novelty in this domain."[152] Among the new inventions was a gigantic walking hat costume which fits the body from the neck down, bearing a placard with the sponser's address. "This transformation of the *homme-sandwich* into the *gentleman-sandwich* is applied to the most diverse *réclames*."[153] Such effects were, perhaps, not yet to be found on the Paris streets, but variations of this sort appeared in the papers. A widely printed advertisement for the liqueur "La Bénédictine" contains a caricature by "Mich" in which three bottles have been transformed into dapper men-about-town in formal evening dress (fig. 118).

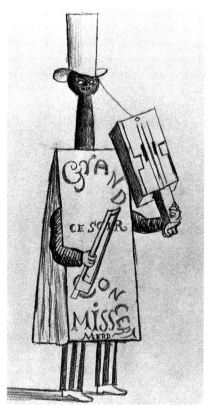

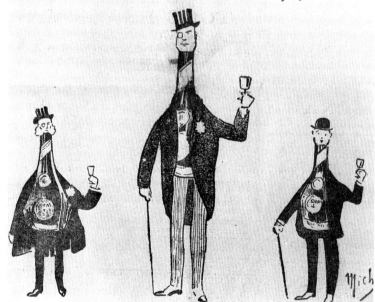

118 (above). Mich, advertisement for La Bénédictine, *Excelsior* (1911).

117 (left). Picasso, sketch for French Manager (1917).

This provides one further measure of contemporaneity in the *Parade* Managers, for Picasso appears to have lifted the Bénedictine idea for an alternate *gentleman-sandwich* Manager construction. One of the *Parade* sketches shows a figure which quite plainly copies the jacket-clad bottle by Mich (fig. 119); the fancy dress, top-hat and walking-stick are shared iconography, and the tall bottle-neck represents an abandoned variation on the gigantesque scale which Picasso retained for the final Managers. (The bottle-neck was also tested in his sandwich-board studies; see figs. 113 and 117). The hyperbole of advertising was, for Picasso, an adaptable burlesque; and the Bénedictine advertisement confirms the actuality of his source material as well as his comic train of thought, in which cubism – which would soon re-emerge as a design principle in the costumes – was perfectly compatible with a broad, comic novelty more familiar to popular culture than to the coventions of the ballet stage.

In the end, Picasso arrived at a combination of the overhead and body-enclosing sign-boards which, as can be observed in a see-through profile sketch (fig. 120), was both stood atop and suspended from the dancers' shoulders. As the design grows increasingly complex (fig. 121), two or three sign-boards multiply into a half-dozen or so floating and intersecting planes. Signs of profession and place of origin are pasted or painted on the geometrical pile, such as a top-hatted head, billowing trees, a house, skyscrapers and flags. In both the drawings and the costume itself, the French Manager holds a white

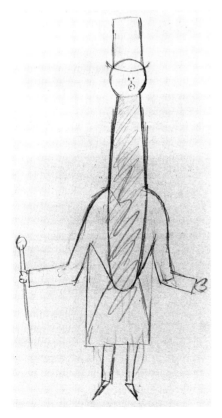
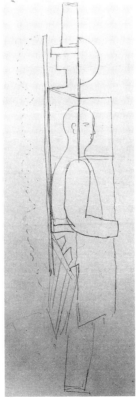

119 (far left). Picasso, sketch for French Manager (1917).

120 (left). Picasso, sketch for French Manager (1917).

121. Picasso, sketch for French
Manager (1917).

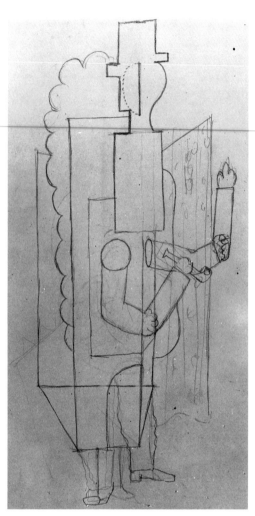

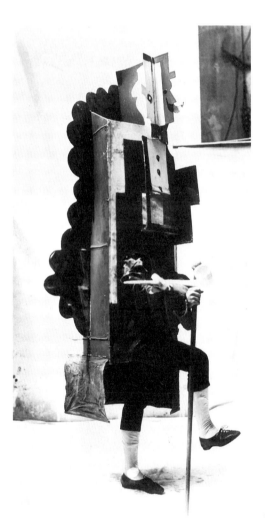

122. Picasso, French Manager
costume (1917).

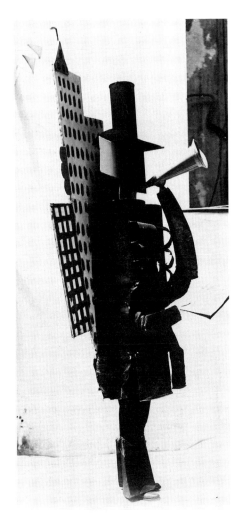

123. Picasso, New York
Manager costume (1917).

clay pipe and a walking-stick; in the actual "New York" costume, a megaphone is attached to a huge fake arm. In the sketches, and even in the profile-view photos of the finished costumes (figs. 122 and 123), the original front and back sandwich-boards are still fairly clear; the skyscrapers, for example, face forward and are completely flat. This despite the fact that each of the constructions is an elaborate, all-encompassing affair out of which the dancers' real arms and legs emerge with some trouble – heavy frames, as Cocteau and Apollinaire had explained, that transformed the choreography into an "organized accident" of co-ordinated stumbling.[154]

The *Parade* Managers, the Horse, the construction costumes and the unrealized proposals are all members of one pool. Despite their distance from the early sandwich-board conceptions, Cocteau would refer to the actual Managers in 1923 as "hommes-sandwichs" whose "carcasses" were "badly constructed by a futurist after reduced models."[155] And in his lengthy review of *Parade* in May 1917, Souday (who presumably had no knowledge of Picasso's original drawings) described the Managers as "two cubist

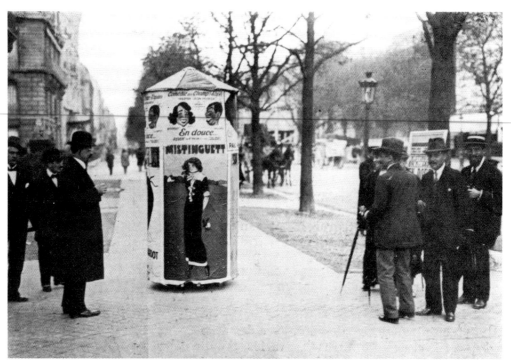

124. Photograph of a "walking Morris column" from *La Publicité* (1913).

monsters, similar to *hommes-sandwich* who would not carry simple placards, but heaps of inextricable and baroque props."[156] In fact, even the final Manager costumes can be synchronized with fairly recent developments in the design of the *homme-sandwich*. The magazine *La Publicité* may seem almost wistful in its 1912 update on the bold esthetic freedom of American advertising, but it did not take very long for the French to push back their own frontiers of *publicité ambulante*. In September 1913, the periodical published "La Publicité dans la Rue," subtitled "Nouvelle utilisation des Hommes Sandwiches" (*sic*). Noting the prevalence over recent years of *hommes-réclame* including Indian, Scottish, Turkish and Chinese costumes for movie-theater advertising, *La Publicité* is happy to report an "original" new member to the ranks of the *homme-sandwich*: the walking Morris column, which is shown in a photograph "taken from life," bearing posters for the music-hall star Mistinguett (fig. 124). The ordinary Morris column, a roofed column generally about ten to twelve feet high and plastered with notices for upcoming *spectacles* (fig. 125), had long been a familiar sight on the boulevard, "but we had not yet seen a roving column sliding gently along the ground to the bewilderment of passers-by." The apparatus was actually worn and carried from within, stopping at busy intersections ("spontaneous edifice, sidewalk mushroom") to touch down and pose as an actual Morris column. *La Publicité* emphasizes the novelty and shock of the walking column, crucial ingredients of its success; "undeniably strange," even "disconcerting," it also leaves its public "amused."[157]

That blend of the startling and the comic will, of course, be applied by critics,

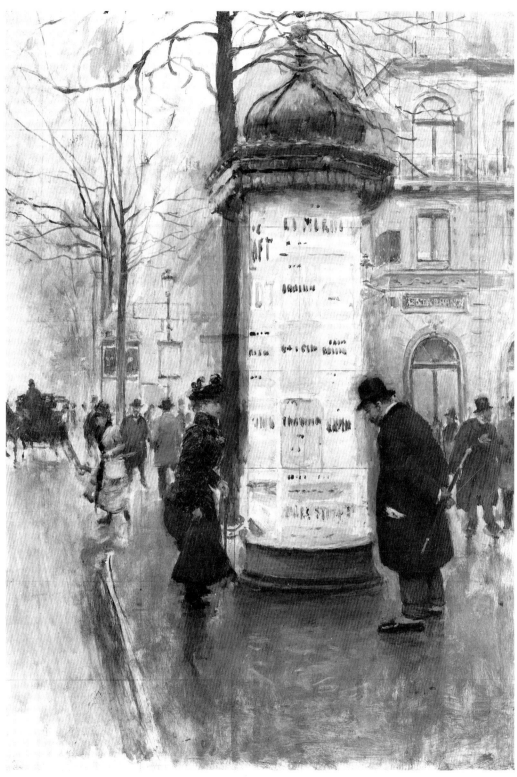

125. Jean Béraud, *Morris Column* (date unknown).

beginning with Cocteau himself, to the unexpected and, for some, unpleasant surprise of Picasso's Managers on the boards of the Châtelet. They were sensationalistic, "vulgar divinities of *réclame*," Cocteau warned in "Avant 'Parade'," who will "shock perhaps because of their giant size";[158] and in his post-*Parade* statement, Cocteau shared the epithet "surhumain" with Abel Hermant, in his review of the ballet for *Excelsior*.[159] For others, the Managers were "impresarios carrying actual monuments on their shoulders,"[160] or caged inside "hideous geometrical constructions."[161] As "two monstrous characters who have legs like you and me and a monumental body of right angles,"[162] the disproportion in scale could be both jarring and funny: "there are geometrical planes and volumes in a fantastical arrangement; but under the belly of one emerge two little human legs, which wiggle ignobly."[163] The critic for *Fantasio* was, for our purposes, most to the point, complaining that a cubist ballet, with its onstage appearance of a "man who has the air of a walking kiosk," constitutes "a defiance of good sense."[164] Picasso's sketches actually show that the costumes passed through a reductive phase in which they were envisioned as tall, flag-decked cylindrical drums which contain their dancers down to the barest projection of ankles and feet (fig. 126), an early, more literal permutation of the Morris-columnar *hommes-réclame*.

A second example of the new *homme-sandwich* helps us further contextualize the two giants of *Parade*. In an advertisement for Potages Knorr (fig. 127), the sign-boards are replaced by a cubical box, while overhead "floats" a large dirigible emblazoned with the

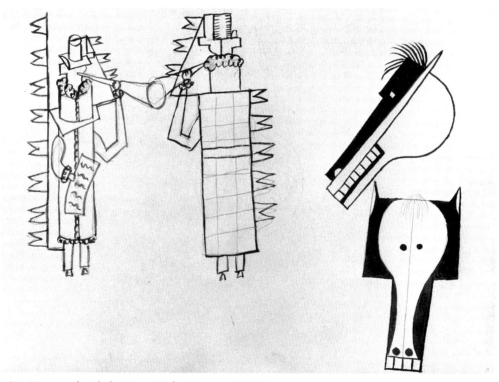

126. Picasso, sketch for New York Manager (1917).

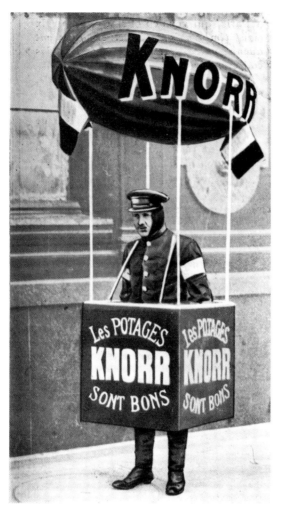

127. Illustration of an
*homme-sandwich* for
Potages Knorr, *La
Publicité* (1914).

brand name. The editors of *La Publicité* praise the outfit as a successful attention getter, and only object to the indiscrete addition of the French tricolor, since it is a matter of "public notoriety that Potages Knorr is a German brand."[165] While the final *Parade* Managers do not closely resemble the Morris column or the Knorr costume *per se*, the principle, of an occupant subsumed by a large-scale, semi-architectural suit that fulfills a practical and esthetic demand for unfamiliarity or surprise, is identical. So is the mutual morphological evolution that they represent, the transformation from original *homme-sandwich* to largescale "walking" construction. As such, the Managers adhere to a fundamental shift in the iconographical function of the *homme-sandwich*, which had come, over time, to abandon the abstract purity of the single or double sign-board, and to imitate or incorporate other objects instead; likewise the Manager constructions, whose configurations grow increasingly abstract, with the introduction of intersecting cubist planes, yet distinctly anecdotal, with top-hats, skyscrapers and trees.

Within the narrative demands of the *Parade* scenario, the *homme-sandwich* was a perfect dramatic prototype as well. In modern *forain* slang, the fairground entrepreneur was a "manager," and the barker a "Barnum," after the legendary circus impresario whose name was synonymous with the art and science of modern *réclame*.[166] Picasso was probably well aware of the terminology from his early association with professional *saltimbanques* and clowns.[167] The two appropriated English words of "manager" and "Barnum" serve to convey in French the performer's antipathy for his boss.[168] Thus, the implications of a popular-theater "manager" figure were, in a sense, both satirical and larger-than-life from the start. The manager stands, above all, for noise, a brash kind of relentless *réclame*. However, after Cocteau dropped his idea for actual disembodied voices which were to represent the cajoling cry of the stageshow barker, the Manager characters in *Parade* had to express themselves in dance or mime alone, and maintain the conceit of ballet as a silent tableau accompanied by music. This very shift recapitulates the professional conditions of the *homme-sandwich*. The art of the *bonimenteur* was generally acknowledged to have been a dying one by the pre-war years, and, in most cases, it appears that local officials had put a ban on the vocal *cri* or sales-pitch, which was regarded as a public nuisance. As *La Publicité* noted in 1913, a recent police ordinance had prohibited the *homme-sandwich* (in fact, all forms of *homme-réclame*) from practicing the *boniment*.[169] Restricted to visual means, the *homme-sandwich* was quite literally a mute barker compelled to substitute visual for vocal claims. For Picasso, the constraints on the *homme-sandwich* were, then, the appropriate confines within which to develop a character whose enforced silence was conspicuous. At once dehumanizing, comic and declamatory, the evolving bells-and-whistles mode of *réclame* costume suits the Managers well as a stand-in for the din and clamor of hard-core, Barnumesque promotionalism. For Picasso, the *homme-sandwich* was an ideal, almost self-parodic, demonstration model. In effect, the exigencies of the stage and the street were in concert, their progeny nearly interchangeable creatures of fact and fiction.

The Managers are, of course, satirical representations of the impresario as a crass huckster. In this regard, Cocteau was certainly right to describe them as vulgar "divinities of *réclame*." But if the Managers are the villains of the *Parade* tale, they are also its sole purveyors of cubism, something which was remarked by critics who had been prepared for far worse; as such, they damage Cocteau's original plan. For the audience, both fictional and real, cubism was presented as monstrous and provoking; in the body of the Managers, it fulfills critical expectations by representing its pre-war self, an attention getting mystification that embodies "avant-gardism" at its worst. Picasso might have put a best face on cubism by attaching cubist style in some way to the Acrobat, a familiar figure from the *dramatis personae* of his past whose risk-taking agility was, at the very least, a safe, tested, even traditional metaphor of artistic genius. Instead, Picasso's first broad public display of cubism amounts to nothing less than a personification of avant-garde promotional mien. Clearly, Picasso was not afraid to subject cubism to vilification. In fact, it might be said that he was attracted by a fresh opportunity to reinvest cubism with controversy, even challenged and entertained by the great formal and iconographic potential of the Manager, the only graceless non-performer in a work that is about theatrical performance; and, perhaps mischievously, by the fact that Cocteau intended the

Manager to be a *repoussoir*, a contrast which heightens the overall atmosphere of appeasement and charm. In that sense, the Managers show cubism in character, members of the company who are out to break the rules.

The Manager is an enormous physical irony. In design and bearing, he not only resembles the *homme-sandwich*, he also functions as one both inside and outside the confines of the ballet narrative. Cocteau coined the phrase *hommes-décor* in describing the constructions, something between costume and scenery.[170] Yet the Manager also embodies a kind of *cubisme-ambulant*, a self-promotional cubist construction with legs roving from place to place, scaring children and drawing crowds: modern art on the march. It is, in effect, Picasso's practical joke on the indignant spectator, an incarnation of the philistine's worst fears and an accessible lampoon of personality as *spectacle* that is, all the same, a vehicle of advanced style. In addition, the Manager presents the *homme-sandwich* in all its permutations as a pun on cubist form. Adapting the *homme-sandwich* was a simple stroke of observational genius, a practical yet multivalent solution to the problem of *wearing* cubism.

The Manager constructions did not, of course, simply emerge unannounced from Picasso's work. Both the essential sculptural vocabulary that they represent, and their very nature as large-scale anthropomorphic constructions, can be traced back to the sculptural cubism of 1912 to 1914. Their open structure of painted, intersecting abstract and representational planes is, for example, presaged by the formal principles of small but pithy free-standing constructions, such as *Bottle of Bass, Glass and Newspaper* from early 1914 (fig. 128), itself an offspring of the constructed *Guitar* from 1912. Specifically, as large-scale figural constructions, the Managers are also heralded by the guitar-player assemblage with newspaper arms from 1913, known only from a studio photo (fig. 129), and, even more persuasively, by a good number of sketches and drawings for unrealized works from the same period in which anthropomorphic presence is conjured from a totemic configuration of planar parts (fig. 130).[171] It has been noted that an important precedent for the Managers as cubist figural constructions exists in the work of Archipenko and Baranoff-Rossiné, and most notably in Boccioni's startling combine sculptures, such as *Head + House + Light* from 1912, in which the sitter is appended with objects from his immediate environment.[172] However, this group of obvious examples fails to address the Manager constructions as costumes, designed to contain a human body. More intriguing in this regard are pre-war sketchbook drawings by Picasso which allude to autonomous figures, but which are less explicitly sculptural in their conception. Several such sketches bear close comparison to the Managers, and are especially useful in relation to the Manager studies, where the transparent projection of intersecting planes can be interpreted as a kind of sculptural diagram. In particular, intermediate sketches for a Manager guitar-player (fig. 131) as well as later drawings for the final French Manager (see fig. 121) can be meaningfully juxtaposed to a drawing of two guitar-players from 1915, one simple, the other more convoluted and complex (fig. 132).

Curiously, these sketches suggest that some kind of internal challenge relating to an

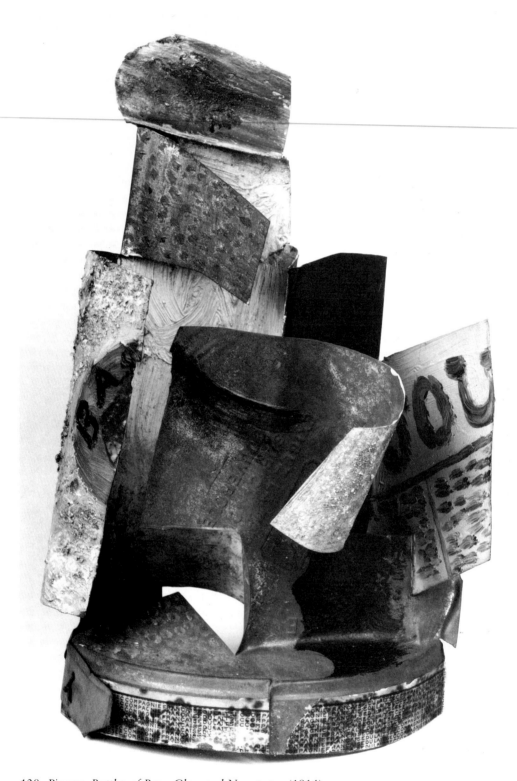

128. Picasso, *Bottles of Bass, Glass and Newspaper* (1914).

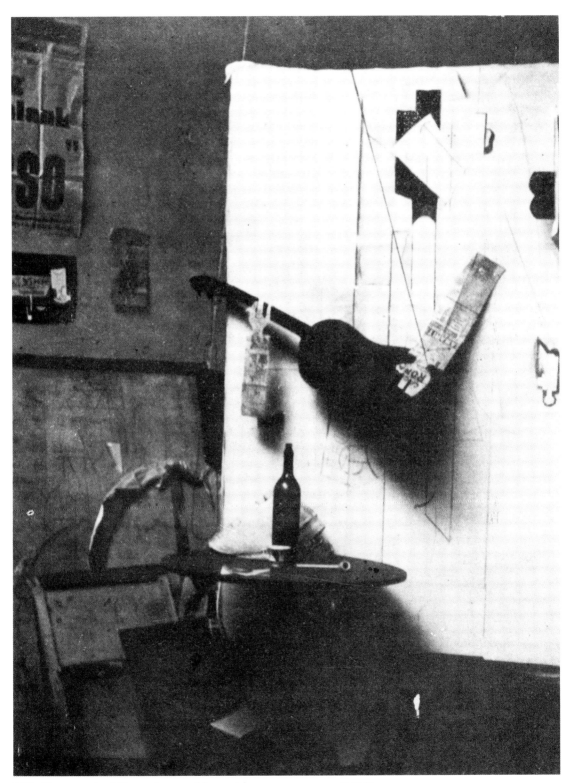

129. Photograph of Picasso's assemblage with newspaper arms (1913).

130. Picasso, sketch for a
construction (1917).

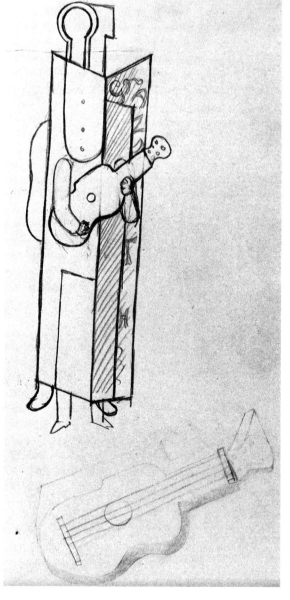

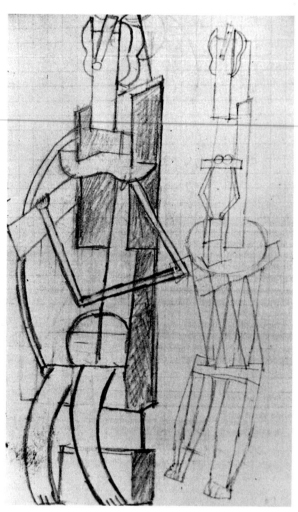

131. Picasso, sketch for a Manager
(1917).

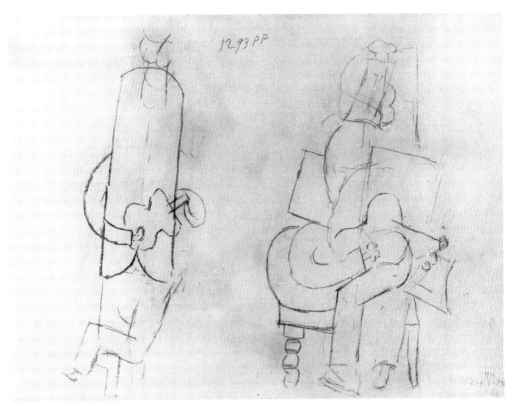

132. Picasso, *Two Guitar-Players* (1915).

integration of sculpture and body had long been at work in Picasso's early experiments with the implications of cubist construction. Like the Manager designs, the two guitar-players possess legs that appear real, relatively naturalistic and fully operable. They are not alone. In a *carnet* sketch that is possibly related to the guitar-player with newspaper arms, the upper body of a seated man is represented by a large blank rectangular plane, to which head and arms are depicted as if attached or suspended, suggesting an assemblage sculpture (fig. 133); out from beneath the plane, however, emerge two legs that are drawn with curves indicating flesh and muscle. The impression is unmistakable: that of someone underneath – a person inside the cubism, wearing it as if it were a costume. The scale of the legs suggests that the occupant would be about two-thirds the height of the construction, as in the actual Manager costumes. In a second version of the *carnet* figure, showing a firmer line and more definite shape and composition, the legs have been transformed into a geometry of assembled slats, and the hands now hold a guitar (fig. 134). We are left to wonder whether Picasso first conceived the figure in relation to a real body, with the intention of finally eliminating all trace of it, or whether the first sketch represents a separate rather than preliminary notion of sculpture as a kind of outfit. Of course, we are reminded of the *homme-sandwich*, before whose body hangs a great stiff placard, a geometrical cloak.

The structural principle of the *homme-sandwich* is apparent in these designs, in which

133. Picasso, *Seated Man* (*c.*
1913).

large flat figures of abstract geometry do not simply replace the human figure, but attend it. It is impossible to say whether this sort of juxtaposition was invented by Picasso, or discovered by him. The maturation of cubism, beginning in 1908, encouraged a number of experiments with form and composition that were internal to the evolving character of cubist style; in this sense, the Manager costumes can be traced to aspects of cubism that are wholly removed from any dependence on the outside world. Yet the evidence of Picasso's figural work equally suggests that the example of the sandwich-board was appropriated by the artist as early as 1912, long before *Parade*. In this case, with the evolving characteristics of cubism, Picasso was newly receptive to accidental or readymade "popular" manifestations of cubist research. Therefore, in reaching back to earlier work in his designs for the Manager costumes, he was actually reinvigorating the

134. Picasso, *Seated Man* (*c.* 1913).

*homme-sandwich*, which was already an established option in his formal and iconographical inventory.

It is possible to read backwards from Picasso's early *Parade* designs for signs of the *homme-sandwich* in his pre-war work. Returning to the *carnet* sketches of the seated man, for example (see fig. 133), two parallel diagonal lines project off the upper corners of the rectangular torso placard, implying the presence of a second sign-board, attached at the top and swinging away to admit a body inbetween. In a related assemblage sketch, another seated guitarist is even more clearly composed of two tall planks or boards which are attached by a hinge at the top (fig. 135). This visual trope recurs throughout 1912 to 1917 in several variations: as a folded plane, as two rectangular planes leaning towards each other, or as two planes actually joined at the upper edge – a classic

135. Picasso, *Sheet of Studies with a Guitarist; idea for a construction* (*c*.1912–13).

sandwich-board. It is not restricted to figural works, appearing as a compositional motif in still life as well (fig. 136); but it is especially common in depictions of the seated man, where schematic but ungeometrized glimpses of the sitter's anatomy are contrasted to the planar geometry of the boards or flats. The 1915 drawing of a seated man in a melon hat is a flagrant example (fig. 137). In this work, which is governed by a skewed representation of shallow perspective, two sandwich-boards dominate as a structural motif of folded planes; the upper body of the figural subject is depicted in contour lines as if traced upon, as well as situated behind, the foremost plane. The effect is one of successive transparency and opacity, of playfully collapsing and expanding pictorial space.

The folded plane or sandwich-board motif was introduced with *collage* and *papier-collé*, techniques characterized by flat, autonomous rectangles of cut paper, both painted and printed, that are often juxtaposed on the surface of the picture with more detailed

136. Picasso, *Still Life* (*c.*1913).

passages of cubist drawing. In addition to planar geometry, the development of synthetic cubism was marked by a reintroduction of the recognizable object, both actual and depicted, such as newspapers, labels, still-life paraphernalia and the human figure. Beginning in 1914, schematic naturalism returns, having acquired a firm contour and chiaroscuro; with the sandwich-board, Picasso procured a layered concurrence of abstract geometry and representational shape. As a body fitted with cubist construction, the *homme-sandwich* derivation comprises a dynamic alternative to the conflation of figure and surround in analytic cubism; instead of fragmentation and atomization, which work to solidify space and dissolve solid form, the new appliance is a shuffling mechanism, which integrates abstract planes (and "real" planes such as table-tops and wall molding) with bulky representational forms that have been schematized into planar cut-outs.[173] As a series, the seated man pictures display an incremental accumulation of stacked, overlap-

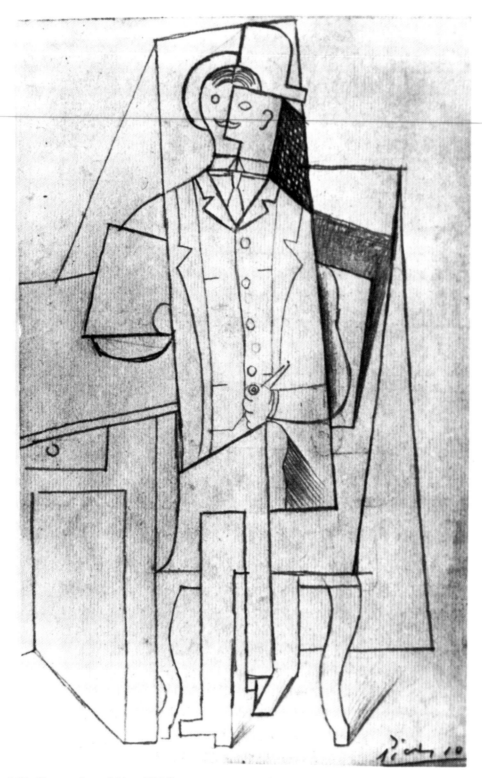

137. Picasso, *Seated Man* (1915).

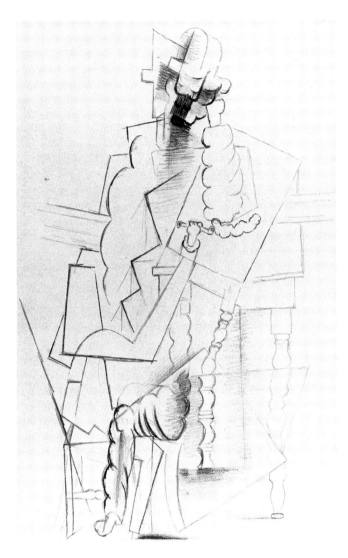

138. Picasso, *Seated Man with a Pipe* (*c*.1915).

ping and intersecting placard planes. In works throughout 1914 to 1916, recognizable heads, arms and legs emerge from behind broad planar configurations of changing complexity (figs. 138 and 139). The little fist which holds a pipe in many of these pictures is an exact precursor to the hands of the *Parade* Managers. Visual puns heighten the effect; matching rows of scallops rhyme table legs with human legs, for example. The group is remarkable, both for its refinement of structural syntax and its deadpan wit. In some of the pictures, a casual, almost sleepy air of leaning repose is all but subsumed by a toppling cascade of large rectangles and squares, transforming the act of leaning into a tragi-comic condition. The contraposition of animated geometry and body at rest, a comedy of abstraction and empathy, actually suggests the pathos that characterizes period descriptions of the ungainly *homme-sandwich*, whose garish coloration mocks a forced vow of silence as he makes his way through the streets of Paris.[174] The full dramatic range

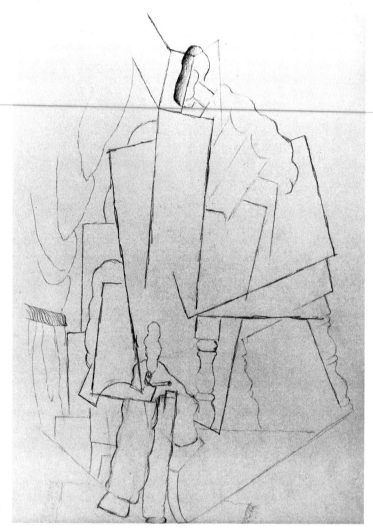

139. Picasso, *Seated Man with a Pipe* (c.1915).

of the sandwich-board can best be demonstrated by contrasting two more fully developed works from the period that might be said to share the device: the outlandishly over-burdened yet comically composed *Man with a Newspaper* (fig. 140), and *Man with a Pipe* (fig. 141), who looms before us, a tattered menace of towering frontality.

Most of Picasso's "seated" *hommes-sandwich* have been stretched tall, elongated by the vertical climb of stacked planes. Their proportions anticipate the Manager costumes, whose scale is oversized in relation to the human body (which can, none the less, be seen emerging from within). In designing the Managers, then, Picasso was developing a visualized discrepancy of scale that was familiar from his earlier figural work; but he was also exploiting a comic feature of the sandwich-board costume, which hides most of the body, thereby encouraging a sight-gag of unexpected distance between, say, the head and feet of its occupant. By the time of *Parade*, *publicité-ambulante* would have

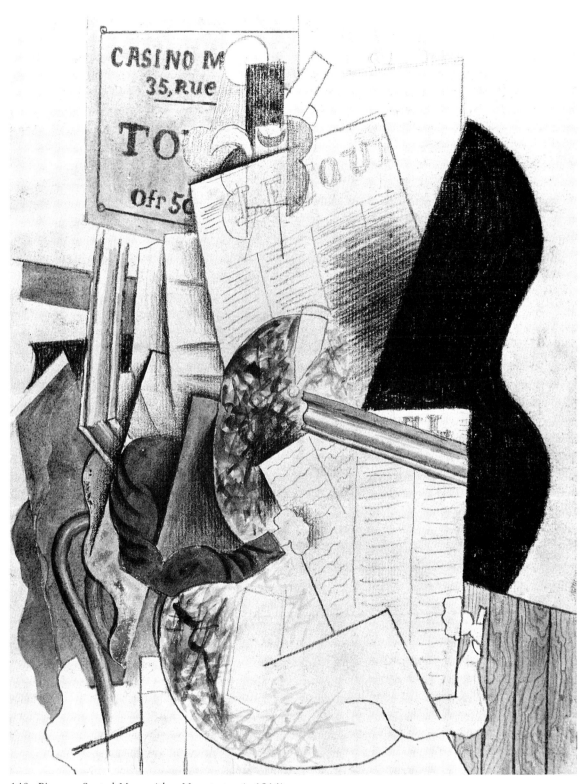

140. Picasso, *Seated Man with a Newspaper* (*c*.1914).

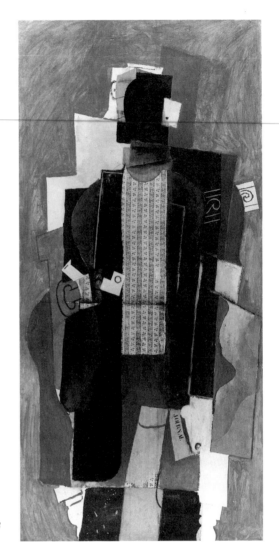

141. Picasso, *Man with a Pipe* (*c.*1915).

already been part of Picasso's repertory, as well as a natural choice for the scenario of the ballet. In rising to the challenge of creating a real theatrical costume, he would have fallen back on the ready-to-wear costume quality of earlier figurative pictures. Re-literalizing the *homme-sandwich* as an exercise in the practical matter of suiting up, Picasso then augmented and expanded the basic principle, until the results appear to be incarnations of a cubist-costume premise – what we might call the *homme-cubiste* – that, before spring 1917, had been limited to the flatland of drawing, painting and collage.

In the sandwich-board, Picasso discovered a cubist object in a non-cubist world, a kind of pun on the structural principles of his art. Like the humorists, though in a vastly more complex and agile manner, Picasso is happy to play a popular-culture joke on cubism, and therewith perpetrate a burlesque of significant esthetic proportions. In maintaining that

the sandwich-board in cubism predates its literal appearance in the *Parade* sketches by as many as five years, we might search for related devices that confirm Picasso's roving eye for "popular" cubism. In fact, evidence from popular culture, specifically from the world of advertising, shows that he was attracted to the sign-board in general as a pun of this sort.

As we have seen, a number of Picasso's *hommes-sandwich* from the early 'teens were envisioned in the sketchbook as sculptural maquettes. Picasso's realized sculptures of the period, however, were rarely as tall and rickety as the sketches would suggest; instead, most were relatively dense or compact wall reliefs assembled from flat shapes which had been cut from cardboard, paper and wood, and often painted. Virtually all of them are still lifes that resemble works from the period in *papier collé* and *collage*, featuring newspaper or brand-name typography as well as imitations or actual specimens of the ordinary café object. Executed as sculptural relief, however, some of these works recall the appearance of shop signs, visible in great number above eye-level throughout the streets and *passages couverts* of the city. The early history of the sign-board is filled with examples of the rebus and the pun, what the cultural historian Victor Fournel called "vagabond syntax" and "capricious orthography."[175] These works are painted, on panel, or forged, in iron, and display a degree of craftsmanship for which they were cherished in early histories of popular culture as anonymous works of true folk art.[176] A second strain, especially common during the nineteenth and early-twentieth century, consisted of a more mundane painted or sculptural representation, a comparatively simple image of the item for sale at the boutique in question. After the turn-of-the-century, these signs were mass-produced in zinc, and available through catalogs.[177] Picasso might be said to have addressed both types: one more complex, with language play that is not unrelated to his *collages* and *papiers-collés*, the other more banal, but modern in its deadpan physiognomy.

It certainly seems impossible to characterize Picasso's cubist assemblages as banal or deadpan; especially during 1913 and 1914 when the works are generally lively, variegated and syntactically unusual. None the less, these qualities are significant. Picasso's arrangement of still-life objects is virtually unprecedented in the tradition of western sculpture,[178] yet commonplace in the vulgate tradition of the advertising sign. In a sculptural context, then, the banal subject matter stands out, more so as a foil for the witty spatial conundrums of cubist relief. The precedent of advertising in this regard can be illustrated by the example of a *coiffeur* sign from the period (fig. 142). Composed of sculpted wooden replicas of a barber's razor and strap that have been assembled inside an oval picture frame, it corresponds to Picasso's framed, frontal, shallow box-space representations of articles from the café or *tabac*, such as a glass, a pipe, a playing card or newspaper (figs. 143 and 144).

Unexpected rapport with the sign-board is further afforded by Picasso's *Absinthe Glass* series from 1914, a run of six cubist glasses cast in bronze and variously decorated with paint and sand. In the sculptural transposition of a *collage* principle, that of attaching fact to fiction, each of the six glasses supports an actual absinthe strainer, which in turn sports a replica sugar cube (fig. 145). In addition to the dummy representation (of a hat or a wine bottle, for example), a sign-board could also incorporate the genuine article. One example can be drawn from the 1902 Concours d'Enseigne de la Ville de Paris, organized by the

142. *Coiffeur* signboard (*c*.1900).

143. Picasso, *Glass, Pipe, Ace of Clubs and Die* (1914).

city to revive the professional craft of the shop-sign. There, an artist named Prignot submitted a sign-board equipped with an actual absinthe glass, as well as a strainer that supports its own imitation sugar cube (figs. 146 and 147).[179] The sign may have been intended to represent a distillery or distributor of absinthe in Switzerland (which was, with France, the largest producing and consuming country of absinthe during the period), since it also depicts a white mountainscape, a typical image in absinthe advertising.[180] With its actual objects inserted into a fictive esthetic space, Prignot's glass and strainer function much as Picasso's strainer, where the alien or esthetic context is the glass itself, a cubist fantasy. If the realm of the sign-board is governed by this sort of esthetic

144. Picasso, *Glass, Newspaper and Die* (1914).

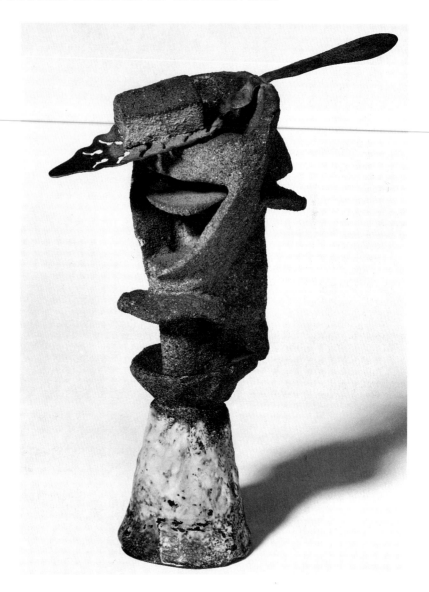

145. Picasso, *Absinthe Glass*
(1914).

license, prohibited in conventional sculpture, then it might easily be presumed that Picasso envisioned the advertising object as an example of "vagabond" structural syntax, rather than solely as a source of pasted typographical stock. The signmaker's unselfconscious ease with devices and effects that are unavailable or inappropriate to the proper comportment of painting and sculpture would be irresistible. He may, then, have been as much an unwitting co-conspirator in the enterprise of cubist sculpture as the tribal maker of the Wobé mask, whose inversion or concretization of formal space was applied by Picasso in 1912 to the landmark *Guitar*.

The sign-board augments the *homme-sandwich*, and allows a context to be established in which the sandwich-board device of 1917 can be traced back into the origins of constructed sculpture in 1912. This further validates the *homme-sandwich* as a structural

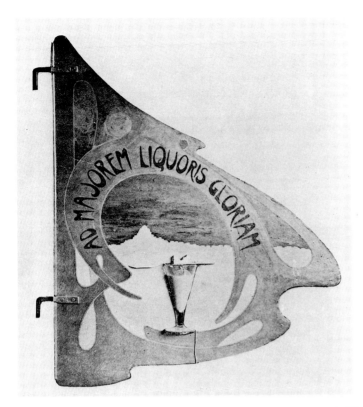

146. Prignot, absinthe
signboard, *Concours d'*
*Enseigne de la Ville de Paris*
(1902).

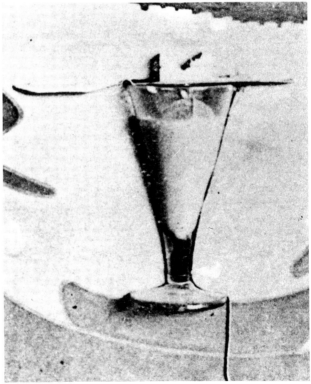

147. Prignot, absinthe signboard
(detail of fig. 146).

model well before it crops up in the form of a costume design. As a popularization, so to speak, of cubist style, Picasso's Managers are therefore delegates from the chronological and conceptual heart of the movement. Like the correspondence between *collage* and the music-hall *revue* at that time, the on-going strain of advertising in cubist sculpture functions as a sort of counterweight, raising cubism from the hermetic depth of its analytic period into a colorful reform phase of interface with culture at large. A multiple pun between cubism and popular culture, this body of work plays a sly conceptual game on the various meanings of "representation," namely, to depict and to promote. Its authenticity as popular cubism is certified by an early parody from 1911 for the newspaper *Paris-Journal*, where a new form of "integral cubism" is said to consist of a stretcher that turns on it axis, successively exposing alternate sides, "much like sign-boards."[181] Finally, the rapport between Picasso's objects and simple *publicité* is also a comic effect: after years of audience incomprehension and hostility, cubism, it would seem, is less a difficult science than an amusement. The comic double-reverse further characterizes the act of sabotage that Picasso and Satie performed on Cocteau's *Parade*, rendering it, through banalization, a slapstick parody of its original self. The compatibility of play and innovation was, for the moment, beyond the reach of Cocteau; it was, however, inadvertantly recognized by the critic for *L'Evènement*, who explains that, when it comes to a portrait of Stravinsky (such a portrait was reproduced in the Ballets Russes program), Picasso draws a nose, an eye, a mouth according to "the laws of nature"; as for cubism, "this extreme fantasy is only admissible as a game," *un jeu*.[182]

## —10—

The Managers, towering puns of cubist *réclame*, are a comic achievement; as such, they shed Cocteau's mere "exterior of *guignol*," and stumble forth in substance as creatures of the music-hall stage. They may, finally, even be understood as variations on an actual music-hall motif, for *hommes* and *femmes-sandwichs* did appear in *revue* performances of the pre-war period.[183] Yet with or without a direct music-hall prototype, Picasso has taken the freedom of the popular stage, or its re-creation at the Châtelet, as an extension of the esthetic latitude which he had already been enjoying in popular street culture. The cubist Manager constructions are decidedly funny, even ridiculous; just as they dwarf the dancers' bodies, they too are dwarfed by the implications of their own iconography – skyscrapers and trees. It is, perhaps, more than coincidence that, during the war, French army *argot* for a tall man was "gratte-ciel," or skyscraper.[184] Above all, the Managers are a dancing confluence of contradictory stylistic and iconographic connotations which make only a fantastical kind of sense, hyperbolic marvels of modern style and models of mystification. Far from softening the blow, Picasso's drop curtain merely aggravates these contradictions by affably beckoning the spectator into an unfamiliar and disruptive stylistic heterogeneity.[185] The defeat of expectations is everywhere at hand.

As principles of comic style, these qualities may be attached to a larger intellectual history during the period. One pair of texts in particular enables us to identify a broader, period-specific scheme of this sort. Though it contains no precise reference to cubism, it was written by Maurice Raynal, the philosopher of cubism whose articles of 1912 to 1913

describe the new painting as a conceptual science.[186] During this time, Raynal was composing a book, to be entitled *Le Manuel du parfait homme d'esprit, en vingt-cinq théoremes et propositions, suivis d'exemples*. The book seems never to have appeared, though at least two of the "theorems" were published as installments in 1913, one in the review *Le Spectateur*, and one in Apollinaire's *Les Soirées de Paris*.[187] Neither article is prefaced by an explanation of the book's premise or purpose, though it would have been something like a literate and refined yet semi-mocking manual of instruction in the science of modern wit.

What emerges in particular from the two surviving excerpts is a focus on the act of inversion as a code of comic expression or, more rigorously, "esprit." One theorem, the "Loi des attributions exceptionnelles," advocates the liberation of things from their "principal and habitual function or reason for being," and in so doing, makes the exception pass for the rule.[188] Illustrations include the depiction of doctors and lawyers in Molière and Voltaire as typically incapable and ignorant ("Meanwhile . . . thanks to the doctors and blood-letters, Candide's illness grew serious"[189]), or Swift's allusion to the widely held maxim that coachmen never drive so well as when they are drunk. According to Raynal, this law belongs especially to the characteristic French "love for excess" (*outrance*); already "successfully vulgarized," it would constitute "one of the most important laws in a Manual of Nastiness (*rosserie*) that it should be quite necessary to compose one day."[190]

A second theorem is called the "Loi des confusions systématiques":

> Be it a person, a fact, an object, a word or a sensation, of which the resemblence to no matter what, no matter how vague, will strike you all of a sudden. To heighten that resemblence immediately, and thus systematically to confound the objects.[191]

More simply stated, it is "to take one thing for another, intentionally and in a facetious sense."[192] The technique, Raynal adds, is shared by vaudevillistes as well as the subtlest of literary satirists. Illustrations are drawn from Molière, Beaumarchais, Mark Twain, Alfred de Musset, Alfred Jarry and Franc-Nohain – the latter writing of a young girl who, after painting her armoire with Ripolin, dreamt of doing the same to her mother. These "recherches de confusion" contain both the origins of ancient *clowneries*, and the inventions of "our modern English and American music-hall 'eccentrics'":

> He who pulls from his pocket an enormous watering-can with which to water the flower he wears in his lapel, who likewise produces an immense saw to cut a cigar which turns out to be made of iron, and who mends the tear in his pants with a padlock, appears to obey this law.[193]

Raynal concludes the article by emphasizing that, with the "confusions," "the burlesque of time past [has become] the humor of our own day."[194]

Raynal's list of practitioners in systematic confusion includes the *excentrique* actor-singer Dranem (Armand Ménard), an acknowledged comic genius of the music-hall stage during the 1900 to 1914 period, and later, still a phonograph favorite at André Breton's surrealist soirées.[195] Dranem, a wild popular success who spawned numerous imitators,[196] was a master of the "genre idiote," songs and monologues in which pretended stupidity is a vehicle for wordplay, nonsense and slapstick. As such, he could be consid-

ered by critical observers to be the perfect Third-Republic *farceur*, a mirror of modern folly, "base demagoguery, parliamentarism and mediocrity"; he is, however, less a satirist than a clown, who "pushes comedy to the extreme limits of incoherence and absurdity."[197] Writing for *Le Feu* in 1910, Emile Zavié stressed Dranem's demeanor and his relationship to the *revue* stage as an artificial world: "très farce" in his tiny hat, his square trousers and his big shoes, Dranem is "out of place" (*dépaysé*) in a land of imitation landscape décor; playing a hapless Don José in a parody of *Carmen*, he "props himself up on the edge of a false zinc bar of painted canvas. The canvas moves, but Dranem does not move"; he acts out a fantastical anecdote, all the while maintaining his natural air – "falling over declaring 'I die of poison', and then picking himself up in order to announce the fifth *tableau*."[198] While Dranem was best known simply as an irresistibly funny man, Zavié's appreciation, like Raynal's, focuses our attention on a perceived esthetics of comic modernism at the music-hall.

Raynal's dry, technical tone in the two "homme d'esprit" articles reminds us of his scientizing tracts on cubism, miniature manuals in their own right such as "Conception et Vision": "The mathematical sciences are exact . . . because they deal with abstract notions. In painting, if one wishes to approach the truth, one must concentrate only on the conception of the objects, for these alone are created without the aid of those inexhaustible sources of error, the senses."[199] His cool mode of address, however, usefully demonstrates how two such apparently unrelated topics – the path of modern art and the refinement of the modern comic spirit – can share space in the same active modernist mind. Moreover, it reveals an unanticipated proximity between "conceptual" painting that avoids the unstable evidence of the senses, and a disorienting form of wit that subverts or inverts perceptual norms and expectations.

Surely this is the province occupied by Picasso's *hommes-cubiste*. Their aspect may resemble little else on the comic stage of 1917, but, as demonstrations in "systematic confusion," they conform with precision to Raynal's manual of comic logic. In 1885, the literary scholar Ferdinand Brunetière anticipated this joining of the tactics of popular culture to the ideals of the elite in a comparison between modern poetry and recent developments in the *café-concert* song. At the *café-concert*, he tells us, the music may be "horribly vulgar" and the words "denuded of sense." However, he explains (sarcastically, we assume, for this member of the academy) that "it is not as easy as you think to empty the words in a language of all that they contain of sense. Some Parnassians of *la décadence*, M. Stéphane Mallarmé, for example, or M. Paul Verlaine, have vainly tried to compete with the *café-concert* song in the contest of incomprehensibility."[200] One man's incomprehensibility may be another's language of *esprit*. Some thirty years later, the modernist was perhaps no longer engaged in unwitting competition, but had joined forces with the other side. In 1916, Brunetière is echoed by the Futurist Fortunato Depero, in his manifesto of "abstract verbalization" (or "onomalangue"), the rudimentary utterance of onomatopoeic sound: "In the monologues of clowns and variety comics, we find typical allusions to *onomalangue*, which will be more fully developed later, constituting the language best suited to the stage, and particularly to hilarious exaggerations."[201]

For Picasso, as early as 1912, a Dranemesque game of expectations and artifice was already at play in the fake wood, real newsprint, imitation *trompe l'œil* and punning

actuality of cubist *collage*. As structural and surface codes of pictorial reality and cubist fantasy collide, the décor wobbles while Picasso, acting the parts of both straight-man and clown, carries on deadpan. Such co-ordinates of true and false, in their way, resonate with contemporary critical observations of avant-garde duplicity and bluff. Likewise the *homme-cubiste*, buried in the sketchbooks of 1912 to 1913, which would soon emerge and evolve in more significant works, finally going public in *Parade*. Onstage, and with respect to the laws of "exceptional attributions" and "systematic confusions," inversion is the driving force; with their broad conflation of iconography and style, Picasso's Managers sidle into the mother and the *armoire*. In this sense, the structural devices of cubism belong idiomatically to a defined period principle of inexpectational wit. The Managers are loaded with comic motifs, some of them readily accessible, others probably truly appreciated by only a very few at the time. Either way, it is clear that Picasso's post-1912 cubism traffics in the larger, developing history of an esthetics of disorientation. In the life and experience of early modernism, this is the true *spectacle intérieur*. We may rightly describe the manner of collage and constructed cubism as a species of private game; but further, the very notion of the game as a comic principle of esthetic pleasure, and the dynamic between inside jokes and uninformed spectators, also exists outside Picasso as a ghost of complexity and contradiction in the early-century cultural machine.[202]

## —11—

The reverberations of *Parade* invest the question of avant-garde farce with widening urgency. On June 24, a little over one month after opening night of the ballet, Apollinaire's "drame sur-réaliste" *Les Mamelles de Tirésias* had its one and only performance at the small Conservatoire Renée Maubel on the rue de l'Orient in Montmartre. The work was presented under the auspices of the avant-garde review *SIC* (a Latin "yes", and an acronym for "Sons, Idées, Couleurs," duly converted into "Société Incohérente de Charlatanisme" by *Le Carnet de la Semaine*), founded in 1915 by the poet-painter Pierre Albert-Birot.[203] The action unfolds in "Zanzibar, de nos jours." In two acts, it tells a madcap narrative of Thérèse, liberated from the maternal duties of womanhood for a future in the halls of politics, transforming herself into the man Tirésias, and leaving her husband behind to solve a national crisis of depopulation by producing, alone and from sheer "audacity," 40,051 children, including one journalist, in eight days. In the end, a repentant Tirésias turns back into Thérèse, and comes home to resume her domestic duties, but not before assorted characters (two bourgeois, the journalist, a gendarme) enact a sequence of improbable comic and tragi-comic sub-plots. According to Birot, Apollinaire developed *Les Mamelles de Tirésias* from the germ of an "amusing idea" he had had years before, and which was actually incorporated into the play itself: a woman, renouncing the ornaments of femininity, opens her blouse and releases her breasts, two helium-filled balloons, which ascend[204] (at the Renée Maubel, Thérèse's breasts are rubber balls, which she hurls into the audience).[205] But Apollinaire's scenario was both promoted and received as burlesque in the service of a serious moralizing theme.[206] While the Zanzibar setting seems to have been an exotic pretext for the fantastic surreality of the

story, the "relevance" of the theme was made clear by the character Lacouf, who insists on taking Zanzibar for Paris. Some critics even expressed mock disappointment that, in castigating feminism and appealing to wartime sentiment concerning the value of family, Apollinaire seemed less avant-garde than reactionary or *passéiste*.[207] To a degree, it is *Tirésias* and not *Parade* which turns out to have fulfilled an agenda of patriotic appeasement: "At bottom," wrote Guillot de Saix in *La France*, "Guillaume Apollinaire is a traditionalist, and beneath the apparent disorder of his ideas, beneath his noisy, clownish and *guignolesque* fantasy, he demands a return to order."[208]

Critics were quick to identify the comic aspect of *Tirésias*, in its Montmartre venue, with the tradition of students and cabarets on the Butte, from Le Chat Noir to the Lapin Agile, designated cradle of cubism.[209] In addition, *Tirésias* was written and produced in a rapid blur by a team of amateurs with no prior stage experience,[210] a low-budget operation that was easy to associate with the genre of *charge d'atelier* or *farce de rapin*. Others, emphasizing the current-events material (feminism, repopulation, food stamps) compared *Tirésias* to a *café-concert* or music-hall *revue*,[211] though the critic for *Le Radical* found too much art in the work to support this claim.[212] Perhaps in anticipation of dismissive critical hostility, certain buffers were established for the production: Apollinaire's supporters came out in force; the author himself appeared in uniform as a wounded veteran, still bandaged about the head from a trepanation; and the event was preceded by a prologue, delivered by Edmond Vallée, who directed and appeared in the production, linking the "nouvel esprit drammatique" to the memory of those stars of the French stage who had fallen at the front.[213]

Further, as Paul Souday wrote in his review "Une pièce cubiste" for *Paris-Midi* (echoing "Un ballet cubiste," his review of *Parade* for the same paper), any impression of "bouffonnerie" does not really come from the text of the play so much as from "jeux de scène," which include cubist décor and costumes by Serge Férat, and noisemusic by Mme Germaine Albert-Birot, Pierre's wife.[214] This distinction between libretto and production makes *Tirésias* a kind of poor-man's *Parade*. Indeed, Férat's work is all but a parody of Picasso's. The stage set, some cubistic houses that *Le Pays* called "décor de la *Parade*,"[215]

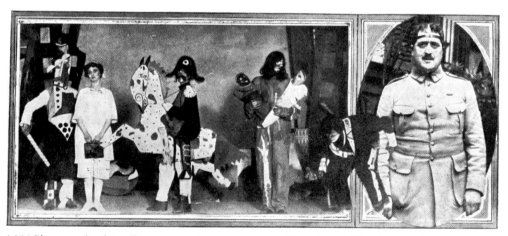

148. Photograph of Apollinaire and the cast from *Les Mamelles de Tirésias* (1917).

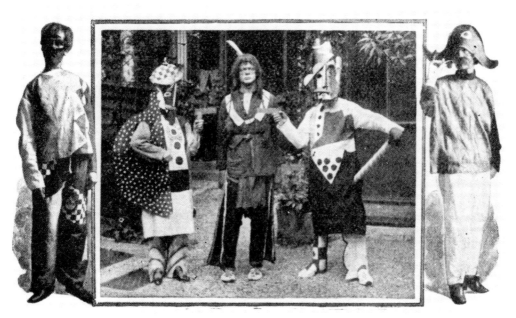

149. Photograph of the cast of *Les Mamelles de Tirésias* (1917).

was created at the last minute from 7 fr.50 worth of colored paper pasted to the wings, with windows represented by irregularly pinned squares of newspaper.[216] Cubist costumes and masks were also made of paper. In surviving production photos reproduced in the theater weekly *La Rampe* (figs. 148 and 149), attention is drawn in particular to "Howard," who portrays "the people of Zanzibar." In addition to his cubist/*négre* mask (with checkerboard cap), which reminded one critic of minstrels and prompted another to call Férat a "gauguin-cubiste,"[217] Howard also wears a large, flat speckled half-moon through which his arm pokes free; the effect is clearly borrowed from the Managers in *Parade*, though it resembles even more closely the costume manner of numerous *homme-sandwich* drawings by Picasso from the 1914 to 1916 period, where tables, newspapers and even rounded guitars are shuffled as large, planar shapes around the body of a seated man (see fig. 140). In the case of his costume for Juliette Norville as a mounted Gendarme (see fig. 148), Férat's imitation of Picasso was noted by critics. *SIC* devoted space to defending the Gendarme against critical comparison with the Horse in *Parade*, pointing out that the *Parade* costume was "le cheval même de Footit," the circus and music-hall clown, with which Férat's horse has no point in common.[218] And, in fact, if the two are only really related as comic horse costumes, the Gendarme does, nevertheless, bear an exact comparison with Picasso's sketches for a mounted *homme-sandwich* (see figs. 114 and 115). Far more explicit, however, is Férat's Kiosque costume, which is not pictured in production photographs, but can be seen in a cubist *hors-texte* illustration for the 1918 special edition of the play (fig. 150). There may have been two of these; while *Le Radical* refers to a single "kiosque à journaux ambulant," *L'Heure* alludes in the plural to "kiosques qui se promènent."[219] From descriptions, we know that both the Kiosque and the Journalist's costume were pasted with fragments of newspaper.[220] The look belongs

both to cubist *collage* and to the music-hall *revue*, where pieces of "le journal" represent the essential source of *l'actualité*. The Kiosque in particular reinforces the Managers' direct kinship to the apparatus of the *homme-réclame*; in copying from Picasso, Férat is more literal than figurative, converting the cubist costume back into a roaming monument of sidewalk merchandising, albeit one which was required to recite lines of verse.

Férat's Kiosque drew no real fire from the critical press in and of itself; clearly, it was less "incoherent" than Picasso's Managers, which had, in any case, reduced the shock factor of avant-garde theatrical costume. This is not to say that Apollinaire's *drame* received anything like universal approbation. Critical grievances were, however, generally expressed in the form of disappointment: "we were expecting more excess still, something newer, a richer revelation," wrote *L'Heure*.[221] It is important to note that the tone of Apollinaire's allegorical message – delivered as it was through a medium of outlandish comedy – did pose a problem of interpretation at the time. This was true for some critics, and especially, it seems, for other members of the avant-garde.[222] Still, in contrast to *Parade*, several things made *Tirésias* less susceptible to critical affront. As a tiny Montmartre production, conditions assured the expectation of a certain freedom of eccentricity; cubism of any kind was bound to be a greater shock coming from the Ballets Russes at the Théâtre du Châtelet. Further, understood as an elaborate satire, *Tirésias* could be seen to conform to an established genre of dramatic comedy, transgressing no fixed borders.[223] And, taken seriously, Apollinaire's patriotic moral was far more explicit than the generalized nostalgia of Cocteau's *Parade* which, in addition, had courted inevitable disaster with its governing theme of avant-garde eccentricity and audience alienation. Finally, *Tirésias* was a genuine team effort, not so easily sabotaged by conflict and cubism as *Parade*, a divided "collaboration" of competing egos.

Even the resemblance of *Tirésias* to the music-hall *revue* was manageable, given both the makeshift quality of the production, and the history of the *revue* as a form of popular satire. Taken as a consistent whole, *Tirésias* is in fact more authentic to a single genre of popular theater than *Parade*. The mix of dialogue, verse and song; the disorienting sense of place (Zanzibar or Paris, with a "Parisian Journalist from America"); the headlong pace and the single overall narrative line disrupted by brief *tableaux* that interject bits of physical humor and newsworthy issues of the day, underscored by a design emphasis on the newspaper; the confluence of farce and sentimentality: all of these reveal *Tirésias* to have been a variation on the *revue* premise, something like the *revue*-style satires that were first developed before the war, such as Muller and Gignoux's *Mil-neuf-cent-douze*.[224] But this elevates *Tirésias* as an art-*revue*, where, by contrast, *Parade* represents an unidiomatic clash of ballet, popular performance, rarefied avant-garde claims and inflammatory slapstick that defies classification.

This bewilderment of motivations and style made *Parade*, more than *Tirésias*, virtually impossible to quantify in 1917. If we must call *Parade* something, however, we might say that it is an accidental farce. Unlike *Tirésias*, which is in many respects its offspring, *Parade* demonstrates no concerted avant-garde effort, but discloses avant-garde purpose to have been fragmented at best. It is in this sense that *Parade* is instructive. In order to define the post-war socio-esthetic conditions that *Parade* portends, we must look to the strange simultaneity – within avant-garde circles – of neo-classicism and dada. Between

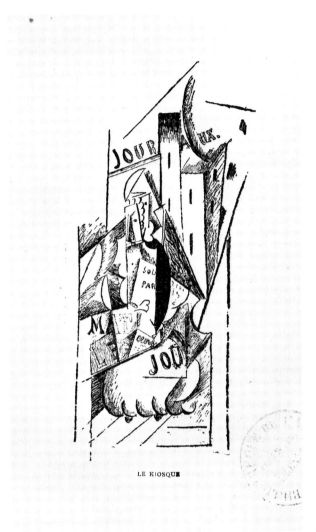

150. Serge Férat, *Le Kiosque*,
illustration for Apollinaire, *Les
Mamelles de Tirésias* (1918).

these two poles, the pre-war motifs of sincerity and ridicule crackle with irresolution. In this sense, *Parade* was emblematic: the "farce" of *Parade* was as much a backstage as an onstage affair, a collision of principles that spills into the laps of the *salle* itself. Cocteau's initial premise of charm and latinate nostalgia was ambushed by the broader comic impulses that occupied subsequent contributions by Satie and Picasso. The production is a comedy of errors in which a wreckless avant-gardism at work infiltrates the tidy and contained allegorical avant-gardism of the narrative plot. As we have read in pre-war criticism, and seen in manifestations of avant-garde art as popular culture, the more extreme avant-garde style becomes, no matter how sincere, the more in danger it is of resembling a parody of itself; if this situation is exploited – if, for example, an allegory of avant-gardism and alienation is transformed into a demonstration of that theme, or if a

representation of popular culture comes inappropriately to suggest the real thing – then the governing esthetic principle is Raynal's "systematic confusion." What, in this regard, was an audience to make of a *Parade* parody at the Cigale music hall in September 1917, which included "a little girl, a juggler, a cow and a fireman, presented by a futurist and two grotesque impressarios dressed *à la manière de Picasso*"?[225] A parody of music-hall performance in turn subjected to music-hall parody, or an avant-garde charade transposed to the music-hall stage as a readymade comic *tableau*?

\*     \*     \*

The formal and iconographical legacy of Picasso's Managers is tied to the themes of *Parade*, and to the momentum of backstage conflicts from which those themes gathered extra meaning. The Managers are veritable *hommes-sandwichs* of attention getting *réclame*, at once objects of amusement and receptacles of scorn. It is still no surprise when, in late 1917, a critic calls his account of the avant-garde "Artistes et Farceurs."[226] After the war, the practitioners of dada exploited the pre-war esthetic antagonisms which had been the subject of *Parade*, externalizing and reifying a quality of experience that was hitherto buried in the second truth of modern art; the source of their humor was the cry "modern art is a hoax." The complex yet burlesque manner in which Picasso fits the practical

151. André Breton at the Théâtre de la Maison de l' Oeuvre (1920).

whimsy of popular culture into a bold vessel of advanced art was a tough act to follow. Yet as a motif, the avant-garde sandwich-man would continue to prove useful.

Dada provocation was openly deliberate; at public performances, recitations were delivered seemingly for the sole purpose of drawing fire. A newspaper review of dada manifestations was certainly correct when, as a headline, it declared, "Dada is nothing but an inconsistent farce,"[227] for dada was dedicated to openly confounding art and hoax. One icon of the moment is a photograph of André Breton as a sandwich-man, reciting Picabia's "Manifeste cannibale" in an evening of dada performance at Lugné-Poe's Maison de l'Œuvre on March 27, 1920 (fig. 151).[228] The program, composed of three acts and fourteen *tableaux*, is as close to variety theater as the avant-garde would ever come, a mirror image that converts the pleasures of the turn and the *féerie* into a spectacle of antagonism and scorn. Breton's placard addresses the audience as a "tas d'idiotes," and is further inscribed in upper-case letters with an epigram by Picabia: "In order for you to like something, you must have seen and heard it for a long time." The motto is both shameless and nonsensical given the incoherence which dada was in the practice of heaping onto the public; as an advertising device, it also punctures the notorious attraction of novelty, a staple of merchandising and modern art. In his recitation, Breton assures the hostile crowd that in three months time, they will be buying pictures painted by the very performers that they claim to despise. As if to signal – or to invite – retaliation from the *salle*, his sign-board is further emblazoned with the concentric rings of a large target. Free of allegory, bald self-promotional avant-garde farce has become its own end. This is the ground-zero of avant-gardism, where the popular culture and popular appraisal of modern art achieve a seamless conflation of medium and message. From here, there is no place to go but up.

# NOTES

## PREFACE

1. Peter Bürger, *Theory of the Avant-Garde*, trans. Michael Shaw (Minneapolis 1984.)

2. "objets représentés à l'aide des lignes et des couleurs sur une surface"; "l'audace de l'artiste ait pour complice la peur du spectateur de passer pour inintelligent ou dépourvu du goût"; "idéologie s'expriment au moyen de signes qui ne deviendront intelligibles qu'à lui seul." Alexandre, "La Semaine artistique – Les deux peurs de l'art actuel. II. La peur de réaliser," *Comoedia* (August 30 1913), 2. Unless otherwise noted, translations from the French throughout the text are my own.

3. "que seuls les initiés à la philosophie ou au culte qui les inspirait"; "certains peintres symbolistes"; "les artistes qui, à notre époque, ont été séduits de bonne foi par l'idée abstraite du cubisme"; "réalité de conception . . . réalité de vision"; "de représenter à la fois sur la même surface et sur les mêmes points de cette surface les aspects de l'objet tels que nous les voyons, et les autres aspects interceptés, tels que nous savons qu'ils existent"; "passant, le plus éclairé comme le plus obtus." *Ibid.*, 2. In his descriptions of cubism, Alexandre is drawing from three recent writings: Albert Gleizes and Jean Met-zinger, *Du Cubisme* (Paris 1912); Maurice Raynal, "Les Arts – Conception et Vision," *Gil Blas* (August 29 1912), 4; and Apollinaire, "Le Cubisme," *Intermédiaire des chercheurs et des curieux* (October 1912), 474. For a further discussion of the conception/vision opposition in period literature on symbolism and cubism, see Christine Poggi, "Braque's Early *Papiers Collés*: The Certainties of *Faux Bois*," in Lynn Zelevansky ed., *Picasso and Braque: A Symposium* (New York 1992), 129–49.

4. "Avez-vous vu les natures-mortes de Picasso, chez Kahnweiler, ou celles reproduites dans les *Soirées de Paris*?"
"Celles formées de fragments de journaux et de sapin découpé?"
"Aussi celle où l'on voit le couvercle d'une boîte de carton avec l'inscription 'Au Bon Marché, Rayon de Mercerie,' et l'autre, ou les tripes d'un violon s'exhibent sur une toile cirée de cuisine. Est-ce une mystification?"
"Plutôt, je crois, de l'auto-suggestion."
"Que voulez-vous dire?"
"Qu'inconsciemment tous ces peintres – mais peut-on les nommer encore ainsi –, se forcent à trouver des étonnements nouveaux. Ce sont des défis qu'ils se jettent, une surenchère perpétuelle et folle." François Fosca, "Conversation sur la Peinture au Salon d'automne," *L'Occident* (December 1913), 482–3. There is no critical literature as such on collage in the pre-war press, but a number of other small references exist. For one related treatment of Picasso's collages as a "mystification," and the bad example that they set for his followers, see Tabarant, "Gazette des Arts – Le Salon des Indépendants," *Paris-Midi* (March 2 1914), 2. Conversely, for a tentative but striking appreciation of collage and constructed sculpture, see (Maurice Testard?), "Les Soirées de Paris," *L'Art Décoratif* (November 1913), supplément, 2, which briefly describes the "cinq curieuses reproductions de natures mortes de Picasso" that appeared in Apollinaire's review. Other issues concerning the significance of Picasso's constructions as they appeared in Les Soirées de Paris are discussed in Alexandra Parigoris, "Les constructions cubistes dans 'Les Soirées de Paris': Apollinaire, Picasso et les clichés

Kahnweiler," *Revue de l'Art* (4ᵉ trimestre 1988), 61–74.

## CHAPTER 1

1. Spectator, "Et Voilá!," *Comoedia illustré* (November 15 1911), 114.

2. Louis Schneider, "Au Théâtre des Capucines," *Comoedia* (October 13 1911), 3.

3. Gertrude Stein, *The Autobiography of Alice B. Tolkas* (New York 1933), 136.

4. Maurice Jardot was the first to identify the origins of the phrase "ma jolie" in the refrain from Fragson's "Dernière chanson"; see Jardot, *Picasso* (Paris 1955), no. 26. More specific information about the song is obtained from the sheet music published in 1911 by Edouard Salabert (Paris), which can be found in the collection of the Bibliothèque Nationale, Paris.

5. See Crispin, "Théâtres et Concerts," *Le Journal* (October 4 1911), 5; (October 7), 6; (October 9), 9; (October 11), 5; (October 14), 5; (October 16), 5. For more on Fragson, born Léon-Victor Philippe Pot (shot and killed by his father in December 1913), see Chantal Brunschwig, Louis-Jean Calvet and Jean-Claude Klein, *Cent Ans de Chanson française* (Paris 1972), 156; and Dominique Jando, *Histoire mondiale du music-hall* (Paris 1979), 140. In addition, a dossier of newspaper and magazine clippings concerning Fragson is available at the Bibliothèque de l'Arsenal, Paris.

6. "Une des chansons de Fragson à l'Alhambra," *Excelsior* (October 5 1911), 9; and *Le Journal* (October 12 1911), 7. The text accompanying the reprint of "Ma Jolie" is identical in both newspapers. It is likely that the entire item was promotional copy placed there by the Alhambra music-hall or the publisher of the song, whose name appears at the bottom. Newspaper advertisements of the period were often presented in a form that resembles a piece of news; space in the front page "Echos" section of many major papers, for example, could be purchased. On the subject of this *publicité masquée*, see J. Arren, *Comment il faut faire de la publicité* (Paris 1912), 169, 173–4; 234–96 for advertising tarifs for the "principle periodicals of Paris."

7. Jaime Sabartes makes an explicit reference to Picasso and friends at the Cabaret l'Ermitage, and to performances of "Dernière chanson" there. See Sabartes, *Picasso: Documents iconographiques* (Geneva 1954), no. 101. For a period recollection of "Dernière chanson" as a popular tango in "restaurants élégants," see Alice Halicka, *Hier (Souvenirs)* (Paris 1946), 35; for the Picasso circle at the Cabaret (or "Café") l'Ermitage see Halicka, 54; and Fernande Olivier, *Picasso and His Friends*, trans. Jane Miller (London 1964), 171–2.

8. On stylistic grounds, *Ma Jolie* is placed by Pierre Daix and Joan Rosselet in fall 1911; see Daix and Rosselet, *Picasso: The Cubist Years 1907–1916, A Catalogue Raisonné of the Paintings and Related Works* (Boston 1979), no. 430. Most recently, William Rubin puts the painting in winter 1911–1912; see Rubin, *Picasso and Braque: Pioneering Cubism* (New York 1989), 210. Of course, Picasso may have retained the "ma jolie" lyric for months or more. Since even the exact date of the beginning of Picasso's relationship with Eva is unknown, I am merely suggesting that iconographical evidence adds a fresh (an earlier) piece to the puzzle. The words of the refrain, which are always quoted in the context of Picasso's painting, are:
"O Manon ma jolie / Mon coeur te dit bonjour /
Pour nous les Tziganes jouent m'amie / La chanson d'amour
(Oh Manon, my pretty one / My heart greets you /
For us the gipsies play my friend / The song of love).
It is intriguing, however, to consider the refrain in the context of the song's three verses. They are sung by a man to a woman of his past whose love he hopes to rekindle. The "ma jolie" refrain is initially a "song of love," but after the third verse, when it is clear that the lover is forever lost, the song has become a "song of farewell" ("chanson d'adieu") and "our last song" (hence the title "Dernière chanson"). Given the bittersweet character of the lyric, could the subject of *Ma Jolie* be *both* Fernande Olivier and Eva? Such a sentimental ambiguity would not be out of place in a picture of a woman whose identity is otherwise indecipherable. In ad-

dition, Picasso's interest in "Dernière chanson" as an expression of transient love would be consistant with his choice of sheet music one year later, for collage. There may be a second Fragson song lyric in Picasso's work. Sheet music with the title "Si tu veux" is held by a harlequin-violinist in *Harlequin with Violin (Si Tu Veux)* (1918); "Si tu veux, Marguerite" was another Fragson hit, and Picasso may be remembering the song from his pre-war days. This seems a more likely source for the song title in the picture than Eric Satie's "Je te veux," which was proposed by Helen O. Borowitz, "Three Guitars: Reflections of Italian Comedy in Watteau, Daumier, and Picasso," *The Bulletin of the Cleveland Museum of Art* (February 1984), 127 and n. 54; "Je te veux" was first published in 1903, while "Si tu veux, Marguerite" was composed in 1913, and enjoyed popular success on a far grander scale.

9. For an intellectual history of modernists at the music-hall, see Giovanni Lista, in *La Scène Futuriste* (Paris 1989), 115–28.

10. F.T. Marinetti, "The Variety Theater" (1913), in ed. Umbro Apollonio, trans. R.W. Flint, *Futurist Manifestos* (London 1973), 127.

11. "Cette force de vie qui s'exprime sur une scène de music-hall démode au premier coup d'œil toutes nos audaces." Jean Cocteau, *Le Coq et l'Arlequin* (Paris 1918), 34.

12. For two recent, distinctly different readings of humor in cubist collage, see: Patricia Leighten, " 'La Propagande par le rire': Satire and Subversion in Apollinaire, Jarry and Picasso's Collages," *Gazette des Beaux-Arts* (October 1988), 163–72; and Natasha Staller, "Meliès' 'Fantastic' Cinema and the Origins of Cubism," *Art History* (June 1988), 202–32. Staller's article proposes a popular entertainment source for cubism in general, as well as collage (see also John Frazer, "Le Cubisme et le Cinéma de Georges Méliès," in *Méliès et la naissance du spectacle cinématographique* (Paris 1984) 157–67).

13. There are dozens of histories of the *café-concert* and the music-hall in England and France where this information can be found. The following is a selection. For the music-hall in London, see Archibald Haddon, *The Story of the Music-Hall* (London 1935); M. Willson Disher, *Music-Hall Parade* (London 1938); Raymond Mander and Joe Mitchenson, *British Music-Hall* (London 1974); ed. Benny Green, *The Last Empires: A Music-Hall Companion* (London 1986); *Music-Hall: The Business of Pleasure* (Philadelphia 1986). For Paris, see Georges d'Esparbes, André Ibels, Maurice Lefèvre and Georges Montorgueil, *Les Demi-Cabots: Le Café-Concert – Le Cirque – Les Forains* (Paris 1896); André Chadourne, *Les Cafés-concerts* (Paris 1889); E. Rouzier-Dourcières, "L'Evolution du Café-Concert," *La Semaine politique et littéraire de Paris* (September 1 1912), 13–16; Gustave Fréjaville, *Au Music-Hall* (Paris 1922); J.-L., "Music-halls: Du "café-chantant' au "music-hall', "*Le Temps* (October 5 1912), 4–5; (October 7), 5–6; (October 13), 5; Paul Derval, *The Folies-Bergère* (London 1955); Jacques Charles, *Cent Ans de Music-Hall* (Paris 1956); Jando, *Histoire Mondiale du music-hall*; François Caradec and Alain Weill, *Le Café-Concert* (Paris 1980; André Sallée and Phillipe Chauveau, *Music-hall et café-concert* (Paris 1985).

14. Maurice Talmeyr, "Cafés-Concerts et Music-Halls," *Revue des Deux-Mondes* (1902), 178. For a recent discussion of music-hall and class, see Charles Rearick, *Pleasures of the Belle Epoque* (New Haven 1985), 83–115.

15. Santillane, "Les Music-Halls," *Gil Blas* (September 12 1901), 1.

16. "nouveau genre qu'engendra la fusion de deux plaisirs autrefois distincts: celui du café-concert et celui du cirque." Akademos, "En sortant d'un music-hall," *Gil Blas* (September 13 1912), 1.

17. Marinetti, "The Variety Theater," 126.

18. There is a great deal of literature on the *saltimbanque* and related themes in Picasso's Rose Period work. The most thorough overall iconographical treatment remains Theodore Reff, "Harlequins, Saltimbanques, Clowns and Fools," *Artforum* (October 1971), 30–43. To Reff's discussion of memoires by members of the early Picasso circle which attest to the artist's love for the circus, we might add André Salmon's claim that this circus-mania was attached to a taste for Seurat, reproductions of whose *Le Cirque* and *Le Chahut*, images of the circus and the mu-

sic-hall respectively, first ornamented the walls of Picasso's studio on the rue Ravignon, "à la veille du cubisme." For Salmon, *Le Chahut* was "une des grandes icônes de la devotion nouvelle." See Salmon, *Propos d'Atelier* (Paris 1922), 42; and *Idem., L'Air de la Butte* (Paris 1945), 33.

19. *Carnet* nos. 95, 96, 98, 101 and 102, in the collection of the Musée Picasso, Paris.

20. Pierre Daix republished these illustrations for the first time in "Quand Picasso dessinait pour la presse "parisienne'," *Les Lettres françaises* (March 3 1971); they are also discussed, along with the album for Coquiot, in John Richardson, *A Life of Picasso, Volume I 1881–1906* (New York 1991), 201–3, 253. Picasso signed the drawings "Ruiz" (his mother's maiden name); among the performers he depicted are Grille d'Egout and Jane ("Jeanne") Avril, favorite subjects of Toulouse-Lautrec.

21. This information is contained in a letter from Casagemas and Picasso to Ramon Raventos dated October 25, 1900, reprinted in Josep Palau i Fabre, *Picasso: The Early Years 1881–1907* (New York 1981), app. 8, 513.

22. Max Jacob, "Souvenirs sur Picasso contés par Max Jacob," *Cahiers d'Art* (1927), no. 6, 199.

23. Bloch's whereabouts are readily determined by following newspaper listings for the Cigale throughout the period. The Cigale opened a new *revue* every three to four months, and Bloch was featured in each one.

24. *A nous la veine!* ran from November 7, 1901 through late January 1902, dates which correspond to Picasso's second trip to Paris from May 1901 to January 1902. For a review, see Arlequin, "Soirée Parisienne: A la Cigale – A nous la veine!," *Le Journal* (November 9 1901), 4–5.

25. Olivier, *Picasso and His Friends*, 126.

26. *Ibid.*, 58–60, 101; Daniel-Henry Kahnweiler, *My Galleries and My Painters*, trans. Helen Weaver (New York 1971), 89; André Salmon, *Souvenirs sans fin, Deuxième époque (1908–1920)* (Paris 1956), 79, 92–3, 95–8. The writer Francis Carco, an acquaintance of the Picasso circle in Montmartre, also enjoyed modest fame within the community singing *café-concert* songs at the cabaret Lapin Agile.

See Guillaume Apollinaire, "La boîte aux lettres," *L'Intransigeant* (March 24 1911), reprinted in Apollinaire, *Petites merveilles du quotidien*, ed. Pierre Caizergues (Montpellier 1979), 46; and Halicka, *Hier*, 40. Carco also sang in André Salmon's music-hall styled *revue Garçon! . . . de quoi écrire!* in 1911 (see below).

27. Daix and Rosselet, *Picasso: The Cubist Years*, nos. 513, 518, 519, 520, 521. These works are preceded by two pictures onto which Picasso has stenciled the word *valse* (nos. 504 and 506).

28. A copy of the sheet music for "Sonnet" can be found at the Bibliothèque Nationale, where it is stamped "Depot lègal 1892." "Sonnet" was not otherwise dated by the publisher, but the yellowing paper alone would have told Picasso that the song was already old when he selected it. Lewis Kachur has also traced the appearance of popular sheet music in Picasso's collages; see his "Themes in Picasso's Cubism, 1907–1918", Ph.D. dissertation for Columbia University (New York 1988), 260–4.

29. d'Esparbes et al, *Les Demi-Cabots*, 64–5; F. Berkeley Smith, *The Real Latin Quarter* (New York 1901), 113–21. During the pre-war years, Legay was fondly associated with the pre-1900 Eldorado; see Rouzier-Dorcières, "L'Evolution du café-concert," 15.

30. For the history of the Eldorado, see Sallée and Chauveau, *Music-hall et café-concert*, 143–6; for a pre-war reference to the reputation of the Eldorado, see Curnonsky, "Music-Halls," *Le Théâtre* (December, II, 1913), 30.

31. All of the memoirs concerning Picasso during the pre-war years discuss evenings at the Lapin Agile. See, for example, Olivier, *Picasso and His Friends*, 155–8; Kahnweiler, *My Galleries and My Painters*, 45; Salmon, *Souvenirs sans fin, Première époque (1903–1908)* (Paris 1955), 181–6. For performances of Villon and Ronsard (both songs and recitations) at the cabaret, see Olivier, 156; Roland Dorgelès, *Bouquet de Bohème* (Paris 1947), 18; and Pauline Teillon-Dullin and Charles Charras, *Charles Dullin ou Les Ensorcelés du Chatelard* (Paris 1955), 208–13. For a general history of the Lapin Agile, see also Emmanuel Patrick, "Assommoirs, Bouges, et Cabarets,"

*Courrier français illustré* (April 14 1889), np; Robert Brisacq, "Cabaret du Lapin Agile," *La Revue hebdomadaire* (May 19 1926), 329–37; and Jeanine Delpech, "Frédé, tavernier du Diable," *Nouvelles littéraires* (July 23 1938), 8. For the most comprehensive biographical treatment of the Picasso circle at the cabaret, see the most recent: Richardson, *A Life of Picasso, Volume I*, 369–76.

32. See Arnyvelde, "Frédé (Le Cabaret du Lapin Agile)," *Le Monde illustré* (September 30 1911), 228.

33. Edmond Barbier, "Marcel Legay," *L'Album Musical* (April 1906), 1–2. For a discussion by a member of the Picasso circle of the Lapin Agile as a legendary cabaret, see Salmon *Souvenirs sans fin, Première époque (1903–1908)*, 18.

34. Robert Rosenblum, *Cubism and Twentieth-Century Art* (New York 1960). Rosenblum's pioneering work on the significance of words in cubism is most fully developed in his essay "Picasso and the Typography of Cubism," in *Picasso in Retrospect*, eds. Roland Penrose and John Golding (New York 1973), 49–75. While historians were slow to get the joke, the work of Kasimir Malevich, Kurt Schwitters and many others demonstrates that artists were quick to recognize the implications of wordplay in cubism.

35. Rosenblum, "The Typography of Cubism," 51.

36. Patricia Leighten was the first to indicate the original context of this headline. See Leighten, "Picasso's Collages and the Threat of War, 1912–13," *Art Bulletin* (December 1985), 664.

37. In a recent essay, Rosalind Krauss argues against mass-culture as a context for Picasso's newspaper *papier-collés* of December 1912. See Krauss, "The Motivation of the Sign," in ed. Zelevansky, *Picasso and Braque: A Symposium*, 261–86. Krauss interprets the pictures according to a linguistic model derived from Bakhtin's theory of the dialogic principle of discursive meaning. Bakhtin allows her to temper severe formalism with history and biography, yet avoid what she refers to as the "reflectionist" character of current readings of *papier-collé*, in which such contexts (including politics and mass-culture) are taken to have entered a picture directly, unmediated by the semiological system according to which she choses to describe this form of pictorial representation. This approach isolates the newspaper in Picasso, separating newsprint from the other forms of printed paper that the artist incorporates in his work of the period. While the distinction is valuable to the thesis at hand, concerning Picasso's place in a post-Mallarméan debate over the esthetics of the newspaper, it is otherwise arbitrary since it breaks down beyond the confines of the newsprint pictures. Before divisions of this sort are made among works from the *papier-collé* and collage œuvre, it should be recognized that a cardinal development they all share is the introduction of a range of materials that were lifted from a popular culture of commercial ephemera. Further, contextual study is not merely reflectionist. In this case, as an alternative to the metaphorical relationship between Bakhtinian linguistics and cubism, terms of meaning drawn from within pre-war popular material culture itself can be applied to the visual strategies of Picasso's work of 1912 to 1914.

38. "Une revue, quel cadre! Il n'en existe pas qui permette plus de fantaisie avec plus de réalité . . . La Revue est le triomphe légitime du sans queue ni tête," Henry Buguet, *Revues et revuistes* (Paris 1887), 3, 5. Buguet collaborated with Georges Grison on *Places aux jeunes!* (1886), the first *revue* ever to be performed at the Folies-Bergère; see Eugène Héros, "La Première revue des Folies-Bergère, 30 Novembre 1886," *Le Music-Hall illustré* (December 1911), 14.

39. See below.

40. Robert Dreyfus, *Petite Histoire de la Revue de Fin d'Année* (Paris 1909), from which I have derived my whirlwind synopsis of *revue* history.

41. Buguet, *Revues et revuistes*, 15. In fact, the *revue* was originally invented for troupes of actors at the *foires* St.-Laurent and St.-Germain who, forbidden by larger theaters to perform plays from the conventional repertoire, were driven to stake-out their own territory in material drawn from *actualités*. See Dreyfus, *Petite Histoire de la Revue de Fin d'Année*, 10.

42. "une sorte de spectacle d'actualité incessante." Curnonsky, "La Nouvelle Revue de l'Olympia," *Le Music-Hall illustré* (April 15 1912), 24.

43. For more on the role of the newspaper as a source for the *revue*, see pp. 18–19.

44. Dreyfus, *Petite Histoire de la Revue de Fin d'Année*, XXVIII.

45. "de la vie économique, du machinisme, des applications de la science à l'industrie et au commerce, du perfectionnement continu des moyens de transport et d'échange, ou, comme on disait naguère, des 'progrès' du genie humain." *Ibid.*, XXVIII–XXX.

46. "révolutions, guerres, inventions nouvelles, modes, faits artistiques ou littéraires, crimes, malheurs publics, etc." Arthur Pougin, *Dictionnaire historique et pittoresque du Théâtre et des Arts qui s'y rattachent* (Paris 1885), 653.

47. "de lancer une petite réclame (presque invisible) à l'adresse de son tailleur ou de son bottier, ou en faveur de la couturière et de la modiste de sa femme," Buguet, *Revues et revuistes*, 16–17.

48. "*Signes* des connaissances, et surtout des sentiments, qu'elles supposaient jadis en vie?" Dreyfus, *Petite Histoire de la Revue de Fin d'Année*, XXIV.

49. *Blague* and *rosserie* are two recurring terms used by music-hall critics to describe *revue* jokes, but they also made their way into the language of the *revues* themselves during the pre-war period. For example, the *revue* title *Ça Sent la Rosse* (performed at La Scala music-hall in December 1913) puns from "that smells like a rose" into "that smells like a *rosse*", a person who practices *rosserie*.

50. "Qu'est-ce que l'allusion?

L'allusion, dit Littré, est une "figure de rhétorique consistant à dire une chose qui fait penser à une autre.' Littré ajoute: "On distingue les allusions en historiques, quand elles rappellent un point d'histoire; mythologiques, si elles sont fondées sur un point de fable; nominales, si elles reposent sur un nom; *verbales, si elles consistent dans le mot seulement, c'est à dire dans une équivoque.*'

Cette dernière sorte d'allusions est peut-être la plus répandue dans les revues de fin d'année. Et je crois même qu'elles forment proprement ce qu'on appelle l'esprit de revue.' . . . L'allusion verbale,' comme la nomme Littré, ce chimiste de notre langue, c'est tout simplement ce que nous appelons, nous, sans regarder si à fond, l'*à peu près* et le *calembour*. Assurément, le calembour n'est pas toujours un moyen

d'allusion si humble. . . . Mais j'ai cherché, volontairement, au bas de l'échelle: car le calembour, plus il est rudimentaire, mieux il nous permet d'isoler l'allusion toute nue, l'allusion vide et, comme eût peut-être dit Kant, l'allusion pure.

Cette allusion-là n'est soutenue, avivée, relevée par rien. Aussi le plaisir qu'elle donne – si elle en donne – n'est-il adultéré par rien." *Petite Histoire de la Revue de Fin d'Année*, XIII–XVI.

51. *Ibid.*, XVIII.

52. "l'essentiel et le tout" *Ibid.*, XX.

53. "remarques gaies, rapides, satiriques, philosophiques," *Ibid.*, XX.

54. "L' avalanche des revues en cette saison, la vogue extraordinaire de ce genre à la mode." Anon., "Informations – Pas de Revue!," *Comoedia* (December 4 1911), 4.

55. "Qui n'a pas sa revue! Des scènes à côté et des music-halls, la contagion a gagné les grands théâtres. Hier, c'étaient les Bouffes, aujourd'hui c'est l'Ambigu; ce sera demain le théâtre Réjane. Je sais bien que la revue est ce qu'on appelle un genre souple, si souple qu'à la rigueur il pourrait finir par absorber tous les autres." Léon Blum, "La Revue de l'Ambigu," *Comoedia* (December 1 1911), 1.

56. Anon., "Une Revue Chez Guignol," *Excelsior* (May 19 1911), 6.

57. "La Revue! elle s'évit partout, et la saison théâtrale de 1912 fera date dans l'histoire de cette forme si originale de l'esprit français et pourra fournir à Robert Dreyfus un des chapitres le plus abondants du prochain volume qu'il lui consacrera. Marigny, les Folies-Bergère, l'Olympia, la Scala, le Moulin-Rouge, les Ambassadeurs, l'Alcazar d'Été, les Capucines, Bataclan, et j'en passe, d'une façon générale, tous les cafés-concerts et tous les music-halls, représentent des revues; il n'est pas un faubourg de Paris, où ne se chantent sur un air connu la 'Grève des danseuses,' 'les Aventures de M. Cochon' et autres événements d'actualité qui savent inspirer à nos chansonniers des couplets mordants, fins, ou vivement satiriques, car il se fait sur toutes les scènes parisiennes, grandes ou petites, dans le courant d'une même soirée, une singulière dépense d'esprit. On se prend même parfois à regretter que cet esprit soit ainsi répandu sans compter dans des œuvres, par leur essence même, éphémères, puisqu'elles ne marquent pas

une époque, mais à peine une saison."
Anon., "Bulletin – La Revue Triomphante," *Le Théâtre* (April, II, 1912), 26.

58. André Joubort, "Revue de fin d'année pour 1912," *Paris-Midi* (December 31 1912), 1.

59. The *revue* series, by Victor Hoerter and Eddy Beunke, begins on October 9, 1912, and was resumed in fall 1913.

60. Victor Hoerter and Max Eddy, "Revue Charivarique," *Le Charivari* (October 26 1912), 1; and Victor Hoerter, "Encore une revue d'actualité!," *Le Charivari* (December 29 1912), 6. Intriguingly, the second *revue* is followed by a statement informing readers where Urodonal and Globeol can be purchased. As a result, it is difficult to say whether the *revue* mocks the two drugs, or endorses them, in keeping with Buguet's observation about *revuistes* who benefit by incorporating advertising in their work.

61. "vêtue d'une robe sur laquelle tous les journaux sont collés." Dreyfus, *Petite Histoire de la Revue de Fin d'Année*, 146.

62. See the anonymous review "Le Journal Joué," *Le Music-Hall illustré* (January 15 1912), 23. Music-hall newspaper costumes also lend a certain cultural resonance to Picasso's assemblage of a cubist guitar-player with projecting newspaper arms from 1913, reproduced in *Cahiers d'Art* (February 25 1950), 281. A different ideological context for newspaper in Picasso's *papiers-collés* can be found in David Cottington, "What the Papers Say: Politics and Ideology in Picasso's Collages of 1912," *Art Journal* (Winter 1988), 350–9 (see also Cottington, "Cubism, Aestheticism, Modernism," in ed. Lynn Zelevansky, *Picasso and Braque: A Symposium* (New York 1992), 58–72); and Christine Poggi, *In Defiance of Painting: Cubism, Futurism and the Invention of Collage* (New Haven 1992), 141–4 (material that originally appeared as "Mallarmé, Picasso, and the Newspaper as Commodity," *The Yale Journal of Criticism* (Fall 1987), 133–51). For Cottington, Picasso's *papiers-collés* embody a Mallarmesque estheticism that spurns the popular character of the materials he used; conversely, Poggi construes the use of pasted paper as an open, programmatic critique of Mallarmé, for whom the language of the newspaper was peculiarly banal and corrupt. The mutual

contradiction that these two interpretations represent lies at the heart of my own thesis, namely that conflicting claims and parodic reversals of meaning are defining elements of the pre-war avant-garde. In this case, I would rather say that the *papiers-collés* negotiate, but do not pretend to resolve, conflicts between hermetic language and the commercial word.

63. Dates and statistics regarding Picasso's collages are derived from two sources: Daix and Rosselet, *Picasso: The Cubist Years*; and Edward F. Fry, "Picasso, Cubism and Reflexivity," *Art Journal* (Winter 1988), app. 11, 310.

64. Leighten was the first to demonstrate the sizable quantity of newspaper clippings concerning the Balkan Wars in Picasso's collages. See Leighten, "Picasso's Collages and the Threat of War, 1912–13." For a discussion of this subject matter within the larger context of Picasso's early career and socio-political proclivities, see Patricia Leighten, *Re-Ordering the Universe: Picasso and Anarchism, 1897–1914* (Princeton 1989), 121–42. For an alternate view of Picasso's politics in this context, see David Cottington, "Cubism and the Politics of Culture in France, 1905–1914", Ph.D. dissertation, Courtauld Institute, University of London (1985), 480–1; and Kachur, *Themes in Picasso's Cubism, 1907–1918*, 188–99. Cottington shows that, with regards to politics, irony is a distancing device in these *papiers-collés*; see also his "What the Papers Say," 350–9.

65. The entire refrain runs:

De'barqu'nt leurs troupiers / Tra la la la la / A cheval et à pied / Tra la la la la / De suit' leurs canons / Flanqu'nt des coups de tampon / Tra la la la la / On reçoit des boulets / Tra la la la la / Et les bons Français / Tra la la la la / De la République / Nous disent que c'est / La pénétration / Zim-boum pacifique!

These lyrics are printed in an original program for *La Revue des Folies-Bergère* by P.L. Flers (1912), np. Note: All references to original programs relate to *revue* materials in the Collection Rondel at the Bibliothèque de l'Arsenal. Programs are filed according to the name of the music-hall and the year in which the *revue* was performed; most of them are not paginated.

66. "le programme détaillé de la Revue finale qui sera prochainement donnée sur le Théâtre de la Guerre." Curnonsky, "Programme," *Le Journal* (November 10 1912), 6.

67. Rosenblum was the first to identify the subject of this headline, and to read it as a punning reference to tea and a die; he also suggested that Picasso's "coup de thé" pun might be an allusion to Mallarmé's typographical experiments in the poem *Un coup de dès n'abolira jamais le hasard*, a source that is now simply taken for granted. See Rosenblum, "The Typography of Cubism," 52. For the words "coup de thé" as a stand-in for an actual, or depicted, object, see Cottington, "What the Papers Say," 356.

68. As in "Le Sort en est jeté," *La Petite République* (October 18 1912), 1, a frontpage editorial also concerning the Balkan Wars.

69. Rosenblum, "The Typography of Cubism," 51.

70. Le Monsieur de Promenoir, "A la Gaîté Rochechouart: Madame est Serbie," *Le Music-Hall illustré* (January 1 1913), 12.

71. Original program for *Madame est Serbie* by Lucien Boyer and Bataille-Henri.

72. Daix and Rosselet, *Picasso: The Cubist Years*, no. 463; the three works are nos. 463, 464 and 465.

73. Original program for *L'Année en l'Air* by Mouézy-Eon and Bataille-Henri; for "Tout en l'air," see the original program for *Elle l'a l'sourire!* by Wilfred; for *En avion... marche!* by Rip and Bousquet, see R.B., "Aux Ambassadeurs," *Le Music-Hall illustré* (June 15 1912), 18.

74. Original program for *A la Baguette!* by Dominique Bonnaud, Numa Blès and Georges Arnould.

75. Dr V..., "Cubisme, Futurisme et Folie," *Le Journal* (November 7 1912), 6.

76. "le temps lointains où, tenaillé par les premiers frissons de la vocation, il montrait son cube à tous les passants." Léon Blum, "La Revue de l'Ambigu," *Comoedia* (December 1 1911), 1.

77. For "Le Jeu de Cubes de Sem," see the original program for *En avion... marche!*; for "Paris Cucubique," see the original program for *La Revue de l'Année* by Rip and Bosquet; for the cubism song, see reference in Louis Laloy, "Le Mois – Music-halls et chansonniers: Eldorado,"

*S.I.M.* (December 1 1913), 49; for the "Fauste cubiste," see d'Arbeaument, "Petits Echos – Au Little Palace," *Le Triboulet* (February 8 1914), 12.

78. Anon., "Music-halls," *Le Temps* (November 26 1912), 5.

79. See Gleizes, "A propos de la Section d'or de 1912," *Les Arts Plastiques* (March 1925), 6. My thanks to Matthew Affron for bringing this reference to my attention.

80. Daix and Rosselet, *Picasso: The Cubist Years*, no. 652.

81. *Ibid.*, no. 610.

82. For "Miss Stein/Miss Tolkas", see *Ibid.*, no. 661; for André Level, see no. 660; for *La Côte*, see no. 696.

83. Freddy, "Les Barre-la-vue," *Le Monde illustré* (July 27 1912), 64–5.

84. For the advertising sign-board *tableau*, see Le Monsieur de Promenoir, "A la Gaîté Rochechouart," 10; for "Le Professeur de Publicité Théâtrale," see original program for *A la Baguette!*; for "Publicité ambulante," see Curnonsky, "Music-Halls et Cafés-Concerts – La Cigale," *Le Théâtre* (March, I, 1914), 21; for the *magasin de nouveautés* and "Dr Macaura," see Anon., "Alaczar d'Eté," *Le Music-Hall illustré* (June 1 1912), 18; for the *cartes de visite*, see original program for *La Revue des T.* by H. de Gorsse and G. Nanteuil; for "L'Origine du Prospectus," see original program for *La Revue de Printemps des Folies-Bergère* by Georges Arnould.

85. "On réclame, on réclam' par la voie des journaux; / Dans les réclamations, y a des trucs rigolos." Plébus, Danerty and Serpieri, "On Réclame," *Paris qui chante* (February 17 1912), 12–13.

86. Rosenblum, "The Typography of Cubism," 60.

87. Original program for *En Scène... mon Président!* by Hugues Delorme.

88. Rosenblum, "The Typography of Cubism," 53.

89. "La revue c'est aussi l'art d'incarner les individus, les événements, les moeurs, les ridicules, les modes et les idées du jour en des petites femmes court vêtues qui régalent le public de quelques couplets. Ces couplets peuvent être satiriques, grivois, ou sentimentaux... Leur esprit n'est pas toujours inoffensif. Il en existe des grossiers et de méchants." Ergaste, "Aux Capucines," *Le Théâtre* (December, I, 1911), 23.

90. For *collage* as paper-hanging, see E. Littré, *Dictionnaire de la Langue Française, Tome premièr* (Paris 1878), 664; for the sexual definition of *collage* (which does not appear in Littré, 1878), see John Grand-Carteret, *Les Trois formes de l'union sexuelle: Mariage, Collage, Chiennerie* (Paris 1911).

91. The song appeared in *Paris qui chante* (November 18 1911), 8. Strikingly, the same issue contains words for a song called "Le Cubisme," written to be sung to the tune of "Les Plaisirs de Collage"!

92. The contemporary literature on issues of censorship at the music-hall is vast; during periods of crackdown, items and editorials appeared with frequency throughout the daily press. For articles which address this matter at some length, see: Francis Carco, "La Rénovation du Café-Concert," *Le Feu* (September 1908), 274; Emile Henriot, "D'un Moraliste et d'une Psychologie du Music-Hall," *Vers et Prose* (April–May–June 1910), 181–4; Charles Holveck, "La Moralisation du Café-Concert," *La Renaissance contemporaine* (August 24 1911), 1011–16; André Joubert, "Chez les Antipornographes," *Paris-Midi* (March 25 1912), 3; Curnonsky, "La Morale au Music-Hall," *Le Music-Hall illustré* (August 15 1912), 2–3; J. Paul-Boncour, "La censure et le public," *Excelsior* (November 12 1912), 2; Maurice Hamel, "La Pornographie au Café-Concert," *Paris-Journal* (July 4 1913), 1. For a satirical treatment of censorship, see Robert Dieudonné, "Le Nouveau Café-Concert," *Fantasio* (July 15 1911), 849–50; and the song "La Rénovation du Café-Concert" by J. Combe, A. Danerty and Albert Valsien, published in *Paris qui chante* (May 18 1912), 6–7.

93. See, for example, the *tableau* "Le Café-Concert Moraliste" in the original program for *La Revue de Rip et Bosquet*, which played at the Olympia in fall 1911. Also "Le Senateur et la Danseuse Nue" in the original program for *N . . . U . . . NU, c'est Connu!* by Valentin Tarault and Léon Granier, which played at the Cigale in summer 1913, and where the "senator" is René Bérenger, arch-moralist of the day.

94. Eugène Héros, *Les Lyriques* (Paris 1898), 202. The identical technique was employed by Alfred Jarry for the notorious one-word opening line of his play *Ubu-Roi* (1896), where the scandalous *merde* is transformed into *merdre*. Inserting the "r" creates the music-hall effect of veering away from the vulgar truth at the last second: "mer . . . dre." Of course, since *merdre* is a nonsensee word, it doesn't actually offer any alternative meaning; the original audience reacted as if Ubu had said *merde*. For a description of opening-night, see Roger Shattuck, *The Banquet Years* (New York 1968), 207–8.

95. Anon., "A la Scala," *Le Music-Hall* (January 15 1913), 15.

96. "J'ai un thermomètre, un thermo mo / Un p'tit thermomètre / J'ai un thermomètre épatant / qui monte et qui r'descend." Plébus, Danerty and Serpieri, "Mon Thermomètre," *Paris qui chante* (June 8 1912), 3–4.

97. Eugène Héros, *Les Lyriques*, 202–3.

98. Original program for *R'mettez-nous ça!* by Georges Arnould and Léon Abric, which played at the Eldorado in fall-winter 1910; for *Sauf vot' respect*, see Léon Royan, "Au Théâtre des Capucines," *Comoedia illustré* (November 1 1910), 71–2. Abbreviation and ellipse at the music-hall are, in turn, derived from street slang or *argot*, for which they are standard devices. Thus, the newspaper *l'Intransigeant* becomes "L'Intran;" the Eldorado music-hall is "L'Eldo;" *café-concert* itself is *caf'-conc'*. For an example of slang abbreviation in a pre-collage cubist picture, see Picasso's *Still Life with Fan (L'Indépendant)* of 1911 (Daix and Rosselet, *Picasso: The Cubist Years*, no. 412), where the newspaper title *L'Indépendant* is boldly cropped to read "L'Indép." As in most examples by Picasso, the abbreviation can also be understood as the result of a folded newspaper.

99. For the *Grande Revue*, see Curnonsky, "La Grande Revue du Nouveau Cirque en 16 tableaux," *Le Music-Hall illustré* (March 15 1912), 12–14; for "Les Déstractions Parisiennes," see original program for *La Revue de la Scala* by André Barde and Michel Carré; for Mounet-Sully and Dranem, see "La Revue de l'Ambigu," *Comoedia illustré* (December 15 1911), 190; for Madame Job and Louis XIV, see Anon., "A la Boîte à Fursy," *Le Music-Hall illustré* (15 February 1913), 7–8.

100. "En effet, une action dramatique d'opérette ou de vaudeville . . . est *une* et

comporte des personnages désignés, devant agir d'un bout à l'autre de la pièce, tandis que le cortège d'une revue est composé de personnages multiples, disparates, sans cesse renouvelés, tou-jours forcément étrangers à un postulat initial . . . Tout ceci prouve assez combien la revue est un genre spécial et bien différent de tous les autres. C'est justement le manque de cohésion de la revue qui en fait tout le charme." Trébla, "La Revue à l'Intrigue," *Le Music-Hall illustré* (May 1 1912), 17. The music-hall was still being discussed in exactly these terms during and after the war, most notably in the pages of the advanced cultural journal *L'Esprit Nouveau*, where René Bizet contrasted the narrative "illogic," rhythmic formal prin-ciple of "surprise" and general "absence of method" in music-hall performance to the "monotony" of conventional theater. See Bizet, "Dialogue sur l'Esthétique du Music-Hall," *L'Esprit Nouveau*, no. 6 (1921), 675–78.

101. The best discussion of this property of disjunction is still to be found in the penultimate, and unjustly neglected, chap-ter of Roger Shattuck's *The Banquet Years*, 331–45. Shattuck has identified the key term "juxtaposition," and opposed it to formal and narrative "transition" as a fundamental esthetic principle, in all the arts of the late nineteenth and early twen-tieth centuries. Shattuck recommends the writings of Sergei Eisenstein for further reading on this subject. In Eisenstein's book *Film Form*, the filmmaker traces the origins of montage (the filmic version of collage, or the splicing and "juxtaposi-tion" of autonomous parts) back to the music-hall: "I think that first and foremost we must give credit to the basic principles of the circus and the music-hall – for which I had had a passionate love since childhood . . . The music-hall element was obviously needed at the time for the emer-gence of a 'montage' form of thought. Harlequin's parti-colored costume grew and spread, first over the structure of the program, and finally into the method of the whole production." Eisenstein, *Film Form*, ed. and trans. Jay Leda (New York 1957), 12.

102. Daix and Rosselet, *Picasso: The Cubist Years*, no. 524.

103. *Ibid.*, no. 547.

104. Curnonsky, "A propos de 'La Revue de la Scala'," *Le Music-Hall illustré* (March 1 1912), 12. On Picasso and *Fantômas*, see André Salmon, *Souvenirs sans fin, Deuxième époque (1908–1920)*, 232–4; and J. Charlat Murray, "Picasso's Use of Newspaper Clippings in his Early Collages, unpublished Master of Arts the-sis for Columbia University (New York 1967), 54.

105. Robert Rosenblum, "Picasso and the Coronation of Alexander III: A note on the dating of some *Papiers Collés*," *Burlington Magazine* (October 1971), 605. In the two pictures with the largest *Le Figaro* clip-pings, the old newspaper fragments are placed near bottles of "Vieux Marc," "*old marc.*"

106. In 1912, an intriguing item in *L'Instran-sigeant* disrespectfully suggests that collage was invented for this very reason: "Pour simplifier la main d'œuvre dans son travail, [M.J. Gris] colle délibrément des objets réels sur sa toile. C'est ainsi que l'on peut voir sur l'in de ses tableaux, un vrai miroir, des feuillets imprimés, les étiquettes de flacons de parfumerie, etc., etc." Anon., "Échos – Préfuturisme," *L'Instransigeant* (October 14 1912), 2.

107. Ergaste, "Aux Capucines," *Le Théâtre* (December 1 1911), 23.

108. Louis Delluc, "A l'Olympia, la Revue de Rip et Jacques Bosquet," *Comoedia illustré* (October 15 1911), 58–60; Picrochole, "L'Actualité théâtrale," *Le Charivari* (April 20 1912), 6; Paul Abram, "Le Théâtre: Olympia – La Revue de l'Année," *La Petite République* (November 22 1912), 4; Georges Talmont, "La Revue de l'Année," *Comoedia* (November 25 1912), 1; Curnonsky, "La Revue de l'Année à l'Olympia," *Le Music-Hall illustré* (December 1 1912), 5–13.

109. Anon., "Attractions," *Excelsior* (October 14 1911), 8.

110. Charles Muller and Regis Gignoux, *Mil-neuf-cent-douze* (Paris 1912).

111. Robert de Flers, "Aux Théâtres – Aux Théâtres des Arts: Mil-neuf-cent-douze," *Le Figaro* (April 19 1912), 5; Louis Delluc, "Mil-neuf-cent-douze," *Comoedia illustré* (May 1 1912), 587–90; Ernest La Jeunesse, "La Bataille théâtrale," *Comoedia illustré* (May 1 1912), 585; Curnonsky, "Théâtre des Arts: Mil-neuf-cent-douze," *Le Music-Hall illustré* (May 1 1912), 15–16.

112. Guillaume Apollinaire clearly had the *revue* in mind when he wrote *Les Mamelles de Tirésias*, a wild burlesque set in Zanzibar and Paris, which was performed at the small Théâtre Renée Maubel in Montmartre on June 24, 1917. Its disjointed narrative (written in a tone that was alternately interpreted as sincere and sarcastic) concerns the theme of "repopulation," an *actualité* that was widely discussed in the pre-war and war-time press both in the context of France itself and French colonial Africa. Characters include a newspaper kiosk and Thérèse / Tirésias, the protagonist who transforms herself into a man. In his review of *Les Mamelles*, André Warnod observed, "C'est une art qui fait penser à Jarry, un Jarry à la vingtième puissance, avec un tel souci de l'actualité qu'on croit, par instants, assister à une revue de fin d'année." See Warnod, "Petit Courrier des Arts et des Lettres," *L'Heure* (June 25 1917), 2. For more on *Les Mamelles de Tirésias*, see Chapter IV.

113. André Salmon, *Garçon!... de quoi écrire!*, in *Le Printemps des Lettres* (July–August 1911), 93–127. For commentary, see: Salmon, *Souvenirs sans fin, Deuxième époque (1908–1920)*, 191–9; and André Billy, *L'Epoque contemporaine (1905–1930)* (Paris 1956), 56, 141–2. For an appreciative review, see Robert Fort, "Garçon!... de quoi écrire!," *Vers et Prose* (July–August–September 1911), 222.

114. "Hop! *Excelsior*, hédi, ohé! / Hop! j'offre pour deux sous: / Du Lemaitre et du caoutchouc, / Du Barrès et des chais's en bambou; / J'offre avec du Tristan Bernard / Des liqueurs, du pâté d'canard, / J'offre avec du Lavedan / Une jolie brossee à dents. / Hop! Excelsior! ohé!" Salmon, *Garçon!... de quoi écrire!*, 105.

115. Michel Puy, "Le journal à deux sous," *L'Ile Sonnante* (December 1912), 234–42.

116. Salmon, *Souvenirs sans fin, Deuxième époque (1908–1920)*, 197–8.

117. "Il y eut un esprit de blague et d'atelier dès 1913, au Bateau-Lavoir, où, en même temps, se préparaient sérieusement le modernisme, l'orphisme, le cubisme" *Ibid.*, 199.

118. Dreyfus, *Petite Histoire de la Revue de Fin d'Année*, XXII.

119. Marinetti, "The Variety Theater," 126–9.

120. See Giovanni Lista, "Esthétique du Music-Hall et Mythologie Urbaine chez Marinetti," in ed. Caludine Amiard-Chevrel, *Du Cirque au Théâtre* (Lausanne 1983), 48–64; and Lista, *La Scène Futuriste*. See also Marianne Martin, *Futurist Art and Theory 1909–1915* (New York 1978), 136; Michael Kirby and Victoria Nes Kirby, *Futurist Performance* (New York 1986), 19–27. Among futurist scholars, only Lista reads below the surface of the manifesto into the significance of the music-hall as an institution during the epoch. He is especially good on qualitative distinctions between the tradition of commedia dell'arte and the urban novelty of music-hall performance, though he is less interested in the material facts of music-hall history *c.*1910 to 1914. In general, the relevance of the manifesto is understood to pertain to futurist performance, rather than futurist art overall.

121. Marinetti, "The Variety Theater," 129.

122. *Ibid.*, 130. Concerning the condensed classics, Marinetti notes a "performance of *Parsifal* in forty minutes, now in rehearsal in a great London music-hall" (129). One year later, a "parody" of *Parsifal* was also mounted in Paris, in the *revue* "Pourquoi pas...?" at the Cigale; see Curnonsky, "La Cigale – Pourquoi pas...?," *Comoedia* (February 21 1914), 1.

123. *Ibid.*, 127.

124. *Ibid.*, 129–30. It is not insignificant, in this regard, that Marinetti's publicity persona, one of extravagance and excess, could be addressed as music-hall *revue* material. In 1912, for example, concerning the futurists' international campaign for recognition, *Fantasio* wrote that "ils jouent à Londres un numéro de music-hall." See Le Dévernisseur (Dorgélès?), "Au Salon des Indépendants," *Fantasio* (April 1 1912), 619. In 1914, a critic for *Paris-Midi* wrote that Marinetti's exploits would be a good subject for a "méchante vilaine revue" called *Pan! Pan! la Débinette* (rhymes with *Tangui-Tango, Pan! Pan! la Tanguinette!*, performed at La Scala in 1913), which he has been asked to compose. See Armand du Plessy, "Heures futuristes," *Paris-Midi* (September 14 1912), 2.

125. David F. Cheshire, "Futurism, Marinetti and the Music-Hall," *Theatre Quarterly* (July–September 1971), 56–7.

126. Roland Dorgelès, "Music-Halls, Cafés-

Concerts, Cabarets, etc. – Les Futuristes et le Music-Hall," *Comoedia* (January 9 1914), 4; *Idem.*, "Music-Halls, Cafés-Concerts, Cabarets, etc. – Le music-hall et les futuristes," *Comoedia* (January 11 1914), 4; Curnonsky, "Music-Halls, Cafés-Concerts, Cabarets etc. – Le music-hall école de l'irrespect," *Comoedia* (January 18 1914), 4; Dorgelès, "Music-Halls, Cafés-Concerts, Cabarets, etc. – A la manière de . . . ," *Comoedia* (February 2 1914), 4. As far as I know, the appearance of the manifesto in *Comoedia* is heretofore undocumented. Curiously, there is no existing history for the French-language publication of "The Variety Theater," though the early Italian and English versions, in *Lacerba*, the London *Daily Mail* and the *Mask*, are all accounted for. See ed. Apollonio, *Futurist Manifestos*, 131; Kirby, *Futurist Performance*, 19–20; and Giovanni Lista, *Futurisme: Manifestos, Documents, Proclamations* (Lausanne 1973), 254. The manifesto first appeared in *Lacerba* on October 1, 1913; then in English in the *Daily Mail* on November 21, 1913, where it was entitled "The Meaning of the Music-Hall;" when it appeared in Gordon Craig's the *Mask* in January 1914, it was called "In Praise of the Variety Theatre." Unlike the *Comoedia* version, both English translations are incomplete. It is likely that the manifesto had already been published in French before its appearance in *Comoedia*, though I have been unable to locate a source. A bemused response – the earliest I have found in French – occurs in the *Journal des Debats* (November 30 1913), 1, "Au Jour le Jour – Concert futuriste." A partial translation of the manifesto subsequently appeared in the small review *Le Feu* (February 1914), 176–9.

127. Curnonsky, in the January 18 editorial; and Dorgelès, on February 2.
128. "Tous les directeurs du monde devraient toujours avoir sous les yeux." Dorgelès, on February 2.
129. Curnonsky, on January 18.
130. Marinetti, "The Variety Theater," 130.
131. *Ibid.*, 126.
132. *Ibid.*, 126–7.
133. *Ibid.*, 130.
134. The "Conversation Diplomatique" occured in "Le Bec de Canard," the 27th *tableau*. See the original program for *Re-*

vue des Folies-Bergère* by P.-L. Flers and Hugues Delorme. The program also credits a caricature of the two diplomats by Adrien Barrère, which appeared in the humorist magazine *Fantasio*, as the source for the parodic dance. Concerning the smash-hit success of Moon and Morriss, see Louis Handler, "La Revue des Folies-Bergére," *Comoedia* (December 3 1911), 1; and Curnonsky, "A Propos de la Revue des Folies-Bergére," *Le Music-Hall illustré* (December 15 1911), 9, where the dancers are described as "étonnante de précision." Later, advertisements spotlight the dance as the "clou de cette Revue." See, for example, "La Revue des Folies-Bergère, *Le Music-Hall illustré* (February 1 1912), before p. 1. "L'incident d'Agadir" was big news between July and November 1911. As such, it was covered at great length in the daily press. For highlights from two of the more popular dailies, see: René Puaux, "Pourquoi l'Allemagne est allée à Agadir," *Excelsior* (July 3 1911), 3; Saint-Brice, "L'Incident d'Agadir devient un Problème international," *Le Journal* (July 6 1911), 1; *Idem.*, "L'incident d'Agadir – La Négociation est engagée," *Le Journal* (July 9 1911), 1; Edouard Julia, "La genèse et la fin du "Coup d'Agadir," *Excelsior* (July 18 1911), 2; Saint-Brice, "Les Négociations demeurent stagnantes," *Le Journal* (August 2 1911), 1; *Idem.*, "La Crise internationale évolue," *Le Journal* (August 23 1911), 1; *Idem.*, "L'Accord Franco-Allemand est fait," *Le Journal* (November 3 1911), 1; *Idem.*, "Après quatre mois de crise, l'Accord Franco-Allemand sera signé aujourd'hui," *Le Journal* (November 4 1911), 1–2.
135. Saint-Brice, "Dix Jours d'Entr'acte," *Le Journal* (August 19 1911), 1; Paul Vallon, "Le deuxième acte commence," *Excelsior* (September 5 1911), 2.
136. Marinetti, "The Variety Theater," 128.
137. See Georges Rozet, "Les Sports – Le Sport au Café-Concert," *L'Opinion* (August 6 1910), 189–90; Marcel Millet, "Opinions et Arguments – L'Art Clown," *La Renaissance contemporaine* (January 24 1912), 74–6 (in which the music-hall is described as a place where "nous trouvons l'art véritablement nouveau"); Edouard Pontié, "Sports – La Leçon de Sport dans un Cirque," *Pages modernes* (June 1913), 220–2; and Legrogneux, "Athlètes de Re-

vue," *Fantasio* (July 1 1913), 841.

138. For editorials on this subject, see: Carlos Fischer, "De Molière au 'Caf-Conc'," *L'Opinion* (September 3 1910), 299–300; Gaston de Pawlowski, "La Comédie Populaire," *Comoedia* (August 3 1911), 1; Maurice de Marsan, "Le Caf'-Conc' à l'Odéon," *Le Music-Hall illustré* (October 15 1912), 3–4; Alfred de Tarde, "Notes et Figures – Molière à Bobino," *L'Opinion* (March 8 1913), 299; Nozière, "La Comédie Populaire," *Comoedia illustré* (March 20 1913), 566–7.

139. Reprinted in ed. Joan U. Halperin, *Félix Fénéon: Œuvres plus que complètes T.II* (Geneva 1970), 973–1027; for a discussion, see *Idem., Félix Fénéon: Aesthete and Anarchist in Fin-de-Siècle Paris* (New Haven 1988), 348–58; and Patrick and Roman Wald Lasowski, *Félix Fénéon: Nouvelles en Trois Lignes* (Paris 1990), 5–31.

140. "Un propriétaire de Gabarret (Landes), Capes, a été assassiné chez lui. Il ne semble pas qu'on l'ait tué pour le voler." Ed. Halperin, *Félix Fénéon: Œuvres plus que complètes*, 989.

141. These examples are taken from Eileen M. Baldeshwiler, "Félix Fénéon and the Minimal Story," *Critique* (1972), no. I, 73–4.

142. These are collected in ed. Ornella Volta, *Erik Satie: Écrits*, 102–43 and 185–90; they are also discussed in Jerrold Seigel, *Bohemian Paris* (New York 1986), 329–30.

143. "petite revue d'esprit moderne sous un titre ancien." Salmon, *Souvenirs sans fin, deuxième époque*, 202. Salmon devotes an entire chapter of his memoires to the journal; perhaps significantly, it follows the chapter on his *revue Garçon . . . de quoi écrire!*

144. "Jules Romains a eu tort de me croire contre lui parce que je l'avais blagué, tant dans les échos des *Nouvelles de la République des Lettres* que dans une séquence de *Garçon, de quoi écrire*." *Ibid.,* 200. For Salmon's gags at Romains' expense, see Salmon, "Scènes de la Vie littéraire," *Nouvelles de la République des Lettres* (October 1910), 13; and Salmon, *Garçon!*, 106.

145. Salmon, *Souvenirs sans fin, Deuxième époque (1908–1920)*, 208.

146. "me reprocha d'engueuler tout le monde,

insinuant que ça ne mènerait à rien d'heureux . . . Cher Dalize qui ne put jamais concevoir qu'une revue ne se fonde pas dans le but précis de remplacer la *Revue des Deux mondes*, en la rajeunissant, dame oui!" *Ibid.,* 207.

147. F.F. (Fernand Fleuret?), "L'Iconoclaste," *Les Soirées de Paris* (December 15 1913), 2–4.

148. *Ibid.,* 216.

149. "jeté à la face des écrivains et des artistes, les jeunes, d'entre les mieux covaincus de leur "indépendance'." *Ibid.,* 216.

150. "Comme je rêvais fébrilement, après une longue période de la pire des paresses, à devenir très riche (mon Dieu! comme j'y rêvais souvent!); comme . . . je m'échauffais progressivement à la pensée d'atteindre malhonnêtement à la fortune, et d'une manière inattendue, par la poésie – j'ai toujours essayé de considérer l'art comme un moyen et non comme un but – je me dis gaiement: "Je devrais allez voir Gide, il est millionaire." Cravan, "André Gide," *Maintenant* (July 1913), 39. Excerpts from *Maintenant* (and their pagination) come from a complete reprint edition of the magazine in Cravan, *J'étais cigare,* ed. José Pierre (Paris 1971).

151. Cravan, "Oscar Wilde est vivant!," *Maintenant* (October–November 1913), 63.

152. "Nous sommes heureux d'apprendre la mort du peintre Jules Lefebvre." Cravan, "Différentes Choses," *Maintenant* (April 1912), 37.

153. "Tout d'abord, je trouve que la première condition pour un artist est de savoir nager." Cravan, "L'Exposition des Indépendants," *Maintenant* (March–April 1914), 88.

154. *Maintenant* (October–November 1913), 80.

155. "attitude voulue d'humour et de blague pour approcher des questions les plus vitales." Buffet-Picabia, "On demande: "Pourquois 391? Qu'est-ce que *391*?" (1936), reprinted in Buffet-Picabia, *Rencontres* (Paris 1977), 204–5; and *Ibid.,* "Dada" (1950), 217.

156. "Il n'y a pas de meilleure façon d'influer sur les événements." Billy, *Apollinaire vivant* (Paris 1923), 92; also quoted in Francis Steegmuller, *Apollinaire: Poet Among Painters* (New York 1973), 265.

157. From Huysmans, *Croquis Parisiens* (Paris

1880); English translation by Richard Griffiths in Huysmans, *Parisian Sketches* (London 1886), 68.

158. "Ecoute, Pablo, si *tou* allais chercher des parents à la gare et qu'ils arrivent avec une gueule pareille, *tou* ne serais pas content." As recalled in Roland Dorgelès, *Bouquet de Bohème* (Paris 1947), 230. Dorgelès is careful to note that Manolo's remark was justified especially because Picasso was more interested than other cubists in representing the figure.

## CHAPTER 2

1. Of the first kind: Edward Fry, *Cubism* (London 1966); Lynn Gamwell, *Cubist Criticism* (Ann Arbor 1980); J.M. Nash, "The Nature of Cubism," *Art History* (December 1980), 435–7; and Mark Roskill, *The Interpretation of Cubism* (Philadelphia 1985). Of the second kind, see, for example, David Cottington, "Cubism, law and order: the criticism of Jacques Rivière," *Burlington Magazine* (December 1984), 744–50, and Patricia Leighten, *Re-Ordering the Universe: Picasso and Anarchism, 1897–1914* (Princeton 1989), 98–101. Gamwell's book is not so much an anthology of documents, as an historiographical discussion of cubist criticism from 1907 to 1977. Her bibliography for 1907 to 1914 is the most extensive to date, but her emphasis, like Roskill, is on the well-known critics, such as Apollinaire, Salmon, Morice, Vauxcelles, Allard, Raynal, Olivier-Hourcade, Kahn and Rivière, with a small minority representation of the less familiar or hostile voices, especially from the popular press. I have found that the latter actually constitute a silent majority of cubist criticism. Outside of cubism, Roger Benjamin has conducted an exemplary and singularly dense reading of Matisse criticism through 1908, including the hostile press, though his account deliberately focuses on the developing thought of a handful of chief critics in order to demonstrate their influence on Matisse's own theoretical statement "Notes of a Painter." See Benjamin, *Matisse's "Notes of a Painter:" Criticism, Theory and Context, 1891–1908* (Ann Arbor 1987). The one treatment of avant-garde criticism that stands out for

addressing bad press alone is Marcel Sanouillet, *Dada à Paris* (Paris 1993), originally published in 1965, chapt. XXIII, "Dada et son public." Post-war French Dada is an obvious vehicle for such a study, and Sanouillet is too defensive (dadaists practically invited the sort of bad popular press they received, a crucial ambiguity that he overlooks), but the discussion is an important one. My own account employs a relentless run of excerpts and quotations; the methodology threatens with tedium, but truth to the debates and sentiments of the epoch offers no alternative.

2. A number of these questions have been asked by David Cottington, and his dissertation is required reading in cubist studies; see Cottington, "Cubism and the Politics of Culture in France, 1905–1914," Ph D. dissertation, Courtauld Institute, University of London (1985). This is the only recent work on the art to integrate a close and extensive reading of the critical press, though emphasis is placed largely on the specialist rather than the popular press. My argument differs broadly from Cottington, who privileges period discourse concerning traditionalism, nationalism and modernism as impulses, working both in concert and conflict, that governed the esthetic and ideological choices of cubist groups in Paris before the war. Generally speaking, Cottington scrupulously and expertly charts the shifting cultural politics of cubists against a background of larger ideological developments in France. Where I see a condition of disorientation, and seek to assemble the evidence of this condition in order to identify a forgotten aspect of esthetic experience that permeates the cubist milieu, Cottington files much of the same evidence under very specific micro-debates within the milieu – he sees less disorientation of purpose and comprehension, than ongoing, often conflicted re-orientation of intentions among the sub-groups of advanced art. But Cottington precedes me in aspects of his discussion of the strategies and reception of the avant-garde, and where appropriate in this regard, I cite his work below.

3. This has been done by Jacques Lethève, *Impressionnistes et Symbolistes devant la presse* (Paris 1959).

4. Florian-Parmentier, *La Littérature et l'Epoque: Histoire de la Littérature française de 1885 à nos jours* (Paris 1914), 676–9.

5. "la synthèse de . . . tendances générales;" "crise du roman . . . du théâtre . . . de la peinture et . . . de la musique;" "l' organisation de la presse . . . la mentalité du public . . . des artistes . . . les moeurs." Camille Mauclair, "Le Préjugé de la Nouveauté dans l'Art moderne," *La Revue* (April 1 1909), 289.

6. "On n'entend parler que de 'faire table rase' et de 'recommencer tout'. L'œuvre des prédécésseurs semble peser d'un poids intolérable . . . Chacun compte bien être 'original' . . . 'Faire nouveau' est tout le programme." *Ibid.*, 290.

7. "une ambition singulière, séduissante, dangereuse . . . L'histoire de l'évolution et surtout de la corruption de l'idée de nouveauté en art serait une étude passionnante." *Ibid.*, 290.

8. "la prétention de réinventer . . . la technique et le style d'un art." *Ibid.*, 291.

9. F.T. Marinetti, "The Founding and Manifesto of Futurism," in ed. Umbro Apollonio, *Futurist Manifestos* (London 1973), 24. In France, the original was entitled simply "Le Futurisme," and appeared on the front page of *Le Figaro*, preceded by an editorial disclaimer.

10. This influence of Marinetti's manifesto has been suggested by Cottington, *Cubism and the Politics of Culture in France, 1905–1914*, 284.

11. "Voilà plus de six mois qu'aucun cénacle n'avait sollicité ma conversion. Et mon zèle inlassable de néophyte s'ennuyait de rester ainsi sans emploi. Vous savez que je fais déjà partie de beaucoup d'écoles, et que la liste n'est pas close." Romains, "Réponse à F.T. Marinetti," *Les Guêpes* (March 3 1909), reprinted in Giovanni Lista, *Les Futuristes* (Paris 1988), 151.

12. See p. 10.

13. "Elle légitime même l'explosion du futurisme en ce sens qu'elle montre jusqu'à quel point le virus de la routine, de l'imitation et du pédantisme a infecté une grande partie de la jeunesse qui pense et qui travaille." La Cocherie, "Le Futurisme: Interwiew(*sic*) de M. Marinetti," *Comoedia* (March 26 1909), 1.

14. "On est un peu surpris de savoir qu'une école littéraire se fondé . . . on pensait qu'il y fallait plus de temps et plus de travaux que de paroles; mais un manifeste suffit." M.D., "Au Jour le Jour – Le Futurisme," *Journal des Débats* (February 25 1909), 1.

15. "charlatans sur la place publique . . . la Troisième République aura vu naître, à elle seule, plus de manifestes littéraires que les empires et les royautés qui la précédèrent; manifestes d'ailleurs aussitôt morts que nés." Acker, "Manifestes Littéraires," *Gil Blas* (March 12 1909), 1.

16. Giovanni Lista notes that a response to the primitivism manifesto occurs in *L'Intransigeant* on March 12, even though the manifesto was published in *Poésie* for the first time that summer. See Lista, *Futurisme: Manifestes, Documents, Proclamations* (Lausanne 1973), 76 n. 74.

17. "Il est plus facile d'écrire cent mille manifestes que d'écrire un beau livre." Acker, "Manifestes Littéraires," 1.

18. ". . . bizarrerie, truquage et poudre aux yeux." Mauclair, "Le Préjugé de la Nouveauté," 300.

19. "le silence seul est redoutable." *Ibid.*, 293.

20. "de bon sens et de bonne foi." *Ibid.*, 295.

21. "ne comprend rien à cette profusion de formules neuves qu'on . . . lui vante par la réclame industrielle"; "une grande incertitude masquée par l'emphase de leurs déclarations." *Ibid.*, 298.

22. ". . . que dans un siècle ou deux un rat de bibliothèque . . . connaîtra quelque gloire . . . par la publication lucrative d'une substantielle et, si possible, scandaleuse étude sur 'les Écoles littéraires au début du XXᵉ siècle, avec de nombreux documents inédits' "; "l'éruption des manifestes et de prospectus . . . un symptôme de la générale folie d'enrôlement et de réclame . . . ceintures électriques, pilules merveilleuses et tissans salvatrices." Billiet, "Du Futurisme au primitivisme," *L'Art Libre* (November 1909), 62.

23. ". . . d'éternelle actualité. Pas une semaine ne se passe ou nous ne voyons naître une école littèraire qui s'annonce, à grand fracas, à coups de manifestes tumultueux." Georges Batault, "Ecoles Littéraires," *Arlequin* (December 1909), 35.

24. "dans le domaine des lettres comme dans tous les autres? L'anarchie commerciale." *Ibid.*, 36.

25. Raynaud, *La Mêlée Symboliste (1870–1910)* (Paris 1971), 430; this edition is a

reprint of three undated volumes that were originally published during the 1920s.

26. J.-C. Holl, "Les Parallèlismes," *Les Rubriques nouvelles* (January 25 1910), 11, 12–13.

27. "Comme le Naturalisme, l'Impressionnisme n'est pas une école, mais un groupe de peintres distincts et caractéristiques." *Ibid.*, 13.

28. Specifically in the writings of Maurice Denis, Charles Morice and Louis Vauxcelles. See Benjamin, *Matisse's "Notes of a Painter"*, 88–90, 94–5, 108, 110, 131.

29. "Depuis vingt ans nous sommes fixés sur la soi-disant valeur de ces prophètes amphigouriques ou prétentieux." *Ibid.*, 12. Holl quotes from the 1892 edition of Baju, though the book was republished (but not updated) in 1904. The "anarchy" to which the title refers is the confusing rash of post-symbolist isms. Baju is a good example of the 1890s origin of this critical concern over a breakdown of unity, or reasonable multiplicity, in the arts and letters, and of groups and schools as a form of publicity.

30. This distinction is slightly blurred in the literature. Fry, for example, credits Vauxcelles, who made "first published use of the word 'cube'," for having devised "the name of cubism." See Fry, *Cubism*, 51. Daniel Robbins' "history of the very word 'Cubism'" is, in fact, an account of the use of the word "cubes." See Robbins, *Albert Gleizes 1881–1953: A Retrospective Exhibition* (New York 1964), 20 and n. 19. Robbins takes pains to note that the critic Louis Chassevent "made reference to Cubism as early as 1906," and that since he was discussing Delaunay and Metzinger rather than Picasso or Braque, he has been overlooked; however, the quotation from Chassevent is a reference to "cubes" rather than "cubism" (and Chassevent's article, a review of the 1906 Salon des Indépendants, was only published in 1908, raising some question over the matter of critical chronology). Gamwell refers to the Vauxcelles episode as the "story of the origin of the term 'cubisme'." See Gamwell, *Cubist Criticism*, 15. Vauxcelles himself would later perpetuate the slip. In an uncited account of 1934, he credits Matisse for "le vocable 'cubisme'," recalling a conversation that they had at the

Salon d'Automne (presumably in 1908, though he does not specify), in which the painter told him: "Braque vient d'envoyer ici un tableau fait de petits cubes,"' and demonstrated with a quick sketch on a scrap of paper. See Vauxcelles, "Les Fauves: A propos de l'exposition de la Gazette des Beaux-Arts," *Gazette des Beaux-Arts* (December 1934), 273. The role of Matisse, who, as a salon jury member at the time, is sometimes said to have first used the word "cubes" to describe Braque's works, was originally suggested by Apollinaire in 1911, though rejected by Fry as probably apocryphal, failing a first-hand account by Vauxcelles.

31. On Vauxcelles' use of the word "fauve," see Ellen C. Oppler, Fauvism Re-examined, PhD. dissertation, Columbia University (New York 1969), 13–19.

32. For an account of Matisse and Vauxcelles in this context, see Fry, *Cubism*, 51; Fry also includes a photo-reproduction of Vauxcelles' original review from *Gil Blas* (November 14 1908).

33. "Ne le raillons point, puisqu'il est de bonne foi. Et attendons." *Ibid.*, 51. Fry translates the phrase "il est de bonne foi" as "he is honest;" but the literal translation "in good faith" better alerts us to the fact that Vauxcelles' remark touches upon a recurring critical motif: that of sincerity, which all avant-garde art will soon come to be criticized for lacking. See below.

34. "depuis les 'impressionnistes', les 'pointillistes' et les 'symbolistes' jusqu'aux 'cubistes'." Anon., Echos," *Le Figaro* (March 24 1909), 1.

35. Alvin Martin, "Georges Braque and the Origins of the Language of Synthetic Cubism," in Isabelle Monod-Fontaine and E.A Carmean, Jr., *Braque: The Papiers Collés* (Washington. D.C. 1982), 62; the review appeared on p. 729 of the *Mercure*. The English translation of Morice's remark is from William Rubin, *Picasso and Braque: Pioneering Cubism* (New York 1989), 360. Since Morice placed the word "Cubisme" in quotation marks, we can infer that it was in use at the moment, at least in contexts such as the *Le Figaro* Echos announcement. In her "Documentary Chronology" for *Picasso and Braque: Pioneering Cubism* (435–6 n. 62, and 436–7 n. 77), Judith Cousins usefully synopsizes a number of accounts concerning

"cubes" and "cubism." See also Gamwell, *Cubist Criticism*, 150, n. 25. On the subject of distinguishing early references to geometry as an ism or group-style, note the review by Henri Bidou in 1909, in which allusion is made to works by Matisse at the Stein home ("chez une famille américaine"). See Bidou, "Le Salon des Indépendants," *Journal des Débats* (March 29 1909), 3. These pictures are said to consist of "des cercles et des angles . . . et des pieds équarris." Bidou mentions that, because of his students, Matisse has historical importance; he names no names, but given his characterization of paintings *chez* Stein, we might conjecture that he is tracing the rise of cubism, as a collective style, to the influence of Matisse.

36. "car nous jouissons d'une école de cubistes péruviens!" Vauxcelles, "Le Salon d'Automne," *Gil Blas* (September 30 1909), 5.

37. Oppler, *Fauvism Reexamined*, 17–20.

38. *La Phalange* (November 15 1907).

39. One exception which proves the rule occurs in a review of cubism at the Salon d'Automne in 1911, where, in an overall characterization of new painting as an anarchy of excess, cubists are spared from blame because "ils sont d'une école, école bizarre et surprenante, mais qui a ses maîtres, ses élèves, et même ses règles." See Henri Deauze, "Le Salon d'automne," *La Revue Artistique* (November 1911), 12. Deauze does not specify those painters which he understands to be cubist; among those who are listed as offenders, presumably individualists who stand outside the group, are Kupka and Duchamp. The same issue of the magazine contains a mocking attack of cubism: Henri Debusschère, "Le Cubisme," 2–3.

40. Albert Gleizes, *Cahiers Albert Gleizes, 1. Souvenirs Le Cubisme* (Lyon 1957), 14–15. For a close reading of the Salle 41 episode, and a fascinating analysis of the influence of salon strategy on the development and marketing of cubist painting, see Cottington, *Cubism and the Politics of Culture in France*, 134–42. Cottington describes the emergence of a cubist group in the context of *salonnets* and exhibition societies that populated galleries around 1909–10, and the related phenomenon of groupings at the Salon d'Automne itself.

This is clearly to the point, and can, in turn, be set against the broader syndrome of multiplying isms (writers' as well as artists' groups) which dates back to the symbolist epoch, and which was understood by many observers to have entered a late phase by 1910.

41. "marché aux puces sans signification." *Ibid.*, 16.

42. *Ibid.*, 15–18.

43. *Ibid.*, 19.

44. *Ibid.*, 20.

45. Marcel Pareau, "Des difficultés qu'il y a à dénommer les choses: les cubistes," *Le Spectateur* (January 1913), 10–13. Pareau examines the fact that the cubists have retained their group name despite its origin as a mocking pejorative. According to Pareau, "cubism," which was invented by adversaries as a comical neologism, is so commonly known and accepted that it is virtually impossible to replace. In chosing to accept the epithet, the cubists engage in "l'argument de l'accord inattendu," wherein one adopts an injurious name in order to render its negative connotation meaningless. The only real danger in the name "cubism," the article continues, is that it conjures an image of simple cubic geometry, and is a misrepresentation of the art; the author quotes from a passage in *Du Cubisme* to this effect, in which Gleizes and Metzinger deny the simple understanding of cubism as a study in "volume," and substitute a description of the movement as a search for "la réalisation intégrale de la peinture." One month later, Gleizes himself referred in print to "cubisme, épithète incomplète." Gleizes, "Le Cubisme et tradition," *Montjoie!* (February 25 1913), 3.

46. "les 'ismes' allaient bientôt se multiplier par les volontés d'artistes cherchant plus à attirer l'attention sur eux qu'à réaliser des oeuvres sérieuses." *Ibid.*, 20.

47. "les procédés tels que l'actuel cubisme sont en réalité surtout des moyens de forcer par leur bizarrerie l'attention du public et de la critique. C'est bien plus une forme de réclame qu'un véritable système de peinture. Une inextinguible soif de bruit et de réclame, voilà au fond le vrai mal qui sévit en ce moment avec violence surtout chez les jeunes peintres." Fourreau, "Au Salon d'Automne, *La Phalange* (October 20 1911), 367.

48. "malfaiteurs qui se comportent dans la monde des arts comme les apaches dans la vie ordinaire." Lampué, in Anon., "Le Salon d'automne est un scandale," *Le Matin* (October 5 1912), 1.

49. "n'est pas de diriger, mais d'encourager l'effort artistique de la nation." Communiqué from the Comité du Salon d'automne, reprinted in Anon., "Ne cherchez pas: c'est de l'art," *Le Matin* (October 6 1912), 1.

50. For a broad sample of the debate, see: Georges Lecomte, "Pour l'art français," *Le Matin* (October 7 1912), 1; Louis Vauxcelles, "M. Frantz Jourdain et le 'Salon d'Automne'," *Gil Blas* (October 9 1912), 4; Thiébault-Sisson, "Art et curiosité – La question du Salon d'automne," *Le Temps* (October 9 1912), 4; rejoinder by Georges Lecomte, "Art et curiosité – La question du Salon d'automne," *Le Temps* (October 12 1912), 4; Léon Bailby, "En Passant – Cubistes," *L'Instransigeant* (October 14 1912), 1; Paul Omer, "Le Salon où tout peut entrer," *Eclair* (October 17 1912), 1–2; Sonia, "Billet à M. le doyen Lampué," *Le Figaro* (October 17 1912), 1; J.L. Breton, "Le Scandale du Salon d'automne," *La Lanterne* (October 1912), 1; André Beaunier, "Journeaux et revues – Frivole indignation," *Le Figaro* (October 24 1912), 1; Pierre du Colombier, "Notes d'Art – Le Salon d'Automne," *La Revue Critique des Idées et des Livres* (October 25 1912), 233–7; Charles Malpel, "Beaux-Arts – Le Salon d'Automne," *Pages Modernes* (November 1912), 401–4; Monsigny, "Les cubistes seront à la place 'd'horreur'," *Excelsior* (November 18 1912), 2; M.D., "Petite Gazette des Arts – M. Lampué et le Salon d'automne," *Paris-Midi* (November 20 1912), 2; Louis Vauxcelles, "Les Arts – Les ennemis du "Salon d'Automne'," *Gil Blas* (November 20 1912), 4; Fernand Roches, "Le Salon d'Automne de 1912," *L'Art Décoratif* (November 20 1912), 281–301; Roger Allard, "La Vie Artistique – M. Léon Bérard et le Salon d'Automne," *La Côte* (November 23–4 1912); Pierre du Colombier, "Dernières échos de l'affaire du Salon d'Automne," *La Revue Critique des Idées et des Livres* (December 10 1912), 590–2. For a transcription of the debate as it occured in the Chambre des Députés, see the *Journal Officiel* (1$^{re}$ Séance du 3 Décembre 1912), 2924–6. In addition to editorials, virtually all reviews of the Salon d'automne in 1912 allude to the Lampué controversy. The debate was resumed in fall 1913. See, for example, M.D., "Petite Gazette des Arts – M. Lampué et le Salon d'automne," *Paris-Midi* (November 20 1913), 2; La Palette (André Salmon), "Les Arts – Les colères de M. Lampué," *Gil Blas* (November 20 1913), 3; Louis Vauxcelles, "M. Lampué et l'art moderne," *Gil Blas* (November 21 1913), 1; Francis Carco, "M. Lampué contre le Salon d'Automne – La réplique des organisateurs," *Homme Libre* (November 21 1913), 1; P.S., "Apologie pour M. Lampué," *Le Temps* (November 22 1913), 1. For recent discussions of the debate from a political vantage, see Patricia Leighten, *Re-Ordering the Universe: Picasso and Anarchism, 1897–1914* (Princeton 1989), 99–101; and Arlette Barré-Despond, *Jourdain* (New York 1990), 118–22.

51. Bailby, "En Passant – Cubistes," 1. Intriguingly, ten days later in *Le Figaro*, André Beaunier also accused Breton of betraying his radical political orientation by accusing cubism and futurism of being "anti-artistic and anti-national" when, in fact, these very terms might be used to characterize the Lampué-Breton campaign against new art in the Chambre. See Beaunier, "Journaux et Revues – Frivole indignation," 2. Bailby's allegiances examplify the difficulty of ascribing esthetic orientation to a political agenda. As editor of *L'Instransigeant*, Bailby was, in André Salmon's description, a bourgeois nationalist. See André Salmon, *Souvenirs sans fin, deuxième époque (1908–1920)* (Paris 1956), 35. In this regard, his barb against socialist hypocrisy over cubism in the Chambre is no surprise. Nor, we would think, was his dismissal of cubism as a concerted hoax. But when Salmon left *L'Instransigeant* for *Paris-Journal* in 1910, Bailby replaced him with Apollinaire. See *Ibid.*, 108–10. Apollinaire was an art writer for *L'Instransigeant* from 1910 to 1914 and, under Bailby's tenure at the paper, produced the most sustained support of cubism and the avant-garde to be found anywhere in the popular press.

52. "le premier résultat de cette intervention,

enregistrée par la presse, est de précipiter des curieux vers les horreurs qu'on signalait avec cette excessive énergie à leur attention." Anon., "Au Salon d'automne," *L'Illustration* (October 12 1912), 268.

53. "J'hésitais à parler une fois encore des Cubistes, car c'est un jeu de dupes que de favoriser leur soif indécente de réclame. Le silence, sans doute, vaudrait mieux." Vauxcelles, "Les Arts – Cubistes," *Gil Blas* (November 14 1912), 4.

54. "S'ils peignaient comme tout le monde voit ... personne ne s'arrêterait devant des toiles. Le scandale est bien plus rénumerateur, puisque, de nos jours, le cabotinage prend l'importance d'une vertu sociale. Il est donc probable que ces cubistes, en se moquant de nous, servent la religion utilitaire." M. X . . ., "Echos – Chez les cubistes," *Excelsior* (October 15 1912). This series of Echos ran on successive days from October 15 to 19.

55. Le Bonhomme Chrysale, "Notes de la Semaine – Le Fumisme," *Les Annales Politiques et Littéraires* (October 13 1912), 311–12.

56. "les marchands de programmes nous assourdissent de leurs clameurs contradictoires." Jean Laran, "Le Salon des Indépendants en 1912," *Bulletin de la Société de l'Histoire de l'Art français* (1912), 94–111.

57. For Allard as a member of the Puteaux and Salle 41 circle, see Gleizes, *Cahiers Albert Gleizes*, 14–15. For his early pro-cubist reviews, see Allard, "Au Salon d'Automne de Paris," *L'Art Libre* (November 1910), 442; English translation in Fry, *Cubism*, 62; Idem., "Sur quelques peintres," *Les Marches du Sud-Ouest* (June 1911), 57–64; English translation of excerpts in Fry, 63–64; Idem., "Les Beaux-Arts," *La Revue indépendante* (Auguest 1911), 127–40; and Idem., "Le Salon des Indépendants," *La Revue de France et des Pays Français* (March 1912), 67–73.

58. See Cottington, *Cubism and the Politics of Culture in France*, 356–66; 498–500.

59. "la *qualité* intrinsèque d'une oeuvre d'art ... prétendue *nouveauté* ... Tout une littérature, tout un art, une tournure d'esprit, une manière d'être sont fondées sur la crainte de ne pas paraître suffisament 'avancé'." Roger Allard, "Les Arts plastiques – Futurisme, Simultanéisme et autres Métachories," *Les Ecrits français*

(February 5 1914), 255.

60. "*L'avant-gardisme* n'est pas seulement un ridicule, c'est une plaie ... une sorte de terreur où le chercheur sincère n'est plus en sûreté, où le talent indépendant doit se résoudre à adhérer par force à la section de son quartier ... tant pis pour ceux qui n'ont aucun goût pour les parades de foire et les boniments! L'usage veut que l'artiste présente son ouvrage enveloppé dans du papier imprimé, avec la manière de s'en servir, manifeste, préface et commentaire." *Ibid.*, 255.

61. "Un vocabulaire spécial ... les moyens de déguiser leur ignorance ... Des artistes sincères, des peintres ... intelligents au surplus, sacrifient à cette manie." *Ibid.*, 256.

62. "A l'aide d'articles de presse, d'expositions savamment organisées, avec conférences contradictoires, polémiques, manifestes, proclamations, prospectus et autre publicité futuriste on lance un peintre ou un groupe de peintres ... Reste à savoir combien de temps la farce pourra durer." Allard, "Les Arts plastiques – Le Salon d'automne," *Les Ecrits français* (December 5 1913), 64.

63. "volonté mâle de renaissance caractérise ... les efforts dispersés des générations nouvelles"; "commandement très net de l'Heure présente, si troublé: DONNER UNE DIRECTION A L'ELITE." Canudo, "Salut," *Montjoie!* (February 10 1913), 1.

64. See Jonathan Fineberg, introduction to the reprint edition of *Les Tendances Nouvelles (1904–1914)* (New York 1980), XIII, for a discussion of the journal's projected audience.

65. See Marinetti, "The Founding and Manifesto of Futurism," 22.

66. "C'est parce que nous voulons réussir que nous allons droit au but avec crânerie, que nous plaçons violemment à rebours du goût et de la mesure ordinaire." Marinetti, interviewed by Joseph Bois, "Au Jour le Jour – Le futurisme et son prophète," *Le Temps* (March 14 1911), 2.

67. Arnyvelde, "Séance de boxe futuriste," *Gil Blas* (February 16 1912), 1.

68. M.L., "Une conférence futuriste," *Homme Libre* (June 23 1913), 2.

69. "La peinture est un art, et la publicité en est un autre." Anon., "Exposition des "Futuristes italiens'," *L'Art Décoratif* (February 20 1912), supplément, 2.

70. "coup de grosse caisse pour abasourdir le bourgeois. Il est assez psychologue pour savoir que, seuls, l'anormal, le monstrueux, l'invraisemblable retiennent l'attention, aujourd'hui." Séché, *Le Désarroi de la Conscience française* (Paris), nd., 28. Undated, the book is, however, referred to in the periodical *La Vie des lettres* (April 1914), 155; this gives us a *terminus ante quem*.

71. "La conscience professionnelle . . . a remplacée par le bluff et l'audace." *Ibid.*, 40.

72. "c'est bien là le propre de notre époque de bluff." *Ibid.*, 29. The chapters of Séché's book concern the "disarray of French conscience" as it is manifested in the arts, religion, politics and manners. His comentary on the arts, which is centered around the new "confusion" of tendancies and isms, takes up some 50 pages of text.

73. "Vraiment la Publicité est la reine de notre époque; j'en parle ici surtout au point de vue industriel et commercial, mais qui ne lui rend pas hommage parmi les hommes de lettres, les peintres, les sculpteurs, les musiciens, les médicins, les acteurs, les avocats, les hommes politiques même? . . . C'est vraiment une des caractéristiques de la vie moderne." Arren, *Comment il faut faire de la publicité* (Paris 1912), 34.

74. Anon., "Pour la propreté de Paris," *Journal des Débats* (January 5 1912), 4.

75. Anon., "La Propreté de Paris," *Journal des Débats* (January 6 1912), 1. For a transcription of debates over the prospectus in the Chambre des Députés, see "La Question des Prospectus," *Les Amis de Paris* (January 1912), 206–12.

76. Stéphane Lauzanne, "L'Affaire des prospectus," *Le Matin* (January 12 1912), 1.

77. See, for example, H. de Fels, "Le dernier jour des prospectus," *L'Intransigeant* (January 16 1912), 1; Anon., "Paris en marche vers la Beauté," *Le Matin* (January 16 1912), 1; Louis Latzarus, "La Vie de Paris – Paris sans Papiers," *Le Figaro* (January 17 1912), 1.

78. "la cathédrale laïque de papier et de sensualité." Talmeyr, *La Décadence au XXᵉ Siècle* (Paris 1907), 14. By 1907, Talmeyr had been propagating this sort of rhetoric for some years; see Talmeyr, *Les Gens pourris* (Paris 1886); "L'Age de l'affiche," *Revue des deux mondes* (September 1896), 201–6; and "Cafés-

Concerts et Music-Halls," *Revue des deux mondes* (January 1902), 159–84. In addition to advertising, his targets include popular entertainment, absinthe, prostitution and horse-racing.

79. "Pauvres grands panneaux, trop fiers de votre importance, de vos dimensions colossales, de vos couleurs criardes, vous jouissez de l'animadversion général!" Freddy, "Les Barre-la-vue," *Le Monde illustré* (July 27 1912), 64. Pre-war debates over billboard advertising in the context of avant-garde painting have recently been treated for the first time by Kirk Varnedoe; our conclusions are similar, though applied to different ends. See Varnedoe, "Advertising," in Varnedoe and Adam Gopnik, *High & Low: Modern Art and Popular Culture* (New York 1990), esp. 249–50.

80. "le referendum populaire, avec une unanimité dont on a bien peu d'exemples, s'est prononcez énergiquement contre les affiches gigantesques." *Ibid.*, 65.

81. Anon., "Enfin! On pourra voyager dans un train et regarder le paysage par la portière," *Le Matin* (June 12 1912), 1.

82. "Non seulement ces terribles annonces nous empêchent d'admirer la belle nature, mais encore elles nous assomment . . . parce qu'elles nous font penser à Paris, qu'à ce moment on essaie d'oublier complètement." Freddy, "Les Barre-la-vue," 64.

83. Bailby, "En passant – Pour les belles routes de France," *L'Intransigeant* (June 14 1912), 1.

84. "crime contre l'art et la nature." Arren, *Comment il faut faire de la publicité*, 182.

85. "tombé au rang de panneau-réclame! Allard, "Les Arts plastiques – L'avant-gardisme et la critique," *Les Ecrits françaises* (April 5 1914), 72.

86. "croisade contre le laid, le dessin vulgaire ou grotesque, la forme disgracieuse, la ligne épaisse et grossière, l'inharmonie et le désordre." Claretie, "L'Affiche murale et morale," *Les Amis de Paris* (March 1912), 254–8.

87. In *L'Intransigeant*, Bailby framed the debate over the prospectus in this way, characterizing the Chambre as a body of provincial *deputés* doing a disservice to Paris by not passing the tax. Bailby, "En passant – Contre Paris," *L'Intransigeant* (January 8 1912), 1.

88. In his preface for the catalogue of the Salon d'automne, in 1913, Marcel Sembat reversed the critical equation, and implicitly challenged the hostile press, by *praising* the salutary influence of modern style in painting on the emboldened personality of poster design. Sembat, preface to Société du Salon d'automne, *Catalogue des Ouvrages* (Paris 1913), 56.

89. "imposé par les nécessités commerciales modernes, coupant brutalement un paysage . . . une des choses qui ont le plus fait tempêter les gens dits de bon goût"; "de rupture et de changement"; "cette affiche jaune ou rouge, hurlant dans ce timide paysage, est la plus belle des raisons picturales nouvelles qui soient; elles flanque par terre tout le concept sentimental et littéraire et elle annonce l'avènement du contraste plastique." Léger, "Les Realisations Picturales Actuelles," *Les Soirées de Paris* (June 15 1914), 350; English translation in Fry, *Cubism*, 136 (my translation differs in certain respects). Léger does mention "La Société de protection des paysages," and calls it "stupéfiante et ridicule" (350). He also remarks that "ces mêmes gens qui protestent avec conviction devant le panneau-réclame, vous les retrouvez au Salon des Indépendants se tordant de rire devant les tableaux modernes qu'ils sont incapables d'encaisser comme le reste" (350). For a previous treatment of Léger and the billboard, see also Varnedoe, "Advertising," 251.

90. Arthur Cohen has traced the general origins of avant-garde experiments in typography to developments in printed advertising during the late nineteenth and early twentieth century. See Cohen, "The Typographic Revolution: Antecedents and Legacy of Dada Graphic Design," in Stephen C. Foster and Rudolf E. Kuenzli, *Dada Spectrum: The Dialectics of Revolt* (Iowa City 1979), 76.

91. "son aspect extérieur, c'est à dire sa typographie . . . feuille purement typographique." John Grand-Carteret, *L'Enseigne: Son Histoire. Sa Philosophie. Ses Particularités* (Grenoble 1902), 384.

92. For Sonia Delaunay and advertising in this context, see Daniel Abadie, "Sonia Delaunay, à la lettre," in *Art & Publicité 1890–1900*, exh. cat. Centre Georges Pompidou (Paris 1991), 344–57.

93. Apollinaire, "Zône," *Les Soirées de Paris*, 331.

94. Anon., "Pour la propreté de Paris," 4.

95. On the rise and importance of the department store in Paris at that time, see Michael B. Miller, *The Bon Marché: Bourgeois Culture and the Department Store 1869–1920* (Princeton 1981), especially 48–58 and 166–89.

96. "Et ces nouveautés, après quelques années, nous apparaissent plue désuètes qu'un chapeau de l'avant-dernière saison." Mauclair, "Le Préjugé de la Nouveauté dans l'Art moderne," 296.

97. Aloes Duravel, "Autour du Salon d'Automne," *Les Echos Parisiens* (October 16 1912), 1. Similarly, during the 1912 debate over the propriety of cubism at the Grand Palais, more than one critic pointed out that the building had already been used for trade-fair exhibitions of toys, furniture, automobiles, agricultural equipment and other merchandise. See, for example, Pierre du Colombier, "Notes d'Art – Le Salon d'automne," 233–4. This reasoning was intended to defend the rights of the Salon d'Automne, but it also reveals how the public exhibition space for modern art already suggested a kind of commercial market for the new and improved.

98. "'Mais quelle est la *nouveauté* du Salon?' A cette question fatidique on voudrait en vain éviter de répondre. On voudrait, surtout, se persuader qu'elle est absurde et que la nouveauté en art n'existe pas." Allard, "La 30ᵉ Exposition des Artistes Indépendants," *Les Ecrits français* (April 1914), 3. In the same review, Allard also draws a specific link between *nouveauté* and fashion design (3). He further characterizes avant-garde *nouveautés* as "tics, manies, ou encore, si l'on veut, des *scies*" (3). The *scie* is a "catchword," but it can also refer to a popular *chanson d'idiote*, and Allard plays on both meanings when he goes on to compare the season's esthetic catchphrases to "Merci pour la Langouste," a recent music-hall hit song of 1913 by Harry Fragson, the title of which had been picked up by Parisian society as a kind of nonsense-epithet.

99. ". . . affiches-réclame . . . bien-fait pour l'horrifique publicité 'artistique' de certain grand magasin de nouveautés." Fourreau, "La Peinture aux Salons de Printemps," *La*

*Phalange* (April 20 1914), 356.

100. The comparison of the salon to a bazaar or marketplace dates back as early as the July Monarchy, and will recur when rising numbers and declining quality are taken together to signal a prevailing commercialism. For nineteeth-century examples, see Patricia Mainardi, "The Eviction of the Salon from the Louvre," *Gazette des Beaux-Arts* (July–August 1988), 31–40.

101. See Paul Jarry, *Les Magasins de noveautés* (Paris 1948), 47–8.

102. "le génie à la mode." Fosca, "Au Salon d'automne," *L'Occident* (October 1912), 151.

103. "une mauvaise marque de dentifrice ou de biscuits sec." D.-C.-A. Hémet, "Art et Littérature Vulgarisés par la Publicité," *La Publicité* (February 1912), 78.

104. "conditions actuelles de la vie ... nécessités de leur époque ... légitime consécration de leur génie." *Ibid.*, 78–9.

105. Comfort, "La Publicité et le Charlatanisme," *La Publicité* (January–February 1914), 31–4.

106. "Charlatanisme = tromperie + publicité. ... Publicité = charlatanisme – tromperie." *Ibid.*, 33.

107. "agir sur l'œil, sur l'oreille et sur l'esprit du public ... la foule ne doit pas être traitée de la même maniére, et avec la même finesse, la même discrétion et le même gout que l'élite intellectuelle ... l'homme porte en lui un besoin obscur être ébloui, illusioné, trompé, par la mise en scène et le décor: la vérité toute nue lui fait peur ou ne lui suffit pas. Voilà pourquoi le charlatan ne nous paraît coupable que par la fin malhonnête qu'il vise et non par les moyens de publicité employés." *Ibid.*, 31–2.

108. "de discipline, d'ordre, d'harmonie ... un roi, un chef, un confesseur, un maître d'école ... besoin de servitude." Vauxcelles, "Le Salon des Indépendants," *Gil Blas* (March 18 1913), 1.

109. During the war, the issue of individualism versus collectivity takes a predictable turn. In 1915, esthetic quarrels suddenly became suspect. In Jean Cocteau's review *Le Mot*, isms were said to represent "l'horreur étouffante du collectif" and, as such, a "poison d'Allemagne"; the end of the war would, it was hoped, bring "la mort de l'isme." See Anon., "Isme," *Le Mot* (June 1 1915), np.

110. Benjamin, *Matisse's "Notes of a Painter,* 88, 92–5, 97, 103, 108, 111, 116, 118.

111. "peintre-novateur ... mépris des lois naturelles." Reboux, "Revue des revues – La Doctrine des 'fauves'," *Le Journal* (November 28 1910), 4.

112. "l'art de peindre des ensembles nouveaux avec des éléments empruntés non à la réalité de vision, mais à la réalité de conception. Il ne faudrait pas pour cela faire à cette peinture le reproche d'intellectualisme." Apollinaire, "Le Cubisme," *L'Intermédiaire des chercheurs et des curieux* (October 1912), 474–8. Translation from ed. Leroy C. Breunig, *Apollinaire on Art: Essays and Reviews 1902–1918* (New York 1988), 256. *L'Intermédiaire* is a fascinating periodical. Dating back into the nineteenth century, it was a public forum to which readers could submit factual questions which would, in turn, be answered by other readers willing to contribute their expertise on the subject. The popular context would help explain Apollinaire's defensive tone. His text, which is actually a two-part discussion of both cubism and futurism, was one of several replies to a reader's request for the definition of the avant-garde schools. See also, C. Dehais, "Le Futurisme" and Le Cubisme," *L'Intermédiaire des chercheurs et des curieux* (August 30 1912), 268–71; and Gaston L. Vuitton, "Le Futurisme," *L'Intermédiaire des chercheurs et des curieux* (September 20 1912), 377–9.

113. J. d'Aoust, "La Peinture Cubiste, Futuriste ... et au delà," *Livres et Art* (March 1912), 153–6.

114. "Du moment que l'appréciation de son œuvre dépend de l'artiste seul, le public n'a même plus besoin de la regarder." Alexandre, "La Semaine Artistique – Le Cubisme expliqué," *Comoedia* (November 30 1912), 3.

115. "prétention scientifique." Marcel Boulenger, *Gil Blas* (October 8 1912), 1.

116. "comme les logiciens du moyen âge." Werth, "A travers la Quinzaine – Le Cubisme et le Salon d'Automne," *La Grande Revue* (October 25 1912), 833.

117. "maître des jeux de cirques ... maître des théories." *Ibid.*, 834.

118. "remonter du témoignage des sens à l'intuition mathématique." Puy, "Beaux Arts – Les Indépendants," *Les Marges* (June 1912), 43.

119. "travaillent, non plus dans des ateliers, mais dans des laboratoires." Puy, "Beaux-Arts – Les Indépendants," *Les Marges* (July 1911), 28.

120. "surtout victimes de théories, picturales et littéraires." Fargue, "Notes – Au Salon d'automne," *La Nouvelle Revue Française* (December 1912), 1090.

121. "Il serait facile d'expliquer et de commenter le Cubisme et le Futurisme par dix systèmes philosophiques ou scientifiques. . . . Mais alors, nous ne parlons plus de peinture." *Ibid.*, 1091.

122. "Les Cubistes ne peignent pas la Nature, mais leurs théories sur la Nature . . . Ils ne peignent pas, ils décrivent et se livrent à des analyses scientifiques." Roches, "Le Salon d'Automne de 1912," 300.

123. From an article on Delaunay by Apollinaire called "Réalité, Peinture pure," which appeared in both *Les Soirées de Paris* and *Der Sturm* in December 1912.

124. "en écrivant des livres pour justifier leur œuvre pictural." Goth, "Salon d'Automne – La peinture pure," *Les Hommes du Jour* (December 13 1913), 13. It would appear that Goth did, however, distinguish between incoherence and non-objectivity in the plastic arts. In a previous article on Frantz Jourdain, the interior designer who founded the Salon d'Automne, Goth quotes Jourdain on the intrinsic formal abstractness of music and architecture, and asks why the expression of purly formal values could not also be the aspiration of a new school of painting and sculpture. See Goth, "Frantz Jourdain," *Les Hommes du Jour* (October 12 1912), 3.

125. "pouvaient passer, au goût de l'acheteur, pour un lever de lune, un portrait de jeune fille, une scène de genre ou une marine." Dorgelès, "Comment je suis devenu Fauve," *Fantasio* (October 15 1910), 192.

126. Dorgelès, "Ce que disent les cubes," *Fantasio* (October 15 1911), 190–1. This satire is also discussed in Christopher Green, *Juan Gris* (London 1992), 115–16.

127. The original article appeared on October 19; subsequent coverage can be found in the "Echos" column for October 22, 26, and 28; Léger's letter appeared in the same space on November 3.

128. See Albert Barrère, *Argot and Slang: A New French and English Dictionary* (London 1889), 104; and Georges Delesalle, *Dictionnaire Argot-Français et Français-Argot* (Paris 1896), 83.

129. Henri Guilbeaux, "La Vie et les Arts – Les Indépendants," *Les Hommes du Jour* (April 29 1911), np; *Idem.*, "La Vie et les Arts," *Les Hommes du Jour* (June 24 1911), np; Puy, "Beaux Arts – Les Indépendants" (June 1912), 44; Arsène Alexandre, "Le Salon d'Automne," *Le Figaro* (November 14 1913).

130. For Salmon's disparagement of cubism from 1910 to 1911, see Gamwell, *Cubist Criticism*, 21, 25. In 1912, Salmon began to soften, treating the salon cubists to serious rather than dismissive criticism. None the less, he felt compelled to add, parenthetically, that, concerning the school of cubism, "je le répète, je déteste en tant que dogme." Salmon, "Le Salon des Indépendants," *Paris-Journal* (March 19 1912), 5. Later that year, in a debate with Vauxcelles in the arts column of *Gil Blas*, Salmon reiterates, "le Cube pour le Cube me laisse indifférent et, même, le mouvement n'a eu ma sympathie que parce que je crois l'actuel effort essentiellement variable." Salmon, "Les Arts – L'autre danger," *Gil Blas* (November 4 1912), 4.

131. "Le cubisme est, en réalité, un moyen de composition tout à fait élémentaire, un procédé que pourrait indiquer un manuel à l'usage des debutants; il est acceptable; nous nous refusions seulement à tenir des préparations pour des œuvres." Salmon, "Le 27ᵉ Salon des Indépendants," *Paris Journal* (April 20 1911); the passage is reprinted in Gamwell, *Cubist Criticism*, 155 n. 25; English translation, 24.

132. "prodigieusement simplette et courte." Vauxcelles, "Les Arts – La 'jeune peinture française'," *Gil Blas* (October 21 1912), 4.

133. "la réduction des formes aux volumes géométriques." Vauxcelles, "Les Arts – Encore lui!," *Gil Blas* (December 3 1912), 4.

134. "un retour honteux de l'Ecole des Beaux-Arts." Vauxcelles, "Les ennemis du 'Salon d'Automne'," 4. Vauxcelles attributes this opinion to four "juges autorisés" who attended a meeting of the Comité du Salon d'automne: they are Théodore Duret, Octave Mirbeau, Claude Monet and Auguste Renoir. A few weeks later, Vauxcelles described the cubists as taking "une théorie académique et vieille plus que l'Institut (la théorie de la réduction des formes aux volumes géométriques) pour

une innovation. Ce sont, suivant l'heureuse expression de Xavier de Magallon, des élèves de l'Ecole des beaux-arts qui, sortis par la porte, rentrent par la fenêtre." Vauxcelles, "Les Arts – Encore lui!," *Gil Blas* (December 3 1912), 4. Xavier de Magallon wrote for the review *Le Feu*, where his remark actually appeared one year earlier; making a visual pun the sense of which is lost in Vauxcelle's paraphrase, de Magallon called cubism a "jeu de rébus," and the cubists "pompiers" who "rentrent à l'école par les fenêtres en cassant les vitres." De Magallon, "Le Salon D'Automne," *Le Feu* (November 1911), 460. See also Vauxcelles, "Les Arts – Grammatici certant," *Gil Blas* (October 24 1912), 4, where cubism is said to consist of "de schémas, issus de formules académiques." In 1913, Vauxcelles still claims that cubism is a "retour agressif de l'Ecole" and that the "fameux novateurs" are really "peureux scolastiques"; now, however, and following the earlier example of Salmon, geometric reductivism ("procédé vieux comme le monde") is "une méthode préparatoire." Vauxcelles, "Le Salon des Indépendants," *Gil Blas* (March 18 1913), 1–2. A similar sentiment occurs in Alphonse Roux, "Propos d'Art – Le Salon d'Automne," *La Renaissance Contemporaine* (November 10 1911), 1303, where cubist pictures are described as "des ébauches, des esquisses, de tout ce qui n'est pas travail fini." Elsewhere, in a survey of artists' opinions about cubism, Charles Léandre echos Vauxcelles' charge: "Quel est, je vous le demande, le modeste professeur de dessin, le simple élève d'une Ecole des Beaux-Arts, qui ne sache que les plans formant les surfaces d'un corps peuvent être inscrits dans toutes les figures géométriques! C'est l'*a*, *b*, *c*, du dessin. Non, mais n'est-ce pas enfantin?" Léandre, in Hénriquez-Phillipe, "Le Cubisme devant les Artistes," *Les Annales* (December 1 1912), 473. (Léandre was, in turn, quoted by Vauxcelles; see Vauxcelles, "Les Arts – Encore lui!," 4.) Gleizes was given the last word, having been invited by *Les Annales* to reply to the survey. He did not address Léandre's comment at that time, however, but did so shortly thereafter. See Gleizes, "Le Cubisme et Tradition," 3. Apollinaire himself *defended* cubist preoccupation

with geometry on similar grounds, noting that "les figures géométriques sont l'essentiel du dessin," and that geometry has always been "la règle même de la peintre." Apollinaire, "La Peinture nouvelle – Notes d'Art, *Les Soirées de Paris* (April–May 1912), 89.

135. "certains adversaires . . . retour offensif à l'Ecole . . . tel atelier ou le cubisme s'enseigne en quinze leçons." Salmon, "Le Salon," *Montjoie!* (November–December 1913), 2. Around that time, one critic wrote that the cubists are treated as reactionaries because, despite all their excesses, "ils paraissent vouloir testaurer le culte de la géométrie." See Léon Rosenthal, "L'Actualité artistique – Le Salon d'automne," *Humanité* (November 18 1914), 4.

136. "C'est le cours du soir de l'Ecole des beaux-arts." Picasso, quoted in G.J., "La vie artistique – Le Salon d'Automne," *Le Temps* (October 1 1912), 4.

137. For Walter Crane's *Lines and Forms*, see anonymous item in *L'Excelsior* (October 9 1911), 2; for Durer, see Louis Thomas, "Albert Durer, cubiste," *L'Art et les Artistes* (December 1912), 130–3 (a reproduction from this article was reprinted, with a lengthy caption, as Anon., "Albert Durer, Précurseur du Cubisme," *Le Journal* (December 17 1912), 7); for primitive and ancient art, see Aloes Duravel, "Salon d'Automne," *Les Echos Parisiens* (November 1 1911), 5; Abel Fabre, "Les Salons," *Le Mois littéraire et pittoresque* (Junly 1913), 11–12; Tristan Leclère, "Le Salon d'Automne," *Revue Bleue* (December 16 1913), 727; and Anon., "Les Revues en France et à l'Etranger – Art: Les ancêtres du cubisme," *La Revue* (April 15 1914), an account of an article by Jay and Gove Hambidge which originally appeared in the English magazine the *Century*. In his notorious review of Braque at the Kahnweiler gallery, Vauxcelles was actually the first to draw a parallel between cubist reductivism and "l'art statique des Egyptiens." See the reprint in Fry, *Cubism*, 51. Finally, in a curious variation on this train of thought, the popular magazine *Je sais tout* mounted a "Concours d'Art géometrique" in 1913. The magazine illustrated its announcement with playful caricatures executed in a simplistic planar-geometric style, human bodies composed

of circles and squares, and the contestants responded in kind. Anon., "Concours d'Art géométrique," *Je sais tout* (October 15 1913), 480; and "Notre Concours d'Art géométrique (Résultats)," *Je sais tout* (January 15 1914), 95–8. No mention of cubism was made, but the results of the competition were accompanied by a commentary which notes that the contest winners rival the "maîtres de 'l'art géométrique' d'outre-Manche" (95). This is an allusion to several artists in England who appear to have developed this style of caricature as a group effort. They were published in Anon., "Les Revues en France et à l'Etranger – Art: Le dernier mot de l'Art: Les Géométristes," *La Revue* (June 1 1913), 409–11 (an account of an article which originally appeared in the English magazine the *Strand*). *La Revue* identifies the work as an improvement on cubism. Some illustrations from this article were reproduced as examples by *Je sais tout*, in its contest announcement. In this popular/critical conception of cubism as alternately, even simultaneously, rarefied and naïvely crackpot, cubists might be said to have reinvented the wheel and come up with a cube. In this sense, cubism is taken for a burlesque of esthetic idealism that is knowingly ridiculous, or worse, unintentionally so, and therefore blind to its own folly. For purposes of clarification, it is useful to butress this kind of lampoon with reference to its great prototype, the flying island of Laputa in Jonathan Swift's *Gulliver's Travels* (1726). See Jonathan Swift, *Gulliver's Travels* (London 1985), 195–263. So taken up with abstruse speculation on abstract matters of mathematical science, the self-absorbed upper class men of Laputa (heads reclined to the right or left, one eye turned inward, the other upward) are otherwise hopelessly inept in the "common actions and behavior of life" (205). Appropriately, even their food is presented to them in geometric shapes, and they describe the beauty of a woman "by rhombs, circles, parallelograms, ellipses, and other geometrical terms." Their contempt for practical geometry can be readily observed in poorly built houses and preposterously ill-fitting suits of clothing. Their influence is pernicious; there exists an Academy founded by "projectors" or "advancers of speculative learning" from the land below the island, whose visit to the "airy region" of Laputa had instilled in them a disdain for the ways of their own country, and inspired them to contrive new rules for the arts, agricultural sciences, mechanical engineering and language (221). Naturally, the state-supported projects of the Academy founder in impracticability while, consequently, the whole country lies in a ruinous state. Among their schemes are projects for extracting sunbeams from cucumbers, softening marble for pillows and pin-cushions, and the widespread application of a machine with which "the most ignorant person at a reasonable charge and a little bodily labour, may write books in philosophy, poetry, politics, law, mathematics and theology without the least assistance from genius or study" (227). The device consists of a large frame containing hundreds of tiny cubes to the faces of which are attached all the words of the language; forty students turn forty cranks, randomly changing the disposition of the words and reading them off for the chance occurance of coherent sentence fragments which, ultimately, are to be assembled into "a complete body of all arts and science" (229).

138. See Chapter I.

139. "qui se passe de l'imitation stricte des formes de la nature ... l'ambition des poètes de la génération antérieure." Kahn, "L'exposition des Indépendants," *Mercure de France* (March 16 1914), 414–15, reprinted in Gamwell, *Cubist Criticism*, 183 n. 24; English translation, 58 (my translation differs slightly).

140. "Comme le Symbolisme fut une réaction contre le Parnasse et le Réalisme, le Cubisme est une réaction contre le réalisme outré de la peinture. On a soif d'idéalité, on demande des ailes, on veut se dégager de la matière, planer dans l'empyrée des Essences. Et l'on emploie pour cela les moyens les plus matériels, la technique la plus positive, la science la plus exacte." Vromant, "A propos du Salon des Indépendants – Du Cubisme et autres synthèses," *Comoedia* (April 15 1914), 2. It should be noted that the symbolist 1880s and 1890s actually presaged both interpretations of cubism as an enterprise of hermeticism and of *réclame*. In *L'Anarchie Littéraire*, Anatole Baju addresses the

eccentricity of symbolism as a form of publicity in terms which were to become common currency for the 1910s. (Baju was quoted by J.-C. Holl in his 1910 account of esthetic isms; see n. 29) According to Baju, symbolists "affectent des allures excentriques et parlent un langage paradoxal uniquement pour se faire de la réclame" (8); they promote their "esthétique bizarre" with a "fracas de manifestes" (12); their strategy is shock, a form of *funambulisme* (12).

141. "Cubisme. Ce cubisme, ne serait-ce point le mallarmisme des peintres? S'exprimer selon la loi d'une logique infiniment obscure, et tellement personnelle qu'elle demeure insaisissable pour autrui... pourquoi, après tout, le Cubisme ne nous donnerait-il pas un peintre qui, peignant des choses parfaitement insignifiantes, serait cependant... avec une sorte de magie, au chaos et à l'absurde. Le Mallarmisme nous a bien donné Mallarmé, dont les vers les plus vides de sent et les poèmes les plus opaques dégagent cependant, à cause d'un sentiment raffiné de la musique verbale, une séduction certaine. Les amis du précurseur du Cubisme assurent qu'il fut un tel artiste. Il est vrai que les indifférents n'avaient trouvé, en Picasso cubiste, qu'un garçon d'une riche ironie." Anon., "Marges – Cubisme," *Les Marges* (December 1912), 246.

142. "jamais la séparation ne fut plus absolue entre le public et les artistes." Allard, "Les Arts plastiques – Le Salon d'Automne," 63. For recent interpretations of Picasso's collage and constructed cubism as a neo-mallarmist idiom, see: Ronald Johnson, "Picasso's Musical and Mallarmean Constructions," *Arts Magazine* (March 1977), 122–7; and Christine Poggi, "Mallarmé, Picasso, and the Newspaper as Commodity," *The Yale Journal of Criticism* (Fall 1987), reprinted in ed. Katherine Hoffman, *Collage: Critical Views* (Ann Arbor 1989), 171–92.

143. "la formule en soit donnée." Salmon, *La Jeune Peinture française*, 7. For Redon and Moreau, see also Charles Malpel, "L'Art contemporain – Les Tendances actuelles de la Peinture," *Pages Modernes* (September 1912), 329.

144. Apollinaire wrote a news item on Agelii and his dual interest in cubism and occultism for the *Mercure de France* (September 1 1912); see Pierre Caizergues and Michael Décaudin eds. *Apollinaire: Œuvres en prose complètes III* (Paris 1993) 122–3; see also p. 1186 n. 3 and n. 4 for a brief biography of Agelii and reference to his writings on cubism.

145. "Le portrait d'un espace;" "dessin mental;" "l'architecture... du vide." Abdul-Hâdi, "Les Expositions d'Art à Paris – Celle de la 'Section d'Or' à la Galerie de la Boetie," *L'Encyclopédie Contemporaine* (November 15 1912), 175.

146. "d'exprimer la vie la plus concrète par des formes aussi abstraites que possible." Abdul-Hâdi, "Les Expositions d'Art à Paris – Celle de la 'Section d'Or'...," 175.

147. "doctrine secrète dans les arts plastiques." Abdul-Hâdi, "Chronique d'Art – La 29ᵉ Exposition du Salon des Indépendants," *L'Encyclopédie Contemporaine* (June 30 1913), 40.

148. "certain degré d'initiation"; "la *simple vérité*;" "*l'art pur*, cérébral, ésotérique." Abdul-Hâdi, "Les Expositions d'Art à Paris – Celle de la 'Section d'Or'...," 175. With his esoteric interpretation of cubism as an expression of cerebral and spiritual truths, Abdul-Hâdi was actually the first to refer to the new art as "l'art pur," and its practitioners as "purists." See Abdul-Hâdi, "Pages dédiées à Mercure: Sahaïf Ataridiyah. L'Art pur," *La Gnose* (February 1911), 66–72. This comes almost two years before Apollinaire coined the epithet "la peinture pure," and seven years before Jeanneret and Ozenfant reinvented "purism" for their post-war/post-cubist esthetic program of idealizing reductivism. Of course, it is unlikely that Apollinaire knew Abdul-Hâdi's articles. More importantly, these examples demonstrate a convergent evolution of terminology; that is, the notion that cubism represents a higher truth, and the phrase with which this notion is expressed, have multiple origins.

149. "... mysticisme... *pensaient* la peinture plus qu'ils ne la *voyaient*... suivant cette remarquable idée de la conception qu'on reprise les Cubistes dans un besoin tout différent... Les Cubistes, n'ayant plus comme bésoin de peindre le mysticisme des Primitifs, ont réçu de leur siècle une sorte de mysticisme de la logique, de la science

et de la raison"; "amplifiée et rigoureuse-ment réglée sous le nom bien connu de *quatriéme dimension*." Raynal, "Qu'est-ce que . . . le 'Cubisme'?," *Comoedia illustré* (December 20 1913), np. Excerpts from this article are translated in Fry, *Cubism*, 128–30, and Gamwell, *Cubist Criticism*, 60; my translation differs slightly from both.

150. For a history of references to the fourth dimension in the period literature, see Gamwell, *Cubist Criticism*, 51–52; and Linda Dalrymple Henderson, *The Fourth Dimension and Non-Euclidean Geometry in Modern Art* (Princeton 1983), 59–63.

151. Apollinaire's categories of cubism would be published for the first time in his book *Les Peintres cubistes: Méditations esthétiques*, Paris, 1913. Apparently, how-ever, they first appeared in a speech, now lost, that Apollinaire delivered at the Gallerie de la Boétie on October 11, 1912. See ed. Breunig, *Apollinaire on Art*, 495 n. 48. Gamwell addresses the conceptual/sci-entific label in the literature of 1913 to 1914; see Gamwell, *Cubist Criticism*, 57–8.

152. "cet effroyable vocabulaire scientifico-esthétique"; "Du jour où les peintres ont fréquenté la Closerie des Lilas et quequlues autres popines hautement littéraire ils ont eu peur de ne pas paraître assez cultivés. La moindre initiative plastique, d'une audace souvent bien timide . . . il fallut appeler à la rescousse la mathématique et la géo-métrie. Il devint dc bon ton de parler familièrement de la géométrie de Lobachinsky ou des théories de Wirchow et de Montmartre à Montparnasse ce fut la danse éperdue des logomachies sur le fil de la quatrième dimension." Allard, "Les Arts plastiques – L'avant-gardisme et la cri-tique," 73. My translation of this passage differs in some respects from Gamwell, *Cubist Critcism*, 60–1.

153. The serial appeared in *Comoedia* between February 24 and December 9, 1912; see Henderson, *The Fourth Dimension*, 52.

154. See Henderson, *The Fourth Dimension*, 51–6. Henderson is referring to three articles by Pawlowski: "La Semaine Littéraire – Albert Gleizes et Jean Metzinger, *Du Cubisme*," *Comoedia* (January 5 1913), 3; "La Semaine Littéraire – Guillaume Apollinaire, *Les Peintres cubistes*, *Comoedia* (September 7 1913), 3, from which the specific phrases

in my synopsis of Pawlowski's sentiments have been extracted; and "Aristote à Paris (25) – Le Miroir Cubiste," *Comoedia* (March 30 1914), 1.

155. "Si le cubisme n'existait pas, il faudrait l'inventer." Pawlowski, L'égalité ou la mort." *Comoedia* (November 29 1912), 1; see also, Idem., "Incubes et succubes," *Comoedia* (November 30 1912), 1; and *Idem.*, "Cubistes," *Comoedia* (October 10 1911), 1. Curiously, it is in his 1911 edito-rial, rather than his writings of 1912, that Pawlowski comes closest, by way of a negative criticism, to considering cubism as a pictorial expression of the fourth-di-mension: "Une fois de plus, je n'entends point affirmer, loin de là, que les cubistes aient résolu le problème, qu'ils nous aient révélé des dimensions de l'espace que nous ignorons encore, ou des sensations vibratoires que nos sens n'avaient encore jamais perçues."

156. Pawlowski, "L'égalité ou la mort," 1. The Rose+Croix group comes up often in refer-ences to cubist hermeticism, generally as a mocking example of high-minded preten-tiousness. See, for example, Puy, "Beaux-Arts – Les Paradis du Salon d'Automne," *Les Marges* (December 1911), 167; Abdul-Hâdi, "Les Expositions d'Art à Paris – Celle de la 'Section d'Or' . . . ," 175; Werth, "A travers la Quinzaine – Le Cubisme et le Salon d'Automne," *La Grande Revue* (October 25 1912), 835; Vauxcelles, "Le Salon des Indépendants," 2; Marc Vromant, "La Peinture simultaniste," *Comoedia* (June 2 1914), 3.

157. "dont le caractère humoristique n'a pas été toujours suffisamment compris . . . donna lieu à des fausses interprétations"; "le sens exact de la relativité de toute chose . . . la porte ouverte aux possibilités nouvelles sans lesquelles aucun progrès de l'esprit ne serait possible." Pawlowski, "Examen cri-tique," preface for *Voyage au pays de la quatrième dimension* (Paris 1923), 5. Henderson, who has made the most care-ful reading of Pawlowski's tale, insists that the comic element is largely new to revi-sions of 1923. See Henderson, *The Fourth Dimension*, 119 n. 7. She is especially criti-cal of Jean Clair, in *Marcel Duchamp ou le grand fictif* (Paris 1975), who treats Pawlowski as a source and context for Duchamp.

158. "Après les cubistes, peut-être verra-t-on demain les sphèristes lorsque la sphère aura détrôné le cube, à moins que le cône ne triomphe à son tour avec les cônistes!" Armand Fourreau, "Au Salon d'Automne," *La Phalange* (October 20 1911), 366.

159. "Oui, il y a là-bas, avenue d'Antin, des tachistes, des intentionnistes et des cubistes." H. Ayraud-Degeorge, "Le Salon d'Automne," *Le Rappel* (October 1 1912), 2.

160. "les cubistes, les idéistes, les polyédristes, les simultanéistes, les cérébristes, les futuristes, les divisionnistes et tant d'autres ironistes." Curnonsky, "Tout à l'envers!," *Le Journal* (March 8 1914), 6.

161. "Le Salon des Indépendants abritait, comme l'an dernier, les cubistes, les futuristes, les orphistes, les pluristes, les synchromistes et autres déments." Abel Fabre, "Les Salons de 1914," *Le Mois littéraire et pittoresque* (July 1914), 11.

162. Tabarant, "Gazette des Arts – Le Salon des Indépendants," *Paris-Midi* (March 2 1914), 2.

163. Volubilis, "Le Colorithermométrisme," *L'Ami de Paris* (May 15 1914), 7.

164. "théoricien lucide du cubisme." Le Cireur nègre (Roland Dorgelès), "L'Avenir du Cubisme," *Fantasio* (November 15 1912), 255–6.

165. "une nouvelle école de cuisine qui est à l'ancient art culinaire . . . ce que le cubisme est à l'ancienne peinture . . . La cuisine astronomique est un art et non une science." Apollinaire, "Le Cubisme culinaire," *Fantasio* (January 1 1913), 390.

166. "Un pluriste veut, je suppose, exprimer son concept esthétique de l'Abondance. Dans un coin de sa toile, il peindra une figure de femme, en totalité ou en partie, qui symbolisera l'Abondence. Puis il modelera (en plâtre, en aluminium, ou en terre cuite), quelque sompteux entassement de fruits et de fleurs qu'il appliquers dans un autre coin de sa toile. Les deux derniers coins seront occupés respectivement, l'un par un texte poétique, l'autre par une série de mesures musicales, texte poètique et thème mélodique suggerant tous deux l'Abondance." Anon., "Note – Manifeste du Plurisme, *L'Occident* (October 1912), 156.

167. "spirituelle satire n'a pas empêché M. H.-M. Barzun d'élaborer sa théorie du simultanéisme et je ne sais quel peintre d'inventer une nouvelle peinture synchromiste." Parmentier, *La Littérature et l'Epoque*, 328.

168. "l'incompréhension et raillerie ne sont-elles pas une preuve . . . de l'excellence de nos doctrines?" "l'érudit Lucius Strauss . . . prépare un important ouvrage d'esthétique: *Philosophie et cubisme, de Hegel à Picasso.*" Anon., "Note – Progrès du Plurisme," *L'Occident* (November 1912), 196. The German book may be a parodic allusion to Max Raphael's *Von Monet zu Picasso*, which was forthcoming in 1913.

169. Abel Faivre, "Les Salons," *Le Mois littéraire et pittoresque* (July 1913), 13–14.

170. Salmon, "Les Arts – Orphisme, Orphéisme, ou Orphéonisme?," *Gil Blas* (March 20 1913), 4.

171. Le Chevalier Rouge, "Foutourisme," *La Plume* (September 1 1912), 370–1.

172. "a du être composé en hâte, car il manque de clarté." Salmon, "Orphisme, Orphéisme, ou Orphéonisme," 4.

173. "Etablir une subtile télégraphie sans fil entre tous les postes les plus lointains de la pensée picturale"; "Percevoir le bruit de la Matière et l'ordonner selon les lois de l'idéal transcendental"; "Des peintres qu'unit une foi ardente ont vaillamment défendu ce programme au cours d'expositions très remarquées à Rouen et surtout à Paris, à la Section d'Or." *Ibid.*, 4.

174. Translation in Breunig, *Apollinaire on Art*, 283.

175. Marcus Osterwalder, *Dictionnaire des illustrateurs 1800–1914* (Paris 1983), 695; Ruth Malhorta, Marjan Rinkleff and Bernd Schalicke, *Das fruhe Plakat in Europa und den USA*, Vol. 2 (Berlin 1973–80), 166–71, 570.

176. "L'orphéisme', dont la court destin fut de n'être qu'un balbutiement, est déjà mort . . . Le 'futurisme' continue d'annoncer ses splendeurs par de tintamaresques préfaces, mais a la discrétion . . . de ne pas encombrer nos murailles . . . le 'cubisme' vit toujours." Georges Lecomte, "Au Salon d'Automne Le Cubisme sévit encore," *Le Matin* (November 16 1913), 2.

177. Anon., "L'Evolution de l'Art. Vers l'Amorphisme," *Les Hommes du Jour* (May 3 1913), 10.

178. "L'heure est grave, très grave. Nous sommes à un tournant de l'histoire de l'Art. Les recherches patientes, les tentatives passionnées, les essais audacieux de novateurs hardis . . . vont enfin aboutir à . . . la formule une et multiple qui renfermera en elle tout l'univers visible et sentimental . . . un but éclatant . . . à négliger purement et simplement la forme pour ne s'occuper que de la chose en soi"; "*Ces peintres savaient encore peindre; quelques-uns même dessinaient*"; "vision étrangement lucide de l'interprétation de la beauté disséminée et parsemée dans le flot universel"; "le clair chemin de l'amorphisme"; "le dernier mot de l'art contemporain . . . le premier pas . . . vers l'amorphime. Déjà, les Rouaults, les Matisse, les Derain, les Picasso, les Van Dongen, les Jean Puy, les Picaba, les Georges Bracque, les Metzinger, les Gleizes, les Duchamp (dont on ne peut pas oublier l'irrésistible *Nu descendant un escalier* (1912), ni le *Jeune Homme* (1912), semblent avoir compris et admis la nécessité de supprimer absolument la forme et de s'en tenir uniquement la couleur . . . Ainsi, peu à peu, l'amorphisme s'impose. Certes, on poussera des cris de putois en présence des œuvres prochaines des jeunes pionniers de l'Art . . . critiques indépendants, ennemis de bluff, et sans rapports aucun avec les marchands de tableaux . . . l'Art nouveau, l'Art de demain, l'Art de toujours." *Ibid.*, 10.

179. "Guerre à la Forme! . . . La lumière absorbe les objets. Les objets ne valent que par la lumière où ils baignent. La matière n'est qu'un reflet et un aspect de l'énergie universelle . . . Des rapports de ce reflet à sa cause, qui est l'énergie lumineuse . . . reconstituer la forme, à la fois absente et nécessairement vivante"; "l'œuvre géniale de Popaul Picador . . . Par l'opposition des teintes et la diffusion de la lumière . . . pas visible à l'œil nu." *Ibid.*, 10.

180. Apollinaire, "Du Sujet dans la Peinture moderne," *Les Soirées de Paris* (February 1 1912), 1–4. With regards to the timing of Amorphism, Apollinaire's article was also incorporated into *Les Peintres cubistes* in 1913. The Amorphism manifesto even borrows Apollinaire's reference to Picasso, who studies an object "comme un chiurgien dissèque un cadavre" (4).

181. *Amorpha, Fugue à 2 couleurs* and *Amorpha, chromatique chaude*, nos. 925 and 926 in the catalogue of the Salon d'Automne.

182. "un enchevètrement d'arabesques ovoïdes bleues et rouges sur un fond noir et blanc." Vauxcelles, "Le Salon d'Automne," *Gil Blas* (September 30 1912), 3.

183. Lecomte, "Pour l'art français – Contre les défis au bon sens," 1. Salmon called cubism "la nécessaire révolte contre un art amorphe dont Matisse fut, au-dessus de tous les Fauves, le plus puissant." Salmon, "Le Salon d'Automne," 2.

184. See editorial disclaimer for Dumont, "Les Arts – Les Indépendants," *Les Hommes du Jour* (April 13 1912), 8.

185. "Vers l'Amorphisme," *Camera Work*, special number dated June 1913, np.

186. Maria Lluisa Borràs, *Picabia* (New York 1985), 99, 111–12, who quotes a letter from Stieglitz dated May 26, 1913, thanking Picabia for sending him a collection of "press cuttings," and noting that the special number of *Camera Work* will appear "around 15th June." Jonathan Green also refers to amorphism, with cubism and futurism, as one of "the new theories of expression." See ed. Green, *Camera Work: A Critical Anthology* (New York 1973), 16. The entire amorphism document, complete with empty-frame illustrations, is reprinted in the anthology in both French and English (234–63). The Chronological Article Index to the anthology is actually the first to cite Picabia as possible author, though no explanation is given. The amorphism manifesto is also attributed to Picabia in Denys Riout, "La peinture monochrome: une tradition niée," *Les Cahiers du Musée Nationale d'Art Modern* (winter 1989), 93–5. Riout, who takes the document for a humorist manifesto, appears to read "Popaul Picador" as a pseudonym for Francis Picabia. Finally, "Vers l'Amorphisme" is reprinted without comment in Galeries Nationales du Grand Palais, *Francis Picabia* (Paris 1976), 68.

187. French Dada of the post-war era is riddled with potentially mocking, off-hand references to schools and isms. One example, "Instantanéisme," was authored by Picabia, and occurs on the first page of the review *391* in October 1924. See the reprint of *391* (Paris 1960), 127. The page is emblazoned with slogans and claims, including the cry "Le seul mouvement c'est

le mouvement perpetuel!" This pun on the word *mouvement* may permit us to read "Instantanéisme" as a parodic ism – a mockery of claims for esthetic progress. But Picabia's intentions are always open to interpretation; Michel Sanouillet, for example, believes the manifesto-prospectus to have been a sincere statement of purpose, given the absence of "documents probants" to the contrary (Sanouillet describes it as a repackaging of dada in direct challenge to the appearance that year of Breton's surrealism). See Sanouillet, *Francis Picabia et "391", Vol. II* (Paris 1966), 166. A compromise is to say that "Instantanéisme" was probably a stunt; it appears to have had no substantive afterlife, though Picabia did use the epithet again in November, when it appeared on the Cinéma page of *Comoedia* as the title of his op-ed-style manifesto for René Clair's film "Entr'acte." See Picabia, "Opinions – Instantanéisme," *Comoedia* (November 21 1924), 4.

188. Picabia, "How I see New York," Magazine of *New York American* (March 30 1913), 11; reprinted in Borras, *Picabia*, 110–11. There are a number of interview statements by Picabia in American newspapers during February and March 1913, on the occasion of his visit for the Armory show. Picabia's theoretical pronouncements were also represented in the French press, if less assiduously. See Anon., "Ne riez pas c'est de la peinture" (interview with Picabia). *Le Matin* (December 1 1913), 1.

189. "fluide transparent et vibrant . . . légèrement rectangulaires . . . Alors, vraiment tu parles de bonne foi?" Miguel Zamacoïs, "Mon ami le peintre," *Le Figaro* (October 4 1909), 1.

190. "le bon ouvrier honête et consciencieux, cultivant son petit jardin – et surtout le peignant – avec amour, avec sincérité"; "d'effronterie et de cynisme . . . arriver"; "d'épater les bourgeois et les camarades!"; "la roue a tourné . . . plus ingénieux . . . plus cyniques . . . versé dans l'extravagent, dans le stupéfiant, dans l'abracadabrant"; "cette jouissance intime, inexplicable, délicieuse, qu'éprouvent seuls les artistes sincères en interprétant honnêtement la nature." *Ibid.*, 1.

191. "de vouloir se singulariser et paraître plus original que le voisin." Ernest, in Anon.,

"Les Opinions – L'Individualisme," *Les Tendances Nouvelles* (August 1910), 1121.

192. "tomber dans l'incohérence et le mauvais goût." *Ibid.*, 1118.

193. "cette qualité indispensable: la sincérité." *Ibid.*, 1121.

194. "Ils n'ont même pas la sincerité de rendre exactement ce qu'ils ont sous les yeux. La mauvaise foi pousée à un tel point devient une sorte d'aberration mentale et ne mérite plus les honneurs de la discussion." Jules de Saint-Hilaire, "Salon d'Automne," *Le Journal des Arts* (October 21 1911), 2.

195. "je n'y ai rien compris . . . que des farceurs . . . qui inventèrent le funambulesque cubisme pour attirer sur eux une attention qu'ils ne pouvaient retenir par leurs œuvres normales"; "tout votre aspect . . . d'un homme honnête, réfléchi et sincère." Arnyvelde, "Les Arts – Contribution à l'Histoire du Cubisme," *Gil Blas* (January 2 1912), 3.

196. "'faire moderne' soit étayé par la science du métier et la sincérité." Roger Frène, "Les Oseurs," *L'Ile Sonnante* (December 1911), 343.

197. "de permettre aux Artistes de présenter librement leurs œuvres au jugement du Public." Société des Artistes Indépendants, *Catalogue de la 26ᵐᵉ Exposition 1910* (Paris 1910).

198. "pêle-mêle toutes les tendances, toutes les écoles, toutes les fautes de goût et toutes les distinctions, toutes les vulgarités et tous les raffinements." Warnod, "Le Salon des Indépendants," *Comoedia* (April 21 1911), 1.

199. "Tout le monde peint. Tout le monde expose aux 'Indépendants': artistes, concierges, amateurs, viellards, désœuvrés, fonctionnaires en retraite, jeunes filles du monde." Vauxcelles, "A Travers les Salons – Promenades aux "Indépendants'," *Gil Blas* (March 18 1910), 1.

200. "le type du parfait indépendant." Edouard Sarradin, "Le Salon des Artistes indépendants," *Journal des Débats* (March 19 1910), 3.

201. Apollinaire's pronouncement was printed on a 1914 subscription form for a book of "idéogrammes lyriques et coloriés"; this project, delayed by the war, would re-emerge as the book *Calligrammes* (1918). See André Billy, *Apollinaire vivant* (Paris 1923), 95. The expression recurs in Tony

Tollet, *Sur les Origines de Notre Art Contemporain* (Lyon 1916), 28, as "moi, moi aussi, je suis peintre!"

202. "Le principe de la Société des Artistes Indépendants est donc excellent . . . Combien dépendent de la mode, de ce qu'ils croient être le goût du public, de leur désir d'arriver . . . Chacun essaie de faire croire au public . . . que lui ou son groupe ont trouvé la formule définitive . . . Et puis d'autres suivent sans grande sincérité un maître qui vient de réussir . . . Après M. Siganc, parlons tout de suite de quelques artistes, comment les nommer: mystificateurs? ou sont-ils eux-mêmes leurs propres dupes?" Rémois, "La Peinture à l'Exposition de la Société des Artistes Indépendants," *La Société Nouvelle* (May 1910), 210–11.

203. "composés de carrés, rectangles, trapèzes et autres quadrilatères; je le prend pour un mystificateur inconscient . . . pauvre homme dont on s'est joué, en lui faisant croire qu'il avait du talent. Les bons gogos s'extasient sur sa naïveté: il a eu un semblant de pseudo-célébrité." *Ibid.*, 212.

204. "les outrances insincères, les gaucheries de pseudoprimitifs . . . les gros effets faciles de bluffeurs"; "l'imitation forcenée et menteuse . . . géomètre ignares." Vauxcelles, "A Travers les Salons – Promenades aux 'Indépendants'," 1.

205. "Il faudrait une étude bien longue pour rechercher ici ceux qui, parmi ces novateurs, ont été entraînés sincèrement vers cette évolution et les séparer de la tribu inévitable des imitateurs. Pour ces sincères il est incontestable que leurs recherches, incomprises du public, quelquefois même de l'élite n'est pas, ainsi que beaucoup le croient, une impuissance d'expression différente; ils sont sans doute capables de faire autre chose que ces 'folies'." Ya, "Les Expositions – L'Exposition des Indépendants," *La Revue septentrionale* (June 1911), 164.

206. "Les mystificateurs sont nombreux parmi les peintres." Robin, "Les Arts," *Les Hommes du Jour* (April 16 1910), 10.

207. La Palette (André Salmon), "Courrier des Ateliers – Le Cubisme, voilà l'ennemi!," *Paris-Journal* (October 7 1911), 4.

208. "Admettre tous les efforts d'art consciencieux." Anon., "Ne cherchez pas: c'est de l'art," 1.

209. "moderniser ses procédés . . . formes nouvelles . . . formules inédites, certains exploiteurs de la credulité publique se sont livrés aux plus folles surenchères d'extravagances et d'excentricités." *Journal Officiel* (1ʳᵉ Séance du 3 Décembre 1912), 2924.

210. *Ibid.*, 2925.

211. "Nous avions raison, puisque nous défendions le seul principe solide: notre cause était celle de la liberté de l'Art . . . la liberté, c'est le droit pour chacun de se discipliner soi-même." Sembat, preface for Société du Salon d'Automne, *Catalogue des Ouvrages*, 48–9.

212. "admettre que vous à faire effort de bonne foi, pour comprendre, et ne pas vous résigner trop vite à ne pas comprendre." *Ibid.*, 52.

213. Three examples are: Leclère, "Le Salon d'Automne," 728; Tabarant, "Le Salon d'Automne – Le Vernissage," *Action* (November 14 1913), 1; and Allard, "Le Salon d'Automne," *Les Ecrits français* (November 14 1913), 3, where Sembat's preface is called a "chef d'œuvre de logique, d'esprit, de finesse et de verve."

214. "vaste champ . . . les tendances les plus contradictoires . . . ne soient pas toujours très sincères . . . tantôt d'une mode, tantôt d'un obscur instinct d'arrivisme, et partant d'un peu de 'bluff'"; "l'artiste a le droit de choisir librement ses sources d'inspiration. S'il abuse . . . de son droit, c'est au public qu'il appartient de l'avertir ou de faire justice, en se détournant du 'faiseur' et de l'amateur de scandale." Thiébault-Sisson, "La Vie artistique – Une préface au Salon d'Automne," *Le Temps* (November 13 1913), 3.

215. "pas sincère, il fait une concession aux mensonges de l'optique et de la perspective, il fait un mensonge volontaire . . . essaiera au contraire, de montrer les choses sous leur vérité sensible . . . la *tendance principale de la Peinture contemporaine* . . . était un désir de retrouver la sincérité et la vérité des primitifs . . . Fauves ou cubistes . . . ramenent l'art français à la sincérité et à la vérité." Olivier-Hourcade, "Beaux-Arts – La Tendance de la Peinture Contemporaine," *La Revue de France et des Pays Français* (February 1912), 40–1.

216. "Essai de rénovation de l'Art . . . recherche sincère de la vérité physique." Lemoîne, "Le Cubisme," *L'Œil de Veau* (January

1912), 14–15.

217. "la haine instinctif;" "tout effort à être simple est la suprême garantie de la sincérité." Abdul-Hâdi, "Les Expositions d'Art à Paris – Celle de la 'Section d'Or'," 175–6.

218. See Kahnweiler, *Juan Gris: Sa Vie, son Œuvre, see Écrits* (Paris 1946), 296–7; *Idem., My Galleries and Painters* (New York 1971), 40–1; and E. Tériade, "Entretien avec Henry Kahnweiler," *Cahiers d'Art*, supplément no. 2 (1927), 2.

219. Jacques de Gachons, "La Peinture d'après-demain(?)," *Je sais tout* (April 15 1912), 349–56; a portion of this article is reprinted in Werner Spies, "Vendre des tableaux – donner à lire," in Centre Georges Pompidou, *Daniel-Henry Kahnweiler: Marchand, Editeur, Ecrivain* (Paris 1984), 28–9. Kahnweiler is unnamed in the article, but is unmistakable as the proprietor of a "sobre petite boutique de marchand de tableaux aux environs de la Madeleine" (349); the rue Vignon grazes the northeast corner of the place de la Madeleine. In addition, *Je sais tout* reproduces five works by Picasso and Braque of 1909 to 1911 from Kahnweiler gallery clichés, presumably selected from photoalbums that are described in the article (350).

220. "Pour *Je sais tout*! . . . Je préfère que votre magazine ne parle pas de mes peintres. Je ne veux pas qu'on essaie de les ridiculiser. Mes peintres, qui sont de plus mes amis, sont des sincères, des chercheurs convaincus, des artistes en un mot. Ils ne sont pas de ces saltimbanques qui passent leur temps à ameuter la foule"; "l'extrême avant-garde d'aujourd'hui"; "amour de la réclame. Mes peintres ne sont pas des cubistes." *Ibid.*, 349–50. As it turns out, Kahnweiler was right to anticipate an act of bad faith: beneath a reproduction of Picasso's *Girl with a Mandolin (Fanny Tellier)* (351), the caption reads "Où apparait nettement la volonté d'étonner le bon public."

221. "juste ou injuste." *Ibid.*, 352.

222. La Cocherie, "Le Futurisme: Interview de M. Marinetti," 1; and Joseph Bois, "Au Jour le Jour – Le futurisme et son prophète," 2.

223. Translated in John Golding, "The Futurist Past," *New York Review of Books* (August 14 1986), 16.

224. "Encore des sincérités méconnues! . . . reconnaissants à ces excentriques qui de temps en temps ont le courage de présenter leur loyauté comme cible aux rires ironiques de leurs contemporaines." Lemoîne, "Les Futuristes et l'Ecole dynamique de peinture," *L'Œil de Veau* (March–April 1912), 83.

225. "on ne peut s'empêcher de trouver leur réclame un peu excédante. Pour moi, je veux bien croire qu'ils sont sincères. Mais pourquoi tout ce *bluff* intense et indigne de véritable artistes?" Jean Alazard, "Futurisme et Futuristes," *Homme Libre* (December 13 1913), 2.

226. "fidèlement transcrite." H.G. (Henri Gervaiseau), "Une discussion sur les Futuristes: 'Principes' ou 'faits'?," *Le Spectateur* (April 1912), 154–8.

227. "une figure originale . . . Marinetti m'apparaît comme la raison d'être du Futurisme, et je ne sais si je dois rire ou être sérieux devant ce farceur dont les 'galéjades' toutes méridionales contiennent tant de cinglantes vérités . . . Marinettisme . . . qui tient tantôt de la bouffonnerie, tantôt de l'épopée; il y a surtout un tempérament curieux, original, ultra-moderne." Chignac, "Les Tendances de la Littérature présente," *La Société nouvelle* (May 1912), 183. A similar approach is adopted by André Arnyvelde in an interview with Marinetti in 1913; see Arnyvelde, "F.T. Marinetti: Apôtre de 'Futurisme'," *Revue des Français* (July 10 1913), 10–12.

228. "sous la bouffonnerie de ses propos . . . ce paroxysme des temps modernes." *Ibid.*, 187.

229. "visionnaire . . . la blague qui fait rire, mais il n'en reste pas moins un amour de la vie magnifiée jusqu'à ses puissances les plus secrètes." *Ibid.*, 188.

230. See n. 107.

231. "L'acheteur riche a si souvent peur de paraître un vulgaire 'bourgeois', il se laisse si facilement convaincre qu'il devine un talent et devance son siècle, qu'on lui fait acheter à peu près ce qu'on veut." Roux, Propos d'Art – Le Salon d'Automne," *La Renaissance Contemporaine* (November 10 1911), 1302.

232. "d'un côté les amis d'un académisme ridicule et sans valeur; de l'autre les snobs ou les spéculateurs à l'affût des nouveautés les plus bizarres." Leclère, *Les Derniers Etats*

*des Lettres et des Arts: La Peinture* (Paris 1913), 97.

233. "De joyeux rapins, secondés par des critiques mystificateurs et par des marchands pleins d'astuce, avaient voulu sonder la naïveté du public, mais ils l'ont trouvé insondable ... M. Prudhomme n'entend plus se laisser traiter de Philistin; désormais, il ne juge pas un tableau; peu lui importe que le dessin ressemble aux essais de l'homme des cavernes, et que les couleurs écorchent la rétine; il ne protège pas les arts; il fait une speculation." Gohier, "Notre Peinture," *Le Journal* (October 10 1911), 1.

234. "des cubismes, et autres mauvaises plaisanteries ... les qualités de sincérité." Monsieur Prud'homme, "Chronique Artistique – Le Salon d'Automne," *Livres et Art* (November 1911), 28.

235. "sont tenus pour les maîtres de leur temps." Théodore Duret, "Les Salons en 1912," *La Grande Revue* (May 10 1912), 40.

236. "Il n'y a plus de 'bourgeois', au vieux sens du mot. Ils ont été transformés par le snobisme. Ces malheureux "bourgeois' qui, au siècle dernier, étalaient leur platitude devant les artistes et se plaisaient dans leur incompréhension, en ont eu définitivement honte. Le mépris qu'on leur a prodigue les a poussés à vouloir se sortir d'eux-mêmes. Ils ont prétendu eux aussi à la compréhension ... Ils ne se scandalisent maintenant de rien. Ils sont prêts à se pâmer devant n'importe quelle excentricité. Ah! les 'bourgeois' tels que les bafouaient Courbet et Daumier, qu'ils sont loin!" *Ibid.*, 39.

237. See Anon., "Ne cherchez pas: c'est de l'art," 1.

238. "le public, loin d'être si sot que le disent communément les directeurs de journaux, a beaucoup de bonne volonté"; "Le plus grand mal moderne se trame en effet toujours d'une incompréhension qui n'est ourdie que de malentendus, du défaut de relations entre les gens nés pour se comprendre." Leblond, "Art – Le public et les artistes," *La Vie* (October 25 1913), 119.

239. Fleury, "Promenades d'un Solitaire," *Les Tablettes* (July–September 1912), 29. In a prefatory note, the editors explain that Fleury's article has been left incomplete due to illness; further along, in a footnote, the author notes that the futurist prospectuses arrived at his home by mail on Monday, March 27, 1911.

240. "anéantir le Passé et construire l'Avenir." *Ibid.*, 28.

241. "gardé comme un secret précieux, et connu d'un seul homme, n'a aucun rapport avec ces fariboles ... Le gardien du secret, c'est le Chef de l'Ecole, le Maître ... ce but secret et innommé ... le *Vouloir d'Arriver* ..." *Ibid.*, 29. Much later, Kahnweiler expressed the same suspicion in his on-going disparagement of the avant-garde ism: "'conscious and organized movements' which choose their own name are ... untrustworthy. In doing this they betray either their artificiality or their submission to the will of an ambitious leader." Kahnweiler, *Juan Gris: His Life and Work* (New York 1947), 69 n. 2.

242. "Même quand ils croient de la meilleure foi du monde s'être enfermés dans un tour d'ivoire;" "Ils ne savent pas tous ... où ils vont, où plutôt où on les mène." Vauxcelles, "Le Salon des Indépendants," 1.

243. See n. 60.

244. "Excès de nouveauté? qui sait? je le répète, elle n'est pas dangereuse pour l'art mais seulement pour les artistes médiocres." Apollinaire, "Le Salon d'Automne," *Les Soirées de Paris* (December 15 1913), 49; English translation from ed. Breunig, *Apollinaire on Art*, 335 (where *nouveauté* is translated as "innovation").

245. "l'artiste est un sensible, les théories l'impressionnent, les outrances de certaines œuvres trouvent en lui un spectateur intéressé, les théories abracadabrantes un auditeur bénévole, craignant de ne pas comprendre, d'être injuste devant une découverte, étonnante seulement peut-être par sa nouveauté. De là les déviations énormes d'esprits parfois sincères qui aboutissent aux pointillistes, aux cubistes, aux isocélistes. Ceux-ci, doux moutons entraînés par des bergers pince-sans-rire vers des Salons d'Automne-Abattoirs." Ligeron, "Notes d'Art – Du Métier, des Influences," *Le Cahier de Poètes* (November 1912), 48. The other two articles in this series follow in February–March 1913 (102–4) and April–May 1913 (147–9).

246. "le lot habituel des suiveurs sans importance, de ceux qui se laissèrent prendre à de brillantes théories et en sont les

premières victimes. Nous voulons surtout atteindre ici M. Metzinger et M. Gleizes qui, plus intelligents que la plupart des autres, sont en train de sacrifier à leur arrivisme beaucoup de pauvres diables dont le grand pèche est d'avoir cru que plus une doctrine est ténébreuse, plus elle est vraie. MM. Metzinger et Gleizes se sont fait un piédestal de la sottise ou de la naïveté de leurs contemporaines." Kimley, "Le Salon des Indépendants," *La France* (March 1 1914), 2.

247. "se refuse systématiquement à examiner de bonne foi les œuvres de ces peintres;" "Ma bonne foi est entière, acquise à toutes les tentatives neuves, probes, dignes d'interet. Ridiculisez mes facultés de critique, écrivez que je n'ai ni compétence, ni clairvoyance, ni syntaxe. Vous en avez le droit. Mais ma bonne foi, halte-là! Je ne vous autorise pas à la mettre en doute." Vauxcelles, letter to the editor, *Les Hommes du Jour* (October 19 1912), 10.

248. "Je ne crois pas que la première qualité d'un artiste soit d'être sincère, mais plutôt d'être exercé dans son art"; "par principe ou par application"; "dont la bonne foi s'épanouit dans tout ce qu'ils entreprennent"; "tant d'extravagences." Carco, "La Quinzaine artistique – Les synchromistes," *Homme Libre* (November 10 1913), 4.

249. "il est impossible de distinguer ... le travail intellectuel le plus sérieux de la plus froide fumisterie." In Anon., "A Travers les Expositions – 28e Salon de la Société des Artistes Indépendants," *L'Art Décoratif* (May 5 1912), 6.

250. The two articles are "La Nouvelle Peinture," *Les Soirées de Paris* (April–May 1912), and "La Section d'Or," *L'Intransigeant* (October 10 1912); translation of quote in ed. Breunig, *Apollinaire on Art*, 224 and 254.

251. Apollinaire, "Des Faux," *La Revue blanche* (April 1 1903). 252. ed. Breunig, *Apollinaire on Art*, 254.

253. "Les plus acharnés adversaires des nouvelles écoles de peinture commencent à admettre la sincérité et la loyauté des efforts qu'ils vouaient naguère au ridicule ... Il ne restera bientôt que d'incorrigibles vaniteux pour croire que les artistes adoptent telle ou telles manière dans le but de se moquer d'eux. Se croire l'objet d'une mystification concertée est, à la longue, une manière de délire de la persécution et le signe d'une suffisance insupportable." Allard, "Le Salon d'Automne," 4.

254. "d'épater et d'agacer les bourgeois et les critiques d'art ... Un telle persévérance dans la blague est contradictoire à la nature humaine. Quand on réfléchit un peu, on est forcé d'admettre la bonne foi et la sincérité artistique de ces jeunes hommes dont l'art ne ressemble à rien de connu." Sedeyn, "A propos du Cubisme," *Art et Décoration*, supplément (January 1914), 5.

255. "une inquiétude, une angoisse"; "volontiers d'inventer des procédés d'art"; "spéculateur désorienté"; "les jugements témeraires ... le dogmatisme;" "mais il faut craindre plus encore le scepticisme absolu"; "le spectacle de la laideur ou de la perversion." Hermant, "La Vie à Paris – Les Baraques du Champs de Mars ...," *Le Temps* (March 6 1914), 3.

256. "Bien malin qui démêlera jamais dans une œuvre d'art, la part de la sincérité et celle de la fumisterie"; "le malin de la bande"; "Le Picasso cubiste n'est pas dangereux pour celui des *Bateleurs*! ... Il faut seulement plaindre les innocents qui prennent le premier au sérieux, et ne sont pas capables de profiter du second"; "la parade faite pour attirer le public dans la baraque." Maurel, "Chez les Peintres," *Homme Libre* (March 5 1914), 1.

257. "je suis toujours sympathique à ce qui me révolte d'abord ... J'aime bien mieux chercher à comprendre"; "Ils s'eduquent eux aussi, en même temps que nous. On se rapproche peu à peu, et de la complicité du peintre et de l'amateur, nait l'art d'une époque qui prendra dans l'avenir sa place d'art tout court." *Ibid.*, 2.

258. See n. 238.

259. "L'organisation des salons de peinture, les conditions dans lesquelles s'achètent et se vendent les tableaux contraignent l'artiste à recourir à la publicité. Il est permis de le regretter mais pour ma part je trouve la chose toute naturelle, à condition que cette publicité soit loyale et de bonne foi, qu'elle ne soit pas fondée sur l'équivoque, le mensonge ou la mystification." Allard, "Les Arts plastiques – L'avant-gardisme et al critique," 72.

260. "parfaitement réglé. Je l'ai dit déjà et je me plais à le redire les manifestes de M.

Marinetti demeurent, quelques fautes de goût mises à part, des modèles du genre." *Ibid.*, 72.

261. "nous avons le droit de dire qu'ils se moquent de nous. Vis-à-vis de MM. Picasso, Delaunay, Le Fauconnier, Metzinger, Gleizes, Léger, etc . . . , les futuristes italiens sont apparus partout et toujours comme des imitateurs et des pasticheurs, pour ne pas dire plus." *Ibid.*, 72.

262. "Le discrédit qui commence à peser sur toute *peinture de groupe* a porté au futurisme le coup de mort, les autres écoles ne survivront plus que grâce au talent, au tempérament *personnel* de tel ou tel peintre." *Ibid.*, 72.

263. "Il ne sont pas des fantaisistes: la fantaisie n'est que du plaqué, mais ils sont ce que devrait être tous les artistes: des capricieux; ils s'amusent en un mot. C'est pour cela, sans doute, qu'on les trait en farceurs. Ceci qui scandalise tant de fins connaisseurs est d'une importance extrême, cette hardiesse ouvre des portes, rudement closes, sur des horizons insoupçonnes. C'est par des voies que se renouvelleront tous les arts." Salmon, "Le Salon," 5.

264. Helsey, "En toute indépendance au Salon des Indépendance," *Le Journal* (March 2 1914), 1. The sarcastic sense of "Prenez-garde à la peinture!" was anticipated at least as early as November 1913, by Arthur Cravan, who applies the phrase to a mock-advertisement for the Galérie Clovis Sagot. See Cravan, *J'étais cigare*, 79.

265. In addition to Melville's text, my treatment of *The Confidence-Man* is indebted to Warwick Wadlington, *The Confidence Game in American Literature* (Princeton 1975), 39–41, 137–70; Tony Tanner, "Introduction" for Herman Melville, *The Confidence-Man* (Oxford 1989), vii–xxxvii; and Gary Lindberg, *The Confidence Man in American Literature* (New York 1982), 3–12.

266. For example, Charles Dickens' *Martin Chuzzlewit*, Thomas Mann's *Felix Krull*, and Mark Twain's *Hucklebery Finn*.

267. Mauclair, "Le Préjugé de la Nouveauté dans l'Art Moderne," 289; and Allard, "Le Salon des Indépendants," *La Revue de France et des Pays Français* (March 1912), 68.

## CHAPTER 3

1. Apollinaire, "Le Section d'Or," *L'Intransigeant* (October 10 1912), reprinted in ed. L.C. Breunig, *Guillaume Apollinaire: Chroniques d'Art* (Paris 1960), 262. The description of Duchamp is made by "Louise," in Apollinaire's fictional dialogue between two visitors to the exhibition.

2. See Mikhail Bakhtin, *Rabelais and His World*, trans. Hélène Iswolsky (Bloomington 1984), 5–6, 84. My reference is a loose one; Bakhtin is describing the liberating condition of the comic as it was ritualized during the middle ages in carnival festivities, feast-day rites, oral and written parody, vulgar wordplays of popular speech and other forms of folk culture. These, he believes, "offered a completely different, nonofficial, extraecclesiastical and extrapolitical aspect of the world, of man, and of human relations . . . a second world and a second life outside officialdom" which reflects the "two-world condition" of "medieval cultural consciousness" (6). Certainly, the global scope of Bakhtin's two worlds cannot be approximated by the experience of modern art in Paris from 1909 to 1914, nor is the expression of the pre-war carnavalesque ritualized in any way like Bakhtin's examples from medieval history. None the less, Bakhtin's notion of a double-world in which the comic is an institutionalized critical operation directed against dominant culture is deeply compelling as an archetype.

3. Already in 1959, Robert Lebel attached a short article to the end of his monograph on the artist in which he confesses a certain astonishment at having fully intended yet failed to address the issue of humor in Duchamp. See Lebel, "Marcel Duchamp: Whiskers and Kicks of All Kinds," in Lebel, *Marcel Duchamp* (New York 1959), 95–7.

4. See Rudolf E. Kuenzli, "Introduction," in eds. Kuenzli and Francis M. Naumann, *Marcel Duchamp: Artist of the Century* (Cambridge 1989), esp. 5–8, for an overview of frustration and conflict in Duchamp studies, and the red-flag significance of Duchampian irony. In the same anthology of essays, see also Francis M. Naumann, "Marcel Duchamp: A Recon-

ciliation of Opposites," 20–40. Naumann begins, "Any attempt to establish a formula, a key, or some other type of guiding principle by which to assess or in other ways interpret the artistic production of Marcel Duchamp would be – in the humble opinion of the present author – an entirely futile endeavor." Futile but irresistible; Naumann devotes his essay to the development of just such a guiding formula, called "theories of opposition and reconciliation" (32), the intellectual history of which he traces to Heraclitus, the fifteenth-century Bishop Nicholas Cusanos, Hegel, Max Stirner, Jung (on alchemy) and symbolist poetry. In Duchamp, the "reconciliation of opposites" is observed to be a recurring theme: the duality of Duchamp's sexual persona; the triadic reconciliation of duality in the *Three Standard Stoppages*; the Hegelian "synthesis" of art ("thesis") and non-art ("antithesis") in the readymades; the concept of "sister squares" which Duchamp addresses in his book on chess theory; and the ambiguity of Duchamp's *Door, 11 rue Larrey*, which is simultaneously opened and closed.

Other literature on sources for the content of Duchamp's œuvre concerning the limitations of meaning include: Willis Domingo, "Meaning in the Art of Duchamp, Part I," *Artforum* (December 1971), 72–7, and Part II, *Artforum* (January 1971), 63–8; Jindrich Chalupecky, "Les ready-made de Duchamp et la théorie du symbole," *Artibus et Historiae* no. 13, VII (1986), 153–63; Albert Cook, "The 'Meta-Irony' of Marcel Duchamp," *The Journal of Aesthetics and Art Criticism* (Spring 1986), 263–701; and Thomas McEvilley, "empyrrhical thinking (and why kant can't)," *Artforum* (October 1988), 120–7. McEvilley anticipates Naumann in his identification of an obscure single source for Duchamp that was mentioned once by the artist in a late interview and formerly neglected by scholars: in his case, the fourth-century Greek philosopher Pyrrho of Elis. A related approach is represented by Herbert Molderings, "Objects of Modern Skepticism," in ed. Thierry de Duve, *The Definitively Unfinished Marcel Duchamp* (Cambridge 1991), 243–66. Molderings' Duchamp source is Henri Poincaré, whose popular writings represented a new skepticism over the claims of science to objective truth that is taken as a philosophical model for irony in the readymades and the *Large Glass*.

5. Marcel Duchamp, "The Green Box," in eds. Michel Sanouillet and Elmer Peterson, *The Writings of Marcel Duchamp* (New York 1989), 28.

6. See Philippe Roberts-Jones, "Les 'Incohérents' et leurs Expositions," *Gazette des Beaux Arts* (October 1958), 235; Charles Rearick, *Pleasures of the Belle Epoque* (New Haven 1985), 39; Jean Sagne, *Toulouse-Lautrec* (Paris 1988), 161; Catherine Charpin, "Le Magasin incohérent," in Paris, Musée d'Orsay, *Arts incohérents, académie du dérisoire* (Paris 1992), 78.

7. See Shattuck, "The Demon of Originality" and "Marcel Duchamp" in Shattuck, *The Innocent Eye* (New York 1984), 70–1, 77; 291.

8. According to Jerrold Seigel, the period from Henri Murger to André Breton contains a recurring search for extreme states of subjectivity in both social and esthetic activity that constitutes a working definition of the bohemian life. See Seigel, *Bohemian Paris* (New York 1986). Above all, the search reveals a permeable membrane between bohemia and the bourgeoisie, for whom bohemia was an avenue of escape to a "theater of the self." Class distinctions are dissolved, or at least traversed, by cults of individualism; the bourgeois flirts with liberation on the social margins, and the bohemian moves ambivalently or exploitatively through institutions of bourgeois faith. See chapter five "The Bohemian Fringe," in Frederick Brown, *Theater and Revolution: The Culture of the French Stage* (New York 1980), (for an anticipation of class ambiguity with regards to the Picasso circle.) By the time of the pre-war avant-garde, a broad confusion of bourgeois and bohemian values is well-established, including strategies of new commercialism with which, since the 1870s at least, bohemia marketed itself to the outside. Seigel's picture of 1890 to 1914 features Jarry, Satie and Apollinaire, and addresses the radically subjective conflation of art and life in the case of the first two. In this, the fudamental prototype is Roger Shattuck's *The Banquet Years*, originally published in 1955, a

study of the same phenomenon and the same figures; Seigel recasts the matter as a function or later development of an on-going social and esthetic phenomenon. Seigel's theory of bohemia-bourgeoisie instability is a startling alternative to the recent over-politicization of modern cultural studies, in which actions of the individual are relentlessly assigned to the restricted motivations of class identity. On this matter, Seigel's brief critique of T.J. Clark and Marxist methodological biases is a pithy assessment (403–4); see also his reading of avant-garde relations to commercial activity, which was less a corrupting influence than a "framework" or context that was "absorbed" and "exploited" (334). Seigel establishes a coherent overview, and a deeply valuable corrective, to our comprehension of what has become a bohemia cliché. By necessity, however, his impressive sweep touches upon individual examples only for what they share of the broader, century-long recurrence of the bohemian/bourgeois theme, failing to account for crucial changes of condition and meaning in the context of the pre-war period.

9. *Ibid.*, 295.

10. *Ibid.*, 384 and 389.

11. "*l'art de l'Avant-Garde*; nouveau genre de ridicule." Bac, *Intimités de la III<sup>e</sup> République de Monsieur Thiers au Président Carnot* (Paris 1935), 509–10. For related comparisons between the Incohérents and cubism/futurism or surrealism respectively, see Adolphe Willette, *Feu Pierrot* (Paris 1919), 142; and Vlaminck, *Portraits avant décès* (Paris 1943), 53. Curiously, the Incohérents are omitted entirely from Seigel's vast treatment.

12. Seigel's primary sources here are books by André Warnod, Francis Carco and Roland Dorgelès, most of which are retrospective accounts: Warnod, *Le Vieux Montmartre* (Paris 1911); *Bals, cafés et cabarets* (Paris 1913); and *Les berceux de la jeune peinture: Montmartre, Montparnasse* (Paris 1925); Carco, preface to Apollinaire et al, *Les veilées du "Lapin Agile* (Paris 1919); *Bohème d'Artiste* (Geneva 1940); *De Montmartre au Quartier Latin,* (Seigel uses the Geneva 1942 reprint of the original edition of Paris 1927); and Dorgelès, *Bouquet de Bohème* (Paris 1947). In these memoirs, post-1900 activity is addressed in the context of bohemian activity in Montmartre. For example, Dorgelès remarks that because most of the cubists lived in Montmartre, the public believed it to be a joke (139). Salutary accounts of late-nineteenth century cabaret genius also occured during the pre-war period itself. In 1913, former Chat Noir humorist Maurice Donnay recalled the influence of Emile Goudeau, who founded and chronicled Latin-Quarter student literary groups of the 1880s, such as the Hydropathes, Fumistes, Hirsutes and Zutistes; Goudeau "avait inventé le modernisme et . . . cultivait le parisianisme . . . une invention de la province. Je veux dire que c'est une façon exagérée d'être Parisien." Donnay, "Mes Souvenirs," *La Revue hebdomadaire* (March 15 1913), 319.

13. Compare Salmon on the concurrence of cubism and "l'esprit de blague et d'atelier" with Vlaminck's sour-grapes assessment of Picasso's cubism, which is traced to the influence of "parlottes artistiques du bistrot Azon" on Picasso's "clowneries" (Vlaminck's *Portraits avant décès*, 185). For related ambiguities with regard to mystification and the like as a motivation of Picasso's cubism, see: Sisley Huddleston, *Paris Salons, Cafés, Studios* (London 1928), 129; François Porché, La Poésie récente: "Humoristes, cubistes et Surrealistes," *La Revue de Paris* (June 1 1928), 536–66; and Florent Fels, *L'Art vivant de 1900 à nos jours (I)* (Geneva 1950), 241. For other strictly negative assessments of this kind, see: Camille Mauclair, *La Farce de l'art vivant* (Paris 1929), 33–5, 68–9, 183–5; and Charles Chassé, *Dans les coulisses de la gloire* (Paris 1947), which is entirely devoted to Alfred Jarry and Henri Rousseau as case studies in concerted hoax.

14. "Dans l'art contemporain la blague est érigée en principe . . . On a accepté trop bénévolement tous ces temps-ci les fumistes; il faut à présent les taquer et les empêcher d'accomplir leur néfaste mission." Guilbeaux, "La Vie et les Arts – Le Cubisme et MM. Urbaîn Gohier et Apollinaire," *Les Hommes du Jour* (November 11 1911), np.

15. "On aime bien rire dans les ateliers. La blague est même de rigueur. Elle est joyeuse et sonore et aussi, elle est ironique,

grincheuse, avec des ricanements stridents de sourde révolte . . . Eh bien! les cubistes et les futuristes sont, à mon avis, à part quelques exceptions, des jeunes peintres se proposant de se payer la tête du public." Mercoyrol, *La Vie sportive, théâtrale & mondaine* (March 1 1912), 8.

16. "Mais il ne faut pas que les honnêtes gens s'y trompent: le cubisme n'est qu'une énorme mystification de gens assoiffés de réclame, pour lesquels la conspiration du silence serait la mort." Pierre Bertrand, "Le Salon d'Automne," *Le Parthénon* (November 5 1912), 1137.

17. Others include: Gelett Burgess, "The Wild Men of Paris," *The Architectural Record* (May 1910), 402, for a reference to the precedent of the Incohérents in the context of the pre-war avant-garde; Urbain Gohier, "Notre Peinture," *Le Journal* (October 10 1911), 1, where the new painting at the Indépendants and the Salon d'Automne is traced to "une bonne farce aux expositions des Incohérents" propagated by "joyeux rapins, secondés par des critiques mystificateurs"; H. Ayraud-Degeorge, "Le Salon d'Automne," *Le Rappel* (October 1 1912), 2, where cubists and futurists are either *fumistes* or *impuissants*; André Muller, "On a verni le Salon d'Automne," *Excelsior* (October 1 1912), 2, in which cubism and futurism is "la fumisterie et . . . la déliquescence;" Jean-José Frappa, "Il faut defendre l'art français," *Le Monde illustré* (October 12 1912), 235, where "les joyeux fumistes cubistes et futuristes se sont posés en incompris"; Anon., "Au Salon d'Automne," *L'Illustration* (October 12 1912), 268, where cubist pictures are "des farces de rapins"; Le Bonhomme Chrysale, "Notes de la Semaine –" Le Fumisme, "*Les Annales politiques et littéraires* (October 13 1912), 311–12, where *fumisme* refers to avant-garde art at the salons; Léon Plée," "La Vie Artistique – Le Futuro-cubisme et le Salon d'automne," *Les Annales politiques et littéraires* (October 13 1912), 320, according to which "Le cubisme a dû naître dans l'atelier de quelque joyeux fumiste (*sic*) de la Butte sacrée, dans la mansarde d'un rapin facétieux"; Pawlowski, "L'égalité ou la mort," *Comoedia* (November 29 1912), 1, for a comparison of cubism to the Incohérents and the Salon de la Rose-

Croix; Émile Henriot, "Le Salon d'Automne ouvre ses portes aujourd'hui," *Excelsior* (November 14 1913), 3, where we are told of difficulty separating "la cause de l'art véritable et la cause du bluff et de la fumisterie"; P.S., "Apologie pour M. Lampué," *Le Temps* (November 22 1913), 1, which poses the question of the hour: "Les cubistes, futuristes et synchromistes sont-ils des mystificateurs, des aliénés ou les maîtres de l'avenir?"

18. See chapter two for passages by Emile Sedeyn, Allard and Apollinaire concerning *blague* and mystification as unreasonable accusations against the efforts of the avant-garde.

19. On this subject, Shattuck was originally cautious. See Shattuck's *The Banquet Years* (New York 1968), 283–4, where the hoax charge against cubism is addressed as on-going, and Shattuck explains why cubist pictures themselves, born of commitment and dedication, cannot possibly be the product of a sustained bluff. The rest of the discussion still remains the most attractive and succinct introduction to the ambiguity of the issue. Shattuck allows that the Chat Noir and the Lapin Agile were true "*salons* of the new art," and that "part of the greatness of cubism consisted in its willingness to entertain speculations which other minds would have dismissed as foolishness or mere bluff" (283). Further, "the high spirits that produced cubism acted as a safeguard in a manner lost sight of today because of the unrelieved seriousness with which cubism is treated. The enjoyment of a good hoax – insofar as it was a hoax – prevented most painters from capitulating totally to the theoretical side of the school. Gleizes' and Metzinger's book (*Du Cubisme*) lacks this perspective of self-irony, and its intense earnestness slightly removes it from the central current of cubist thought" (284).

20. See, for example: Robert Lebel, *Marcel Duchamp*, 10–15, 25–34; Jennifer Gough-Cooper and Jacques Caumont, *Plan pour écrire un vie de Marcel Duchamp* (Paris 1977), 63–8; Alice Goldfarb Marquis, *Marcel Duchamp: Eros, c'est la vie: A Biography* (Troy 1981), 67–89. For the most extensive recent account, see Thierry de Duve, *Pictorial Nominalism: On Marcel Duchamp's Passage from Painting to the Readymade*, trans. Dana Polan, (Minne-

apolis 1991), 67–163, in which the circumstances and implications of the so-called rupture in 1912 are addressed at great length as the core material for a historical and critical reassesment of the Duchamp project.

21. Duchamp remembers admiring the cool tonality of Vallotton's work at the time, which he said "heralded the Cubist palette." Cabanne, *Dialoques with Marcel Duchamp* (New York 1987), 23.

22. *Ibid.*, 31.

23. Emile Deflin, "En Passant-Ah! les Salons!" *Gil Blas* (April 11 1913), 1.

24. "des excès et des erreurs d'une certaine peinture"; "un avilissement très inquiètant de l'art français"; "valeureux et sincères" Mauclair, "Le Prolétariat des Peintres," *La Revue hebdomadaire* (January 18 1913), 354.

25. "Le caractère le plus général, le plus frappant de la peinture actuelle, c'est une surproduction inouïe." *Ibid.*, 355.

26. "et enfin la formidable mobilisation des Indépendants"; "Les Salons sont les grands magasins de nouveautés, et le reste s'assimile aux maisons de blanc ou de spécialités." *Ibid.*, 356.

27. "La surproduction est terriblement disproportionnée à l'intérêt du résultat artistique"; "la foule des exposants grandit toujours"; "congestion de peinture"; "qui, commercialement, s'appelle un krach." *Ibid.*, 356–7.

28. "l'espoir de quinze mille peintres"; "l'affolante course à la nouveauté, à l'originalité, qui est une des calamités de notre époque"; "les pires folles" *Ibid.*, 359.

29. "refuge de malcontents"; "ouverts a tout venant sans contrôle." *Ibid.*, 360.

30. "les théories paradoxales déguisent l'ignorance technique, la critique est débordée, l'opinion désorientée" *Ibid.*, 364.

31. "la fatigue et l'ennui du public." *Ibid.*, 369.

32. "Le principal inconvénient de ce système, c'est qu'il laisse entrer pêle-mêle les audacieux qui veulent rajeunir et renouveler la grammaire et les illettrés incapables d'en acquérir les premiers élements. C'est la rançon de la liberté." Laran, "Le Salon des Indépendants en 1912," *Bulletin de la Société de l'Histoire de l'Art français* (1912), 97.

33. "palette, pâte, touche, rhythme et volumes, rapports et passages, écoles, systèmes, courants, filiation." *Ibid.*, 96.

34. "la surproduction actuelle" Gleizes, "L'Art et ses Représentants – Jean Metzinger," *Revue Indépendante* (September 1911), 161.

35. For references to the change, see: Edouard Sarradin, "Le Salon des Artistes Indépendants," *Journal des Débats* (March 19 1912), 3; Tabarant, "Le Salon des Indépendants," *Paris-Midi* (March 19 1912), 2.

36. "Le Dévernisseur" (Roland Dorgelès?), "La Foire aux Tableaux," *Fantasio* (May 1 1911), 668; Tabarant, "Le Salon des Indépendants," 2.

37. "affinité"; "'boucher les trous'." André Warnod, "Le Salon des Indépendants – I. Fauves et Cubistes," *Comoedia* (March 18 1913), 1.

38. "La quantité malheureusement ne supplée pas au manque de qualité et l'on préférerait un choix d'oeuvres intéressantes à la profusion de toiles insignifiantes ou franchement mauvaises qui encombrent les quarante-sept salles." Turpin, "Salon des Indépendants," *Les Rubriques nouvelles* (May 1913), 26.

39. "tentatives tapageuses, qui n'ont même pas souvent le mérite de la sincérité . . . l'effort infructueux de faux artistes qui, manquant de talent pour intéresser le public á leurs œuvres, tentent de surprendre sa curiosité par des excentricités." *Ibid.*, 27.

40. For the nineteenth-century debate, see Patricia Mainardi, "The Eviction of the Salon from the Louvre," *Gazette des Beaux-Arts* (July–August 1988), 31–40.

41. In this way, Duchamp subsumes journalist Alfred Capus' picture of 1912 as simultaneously a year of change and, for the bourgeoisie, "une année réactionnaire:" "Il y a en tout de la mode, l'onde qui passe et nous enveloppe, la nouveauté des choses, le besoin de modifier la coupe de nos habits. Cependant, cette fois, le mouvement est assez marqué et il est parti de tous les points, presque à la même heure; de Paris et de la province, et surtout de milieu bourgeois, ce qui est un signe de durée. Ce genre de réaction, en France, n'a de suite, en effet, que s'il prend naissance dans la bourgeoisie moyenne. C'est de là qu'il se propage en haut et en bas." Capus, "Une Année réactionnaire," in *Les Moeurs*

du Temps (Paris 1912), 285–6.

42. "C'est ne pas la peinture qui importe!" Carco, "Le Quinzaine Artistique – Du Cubisme," *Homme Libre* (October 13 1913), 4.

43. "dans la salle d'honneur du Salon d'Automne, magnifiquement encadrées, des toiles blanches, sur lesquelles des formules, écrites avec soin, remplaceront les couleurs et les formes que, seuls les cubistes, devenus des "pompiers', emploieront encore. L'imagination des visiteurs fera le reste." Anon., "Echos – Une Nouvelle Ecole," *Paris-Midi* (October 5 1912), 1.

44. "C'est à l'observateur . . . de reconstituer la forme." Anon., "L'Evolution de l'Art: Vers l'Amorphisme," *Les Hommes du Jour* (May 3 1913), 10.

45. Anon., "Faits Divers – Paris. Au Salon d'Automne," *Homme Libre* (November 27 1913), 3.

46. See de Duve, *Pictorial Nominalism*, 67–163; for a condensed version of the argument, see *Idem.*, "The Readymade and the Tube of Paint," *Artforum* (May 1986), 110–21.

47. For de Duve, in the milieu of the *Kunstgewerbe*, conflict between artisanal tradition and the new esthetics of industrial functionalism "resonate" with the origins of the readymade, a genre through which Duchamp confronted the paradoxes of that debate. Ultimately, the readymade abandons painting, but belongs to it: as an object of "pictorial nominalism," it retains the name of painting by signifying and ironizing, through materials, iconography and puns, the outmoded elements of painting as craft and tradition. (For that matter, it is, in its utter absence of technique, no less a painting than Malevich's *Black Square*). Thomas McEvilley also accepts Duchamp's "new approaches" beginning in 1912 as having acted to "annihilate . . . the inherited codes that his paintings had been pursuing only the year before." See McEvilley, "empyrrhical thinking (and why kant can't)," 120. McEvilley selectively surveys the Duchamp literature, and the "clues" or "models" which scholars have proposed for Duchamp's sudden turn. None of the conventional "influences" – Jarry, Picabia, Mallarmé, Apollinaire, Bergson, Laforgue, Leonardo, Roussel – "explain the apparent revolution in his general attitude" (122). For these, McEvilley substitutes Pyrrho, though the implication that this single source was responsible for Duchamp's shift seems to strain the notion of causality: to imply, as McEvilley does, that post-1912 Duchamp springs fully-formed from the head or Pyrrho is inadequate to the shaping conditions of pre-war esthetic debate, and diminishes Duchamp's significance as an agent of the paradigm. In any case, according to McEvilley's scenario, Duchamp had already abandoned painting by the time he read Pyrrho as an employee of the Bibliothèque Sainte-Geneviève.

48. For the most penetrating history of Murger's *bohème*, see Seigel, *Bohemian Paris*, especially chapters two and three.

49. Lorédan Larchey, *Les Excentricités du Langage* (Paris 1865), 32; Larchey quotes a reference from 1808, and notes that the etymology is uncertain. Not much progress has been made since; see *Trésor de la Lanque française*, T.4 (Paris 1975), 555.

50. *Grand Dictionnaire universel du XIXᵉ siècle*, T.II (Paris 1867), 784–5.

51. "Le caractère distinctif de la *blague* est d'être complétement inoffensif; c'est une douce raillerie . . . qui ne ruinera personne." Larchey, quoted in *Ibid.*, 785.

52. Translation from Shattuck, "The Demon of Originality," 70.

53. "La blague est un certain goût, qui est spéciaulx Parisiens, et plus encore aux Parisiens de notre génération, de dénigrer, de railler, de tourner en ridicule tout ce que les hommes, et surtout les prud'hommes, ont l'habitude de respecter et d'aimer; mais cette raillerie a ceci de particulier que celui qui s'y livre le fait plutôt par jeu, par amour du paradoxe, que par conviction: il se moque lui-même de sa propre raillerie, il blague"; "Il blague les beautés de l'Italie, et se mettrait à genoux devant un Raphael"; "Il y a dans la blague un certain mépris . . . pour les phrases toutes faites . . . à ce mépris se joint le plaisir de crever les ballons gonflés de vent, de se sentir supérieur en se prouvant qu'on n'est pas dupe." Sarcey, quoted in DuBled, *La Société Françiase du XVIᵉ siècle au XXᵉ siécle. IXᵉ Série: XVIIIᵉ et XIXᵉ siécles: Le Premier salon de France; L'Académie Française; L'Argot* (Paris 1913), 258.

54. "le désastre de 1870." Raynaud, *La Mêlée symboliste (1870–1910)* (Paris 1971), 223.

55. "désarroi profond." *Ibid.*, 229.
56. "fragments et anecdotes...un chaos de formules"; "idéaliste...sceptic et gouailleur"; "Ainsi leur enseignement se neutralisait et nous laissait sans point d'appui, suspendus dans le vide. Avec Cartaut, la blague avait pénétré l'ancien enseignement emphatique et solennel. C'était un mot d'ordre chez les derniers Normaliens d'affecter l'esprit du boulevard et de delaisser l'étude des classiques ...pour se consacrer au journalisme, à l'étude des romanciers en vogue et des vaudevillistes." *Ibid.*, 230.
57. "La politique du jour flottait de l'extrême droite à l'extrême gauche, marquait une opinion versatile et désorientée, fruit de l'agitation cosmopolite en cours." Raynaud, *La Mêlée symboliste*, 231.
58. Conrad, *Nostromo* (New York 1989), 110–12, 356, 358.
59. Smith, *The Real Latin Quarter* (New York 1901), 45–6.
60. DuBled, *La Société française*, 258.
61. "On pourrait presque soutenir que la blague est le pont-aux-ânes de l'athéisme et de l'anarchie morale, et qu'elle les prépare." *Ibid.*, 259.
62. "Le mot n'est pas encore français: il mériterait de le devenir. En attendant, il est parisien, et c'est une des plus heureuses trouvailles de la langue boulevardière"; "définir, c'est limiter, et le champ de la "blague" est infini"; "les caractères essentiels et visibles"; "avant tout, la blague est une démolisseuse, et quand elle est réussi, a une certaine valeur critique. Elle s'attaque à toutes les formes de l'illusion; sous les mirages qu'elle dissipe, elle dévoile les tristesses des choses"; "avec toute espèce de foi, de croyance, de dogmatisme"; "dénomination actuelle"; "état d'esprit"; "Le règne tyrannique de l'intelligence, une perspicacité maligne qui saisit les défauts bien mieux que les qualités, une insouciance paresseuse qui se complaît dans les superficiels aperçus, concourent à former chez le peuple de Paris une espèce de scepticisme léger, hostile à la brutalité des affirmations trop crues et à la lourdeur des principes catégoriques." Wogue, "La Philosophie de la 'Blague'," *La Grande Revue* (March 1 1902), 537–8.
63. "le doute – un doute pessimiste, découragé; elle le mène en joie au nihilisme." *Ibid.*, 538.
64. "le simple rire...il est fort rare que le théâtre comique soit si dangereux"; "facilement reconnus par la foule. Née du peuple, elle s'adresse au peuple"; "Elle est grand Guignol fait pour les grands enfants...Le but est de détendre les nerfs...Le rire y est pacifique, désintéressé, sans amertume" *Ibid.*, 538.
65. "où l'observation satirique, au lieu d'être inoffensive et 'bon enfant', serait plus mordante et significative"; "répertoire dramatique de nihilisme souriant"; "fleur de mal"; "grâce perverse." *Ibid.*, 539.
66. "victime traditionnelle de la verve comique"; "La farce caricaturait – et caricature encore – le bourgeois, et grossissait jusqu'à l'invraisemblance ses petitesses; la 'blague'...lui restitue à la grandeur naturelle les traits de sa personalité" *Ibid.*, 545.
67. "avec une fidelité de photographes" *Ibid.*, 539.
68. Norton, "Buddha of the Bathroom," the *Blindman*, no. 2 (May 1917), reprinted in ed. Joseph Masbeck, *Marcel Duchamp in Perspective* (New Jersey 1975), 71. The original article appeared with "The Richard Mutt Case," probably co-authored by Pierre Roché, Beatrice Wood and Duchamp; together, the two comprise the first printed manifesto statements concerning the readymade.
69. Moreover, William Camfield, who has made an exhaustive study of *Fountain* and its circumstances, describes Norton as "one of only a handful of Duchamp's friends with insider knowledge about the Richard Mutt case," and maintains that "her article reflects not only the conversation within that group of friends but the concepts generated and accepted by Duchamp himself." See Camfield, *Marcel Duchamp: Fountain* (Houston 1989), 39.
70. Reprinted in "Documents: Marcel Duchamp's Letters to Walter and Louise Arensberg, 1917–1921," in eds. Kuenzli and Naumann, *Marcel Duchamp: Artist of the Century*, 204.
71. Duchamp, "A L'Infinitif," 74.
72. "The Richard Mutt Case," reprinted in eds. Anne d'Harnoncourt and Kynaston McShine, *Marcel Duchamp* (New York 1973), 31. The statement runs, "Whether Mr. Mutt with his own hands made the fountain or not has no importance. He

CHOSE it. He took an ordinary article of life, placed it so that its useful significance disappeared under the new title and point of view – created a new thought for that object."

73. Duchamp, "Appropos of 'Readymades'," talk delivered at the Museum of Modern Art, New York, October 19, 1961, reprinted in eds. Sanouillet and Peterson, *The Writings of Marcel Duchamp*, 141.

74. Cabanne, *Dialogues with Marcel Duchamp*, 47. See also Duchamp, "G255300 United States of America," interview with Otto Hahn, in *Art and Artists* (July 1966), 10, for a similar description.

75. Cabanne, *Dialogues with Marcel Duchamp*, 48.

76. Quoted in Nicola Greeley-Smith, "Cubist Depicts Love in Brass and Glass: "More Art in Rubbers Than in Pretty Girl!'," *The Evening World* (April 4 1916), 3; reprinted in ed. Rudolf E. Kuenzli, *New York Dada* (New York 1986), 136. William Camfield, who quotes Crotti, has scoured period documents for observations on *Fountain* and other early readymades that imply a perception of beauty. See Camfield, *Marcel Duchamp: Fountain*, 33–5; 39–41. For Camfield, the readymades represent "not aesthetic indifference but an œuvre of extraordinary visual and intellectual rigor" (43). For other discussions of the readymade as an object of beauty, see Francis M. Naumann, *The Mary and William Sisler Collection* (New York 1984), 160–7, 176–8, 182–4. One excellent study, by Molly Nesbit, addresses the "style" of the readymade in quite different terms. See Nesbit, "Ready-Made Originals: The Duchamp Model," *October* (Summer 1986), 53–64; and "The Language of Industry," in ed. de Duve, *The Definitively Unfinished Marcel Duchamp*, 351–84. For Nesbit, the readymades, along with Duchamp's practice of mechanical representation, were borrowed back from the "aesthetically neutral" manner of technical drawing that was introduced by Eugène Guillaume into French primary education during the 1880s, with its bias towards the utilitarian object of everyday domestic work culture. The ready-made "was articulated through the visual set of the Guillaume method; it demonstrated Duchamp's literacy in the visual language of the quotidian" (62).

77. Camfield, *Marcel Duchamp: Fountain*, 44, 47, 55–8. For an important early reference to a "machine esthetic" of the readymades, see Harriet and Sidney Janis, "Marcel Duchamp, Anti-Artist," *View* (March 1945), 23.

78. Cabanne, *Dialogues with Marcel Duchamp*, 48.

79. Duchamp, "G255300 United States of America," 10.

80. Léger, in Dora Vallier, "La Vie fait l'œuvre de Fernand Léger," *Cahiers d'Art*, 29 no. 3 (1954), 140; English translation from Camfield, *Marcel Duchamp: Fountain*, 44.

81. Duchamp himself had no recollection of this episode; see Schwarz, *The Complete Works of Marcel Duchamp* (New York 1970), 595.

82. "Placer une boule de marbre sur un cube de pierre et intituler cela: "Muse endormi', ne nous paraît pas extrêmement comique." Ayr, "L'Art et les artistes – Le Salon des Artistes Indépendants," *Le Rappel* (March 21 1912), 2.

83. Jean Metzinger and Albert Gleizes, *Du Cubisme* (Paris 1912). As Edward Fry notes, the French printing dates from December 27, though the book was announced for publication in March and October. See Fry, *Cubism* (New York 1978), 111. I will quote from the first English edition: *Cubism* (London 1913).

84. Which purpose Gleizes would continue to express in his "Cubisme et tradition" articles for the review *Montjoie!* in 1913.

85. Gleizes and Metzinger, *Cubism*, 46–7, 50, 53.

86. *Ibid.*, 57.

87. *Ibid.*, 60.

88. *Ibid.*, 61.

89. *Ibid.*, 62.

90. *Ibid.*, 63.

91. *Ibid.*, 64.

92. Duchamp, "The Great Trouble with Art in this Country," from an interview with James Johnson Sweeney, *The Bulletin of the Museum of Modern Art*, vol. XIII, nos. 4–5 (1946); reprinted in eds. Sanouillet and Peterson, *The Writings of Marcel Duchamp*, 125–26. See also Katherine Kuh, "Marcel Duchamp," in *The Artist's Voice: Talks with Seventeen Artists* (New

York 1962), 89; and Cabanne, *Dialogues with Marcel Duchamp*, 48.

93. In our reading of Duchampian play, *blague* possesses a certain atavistic priority over philosophers of arbitrary meaning and paradox such as Stirner and Pyrrho. As a form of French cultural discourse and behavior, *blague* presupposes no moment of conversion, an awkward form of historical argument, which might be inferred from the influence of a single text; the philosophers might, instead, be understood to comprise further reading from which Duchamp derived support or procedural variations on his original premise. But the premise begins with a joke, not a philosophical treatise or a fully-developed belief system, and to this extent, the relevance of *blague*, hoax and related issues as they occur from day to day in Duchamp's own milieu seems clear.

94. Ulf Linde, "La roue de bicyclette," in *Marcel Duchamp: Abécédaire. Approches critiques* (Paris 1977), 35–41; Craig Adcock, *Marcel Duchamp's Notes from the "Large Glass": An N-Dimensional Analysis* (Ann Arbor), 1983, 102–5, 158–62, 169–70, 177–8; Naumann, *The Mary and William Sisler Collection*, 160–6, 178; John F. Moffitt, "Marcel Duchamp: Alchemist of the Avant-Garde," in Los Angeles County Museum of Art, *The Spiritual in Art: Abstract Painting 1890–1985* (New York 1987), 261; Camfield, *Marcel Duchamp: Fountain*, 48–9, 53–9.

95. On the purchase of some readymades see Naumann, *The Mary and William Sisler Collection*, 166, 176; Camfield, *Marcel Duchamp: Fountain*, 50–3; Kirk Varnedoe, "Advertising," in Varnedoe and Adam Gopnik, *High & Low: Modern Art and Popular Culture* (New York 1990), 273–8. Varnedoe has shown that certain readymades, most notably the *Bicycle Wheel* and *Fountain*, reflect the esthetic value system of period trade-show and showroom display culture; this would significantly alter the presumed imbalance of art versus non-art in the readymade. Again, I would argue that such an interpretation is compatible with a preliminary investigation of banality, which, in radical contrast to the extravagences of avant-gardism, clearly remains a principal salient property of the readymade.

96. So too with the *Large Glass*; in 1962,

Duchamp referred to the *Green Box*, a collection of notes for the *Glass*, as an incomplete realization of his intention, which was to have been "somewhat like a Sears, Roebuck catalogue." See Katherine Kuh, *The Artist's Voice*, 83. Later, Duchamp changed this to a "Saint-Etienne" catalogue; see Cabanne, *Dialogues with Marcel Duchamp*, 42. The reference is to the catalogue of the *Manufacture française d'Armes et Cycles de Saint-Etienne*; see Sanouillet, "Marcel Duchamp and the French Intellectual Tradition," 52–3. In addition, on the basis of Duchamp's note from 1913 concerning the "coition through a glass pane with one or many objects of the shop window," we might speculate on the role of a shop-window eros in the choice of glass as a support for his large work. See Duchamp, "A l'Infinitf," 74.

97. "les habitations à bon marché, les jouets, les meubles, les automobiles." Pierre du Colombier, "Notes d'Art – Le Salon d'Automne," *Revue critique des idées et des livres* (October 25 1912), 233. This issue actually originates in Salon criticism of the Second Republic, when the Salon was moved from the Louvre to the Palais de l'Industrie. See Mainardi, "The Eviction of the Salon from the Louvre," 33–37.

98. For detailed description, see Schwarz, *The Complete Works of Marcel Duchamp*, 445; the reference to the quality of the picture as "worst kind" was made by Duchamp to Schwarz.

99. "Ah! comme je comprends maintenant par quoi le grand Palais est honoré. Par tous les agrandissements de chromos, faits à la main, tout à la main, rien qu'à la main, et que, n'était leur dimension, on prendrait pour les images réclames d'un grand chocolat ou d'une grande chicorée." Werth, "A travers la Quinzaine – Le Cubisme et le Salon d'Automne," *La Grande Revue* (October 25 1912), 835.

100. "arrivisme, bluffisme . . . effarer le public dont la curiosité ne s'interesse qu'aux pôles: chromos d'une part, tapageuses et vaines revoltes d'autre part." Eggermont, "Les Arts – A la Galérie Giroux: Les Peintres Futuristes italiens," *La Société Nouvelle* (August 1912), 197.

101. "sales bourgeois . . . des chromos, plus qu'il n'en faut pour fournir de calendriers-primes les grands magasins. Qui

pourrais-je imiter pour être original? Ils imitent tout le monde" Du Colombier, "Notes d'Art – Au Salon des Indépendants," *La Revue critqiue des idées et des livres* (April 25 1912), 240.

102. "première ligne ... l'armée des amateurs et des professionnels impuissants qui peint avec application d'innombrables chromos rappelant à s'y méprendre les portraits en couleurs des photographes ou les "vues' que nous avons tous admirées dans notre enfance au fond de quelque vieille maison provinciale, sur ces panneaux qui fermaient les cheminées pendant la saison chaude." Helsey, "Notes d'Art – La Société des Artistes Indépendants," *La Clarté* (May 1914), 167.

103. Schwarz, *The Complete Works of Marcel Duchamp*, 445.

104. "chef d'œuvre d'énergie mathématique ... tirée du domaine subconscient de la Beauté." Duchamp-Villon, "La Tour Eiffel," reprinted in Galerie Louis Carré, *Duchamp-Villon: Le Cheval majeur* (Paris 1966), 39. The essay is a tribute to the Eiffel Tower as an architectural and sculptural *tour de force*; in one passage that is relevant to a comparison with Duchamp's *Bottle Rack*, Duchamp-Villon imagines the Tower reduced in size to a height of 30 centimeters, in order to appreciate its proportions and economy of means (38).

105. Cendrars' lines are also illustrated by Sonia Delaunay with a silhouette of the Tower encircled like a ring-toss by the Grande Roue. See reproduction in Jacques Damase, *Sonia Delaunay: Rhythms and Colours* (London 1972), 91.

106. Roger Shattuck has deciphered the right-hand side of "Lettre-Océan" as an image of the Grande Roue; see Shattuck, "Apollianire's Great Wheel," in Shattuck, *The Innocent Eye*, 254.

107. For Duchamp's distinction between physical and intellectual art, see Duchamp, "The Great Trouble With Art in this Country," 125; Kuh, *The Artist's Voice*, 81.

108. In addition to many random notes from "The Green Box" and "A l'Infinitif," more substantial examples from the period include four postcards typewritten with meaningless text, known as *Rendez-vous du Dimanche 6 Février 1916 ...*; and the "Dictionary" passage in "A l'Infinitif," 77–8.

109. See "La Cigale," in *Théâtre de Meilhac and Halévy, t.III* (Paris, nd.); presumably, this is the edition referred to by Wogue's article on *blague*, which is subtitled "D'après le Théâtre de Meilhac and Halévy (Tomes I–VI)"; it can, therefore, be dated 1901 or 1902.

110. "hardi novateur"; "un souverain mépris de l'ancienne peinture." Wogue, "La Philosophie de la 'Blague'," 547.

111. Meilhac and Halévy, *La Cigale*, 88. The dismissive epithet "intentionnisme" was still considered apt during the pre-war period; for a reference to the Salon d'Automne of 1912 as the "Salon des intentionnistes," see G.J., "Art et Curiosité – Le vernissage du Salon d'Automne," *Le Temps* (October 1 1912), 4.

112. "je fais de la peinture qui n'est pas de la peinture." *Ibid.*, 89.

113. *Ibid.*, 117.

114. *Ibid.*, 87.

115. "C'est admirable."
"C'est original ... Il n'y a pas de mal à mettre un peu d'originalité dans la peinture." *Ibid.*, 125.

116. "le tableau-rébus ou encore, sous une form inattendue, la peinture intellectuelle." Wogue, "La Philosophie de la 'Blague'," 548.

117. The work is described in Félix Fénéon's review of the Incohérents exhibition in 1883. See Fénéon, "Les Arts incohérents," *La Revue Libre* (November 1 1883), reprinted in ed. Joan U. Halperin, *Felix Feneon: Œuvres plus que complètes, T.I* (Geneva 1970), 12. The reverse gag – an all-black picture – is suggested by titles of works from the 1889 Incohérents: no. 4, *Eclipse totale de soleil en Afrique centrale*; no. 166, *Un wagon de Fumeurs sous un tunnel*. See *Catalogue illustré de l'Exposition Universelle des Arts Incohérents* (Paris 1889). For the record, Apollinaire had a copy of the 1886 Incohérents exhibition catalogue in his library; see Gilbert Boudar and Pierre Caizergues, *Catalogue de la Bibliothèque de Guillaume Apollinaire II* (Paris 1987), 105. See Charpin, "Le Magasin incohérent," 69–70, for the running joke of monochromatic pictures in Incohérent exhibitions, most of which show faint or fragmented imagery that is difficult to make out. Charpin describes this as a strategy of the Incohérents' claim to represent

the art of amateurs, novices and primitives, and notes that it is perpetuated in Emile Cohl's animated film *Le Peintre néo-impressionniste* (1910).

118. Denys Riout, "La peinture monochrome: une tradition niée," *Les Cahiers du Musée National d'Art Moderne* (winter 1989), 81–99. Allais' picture has been previously used by Roger Shattuck to illustrate the concept of *blague*. Shattuck, "The Demon of Originality," 77.

119. Dorgelès, "Comment je suis devenu fauve," *Fantasio* (October 15 1910), 192.

120. "charges d'atelier atteignent un snobisme justiciable de la 'blague'." Wogue, "La Philosophie de la 'Blague'," 548.

121. "prend l'excentricité pour l'originalité." *Ibid.*, 548.

122. Cabanne, *Dialogues with Marcel Duchamp*, 33.

123. Concerning his pre-war activity, Duchamp later confessed that "deep down I'm enormously lazy. I like living, breathing better than working." *Ibid.*, 72.

124. "Tiens . . . c'est mieux qu'avant!" Meilhac and Halévy, *La Cigale*, 118.

125. Cabanne, *Dialogues with Marcel Duchamp*, 75.

126. *Ibid.*, 89.

127. The play was published that year as an edition of the periodical *L'Illustration Théâtrale* (March 13 1906).

128. "Un chef-d'œuvre d'estaminet." Salmon, *Max Jacob, poète, peintre, mystique et homme de qualitré* (Paris 1927), 21. (It should be noted that Duchamp was still living in Montmarte at the time.) Salmon went with Max Jacob, who stood up during the Act III brasserie scene and publicly protested Courbet's speech.

129. "L'anathème des malchanceux, des pas en train, / des ratés, des blagueurs, des déchus, des athées." Mendès, *Glatigny*, 28.

130. "mot cruel *raté* pour designer l'homme parvenu à la maturité sans avoir donné la mesure de son talent." Descaves "Autres Moeurs," *Le Journal* (October 19 1906).

131. "ces rapins sans ateliers, ces journalistes sans journaux, ces poètes sans éditeurs, ces dramaturges sans théatres"; "ceux qui restent au bagne regarderaient d'un mauvais œil les anciens forçats qui s'aviseraient d'y revenir en visiteurs. Mais toutes les victimes de la paresse ou du guignon, tous les impuissants et tous les forts réduits à l'impuissance se groupaient là. Et ils s'y réjouissaient cruellement. La Brasserie prenait contre les insultants triomphes toute la revanche qu'on peut prendre par le dénigrement et la parodie. Et ce qu'il y avait d'épouvantable, c'est que, la plupart des réputations étant, en réalité, illégitimes, elle avait souvent raison, l'envieuse! In Léo Marchès, "Glatigny," *Liberté* (September 15 1906).

132. "désolant prolétariat de ratés"; "l'homme qui se croit artiste et n'a rien à dire." Mauclair, "Le Prolétariat des peintres," 361. Mauclair's discussion of the *raté* actually covers 361–4.

133. "un besoin d'étonner, de heurter, de se draper dans une attitude de raté agressif. Chez X, c'est la revanche de ses insuccèss; chez Y, la soif de faire cyniquement connaître son nom; chez Z, simple galéjade." Vauxcelles, "Les Arts – Grammatici certant," *Gil Blas* (October 24 1912), 4. See also Thiébault-Sisson, "La Vie artistique – Une préface au Salon d'Automne," *Le Temps* (November 13 1913), 3: "parmi ces quelques centaines de révolutionnaires, les 'faiseurs', les ratés et les copistes attardés sont le grand nombre."

134. For example, Alphonse Daudet's novel *Jack* treats the subject of the bohemian *raté* and the effects of *raté* "impotence" on the lives of his own wife and child. See the account of *Jack* in Émile Montégut, "Les nouveaux romanciers," *Revue des Deux Mondes* (December 1 1876), 629–30.

135. "Encouragés par le snobisme le plus niais et l'ignorance la plus crasse, ces épuisés de la peinture vont chercher . . . cette soi-disant *originalité* qui contrsigne précisé-ment leur *impuissance*." J.-C. Holl, "La Vie qui passe – L'Art qui demeure: Un lot d'impuissants," *Les Hommes du Jour* (December 30 1911), 10.

136. Armand Fourreau, "Au Salon d'Automne," *La Phalange* (October 20 1911), 367. For the epithet, see also: Ya, "Les Expositions – L'Exposition des Indépendants," *La Revue septentrionale* (June 1911), 164; Ayraud-Degeorge, "L'Art et les artistes – Le Salon des Artistes Indépendants," 2; *Idem.*, "Le Salon d'Automne," *Le Rappel* (October 1 1912), 2; Georges Lecomte, "Pour l'art français – Contre les défis au bone sens," *Le Matin* (October 7 1912), 1.

137. Duchamp, "The Green Box," 68.

138. *Ibid.*, 48–50.
139. *Ibid.*, concerning the "Malic Moulds," 51–3.
140. See Schwarz, *The Complete Works of Marcel Duchamp*, 108–9.
141. "onanisme artistique." Guilbeaux, "La Vie et les Arts," *Les Hommes du Jour* (June 24 1911), 8.
142. Cabanne, *Dialogues with Marcel Duchamp*, 76.
143. See, for example, Achille Guillard, "La Dépopulation," *Le Petit Journal* (January 15 1912), 1; Anon., "Une Statistique intéressante – La France se dépeuple," *Excelsior* (November 2 1912), 4; Anon., A la commission de la repopulation," *Le Journal* (December 7 1912), 2; Anon., "On reparle de la dépopulation," *Homme Libre* (June 18 1913), 1; J.-L. Breton, "Le Problème de la dépopulation," *Les Documents de Progrès* (January 1913), 62–73; Anon., "Au Senat – Contre la dépopulation," *Le Journal* (March 6 1914), 2.
144. See, for example, "Couplets de l'impôt sur les Célibataires," in the *revue Tangui-Tango, Pan! la Tanguinette!* at La Scala (September 1913). The refrain runs: "Le célibataire, / Sur terre (*bis*) / Est le plus chouette intrument / Pour repeupler proprement. / C'est notr' p'tit frère, / P'tit frère (*bis*), / Quand quelque part il vient s'planter, / C'est pour l'Humanité." See also the song "Repeuplez donc!" by Saint-Gilles and Paul Gay, in *Paris qui chante* (November 2 1912), 14.
145. Duchamp, "The Green Box," 30.
146. For such a description of the Dreyfus affair, see François Caradec, *Le Farce et le Sacré: fêtes et farceurs, mythes et mystificateurs* (Paris 1977), 111–12.
147. "un vent de mystification a soufflé sur notre soicété." René Doumic, "Revue littéraire – Nos humoristes," *Revue des Deux-Mondes* (October 15 1899), 933. For a recent study of Paul Masson, alias Lemice-Terrieux, see Caradec, *Le Farce et le Sacré*, 49–105. During the pre-war, Lemice-Terrieux was still the model for this kind of exploit; see Henri Turot, "La Vie de Paris – Le Plaisir de mystifier," *Le Figaro* (January 3 1909), 1.
148. "les pièges dans lesquels on fait tomber un homme simple et crédule, que l'on veut persifler"; "abuser de la crédulité de quelqu'un pour s'amuser à ses dépens." (Paul Lacroix), *Mystificateurs et mystifiés:*

*Histoires comiques* (Paris 1875), 10. See also Raynaud, *La Mêlée Symboliste*, 233–4, for the symbolist-period phenomenon of spiritism, a form of charlatanism that marries mysticism with mystification.
149. "être froid et impassible... calme parmi tous les gens qu'il agite et met en révolution autour de lui; ce grand mécanisme social caché sous un habit bourgeois, qui, suivant son malin plaisir fait pivôter, reculer, voire même sauter en l'air tous les petits rouages auxquels il donne le mouvement"; "placer à votre côté, partage votre étonnement de l'air le plus sincère"; "véritable aristocratie sociale." A.A., "Statistique individuelle – Le Mystificateur," *La Silhouette* (October 4 1830), 19–20. Thanks to Stephanie Carroll, who drew this article to my attention.
150. For the etymology of *fumiste*, see *Trésor de la Langue française*, T.8, 1329. In a pun on this double meaning, Lemice-Terrieux advertised a *conférence* on *fumisterie* which turned out to be a lecture concerning various modes of home heating; see Doumic, "Revue littéraire – Nos humoriste," 933.
151. Goudeau, *Dix ans de Bohème* (Paris 1889), 100.
152. "blagueur à froid, ces essais de mise en scène fumiste." *Ibid.*, 101.
153. *Ibid.*, 95. See also the discussion of the Goudeau circle in Seigel, *Bohemian Paris*, 221–3.
154. "Combien plus génial à la fois et plus compliqué est le fumiste qui sous une enveloppe quasi prudhomesque, et, partant, naïve, dissimule ce fond de scep-ticisme qui est l'étoffe même de l'esprit. Faire sentir à quelqu'un... qu'il est un imbécile, c'est le propre de l'esprit. Abonder dans son sens et lui faire donner la quintessence même de son imbécillité, c'est le propre du fumisme. L'esprit demande à être payé sur-le-champ par des bravos ou de discrets sourires, le fumisme porte en lui-même sa propre récompense: il fait de l'art pour l'art. Afin de passer pour homme d'esprit, il suffit parfois d'être une âne couvert de la peau du lion; pour être bon fumiste il est souvent indispensable d'être un lion couvert d'une peau d'âne. Dans le premier cas l'effet est direct, dans le second il est une fois, deux fois, souvent dix fois réflexe." Fragerolle, "Le

Fumisme," *L'Hydropathe* (May 5 1880), 2.

155. For early descriptions of Sapeck and his *mystifications*, see: Alphonse Allais, "Sapeck," *L'Hydropathe* (February 8 1880), 6; Idem., "L'Hydropathe "Illustre Sapeck'," *L'Hydropathe* (March 15 1880), 2, where he is described as "le grand-maître du Fumisme, le beau rieur infati-gable qui a osé jeter au nez des bour-geois de la rive gauche le premier éclat de rire que l'ont ait entendu depuis la guerre"; Félicien Champsaur, *Dinah Samuel* (Paris 1889), 115–17, a *roman à clef* of the Hydropathe and Fumiste movement which was republished in 1925 using actual names; Goudeau, *Dix Ans de Bohème*, 31, 61–2, 95. More recently, see eds. François Caradec and Noel Arnaud, *Encyclopédie des Farces et Attrapes et des Mystifications* (Paris 1964), 54–7; and Léopold Saint-Brice and Aurélien Marfée, "Les Fumistes Hydropathes," *A Rebours*, numéro spécial 34–5 (1986), 13–15, 26, 49–69.

156. The irony of post-student life for the Latin Quarter *fumistes* is that most all of them were destined to become bourgeois pro-fessionals and civil servants; Sapeck, for example, became a legal counselor for the préfecture in Jura. See Champsaur, *Dinah Samuel*, 125; and the biographies of the primary *fumistes* in Saint-Brice and Marfée, "Les Fumistes Hydropathes," 47–103. See also the account of the *rapin's* road from Bohemia to bourgcoisie in Louis Thomas, *André Rouveyre* (Paris 1912), 14–18.

157. The phrase is Billy's, from *L'Epoque 1900*, 183.

158. "le secret du rire chatnoiresque." Jean de Pierrefeu, "La Vie littéraire – Anthologie des Humoristes français contemporains," *L'Opinion* (February 24 1912), 242, a review of the anthology by Mille.

159. "le véritable humoriste doit être grave, et même d'apparence raisonnable; et de prémisses logiques, froides, sensées, banales même, il arrive brusquement à une conclusion inattendue, baroque, énorme." Mille, *Anthologie des Humoristes Français contemporains*, XIV.

160. *Ibid.*, XV; see also Gustave Kahn, "L'Art et le Beau," *Montmartre et ses Artistes* (1907), 28.

161. "Il immolait le philistin sur l'autel de sa pensée." Kahn, "Charles Cros," *Le*

*Figaro: Supplément littéraire* (September 6 1924), 1.

162. "excessive sobriété. *Ibid.*, 1. Kahn likened this economy of means to the early work of humorist-illustrator Willette, who drew Pierrot with tiny rectangular facial fea-tures, an expression of "l'ahurissement quasi mathématique"; "scientifiquement ironique et très pince-sans-rire." Kahn, "L'Art et le Beau," 30.

163. "laborieux et indolent"; "indifférence philosophique" Kahn, "Charles Cros," 1. On Cros as poet, humorist and inventor, see also Alphonse Allais, "Charles Cros," *Les Hydropathes* (sic) (March 20 1879), np; Goudeau, *Dix Ans de Bohème*, 123–29; and Richard Noël, *A l'Aube du Symbolisme* (Paris 1961), 52.

164. See Paul Vivien, "L'Hydropathe Alphonse Allais," *L'Hydropathe* (Janury 28 1880), 2; more recently, ed. Jean-Claude Carrière, *Humour 1900* (Paris 1963), 345–6, 353–6, 451–3.

165. Kahn, "L'Art et le Beau," 33, for reference to his "meillures fantaisies, les plus folles, les plus logiquement folles, car il avait l'esprit scientifique."

166. "un admirable clown de la logique, un merveilleux mécanicien de la fantaisie." Donnay, "Mes Souvenirs," 326.

167. "Allais, voué à la chimie et aux sciences naturelles, développait ses raisonne-ments burlesques avec une rigueur si impitoyable et si impressionante qu'on connut, oserai-je dire, comme une sorte de frisson nouveau." Carlos Fischer, "A Alphonse Allais, la patrie reconnaissante," *L'Opinion* (July 23 1910), 109.

168. "humoristes d'attitude dont la comique est issu du contraste entre la gravité de leur débit et l'absurdité joyeuse de ce qu'ils débitent . . . ces mystificateurs lucides, pondérés, ces mathématiciens rigoureux de l'absurde." Pierrefeu, "La Vie Littéraire – Anthologie des Humoristes français contemporains," 242.

169. See Shattuck, *The Banquet Years*, 238.

170. Gide, *c.* 1895, as quoted in translation by Shattuck, *The Banquet Years*, 212.

171. "Sous des allures calmes, avec son regard placide, nul ne goûtait, comme André Derain, les joies de la mystification. Dans la blague à froid, il était passé maître . . . Pour Derain, la mystification était une manière d'être." Vlaminck, *Portraits avant décès*, 24.

172. On Moréas and his disciples at the Vachette, see Antoine Albalat, *Souvenirs de la Vie littéraire* (Paris 1924), 87–90, 94–6; André Rouveyre, *Souvenirs de mon commerce* (Paris 1921), 207–10. From the pre-war period, see: Louis Piérard, "Jean Moréas," *La Société nouvelle* (April 1910), 93–101; Salmon, "Les Lettres – Le Café des Muses," *Gil Blas* (June 9 1913); *Idem.*, "Feu Vachette," *Fantasio* (July 1 1913), 833; Apollinaire, items from 1910 collected in *Petites Merveilles de Quotidien* (Paris 1979), 28–9, 43.

173. For Brunner, see Dorgelès, *Bouquet de Bohème*, 164–6; for Vaillant, 153–4.

174. See Albert Thibaudet, "Les Copains par Jules Romains," *La Nouvelle Revue française* (July 1 1913), 153–4; *Idem.*, "Reflexions sur la litérature: Unanisme," *Nouvelle Revue française* (July 1 1921), 85–92; and André Cuisenier, *Souvenirs Unanimistes* (La-Celle-Saint-Cloud 1975), 55.

175. "boniment, bluff et l'imposition d'idées." Spectator, "Causerie," *La Publicité* (January–February 1914), 1–2, see also Apollinaire, *Le Flâneur des deux rives* (Paris 1918), 81–2; and Simon Arbellot, "Mystifications parlementaires," *Problèmes* (January–February 1955), 31–4.

176. "La folie a des limites, mais qui pourrait en assigner à la mystification? J'attend les œuvres d'Hégésippe Simon, ce grand patron des Précurseurs." Tabarant, "Gazette des Arts – Le Salon des Indépendants," *Paris-Midi* (March 2 1914), 2.

177. "La plus audacieuse négation que l'on puisse faire d'une chose, c'est de la reproduire . . . Il se présente et se dénie en même temps." Cassou, "Max Jacob et la Liberté," in *Pour la Poésie* (Paris 1935), 230–2.

178. Carco, *De Montmartre au Quartier Latin*, 27–8; Vlaminck, *Portraits avant décès*, 218, 221, 224; Paul Fort and Louis Mandin, *Histoire de la Poèsie française depuis 1850* (Paris 1926), 305.

179. Jacob, "Souvenirs sur Guillaume Apollinaire (I)," *Io*, special number *Pour revenir à Max Jacob* (1969), 103.

180. See Salmon, *Souvenirs sans fin. Deuxième époque (1908–1920)*, 91–5, 261–2; and Dorgelès, *Bouquet de Bohème*, 116–18. Jacob's behavior and wit, in a tone "somewhere between irony and skepticism," reminded Giorgio de Chirico of "certain chansonniers in Montmartre who improvised verses and songs and then circulated among the tables ridiculing clients." See de Chirico, *The Memoirs of Giorgio de Chirico*, trans. Margaret Crosland (London 1971), 66.

181. Carco, *De Montmartre au Quartier Latin*, 27.

182. Salmon, *Souvenirs sans fin. Deuxième époque (1908–1920)*, 94; and Jean Metzinger, *Le Cubisme était né. Souvenirs* (Paris 1972), 35.

183. "fondateur de l'école druidique, cubiste et professeur de Kabbale." De Tout un Peu, "Druide-Chauffeur," *Les Hommes du Jour* (October 14 1911), 8.

184. "moins pour des raisons techniques, à quoi l'on n'entend pas grand-chose, que comme une source d'exemples de lyrisme, d'invention ou d'audace non conformiste;" "ce qui a trait à l'hermétisme, à la magie, à la kabbale, à l'ésotérisme en général." Raynal, "Montmartre au temps du "Bateau-Lavoir'," *Médecine de France*, no. XXV (1952), 26.

185. Salmon, *Souvenirs sans fin: Deuxième époque (1908–1920)*, 232–4.

186. "Son érudition était toute moderne. Il lui arrivait d'inventer ce qu'il ne savait pas." Jacob, "Souvenirs sur Guillaume Apollianire," 102.

187. "partie de ce système de mystification où il excellait. A vrai dire, je ne l'ai jamais su." Buffet-Picabia, "Guillaume Apollinaire" (1936), reprinted in Buffet-Picabia, *Recontres* (Paris 1977), 64.

188. Cabanne, *Dialogues with Marcel Duchamp*, 24; the word "blagues" restored from the original French: Cabanne, *Marcel Duchamp, Ingénieur du Temps Perdu* (Paris 1977), 39.

189. See, for example: Billy, *Apollinaire vivant* (Paris 1923), 9; Carco, *De Montmartre au Quartier Latin*, 92, 183–4, 187; André Rouveyre, *Apollinaire* (Paris 1945), 50, 52–3, 190–1. Apollinaire's biographers consider the matter to have been essential. See Emmanuel Aegerter and Pierre Labracherie, *Guillaume Apollinaire* (Paris 1943), chapter seven: "Apollinaire et la mystification"; Marcel Adéma, *Apollinaire* (London 1952), 137–8; Shattuck, *The Banquet Years*, 315; Francis Steegmuller, *Apollinaire: Poet Among the Painters* (New York 1986), 153–4, 217.

190. "mystérieux et secret . . . deliciéusement

impénétrable." Rouveyre, *Apollinaire*, 10.

191. See Fernand Fleuret, *De Gilles de Rais à Guillaume Apollianire* (Paris 1933), 283–4; and Alice Halicka, quoted in Steeg-muller, *Apollinaire: Poet Among the Painters*, 153.

192. "à la fois prud'hommesque et persifleur." Faure-Favrier, *Souvenirs sur Apollinaire*, 71; see also André Billy, *Apollinaire vivant*, 30. For parody and satire in *Les Soirées de Paris* itself, see Alexandra Parigoris," Les constructions cubistes dans 'Les Soirées de Paris': Apollinaire, Picasso et les clichés Kahnweiler," *Revue de l'Art* (4ᵉ trimestre 1988), 61–74.

193. See a full account of this incident in Steegmuller, *Apollinaire: Poet Among the Painters*, 159–95; see also Toussaint-Luca, *Guillaume Apollianire*, 40–50, 82–5.

194. Martineau's review and Apollinaire's reply (which was only published for the first time in 1958) are reprinted in Steegmuller, *Apollinaire: Poet Among the Painters*, 213–14; I have retranslated Martineau's phrase "à pousser la farce jusqu'à la mystification." See Martineau, "Les Poèmes – Guillaume Apollinaire, *Alcools*," *Le Divan* (July–August 1913), 268.

195. "devant trois verres de vermouth." Billy, *Apollinaire vivant*, 54–5.

196. See Billy, *Guillaume Apollinaire* (Paris 1954), 29; and Michel-Georges Michel, *Peintres et sculpteurs que j'ai connu, 1900–1942* (Paris 1942), 14–15; see also Marcel Adéma, "Guillaume Apollinaire au temps des Soirées de Paris et d'Alcools (1912–13)," *Médicine de France* (1952), 38–9. In 1922, Pierre de Massot addressed the poetic innovations of both Jacob and Apollinaire as a form of "mystification" that both conceals and expresses original talent, and as such, that announces dada; see de Massot, *De Mallarmé à 391* (Saint-Raphael 1922).

197. For a complete account, see Aegerter and Labracherie, *Guillaume Apollinaire*, 167–72.

198. See Noël Richard in *Profils Symbolistes* (Paris 1978), 189–202; and Raynaud, *La Mêlée Symboliste*, 483–8. See also Roger Picard, *Artifices et mystifications littéraires* (Paris 1945), 99–116, for an account of Adoré Floupette in the context of other symbolist and post-symbolist period mystifications.

199. See *Nouvelles de la République des Lettres* (July 1910), 12; (October 1910), 14; (November–December 1910), 11. Salmon makes no mention of the monument in his chapter on the *Nouvelles* in *Souvenirs sans fin*, but based on the tone and the subscription lists as well as the parodic nature of the *Nouvelles* in general, the hoax is obvious. It is significant, however, that Salmon later honored Beauclair, one of the authors of *Déliquescences*, with unequivocal praise for his stature as a *mystificateur*: "Celui qui avait écrit ça au nom d'Adoré Floupette . . . paraissait immense. Sa forme devenait celle d'un être de génie, d'un tyran de l'esprit. Sur quoi le plaisantin de l'ancien boul' Mich', le rigolo de chez les Hydropathes et de chez les Zutistes, quelque temps grand homme du journal des concierges, s'affala ainsi qu se dégonfle un ballon." Salmon, *Souvenirs sans fin: Deuxième Epoque (1908–1920)*, 309.

200. "heureuse influence l'auteur des Déliquescences eut sur ses contemporains et sur les poètes actuels." Anon. (Salmon), "Un Monument," *Nouvelles de la République des Lettres* (July 1910), 12.

201. Tailhade, "Quelques fantômes de jadis," *La Plume* (January 1 1913), 528.

202. "Le pastiche fut à la mode." Billy, *L'Époque contemporain (1905–1930)*, Paris, 1956, 150.

203. See Alexandra Parigoris, "Pastiche and the Use of Tradition, 1917–1922," in eds. Elizabeth Cowling and Jennifer Mundy, *On Classic Ground: Picasso, Léger, de Chirico and the New Classicism 1910–1930* (London 1990), 296–308. This article poses a significant challenge to reductive political interpretations of postwar neo-classicism.

204. "Comme telle, leur œuvre est un objet de science. Tout en n'ayant d'autre but apparent que de nous amuser par des imitations admirablement réussies, ils ont réalisé une sorte de critique littéraire, dont la vérité nous étonne"; "Leur titre est significatif. La manière, cette manifestation de la malade moderne de l'originalité, c'est cela qu'ils ont mis en lumière . . . nos contemporains n'ont autre but que d'atteindre à tout prix à cette originalité. De là, cette recherche désastreuse du terme rare, du sujet singulier." Pierrefeu, "La Vie Littéraire – Les Livres de la Semaine," *L'Opinion* (April 19 1913), 493.

205. "géniaux démolisseurs d'illusions litté-

raires, la parodie esbrouffante . . . l'intellectualité de ces jeunesses du moment, qui, à côté nous prônent le futurisme, le cubisme, l'orphéisme." Armory, "La Vie Parisienne," *Pages Modernes* (April 1913), 160.

206. "notre époque où règene la fumisterie inconsciente des unanimistes, des futuristes et des rejetons du fade symbolisme." Maurice Privat, "Les Humoristes contemporains," *Le Parthénon* (March 20 1912), 153.

207. "Holà! grands peintres excessifs mes frères, holà, pinceaux sublimes et rénouvateurs, brisons les ancestrales palettes et posons les grands principes de la peinture de demain. Sa formule est l'Excessivisme . . . L'excess en tout est une force." La Peintre exigeant (Dorgelès), "Boronali-Aliboran," *Fantasio* (April 1 1910), 600. For a complete account of the Boronali hoax, see Carco, *De Montmartre au Quartier Latin*, 46–8; and Dorgelès, *Bouquet de Bohème*, 232–40.

208. *Société des Artistes Indépendants. Catalogue de la 26ᵐᵉ Exposition 1910* (Paris 1910), 50.

209. (Dorgelès), "Boronali-Aliboran," 599.

210. *Ibid.*, 599.

211. Dorgelès, *Bouquet de Bohème*, 232–3, 238.

212. Warnod, "Un Ane chef d'Ecole," *Le Matin* (March 28 1910), 4; photographs of the Boronali painting and the certified document were also published in Anon., "Une 'Beffa' au Salon des Indépendants," *L'Illustration* (April 2 1910).

213. "persuadé qu'une fumisterie de ce genre peut avoir une grande influence sur le goût du public et la confiance qu'il montre pour tout ce qui lui paraît extraordinaire." Quoted in Warnod, "L'âne et le Salon des Indépendants," *Comoedia* (March 30 1910), 2; for other references to Boronali in 1910, see: Anon., "Enquêtes a propos des Indépendants," *Tendences Nouvelles* (May 1910), 1091–3; Emile Zavie, "Les Arts – Le Salon des peintres indépendants," *Le Feu* (May 1910), 183–4; Victor Meric, "Notre maître Boronali," *Les Hommes du Jour* (April 2 1910), 7.

214. Dorgelès, "Boronali-Aliboran," 600.

215. Vauxcelles wrote of "cubico-boronalisme" at the Salon d'Automne in 1911; see Vauxcelles, "Des Cubistes et, surtout, de quelques autres," *Gil Blas* (November 24 1911). For other references to cubism or futurism and Boronali, see Debusschere, "Le Cubisme," *La Revue artistique* (November 1911), 2; Chevalier de Beaufort, "Les fou-touristes," *La Plume* (March 1 1912), 130; J.-C. Holl, "La Vie qui passe – L'Art qui demeure: Un lot d'impuissants," 10; L. Klotz, "Les Futuristes," *Le Gaulois du Dimanche* (July 5–6 1912), 23; M.A. Robida, in Henriquez-Phillipe, "Le Cubisme devant les Artistes," *Les Annales* (December 1 1912), 474; Laran, "Le Salon des Indépendants de 1912," 109. As late as 1920, Boronali was cited as a precursor of dada; see Rigadin, "Le Petit Cinéma – Dadaïsme, Futurisme et Boronalisme," *Presse du Soir* (August 14 1920).

216. "raison mème, étant la géometrie transcendante"; "libre instinct . . . l'inconsciente inspiration"; "poète fou"; "dans l'âme des bourgeois." Ed(ouard) S(arradin), "Le Salon des Artistes Indépendants," *Journal des Debats* (March 19 1912), 3 (this review appeared *verbatim* the following day in the *Journal du Soir*, signed Henri Schaunard).

217. "selon la dernière formule de M. Picasso; "provoquer . . . des palabres d'un ordre nouveau"; "Nous demeurerons étrangers au débat . . . demander à MM. Derain, Braque et à certain jeunes cubistes que leur admiration éclairée pour Picasso peut griser, s'il est vrai, selon la rumeur, que *Férat* soit le pseudonym de l'un d'entre eux féru en l'occurence de mystification"; "Et si M. Férat existait? Il lui faudrait encore se justifier." Anon., "Notes," *Les Ecrits français* (March 5 1914), 96–6. The debate to which Férat's "Lacerba' picture is said to allude is somewhat mysterious, though it may pertain to a contemporary controversy between the French and Italian avant-garde over issues of precedence and influence. For that controversy, see ed. Breunig, *Apollinaire on Art*, 503–6. Apollinaire made no mention of the presumed mystification in his Salon review for *L'Instransigeant* on February 28, and specifically praised Férat's still life; see *Apollinaire on Art*, 355.

218. For Férat, see Billy, *Les Soirées de Paris*, exhibition catalogue for the Galerie Knoedler (Paris 1958), np.

219. Pierre Daix and Joan Rosslet, *Picasso: The Cubist Years, 1907–1916: A Catalogue Raisonné of the Paintings and Related*

*Works* (New York 1979), nos. 701 and 702. The issue of *Lacerba* is date January 1, 1914.

220. "Est-ce l'œuvre d'un disciple . . . ou d'un fumiste?"; "Et voici André Derain lavé d'une terrible accusation, laquelle a dû le mettre en joie." Anon., "Les Arts – Férat?," *Gil Blas* (March 11 1914), 3.

221. For Duchamp and Brisset, see: Sanouillet, "Marcel Duchamp and the French Intellectual Tradition," 51–2; George H. Bauer, "Duchamp's Ubiquitous Puns," in eds. Kuenzli and Naumann, *Marcel Duchamp: Artist of the Century*, 127–48, in which Brisset is discussed (132, 142–5), and for which he is a kind of governing methodological model; Dominique Chateau, "Langue philosophique et théorie de l'art dans les écrits de Marcel Duchamp," *Les Cahiers du Musée National d'Art Moderne* (Autumn 1990), 45–6; and Jack J. Spector, "Duchamp's Androgynous Leonardo: 'Queue' and 'Cul' in *L.H.O.O.Q.*, *Source*" (Fall 1991), 31–5.

222. Reboux, "Le Prince des Penseurs," *Le Journal* (January 14 1913), 6. Reboux notes the recent publication of Brisset's book *Les Origines Humaines*, in which Brisst's linguistic investigations were specifically applied to questions of natural history. He also remarks that Brisset was elected with 200 votes, winning over Bergson, Barrès and assorted others.

223. "une affreuse blague"; "Point n'est besoin de se mettre à la recherche d'âmes simples" Meric, "De Sales Blagues," *Les Hommes du Jour* (April 19 1913), 10. For an unannotated, apparently first-hand account of the Brisset hoax, see Charles Picart Le Doux, "Pierre Brisset," in Caradec and Arnaud eds., *Encyclopédie des Farces et Attrapes et des Mystifications*, 59–60; according to Le Doux, the ceremony was followed by a large banquet at the restaurant Léon on the rue Saint-Honoré (with numerous congratulatory toasts), and after-dinner festivities at the Moulin de la Galette. The affair was also treated as a parody in an unsigned item in *Eclair*, "Le Prince des Pensurs," April 14, 1913, 1.

224. On Rousseau's contribution, see especially Shattuck, *The Banquet Years*, 107–11; and Carolyn Lanchner and William Rubin, "Henri Rousseau and Modernism," in the exhibition catalogue *Henri Rousseau* (New York 1984), 35–89. Rousseau's influence on the avant-garde was recognized at the time; see Guilbeaux, "Paul Signac," *Les Hommes du Jour* (April 22 1911), 4.

225. For complete details of these episodes, see Shattuck, *The Banquet Years*, 59, 66–72; and Henry Certigny, *La Verité sur le douanier Rousseau* (Paris 1961).

226. Jean Lecoq, "Propos d'Actualités – Mystification," *Le Petit Journal* (January 10 1909), 1.

227. See William Rubin, "From Narrative to 'Iconic' in Picasso: The Buried Allegory in *Bread and Fruitdish on a Table* and the Role of *Les Demoiselles d'Avignon*," *Art Bulletin* (December 1983), 638; see also Salmon's defense of the avant-garde against charges of mystification at Rousseau's expense in La Palette (Salmon), "Les Arts – Henri Rousseau," *Gil Blas* (November 1 1912), 4; and his first-hand account of the banquet in *Souvenirs sans fin: Deuxième Epoque (1908–1920)*, 50–5.

228. Salmon, in "Testimony against Gertrude Stein," *Transition* (supplement to February 1935), 15.

229. Anon. (Georges de Céli?), "Notes d'Actualités – L'Exposition Rousseau," *Gazette de France* (October 30 1912), 1.

230. Significantly, Sylvain Bonmariage later claimed that "Nous comparions les œuvres de Rousseau à celles des préraphaélites, de Van Eyck, de Giotto et du maître d'Oultremont, avec le même esprit de mystification que nous mîmes, plus tard, à evoquer Ingres à propos de la première toile que notre camarade Metzinger avait couverte de cubes gris pour le Salon d'Automne de 1909." See Bonmariage, "Apollinaire et Rousseau," *Partisans* (May 1924), 7. That is, Rousseau and Metzinger are linked not only in their mutual pictorial simplification of form, but as stylists whose modernity was just as counterfeit as any claim that they might lay to membership in the great traditions of true art.

231. Lanchner and Rubin, "Henri Rousseau and Modernism," 35–44.

232. Duchamp, "The Great Trouble with Art in this Country," 126.

233. Cabanne, *Dialogues with Marcel Duchamp*, 23–4, 39. It is not my intention to question Princet's influence on avant-garde interest in the fourth dimension, only to reframe the context of his role. For

Princet's contact with cubists around Montmartre and Puteaux, and speculation over his impact on their work, see Fry, *Cubism*, 61 (who notes that Princet's sole extant writing, a catalogue preface for a Delaunay exhibition at the Galerie Barbazanges in Paris, February to March 1912, is devoid of theory); Gamwell, *Cubist Criticism* (Ann Arbor 1980), 33, 51, 66, 162 n. 86, where the earliest references to Princet – by Metzinger and Salmon in 1910 – are reprinted; and Henderson, *The Fourth Dimension*, esp. 67–72. Henderson attributes the tone of Duchamp's remarks on Princet to "distance from the idealistic Cubist era in which the fourth dimension and the new geometries had been such major concerns, as well as simple lapses of memory." (118).

234. Duchamp, "The Great Trouble with Art in this Country," 126. Duchamp's remark occurs in the context of a discussion on the influence of the fourth dimension, and just before his description of Brisset. See also Billy, *Guillaume Apolinaire*, 18: "Si mystifier les gens, c'est se moquer d'eux et les in-duire en erreur, non, Apollinaire n'avait pas l'esprit de mystification, mais si mystifier, c'est jouer avec la part de hasard, de risque et de mystère que renferme toute entreprise humaine et qui dètermine dans une certaine mesure son orientation et son succès, oui, Apollianaire avait l'esprit de mystification".

235. For Duchamp and Roussel, see Sanouillet, "Marcel Duchamp and the French Intellectual Tradition," 52–3; Jindrich Chalu-pecky, "Nothing but an Artist," *Studio International* (January–February 1975), 36; Georges Raillard, "Roussel – les fils de la Vierge," in *Marcel Duchamp: abcédaire*, 185–200; George H. Bauer, "Duchamp's Ubiquitous Puns," 132–3; and Dominique Chateau, "Langue philosophique et théorie de l'art dans les écrits de Marcel Duchamp," 45–6. For a biographical study of Roussel, see Jeanine P. Plottel, "Raymond Roussel: Flotsam and Jetsam," *Dada/Surrealism* (1982), 95–105.

236. Sanouillet, "Marcel Duchamp and the French Intellectual Tradition," 52.

237. Duchamp, "The Great Trouble with Art in this Country," 126; see also Cabanne, *Dialogues with Marcel Duchamp*, 33–4, 40–1.

238. "cauchemar lucide"; "réalité chimérique."

Eragaste, "Théâtre d'Antoine," *Le Théatre* June (I) 1912, 23–4; the critic quotes to this effect from other reviews in *Le Gaulois*, *Le Journal* and *Revue internationale illustré*.

239. "se réclame à la fois de la féerie, de la revue, de l'opéra, du cinéme, de la farce et de quelques autres genres" Anon., "Au Théâtre Antoine," *Comoedia illustré* (May 15 1912), 680.

240. "si M. Roussel, au lieu de signer lui-même son oeuvre, l'eût fait signer par un de ses palefreniers, et se fût donné comme mécène, une école d'art se serait formée, on aurait crié au génie, comme il se fait d'habitude, et, en ce cas, la mystification eut été réussie et complète." Picrochole, "Le Charivari théâtrale – L'Actualité Théâtrale," *Le Charivari* (June 6 1912), 6.

241. Duchamp, "The Great Trouble with Art in this Country," 126.

242. Cabanne, *Dialogues with Marcel Duchamp*, 37.

243. *Ibid.*, 48.

244. Duchamp, "A Conversation with Marcel Duchamp," a 1956 television interview with James Johnson Sweeney that is excerpted as "Regions which are not ruled by time and space," in eds. Sanouillet and Peterson, *The Writings of Marcel Ducamp*, 130.

245. "Le cubisme basé sur une formule géométrique est le produit d'une cérébralité sèche. Il bannit l'émotion, sacrifie la couleur aux recherches linéaires." Guilbeaux, "La Vie et les Arts – Les Indépendants," *Les Hommes du Jour* (April 29 1911), 8.

246. "cette volupté que leurs confrères essayent d'enfermer dans un corps nu; ils aspirent à l'essence, à l'idée pure, à une ivresse speculative comparable à celle qui jaillit de l'étude des mathématiques." Michel Puy, "Beaux-Arts – Les Indépendants," *Les Marges* (July 1911), 28.

247. Regarding the iconography of science and pseudo-science, see especially: Lawrence D. Steefel, *The Position of Duchamp's "Glass' in the Development of His Art* (New York 1977); Ivor Davies, "New Reflections on the *Large Glass*: The Most Logical Sources for Marcel Duchamp's Irrational Work," *Art History* (March 1979), 85–92; Adcock, *Marcel Duchamp's Notes from the "Large Glass"*; Linda Henderson, *The Fourth Dimension and Non-Euclidian Geometry in Modern Art*

(Princeton 1983). Henderson is currently preparing a monograph on "electricity, chemistry and physics in the *Large Glass*"; presumably, this will incorporate material from a talk delivered at the 1991 CAA conference, "Marcel Duchamp's 'Painting of Frequency': Science and Technology in the *Large Glass*," concerning an iconography of electromagnetism. For Duchamp and medieval alchemy, see: Arturo Schwarz, "The Alchemist Stripped Bare in the Bachelor, Even," in d'Harnoncourt and McShine, *Marcel Duchamp*, 81–98; Maurizio Calvesi, *Duchamp invisibile: La costruzione del simbolo* (Rome 1975); Jean Clair, *Marcel Duchamp, ou, Le Grand Fictif* (Paris 1975); Jack Burnham, "An Abstract: Duchamp and Kabbalah – Levels of the Mystical Imagination," *Presentations On Art Education Research*, no. 5 (1979), 85–91; and John F. Moffitt, "Marcel Duchamp: Alchemist of the Avant-Garde," in Los Angeles County Museum of Art, *The Spiritual in Art: Abstract Painting 1890–1985* (New York 1987), 257–69.

248. When Cabanne mentioned recent "interpretations" of the *Glass* and asked "What is yours," Duchamp responded: "I don't have any because I made it without an idea." Cabanne, *Dialogues with Marcel Duchamp*, 42.

249. *Ibid.*, 39.

250. "Il n'est rien dont on soit plus cruellement puni que d'avoir supposé de l'intelligence à un peintre. Sitôt qu'on croit avoir fortifié sa position en expliquant le sens de sa recherche il vous inflige un éclatant démenti et fait savoir à tout le monde que vous n'avez rien compris à son affaire ... A quoi bon critiquer leurs œuvres? Je voudrait seulement décrire leur état d'esprit. Ils prétendent penser; à les en croire, ils sont des théoriciens; l'intelligence en eux domine la sensibilité. Ils one bien senti que, pour être neufs, c'est en intellectualistes qu'il fallait se poser ... Mais dans leur cervelle il n'y a rien: aussi l'idée s'y dilate-t-elle, comme un gaz dans le cylindre d'un moteur; aspirée par la place à remplir, elle s'enfle, elle les gonfle, elle les emporte en avant"; "montrer les objets ... dans 'les quatre dimensions de l'espace esoterique'." Rivière, "Le Salon des Indépendants," *La Nouvelle Revue française* (May 1 1912),

891–2.

251. "intelligent mais dèvoyé ... une épure de trigonométrie." Vauxcelles, "Le Salon d'Automne," *Gil Blas* (September 30 1912), 3.

252. Vauxcelles, Letter to the editor, *Les Hommes du Jour* (October 19 1912), 10; "Les Arts – Discussions," *Gil Blas* (October 22 1912), 4; "Les Arts – Cubistes," *Gil Blas* (November 14 1912), 4; "Les Arts – Encore lui!," *Gil Blas* (December 3 1012), 4.

253. "agréables synthèses de mystification." Tabarant, "Petite Gazette des Arts – Le Salon de la Section d'Or," *Paris-Midi* (October 10 1912), 2.

254. "je vous accorde que le titre n'est pas heureux. Je crois, pour ma part, que le peintre a voulu évoquer la sensation en nous de ces étranges obsessions – trop connues des surmenès intellectuels – obsessions qui tourment d'un chaos hallucinant d'absurdités, le cerveau fatigué de logoque." Goth, "Les Arts (reply to Vauxcelles)," *Les Hommes du Jour* (October 26 1912), 17.

255. Gleizes and Metzinger, *Cubism*, 64.

256. Cabanne, *Dialogues with Marcel Duchamp*, 52.

257. See Milton Brown, *The Story of the Armory Show* (New York 1963), 107–15.

258. Duchamp, "G255300 United States of America," 10.

259. Camfield, *Fountain*, 17, including n. 6.

260. For the Society, see Francis Naumann, "The Big Show: The First Exhibition of the Society of Independent Artists, Part I," *Artforum* (February 1979), 34–8, and "Part II: The Critical Response," *Artforum* (April 1979), 48–53; Clark S. Marlor, "A Quest for Independence: The Society of Independent Artists," *Art and Antiques* (March–April 1981), 75–81; and Camfield, *Fountain*, 14–20.

261. See Thierry de Duve, "Given the Richard Mutt Case," in ed. De Duve, *The Definitively Unfinished Marcel Duchamp*, 187–230.

262. For the most detailed account, see Camfield, *Fountain*, 24–6.

263. See Duchamp, "G255300 United States of America," 10; Camfield, *Fountain*, 22–4; Varnedoe, "Advertising," 274–6.

264. "The Richard Mutt Case," 31.

265. For Duchamp's so-called bisexuality and/or androgyny, see Lebel, *Marcel*

Duchamp, 46; and Schwarz, *The Complete Works of Marcel Duchamp*, 484–5; Calvesi, *Duchamp invisibile*, 285–8; Jack J. Spector, "Freud and Duchamp: The Mona Lisa "Exposed'," *Artforum* (April 1968), 56; Theodore Reff, "Duchamp & Leonardo: L.H.O.O.Q.-Alikes," *Art in America* (January 1977), 90–1; for a mathematical analysis, see Craig Adcock, "Duchamp's Eroticism: A Mathematical Analysis," in eds. Kuenzli and Naumann, *Marcel Duchamp: Artist of the Century*, 149–67.

266. "Za la Vie, Za la mort!' devint par blague le cri de ralliement." Carco, *De Montmartre au Quartier Latin*, 1927, 208. Zavié remains "Zavié" in all of the art criticism with his by-line that I have collected. In his memoirs, however, Salmon refers to him as "Zavie"; see Salmon, *Souvenirs sans fin: Deuxième Époque (1908–1920)*, 235.

267. For issues of the *Blindman* in Apollinaire's library, see Boudar and Caizer-gues, *Catalogue de la Bibliothèque de Guillaume Apollinaire II*, 157; for a reprint of the recently recovered article, which appeared unsigned in the June 16, 1918 issue of *Mercure*, see ed. Caizergues, "Echos et anecdotes inédits d'Apollinaire," *Cahiers du Musée national d'art moderne*, no. 6, 1981, numéro spécial Guillaume Apollinaire, 15.

268. "moins libéraux que les Indépendants de Paris qui exhibèrent le tableau de Boronali, tout en sachant bien qu'il s'agissait d'une blague ou plutôt d'un coup monté … ils ne se reconaissaient pas le droit d'empêcher même une farce." Apollinaire, "Le cas de Richard Mutt," 15.

269. "essayer de faire croire au public que les Indépendants, les peintres, les critiques et les amateurs d'avant-garde avaient été mystifiés … un foi de plus que les journaux français se sont fait une ligne de conduite de s'opposer par toute la force de leur tirage à tout ce qui est jeune et neuf, en art aussi bien qu'en science et qu'en littérature." *Ibid.*, 15.

## CHAPTER 4

1. "Une seule chose peut sauver la peinture, c'est la blague … La blague est toute-puissante. Avec la blague on se sort de tout." Derain, *Lettres à Vlaminck* (Paris 1955), 178.

2. "*Parade*, c'est l'histoire du public qui n'entre pas voir le spectacle intérieur malgré la réclame et sans doute *à cause de la réclame* qu'on organise à la porte." Jean Cocteau, "Avant 'Parade'," *L'Excelsior* (May 18 1917), 5.

3. This assumption has become taken for granted in the recent literature. See in particular: Richard Axsom, *Parade: Cubism as Theater* (New York 1979), 60–3; Jerrold Seigel, *Bohemian Paris: Culture, Politics and the Boundaries of Bourgeois Life, 1830–1930* (New York 1986), 362; Kenneth Silver, *Esprit de Corps: The Art of the Parisian Avant-Garde and the First World War, 1914–1925* (Princeton 1989), 117–18; Christopher Green, *Cubism and its Enemies* (New Haven 1987), 144–5; Deborah Menaker Rothschild, *Picasso's "Parade"* (New York 1991), 75, 189.

4. "Toute œuvre vivante comporte sa propre parade. Cette parade seule est vue par ceux qui n'entrent pas. Or, la surface d'une œuvre nouvelle heurte, intrigue, agace trop le spectateur pour qu'il entre. Il est détourné de l'âme par le visage, par l'expression inédite qui le distrait comme une grimace de clown à la porte. C'est ce phénomène qui trompe les critiques les moins esclaves de la routine." Jean Cocteau, "Preface (1922)" for *Les mariés de la Tour Eiffel*, reprinted in Cocteau, *Antigone, suivi de les mariés de la Tour Eiffel* (Paris 1986), 66.

5. See Alan Bowness, "Picasso's Sculpture," in eds. Roland Penrose and John Golding, *Picasso in Retrospect* (New York 1973), 133. This excepts Picasso's participation at the Salon d'Antin and the Lyre et Palette gallery, both in 1916. In his biography of Cocteau, Francis Steegmuller notes that Picasso's first one-man show in 16 years, at the Paul Guillaume gallery, followed *Parade* in 1918; see Steegmuller, *Cocteau: A Biography* (Boston 1970), 191.

6. See especially: Douglas Cooper, *Picasso Theater* (New York 1968), 16–20; Steegmuller, *Cocteau*, 145–82; and Rothschild, *Picasso's Parade*, 42–7.

7. "Le décor représente les maisons à Paris un Dimanche. / Théâtre forain. Trois numéros de Music-Hall servent de Parade. / Prestidigitateur chinois. / Acrobates. / Petite fille américaine. /

Trois managers organisent la réclame. Ils se communiquent dans leur langage terrible que la foule prend la parade pour le spectacle intérieur et cherchent grossièrement à le lui faire comprendre. / Personne n'entre. /
Après le dernier numéro de la parade, les managers exténués s'écroulent les uns sur les autres. /
Le chinois, les acrobates et la petite fille sortent du théâtre vide. Voyant l'effort suprême et la chute des managers, ils essayent d'expliquer à leur tour que le spectacle se donne à l'intérieur." Cocteau, *Théâtre t.II* (Paris 1957); English translation from Silver, *Esprit de Corps*, 117, with some adjustments.

8. Lydia Sokolova, who was a dancer in the Ballet Russes at the time, describes the Mangers as having been eight feet tall; see *Dancing for Diaghilev* (New York 1961), 103. But an examination of the production photos suggests that they were much bigger than that; writing to Léonce Rosenberg several days after opening night, Juan Gris said they were "double grandeur nature" (from a letter in the archives of the Centre Georges Pompidou, Paris, no. C679600.422).

9. Louise Faure-Favier, "La Vie heureuse d'une petite danseuse," *Paris-Midi* (May 19 1917), 2.

10. For the pantomime motifs, see Cocteau, "La Collaboration de 'Parade'," 31; for the "Rag" music, see Ornella Volta, *Erik Satie & la Tradition Populaire* (Paris 1988), 26, 28; see also the letter from Satie to Cocteau dated October 19, 1916, reprinted and translated in Cooper, *Picasso Theater*, 335.

11. From unpublished notes by Cocteau quoted in Martin, "The Ballet *Parade*," 108.

12. Cocteau, "La Collaboration," 31.

13. This is a composite of three such readings of Picasso's drop curtain: Axsom, *Parade*, 103–7 and 179–80; Martin, "The Ballet *Parade*," 101–4; and Melissa A. McQuillan, "Painters and the Ballet, 1917–1926: an Aspect of the Relationship between Art and Theatre," Doctoral dissertation, Institute of Fine Arts (New York 1979), 170–5, 182. (It should be noted that a comparison between *Parade* and futurism was first proposed by Marianne Martin in a College Art Association talk in January 1973, though only published by her for the first time in the 1978 article.)

14. McQuillan, *Painters and the Ballet*, 185.

15. Silver, *Esprit de Corps*, 115–26 (the Vanelli is reproduced on 120); Green, *Cubism and its Enemies*, 145, citing Silver. Most recently, Rothschild has added a valuable profusion of source material to support this version, as well as precise iconography for other topics that have been previously proposed in the *Parade* literature, but relatively undeveloped: the real life of the fairground *spectacle*; related subject matter in the poetry of Verlaine and Apollinaire; prior depictions of the fairground from the history of French painting; Picasso's own early work on *saltimbanque* and *commedia dell'arte* themes; and the artist's biography around 1917. See Rothschild, *Picasso's "Parade"*, 209–68. In fact, her global treatment of the curtain contains both interpretations that dominate *Parade* studies: a spatially complex expression of cubism masked beneath the appearance of simple charm (209, 212, 214); and, with references to Silver, a nostalgic, Latinate or Mediterranean banquet scene infused with the sentiments of wartime nationalism (245–8, 263–4, 266).

16. Rothschild, for example, makes numerous allusions to the critical reception of *Parade*, but cites no primary critical literature of 1917; see Rothschild, *Picasso's "Parade"*, 32, 35, 41, 90, 97, 99, 186, 189, 207, 214, 266. For Silver, Cocteau's miscalculation and the failure of *Parade* are understood almost wholly in political terms; see Silver, *Esprit de Corps*, 118. In a reading which recalls Cooper (*Picasso Theater*, 27), he stresses that the excesses of all modern art had, by 1917, been commonly associated in the xenophobic French public mind with the putative esthetic barbarism of German culture, and that Cocteau simply misjudged his audience in this respect (even with regards to the anticipated sympathy of the fashionable society elite). Further, though politically correct in his inclinations, Cocteau failed to recognize the flammability of certain basic ingredients onstage: Picasso, a notorious "revolutionary" of pre-war art, was joining hands with a ballet troupe from Russia, where, the French feared, revolutionary politics

might topple the war-effort. Thus, the hostility which greeted *Parade* is said to have come as something of a surprise. This argument is certainly persuasive given Silver's larger discussion of the wartime politics of culture; but it is not substantiated by more than a few passages from actual opinion of the time, and a survey of the critical press on *Parade* reveals that it accounts for a small fraction of the documentable hostility. On the subject of the drop curtain, Silver maintains that it apparently fulfilled its intended function. But according to the criticism, the drop curtain went unappreciated as a work of Latinate beauty. Ingresque classicism does indeed come up, but the implication is that the curtain fails as such: see Abel Hermant, "Théâtres – Les Ballets Russes," *L'Excelsior* (May 20 1917), 5. In other cases, the curtain is simply dismissed as garish or self-consciously naïve: see Anon., "Les ballets russes," *Le Cri de Paris* (May 27 1917), 13; and Jean Poueigh, "Le Carnet des Coulisses. La Musique – Parade . . . ," *Le Carnet de la Semaine* (June 3 1917), 12.

17. This is particularly the case throughout Silver's discussion, and for Axsom, who explains that his emphasis on Cocteau is intended to redress what he perceives as disproportionate attention in the *Parade* literature to Picasso and Satie; see Axsom, *Parade*, 33. Rothschild makes the same claim for her study; see Rothschild, *Picasso's "Parade,"* 43. Steegmuller also addresses "the minimizing of [Cocteau's] role in *Parade*," tracing it back to "professional jealousies of the period"; see Steegmuller, *Cocteau*, 189. Accordingly, Steegmuller (61), Axsom (60–4) and Rothschild (70) propose that Cocteau intended the *Parade* narrative to be as much an allegory of his own career frustrations as an allusion to the plight of the avant-garde in general.

18. I will be distinguishing between the value of Cocteau's statements on *Parade* from spring-summer 1917 – the immediate vicinity of the ballet's début – and his later reflections on the work; both, however, are as interesting for what they imply as what they state outright, and must not be taken at face value. Recent interpretations of *Parade*'s failure at the Châtelet, however, do not distinguish between Cocteau's writings from 1917 and those from 1918 and after, composed from outside the heat of the moment. This is true not only of Cooper, Axsom, Silver and Rothschild, but of Jerrold Seigel, who discusses *Parade* in the context of his larger thesis concerning the "confusion that had grown between art and the life that parodied it, the entanglement of modernism with Bohemia." See Seigel, *Bohemian Paris*, 359–65, for his discussion of *Parade*. Seigel bases his treatment of *Parade*'s failure almost exclusively on Cocteau's statements from 1918–22, a curious limitation given his signal interest in issues of artist-audience (bohemian-bourgeois) dynamic. As a result, he neglects the authentic response of 1917, and misrepresents the ambiguities of *Parade* as having been deliberately built into the work by Cocteau from its inception.

19. Cooper, *Picasso Theater*, 20–3, for an account of Satie's correspondence concerning the rift between Picasso and Cocteau; and 333–7, for a reprint of the correspondance itself. See also Steegmuller, *Cocteau*, 166–8, for a discussion of the conflict.

20. Citing the gradual simplification and legibility of cubism during the war, and its apparent appeal to a fashionable upper-class audience, Rothschild is at pains to reject the notion that cubism was provocative in 1917; elements of cubism in *Parade* are "mellow" at best, and "not the cause of the shock and dismay experienced by *Parade*'s first audience." See Rothschild, *Picasso's "Parade"*, 32, 35, 189, 204. Following Cocteau's post-production defense of the ballet and later accounts by other members of the Ballets Russes, she suggests instead that audience "outrage" was derived from aspects of popular entertainment that dominate the work, violating audience expectations of a "highbrow" ballet performance. The actual press reveals a different, more complicated scenario, wherein antagonism towards popular culture emerges as a prominent but variegated category of response that is otherwise inextricable from questions concerning the nature and purpose of cubism and the avant-garde, questions which are central to the allegory of the ballet, the substance of Cocteau's own ambivalence, and the critical debate.

21. Apollinaire, "'Parade' et l'Esprit Nou-

veau," *L'Excelsior* (May 11 1917), 5; Cocteau, "Avant 'Parade'," (as in n. 1). This should not be taken to imply that Cocteau and Apollinaire were working in concert; Apollinaire's statement is notorious for having named Satie, Massine and Picasso as collaborators on the ballet, while referring to Cocteau only as the inventor of the epithet "ballet réaliste." Steegmuller discusses the possible antipathy between the two at the time. See Steegmuller, *Cocteau*, 182–3.

22. "*Parade* renversera les idées de pas mal de spectateurs. Ils seront surpris certes, mais de la plus agréable façon et charmés, apprendront à connaître la grâce des mouvements modernes dont ils ne s'étaient jamais doutés." Apollinaire, "Parade'et l'Esprit Nouveau." English translations are from ed. and trans. Susan Suleiman, *Apollinaire on Art: Essays and Reviews 1902–1918* (New York 1988), 452–3.

23. "qui cache des poésies sous la grosse enveloppe du guignol. Le rire . . . c'est une arme trop latine pour qu'on la néglige"; "La force de la France . . . qui s'opposent au lourd esthétisme germain"; "que la rôle de chacun épouse celui de l'autre sans empiéter sur lui"; "des figures géantes, fraiches comme des bouquets"; "les divinités vulgaires de la réclame . . . affiches arrogantes, machines . . . personnages inhumains." Cocteau, "Avant 'Parade'," 5.

24. Cocteau, "Scandales," *The New Criterion* (January 1926), 136.

25. "mois admirables . . . cette petite chose si pleine et dont la pudeur consiste justment à n'être pas agressive." Cocteau, "La Collaboration de 'Parade'," *Nord/Sud* (June–July 1917), 29.

26. "Une attitude d'humoriste, qui date de Montmartre, empêche le public distrait d'entendre comme il faut la musique . . ." *Ibid.*, 29.

27. "n'avaient rien d'humoristique. Elles insistaient au contraire sur le côté occulte, sur le prolongement des personnages, sur le verso de notre baraque foraine. Le Chinois y était capable de torturer des missionnaires, la petite fille de sombrer sur le Titanic, l'acrobate d'être en confidence avec les astres." *Ibid.*, 29.

28. Cocteau's notes, quoted in Martin, "The Ballet *Parade*," 88.

29. "sobre, nette . . . dimension inconnue grâce à laquelle on écoute simultanément la parade et le spectacle intérieur." Cocteau, "La Collaboration de 'Parade'," 29.

30. Axsom, *Parade*, 37.

31. "C'est *son* drame et le drame éternel entre le public et la scène"; "Ma part de travail ne lui tend pas la perche farce." Cocteau, letter to Misia Sert, reprinted in Misia Sert, *Misia* (Paris 1952), 205–6.

32. "trou amplificateur (imitation théâtrale du gramaphone forain, masque antique à la mode moderne)." Cocteau, "La Collaboration de 'Parade'," 29.

33. "J'imaginai donc les 'Managers' féroces, incultes, vulgaires, tapageurs, nuisant à ce qu'ils louent et déchainant (ce qui eut lieu) la haine, le rire, les haussements d'épaule de la foule, par l'étrangeté de leur aspect et de leurs mœurs." *Ibid.*, 30.

34. "en *mieux, derrière* Cocteau"; "étourdissant! Prodigieux!" Satie, in a letter to Valentine Hugo dated September 14, 1916, reprinted and translated in Cooper, *Picasso Theater*, 334.

35. *Ibid.*, 21, 23. Rothschild maintains that Satie is referring simply to Cocteau's barker lines, though the two conflicting "texts" to which he alludes, Cocteau's versus Picasso's, more likely refer to the overall scenario of the ballet (Picasso submitted no new barker libretto); see Rothschild, *Picasso's "Parade"*, 132. In a letter of September 20, 1916, Satie is relieved to report that Cocteau and Picasso "have reached an agreement," though the evidence of Cocteau's *Nord/Sud* statement, and Cocteau's attempt to save the lines of *réclame*, suggests that the agreement was conflicted at best. For Satie's letter, see Cooper, *Picasso Theater*, 334.

36. "ouvrant une brèche sur le rêve." Cocteau, "La Collaboration de 'Parade'," 29. Rothschild takes the Managers to have been consistent with Cocteau's original plan; see Rothschild, *Picasso's "Parade*," 133.

37. "l'obligèrent à rompre avec d'anciennes formules"; "accident organisé, des faux pas . . . une discipline de fugue." Cocteau, "La Collaboration de 'Parade'," 30. Cocteau borrowed this characterization of the Managers' dance from his own Rome notebook; see Cooper, *Picasso Theater*, 23 n. 41 for the early quote. It was Apollinaire, however, who first made

this point in print, insisting that the Manager costumes were not an obstacle to Massine, but an agent of "désinvolture." See Apollinaire, "'Parade' et l'Esprit Nouveau," 5.

38. Cocteau, *Le Coq et l'Arlequin* (1918), Paris, 1979, 67. For the dancers' dissatisfaction with the size and weight of the Manager costumes, see S.L. Grigoriev, *The Diaghilev Ballet 1909–1929* (London 1953), 121.

39. "cheval du fiacre de Fantômas, en monture de Charlie Chaplin"; "décidérent Picasso à lui laisser cette silhouette fortuite"; "Nous ne pouvions pas supposer que le public prendrait si mal une des seules concessions qui lui faites." Cocteau, "La Collaboration de 'Parade'," 30.

40. "plus du music-hall et de la baraque foraine que de la véritable peinture." R. Kimley, "Le Salon des Indépendants," *La France* (March 3 1914), 2.

41. Axsom, *Parade*, fig. 96.

42. "L'opposition de la masse aux élites stimule le génie individuel"; "L'extrême limite de la sagesse, voila ce que le public baptise folie"; "force de vie qui s'exprime sur une scène de music-hall démode au premier coup d'œil toutes nos audaces"; "A *Parade*, le public prenait la transposition du music-hall pour du mauvais music-hall"; "Notre *Parade* était si loin de ce que j'eusse souhaité, que je n'allai jamais la voir dans la salle." Cocteau, *Le Coq et l'Arlequin*, 55, 74, 64, 69, 66–7, 56 respectively.

43. "l'esprit de bouffonnerie est le seul qui autorise certaines audaces." Cocteau, Preface (1922) for *Les mariés de la tour Eiffel*, 69.

44. "de faire sortir auteurs, critiques et public de l'abominable comédie de bluff et de mensonge qu'ils se jouent les uns aux autres depuis une vingtaine d'années." Anon. and untitled editorial, *L'Effort* (supplement, June 1 1910), 1–4.

45. For this aspect of the nineteenth-century fairground, see Marilyn Brown, *Gypsies and other Bohemians: The Myth of the Artist is Nineteenth-Century France* (Ann Arbor 1985), 29; for hucksterism during the pre-war period, see G. Torlet, "Le Régime administratif applicable aux Nomades et marchandes forains," Doctoral Thesis, Faculté de Droit (Paris 1913), 8–27.

46. Paula Hays Harper, *Daumier's Clowns: Les Saltimbanques et Les Parades* (New York 1981), 18–29.

47. *Ibid.*, 30–34.

48. Georges Delesalle, *Dictionnaire Argot-Français et Français-Argot* (Paris 1896), 254.

49. Angelin Ruelle, *A la Fête de Neuilly: Silhouettes foraines* (Paris 1908), 91–2.

50. Anon., *La Foire aux Calembours* (Paris 1897); Anon., *Almanach des Abrutis* (Paris 1882); Anon., *Les Blagues de Papa Rigolo: Nouveau Recueil de Calembours, Jeux de Mots, Nouvelles à la Main, etc* (Paris 1897).

51. Swing, "Bonimenteurs d'aujourd'hui," *Fantasio* (October 1 1911), 162; Ernest Laut, "Bonimenteurs d'autrefois," *Fantasio* (October 1 1911), 163–5.

52. *Ibid.*, 165.

53. "On les traite de farceurs, de charlatans se moquant du public et battant la grosse caisse autour de leurs œuvres, lorsqu'ils sont au contraire des observateurs sévères et convaincus . . . Singuliers farceurs que ces martyres de leurs croyances!" Zola, "Le Naturalisme au Salon," *Le Voltaire* (June 18 1880), quoted in Harper, *Daumier's Clowns*, 82. Harper also addresses other relevant issues as they occured in the nineteenth century: the artist's identification with the clown as a performer who exhibits his skills before an audience, and as an estranged social outcast (78–92); and examples of the *parade* in mid nineteenth-century caricature as a metaphor for political and commercial charlatanism (161–5). Art historians writing about Picasso's early work have ignored the potential association of *saltimbanques* with the fairground as a milieu of fraud, favoring instead the metaphor of the bohemian outcast or the virtuoso performer. See Ellen H. Bransten, "The Significance of the Clown in Paintings by Daumier, Picasso and Rouault, *The Pacific Art Review* (1944), 21–39; Peter H. von Blanckenhagen, "Rilke und 'La Famille des Saltimbanques' von Picasso," *Das Kunstwerk* (1951), no. 4, 43–54; Theodore Reff, "Harlequins, Saltimbanques, Clowns and Fools," *Artforum* (October 1971), 30–43; Marilyn McCully, "Magic and Illusion in the Saltimbanques of Picasso and Apollinaire," *Art History* (December 1980), 425–33; Rothschild,

Picasso's "Parade", 227, 229, 231. None the less, the hucksterism of the *fête foraine* was a given for Apollinaire, who described Picasso's *saltimbanque* figures accordingly in 1905: "Sous les oripeaux éclatants des ses saltimbanques sveltes, on sent vraiment des jeunes gens du peuple, versatiles, rusés, adroits, pauvres et menteurs." Apollinaire, "Picasso, Peintre et dessinateur," *La revue immoraliste* (April 1905), 40 (English translation in ed. Leroy C. Breunig, *Apollinaire on Art*, 13). Gustave Coquiot, an early friend and patron of Picasso, and author of several lengthy appreciation pieces on popular performance of the period, highlighted the disorienting claims of the *parade* as a guilty pleasure of the *fête foraine*: "la moitié du spectacle est à la rue en parade ... toute la non-pareille théorie des jeux, la grosse farce des baraques ... la verve des parades singeant le pompeux, l'étourdissante ingéniosité des compères, tout le truc bon enfant et plaisant du mensonge, le rire, l'incompréhensible, le benêt, le hue donc! que je te pousse! l'insouciance, la blague du forain." Coquiot, "Fêtes Foraines" (1896), in *Les Féeries de Paris* (Paris 1909), 102.

54. "la parade faite pour attirer le public dans la baraque." André Maubel, "Chez les Peintres," *Homme Libre* (March 5 1914), 1.

55. H. Ayhaud-Degeorge, "Les Salons de 1913 – Salon des Indépendants," *Le Rappel* (March 26 1913), 2.

56. Armand Fourreau, quoted in Tristan Leclère, *Les Derniers Etats des Lettres et des Arts. La Peinture* (Paris 1913), 92.

57. "reconnaîtrait le son d'un bel instrument dans une parade foraine." M.C. Jacquemaire, "Le Salon d'Automne," *Homme Libre* (November 24 1913), 1.

58. "l'illustre mémoire du Banquiste Mangin." Lucien Métivet, "La Marchande de Crayons," *Fantasio* (December 1 1912), 352.

59. "Ainsi finit la parade dans les rires et les sifflets." Anon., "M. Marinetti chez les étudiants," *Le Matin* (March 10 1911), 3.

60. La Palette (André Salmon), "Courrier des Ateliers – Voici les Futuristes," *Paris-Journal* (January 18 1912), 4.

61. Chevalier de Beaufort, "Vérités-Sévérités – Les grotesques," *La Plume* (January 1 1911), 68.

62. Roger Allard, "Futurisme, Simultanéismes et autres Métachories," *Les Ecrits français*

(February 5 1914), 255.

63. "A la porte du cirque ... se sont eux-mêmes proclamés les pitres chargés du boniment." Léon Bailby, "En Passant – Cubistes," *L'Intransigeant* (October 14 1912), 1.

64. Siegel, *Bohemian Paris*, 365.

65. From letters to Léonce Rosenberg in the archives of the Centre Georges Pompidou, Paris, nos. C659600.421.424.

66. Cooper, *Picasso Theater*, 19; Steegmuller, *Cocteau*, 190.

67. See, most prominantly, Paul Souday, "La Semaine Théâtrale et Musicale – Un Ballet cubiste," *Paris-Midi* (May 22 1917), 3.

68. "Afin de ne pas trop surprendre le spectateur, il a eu l'habileté de placer ses conceptions les plus audacieuses sur des tréteaux de foire et de leur opposer quelques purs dessins au sujet desquels des critiques parleront d'Ingres." Régis Gignoux, "Courrier des Théâtres – Avant Première," *Le Figaro* (May 18 1917), 4.

69. "la pensée allégorique du poète a été trahie par les réalisations picturales et scéniques"; "le public du Châtelet ... est censé faire la sourde oreille ... les metteurs en scène de *Parade*, au lieu d'utiliser des figurants payés, parce que professionels, se servent des figurants payants, installés dans les salle. Mais qu'arriverait-il si ceux-ci, répondant à l'appel des managers, se ruaient à l'assaut du théâtre, en bousculant les musiciens de l'orchestre?" Simone de Caillavet, "Ballets Russes," *Le Gaulois* (May 25 1917), 1.

70. L'Horloger, "Le Ballet cubiste," *L'Heure* (May 23 1917), 2.

71. "Ironiste à froid, il sait mettre de l'humour partout, sauf dans sa musique." Poueigh, "Le Carnet des Coulisses. La Musique – Parade," 12.

72. "semble avoir tourné le dos aux rèves de beauté qui berçaient son adolescence pour se vouer tout entier à la blague et même la fumisterie. M. Satie n'aurait-il eu pour but ... que l'élaboration de farces de rapin musicale qui n'ont le plus souvent de drôle que leur titre ou les apophtegmes facétieux qu'il inscrit entre les portées?"; "La mystification est épaisse." Jean Marnold, "Musique – Les Ballets Russes," *Mercure de France* (September 1 1917), 135.

73. "l'Alphonse Allais de la musique ... en mettant au dessous des cinq lignes ordinaires une ligne supplémentaire

d'écri-ture"; "si l'on enlève le texte, il ne reste plus rien d'hilare"; "où les futuristes et les cubistes s'arrêtent, et où commencent les fumistes et les puffistes." Octave Séré, "Le Cubisme et la Musique," *La Rampe* (May 24 1917), 1.

74. Rothschild, *Picasso's "Parade"*, 30, 32, 35.

75. "on a vu cent fois cette invention au cirque, et les clowns anglais y mettent plus de fantaisie." Henry Bidou, "La Semaine Dramatique – A propos de ballets," *Journal des Débats* (May 21 1917), 3. For similar remarks, see also Pierre Lalo, "La Musique – Au théâtre du Châtelet," *Le Temps* (May 25 1917), 3; Jean Marnold, Musique – Les Ballets russes," 134; Camille Le Senne, "Derniers Créations de la Saison – Nouveautés et Reprises," *Les Spectacles* (May 30–June 14 1917), 3. Following Sokolova's account of opening night, Axsom suggests that *Parade*'s original audience responded enthusiastically to the Horse as a familiar comic turn. See Axsom, *Parade*, 74. To be true to the ambiguous reception of *Parade*, however, note that genuine amusement was difficult to distinguish from mocking derision.

76. "Imaginez trois numéros de music-hall servant de parade à un théâtre forain, tandis trois managers organisent la réclame. Ce n'est ni amusant, si spirituel, ni joli à regarder, ni novateur ainsi qu'on voudrait nous le faire accroire"; "nous persistons à ne découvrir la moindre parcelle d'art et d'agrément dans ces élucubrations, alors que le clown de Médrano ou du Nouveau-Cirque dépense et renouvelle chaque soir le trésor de son génie prime sautier." Jean Poueigh, "La Critique Musicale – Châtelet: Les Ballets Russes," *La Rampe* (May 31 1917), 4.

77. "à reproduire les effets burlesques qu'une douzaine de musiciens de foire produisent sans efforts." Henri Quittard, "Courrier des Théâtres – Les ballets russes au Châtelet," *Le Figaro* (May 20 1917), 3.

78. "Il est inutile de déranger tant d'artistes de grand talent pour un tel résultat obtenu, chaque jour, au Nouveau-Cirque, à Médrano et à l'Alhambra, à bien meilleur compte et sans prétention." A.F., "La Semaine dramatique et musicale – Chatelet. Les Ballets Russes," *L'Eclair* (May 23 1917), 2. Cocteau himself came close only once to abetting the evaluation of *Parade* as an imitation of popular performance. In a defense of *Parade* written for the American magazine *Vanity Fair*, Cocteau relates the ballet's narrative as mere plot, making no allusion whatsoever to allegory. See Cocteau, "Parade: Ballet Réaliste," *Vanity Fair* (September 1917), 37, 106. "The story of *Parade*," he maintains, "is the tragedy of an unsuccessful theatrical venture. Simple – innocent enough . . . No symbolism is hidden in it" (37). He even refers to the horse as a circus device, claiming that the ballet in general was intended to entertain in the manner of a Punch and Judy show. Cocteau appears to be experimenting here with a simplified version of his defense that circumvents the more complex issues of the debate back home.

79. "Le public a fait à *Parade* un accueil tumultueux, où les applaudissements et les sifflets étaient mélés. *Parade* n'en méritait pas tant. Et certes il n'en eût pas tant obtenu, si les spectateurs n'eussent été avertis, par les notices imprimées comme par les bruits répandus, que ce ballet était la première manifestation d'un art nouveau, d'une décoration, d'une chorégraphie et d'une musique également cubistes, destinées à faire une révolutions dans l'ésthetique de l'univers. *Parade* n'est rien de tout cela: rien qu'une chose fort banale." Pierre Lalo, "La Musique – Au théâtre du Châtelet," 3.

80. "Trop est trop . . . une petite chose, une très petite chose . . . qui ne semble pas . . . destinée à changer le train du monde." Henry Bidou, "La Semaine Dramatique – A propos de ballets," 3.

81. Guillot de Saix, "Le Théâtre – Les Ballets russes au Châtelet," *La France* (May 24 1917), 2; B. de Lomagne, "Chronique musicale – Châtelet: Les Ballets russes," *Le Soir* (May 27–8 1917), 2; Jean Poueigh, "La Musique – Parade," 12; Abel Hermant, "Théâtres – Les Ballets russes," 5; Pierre Lalo, "La Musique – Au théâtre du Châtelet," 3.

82. Examples are described in Jacques Garnier, *Forains d'hier et d'aujourd'hui* (Orleans 1968), 121–51 and 274–95. Both Axsom and Rothschild cite Garnier, though they mistakenly take Garnier's descriptive chapter title "Les Theatres de Magie – Varietés – Music-Hall" for the

period name of a single genre. See Axsom, *Parade*, 36; and Rothschild, *Picasso's "Parade"*, 75.

83. Until Rothschild, the pre-war and wartime history of *Parade*'s popular performance prototypes had been spared serious attention in much of the literature, which contains scattered, glancing references to the music-hall and the circus. Only Axsom took the trouble to note that, according to Huntly Carter in *The New Spirit in the European Theatre, 1914–1924* (London 1925), 49, "vaudeville" was far more popular than "conventional stage drama" during the war years in Paris; see Axsom, *Parade*, 56.

84. An intriguing notice concerning fairground entertainment appeared in the daily *Excelsior* (June 3 1917), 1, announcing that, in conformance with measures maintained since the beginning of the war, *fêtes foraines* were "Interdites en principe," and that, under special authorisation, only sales booths and shooting galleries would be permitted.

85. "la plus belle des portes ouvertes sur le rêve." Le Régisseur, "Le Théâtre au Front," *Mercure de France* (September 1 1917), 131. The phrase recalls Cocteau's own reference to the way in which the anonymous barker's voice in *Parade* would have acted to open "une brèche sur le rêve." Cocteau, "La Collaboration," 29.

86. "Ingéniosité," "esprit," "finesse," and "sense comique." *Ibid.*, 132.

87. Adolphe Brisson, "Chronique Théâtrale – Les Revues," *Le Temps* (August 13 1917), 3. See also Guillot de Saix, "Le Théâtre – La Revue de Music-Hall," *La France* (August 11 1917), 2.

88. Charles Darnatière, "Chronique Théâtrale," *La Revue Contemporaine* (August 25–September 25 1917), 630.

89. Brisson, "Chronique Théâtrale," 3.

90. The *revue* reform is inherited from the pre-war, as discussed in chapter one. It was, however, still an issue during the war. See, for example, Léo Claretie, "La Critique dramatique – Une revue au Théâtre Antoine," *La Rampe* (June 22 1916), 4.

91. "une énorme faute de goût"; "Qu'est-ce qui l'empêche de s'élever en dignité, de quitter le ton de la chansonnette et de la calembredaine pour atteindre à celui de la comédie et de la poèsie même?" Paul Souday, "La Semaine théâtrale et musicale–La Revue du Vaudeville," *L'Action*, August 1, 1917, 3.

92. Original program for the Olympia dated January 11, 1902. As in chapter one, unless otherwise noted, all references to original programs relate to music-hall materials in the Collection Rondel, Bibliothèque de l'Arsenal, Paris. In the case of non-*revue* evenings, there are no performance titles per se.

93. Rothschild, *Picasso's "Parade,"* 35.

94. Henry Bidou, "La Semaine Dramatique – A propos de ballets," 3.

95. Rothschild, *Picasso's "Parade,"* 75–76, 79, 101, 111.

96. *Ibid.*, 79, 81, 83, 111, 124.

97. For "The Yankee Girl," see original program for the Apollo from October, 1908; for "La New american 'Rag' reel dance," see original program for *Miss Alice des P.T.T.,* a *revue* by Tristan Bernard and Maurice Vicaire, at the Cigale in December 1912; for "Le Rage Time," see original program for *La Revue des Folies-Bergère* by Michel Carré and André Barde, at the Folies-Bergère in October 1913; for the "American Ragtimers," see Curnonsky, "A l'Olympia – 'La Revue légère," *Comoedia* (January 10 1914), 1.

98. For Le Professeur de Publicité Théâtrale, see original program for *A la Baguette!,* a *revue* by Dominique Bonnaud, Numa Blès and Georges Arnould.

99. See Axsom, *Parade*, 76, for a reference to the *compère* figure.

100. "la place de la Concorde, arrangée ou plutôt dérangée selon l'esthétique cubiste, l'obélisque est retourné comme une simple crêpe, les palais de Gabriel sont plantés *de traviolle*. Et tout cela a un joli petit air de catastrophe et de tremblement de terre." Curnonsky, "La Revue de l'Année à l'Olympia," *Le Music-Hall illustré* (December 1 1912), 5.

101. See original programs for the following *revues*: *Tangi-Tango: Pan! Pan! la Tanguinaette*! by Gardel-Hervé, at La Scala in September 1913; *Merci pour la langouste!* by Lucien Boyer and Bataille-Henri, at the Cigale in December 1913; *A vos Souhaites!* by Robert Dieudonné, at the Boîte à Fursy in November 1911; *La Grande revue sensationnelle!* by Léo Lelièvre and Henri Varna, at the Concert Mayol in July 1917; *La Revue Merveilleuse* by Quinel and Moreau, at the Olympia in May 1913.

102. "n'est pas, hélas!, exagérée, pas plus que leur tableau de Nijinsky et des nymphes que l'on prend pour une parodie." Xanrof, "La Comédie au Music-Hall et dans ses environs – 'La Revue de l'Année' à l'Olympia," *Comoedia illustré* (December 5 1912), 224.

103. The program for this performance is in the collection of the Musée de Montmartre, Paris. It is undated, but judging from celebrities on the bill, including Otéro, Mounet Sully and Sarah Bernhardt (it is unclear whether they actually appeared, or were imitated by other artists), it can be placed *c.* 1900 to 1910.

104. Grosbob, "La Redoute du 7 Mai" and "La Redoute de ce soir," *Comoedia* (May 7 1908).

105. Cooper, Steegmuller, McQuillan and Rothschild all feel compelled to defend *Parade* against its contemporary critics, to which end they cite later appreciations of the ballet by supporters of the avant-garde, featuring praise from within the community over the critical press of spring-summer 1917. See Cooper, *Picasso Theater*, 27–8; Steegmuller, *Cocteau*, 188, 190; McQuillan, *Painters and the Ballet*, 425–6; Rothschild, *Picasso's "Parade"*, 41, 99.

106. Axsom, *Parade*, 54–7; Martin, "The Ballet *Parade*," 87–90, 92, 101, 107–8; McQuillan, *Painters and the Ballet*, 121–2. This is not to deny that popular performance was a shared source for ideas on new theater during the period. None the less, in charting a kind of ideological network from modernist to modernist, the contact between the avant-garde and the outside world is sanitized, neglecting popular culture as a tangible model with its own history.

107. Anon., "Le Carnet du Liseur – Littérature," *Le Carnet de la Semaine* (June 10 1917), 9.

108. For Cooper, "Picasso's uncanny grasp of how to handle a theatrical spectacle played a large part in making *Parade* a humanly eloquent, witty and enjoyable entertainment which never lapsed into burlesque or pantomime." See Cooper, *Picasso Theater*, 26. Even without critical evidence, as well as Cocteau's statements, the unavoidable conclusion seems quite to the contrary – that Picasso's Managers and Horse are directly responsible for bringing authentic burlesque and pantomime into the ballet.

109. "Si *Parade* est une parodie, une farce de rapins spirituels, tout va bien. Mais les manifestes de ces messieurs me font craindre qu'ils n'aient voulu atteindre au sublime, et que leur ballet raliste ne soit la manfestation d'avant-garde d'une esthétique inouïe." De Caillavet, "Ballets Russes," 1.

110. "ont voulu s'amuser et nous mettre en présence d'une grosse pochade sans prétention." A.F., "La Semaine dramatique et musicale – Chatelet. Les Ballets russes," 2.

111. "une farce d'atelier, médiocrement divertissante." Lalo, La Musique – Au théâtre du Chatalet," 3.

112. "prétendue bouffonnerie dénuée de tout intérêt et plus encore du comique." H.G. Ibels, "L'Enseignement des Ballets Russes," *La Rampe* (June 14 1917), 9.

113. "à mettre en scène des objets réels qui perdent leur réalité du moment même qu'on les introduit dans un milieu factice"; "assez obscur . . . un amusant charge d'atelier, avec mise en scène plaisamment appropriée, musique à l'avenant, et qui somme tout, en dépit de quelques protestations, a paru divertir la grande majorité du public." De Lomagne, "Chronique Musicale – Chatelet: Les Ballets russes," 2.

114. "musique éclatante qui se souvient des orchestres de foire et de music-hall. Les initiés savent que ce ballet veut représenter le caractère de notre époque, que c'est une expression superréaliste de la vie moderne. Mais on peut supposer que tous les spectateurs ne sont pas initiés . . . Alors, pourquoi ce tapage, ces acclamations, ces bravos, ces sifflets, ces hourrahs et ces chut? Pouquoi s'effaroucher du burlesque dans un spectacle qui doit être burlesque?" André Warnod, "Petit Courrier des Arts et des Lettres – Parade," *L'Heure* (May 23 1917), 2.

115. "Avec cette *Parade* . . . nous nageons en plein paradoxe"; "La fantaisie a ses droite; la fumisterie même est un genre littéraire (ou artistiue), parfois savoureux. Seulement, il faudrait, autant que possible, éviter les malentendus"; "cette incompréhension . . . prouve que les auteurs ont atteint leur but . . . On écrit pour être compris, et aussi pour n'être pas compris, a dit Nietzsche(*sic*). Ce second objectif avait peut-être le premier rang dans les am-

bitions de MM. Jean Cocteau, Léonide Massine, Pablo Picasso et Erik Satie"; "Appeler 'réaliste' un ballet cubiste, c'est commencer loyalement par avertir son monde. Le cubisme est la négation même du réalisme"; "une vérité si lyrique, si humaine, si joyeuse qu'elle serait bien capable d'illuminer ... l'effroyable soleil noir de la *Mélancolie* d'Albert Durer"; "nous savons avec certitude qu'il s'agit d'une farce." Souday, "La Semaine théâtrale et musicale – Un Ballet cubiste," 3.

116. "A prendre *Parade* pour une folie, une bouffonnerie énorme, on ne peut en être choqué et l'on peut même la trouver assez drôle"; il est probable que ce symbole nous échapperait. Nous n'attribuerions point à la parade cette signification"; "On pourrait, d'ailleurs, en cherchant un peu, lui en attribuer d'autres. On peut surtout ne lui en attribuer aucune, et s'en amuser bonnement, comme d'une véritable entrée de clowns, d'un numéro de Guignol ou d'un épisode du bal des Quat'z-Arts"; "Et la partition de M. Erik Satie est, si l'on veut, une mystification, mais assez divertissante." *Ibid.*, 3.

117. "Avec ces innovations auxquelles on ne comprend rien, on ne sait plus quelle contenance prendre." Souday, "La Vie intellectuelle – Un Prétendu Scandale," *L'Action* (June 9 1917), 3. In 1919, Cocteau referred to Souday's article as the only defense of *Parade*'s collaborators against charges of esthetic criminality. See Cocteau, *Carte Blanche* (Paris 1920), 48.

118. "Mais précisément en raison des libertés qu'il s'accorde, le cubisme dispose d'excellentes ressources pour la caricature et la charentonnade." Souday, "Le Semaine Théatrale et Musicale – Un Ballet cubiste," 3.

119. "Les gens dits sensés te traiteront de fou si tu leur présentes un tableau composé de cette façon." Quoted from Christian Derouet, ed. *Fernand Léger: Une Correspondance de Guerre*, special edition of *Les Cahiers du Musée National d'Art Moderne* (Paris 1990), 72.

120. For the most extended discussion of the Maison Cubiste, see Nancy J. Troy, *Modernism and the Decorative Arts in France* (New Haven 1991), 79–96.

121. *Ibid.*, 93.

122. *Ibid.*, 85–95, for the theoretical program

behind the Maison Cubiste; see André Vera, "Les arts décoratifs au Salon d'automne," *La Grande Revue* (25 October 1912), 837–8, where eclecticism is criticized for being inconsistent and tame.

123. *Ibid.*, p. 243 n. 72.

124. Marie-Noelle Pradel, "La Maison cubiste en 1912," *Art de France* no. 1, (1961), 183; George Heard Hamilton and William C. Agee *Raymond Duchamp Villon 1876–1918* (New York 1967), 65–9; and Troy, *Modernism and the Decorative Arts in France*, 92–3.

125. Pradel, "La Maison cubiste en 1912," 184; Hamilton and Agee, *Raymond Duchamp-Villon*, 67; Ivan Margolius, *Cubism in Architecture and the Applied Arts, Bohemia and France 1910–1914* (London 1979), 7–8.

126. Le Cireur Nègre (Roland Dorgelès?), "L'Avenir du Cubisme," *Fantasio* (November 15 1912), 255–6.

127. To a certain degree, this kind of cubistic caricature was in turn anticipated by an autonomous development of geometric simplification in humorist illustration. Both Sem and Moriss were counted among the exponants of this trend as early as 1907, in an article for *La Grande Revue* which actually describes this tendency as a kind of "virtuosité cérébrale" that emphasizes *intelligence* over *émotion* – a value judgement that, as we have seen, would become a staple of cubist criticism beginning in 1910. See George Desvallières, "Aux Humoristes," *La Grande Revue* (July 10 1907), 538 and 546. These associations of geometry and cerebrality in the context of humor, which recall the "scientific" deadpan of mystification and *blague*, also reveal the popular dimension of critical observations otherwise understood to be the province of "high" art and its critics (as in Roger Benjamin, *Matisse's "Notes of a Painter": Cirticism, Theory, and Context, 1891–1908* (Ann Arbor 1987), 88, 92–5, 111); and this dimension suggests how the shared discourse affords an easy devaluation of modern style.

128. The film is one of a series of comic shorts produced by the company Pathé frères concerning the escapades of Rigadin, a character played by the performer Prince. Barrère's other (non-cubist) posters for the series are reproduced in Ruth

Malhorta, Marjan Rinkleff and Bernd Schalicke, *Das Fruhe Plakat in Europa und den USA*, vol. 2 (Berlin 1973–80), nos. 39–45. The film *Rigadin, Peintre cubiste* is also discussed by Jean Laude, for whom its satire of cubist style expresses a larger pre-war esthetic phobia for straight lines, angles and cubes. See Laude and Nicole de Romilly, *Braque: le cubisme fin, 1907–1914* (Paris 1982), 13. In their reading, caricature of cubism is of a piece with the hostile critical press, all of which manifests a resistence to cubism as the herald of a perceived change in cultural sensibility during the Belle Epoque (an opposition between the cerebral and the natural, which is exemplified by the still-pervasive art nouveau esthetic of organic form). Laude and de Romilly stand out in the cubist literature for their treatment of this issue. Further investigation of the matter, however, reveals that distaste for cubist geometry is difficult to contain within one over-arching cultural paradigm (see chapter two); and moreover, that humorists also appropriated cubism as a fertile language of comic burlesque, not strictly a form of satirical reproach (see discussion which follows).

129. In his memoirs, Chevalier himself describes the "Valse renversante," which he first danced *c.* 1910; see Chevalier, *Ma Route et mes chansons 1.* (Paris 1946), 192–4.

130. Or perhaps this technique was borrowed back: in 1913, the celebrated illustrator Willette wrote a letter to the journal *L'Action d'Art* claiming to have invented so-called "futurist" devices for the representation of movement years before in his drawings for *Le Chat Noir*; see Adolphe Willette, *Action d'Art* (May 10 1913), 3. David Kunzle traces this manner of "oscillation" back to 1865, in the caricatures of Wilhelm Busch, well before Willette, as well as the photographs of Muybridge and Marey. Kunzle believes that the original source for the visual device came from optical toys. See Kunzle, *The History of the Comic Strip: The Nieteenth Century* (Berkeley and Los Angeles 1990), Chapter 15, "Movement Before Movies: The Language of the Comic Strip," especially 351–65.

131. Jean Lafranchis, *Marcoussis: sa vie, son œuvre* (Paris 1961), 55. For Lafranchis, "dessin journalistique" was a burden which Marcoussis left behind, along with a bourgeois lifestyle, after his break with Marcelle Humbert.

132. Apollinaire, "Vernissage," *L'Intransigeant* (March 27 1912); English translation in ed. Breunig, *Apollinaire on Art*, 221.

133. See Raymond Bachollet, "Juan Gris, Dessinateur de presse," in *Juan Gris et les dimanches de Boulogne* (Boulogne-Billaincourt 1987), 15–26.

134. For the sociology of the *caboulot*, see Auguste Vermorel, *Ces Dames: Physionomies parisiennes* (Paris 1860); for the art, see John Grand-Carteret, *Raphael et Gambrinus, ou l'Art dans la brasserie* (Paris 1886), 23–31, 69–70. For a mid-nineteenth century example, see Renoir's painting *Cabaret of Mère Anthony* (1866), which is reproduced and discussed in Galeries nationales du Grand Palais, *Renoir* (Paris 1985), 66–8; the background of the picture represents a wall of caricatures, including a portrait of Henri Murger by Renoir himself.

135. For description, see Francis Carco, "Un cabaret pittoresque," *Homme Libre* (October 1 1913), 1; *Idem.*, *De Montmartre au Quartier Latin* (Paris 1927), 69; Alice Halicka, *Hiers (Souvenirs)* (Paris 1946), 44; Roland Dorgelès, *Bouquet de Bohème* (Paris 1947), 229.

136. See Raoul Gineste, *L'Art à la Taverne de Paris* (Paris 1906).

137. See John E. Bowlt, "Natalia Goncharova and Futurist Theater," *Art Journal* (Spring 1990), 44–51.

138. Anon., "Echos – Le Triomphe du cubisme," *Homme Libre* (May 12 1913), 1.

139. For the earliest reference to Sonia Delaunay's dress, see Edmond Courtot, "De la Mode Esthétique Vivante," *Montjoie!* (April-May-June 1914), 23–4, where it is reproduced twice, from the front and the back, and labeled "Robe 1913 et Voilette 1912 'Simultané'." See also Robert Delaunay, "Sonia Delaunay-Terk" (1938) and "The 'Simultaneous' Fabrics of Sonia Delaunay" (1938), in ed. Arthur A. Cohen, and trans. David Schapiro and Arthur A. Cohen, *The New Art of Color: The Writings of Robert and Sonia Delaunay* (New York 1978), 132–9; and Virginia Spate, *Orphism: The Evolution of Non-Figurative Painting in Paris, 1910–1914* (Oxford 1979), 56–7. For

Robert Delaunay and the cenacle at the Closerie des Lilas, see Bernard Dorival, "Robert Delaunay et le Cubisme," in *Travaux IV: Le Cubisme* (Saint-Etienne 1971), 96.

140. Spate, *Orphism*, 56–7.

141. *Ibid.*, 56–7.

142. See Gopnik, "Caricature," in Gopnik and Varnedoe, *High and Low, Modern Art and Popular Culture* (New York 1990), 133. In addition to that essay, see also Gopnik, "High and Low: Caricature, Primitivism and the Cubist Portrait," *Art Journal* (winter 1983), 371–6.

143. See Christopher Green, *Juan Gris* (London 1992), 115–23.

144. Axsom, *Parade*, 74–5; Martin, "The Ballet Parade," 106; McQuillan, *Painters and the Ballet* 187, 420; Rothschild, *Picasso's "Parade,"* 133, 165.

145. This was proposed first by Kenneth Silver in his essay "Jean Cocteau and the *Image d'Epinal*: An Essay on Realism and Naiveté," for *Jean Cocteau and the French Scene* (New York 1984), 81–105. Silver submits that Cocteau suggested the "Cris de Paris" to Picasso as source material.

146. Henri Beraldi, *Paris Qui Crie: Petits Métiers* (Paris 1890), X–XI.

147. "En ce moment même, nous assistons à diverses tentatives de transformation de la publicité française. Ces tentatives sont encore à l'état d'enfance; elles ont trop peu de vie pour qu'il soit possible, dès maintenant, de leur assigner une palce définitive dans l'existence intellectuelle de Paris, mais elles marquent cependant le début d'une évolution singulière qu'il faut souligner." Ernest Maindron, *Les Affiches illustrées (1886–1895)* (Paris 1896), 27.

148. A. Coffignon, *Le Pavé Parisien* (Paris n.d.), 125–43. A *terminus post quem* for *Le Pavé Parisien* can be established at 1886, a date which is referred to in the text.

149. Pierre Mac Orlan, "Petits Métiers de Paris – L'Homme Sandwich," *Le Journal* (March 8 1914), 6. One dissenting opinion concerning the currency of the *homme-sandwich* should be noted. See G. d'Avenel, *Le Mécanisme de la vie moderne*, vol. 4 (Paris 1902), 168, where the sandwich-board and related devices are said to be in decline, an opinion which is contradicted by most other evidence.

150. See Cooper, *Picasso Theater*, 26.

151. Cocteau, "Le Théâtre de la Rue," in *Le Foyer des Artistes* (Paris 1947), 10–12.

152. "Le citoyen . . . pense et agit plus audacieusement. Rien ne semble exagéré, et la concurrence provoque en ce domaine nouveautés sur nouveautés." Comfort, "Variétés Américaines," *La Publicité* (January 1912), 35.

153. "Cette transformation de l'homme-sandwich en gentleman-sandwich s'applique aux réclames les plus diverses." *Ibid.*, 35. However, oversized mock-ups of commodities – including a giant hat – were displayed on horse-drawn carts in London as early as the 1840s (the hat was described by Thomas Carlyle in *Past and Present*); see Thomas Richards, *The Commodity Culture of Victorian England* (Stanford 1990), 48–9.

154. "accident organisé." See Cocteau, "La Collaboration," 30.

155. "carcasses, mal construites par un futuriste d'après les modèles réduits." Cocteau, "Picasso" (1923), reprinted in Cocteau, *Entre Picasso et Radiguet* (Paris 1967), 124. In his memoirs of the Ballets russes, Boris Kochno also refers to the *cartonnier*'s bad construction of the Horse, which, as Cocteau maintained, resulted in heightening the comic effect. See Kochno, *Le Ballet* (Paris 1954), 206. In a later recollection, Cocteau names Prampolini, Balla and Carrà as the futurists who helped construct the Manager costumes. See Cocteau, *My Contemporaries* (Philadelphia 1968), 71, cited in McQuillan, *Painters and the Ballet*, 284. There is also evidence that the *cartonnier* in question was the futurist artist and scenographer Fortunato Depero. See Martin, "The Ballet Parade," 101, 110 n. 25, who cites Bruno Passamani, "Depero e la scena," *Nadar*, 2 (1970), 61 n. 15. The full implication of a faulty realization of Picasso's costume designs remains to be explored.

156. "Deux monstres cubistes, pareils à des hommes-sandwich qui ne porteraient pas de simples écriteaux, mais des amoncellements d'accessoires inextricables et baroques." Souday, "Un Ballet Cubiste," 3.

157. "mais nous n'avions pas encore vu la colonne baladeuse glissant doucement sur le sol, à l'effarement des passants"; "édifice spontané, champignon de trottoir"; "l'étrangeté . . . est indéniable"; "décon-

certant . . . amusés." F. Bacon, "La Publicité dans la Rue: Nouvelle utilisation des Hommes Sandwiches," *La Publicité* (September 1913), 327–8.

158. "les divinités vulgaires de la réclame . . . étonneront peut-être par leur taille géante." Cocteau, "Avant 'Parade'," 5.

159. Hermant, "Théâtres – Les Ballets Russes," 5.

160. "des impresarii portant sur leurs épaules de véritables monuments." L. Lefranc, "En pleins chants," *Le Strapontin* (June 1917), 4.

161. "hideuses constructions géométriques." Poueigh, "Le Carnet des Coulisses: La Musique – Parade . . . ," 12.

162. "deux personnages monstrueux, qui ont des jambes comme vous et moi et un corps monumental d'angles droits." De Saix, "Le Théâtre – Les Ballets russes au Châtelet," 2.

163. "ce sont des plans, des volumes géométriques d'un agencement fantasique. Mais sous le ventre de l'un sortent deux petites pattes humaines, qui se trémoussent ignoblement." Bidou, "La Semaine Dramatique – A propos de ballets," 3.

164. "un monsieur qui a l'air d'un kiosque qui marche"; "un défi au bon sens." Felix Potin, "La Potinière," *Fantasio* (September 15 1917), 659.

165. "notoriété publique que les Potages Knorr sont une marque allemande." Anon., "Ce que l'on a pu voir à Paris," *La Publicité* (March 1914), 63.

166. Gabriel Mourey, *Fêtes Foraines de Paris* (Paris 1906), 78. For Barnum as a high-priest of "la déesse Réclame," see Marcel Schwob, "Barnum," *L'Evènement* (April 12 1891), reprinted in Schwob, *Les Œuvres complètes de Marcel Schwob (1867–1905): Chroniques (inédit)* (Paris 1928), 91–6.

167. For a review of the various first-hand accounts of Picasso's contact with the circus and *fête foraine* community, see Reff, "Harlequins, Saltimbanques, Clowns and Fools," 33; and Rothschild, *Picasso's "Parade*," 225.

168. Mourey, *Fêtes Foraines de Paris*, 77–8. See Brown, *Gypsies and Other Bohemians*, 31, concerning the formation of a Union foraine during the Second Empire, and the gradual transformation of the itinerant, bohemian *fête foraine* into an organized business, a condition which probably intensified friction between performers and fairground management. Concerning the role of the Managers as barkers, Martin and Rothschild believe that the French Manager might be a caricature of Diaghilev, an impresario and public-relations man; see Martin, "The Ballet *Parade*," 106; Rothschild, *Picasso's "Parade*," 171.

169. F. Bacon, "La Publicité dans la Rue: Nouvelle utilisation des Hommes Sandwiches," 327.

170. Cocteau, "La Collaboration," 30.

171. This 1913 antecedent has been remarked upon by Michèle Richet, *Musée Picasso: Catalogue sommaire des collections, vol. II* (Paris 1987), 154, and developed by Rothschild, *Picasso's "Parade*," 165, 186.

172. Axsom, *Parade*, 80–3; and Martin, "The Ballet *Parade*," 106.

173. Rothschild notes a stylistic similarity between the Managers and drawings from this series; see Rothschild, *Picasso's "Parade*," 167.

174. See Coffignon, *Le Pavé Parisien*, 127–8; Maindron, *Les Affiches illustrés*, 28; Mac Orlan, "Petits Métiers de Paris – L'Homme Sandwich," 6.

175. "syntaxe vagabonde . . . orthographe capricieuse." Victor Fournel, *Ce qu'on voit dans les rues de Paris* (Paris 1858), 285.

176. Such objects were, by the turn-of-the-century, subjected to careful historical study. See, for example, John Grand-Carteret's monograph, *L'Enseigne. Son histoire. Sa Philosophie. Ses Particularités* (Grenoble 1902).

177. Reproductions from a catalogue of this kind published in 1909 by Collomb and Mossan, a manufacturer of architectural ornaments for commercial use, can be found in Musée de la Publicité, *A la belle Enseigne* (Paris 1983), inside covers.

178. A partial exception would be Boccioni's free-standing *Development of a Bottle in Space*, 1912.

179. This is the same competition to which Gérôme submitted his celebrated optician's sign – a monocled terrier underneath of which is inscribed the syllabic pun "O PTI CIEN." It is pl. 2 in the catalogue.

180. Marie-Claude Delahaye, *L'Absinthe, Histoire de la Fée Verte* (Paris 1986), 55–60. The shape of the fake sugar cube, echoing the sillhouette of the mountain, also represents the dissolving effects of water, which is poured over the sugar through the

strainer during the preparation of a glass of absinthe.

181. Louis-Frédéric Sauvage, "Le Cubisme intégral," *Paris-Journal* (December 11 1911), 4.

182. "lois absolues de la nature"; "cette extrême fantaisie n'est admissible que comme un jeu." Kean, "La Vie Théâtrale – Théâtre du Chatelet: Ballets russes," *L'Evènement* (May 23 1917), 3.

183. For *hommes-sandwich*, see program for *La Revue des Folies-Bergére* by P.-L. Flers, October 1912; for *femmes-sandwich*, see program for *La Revue de l'Année* by Rip and Bosquet, November 1912.

184. Lazare Sainéan, *L'Argot des tranchées* (Paris 1915), 112, 148.

185. This disruption is remarked by most commentators of *Parade*, and it is generally treated as a shocking contrast for the audience. In favoring Cocteau as the dominant author of the ballet's design, however, it is easy to neglect the possibility that the jolt may have been calculated as such by Picasso. Silver, for example, simply credits Cocteau with the juxtaposition of Latinism and cubism, and treats it as a well-intentioned miscalculation. See Silver, *Esprit de Corps*, 123. (This would conform to Cocteau's own appeasing defense of *Parade* in *Vanity Fair*, where he explains that "to show that it was not our intention to surprise the public but, on the contrary, to follow in the footsteps of the masters, Picasso and Satie opened the spectacle with a curtain and a fugue of a classic nature, from which all the scenery and all the music that followed seemed to flow as a natural development." See Cocteau, "Parade: Ballet Réaliste," 106.) Stylistic heterogeneity, however, is a cardinal feature of Picasso's cubism beginning in 1912; and by 1917, even the shuffling of classicizing realism and cubist stylization was part of Picasso's standard pictorial syntax.

186. See, for example, Raynal, 'Conception et vision," *Gil Blas* (August 29 1912), 4; and "Qu'est-ce que . . . le "Cubisme'," *Comoedia illustré* (December 20 1913), np. See also Lynn Gamwell's synopsis of Raynal on cubism in Gamwell, *Cubist Criticism* (Ann Arbor 1980), 46–8, 60–1.

187. Raynal, "Manuel du parfait homme d'esprit," *Les Soirées de Paris*, no. 7 (1913), 147–52; and "Manuel du parfait homme d'esprit," *Le Spectateur* (October 1913), 399–403. In subsequent notes, they will be referred to respectively with the Roman numerals I and II. Both articles contain a footnote that refers to the forthcoming book, which, however, I have been unable to locate. Apollinaire refers to the work as early as July 1911, in an item for *Intransigeant*, noting that the epigraph reads: "l'esprit est une science, et non pas un art." Reprinted in Pierre Caizergues ed., *Petits Merveilles du Quotidien par Guillamre Apollinaire* (Paris 1979), 48–9.

188. "raison d'être principales et habituelles." Raynal, "Manuel du parfait homme d'esprit," I, 147.

189. "Cependant . . . à force de médicines et de saignées, la maladie de Candide devint sérieuse." *Ibid.*, 149.

190. "a été vulgarisé avec succès . . . une des lois importantes d'un Manuel de la Rosserie qu'il faudra bien écrire quelque jour." *Ibid.*, 148.

191. "Soit une personne, un fait, un objet, un mot ou une sensation, dont la ressemblance avec quoique ce soit et quelle que vague qu'elle soit, vous frappera subitement. Relever immédiatement cette ressemblance et en confondre systématiquement les objets." Raynal, "Manuel d'un parfait homme d'esprit," II, 399.

192. "de prendre une chose pour une autre intentionnellement et dans un sens facétieux." *Ibid.*, 399.

193. "nos modernes "excentrics' anglais ou américains. Celui qui tirait ingénument de sa poche un énorme arrosoir pour arroser la fleur qu'il portait à sa boutonnière, qui sortait de même une immense scie pour couper un cigare qui se trouvait être de fer, et qui raccomodait les déchirures de son pantalon avec un cadenas, sembler obéir à la loi." *Ibid.*, 400.

194. "le burlesque d'autrefois étant devenu l'humour de nos jours." *Ibid.*, 403.

195. François Caradec and Alain Weill, *Le Café-Concert* (Paris 1980), 130.

196. Henry de Forge, "Simili-Etoiles," *Comoedia illustré* (supplement to June 15 1910), 530–1.

197. "de basse démagogie, de parlementarisme, et de médiocrité"; "qui pousse le comique jusqu'aux extrêmes limites de l'incohérence et de l'absurdité." Gavroche, "Dranem," *Les Hommes du Jour* (December 29 1910), 2.

198. "s'appuie sur le rebord en faux zinc de la toile peinte. La toile bouge; mais Dranem ne bouge pas"; "tomber en disant: 'je meurs empoisonné', et de se relever ensuite pour annoncer le cinqième tableau." Émile Zavié, "Dranem à l'Odéon," *Le Feu* (October 1910), 51.

199. Raynal, "Conception et vision," *Gil Blas* (August 29 1912); English translation in Edward Fry, *Cubism* (New York 1978), 96.

200. "horriblement vulgaire...dénuées de sens...Il n'est pas si facile qu'on le croit de vider les mots d'une langue de tout ce qu'ils contiennent de sens. Quelques Parnassiens de la décadence, M. Stéphane Mallarmé, par exemple, ou M. Paul Verlaine, ont vainement essayé de lutter d'incompréhensibilité avec la chanson de café-concert." Brunetière, "Les Cafés-Concerts et la Chanson française," *Revue des Deux Mondes* (October 1 1885), 694.

201. "Dans les monologues des clowns et des comiques de variété on trouve des allusions typiques à l'onomalangue qui connaîtront plus tard des développements, en constituant la langue la mieux adaptée à la scène et particulièrement aux exagérations hilarantes." Depero, "L'onomalangue – Verbalisation abstraite," (1916), in Giovanni Lista, *Futurisme: Manifestes, Documents, Proclamations* (Lausanne 1973), 152. Lista also notes (152–35) that abstract and onomatopoeic poetry was futurist cabaret fare in 1914, two years before Hugo Ball's "discovery" of the phonetic poem at the Cabaret Voltaire in Zurich, in June 1916.

202. With regards to "systematic confusions," much later, Picasso was quoted as describing an esthetic principle of "rapports de grand écart – the most unexpected relationship possible between the things I want to speak about." See F. Gilot and C. Lake, *Life With Picasso* (New York 1964), 53.

203. For information both general and specific on *SIC* and *Les Mamelles de Tirésias*, see: Anon., "Le 24 Juin 1917," *SIC* (June 1917), np; Pierre Albert-Birot, "Les Mamelles de Tirésias," *Rimes et Raisons* (cahier spéciale consacré à Guillaume Apollinaire 1946), 43–7; Pierre Albert-Birot, "Naissance et vie de 'SIC'," *Les Lettres Nouvelles* (September 1953), 843–59. For the comical reading of the SIC acronym, see Anon., "Le Carnet du

Liseur – Les Périodiques," (July 1 1917), 14. Most recently, see Annabelle Melzer, *Latest Rage the Big Drum: Dada and Surrealist Performance* (Ann Arbor 1980), 122–35. Compared to *Parade*, *Les Mamelles de Tirésias* is otherwise neglected in literature on the avant-garde of the period. For elements of the music-hall in Apollinaire's writings for the theater, including *Tirésias*, see Willard Bohn, *Apollinaire et l'Homme sans Visage. Création et Evolution d'un Motif Moderne* (Rome 1984), 144–9.

204. Birot, "Les Mamelles de Tirésias," 43–4.

205. See Anon., "Le Carnet des coulisses – Les Mamelles de Tirésias," *Le Carnet de la Semaine* (June 24 1917), 16.

206. Anon., "Les Mamelles de Tirésias," *Nord-Sud* (June – July 1917), 3; Guillot de Saix, "Le Théâtre – *Les Mamelles de Tirésias* au Théâtre Renée Maubel," *La France* (June 29 1917), 2; R. de Bury, "Les Journaux – *Une esthétique nouvelle* (Le Pays, 24 juin)," *Mercure de France* (July 15 1917), 330–1; Victor Basch, "Critique dramatique – Conservatoire de Mme Renée Maubel," *Le Pays* (July 15 1917), 2.

207. Paul Souday, "La Semaine Théâtrale et Musicale – Une pièce cubiste," *Paris-Midi* (June 26 1917), 3; Pierre Verron, review of *Tirésias* from *La Semaine de Paris*, quoted in Anon., "Extraits de la presse concernant la représentation des 'Mamelles de Tirésias' le 24 juin 1917," *SIC* (July–August 1917), np. Like Cocteau's subscription to the Argus press-clipping service, this seven-page collection of extracts in *SIC* encourages us to recognize that the critical press was not dismissed, but watched by the avant-garde. In one letter to Birot around the time of *Tirésias*, Apollinaire questions Birot's decision to devote part of an issue of *SIC* to extensive extracts from the press, remarking that they are "sans grand intérêt"; subsequent letters show, however, that he was quite concerned over bad notices. See Apollinaire, *Œuvres complètes de Guillaume Apollinaire*, ed. Michel Décaudin (Paris 1966), vol. 3, 888–91.

208. "Au fond, Guillaume Apollinaire est traditionnaliste et sous l'apparent désordre des idées, sous sa fantaisie tintamarresque, clownesque, guignolesque, il demande le retour à l'ordre." De Saix, "Le Théâtre – *Les Mamelles de Tirésias* au Théâtre Renée

Maubel," 2.

209. Paul Souday, "La Semaine Théâtrale et Musicale – Une pièce cubiste," 3; review from *La Griffe* (July 6 1917), quoted in Anon., "Extraits de la presse concernant la représentation des "Mamelles des Tirésias' le 24 juin 1917," np; Victor Basch, "Critique dramatique – Conservatoire de Mme Renée Maubel," 2; André Geiger, "Notes et Impressions – Théâtre Ancien et Théâtre Nouveau," *La Revue Bleue* (July 14–21 1917), 447.

210. Birot, "Les Mamelles de Tirésias," 45–6.

211. Anon. (André Warnod?), "Petit Courrier des Arts et des Lettres," *L'Heure* (June 25 1917), 2; René Wisner, "Le Carnet des coulisses – Premières et Reprises," 15.

212. Quoted in Anon., "Extraits de la presse concernant la représentation des 'Mamelles de Tirésias' le 24 juin 1917," np.

213. See accounts by Louise Faure-Favier, *Souvenirs sur Apollinaire* (Paris 1945), 168; Anon., "Le 24 Juin 1917," np; and Victor Basch, "Critique dramatique – Conservatoire de Mme Renée Maubel," 2.

214. Souday, "La Semaine Théâtrale et Musicale – Une pièce cubiste," 3.

215. Victor Basch, "Critique dramatique – Conservatoire de Mme Renée Maubel," 2.

216. For descriptions of Férat's stage set, see G. Divin de Champclos, "Une Manifestation 'Sic': *Les Mamelles de Tirésias*," *Le Rampe* (July 12 1917), 10; *Idem.*, review for *Le Petit Bleu*, quoted in Anon., "Extraits de la presse concernant la représentation des 'Mamelles de Tirésias' le 24 juin 1917," np; Anon., "Le 24 Juin 1917," np; Birot, "Les mamelles de Tirésias," 47.

217. For "minstrels," see André Geiger, "Notes et Impressions – Théâtre Ancien et Théâtre Nouvelle," 447; for "Gauguin cubiste," see Anon. (André Warnod?), "Petit Courrier des Arts et des Lettres," 2.

218. See M. G. Rémon, review for *Le Radical*, quoted in Anon., "Extraits de la presse concernant la représentation des 'Mamelles de Tirésias' le 24 juin 1917," np., who refers to the "gendarme chevauchant une délicieuse monture de Picasso"; and Anon., "Le 24 Juin 1917," np., for defense of Férat's costume aganst accusations of mere imitation.

219. Both references appear in Anon., "Extraits de la presse concernant la représentation des 'Mamelles de Tirésias'," np.

220. See Anon., "Le 24 Juin 1917," np; and de Saix, "Le Théâtre – *Les mamelles de Tirésias* au Théâtre Maubel," 2. In a letter to Férat, Apollinaire specifies the necessary ingredients for each costume, describing the "Journaliste parisien d'Amérique" as a "costume sauvage avec les journaux, masque et chapeau." See *Œuvres complètes de Guillaume Apollinaire*, vol. 3, 782.

221. "on s'attendait à plus d'outrance encore, à quelque chose de plus nouveau, à une révélation plus riche." Anon. (André Warnod?), "Petit Courrier des Arts et des Lettres," 2.

222. For critic René Wisner in particular, "L'œuvre de M. Apollinaire est une gageure, une façon de se moquer de tout . . . elle est tout à la fois simultanéiste, satirique, futuriste, fumiste, alchimique, réaliste et sur-réaliste." Wisner, "Le Carnet des Coulisses – Premières et Reprises," *Le Carnet de la Semaine* (July 1 1917), 15. In addition, *Tirésias* appears to have sparked a controversy within the avant-garde. In a letter to *Les Hommes du Jour*, eight painters publicly disavowed any association with the "manifestations de *Sic*." See Metzinger, Juan Gris, Diégo Rivera, André Lhote, Henri Hayden, Kissling and Gino Severini, letter to the editor, *Les Hommes du Jour* (June 7 1917), np. Though the letter was published over two weeks before the performance of *Tirésias*, Apollinaire referred to "Metzinger, Gris et d'autres culs de cette sorte" in his own letter to Pierre Reverdy dated June 28, directly linking their protest to *Tirésias*, which would have been in production when the letter was composed. See Apollinaire, *Œuvres complètes de Guil-laume Apollinaire*, vol. 3, 890. The reason for the dissent is never made explicit but, at the least, it suggests a conflict of the comic and the sincere in period appreciation of the piece. Roughly one year later, in the pages of *SIC*, Louis Aragon would recall this incident, noting that the "vraie signification" of *Tirésias* was misunderstood by certain "ingrats, (qui) avaient bien ri cependant!" See Aragon, "Le 24 Juin 1917," *SIC* (March 1918), np. It remains impossible to settle this question of "vraie signification." As reported in chapter three, depopulation had been an issue of national interest since

1912. Interestingly (given Apollinaire's choice of Zanzibar as a setting for the play), depopulation was also addressed at the time as a serious concern in French colonial Africa. See J. Arren, "L'Afrique se dépeuple," *L'Eclair* (February 28 1914), 1; René Le Coeur, "Pourquoi l'Afrique se dépeuple-t-elle," *Le Journal* (March 6 1914), 6. Depopulation in France was attributed to a declining birthrate; in Africa, to disease, including syphillis, contracted from colonialists. Naturally, however, depopulation was bound to be a topic of particular nationalistic concern during the war. In fact, Apollinaire himself wrote an editorial on the subject, in which he laments the low birth rate in wartime France, and calls for a "military salute to pregnant women." See Apollinaire, "Anecdotiques – Le Salut militaire aux femmes enceintes," *Mercure de France* ( January 16 1917); reprinted in ed. Michel Decaudin, *Œuvres complètes de Guillaume Apollinaire, Vol. 2* (Paris 1965), 488–9. But Apollinaire's reputation as a *mystificateur* leaves the sincerity of his statement, and therefore of *Tirésias*, open to question. See Francis Steegmuller, *Apollinaire: Poet among the Painters* (New York 1986), 261.

223. This was despite the fact that Apollinaire had previously expressed his faith specifically in the burlesque energy of the circus as a possible model for new theater. See Apollinaire, "Les Tendances nouvelles," *Sic* (August–September–October 1916), np.

224. As we have seen in chapter three, the depopulation *actualité* was a topic of the music-hall *revue*, anticipating Apollinaire's more sustained treatment in *Tirésias*.

225. "une petite fille, un jongleur, une vache et un pompier, présentés par un futuriste et deux impressarii grotesques habillés à la manière de Picasso." Guillot de Saix, "Le Théâtre – *La Revue des Femmes* à la Cigale," *La France* (September 27 1917). One critic noted that this send-up of the "loufoqueries des Picasso-Satie-Cocteau" was inadequately caricatured, and therefore only mildly amusing; in addition, the role of the two Managers, "qui portent leur maison," was given to two extras who did not really know how to dance. See André Fougère, "Boulevards-Montmartre et Retour – A la Cigale," *Les Spectacles* (September 30–October 14), 1917, 6. There was at least one other such parody, at the Concert Mayol in August. There, a woman, "affolée par les Ballets russes," improvised a performance with her husband Philistin, her daughter Philogène, and her lover, "un faux Nijinsky." Apparently, the focus of attention was Satie's music for *Parade* (and Cocteau's plans for a "trompe l'oreille" instrumentation); the score was mocked by an orchestration incorporating a coffee grinder, an automobile horn, cymbals, violas d'amour, chinese hats, accordeons, harps, castanets, English fifes and a Basque drum. See Guillot de Saix, "Le Théâtre – *La Revue Sensationnelle* au Concert Mayol," *La France* (August 1 1917), 2.

226. Génold, "Artistes et farceurs," *La Forge* (4ème 1917), 116–20.

227. M. B., "Variété – Le Dadaisme n'est qu'une farce inconsistante," *L'Action française* (February 14 1920), 2.

228. For a detailed account of the performance, see Michel Sanouillet, *Dada à Paris* (Paris 1993), 171–7.

# INDEX